THE ENCYCLOPEDIA OF
WAR MOVIES

THE ENCYCLOPEDIA OF
WAR MOVIES

*The Authoritative Guide to Movies
About Wars of the Twentieth Century*

ROBERT DAVENPORT

Checkmark Books®
An imprint of Facts On File, Inc.

The Encyclopedia of War Movies

Checkmark Books
An imprint of Facts On File, Inc.
132 West 31st Street
New York NY 10001

Library of Congress Cataloging-in-Publication Data

Davenport, Robert Ralsey, 1950–
The encyclopedia of war movies: wars 1900 to the present /Robert Davenport.
p. cm.
Includes bibliographical references and index.
ISBN 0-8160-4478-3 (hc. : acid-free paper)
ISBN 0-8160-4479-1 (pbk. : acid-free paper)
1. War films—Catalogs. I. Title
PN1995.9.W3D38 2003
791.43'658—dc21 2002045201

Checkmark Books are available at special discounts when purchased in bulk
quantities for businesses, associations, institutions, or sales promotions.
Please call our Special Sales Department in New York at
(212) 967-8800 or (800) 322-8755.

You can find Facts On File on the World Wide Web at
http://www.factsonfile.com

Text design by Cathy Rincon
Cover design by Nora Wertz

Printed in the United States of America

VB FOF 10 9 8 7 6 5 4 3 2 1

This book is printed on acid-free paper.

Contents

Acknowledgments

There are people whom I would like to thanks for their help, support, and inspiration
in the compilation of this work.

Special thanks must go to Jake Elwell, at Wieser and Wieser, my book agent, without whom
I would never have written this book; to Gary Goldstein, who acquired the book for Facts On
File; and of course to James Chambers, my long-suffering editor at Facts On File,
who had to deal with my mammoth manuscript.

I would also like to thank Lenny Bekerman, my manager, for his indefatigable
efforts on behalf of my feature film scripts.

A large part of this book was written during my deployment to the Balkans as a lieutenant
colonel with the Kosovo Force. I want to thank those with whom I served during that
deployment, including my good friends Major General Amilcare Casalotto (Italian army),
Captain Cosimo Prencipe (Italian army), Rexhep Meidani (president of Albania),
and General Ramadani (Albanian army).

Lastly, I would like to dedicate this book to my father,
Commander Harry Augustus Davenport, United States Coast Guard,
who served during World War II, Korea, and Vietnam;
my uncle, Colonel Richard Morton Cosel, United States Air Force
(World War II, Korea, and Vietnam); and my grandfather,
Lieutenant Colonel Harry A. Davenport, United States Army,
who served in the Mexican Border Campaign, World War I, and World War II—
all of whom instilled in me an appreciation for military service,
and an inexhaustible appetite for war movies.

Introduction

> Private: Why us? Why does it have to be us?
> Sergeant: Because we're here, lad. Just us,
> and nobody else.
> —Quote from the film *Zulu*

In one respect, the war film is the perfect cinematic form, because it contains the three vital ingredients—conflict, conflict, and conflict—that in film school every screenwriter is taught must be in every scene of every screenplay. Inherent in the war film are not only the inevitable conflict with the enemy, the classic battle of good versus evil, but also conflict between the hero and his superior officers and conflict between the hero and his fellow soldiers.

In many ways, the war film is the original action adventure film and still the mainstay of the action film genre. In addition, the war film easily accommodates many other genres, such as the romantic comedy (*The Americanization of Emily*), within its structure making it among the most versatile of all film forms.

The war film has been a popular staple of the movie business since its inception. The same period of creative mechanical invention that brought about the movie camera, which is the very foundation of modern show business, also unleashed on civilization the machines that signify modern warfare: the airplane, the machine gun, the tank. The wars that occurred during the evolution of the film business became the natural subject for feature films, and our perception of this facet of our history is shaped as much by the films about war as by our perceptions of the actual events. While a very small percentage of people actually experience combat in each generation, everyone experiences the films made about these wars, and it is the war films, rather than the actual wars, that define our perceptions of this facet of our history. For example, while relatively few soldiers actually took part in Operation Market Garden during World War II, the sacrifices of those who took part in the campaign will never be forgotten because of the feature film *A Bridge Too Far*. While some may quibble about various minute historical inaccuracies, by and large most agree that this is a very accurate portrayal of the battle. And even were it not accurate, for the great majority of the population, this film, and not the numerous scholarly books on the subject, will define this battle for generations to come.

Because the war film carries with it this almost sacred trust to preserve history, it is the opinion of this author that writers, directors, and producers, whenever possible, should try to stay as close as possible to the actual historical reality when producing war films. As a screenwriter myself, I acknowledge the difficulties that are sometimes attendant to serving both the story, the popular moviegoing public, and history, but I still advocate, when the choice is there for the creative talent, a lean toward the historical.

Because films by and large both reflect history and distort it, I have tried within the boundaries of this tome to present the reader with a guidebook, if not an armchair companion, to war films history. This is one of the most important benefits of owning this book. For each film that portends to reflect a real moment in history, I have endeavored to include information about both the actual historical battle, as well as those ways in which the film deviates from the historical record. With this guidebook in hand, war movie aficionados can watch all of their favorite movies once again, with a weather eye on history.

The Academy Awards, that pinnacle of industry approval, are also a reflection of the public's continuing fascination with the war film. The very first Oscar for best picture was given to Wings, a film about air combat in World War I. It was followed very shortly thereafter by a win for *All Quiet on the Western Front*, a classic story of trench warfare, told uncharacteristically from the German point of view. Other war films that received the top Oscar for best picture include *Gone With the Wind, From Here to Eternity, The Bridge on the River Kwai, Lawrence of Arabia, Patton, The Deer Hunter, Platoon, and Braveheart*. Not only has the top Oscar gone to many war films over the years, but it has also gone to films that might not be classified strictly as war films but are set during or after a war,

such as *Mrs. Miniver, Casablanca, The Best Years of Our Lives, Schindler's List, Forrest Gump,* and *The English Patient.*

War movies are a classic genre, and are never out of style. Recent nominees for best picture have included *Saving Private Ryan* and *The Thin Red Line,* and I worked as a technical adviser on *Pearl Harbor.* War movies not only grab the critical honors, but they are also good box office.

War films have one great distinction over other genres, like westerns or horror films, in that they are often based on real events. Some films, like *Patton, Sergeant York,* or *The Court-Martial of Billy Mitchell,* convey stories very close to the actual historical facts. But even films that are totally fictional, such as *From Here to Eternity or Platoon,* give us a realistic picture of the actual historical events into which the fictional characters are placed. *From Here to Eternity* captures the actual attack by the Japanese on Pearl Harbor, and *Platoon* reflects the real-life experiences of Vietnam veterans in combat.

The history of film is also the history of the war film. One of the earliest commercial films was 1898's *Tearing Down the Spanish Flag,* from the Vitagraph Company. Because of its release amid the hysteria of the Spanish-American War, it was extremely successful. It taught the infant film industry an important lesson: Films about war, especially the current war in progress, will be enthusiastically embraced by the film-going public.

With the United States entry into World War I, films about the evil Hun abounded, and this continued during the interwar period. The biggest money-maker of the silent era was *The Big Parade,* a film by director King Vidor. It not only had lavish battle sequences, but also audiences were titillated by lip reading all of the vulgarities mouthed by the heroes in this silent epic. Films about the Great War remained a staple until supplanted by the best war ever to come along for the movie maker, World War II.

This war made perfect moviemaking for a number of reasons. The enemy this time was really, really evil, whether it was the goose-stepping Nazis overrunning Europe or the treacherous Japs sneaking up on Pearl Harbor. The combat took place worldwide, so that films could be set in any locale, from Tarzan fighting the Nazis in deepest Africa to Doolittle's aviators being forced down in China.

Every film made during the war carried the same patriotic message: It was the loyal duty of every patriotic American to support the war effort. Those on the home front were convinced that using that extra gallon of gas for a Sunday drive would be playing right into Tojo's hands.

At the beginning of the war, in films such as *Wake Island* (1942), the United States is definitely on the losing end of the war. The marines bravely hold out, until overrun by the overwhelming hordes of Japs. Similarly, in *Bataan* (1943), in the last memorable scene, Robert Taylor, the sole survivor of his infantry squad, is on his machine gun, blasting away at the banzai charge that is going to seal his fate. The studios made the effort to showcase all of the services, and *Destination Tokyo* (1943), with Cary Grant as a submarine skipper, and *Air Force* (1943), directed by Howard Hawks, are excellent examples of the efforts of the studios to focus on all branches equally. As the war turned in the Allies' favor, so did the movies, with films such as *Guadacanal Diary* (1943) and the inspiring *Thirty Seconds Over Tokyo* (1944), reassuring the populace that an Allied victory was in the making.

Films about World War II have continued down to the present day. The latest surge of such films has been fueled by the success of such movies as *Saving Private Ryan.* World War II will always be the "good war," in which the lines about good and evil are clearly drawn, men are fighting and dying for a reason, and everyone on the home front is behind them.

However, a different tenor pervades films made during and about the Korean and Vietnam conflicts. The lines are not as clear-cut, and as a result the attitudes expressed in these films often reflect on the absurdity of war, as in *M*A*S*H,* the classic story of army doctors in Korea, *The Bridges at Toko-Ri,* with William Holden as a fighter pilot questioning why he is fighting and dying in a mud ditch in Korea, and *The Deer Hunter,* which depicts the confused mental state of soldiers fighting in Vietnam. During the height of the Vietnam conflict, such uncertainty about the virtues of war permeated even films about earlier eras, giving rise to such movies as *Gallipoli,* about the ill-fated World War I campaign by the Australians; *A Bridge Too Far,* about the failed British Operation Market Garden during World War II; and Breaker *Morant,* about Australian soldiers being sacrificed for political reasons as the British try to stop an unpopular war. The allegory to an America bogged down in Vietnam is only too obvious.

However, Hollywood always bounces back to its old standby, World War II. During the height of the Vietnam War, with all of Hollywood actively campaigning against the war, the power moguls still made *Patton,* which went on to garner best picture nods from Oscar, and which still stands not only as one of the best war films, but also as one of the best film biographies ever made.

This is probably the best juncture in this introduction to reflect on the limits that were placed on the

author by the editors in their definition of "war movies." Although recognizing that the term "war movies" can span the entire epoch of man, for the purposes of this encyclopedia, the films were restricted to those of the 20th century, in effect beginning with the Boxer Rebellion of 1900 (with 55 *Days at Peking*) and ending with the Gulf War and the campaigns in the Balkans. By restricting the war movies to this epoch, the concentration has remained on those wars that occurred during the movie era. This was the same time period in which the motion picture camera was coming of age, and the films made during this period of history reflect more accurately than any others the reality of their times.

The author is painfully aware of the large number of quality war movies that are excluded by this definition, many of which are among my favorites. Whether it is the history of the ancients, such as *300 Spartans*, the British colonial wars, typified by the classic *Zulu*, early American history, with Spencer Tracy in *Northwest Passage*, or John Ford's cavalry trilogy of *Fort Apache, She Wore A Yellow Ribbon*, and *Rio Grande*, I am aware that the number of films set in conflicts prior to 1900 is legion. Eventually there will be a companion volume to make its way to the bookstores, to ensure that *Spartacus, Gladiator, Drums Along the Mohawk, The Buccaneer, The Patriot*, and hundreds of other great war films are properly documented.

The war film, as it evolves and becomes more sophisticated with time, tackles increasingly complex issues, and the characters become more complex. No longer the simple us-against-the-enemy formula that sufficed for *Tearing Down the Spanish Flag*, the war film will continue to evolve, like every other film genre, as the plots become more complex, the characters more multidimensional. Only one thing is certain, the war movie is a classic film genre that will always remain a standby of the film industry. The wars may change, but the war film will never be abandoned by the moviegoing public.

Newspaper Editor: When the legend becomes fact, print the legend.

—Quote from the film
The Man Who Shot Liberty Valance

Entries A to Z

ABOVE AND BEYOND

Metro-Goldwyn-Mayer, 1952, b&w, 122 minutes.

Producers: Melvin Frank and Norman Panama; **Directors:** Frank and Panama; **Screenwriters:** Beirne Lay Jr., Frank, and Panama; **Music:** Hugo Friedhofer; **Distributor:** MetroGoldwyn-Mayer; **Cast:** Jim Backus, John Baer, Robert Burton, John Close, G. Pat Collins, Patrick Conway, Jonathan Cott, Lawrence Dobkin, Stephen Dunne, Marilyn Erskine, Robert Forrest, Roger Fuller, Larry Gates, Frank Gerstle, Don Gibson, Dabbs Greer, John Hedloe, Larry Keating, Dorothy Kennedy, William Lester, Lee MacGregor, Roger McGee, John McKee, Sammy McKim, Ewing Mitchell, Christie Olsen, Eleanor Parker, John Pickard, Jack Raine, Jeff Richards, Hayden Rorke, Barbara Ruick, Dick Simmons, Robert Taylor, Gregory Walcott, Harlan Warde, Crane Whitley, James Whitmore, Mack Williams.

Robert Taylor stars as Colonel Paul Tibbets in the story of the Army Air Force officer who commanded the mission that dropped the atomic bomb on Hiroshima. This was the first of the two atomic bombs that forced Japan to surrender, thus ending the war in the Pacific during World War II.

INTERESTING FACT

- The U.S. Army placed an order for the manufacture of 1 million Purple Hearts, based on its estimation of the number of soldiers who would be killed or wounded in an invasion of Japan. Because the atomic bombs were dropped, there was no need for these decorations. As a result, that supply of medals was used for wars in Korea, Vietnam, the Gulf War, Bosnia, and Kosovo, and most of them remain in the army inventory today for issue to soldiers killed or wounded in action. Failing another catastrophic conflict like World War II, the U.S. military will probably never suffer enough casualties in the remainder of its history to use the Purple Hearts that would have been needed for the invasion of Japan.

MILITARY SERVICE

- The real Col. Paul Tibbets flew antisubmarine patrols over the Atlantic, commanded 25 bomber missions in Europe, and participated in the North African campaign before being assigned to this historic mission. On August 6, 1945, while in command of the aircraft Enola Gay, a B-29 bomber, he dropped the first atomic bomb to be used in combat on Hiroshima, Japan.

AWARDS

Academy Awards (Oscar), USA, 1953
 Nominated: *Best Music, Scoring of a Dramatic or Comedy Picture*, Hugo Friedhofer; *Best Writing, Motion Picture Story*, Beirne Lay Jr.

Writers Guild of America (WGA Screen Award),
USA, 1952
Nominated: *Best Written American Drama*, Melvin
Frank, Beirne Lay Jr., and Norman Panama.

ABOVE US THE WAVES

Rank Organisation, 1955, b&w, 92 minutes.

Producers: William MacQuitty, Earl St. John; **Director:** Ralph Thomas; **Screenwriters:** James D. Benson, Robin Estridge, Charles Esme Thornton Warren; **Music:** Arthur Benjamin; **Distributor:** General Film Distributors; **Cast:** Basil Appleby, Theodore Bikel, Lyndon Brook, Cyril Chamberlain, Raymond Francis, William Franklyn, John Gregson, O.E. Hasse, Thomas Heathcote, John Horsley, James Robertson Justice, James Kenney, Guido Lorraine, Michael Medwin, John Mills, Anthony Newley, Lee Patterson, William Russell, Donald Sinden, Harry Towb, Anthony Wager, Leslie Weston.

The greatest threat to the British navy is the German battleship Tirpitz. Anchored in a Norwegian fjord, it is impossible to attack by conventional means with any chance of success. But the Royal Navy trains a special commando unit, in six midget submarines that can plant underwater explosives.

This film is based on a true story and on the following books:

Benson, James D., and Charles Esme Thornton Warren. *Above Us the Waves*. London: Harrap, 1953, and Warren, Charles Esme Thorton. *The Midget Raiders*. New York: W. Sloane Associates, 1954.

ABSENT WITHOUT LEAVE

Meridian Film Productions, 1992, color, 95 minutes.

Producer: Robin Laing; **Director:** John Laing; **Screenwriters:** James Edwards, Graeme Tetley; **Music:** Don McGlashan; **Distributor:** New Zealand Film Commission; **Cast:** Tony Barry, Francis Bell, Ken Blackburn, Margaret Blay, Jed Brophy, Chris Brougham, Tony Burton, Jodie Douglass, Grant Edgar, Joan Foster, Stephen Gledhill, Mark Hadlow, Michael Haigh, Katrina Hobbs, Rebecca Hobbs, Ross Jolly, Murray Keane, Desmond Kelly, Stephen Lovatt, Robyn Malcolm, Craig McLachlan, Danny Mulheron, Lewis Rowe, Patrick Smyth, Clinton Ulyatt.

When Daisy gets pregnant and Ed agrees to marry her, love comes as a surprise, but the army is on Ed's trail.

ACE OF ACES

RKO Radio Pictures Inc., 1933, b&w, 74 minutes.

Producers: Merian C. Cooper, Sam Jaffe; **Director:** J. Walter Ruben; **Screenwriters:** H. W. Hanemann, John Monk Saunders; **Music:** Max Steiner; **Distributor:** RKO Pictures; **Cast:** Elizabeth Allan, Ralph Bellamy, William Cagney, Frank Clark, Frank Conroy, Richard Dix, Betty Furness, Claude Gillingwater Jr., Helmut Gorin, Carl Eric Hansen, Arthur Jarrett, Anderson Lawler, George Lollier, Frank Melton, Theodore Newton, Joe Sawyer, Clarence Stroud, Claude Stroud, Grady Sutton, Frank Tomick, Nella Walker, Howard Wilson.

A sensitive young sculptor who wants no part of World War I is shamed by his wife into joining the army. He becomes a fighter pilot and undergoes a complete personality change. The more planes he shoots down, the more he becomes obsessed with gaining additional victories and medals. Finally, with 40 kills, he becomes the "Ace of Aces," a bloodthirsty killer. His wife becomes a Red Cross nurse, and he is reunited with her in a Paris bistro. She realizes that the war she forced him to join has turned him into a maniacal killer whom she can no longer love.

INTERESTING FACTS

- The film is based on *Bird of Prey*, by John Monk Saunders, and borrows several aerial action scenes from Howard Hughes's air epic HELL'S ANGELS.
- This was one of the first war films to follow the trend set by ALL QUIET ON THE WESTERN FRONT, and to combine an action-filled war film with a serious antiwar theme.

ACES HIGH

Cine Artists Pictures, 1976, color, 114 minutes.

Director: Jack Gold; **Screenwriters:** Howard Barker, Cecil Lewis, R. C. Sherriff; **Music:** Carlo Rustichelli; **Cast:** Jane Anthony, David Arnold, Christopher Blake, Judy Buxton, Gilles Béhat, Pascale Christophe, Elliott Cooper, Evelyn Cordeau, James Cormack, David Daker, Jean Driant, Peter Firth, John Gielgud, Paul Henley, Trevor Howard, Penny Irving, Barry Jackson, Richard Johnson, Kim Lotis, Jacques Maury, Malcolm McDowell, Ray Milland, Tricia Newby, Steven Pacey, Gerard Paquis, Jeanne Patou, Ron Pember, Tim Pigott-Smith, Christopher Plummer, Colin Rix, Paul

Rosebury, John Serret, Roland Viner, James Walsh, Simon Ward, David Wood.

A naive young officer straight from flight school arrives on the western front to fight the air war against the Germans. However, the life expectancy of inexperienced pilots is not very long; he has seven days of life before he will be killed in action.

The film is based on Journey's End, a 1929 play by R. C. Sherriff. He did not live to see the film adaptation of his play; he died in 1975.

INTERESTING FACTS

- Cameo appearances by Trevor Howard, Richard Johnson, John Gielgud, and Ray Milland.
- The setting for the original play was a dugout on the western front in World War I. This film relocates the story to an airfield in France, but the characters and the plot are essentially the same.

ACES HIGH: IRON EAGLE III

Carolco Pictures, 1992, color, 98 minutes.

Producers: Michael R. Casey, Stanley Neufeld, and Ron Samuels; **Director:** John Glen; **Screenwriter:** Kevin Elders; **Music:** Harry Manfredini; **Distributor:** New Line Cinema; **Filmed at:** Tuscon, Arizona; **Cast:** Tom Bower, Horst Buchholz, Christopher Casenove, Sonny Chiba, Rob Estes, Juan Fernandez, J. E. Freeman, Paul Freeman, Louis Gossett Jr., Phil Lewis, Ray "Boom Boom" Mancini, Rachel McLish, Inez Perez, Mitch Ryan, Fred Dalton Thompson.

Louis Gossett Jr. leads a group of aging action stars in vintage airplanes to confront a South American drug-smuggling operation run by a one-time Nazi, where they free a small village from the villain's control.

ACROSS THE PACIFIC

Warner Bros., 1942, b&w, 97 minutes.

Producers: Jack Saper, Jerry Wald; **Directors:** John Huston, Vincent Sherman; **Screenwriters:** Robert Carson, Richard Macaulay; **Music:** Adolph Deutsch, Heinz Roemheld, Clifford Vaughan; **Distributor:** Warner Bros.; **Cast:** Philip Ahn, Mary Astor, Monte Blue, Humphrey Bogart, Spencer Chan, Roland Drew, Frank Faylen, Lee Tung Foo, Chester Gan, Roland Got, Sydney Greenstreet, Charles Halton, John Hamilton, Richard Loo, Keye Luke, Lester Matthews, Frank

Mayo, Rudy Robles, Paul Stanton, Tom Stevenson, Kam Tong, Frank Wilcox, Victor Sen Yung.

Humphrey Bogart makes no secret of the fact that he has no loyalty to his country after he is court-martialed, stripped of his commission as an artillery officer, and expelled from the U.S. Army. He boards a Japanese ship for the Orient in late 1941. But has Bogart really been dishonorably discharged, or is there some other motive for his getting close to fellow passenger Sidney Greenstreet? His motive for getting close to attractive traveler Mary Astor is obvious. As an undercover American agent, he obtains the details of a Japanese plot to attack the Panama Canal and Pearl Harbor.

INTERESTING FACTS

- Director John Huston joined the war effort before the film was finished, and Vincent Sherman directed the final scenes.
- The bullet-ridden ending, according to Huston, was imposed by the studio.
- The studio (Warner Bros.) used its successful team from the previous year's hit, *The Maltese Falcon*, director John Huston and its three stars, Mary Astor, Humphrey Bogart, and Sidney Greenstreet.
- This film was in production before Pearl Harbor and released afterward.

MILITARY SERVICE

- Director John Huston, son of actor Walter Huston, entered the Mexican army at the age of 19 and served as a lieutenant of cavalry for two years. He then became a director in Hollywood, and at the outbreak of World War II, he walked off this movie, was commissioned a second lieutenant in the U.S. Army Signal Corps, and was put to work making propaganda films. He was almost immediately sent to the Aleutians, which was the only theater of operations in which Americans were in combat at that point in the war. For four months he flew on B-24 missions, filming the attacks, and on one flight he actually manned the guns. This film eventually became *Report from the Aleutians*. When in 1943 the ship carrying the film of the invasion of North Africa was sunk, Huston was assigned by an embarrassed high command with recreating the invasion in the Mojave Desert. They actually showed the film, entitled *Tunisian Victory*, to President Roosevelt as the real thing. However, Huston was soon involved in serious filmmaking again, when he was assigned to film the Allied entry into Rome. Following the 143rd Infantry Regiment, he recorded a tank battle

at the town of San Pietro in which 12 of the 16 American tanks were destroyed. His film *The Battle of San Pietro* was a vivid and realistic account of the battle, and the army accused him of making an antiwar film. His reply was "If I ever make anything other than an antiwar film, I hope you take me out and shoot me." He was saved by General George Marshall, who loved the film. He was promoted to major and awarded the Legion of Merit.

Jack Warner, one of the founders of Warner Bros., had enlisted with his brother Sam, another founder of Warner Bros., in the U.S. Army Signal Corps during World War I and produced documentaries for the army. At the start of World War II, he was commissioned a lieutenant colonel and assigned to the Motion Picture Unit of the U.S. Army Air Force.

ACTION IN ARABIA

RKO Radio Pictures Inc., 1944, b&w, 72 minutes.

Producer: Maurice Geraghty; **Director:** Léonide Moguy; **Screenwriters:** Herbert J. Biberman, Philip MacDonald; **Music:** Leigh Harline, Roy Webb; **Cast:** Robert Anderson, Michael Ansara, Robert Armstrong, Lénore Aubert, Virginia Bruce, André Charlot, Marcel Dalio, John Hamilton, Jamiel Hasson, Gene Lockhart, Alan Napier, George Sanders, Rafael Storm, H. B. Warner.

In Damascus, the Allies and Nazis struggle for control of Arab sympathies. Virginia Bruce portrays a special agent bent on stopping Nazi spies from destroying the Suez Canal. George Sanders is in impeccable form as a New York reporter (with a British accent) on the trail of Nazi sympathizers in the desert. When his fellow reporter is murdered, Sanders (in a white dinner jacket that predates Sean Connery's jacket in *Goldfinger* by about 20 years) sets off coolly to track down the killers, uncovering a plot in which the Nazis aim to unite the Arab tribes against the Allied forces.

Some of the action and the audacity of the plot are breathtaking, and anyone who enjoys the Saint or the Falcon films, or even CASABLANCA, will probably enjoy this film. It's a pity Sanders didn't make more films as the hero. After this, he would play only the sneering villain. If you like this movie, check out the novel by George Sanders (actually ghosted by Falcon screenwriter Craig Rice) called *Crime on My Hands*, in which Sanders has to solve a murder on a film set. It's light, amusing, and reminiscent of the Saint/Falcon films that made Sanders a star in the first place.

ACTION IN THE NORTH ATLANTIC

Warner Bros., 1943, b&w, 126 minutes.

Producers: Jerry Wald, Jack L. Warner; **Directors:** Lloyd Bacon, Byron Haskin, Raoul Walsh; **Screenwriters:** A. I. Bezzerides, W. R. Burnett, Guy Gilpatric, John Howard Lawson; **Music:** Adolph Deutsch; **Distributor:** Warner Bros.; **Cast:** Tod Andrews, Iris Adrian, Irving Bacon, Julie Bishop, Humphrey Bogart, Chick Chandler, Dane Clark, Alec Craig, Donald Douglas, James Flavin, Art Foster, Ruth Gordon, Alan Hale, Creighton Hale, Dick Hogan, J. M. Kerrigan, Sam Levene, Raymond Massey, Ray Montgomery, George Offerman, Frank Puglia, Kane Richmond, Glenn Strange, Ludwig Stössel, Elliott Sullivan, Charles Trowbridge, Wilhelm von Brincken, Minor Watson, Dick Wessel, Peter Whitney.

This film is a tribute to the Liberty ships of the U.S. Merchant Marine in World War II and the navy gun crews who were assigned to the ships. An American tanker is sunk by a German U-boat, and then the survivors' lifeboat is rammed by the U-boat. Those who live through this ordeal spend 11 days at sea on a raft. After their rescue, they are assigned to the Liberty ship *Sea Witch* bound for Murmansk, Russia, through the U-boat-infested North Atlantic.

The film is based on *Action in the North Atlantic*, by Guy Gilpatric, (New York: Dutton, 1943), and referenced in "Legacy of the Hollywood Blacklist" 1987 (TV).

INTERESTING FACTS

- The screenplay was written by John Howard Lawson, known for his liberal politics. At the end of the film, when the Liberty ship makes it safely into a Russian port, the jubilant Russians shout "*Tovarich!*" which means "comrade." The scenes of friendly Russians were deleted from some prints of the film.
- Jack Warner was awarded the Maritime Service Victory Flag when the movie premiered in New York City.
- Henry J. Kaiser, the shipbuilder, thought it was such a good propaganda film he showed it to all of his war workers.
- The film was originally titled *Torpedoed*, a reference to the fact that the crew has their first ship shot out from under them.
- In the original script, there was an African-American steward who questions why he should fight for white America. His part was cut from the

film, for fear it would negatively impact black recruiting during the war.

Bogart [when a young sailor is buried at sea]: A lot more people are going to die before this is over, and it's up to the ones who make it through to make sure they didn't die for nothing.

Voice-over by FDR: We shall build a bridge of ships to our allies over which we shall roll the implements of war. The goods will be delivered where they are needed and when they are needed. Nothing on land, in the air, on the sea, or under the sea shall prevent our final victory.

AERIAL GUNNER

Paramount Pictures, 1943, b&w, 78 minutes.

Producers: William H. Pine, William C. Thomas; **Director:** William H. Pine; **Screenwriter:** Maxwell Shane; **Music:** Daniele Amfitheatrof; **Distributor:** Paramount Pictures; **Filmed at:** Harlingen Aerial Gunnery School, Texas; **Cast:** Richard Arlen, William "Billy" Benedict, Jimmy Lydon, Robert Mitchum, Chester Morris, Dick Purcell, Keith Richards, Ralph Sanford, Lita Ward.

During World War II, Chester Morris is an instructor at an air gunnery training school, when his old nemesis Richard Arlen arrives as a student. After the completion of flight training, they are both assigned to the same bomber and sent to the South Pacific. When their aircraft is forced down by Japanese fighters, they must land on a hostile enemy-held island. After repairs, Chester Morris sacrifices his life so that Richard Arlen can take off with the plane.

Shot at a real-life gunnery school, the film contains excellent footage of gunnery training exercises during World War II.

AFRICAN QUEEN, THE

Horizon Films, Romulus Productions, 1951, color, 105 minutes.

Producers: Sam Spiegel, John Woolf; **Director:** John Huston; **Screenwriters:** James Agee, C. S. Forester, John Huston, Peter Viertel; **Distributor:** Independent Film Distributors Ltd.; **Filmed in:** Africa; **Cast:** Theodore Bikel, Humphrey Bogart, Peter Bull, Walter Gotell, Katharine Hepburn, Errol John, Richard Marner, Robert Morley, Gerald Onn, Peter Swanwick.

At the start of World War I, Charlie Allnut (Humphrey Bogart) uses his old steamer, the African Queen, to ferry supplies to villages in East Africa. When German troops kill a local missionary, Charlie agrees to take the minister's sister, Rose (Katharine Hepburn), back to civilization. As expected, love blooms between the two leads, and in the process, they manage to fire a torpedo to take out the German patrol boat that controls Lake Victoria.

Bogart, in order to move the *African Queen* forward when they get lost in the reeds, has to get into the water and literally pull the boat forward by the anchor chain. When he comes out and takes off his shirt, his body is covered with leeches.

- The first choices for the lead roles were John Mills and Bette Davis.
- The movie was filmed in Africa, but the scenes in the reed-filled river bank were filmed in Dalyan, Turkey.
- Katharine Hepburn wrote *The Making of the African Queen* (New York: Knopf, 1987)

- When Charlie and Rose are arguing about who is going to steer the torpedo, a cigar suddenly appears in Charlie's mouth.

Charlie: We can't do that!
Rose: How do you know? You never tried it.
Charlie: Well, yeah, but I never tried shooting myself in the head neither.
Captain of Louisa: By the authority vested in me by Kaiser Wilhelm II, I pronounce you husband and wife. Proceed with the execution.

Academy Awards, USA, 1951
 Won: *Oscar, Best Actor,* Humphrey Bogart
 Nominated: *Oscar, Best Actress,* Katharine Hepburn; *Best Director,* John Huston; *Best Writing, Screenplay,* James Agee, John Huston

British Academy Awards, 1953
 Nominated: *BAFTA Film Award, Best Film from Any Source—USA; Best Foreign Actor,* Humphrey Bogart—USA

National Film Preservation Board, USA

National Film Registry

AIR FORCE

Warner Bros., 1943, b&w, 124 minutes.

Producer: Hal B. Wallis; **Director:** Howard Hawks; **Screenwriters:** William Faulkner, Dudley Nichols; **Music:** Franz Waxman; **Filmed at:** Tampa, Florida; **Cast:** Murray Alper, Lynn Baggett, Leah Baird, Henry Blair, Rand Brooks, Edward Brophy, James Brown, James Bush, Harry Carey, Bill Crago, Ann Doran, Warren Douglas, Charles Drake, Faye Emerson, James Flavin, Ross Ford, Ruth Ford, William Forrest, John Garfield, Sol Gorss, William Hopper, Marjorie Hoshelle, Arthur Kennedy, Richard Lane, James Millican, Ray Montgomery, Tom Neal, George N. Neise, George Offerman, Moroni Olsen, Dorothy Peterson, Addison Richards, John Ridgely, Stanley Ridges, Willard Robertson, Walter Sande, George Tobias, Theodore von Eltz, Ward Wood, Gig Young.

The *Mary Ann*, a B-17 Flying Fortress, takes off from California to ferry the aircraft to Hawaii on December 6, 1941. It arrives in the middle of the sneak Japanese attack on Pearl Harbor. Subsequently the crew takes the *Mary Ann* through action at Wake Island, the Philippines, and the Battle of the Coral Sea.

The *Mary Ann* is badly shot up, and the island commander orders the bomber destroyed so that it does not fall into enemy hands. The crew begs, borrows, and steals the spare parts it needs, works all night, and gets it into flying shape just in time, taking off in the middle of a banzai attack on the airfield.

Air Force is the true story of B-17 *Mary Ann* and its crew. The action is contemporaneous with the events it depicts. After the film was released, the *Mary Ann* was shot down over the Pacific and all its crew was lost.

Its characters became the basis for a subplot in Quentin Tarantino's *Pulp Fiction* 50 years later. In *Pulp Fiction*, Christopher Walken's character tells the young "Butch" about his grandfather on Wake Island giving his watch to a passing bomber crewman before the Japanese invade. The crewman he gave it to was called Winocki. In *Air Force*, John Garfield plays that crewman.

INTERESTING FACT

- The film used actual combat camera footage from the Battle of the Coral Sea.

MILITARY SERVICE

- Director Howard Hawks was trained as an army aviator in 1917 and served during World War I. Discharged in 1920, he worked for a short time as a civilian pilot.

QUOTES

George Tobias [referring to an enemy airplane]*:* Fried Jap coming down!

One of the officers on the bomber asks a marine on Wake Island (a force of 400 marines, fighting an invasion force of thousands of Japanese)*:* Anything we might do for you in Manila?

The marine's answer: Send us more Japs.

AWARDS

Academy Awards, USA, 1943
 Won: *Oscar, Best Film Editing,* George Amy
 Nominated: *Oscar, Best Cinematography, Black-and-White;* Elmer Dyer, James Wong Howe, Charles A. Marshall; *Best Special Effects,* Hans F. Koenekamp (photographic), Nathan Levinson (sound), Rex Wimpy (photographic); *Best Writing, Original Screenplay,* Dudley Nichols.

ALL QUIET ON THE WESTERN FRONT

Universal Pictures, 1930, b&w, 131 minutes.

Producer: Carl Laemmle Jr.; **Director:** Lewis Milestone; **Screenwriters:** George Abbott, Maxwell Anderson, Del Andrews, Walter Anthony, Lewis Milestone, Erich Maria Remarque; **Music:** David Broekman, Sam Perry, Heinz Roemheld; **Distributor:** Universal Pictures; **Cast:** Ben Alexander, Richard Alexander, Poupée Andriot, Yola d'Avril, Lew Ayres, William Bakewell, Vince Barnett, Daisy Belmore, Edmund Breese, Marion Clayton, G. Pat Collins, Heinie Conklin, Renée Damonde, Owen Davis Jr., Arthur Gardner, Russell Gleason, Harold Goodwin, Raymond Griffith, Ellen Hall, Bill Irving, Scott Kolk, Tom London, Arnold Lucy, Bertha Mann, Joan Marsh, Edwin Maxwell, Beryl Mercer, Robert Parrish, Walter Rogers, Bodil Rosing, Slim Summerville, David Tyrell, Louis Wolheim, John Wray, Fred Zinnemann.

A group of German schoolboys are pressured by their jingoistic teacher into enlisting at the beginning of World War I. As the boys witness death and mutilation all around them, any preconceptions about "the enemy" and the "rights and wrongs" of the conflict disappear, leaving them angry and bewildered. This is highlighted in the scene wherein their leader, Paul, mortally wounds a French soldier and then weeps bitterly as he fights to

save the man's life while trapped in a shell crater with the body. By the end, all of the boys have been killed.

In the most memorable scene, during a mass infantry attack against his trench, the hero witnesses the force of an artillery barrage on the men who are attacking. One of the Frenchmen grabs the barbed wire with his hands; a second later, his body is blown to bits by the artillery, only his hand remaining, still clutching the barbed wire.

The film is based on the worldwide best-seller *All Quiet on the Western Front*, by Erich Maria Remarque.

Other memorable scenes feature a new pair of boots being continually taken over as successive owners are killed; Lew Ayres talking impotently about the brotherhood of man and the futility of killing as he watches his French enemy die beside him in a shell crater (the latter in a marvelous performance by Raymond Griffith in his last film role); Ayres carrying the wounded Wolheim on his back and talking cheerfully to him, not realizing he has been killed by a shell; and the closing scene of the hand reaching out from the trenches to seize a butterfly, only to fall back slowly as he is killed by an enemy sniper.

In 1939 the film was rereleased with two major changes: The first was the addition of a voice-over narration comparing World War I German soldiers, depicted favorably, to the Nazi army that had just begun to sweep across Europe. The second change was the addition of a new scene at the end showing Nazis burning books—including the one on which the film is based.

Reissue prints (particularly for the 1940s and later TV releases) were cut by some 35 minutes and the soundtrack altered by the distributor, especially during the final sequence where music was added, contrary to director Lewis Milestone's wishes. In 1980, before his death, Milestone asked Universal to restore the film and remove the music in the final scene. In 1998 about 30 minutes were reinstated to resemble the original 1930 cut, and Milestone's wishes were finally honored.

INTERESTING FACTS

- A sequence with ZaSu Pitts was included in the silent version but was cut and refilmed with Beryl Mercer, because preview audiences laughed, since Pitts was associated with comedy.
- In the closing scene, director Lewis Milestone's hand is used for that of hero Ayres, when he reaches for a butterfly.
- During the film's German release, the Nazis (not yet in power) interrupted screenings by shouting martial slogans and releasing rats and stink bombs into the theaters.

- The battles are filmed in the same cinematic style as the battles in *SAVING PRIVATE RYAN*, using slightly speeded-up cinematography, with an odd frame-rate that gives them a realistic, yet subliminal, feel.

MILITARY SERVICE

- The star, Lew Ayres, became a pacifist as a result of this movie and later served as a noncombatant, a medic, in World War II.
- To ensure authenticity, director Lewis Milestone instructed the studio to find German army veterans living in the Los Angeles area so that he could have them authenticate German uniforms and equipment. So many of them were found that Milestone cast a lot of them as German officers in the film and had them drill the extras playing German troops. (The scene in which they are laying communication wire in the forward trenches was led by a former German soldier whose job during the war was to do exactly that.)

QUOTES

Paul Baumer: You still think it's beautiful to die for your country. The first bombardment taught us better. When it comes to dying for country, it's better not to die at all.

Paul Baumer: We live in the trenches out there. We fight. We try not to be killed, but sometimes we are—that's all.

AWARDS

Academy Awards, USA, 1929–30
 Won: *Oscar, Best Director,* Lewis Milestone; *Best Picture,* Carl Laemmle Jr.
 Nominated: *Oscar, Best Cinematography,* Arthur Edeson; *Best Writing Achievement,* George Abbott, Maxwell Anderson, Del Andrews

National Film Preservation Board, USA, 1990

National Film, Registry

Photoplay Award, 1930
 Won: *Medal of Honor,* Carl Laemmle Jr.

ALL THE YOUNG MEN

Columbia, 1960, b&w, 90 minutes.

Producers: Hall Bartlett, Alan Ladd; **Director:** Hall Bartlett; **Screenwriter:** Hall Bartlett; **Music:** George Duning; **Cast:** Mario Alcalde, Paul Baxley, Glenn Corbett, James Darren, Richard Davalos, Michael

Davis, Joseph Gallison, Ingemar Johansson, Lee Kinsolving, Alan Ladd, Leonard Mountain Chief, Sidney Poitier, Charles Quinlivan, Paul Richards, Mort Sahl, Ana St. Clair, Marie Tsien.

Eleven U.S. Marines are sent on a suicide mission to protect a strategic farmhouse on the 38th parallel from the Chinese Communists during the Korean War. When their lieutenant is killed, Sidney Poitier, as the sergeant, must take command, a situation that racist soldier Alan Ladd finds intolerable. However, when Ladd is badly wounded and requires a blood transfusion, the only person in the squad with the right blood type is Poitier.

INTERESTING FACTS

- Mort Sahl, who delivers several monologues, was actually a stand-up comedian.
- Actor Ingemar Johansson was a former boxing champion.
- *THE BATTLE OF BLOOD ISLAND*, released the same year, was another attempt to deal with racism on the battlefield, in that case anti-Semitism.

MILITARY SERVICE

- Sidney Poitier was living on the street when he enlisted in the U.S. Army in 1943. He was assigned to the 1267th Medical Detachment, an all-black medical unit attached to the veteran's hospital at Northport, Long Island (New York), caring for psychiatric patients suffering from battle fatigue. Perhaps because he empathized with his patients, he was medically discharged with a violent mental disorder.

ALWAYS ANOTHER DAWN

Embassy Pictures Corporation, 1947, 108 minutes.

Producer: T. O. McCreadie; **Director:** T. O. McCreadie; **Screenwriters:** T. O. McCreadie, Zelma Roberts; **Distributor:** Universal Pictures Corporation; **Filmed at:** Flinders Naval Depot, Sydney, Australia, and on actual naval exercises; **Cast:** Queenie Ashton, Guy Doleman, Max Gibb, Douglas Herald, Betty McDowall, Charles "Bud" Tingwell, Charles Zoll.

During World War II the hero, following in his father's footsteps, enlists in the navy and sees action in the Mediterranean and the Pacific.

A shortened version was released in England with some success a year after the film's failure in its initial Sydney release.

AMBASSADOR, THE

Northbrook Films, 1984, color, 97 minutes.

Producers: Yoram Globus, Menahem Golan, Isaac Kol; **Director:** J. Lee Thompson; **Screenwriters:** Max Jack, Elmore Leonard; **Distributor:** Cannon Group; **Filmed at:** Jerusalem, Israel, and Jerusalem, Jordan; **Cast:** Assi Abaiov, Albert Amar, Chaim Banai, Michal Bat-Adam, Josef Bee, Shimon Ben-Ari, Gilad Ben-David, Dana Ben-Yehuda, Ellen Burstyn, Peter Freistadt, Sasson Gabai, Uri Gavriel, Chaim Girafi, Heli Goldenberg, Rock Hudson, Albert Iluz, Moshe Ivgi, Zehava Keilos, Yftach Katzur, Avi Kleinberger, Shmulik Kraus, Ori Levy, Yoni Lucas, Robert Mitchum, Yitzhak Ne'eman, Dani Noiman, Zachi Noy, Donald Pleasence, Avi Pnini, Shai Schwartz, Ross Shepher, Joseph Shiloach, Moti Shirin, Ben Ami Shmueli, Rachel Steiner, Bob Stevens, Harmati Talmon, Fabio Testi, Dan Toren, Ran Vered, Yossi Virginsky, Esther Zebco, Haim Zinovich.

Robert Mitchum is a controversial U.S. ambassador to Israel who tries to solve the Israeli-Palestinian controversy by unorthodox means. While he is being criticized for his methods by friend and foe alike, his wife has an affair with the Palestine Liberation Organization chief. To make matters worse, one faction threatens to reveal a film of her affair if a ransom isn't paid, and another faction places a hefty price on his head, encouraging his assassination.

The film is based on Elmore Leonard's *52 Pick-Up*.

INTERESTING FACT

- This is Rock Hudson's last feature film. He plays the ambassador's loyal security officer and friend, who saves his life in an assassination attempt and who tries to stop the adultery film from being shown.

AMBUSH BAY

United Artists, Schenck-Zabel Productions, 1966, color, 109 minutes.

Producers: Hal Klein, Aubrey Schenck; **Music:** Richard LaSalle; **Director:** Ron Winston; **Screenwriters:** Marve Feinberg, Ib Melchior; **Distributor:** United Artists; **Cast:** Amado Abello, Gregg Amsterdam, Jim Anauo, Nonong Arceo, Tisa Chang, Joaquin Fajardo, Buff Fernandez, Limbo Lagdameo, Harry Lauter, Peter Masterson, James Mitchum, Hugh O'Brian, Bruno Punzalan, Max Quismundo, Mickey Rooney, Tony Smith, Clem Stadler, Juris Sulit.

A patrol of nine marines is sent to an island on a secret mission to make contact with a Japanese spy who has information vital to General MacArthur's upcoming invasion of the Philippines. The marines die, one by one, as they fight their way across the island, only to discover that the spy they are trying to locate is a Japanese American whose parents are in an American concentration camp back home. She also dies helping the patrol, now greatly reduced in numbers, to get to a radio. James Mitchum is the narrator and also the only survivor of the patrol.

MISTAKES

- Toward the beginning of the film, actors Hugh O'Brian (Sgt. Steve Corey) and Clem Stadler (Capt. Alonzo Davis) shoot three Japanese soldiers. The blood on these bodies is obviously paint.
- In the first major battle, the Japanese use an American Sherman tank. The C4 explosive used to blow up the tank was excessive, but when the tank blows up, the hatch just opens normally.
- When one of the marines is killed, he drops a rifle— notice that the rifle is made of wood.
- At the end of the film, Sgt. Corey fires a strip-fed Japanese machine gun, but earlier it's belt-fed.
- The electronics at the Japanese radio station are too modern for World War II.
- Actor Amado Abello's film name is Amado; Max Quismundo's is Max; James Mitchum's is James; and Pvt. George's name really is Pvt. George George.

QUOTE

Mickey Rooney (speaking to the Japanese soldiers who have just captured him): "Guess what I got for you. Baked potatoes. You can eat these with the jackets on them." As the Japanese shoot him, he throws the grenades.

AMERICAN GUERRILLA IN THE PHILIPPINES, AN

20th Century-Fox, 1950, color, 105 minutes.

Producer: Lamar Trotti; **Director:** Fritz Lang; **Screenwriters:** Lamar Trotti, Ira Wolfert; **Distributor:** 20th Century-Fox Film Corporation; **Filmed in:** Philippines; **Cast:** Miguel Anzures, Robert Barrat, Sabu Camacho, Tommy Cook, Erlinda Cortes, Jack Elam, Tom Ewell, Arling Gonzales, Fred Gonzales, Eddie Infante, Orlando Martins, Robert Patten, Tyrone Power, Micheline Presle, Eduardo Rivera, Rosa Del Rosario, Kathy Ruby, Juan Torena, Chris De Varga, Carleton Young.

Tyrone Power is a navy ensign who takes refuge in the jungle after his PT boat is destroyed by the Japanese during their invasion of the Philippines during World War II. He joins forces with local Filipino guerrillas and the wife of a slain French plantation owner to fight the Japanese invaders.

The film is based on Ira Wolfert's *An American Guerrilla in the Philippines* (New York: Simon and Schuster, 1945).

AMERICANIZATION OF EMILY, THE

Metro-Goldwyn-Mayer, 1964, b&w, 115 minutes.

Producers: John Calley (associate), Martin Ransohoff; **Director:** Arthur Hiller; **Screenwriters:** Paddy Chayefsky, William Bradford Huie (novel); **Music:** Johnny Mandel, Johnny Mercer; **Distributor:** Metro-Goldwyn-Mayer; **Cast:** Julie Andrews, Ed Binns, Lou Byrne, Judy Carne, James Coburn, Gary Cockrell, John Crawford, Bus Cummings, Melvyn Douglas, Steve Franken, Bill Fraser, Liz Fraser, James Garner, Janine Gray, Joyce Grenfell, Douglas Henderson, Alan Howard, Kathy Kersh, Linda Marlowe, Paul Newlan, Edmon Ryan, Alan Sues, Sharon Tate, William Windom, Keenan Wynn.

During the Allied buildup to D day in 1944, the British are host to thousands of American soldiers who are "oversexed, overpaid, and over here." One of them is James Garner, and as a "dog robber," an admiral's aide, he knows all the angles to make life as smooth and as risk-free as possible for his commander and himself. He is a self-proclaimed coward, and the war for him is one big party, until he falls in love with an English woman, Julie Andrews.

Melvyn Douglas is delightful as an eccentric admiral who is determined that the first man to die on Omaha Beach will be a navy man. The cowardly Garner is determined that, when "the balloon goes up," he will be nowhere to be found, especially not on Omaha Beach. But James Coburn has other ideas. He has selected Garner for the honor of being the first dead man on the beach.

MISTAKE

- One of the admirals says that D day must be on June 5 or 6 because there would be a neap tide on those days. In fact, the date was selected for the opposite

reason: There would be a spring tide, which was what was needed.

AWARDS

Academy Awards, USA, 1964
> **Nominated:** *Oscar, Best Art Direction—Set Decoration, Black-and-White*, Robert R. Benton, George W. Davis, Henry Grace, Hans Peters, Elliot Scott; *Best Cinematography, Black-and-White*, Philip H. Lathrop

British Academy Awards (BAFTA), UK, 1964
> **Nominated:** *BAFTA Film Award, Best British Actress*, Julie Andrews.

ANGELS ONE FIVE

Templar Production, 1953, b&w, 98 minutes.

Producers: John W. Gossage, Derek N. Twist; **Director:** George More O'Ferrall; **Screenwriters:** Pelham Groom, Derek N. Twist; **Music:** John Wooldridge; **Cast:** Ronald Adam, Freda Bamford, John Barry, Gordon Bell, Elwin Daniel, Michael Denison, W. Thorp Deverreux, Josephine Douglas, Richard Dunn, Vari Falconer, Harry Fowler, Harold Goodwin, Dulcie Gray, Karen Grayson, John Gregson, John Harvey, Jack Hawkins, Vida Hope, Russell Hunter, Douglas Hurn, Veronica Hurst, Peter Jones, Geoffrey Keen, Sam Kydd, Ann Lancaster, Humphrey Lestocq, Richard Levin, Harry Locke, Rosemary Lomax, Terence Longdon, Victor Maddern, Gillian Maude, Donald McLisky, Anthony Moore, Hugh Moxey, Andrew Osborn, John Philips, Norman Pierce, Cyril Raymond, Wendy Remington, Bryn Roberts, Ewan Roberts, John Sharp, Harold Siddons, Philip Stainton, Joan Sterndale-Benne, Helen Stirling, Marianne Stone, Colin Tapley, Amy Veness, Russell Waters, Neil Wilson.

Jack Hawkins joins a front-line Royal Air Force squadron at the height of the Battle of Britain.

For a historical description, see THE BATTLE OF BRITAIN. Winston Churchill said of the RAF, "Never in the field of human conflict was so much owed by so many to so few."

ANGEL WORE RED, THE

Metro-Goldwyn-Mayer, Spectator, Titanus, 1960, b&w, 99 minutes.

Producer: Goffredo Lombardo; **Director:** Nunnally Johnson; **Screenwriters:** Nunnally Johnson, Bruce Marshall, Giorgio Prosperi; **Distributor:** Metro-Goldwyn-Mayer; **Filmed at:** Catania, Italy; **Cast:** Dirk Bogarde, Robert Bright, Franco Castellani, Nino Castelnuovo, Renato Terra Caizzi, Joseph Cotten, Bob Cunningham, Finlay Currie, Gustavo De Nardo, Vittorio De Sica, Aldo Fabrizi, Arnoldo Foà, Ava Gardner, Aldo Pini, Leonardo Porzio, Rosanna Rory, Enrico Maria Salerno.

Dirk Bogarde is a Catholic priest who leaves his calling to join the Loyalist side during the Spanish Civil War, where he finds himself attracted to a beautiful entertainer.

From 1936 to 1939, Spain endured civil war. Francisco Franco's right-wing fascists were supported by Nazi Germany and Mussolini's Italy, and the Soviet Union supported the republicans, known as the Loyalists. Other countries were officially neutral, but many volunteers traveled to take part in this ideological struggle that many saw as a precursor to an inevitable struggle between freedom and the Axis powers. Germany, Italy, and the Soviet Union used the conflict to test weapons and tactics they would later use to great effect in World War II. Those from neutral America who joined the Loyalist side served in what was called the Abraham Lincoln Brigade. When war did come, Hollywood immediately labeled many of its heroes as veterans of the Spanish Civil War. For example, in CASABLANCA, the background story is that before opening Rick's Café Americain, Humphrey Bogart fought with the Loyalists.

The film is based on *The Angel Wore Red*, by Bruce Marshall (Boston: Houghton, Mifflin, 1953).

ANGRY HILLS, THE

Metro-Goldwyn-Mayer, 1959, b&w, 105 minutes.

Producers: Victor Lyndon, Raymond Stross; **Director:** Robert Aldrich; **Screenwriters:** A. I. Bezzerides, Leon Uris; **Cast:** Stanley Baker, Theodore Bikel, Sebastian Cabot, Marita Constantinou, George Eugeniou, Marius Goring, Peter Illing, Patrick Jordan, Jackie Lane, Alec Mango, Robert Mitchum, Kieron Moore, Elisabeth Müller, George Pastell, Leslie Phillips, Gia Scala, Stanley Van Beers, Donald Wolfit.

During the latter part of World War II, Robert Mitchum, an American war correspondent in Greece, accidentally gains knowledge of a secret list of collaborators. As a result, he is pursued by both the Nazis and the Greek resistance.

The film is based on Leon Uris's *The Angry Hills*, (New York: Random House, 1955).

ANNAPOLIS STORY, AN

Allied Artists Pictures Corporation, 1955, color, 81 minutes.

Producer: Walter Mirisch; **Director:** Don Siegel; **Screenwriters:** Daniel Mainwaring (as Geoffrey Homes), Daniel B. Ullman (also story); **Music:** Marlin Skiles; **Distributor:** Allied Artists; **Cast:** James Anderson, John Ayres, Fran Bennett, Robert Bonoil, Barbara Brown, Richard Carlson, Pat Conway, John Derek, John Doucette, Chris Drake, George Eldredge, Betty Lou Gerson, Dabbs Greer, Don Haggerty, Tom Harmon, L.Q. Jones, Don Keefer, Don Kennedy, John Kirby, John Lehman, Diana Lynn, Kevin McCarthy, Alvy Moore, Robert Osterloh, Sam Peckinpah, Robert Pike, William Schallert, Richard Travis.

Two brothers, played by John Derek and Kevin McCarthy, are both in love with the same woman, played by Diana Lynn. They take their rivalry from Annapolis to Korea, where they both serve as navy fighter pilots. When McCarthy, the older brother, is shot down, Derek must rescue him.

The film is also known as *The Blue and the Gold* in the United Kingdom.

ANOTHER DAWN

Warner Bros., 1937, b&w, 73 minutes.

Producers: Harry Joe Brown, Hal B. Wallis; **Director:** William Dieterle; **Screenwriters:** Laird Doyle, W. Somerset Maugham (story, "The Ambassador's Wife"); **Music:** Erich Wolfgang Korngold; **Distributor:** Warner Bros.; **Filmed at:** Imperial County, California, Lasky Mesa, near Agoura, California, and Yuma, Arizona; **Cast:** Charles Austin, Kenneth Hunter Benton, Billy Bevan, Tyrone Brereton, David Clyde, Clyde Cook, Errol Flynn, Mary Forbes, Kay Francis, Martin Garralaga, Sam Harris, Ian Hunter, G. P. Huntley, Frieda Inescort, Charles Irwin, Noel Kennedy, Eily Malyon, Stefan Moritz, Leonard Mudie, Herbert Mundin, Richard Powell, Jack Richardson, Reginald Sheffield, Yorke Sherwood, Will Stanton, Spencer Teakle, Joseph R. Tozer, Clare Verdera, Ben Welden.

At a remote British outpost in North Africa, Kay Francis plays the wife of the post commander, played by Ian Hunter, but she is in love with the dashing captain, played by Errol Flynn. Flynn is wounded when his patrol is almost wiped out by rebels. When Hunter learns that his wife and Flynn are truly in love, but that they will not betray him, he flies a suicide mission. He destroys a dam built by the rebels to stop the supply of water to the villagers and is killed.

INTERESTING FACT

- Before this movie was made, any Warner Bros. film that showed a movie marquee had to indicate that a movie called *Another Dawn* was playing at the theater. Unable to come up with a title for this film, they decided to actually title it *Another Dawn*.

ANZIO

Columbia Pictures Corporation, Dino de Laurentiis Cinematografica, 1968, color, 117 minutes.

Producer: Dino De Laurentiis; **Director:** Edward Dmytryk; **Screenwriters:** Harry A. L. Craig, Frank De Felitta, Giuseppe Mangione, Wynford Vaughan-Thomas; **Music:** Riz Ortolani; **Distributor:** Columbia Pictures; **Cast:** Elsa Albani, Annabella Andreoli, Jed Curtis, Vittoria Dal Verme, Mark Damon, Giorgia Della Giusta, Gene Evans, Peter Falk, Arthur Franz, Giancarlo Giannini, Wolfgang Hillinger, Earl Holliman, Thomas Hunter, Arthur Kennedy, Patrick Magee, Dante Maggio, Robert Mitchum, Tiberio Mitri, Wolfgang Preiss, Wayde Preston, Robert Ryan, Reni Santoni, Carmen Scarpitta, Tonio Selwart, Anthony Steel, Elisabeth Tompson, Enzo Turco, Marcella Valeri, Venantino Venantini, Joseph Walsh.

Robert Mitchum and Peter Falk land at Anzio during World War II, pick up a jeep, and drive directly to Rome and back, scarcely seeing a German. However, the cautious American general in charge of the invasion wastes valuable time assembling his troops on the beach and delays his movement inland. By the time he is ready to proceed, German troops have moved into position. Mitchum and Falk's squad is almost wiped out by the Germans, and the survivors must carry on behind enemy lines.

The objective of the landing at Anzio was to take Rome, the political and logistical capital of Italy, which was just 30 miles away. The landing took the Germans totally by surprise, with little more than small-arms fire directed against the landing troops. But the general in charge of the invasion was very cautious, wasting valuable days assembling his invasion force on the beachhead. As the Allies waste time better spent on advancing unopposed through the countryside, the Germans rush troops to the area. By the time the Americans are ready to move off the beach,

they march right into the face of heavy German resistance. Rome, which could have been taken in a day, becomes a campaign that costs four months and 30,000 casualties, and results in one of the bloodiest battles of World War II.

Compare the cautious general in this film with General George S. Patton, portrayed by George C. Scott. Specifically, note the scene in *PATTON* in which Scott, after being given a casualty list and suffering a withering look from Omar Bradley (the "soldier's general"), remarks, "Ask yourself how many men we would have lost if we were still down there struggling along that road."

The film is based on *Anzio*, by Wynford Vaughan-Thomas (New York: Holt, 1961).

Both *THE BIG RED ONE* and *TO HELL AND BACK* feature scenes set in the Anzio campaign.

APOCALYPSE NOW

Zoetrope Studios, 1979, color, 155 minutes.

Producers: John Ashley, Francis Ford Coppola, Gray Frederickson, Eddie Romero, Fred Roos, Mona Skager, Tom Sternberg; **Director:** Francis Ford Coppola; **Screenwriters:** Francis Ford Coppola, Michael Herr, John Milius (based on *Heart of Darkness* by Joseph Conrad); **Cinematography:** Vittorio Storaro; **Music:** Carmine Coppola, Francis Ford Coppola, John Densmore, Mickey Hart, and Robby Krieger; **Distributors:** United Artists; **Filmed in:** Philippines; **Cast:** Sam Bottoms, Marlon Brando, Bo Byers, Colleen Camp, George Cantero, Larry Carney, Linda Carpenter, Francis Ford Coppola, Marc Coppola, Robert Duvall, R. Lee Ermey, Laurence Fishburne, Harrison Ford, Frederic Forrest, Scott Glenn, Bill Graham, Albert Hall, Dennis Hopper, Hattie James, James Keane, Harvey Keitel, Daniel Kiewit, Damien Leake, Tom Mason, Ron McQueen, Herb Rice, Jerry Ross, Kerry Rossall, Martin Sheen, G. D. Spradlin, Vittorio Storaro, Jack Thibeau, William Upton, Glenn Walken, Dick White, Cynthia Wood, Jerry Ziesmer.

Apocalypse Now is an adaptation of the book *Heart of Darkness*, by Joseph Conrad, transplanting the story-line from colonial Africa to the Vietnam War. Burnt-out Captain Willard (Sheen) is sent on a mission into Cambodia to assassinate a renegade Green Beret (Brando) who has set himself up as a god among a local tribe that has become his own private army. As Willard travels toward his objective, he is slowly overtaken by the jungle's mesmerizing powers and by the battles and insanity that surround him. His crew succumb to drugs and are killed off one by one. Willard becomes more and more like the man he was sent to kill, until he finally reaches his goal and must complete his mission.

It took 10 years for Coppola to acquire the funds to make this landmark film. Not until after he had made *The Godfather* (1972) and *The Godfather: Part II* (1974) could he convince the studio that he could handle such a large production. Originally scheduled to be shot in six weeks, the film ended up taking 16 months, and what should have been a labor of love turned into the labor of a lifetime. Harvey Keitel, originally cast as Capt. Willard, was replaced two weeks into shooting by Sheen, but numerous other delays plagued the production. A typhoon destroyed some of the sets, and the crew was forced to work around the availability of helicopters and pilots provided by Ferdinand Marcos and the Philippine government, which sometimes withdrew them for use in fighting a war against rebels.

Among the cast of stars, Marlon Brando was paid $1 million in advance of filming, but later threatened to quit and keep the advance. Coppola threatened to replace him with Jack Nicholson, Robert Redford, and then Al Pacino, and Brando relented. When he eventually turned up, he was late, drunk, and overweight, and he hadn't read the screenplay or even *Heart of Darkness*. After reading Coppola's script, he refused to do it, arguing for days over single lines of dialogue until an ad-lib style was agreed upon and shot, according to Brando's stipulations, in shadows.

Coppola, who lost 100 pounds during the filming, was forced to invest millions from his own money when the picture ran over its budget and schedule. The emotional tension led him to threaten to commit suicide several times during the shoot.

Perhaps the most serious incident occurred when Sheen suffered a heart attack during the filming; some scenes of his character shown only from behind had to be shot with a stand-in.

There are four different treatments of the ending and credits. In the 35mm version, the credits roll over surrealistic explosions and burning jungle as the air strike occurs. The 70mm version has none of this, no credits, nothing but a one-line copyright notice at the end. Both versions are available on video. The 70mm version has been letterboxed. A third version has the credits rolling over a black background.

A five-and-a-half-hour work print version exists. It has never been officially released but circulates as a video bootleg.

INTERESTING FACTS

- Laurence Fishburne lied about his age. He was 14 at the time production began in 1976.

Apocalypse Now (UNITED ARTISTS/AUTHOR'S COLLECTION)

- The name of the character played by Sheen combines the names of Harrison Ford's two oldest sons, Benjamin and Willard.
- The sound of the choppers was created on a synthesizer.
- Martin Sheen's scenes in his hotel room were intentionally performed drunk, and were entirely ad-libbed. Sheen did not mean to smash the mirror with his hand; this was a result of his drunken stupor.
- A second sequence featuring the Playmates was filmed but cut. The patrol boat crew encounters the Playmates' helicopter, which has run out of fuel. They swap some gasoline in exchange for a chance at sex with the three girls. Lynda Carter was originally cast as one of the girls but was replaced by Colleen Camp due to unforeseen production delays.
- Sam Bottoms reportedly was on speed, LSD, and marijuana during the shooting of the movie.

- The photojournalist quotes two T. S. Eliot poems. In a late scene in the film, a slow pan over a table in Kurtz's room shows a copy of *From Ritual to Romance*, a book by Jessie Weston that inspired Eliot's poem *The Waste Land*.
- Kurtz reads from the T. S. Eliot poem *The Hollow Men*. Eliot was inspired to write this poem by Joseph Conrad's *Heart of Darkness*. The first line of the poem reads: "Mistah Kurtz—he dead." Kurtz leaves this line and the following line out when he reads. Also, the photojournalist says, "This is the way the fucking world ends. Look at this fuckin' shit we're in, man. Not with a bang, but with a whimper, and with a whimper, I'm fucking splitting, Jack." This is taken from the same poem's famous last two lines, "This is the way the world ends / Not with a bang but with a whimper."

- Coppola was unable to find a satisfactory way of ending the film until his wife, Eleanor Coppola, witnessed the Ifugao natives used as extras performing an animal sacrifice.
- There are no opening credits or titles. The title of the movie appears as graffiti late in the film.
- An entire set of scenes was cut, in which Willard and company find a riverside French colony. This cut made the symbolism of the journey back through time more apparent: Vietnam War to French colony to jungle culture.
- Carmine Coppola, the director's father, wrote the score for this film.
- Harrison Ford's character wears a name badge that reads Lucas. George Lucas directed Ford in *American Graffiti* (1973) and *Star Wars* (1977), two films that made Ford famous.
- G. D. Spradlin's character is named R. Corman, after producer Roger Corman.
- Eleanor Coppola filmed and recorded the making of this film, resulting in *Hearts of Darkness: A Filmmaker's Apocalypse* (1991).
- The character of the photojournalist (Dennis Hopper) was reportedly inspired by legendary photographer Tim Page, author of *Nam* and *Derailed in Uncle Ho's Victory Garden*, among other books.
- Robert Duvall and Dennis Hopper leave the film the exact same way, by standing up from a squatting position and walking out of the frame to the right.
- Scenes featuring Aurore Clément as the owner of a French plantation were filmed but cut from the finished picture.

MISTAKES

- The magnetic tape on the reel-to-reel player in the helicopter does not pass over the play heads.
- The blades of the Huey helicopter when the Playmate of the Year arrives reveal a continuity error.
- When Willard's boat pulls out from the Dulong Bridge, you can see the wake caused by the camera boat.
- The army did not have the 30-round banana clips portrayed in the movie until the mid-70s.
- The thickness of the pages when Willard flips through Kurtz's manuscripts after he is killed is inconsistent.
- The maximum gross weight of a Huey helicopter is 10,500 pounds. It would be impossible, as shown in the film, for such an aircraft to lift a patrol boat riverine (PBR), which weighs between 15,000 and 19,000 pounds.
- After the canopy of the boat is destroyed and is replaced by giant leaves, the canopy reappears while the crew is at the bridge. In subsequent shots, the canopy is gone again and replaced by the leaves.
- Kilgore talks about surfing Charlies Point. When we see it, it is obviously a beach break, not a point break.

QUOTE

Colonel Walter E. Kurtz: It's impossible for words to describe what is necessary to those who do not know what horror means. Horror. Horror has a face, and you must make a friend of horror. Horror and mortal terror are your friends. If they are not, then they are enemies to be feared. They are truly enemies.

AWARDS

Academy Awards (Oscar), USA, 1979
Won: *Best Cinematography*, Vittorio Storaro; *Best Sound*, Richard Beggs, Mark Berger, Nathan Boxer, Walter Murch

Nominated: *Best Art Direction—Set Decoration*, Angelo P. Graham, George R. Nelson, Dean Tavoularis; *Best Director*, Francis Ford Coppola; *Best Film Editing*, Lisa Fruchtman, Gerald B. Greenberg, Richard Marks, Walter Murch; *Best Picture*, Francis Ford Coppola, Gray Frederickson, Fred Roos, Tom Sternberg; *Best Supporting Actor*, Robert Duvall; *Best Writing, Screenplay, Based on Material from Another Medium*, Francis Ford Coppola, John Milius

American Cinema Editors (Eddie), USA, 1980
Nominated: *Best Edited Feature Film*, Lisa Fruchtman, Gerald B. Greenberg, Richard Marks, Walter Murch

British Academy Awards (BAFTA), UK, 1980
Won: *Best Direction*, Francis Ford Coppola; *Best Supporting Actor*, Robert Duvall

Nominated: *Anthony Asquith Award for Film Music*, Carmine Coppola, Francis Ford Coppola; *Best Actor*, Martin Sheen; *Best Cinematography*, Vittorio Storaro; *Best Editing*, Lisa Fruchtman, Gerald B. Greenberg, Richard Marks, Walter Murch; *Best Production Design*, Dean Tavoularis; *Best Sound Track*, Nathan Boxer, Richard P. Cirincione, Walter Murch.

Cannes Film Festival, 1979
Won: *FIPRESCI Award Competition*, Francis Ford Coppola

Won: *Golden Palm*, Francis Ford Coppola

César Awards, 1980
Nominated: *Best Foreign Film*, Francis Ford Coppola

Golden Globes, USA, 1980

> **Won:** *Best Director—Motion Picture,* Francis Ford Coppola; *Best Motion Picture Actor in a Supporting Role,* Robert Duvall; *Best Original Score—Motion Picture,* Carmine Coppola, Francis Ford Coppola
>
> **Nominated:** *Best Motion Picture—Drama*

National Society of Film Critics Awards (NSFC Award), USA, 1980

> **Won:** *Best Supporting Actor,* Frederic Forrest

Writers Guild of America (WGA Screen Award), USA, 1980

> **Nominated:** *Best Drama Written Directly for the Screen,* Francis Ford Coppola, John Milius.

APPOINTMENT IN BERLIN

Columbia Pictures Corporation, 1943, b&w, 77 minutes.

Producer: Samuel Bischoff; **Director:** Alfred E. Green; **Screenwriters:** B. P. Fineman, Michael Hogan, Horace McCoy; **Cast:** Felix Basch, Marguerite Chapman, Alec Craig, Donald Douglas, Arno Frey, Steven Geray, Jack Lee, Leonard Mudie, Alan Napier, George Sanders, H. P. Sanders, Reginald Sheffield, Gale Sondergaard, Onslow Stevens, Frederick Worlock, Wolfgang Zilzer.

George Sanders, secretly enlisted into the British secret service, poses as a German collaborator to gain vital information for the Allies in Berlin.

ARMORED COMMAND

Allied Artists Pictures Corporation, 1961, b&w, 99 minutes.

Producer: R. W. Alcorn; **Director:** Byron Haskin; **Screenwriter:** R. W. Alcorn; **Music:** Bert Grund; **Distributor:** Allied Artists; **Filmed in:** Germany; **Cast:** Warner Anderson, Peter Capell, James Dobson, Clem Harvey, Earl Holliman, Marty Ingels, Howard Keel, Tina Louise, Maurice Marsac, Charles Nolte, Burt Reynolds, Thomas A. Ryan, Carleton Young.

A Nazi spy uses her sexual powers on Earl Holliman and Burt Reynolds, American soldiers trapped in a small town by a German counterattack. However, her scheme is thwarted by their colonel, Howard Keel. During the final battle, she shoots Reynolds and is in turn killed by Holliman.

ARMY SURGEON

RKO Radio Pictures Inc. 1942, b&w, 63 minutes.

Producer: Bert Gilroy **Director:** A. Edward Sutherland; **Screenwriters:** Everett Lavery, Barry Trivers, John Twist; **Music:** Roy Webb; **Cast:** Eddie Acuff, Jack Briggs, James Burke, Cliff Clark, George Cleveland, Ann Codee, Eddie Dew, James Ellison, Richard Martin, Walter Reed, Cyril Ring, Kent Taylor, Russell Wade, Jane Wyatt.

During World War I, an aviator, played by Kent Taylor, competes against James Ellison, an army doctor, for the love of Jane Wyatt, a nurse.

All three of them are buried alive in a field hospital, and the two officers compete to save the object of their mutual love.

INTERESTING FACT

- This low-budget effort, released during World War II, when virtually every war film was profitable, ended up losing money for its studio.

ASCENT, THE

RHI Entertainment Inc., 1994, color, 96 minutes.

Producers and Screenwriters: Njeri Karago, Jeffrey Lawenda; **Director:** Donald Shebib; **Cast:** Ben Cross, John De Veillers, Mark Ingall, Tony Lo Bianco, Vincent Spano, Rachel Ward.

During World War II, Italian prisoners of war challenge their British captors to a race up the face of nearby Mount Kenya. POW Vincent Spano is intent on turning the friendly rivalry of the race into an escape attempt.

This film is based on a true story.

ASSIGNMENT IN BRITTANY

Metro-Goldwyn-Mayer, 1943, b&w, 96 minutes.

Producer: Walter Ruben; **Director:** Jack Conway; **Screenwriters:** Helen MacInnes (novel), Howard Emmett Rogers, Anthony Veiller, William H. Wright; **Music:** Lennie Hayton; **Distributor:** Metro-Goldwyn-Mayer; **Cast:** Morris Ankrum, Jean-Pierre Aumont, Henriette Corlay, George Coulouris, William Edmunds, John Emery, Signe Hasso, Darryl Hickman, Charles Irwin, Frank Lackteen, Peter Lawford, Paul Leyssac, Miles Mander, Odette Myrtil, Alan

Napier, Reginald Owen, Sarah Padden, Susan Peters, Lucien Prival, Juanita Quigley, Lionel Royce, Hans Schumm, George Travell, Richard Whorf, Rex Williams, Margaret Wycherly.

Jean-Pierre Aumont, who works for the French underground, is a look-alike for a pro-Nazi collaborator. He uses this resemblance to his advantage to obtain information about a secret Nazi submarine base, so that British commandos can destroy it.

The film is based on Helen MacInnes's *Assignment in Brittany* (Boston: Little, Brown and Company, 1942).

ASSISI UNDERGROUND, THE

Cannon Film Distributors, 1985, color, 115 minutes.

Producers: Yoram Globus, Menahem Golan; **Director:** Alexander Ramati; **Screenwriter:** Alexander Ramati; **Distributor:** Cannon Film Distributors; **Cast:** Roberto Bisacco, Delia Boccardo, Geoffrey Copleston, Ben Cross, Riccardo Cucciolla, Eurilla Del Bona, Gabriella D'Olive, Tom Felleghy, Karlheinz Hackl, Angelo Infanti, Marne Maitland, Paolo Malco, James Mason, Alessandra Mussolini, Irene Papas, Maurice Poli, Giancarlo Prete, Edmund Purdom, Alfredo Péa, Didi Ramati, Maximilian Schell, Venantino Venantini.

The Catholic Church attempts to rescue hundreds of Jews from certain death at the hands of the Nazis during the 1943 occupation of Italy by the German army.

INTERESTING FACT

• A four-hour cable version also exists.

ATLANTIC CONVOY

Columbia Pictures Corporation, 1942, b&w, 66 minutes.

Producer: Colbert Clark; **Director:** Lew Landers; **Screenwriter:** Robert Lee Johnson; **Music:** Morris Stoloff; **Distributor:** Columbia Pictures; **Cast:** John Beal, Bruce Bennett, Lloyd Bridges, Stanley Brown, Virginia Field, Victor Kilian, Eddie Laughton, Larry Parks, Erik Rolf, Hans Schumm, Clifford Severn.

John Beal, a weatherman in Iceland during World War II, is suspected of supplying Nazi submarines with information about American shipping. Even though he rescues an injured American pilot and several children in a daring airplane landing, this does not allay suspicion that he is collaborating with the enemy. He absolves himself of suspicion only when he leads a U.S. air patrol to a German submarine.

ATTACK!

The Associates & Aldrich Company Inc., 1956, b&w, 107 minutes.

Producers: Robert Aldrich, Walter Blake; **Director:** Robert Aldrich; **Screenwriters:** Norman Brooks, James Poe; **Music:** Frank De Vol; **Distributor:** United Artists; **Cast:** Eddie Albert, Holly Bane, Leonard Bremen, Buddy Ebsen, Steven Geray, Jimmy Goodwin, Richard Jaeckel, Strother Martin, Lee Marvin, Ron McNeil, Louis Mercier, Jack Palance, Henry Rowland, Jon Shepodd, William Smithers, Robert Strauss, Jud Taylor, Peter van Eyck.

During the Battle of the Bulge in World War II, Eddie Albert plays a cowardly captain whose weakness results in the death of a number of soldiers. Jack Palance tries to get him relieved of his command, because he knows the captain is a danger to him and his men. But their commander, played by Lee Marvin, who knows that Eddie Albert has political power in their hometown in the states, refuses to relieve Albert. When Jack Palance and his men are almost wiped out because of Albert, one of them returns to the headquarters and kills him.

MILITARY SERVICE

• In stark contrast to his cowardly role in this film, Eddie Albert had a distinguished war record. He was under contract to Warner Bros. before the war, and when he sailed a boat to Mexico in 1938, he observed Japanese fishermen (actually, spies) taking depth readings. He reported this to army intelligence and was sent back south of the border where he was successful in gathering information on German activities in Mexico. When World War II started, he received a direct commission as a lieutenant (j.g.) and was assigned to the USS *Sheridan*, an attack transport. After training in amphibious landing techniques with the First Battalion, Eighth Marines, he was at the landings at Tarawa. After landing his troops, he was involved in returning to the reefs, ultimately rescuing approximately 150 wounded marines who were trapped by Japanese machine-gun fire and snipers. He was cited for "outstanding performance of duty" for his actions that day. He subsequently received two Oscar nominations, but is best known for his role on TV's *Green Acres*, the 1960s sitcom.

Costa: Listen to me, Cooney! If you put me and my men in a wringer—if you send us out there and let us hang—I swear, I swear by all that's holy, I'll come back. I'll come back and take this grenade and shove it down your throat and pull the pin!

ATTACK FORCE Z

Fauna Productions, John McCallum Productions, 1982, color, 93 minutes.

Producers: Betty Bernard, George F. H. Chang, Beney C. P. Chao, Ming Chi, Kuo-Liang Hsu, Lee Robinson; **Directors:** Tim Burstall, Jing Ao Hsing; **Screenwriter:** Roger Marshall; **Music:** Eric Jupp; **Filmed in:** Taiwan; **Cast:** Val Champion, Sylvia Chang, Ned Chun, Mel Gibson, Chris Haywood, Hsa Li-Wen, Koo Chuan Hsiung, John Phillip Law, Sam Neill, Lung Shuan, John Waters, Wang Yu, Vi Yuan.

A small commando unit operates behind Japanese lines to rescue the survivors of a downed aircraft on the Japanese-controlled Malay Peninsula during World War II.

Hollywood does not seem to particularly care that Australia also fought in World War II, so the Australians must make their own movies.

INTERESTING FACT

• This is an early film for Mel Gibson.

ATTACK ON THE IRON COAST

Oakmont Films, Mirisch Films, 1968, color, 89 minutes.

Producers: John C. Champion, Ted Lloyd, Irving Temaner; **Director:** Paul Wendkos; **Screenwriters:** John C. Champion, Herman Hoffman; **Music:** Gérard Schurmann; **Distributor:** United Artists; **Cast:** John Abineri, Sean Barrett, Victor Beaumont, Gavin Breck, Lloyd Bridges, Keith Buckley, Ernest Clark, Joan Crane, Maurice Denham, Mark Eden, Murray Evans, John Golightly, Walter Gotell, Robin Hawdon, Dick Haydon, Bill Henderson, Andrew Keir, John Kelland, Sue Lloyd, George Mikell, Glyn Owen, Howard Pays, Simon Prebble, Richard Shaw, Mark Ward, John Welsh, Michael Wolf.

Working under the specter of a previous raid, whose failure resulted in the death of a large number of commandos, Lloyd Bridges works to train a new squad for a special mission, code-named "Operation Mad Dog." Despite the lack of promised air cover, the commandos cross the channel and successfully raid a German naval base on the French coast.

AWAY ALL BOATS

Universal-International Pictures, 1956, color, 114 minutes.

Producer: Howard Christie; **Director:** Joseph Pevney; **Screenwriters:** Kenneth M. Dodson, Ted Sherdeman; **Music:** Heinz Roemheld, Frank Skinner; **Cast:** Julie Adams, Keith Andes, Parley Baer, Raymond Bailey, Lex Barker, Dan Barton, Hal Baylor, Nicky Blair, Richard Boone, Jeff Chandler, Kendall Clark, Chuck Courtney, George Dunn, Clint Eastwood, Frank Faylen, Sam Gilman, Dabbs Greer, Charles Horvath, Robert F. Hoy, David Janssen, Don Keefer, Mickey Kuhn, Jock Mahoney, Gerard Masterson, Roger McGee, Charles McGraw, John McIntire, Danny Mummert, George Nader, Voltaire Perkins, John Pickard, George Ramsey, William Reynolds, Ralph Scalzo, Floyd Simmons, Arthur Space, Jarl Victor, James Westerfield, Grant Williams, Rod Williams, Henry Wills.

The USS *Belinda,* Attack Transport PA22, is launched late in 1943 with regular-navy captain Jeff Chandler and former merchant captain George Nader, now a regular-navy lieutenant. Despite personal friction, the two have plenty to deal with as the only experienced officers on board during the shakedown cruise. The crew gradually improves but remains far from perfect when the ship sees action, landing troops on enemy beachheads at Okinawa and Makin, as well as surviving a kamikaze attack. In the end, Jeff Chandler is killed in action, and the crew finally realizes that they have come through it all because the captain pushed them hard in their training.

Based on *Away All Boats,* a novel by Kenneth Dodson (Boston: Little, Brown, 1954).

INTERESTING FACT

• Look for Clint Eastwood in a small role as a marine medic.

QUOTE

Narrator: [speaking of Jeff Chandler, the captain, after he dies]: All of us are better than we thought we could be because of what he gave us, and we'll go home again because of him.

BACK DOOR TO HELL

20th Century-Fox Film Corporation, Lippert Pictures Inc., 1964, b&w, 68 minutes.

Producers: Robert L. Lippert, Ronald Remy, Fred Roos; **Director:** Monte Hellman; **Screenwriters:** Richard A. Guttman, John Hackett; **Music:** Mike Velarde, **Filmed in:** Philippines; **Distributor:** 20th Century-Fox; **Cast:** Henry Duval, John Hackett, Annabelle Huggins, Conrad Maga, Johnny Monteiro, Jack Nicholson, Ben Perez, Jimmie Rodgers, Joe Sison, Vic Uematsu.

During World War II, just prior to MacArthur's return, a three-man commando team is sent to the Philippines to knock out a Japanese communication center.

INTERESTING FACTS

- Actor Jimmie Rodgers is a one-time pop singer.
- The film shows a very young Jack Nicholson.
- Theatre owner Lippert is credited as an executive producer, and the film is reminiscent of his earlier release *SILENT RAIDERS*.

BACK TO BATAAN

RKO Radio Pictures Inc., 1945, b&w, 95 minutes.

Producers: Robert Fellows, Theron Warth; **Director:** Edward Dmytryk; **Screenwriters:** Ben Barzman, William Gordon, Richard H. Landau, Aeneas MacKenzie; **Music:** Max Steiner, Roy Webb; **Filmed in:** Philippines; **Distributor:** RKO Radio Pictures Inc.; **Cast:** Philip Ahn, Erville Alderson, Abner Biberman, Beulah Bondi, Robert Clarke, Paul Fix, Benson Fong, Harold Fong, Fely Franquelli, Edmund Glover, Alex Havier, Richard Loo, Ducky Louie, Kenneth McDonald, John Miljan, Anthony Quinn, Vladimir Sokoloff, Leonard Strong, Ray Teal, Lawrence Tierney, John Wayne, Bill Williams.

After the fall of the Philippines to the Japanese in World War II, John Wayne, a colonel in the U.S. Army, stays behind in the islands to organize the guerrilla fight by the Filipino resistance against the invaders.

A haunting scene is when the town's Filipino schoolteacher, played by Vladimir Sokoloff, refuses to haul down the American flag in the schoolyard. The Japanese invaders pull down the flag, and hang him from the flagpole in its stead.

INTERESTING FACTS

- During World War II, the Philippines was still a part of the United States; thus the American flag was the official flag of the country at the time of the Japanese invasion.
- The Bataan Death March depicted in the film is a very accurate portrayal of the actual event.

- Actual survivors of the Bataan Death March, liberated from the Cabanatuan prison camp, were used in the filming of the movie.

BAMBOO BLONDE

RKO Radio Pictures Inc., 1946, b&w, 67 minutes.

Producers: Sid Rogell, Herman Schlom; **Director:** Anthony Mann; **Screenwriters:** Olive Cooper, Lawrence Kimble, Wayne Whittaker; **Distributor:** RKO Radio Pictures; **Cast:** Iris Adrian, Jean Brooks, Robert Clarke, Ralph Edwards, Jane Greer, Paul Harvey, Frances Langford, Richard Martin, Tommy Noonan, Walter Reed, Jason Robards Sr., Dorothy Vaughan, Glen Vernon, Russell Wade, Regina Wallace.

Russell Wade, the pilot of a B-29, falls in love with Frances Langford, a singer in a New York nightclub, but he has to leave the next day for action in the South Pacific. He paints her picture on the nose of his bomber, which becomes known as the "Bamboo Blonde." As the bomber's exploits make the "Bamboo Blonde" famous, the fame also attaches to the singer, and her career takes off.

MILITARY SERVICE

- Radio and TV commentator Paul Harvey enlisted in the U.S. Army Air Force, expecting to be assigned as an Air Corps cadet but instead ended up in the infantry. After four months of basic training, he was injured in the foot on an obstacle course and received a medical discharge.

 Jason Robards served overseas as a radioman aboard cruisers in the South Pacific during World War II. He fought in 13 major engagements and twice was on ships that were torpedoed. He was aboard the USS *North Hampton* when it was sunk by a submarine at Guadalcanal and also on the *Honolulu* when it was torpedoed near Formosa. Although some accounts state he was at Pearl Harbor on December 7, he was actually at sea returning from supplying Wake Island and did not enter Pearl Harbor until December 8.

BAMBOO PRISON, THE

Columbia Pictures Corporation, 1954, b&w, 79 minutes.

Producer: Bryan Foy; **Director:** Lewis Seiler; **Screenwriters:** Edwin Blum, Jack DeWitt; **Cast:** Jerome Courtland, King Donovan, Dianne Foster, Robert Francis, Leo Gordon, Pepe Hern, Earle Hyman, Dickie Jones, Brian Keith, Jack Kelly, George Keymas, Weaver Levy, Richard Loo, Keye Luke, E. G. Marshall, Murray Matheson.

During the Korean War, American soldiers try to survive in a prisoner-of-war camp while the peace negotiations drag on at Panmunjom. Robert Francis and Brian Keith are soldiers planted in the camp by the Americans. Robert Francis cooperates with the enemy as a cover for his mission and is despised by his fellow prisoners for it. E. G. Marshall is a communist agent disguised as an American priest who spies on the soldiers.

BANDIDO

Bandido Productions, 1956, color, 92 minutes.

Producer: Robert L. Jacks; **Director:** Richard Fleischer; **Screenwriter:** Earl Felton (also story); **Music:** Max Steiner; **Distributor:** United Artists; **Cast:** Rodolfo Acosta, Henry Brandon, José Ángel Espinosa Ferrusquilla, Douglas Fowley, Miguel Inclán, Víctor Junco, Margarito Luna, Arturo Manrique, Robert Mitchum, José Muñoz, Manuel Sánchez Navarro, Alberto Pedret, Gilbert Roland, Antonio Sandoval, Zachary Scott, Alfonso Sánchez Tello, Ursula Thiess, José Torvay.

American arms dealer Zachary Scott hopes to make a killing by selling to the *regulares* in the 1916 Mexican revolution. American mercenary Robert Mitchum makes a deal with the rebel faction, headed by Gilbert Roland, to hijack Scott's guns. Their scheme is complicated by the fact that Mitchum also has an eye on hijacking Scott's wife (Ursula Thiess). Raids, counterraids, and escapes follow in a veritable hail of bullets.

BARRICADE

20th Century-Fox Film Corporation, 1939, b&w, 71 minutes.

Producer: Darryl F. Zanuck; **Director:** Gregory Ratoff; **Screenwriter:** Granville Walker; **Music:** David Buttolph, Alfred Newman; **Distributor:** 20th Century-Fox; **Cast:** Philip Ahn, Philson Ahn, Warner Baxter, Joan Carroll, Edward Earle, Alice Faye, Willie Fung, Chester Gan, Jonathan Hale, Harry Hayden, Wai Kang, Doris Lloyd, Richard Loo, Keye Luke, Eily

Malyon, Paul McVey, Moroni Olsen, Leonid Snegoff, Charles Tannen, Arthur Treacher, Charles Winninger, Victor Sen Yung.

In the strife-torn China of the 1930s, Americans seek refuge in a consulate compound against a siege by a large band of Mongolian bandits. Warner Baxter is an alcoholic down-on-his-luck reporter, Alice Faye is a showgirl on the run from a crime, and Charles Winninger is consul at the American embassy.

BATAAN

Metro-Goldwyn-Mayer, 1943, b&w, 113 minutes.

Producer: Irving Starr; **Director:** Tay Garnett; **Screenwriter:** Robert Hardy Andrews; **Music:** Bronislau Kaper, Eric Zeisl; **Filmed at:** back lot; **Cast:** Ernie Alexander, Desi Arnaz, Lee Bowman, Lynne Carver, Donald Curtis, Tom Dugan, Roque Espiritu, Bud Geary, Alex Havier, Mary McLeod, Thomas Mitchell, Dorothy Morris, George Murphy, Barry Nelson, Lloyd Nolan, Phil Schumacher, Kenneth Spencer, Robert Taylor, Phillip Terry, Robert Walker.

Thirteen men are left behind to hold a bridge and fight a rear-guard action to ensure the success of the Allied retreat from Bataan. The men are George Murphy, a U.S. Air Force lieutenant; Lloyd Nolan, a smart and compassionate corporal; Thomas Mitchell, a career NCO; Desi Arnaz, a friendly Hispanic; Lee Bowman, the captain who dies from a sniper's bullet; Robert Walker (in his screen debut), who almost breaks down from homesickness; Kenneth Spencer, one of the first black soldiers portrayed in an integrated unit in films; and Robert Taylor, the tough heroic sergeant who is the last of the 13 to die.

INTERESTING FACTS

- After the Japanese invasion of the Philippines in December 1941 and the fall of Manila on January 2, 1942, the defending Americans and Filipinos withdrew to Bataan, foiling Japanese efforts to split the forces of General Douglas MacArthur.
- Robert Taylor proved to Hollywood he was more than a "pretty boy," coming across as a serious actor with a dramatic range.
- The film is also available in a colorized version.

QUOTE

Robert Walker: It doesn't matter where a man dies so long as he dies for freedom.

BATTLE AT BLOODY BEACH

20th Century-Fox Film Corporation, 1961, b&w, 83 minutes.

Producer: Richard Maibaum; **Director:** Herbert Coleman; **Screenwriters:** Richard Maibaum (also story), William Willingham (as Willard Willingham); **Music:** Henry Vars; **Distributor:** 20th Century-Fox; **Cast:** Philip Ahn, June Allyson, Humphrey Bogart, William Campbell, Danny Chang, Jonathan Cott, Steve Forrest, Robert Keith, Adele Longmire, Ann Morrison, Jeff Richards, Sarah Selby, Perry Sheehan, Dick Simmons, Patricia Tiernan, Helen Winston, Keenan Wynn.

Audie Murphy is a civilian working for the navy, helping supply Filipino guerrilla insurgents fighting against the Japanese during World War II. His motive is neither politics nor bravery; he wants to find the bride from whom he was separated during the Japanese invasion. Unfortunately for Murphy, she has fallen in love with the guerrilla leader, Alejandro Rey.

INTERESTING FACTS

- This is only the second Audie Murphy movie set in World War II after his autobiographical *TO HELL AND BACK*.
- The film is known as *Battle on the Beach* in the U.K.
- The screenwriter, Richard Maibaum, wrote several of the James Bond films.

BATTLE CIRCUS

Metro-Goldwyn-Mayer, 1953, b&w, 90 minutes.

Producer: Pandro S. Berman; **Director:** Richard Brooks; **Screenwriters:** Richard Brooks, Laura Kerr, Allen Rivkin; **Music:** Lennie Hayton; **Cast:** Philip Ahn, Humphrey Bogart, William Campbell, Danny Chang, Jonathan Cott, Steve Forrest, Robert Keith, Jeff Richards, Dick Simmons, Keenan Wynn, June Allyson, Adele Longmire, Ann Morrison, Sarah Selby, Perry Sheehan, Patricia Tiernan, Helen Winston.

Humphrey Bogart is a hard-bitten army surgeon in a Mobile Army Surgical Hospital (MASH) who has a romance during the Korean War with a new nurse, June Allyson, who is out to save the world.

INTERESTING FACTS

- Devotees of the *M*A*S*H* film and TV show will recognize a lot of the same elements in this film, which was actually made during the Korean War.

- The name of the film derives from the character played by Keenan Wynn, who used to work in a circus and who utilizes his talents as a former roustabout in the constant striking and putting up of the MASH tents and equipment.
- Robert Keith, the father of Brian Keith, portrays Bogart's commanding officer.

BATTLE CRY

Warner Bros., 1955, color, 149 minutes.

Director: Raoul Walsh; **Screenwriter:** Leon Uris; **Music:** Max Steiner; **Filmed at:** Vieques, Puerto Rico, and San Diego and Camp Pendleton, California; **Distributor:** Warner Bros.; **Cast:** Lee Allen, Jonas Applegarth, Roxanne Arlen, David Armstrong, Joan Arnold, John Ayres, Rayford Barnes, Hal Bokar, Willis Bouchey, Budd Buster, William Campbell, Chick Chandler, Tommy Cook, Dean Cromer, Patrick Curtis, Glenn Denning, Jack Downs, Don Durant, Frank Ferguson, Anne Francis, Mona Freeman, Paul Grant, Fred Hanson, Carl Harbaugh, Lumsden Hare, Van Heflin, Chuck Hicks, Clark Howat, Tab Hunter, L. Q. Jones, Jack Jordan, Byron Keith, Harold Knudsen, Perry Lopez, John Lupton, Dorothy Malone, Raymond Massey, June McCall, Allyn Ann McLerie, Victor Millan, Fay Morley, Susan Morrow, Felix Noriego, Nancy Olson, Fess Parker, Hilda Plowright, Aldo Ray, Jack Rollens, Sarah Selby, Jack Shea, Kay Stewart, Ralph Volkie, Gregory Walcott, James Whitmore, Rhys Williams, Carleton Young.

In 1942, the usual stereotypical group joins the marines: a slum kid, an all-American boy, a farmer, a lumberjack, a practical joker, and even a bookworm who reads Plato. Primed for battle, they are frustrated by many noncombat assignments, and use their free time to pursue wartime romances in New Zealand. Finally, the squad sees action at Saipan.

INTERESTING FACTS

- Dorothy Malone comes off best in this film, overshadowing the male actors, as a desperate over-30 woman attracted to a younger man, Tab Hunter.
- The U.S. Marines fully cooperated with the filming.
- While shooting the battle scenes at Vieques, a small island off Puerto Rico, the production company had the use of men and equipment then taking part in regularly scheduled marine amphibious exercises.
- The film had the advantage of the expertise of Col. Jim Crowe, of Tarawa fame, who served as the film's technical adviser.

- Thanks to the U.S. Marine Corps' subsequent assistance at the Marine Recruit Depot at San Diego and at Camp Pendleton, where the story's New Zealand sequences were filmed, the film has an authenticity of marines in training.
- During filming, a general came up to director Raoul Walsh and told him that he had joined the marines after seeing his film *What Price Glory?*
- Director Walsh cleverly sidestepped the puritanical production code of the time, which prohibited complete nudity, by having Malone disrobe completely while sitting sideways in a chair, which was strategically arranged in front of the camera to hide the naughty bits.
- The film is based on Leon Uris's *Battle Cry* (New York: Putnam, 1953).

BATTLE FLAME

Allied Artists Pictures Corporation, 1959, b&w, 78 minutes.

Producer: Lester A. Sansom; **Director:** R. G. Springsteen; **Screenwriters:** Lester A. Sansom, Elwood Ullman; **Music:** Marlin Skiles; **Distributor:** Allied Artists; **Cast:** Robert Blake, Scott Brady, Richard Crane, Elaine Edwards, Richard Harrison, Wayne Heffley, Gordon Jones, Gary Kent, Ken Miller, Peggy Moffitt, Scott Petrie, Jean Robbins, Arthur Walsh.

When a group of American nurses are captured by North Koreans, the U.S. Marines, led by Lieutenant Scott Brady, manage to rescue them. In the course of the rescue, Brady falls in love with one of the captives, navy nurse Elaine Edwards, who has to choose between her navy surgeon fiancé and Brady, her heroic rescuer.

INTERESTING FACT

- The film uses stock action footage intercut with the film footage.

BATTLEGROUND

Metro-Goldwyn-Mayer, 1949, b&w, 118 minutes.

Producers: Robert Pirosh, Dore Schary; **Director:** William A. Wellman; **Screenwriter:** Robert Pirosh; **Music:** Lennie Hayton; **Distributor:** MGM; **Filmed at:** soundstage; **Cast:** Leon Ames, Herbert Anderson, James Arness, Scotty Beckett, Nan Boardman, Tommy Bond, Thomas E. Breen, Michael Brown, George Chandler, Jerome Courtland, Bruce Cowling, Denise

Darcel, Chris Drake, Jim Drum, Douglas Fowley, John Hodiak, David Holt, Richard Jaeckel, Van Johnson, Dickie Jones, Tommy Kelly, Brett King, William Lester, Ian MacDonald, Dewey Martin, Ricardo Montalban, George Murphy, John Mylong, Tommy Noonan, George Offerman, Jerry Paris, Steve Pendleton, Henry Rowland, Edmon Ryan, William Self, Don Taylor, Marshall Thompson, Ivan Triesault, Roland Varno, James Whitmore.

James Whitmore is the sergeant in charge of a squad from the 101st Airborne Division fighting the Germans near Bastogne in the snowy, foggy winter of December 1944. The thick fog makes movement and identification difficult and, most importantly, prevents Allied air support. As they wait for the clouds to break, they must survive German spies in U.S. Army uniforms, enemy artillery, winter weather, and the lack of fuel, rations, and ammunition. The Germans incessantly encourage their surrender via radio and leaflets, and there is the constant threat of being cut off and annihilated by a counter-attack.

The Nazis, in the face of the onrushing Allies, had turned in their retreat toward Germany and pushed into the Ardennes Forest in Belgium and Luxembourg for what would be their last major offensive of World War II. During the Battle of the Bulge, they surrounded the town of Bastogne, Belgium, trapping the 101st Airborne Division. To make matters worse, thick clouds covered the area for most of the battle, preventing the Allies from providing air cover and air-dropping supplies to their troops on the ground.

MILITARY SERVICE

- James Whitmore was a prelaw student at Yale at the beginning of World War II, playing football under coach Gerald R. Ford. He enlisted in the marines and saw action at Saipan, the Mariana Islands, and Tinian, earning a battlefield commission to lieutenant. After his discharge, he joined the USO and returned to the Pacific to entertain occupation troops.
- James Arness enlisted in the army at the age of 19, and was wounded in the leg during the invasion of Italy at Anzio in January 1944. He is best known for his role as Marshall Dillon on TV's *Gunsmoke*.

QUOTES

Hansan: This is an M-1, semiautomatic, high velocity . . .
Soldier: Look, you're not selling it to me, you're showing me how to fire it!

AWARDS

Academy Awards, USA, 1949
Won: *Oscar*, *Best Cinematography, Black-and-White*, Paul Vogel; *Best Writing, Story and Screenplay*, Robert Pirosh
Nominated: *Oscar*, *Best Director*, William A. Wellman; *Best Film Editing*, John D. Dunning; *Best Picture*, Dore Schary, *Best Supporting Actor*, James Whitmore

Golden Globes, USA, 1950
Won: *Golden Globe, Best Screenplay*, Robert Pirosh; *Best Supporting Actor*, James Whitmore,

Photoplay Awards, 1950
Won: *Gold Medal*

Writers Guild of America, USA, 1950
Nominated: *WGA Screen Award, Best Written American Drama*, Robert Pirosh.

BATTLE HYMN

Universal-International Pictures, 1957, color, 108 minutes.

Producer: Ross Hunter; **Director:** Douglas Sirk; **Screenwriters:** Vincent B. Evans, Charles Grayson; **Music:** Frank Skinner; **Distributor:** Universal; **Cast:** Philip Ahn, Don DeFore, Dan Duryea, James Edwards, Alan Hale Jr., James Hong, Rock Hudson, William Hudson, Martha Hyer, Anna Kashfi, Richard Loo, Jock Mahoney, Art Millan, Earle E. Partridge, Jung Kyoo Pyo, Carl Benton Reid, Bartlett Robinson, Simon Scott, Teru Shimada, Paul Sorenson, Carleton Young.

Rock Hudson is a fighter pilot who enters the ministry to atone for accidentally bombing a German orphanage during World War II. However, coming to believe he is a failure as a minister, he doesn't resist when he is recalled to active duty during the Korean War to help train new fighter pilots. In Korea, he is shocked to find young orphans raiding the garbage cans at his airbase. With the aid of a teacher, he starts an orphanage. But he realizes that to protect his charges, he must kill again.

The film is based on the real-life story of Col. Dean Hess, a fighter pilot and minister.

AWARD

Golden Globes, USA, 1957
Won: *Best Film Promoting International Understanding.*

BATTLE OF BLOOD ISLAND

Filmgroup, 1960, b&w, 64 minutes.

Producer: Stanley Bickman; **Director:** Joel Rapp; **Screenwriter:** Joel Rapp; **Cast:** Richard Devon, Ron Kennedy.

During World War II, two American soldiers hide out in a cave in the Pacific, after their unit is wiped out trying to take the Japanese-held island. When the Japanese soldiers learn that the war is over, they commit mass suicide.

BATTLE OF BRITAIN

Spitfire, 1969, color, 133 minutes.

Producers: Benjamin Fisz, Harry Saltzman; **Director:** Guy Hamilton; **Screenwriters:** Wilfred Greatorex, James Kennaway; **Music:** Ron Goodwin, William Walton; **Distributor:** United Artists; **Filmed at:** San Sebastián, Guipúzcoa, Spain; Huelva's Beach, Huelva, Spain; El Corporo air base and Tablada air base, Sevilla, Spain; North Weald Aerodrome, Essex, England; Dragon Road, London, England; Katherine Docks, London, England; RAF Duxford, England; RAF Hawkinge, England; **Cast:** Wilfried von Aacken, Karl-Otto Alberty, Alexander Allerson, Harry Andrews, John Baskcomb, Michael Bates, Isla Blair, Michael Caine, Tom Chatto, James Cosmo, Robert Flemyng, Barry Foster, Edward Fox, W. G. Foxley, Dietrich Frauboes, David Griffin, Jack Gwyllim, Peter Hager, Wolf Harnisch, Reinhard Horras, Trevor Howard, Myles Hoyle, Alf Jungermann, Curd Jürgens, Helmut Kircher, Duncan Lamont, Sarah Lawson, Mark Malicz, André Maranne, Ian McShane, Kenneth More, Richardson Morgan, Paul Neuhaus, Anthony Nicholls, Laurence Olivier, Nigel Patrick, Nicholas Pennell, Malte Petzel, Christopher Plummer, Manfred Reddemann, Michael Redgrave, Hein Reiss, Ralph Richardson, John Savident, Andrzej Scibor, Robert Shaw, Rolf Stiefel, Nick Tate, Reg Thomason, Jean Wladon, Patrick Wymark, Susannah York.

Battle of Britain (UNITED ARTISTS/AUTHOR'S COLLECTION)

In the early days of World War II, an air war was fought for control of the skies over Britain between the Luftwaffe and the Royal Air Force. Hitler knew that he could not invade Britain until he took control of the air over England, and the British were determined to deny him that control.

There are no "good guys" and "bad guys" in this film; the English and the German aviators are treated equally as young men engaged in a titanic struggle for control of the sky.

If you fly a plane over England, you can still see that the countryside is littered with hundreds of airfields, all of them built during the Battle of Britain, a battle of air forces that lasted from August 8 to October 31, 1940. The Luftwaffe, with vastly superior air power, tried to reduce British morale and soften Britain's defenses in preparation for Hitler's planned invasion of England. At first the Germans targeted shipping and the ports. Then they concentrated on bombing airfields and the midland industries. When this did not bring England to its knees, Hitler decided to destroy London. His theory was that the British people could not stand by and see their precious London destroyed, that this would break their spirit and their will to continue. He was completely wrong; it had the opposite effect and only strengthened their resolve. The Royal Air Force (RAF) proved to be technically and tactically superior to the Luftwaffe.

INTERESTING FACTS

- This is a historically accurate reenactment of the air war.
- In the Battle of Britain the RAF lost only 900 planes to the Germans' 2,300. Lacking air superiority, Hitler was forced to abandon his plans to invade England.
- The Messerschmitt 109 aircraft in the film were actually German-designed Hispano Buchon aircraft purchased from the Spanish air force and powered by Rolls-Royce Merlin engines. To any aviation buff the fact that these Messerschmitts and Dorniers had Rolls-Royce Merlins instead of Daimler-Benz engines is painfully obvious but does not detract too much from the film.
- The large number of aircraft collected for this production made it the 11th largest air force in the world.

MISTAKES

- About one-third of the way into the film, a shot-up plane falls out of the sky and crashes into a farmer's field. On impact it explodes into a fireball and continues moving on the ground—leaving the crop undamaged behind it.
- As Ian McShane and Robert Shaw exit a white cottage, a modern-style plastic doorbell button is visible. These did not come into use until the 1960s.
- Set in 1940, the German army's convoy in Nazi-occupied France contains at least three Mack B trucks, which were built only from 1952 to 1966.
- When Shaw and McShane come out of the cottage, you also see an up-and-over garage door, which had not been invented in 1940.

QUOTES

Air Chief Marshal Sir Hugh Dowding: But the essential arithmetic is that our young men will have to shoot down their young men at the rate of four to one, if we're to keep pace at all.

Winston Churchill: Never in the field of human conflict was so much owed by so many to so few.

AWARD

British Academy Awards, 1970
 Nominated: BAFTA Film Award, Best Sound Track, Teddy Mason, James Shields.

BATTLE OF THE BULGE

United States Pictures, Cinerama, Warner Bros., 1965, color, 167 minutes.

Producers: Milton Sperling, Philip Yordan; **Director:** Ken Annakin; **Screenwriters:** Bernard Gordon, John Melson, Milton Sperling, Philip Yordan; **Music:** Benjamin Frankel; **Cast:** Karl-Otto Alberty, Axel Anderson, Dana Andrews, Pier Angeli, Richard Baxter, Hans Christian Blech, William Boone, Victor Brandt, Janet Brandt, Charles Bronson, Sebastian Cavalieri, Bill Christmas, John Clark, Quinn Donoghue, Paul Eslheman, Henry Fonda, John Friess, Jack Gaskins, Reginald Gillam, Peter Grzcegorczyna, Ty Hardin, Peter Herendeen, Richard Laver, Harry Van der Linden, James MacArthur, Ward Maule, George Montgomery, Raoul Perez, Werner Peters, Donald Pickering, Paul Polansky, Carl Rapp, Derek Robertson, Martin Rolin, Steve Rowland, Robert Royal, Robert Ryan, Telly Savalas, John Schereschewsky, Robert Shaw, Max Slaten, Charles Stalmaker, Russ Stoddard, Bud Strait, Ben Tatar, David Thomson, Freddie Toehl, Barbara Werle, Robert Woods, Leland Wyler, Richard Ziedman.

The Germans plan to win World War II by a massive counteroffensive in the Ardennes Forest of Belgium. The spearhead of their blitzkrieg attack is a panzer

Battle of the Bulge (WARNER BROS./AUTHOR'S COLLECTION)

division using a new, improved Tiger tank, under the command of Col. Hessler, a brilliant but fanatical German officer (Robert Shaw). But as the Germans are short on fuel, a crucial part of the plan is the capture of a large Allied fuel depot. This must be accomplished in 48 hours, the time clock that the German weathermen have predicted is the extent of a bad weather front that will protect the panzer attack from annihilation by Allied bombers.

Colonel Hessler refuses to abandon his tank as it climbs up a hill toward the Allied fuel depot, even though Henry Fonda, James MacArthur, and Telly Savalas are rolling drums of fuel down the slope toward the Tigers, ultimately engulfing his tank in flames.

INTERESTING FACTS

- The response of the American commanding general in Bastogne, when asked by the Germans to surrender, was "Nuts."

- This is the definitive film on the German counter-offensive in the Ardennes Forest in Belgium in the last months of World War II.
- North of Bastogne is a great monument to the men who fought there. It is in the shape of a five-pointed star, and the view from the roof gives you a panorama of the entire battleground.

MISTAKES

- The German Tiger tanks and American Sherman tanks were actually American tanks from the Korean War era. Any remaining Sherman and Tiger tanks were in museums.
- The Battle of the Bulge was fought in the densely wooded Ardennes Forest of Belgium, not in a desert.
- The U.S. fuel dump seen at the end of the film did not exist. The only American fuel dumps nearby during the battle were well to the north and were bypassed by the Germans because they did not know of their existence.

- The supposed German-American infiltrators never did cause a major problem. The main impact they had was a scare at all American levels, causing every high-ranking general to be guarded more heavily.
- The opening narration states that "Montgomery's Eighth Army was in the north." Montgomery did command the British forces in northwestern Europe, but the Eighth Army, formerly commanded by him, was in Italy.

AWARD

Golden Globes, USA, 1966
> **Nominated:** *Golden Globe, Best Original Score,* Benjamin Frankel; *Best Supporting Actor,* Telly Savalas.

BATTLE OF THE CORAL SEA

Columbia Pictures Corporation, 1959, b&w, 80 minutes.

Producer: Charles H. Schneer; **Director:** Paul Wendkos; **Screenwriters:** Stephen Kandel, Daniel B. Ullman; **Music:** Ernest Gold; **Cast:** Gene Blakely, Patricia Cutts, Rian Garrick, James T. Goto, Robin Hughes, Gordon Jones, L. Q. Jones, Tom Laughlin, Carlyle Mitchell, Cliff Robertson, Gia Scala, Teru Shimada, K. L. Smith, Larry Thor, Patrick Westwood, Eiji Yamashiro.

Cliff Robertson is one of the officers of a submarine crew who is captured while gathering intelligence about Japanese warships. Robertson and two other officers finally manage to escape in a Japanese torpedo boat and convey their information back to the fleet on the eve of the Battle of the Coral Sea.

BATTLE OF THE RIVER PLATE, THE

Rank Organisation, Arcturus Productions, 1956, color, 119 minutes.

Producers: Michael Powell, Emeric Pressburger, Earl St. John, Sydney Streeter; **Directors:** Michael Powell, Emeric Pressburger; **Screenwriters:** Michael Powell, Emeric Pressburger; **Distributor:** Rank Organisation; **Cast:** Edward Atienza, Alan Beale, Anthony Bushell, John Chandos, Ronald Clarke, Andrew Cruickshank, Gron Davies, Roger Delgado, Peter Dyneley, Eynon Evans, Jack Faint, David Farrar, Peter Finch, Barry Foster, Richard George, Michael Goodliffe, John Gregson, Jack Gwyllim, Ian Hunter, Peter Illing, Bernard Lee, Christopher Lee, Patrick Macnee, María Mercedes, John Merivale, John Le Mesurier, Donald Moffat, George Murcell, Lionel Murton, Anthony Newley, Joseph O'Conner, April Olrich, Columba Powell, Edward B. Powell, Anthony Quayle, John Schlesinger, Julian Somers, William Squire, Nigel Stock, Douglas Wilmer, Brian Worth.

The Allies hunt down and destroy the *Graf Spee,* one of the most successful Nazi maritime raiders, which was cutting a swath through Allied merchant marine shipping during World War II. Three lightly armed cruisers with only 6- and 8-inch guns boldly take on the faster, heavier battleship armed with radar-controlled 11-inch guns.

During the early years of World War II, the Allies struggled for control of the North Atlantic. The Royal Navy was fighting a desperate battle to keep the convoy routes open, part of the vital mission to keep the British Isles supplied. One of the greatest dangers was surface raiders, huge battleships that had slipped out of German waters just before war was declared. The *Bismarck, Scharnhorst, Gneisenau,* and *Graf Spee* were supplied by tanker and could strike anywhere.

The movie is based on the following books: Dove, Patrick (Capt.), *I Was Graf Spee's Prisoner* (London: Withy Grove Press, 1940); Pope, Dudley, *The Battle of the River Plate* (London: Secker, 1987); Powell, Michael, *Graf Spee* (London: Hodder & Stoughton, 1956); Powell, Michael, *Death in the South Atlantic* (New York: Rinehart, 1957).

INTERESTING FACT

- These ships were used in the film: HMS *Sheffield* as HMS *Ajax,* INS *Delhi* (formerly HMNZS *Achilles*) as HMNZS *Achilles,* HMS *Cumberland* as heavy cruiser HMS *Cumberland,* USS *Salem* as the German pocket battleship *Admiral Graf* Spee.

QUOTES

Gunnery Officer [On board a badly shot-up HMNZS *Achilles*]: Captain, sir.
Capt. Parry: Yes, guns?
Gunnery Officer: We've fired nearly 1,200 rounds, sir. About one-third of the arsenal only remaining.
Capt. Parry: Thank you. Are you all right?
Gunnery Officer: A few new ventilation gaps here, sir. A bit draughty but otherwise all right.

BATTLE OF THE UNSEEN HEROES, THE

N.T.A. Eros, 1958, b&w, 85 minutes.

Producer: George Maynard; **Director:** Vernon Sewell; **Screenwriters:** Jack Henley, Bernard Newell, Eryk Wlodek; **Distributor:** N.T.A. Eros; **Cast:** Geoffrey Chater, Tom Clegg, Jan Conrad, Gregory Dark, Carl Duering, John G. Heller, Carl Jaffe, David Knight, Esmond Knight, Christopher Lee, Peter Madden, Patricia Medina, George Pastell, George Pravda, Robert Raikes, Michael Rennie, Harold Siddons, Julian Somers, Gordon Sterne, Henri Vidon, Milly Vitale, Valerie White, Stanley Zevic.

During World War II, the British work with Polish partisans to destroy the Nazis' V-1, their feared ballistic terror weapon that was raining death and destruction on London.

BATTLE STATIONS

Columbia Pictures Corporation, 1956, b&w, 81 minutes.

Producer: Bryan Foy; **Director:** Lewis Seiler; **Screenwriters:** Charles S. Gould, Crane Wilbur; **Music:** Mischa Bakaleinikoff, Mario Castelnuovo-Tedesco, George Duning, Arthur Morton, Joseph Nussbaum; **Cast:** Claude Akins, William Bendix, Eric Bond, Richard Boone, Keefe Brasselle, Dick Cathcart, Frank Connor, John Craven, Jack Diamond, Robert Forrest, Eddie Foy III, Gordon Howard, William Leslie, James Lilburn, John Lund, Jimmy Lydon, George O'Hanlon, Chris Randall.

Richard Boone is the demanding captain of a U.S. Navy aircraft carrier who constantly drills his crew during World War II to prepare for his battle against the Japanese.

INTERESTING FACT

- Old newsreels and documentaries are used for the battle sequences.

MILITARY SERVICE

- Richard Boone attended San Diego Army and Navy Academy. During World War II, he was in the Pacific as an aerial gunner on torpedo planes. He served aboard the aircraft carriers USS *Intrepid*, USS *Hancock*, and USS *Enterprise*.

BATTLE TAXI

Ivan Tors Films, 1955, b&w, 82 minutes.

Producers: Art Arthur, Ivan Tors; **Director:** Herbert L. Strock; **Screenwriters:** Art Arthur, Malvin Wald; **Music:** Harry Sukman; **Distributor:** United Artists; **Cast:** Andy Andrews, Jay Barney, Michael Colgan, John Dennis, Arthur Franz, John Goddard, Sterling Hayden, Dale Hutchinson, Joel Marston, Capt. Vincent McGovern, Leo Needham, Robert Sherman, Vance Skarstedt, Marshall Thompson.

During the Korean War, Sterling Hayden is the commander of a U.S. Air Rescue Service helicopter team. He must prove to a former hot-shot jet pilot, who would rather be flying in combat, the importance of rescue work and turn him into a team player.

INTERESTING FACTS

- The film relies heavily on newsreel and documentary footage for its action sequences.
- The film was made with the cooperation of the Department of Defense.

BATTLE ZONE

Allied Artists Picture Corporation, 1952, b&w, 82 minutes.

Producer: Walter Wanger; **Director:** Lesley Selander; **Screenwriter:** Steve Fisher; **Music:** Marlin Skiles; **Cast:** Philip Ahn, Linda Christian, Richard Emory, John Fontaine, John Hodiak, Todd Karns, Jack Larson, Stephen McNally, Martin Milner, Gil Stratton, Dave Willock, Carleton Young.

John Hodiak is a U.S. Marine Corps combat cameraman, assigned to photograph installations behind enemy lines during the Korean War.

INTERESTING FACT

- The film includes actual combat camera footage.

BAT*21

TriStar Pictures, Vision PDG, Eagle, 1988, color, 105 minutes.

Producers: Michael Balson, Mark Damon, Evzen Kolar, Gary A. Neill, Jerry Reed, David Saunders; **Director:** Peter Markle; **Screenwriters:** William C.

Anderson, George Gordon; **Music:** Christopher Young; **Filmed at:** Sabah, Borneo, Malaysia; **Cast:** Jim Aman, Erich Anderson, Jeff Baxter, Freddie Chin, Dennis Chong, Liow Hui Chun, Joe Dorsey, Timothy Fitzgerald, Danny Glover, David Marshall Grant, Gene Hackman, Stuart B. Hagen, Scott Howell, Fung Yun Khiong, Alan King, Willie Lai, Henry Lee, Michael Lee, Fredolin Leong, Jeffrey Liew, Benedict Lojingkau, Walter Lojingkau, Johnny Michael, Clarence Mojikon, Reverend Michael Ng, Wilod Nuin, Michael Raden, Jerry Reed, Clayton Rohner, Don Ruffin, Harold Sinpang, Conidon Wong, Bonnie Yong, Paul Yong, Martin Yong, Robert Zajonc.

In Vietnam, a U.S. observation plane is hit by a Vietcong missile. The only survivor of the crew is Lt. Col. Hambleton (Gene Hackman), a desk-bound expert in missile weaponry who has never been out in the field. Because of his specialized weapons knowledge, it is crucial to rescue him before he is captured by the Vietcong. The pilot who sticks with him, and tries to get him out, is Danny Glover. The rescue is made all the more difficult because the enemy is listening to Hambleton's radio transmissions.

Based on a book by William C. Anderson, the film recounts the real-life experience of Lt. Col. Hambleton, who survived in the Vietnamese bush before being rescued by a black U.S. Air Force captain who had honed in on the colonel's radio signal.

INTERESTING FACT

- The title of the film refers to the code name of the downed airman as he communicates on the radio with his rescuer.

MILITARY SERVICE

- Gene Hackman enlisted in the U.S. Marine Corps in 1947 at the age of 16. He was sent to China, where he worked as a disc jockey for Armed Forces Radio, but communist victories on the mainland forced the relocation of his unit to Japan. As the result of a motorcycle accident, in which he broke both his legs, he was ineligible to reenlist. His unit was sent to Korea, and suffered 90 percent casualties. Although he loved the Marine Corps, he had difficulty with its discipline; he was promoted three times to corporal, and three times he was busted back to private.

BEACHHEAD

Aubrey Schenck Productions, 1954, color, 89 minutes.

Producer: Howard W. Koch; **Director:** Stuart Heisler; **Screenwriters:** Richard G. Hubler, Richard Alan Simmons; **Distributor:** United Artists; **Music:** Arthur Lange, Emil Newman; **Cast:** Dan Aoki, Tony Curtis, John Doucette, Eduard Franz, Akira Fukunaga, Skip Homeier, Frank Lovejoy, Steamboat Mokuahi, Mary Murphy, Alan Wells.

Frank Lovejoy leads a patrol of four marines sent to obtain vital information on Japanese minefields from a French planter prior to the Marine Corps landing on Bougainville during World War II. His patrol constantly reminds Lovejoy that his last platoon was wiped out on Guadalcanal.

The film is based on Richard G. Hubler's *I've Got Mine* (New York: Putnam, 1946).

INTERESTING FACT

- Bougainville, the largest of the Solomon Islands, was invaded by the Third Marine Division on November 1, 1943. It was used as a platform on which to construct three bomber and two fighter airfields for the air war against Japan. The island was finally completely secured by Australian troops in 1945.

MILITARY SERVICE

- Tony Curtis was trained as a signalman in the U.S. Navy during World War II. A visit to the Hollywood canteen convinced him that he wanted to be an actor when he was discharged. He served aboard the USS *Proteus*, a submarine tender, and as a relief torpedoman aboard the submarine USS *Dragonette*. Injured when a winch chain broke while he was cleaning the side of the *Dragonette*, he was hospitalized and then assigned to the *Proteus*, where he was serving when the ship entered Tokyo Bay for the signing of the Japanese surrender in September 1945.

BEACH RED

Theodora Productions, 1967, color, 105 minutes.

Producer: Cornel Wilde; **Director:** Cornel Wilde; **Screenwriters:** Peter Bowman, Clint Johnston, Jefferson Pascal, Don Peter, Cornel Wilde; **Music:** Antonio Buenaventura; **Distributor:** United Artists; **Filmed in:** Japan, Philippines; **Cast:** Linda Albertano, John Allen, George Bayot, Phil Beinke, Gene Blakely, Jun Bona, Mazamo Chizuki, Burr DeBenning, Bill Dunbar, Ed Finlan, Fred Galang, Jan Garrison, Michio Hazama, Pat Hitlock, Ernie Holt, Dale Ishimoto, Hiroshi Kiyama, Genki Koyama, Mike McMichael, Rod Mier, Norman Pak, Michael Parsons, Dewey Stringer, Jaime Sánchez, Kiyoma Takezawa, Rip Torn,

Dennis Ullman, Jean Wallace, Charles Weaver, Cornel Wilde, Patrick Wolfe.

Cornel Wilde is a war-hating captain who leads his troops ashore and pushes inland on a Japanese-held island during World War II. Soldiers on both sides are haunted by memories of home and the horrifying, sickening images they witness in combat.

The film is based on Peter Bowman's *Beach Red* (New York: Random House, 1945).

MILITARY SERVICE

- Rip Torn enlisted in the U.S. Army in 1953 and served for two years as a military policeman.

QUOTE

Gunnery Sergeant Ben Honeywell (as a sadistic sergeant who has just broken the legs of a prisoner.): I'm a marine. I'm gonna kill those bastards, I'm gonna shoot them, I'm gonna bayonet them, I'm gonna break their arms. That's what we're here for, to kill. The rest is just crap.

BEAST, THE

A&M Films, 1988, color, 104 minutes.

Producers: Christopher Dalton, John Fiedler, Gil Friesen, Dale Pollock; **Director:** Kevin Reynolds; **Screenwriter:** William Mastrosimone; **Filmed in:** Israel; **Cast:** Erick Avari, Claude Aviram, Stephen Baldwin, Beni Baruchin, Steven Bauer, Kabir Bedi, George Dzundza, Avi Gil-Or, Chaim Girafi, Don Harvey, Rami Heuberger, Avi Keedar, Victor Ken, Shoshi Marciano, Osnat Mor, Itzhak Bbi Neeman, Jason Patric, Roberto Pollak, David Sherrill, Moshe Vapnik.

During the war in Afghanistan, a Soviet tank crew commanded by a tyrannical officer struggles to get back to their own lines through the mountains, but they are pursued by a band of mujahideen guerrillas bent on their destruction.

The movie is based on William Mastrosimone's book *Nanawatai: A Play in Two Acts.* (New York: S. French, 1986).

The war in Afghanistan is often called the Russian Vietnam, because Russia was engaged in the same kind of no-win situation that plagued the United States.

QUOTE

Daskal: Out of commission, become a pillbox. Out of ammo, become a bunker. Out of time, become heroes.

BEAST OF BUDAPEST, THE

Barlene Corporation, 1958, b&w, 72 minutes.

Producer: Archie Mayo; **Director:** Harmon Jones; **Screenwriters:** John McGreevey, Louis Stevens (story); **Music:** Marlin Skiles; **Distributor:** Allied Artists Pictures Corporation; **Cast:** John Banner, Robert Blake, Charlie Brill, Booth Colman, Svea Grunfeld, John Hoyt, Tommy Ivo, Colette Jackson, Kurt Katch, Michael Mills, Gerald Milton, John Mylong, Violet Rensing, Greta Thyssen, Ernst Tolnai, Joe Turkel, Otto Zagon.

Gerald Milton is the "Beast of Budapest," a Hungarian who is the head of the dreaded secret police, which enforces the Russian-dominated puppet regime in Hungary. Aligned against him in the revolt is the Resistance, determined to rid their country of the oppressive Russian communist domination.

This film is set against the actual unsuccessful revolt of the Hungarian people against their Russian oppressors in 1956.

INTERESTING FACT

- The films uses actual newsreel footage of Russian tanks putting down the revolt.

BEASTS OF BERLIN

Producers Pictures Corporation, 1939, b&w, 87 minutes.

Producers: Ben Judell, Sigmund Neufeld; **Director:** Sam Newfield (as Sherman Scott); **Screenwriter:** Shepard Traube; **Music:** David Chudnow; **Distributor:** Producers Distributing Corporation; **Cast:** Vernon Dent, Abe Dinovitch, Roland Drew, Steffi Duna, John Ellis, Frederick Giermann, Greta Granstedt, Hans Joby, Willy Kaufman, Alan Ladd, Anna Lisa, Frederic Mellinger, Hans von Morhart, Paul Panzer, John Peters, Lucien Prival, George Rosener, Bodil Rosing, Hans Schumm, Walter O. Stahl, Bob Stevenson, Walter Thiele, Hans Heinrich von Twardowski, Frederick Vogeding, Dick Welles, Dick Wessel, Glen Wilenchick, Wolfgang Zilzer, Henry von Zynda.

The German underground fights against the atrocities of the Gestapo to free their country from the control of the Nazis.

The film is based on Shepard Traube's *Goose Step.* Other versions are also known as *Beasts of Berlin* (1939), *Goose Step* (1939), *Hell's Devils* (1939), and *Hitler—Beast of Berlin* (1939).

- This movie was banned in New York as too inflammatory; the board of censors was afraid it would incite the large German population in New York City. After some cutting, it was released as *Beasts of Berlin*. When it was rereleased as *Hell's Devils*, it was advertised as starring Alan Ladd.
- This was the first Hollywood feature to openly attack Nazi atrocities, a theme that would become common in World War II movies. The film depicts the inhuman methods of the Gestapo and reveals information about the concentration camps.
- New York City critics, because of the candor of the film about conditions in Nazi Germany, loved this film and gave it good reviews, overlooking the cuts that undermined the artistic value of the film.

BEHIND THE RISING SUN

RKO Radio Pictures Inc. 1943, b&w, 88 minutes.

Director: Edward Dmytryk; **Screenwriters:** Emmet Lavery, James R. Young (book); **Music:** Roy Webb; **Cast:** Philip Ahn, Abner Biberman, Luke Chan, Donald Douglas, Fred Essler, Benson Fong, Mei Lee Foo, Lee Tung Foo, Nancy Gates, George Givot, Gloria Holden, Allen Jung, Robert Katcher, Daisy Lee, Connie Leon, Shirley Lew, Leon Lontoc, Richard Loo, Charles Lung, Margo, Mike Mazurki, J. Carrol Naish, Tom Neal, Adeline De Walt Reynolds, Robert Ryan, Leonard Strong, H. T. Tsiang, Barbara Jean Wong, Beal Wong, Bruce Wong, Iris Wong, William Yip, Wolfgang Zilzer.

A Cornell-educated Japanese citizen returns home just before Pearl Harbor, hoping to work for an American engineer in Tokyo, but instead he is drafted into the Imperial army. War service in China hardens him to atrocities, and he returns to Japan a staunch supporter of Japan's imperialist aims. His father, a cabinet minister, is disillusioned by what the war has done to his family and his country. When his son is killed in action fighting American planes over the skies of Japan, he commits suicide.

The Japanese atrocities depicted in the film are from a nonfiction book written by James R. Young, a foreign correspondent for the International News Service, who lived in Tokyo before the war.

BEHOLD A PALE HORSE

Columbia Pictures Corporation, Highland-Brentwood Productions, 1964, b&w, 121 minutes.

Producers: Alexandre Trauner, Fred Zinnemann; **Director:** Fred Zinnemann; **Screenwriters:** J. P. Miller, Emeric Pressburger; **Music:** Maurice Jarre; **Distributor:** Columbia Pictures; **Cast:** Laurence Badie, Martin Benson, Jean-Claude Bercq, Claude Berri, Claude Confortès, Rosalie Crutchley, Mildred Dunnock, Michel Lonsdale, Adieu Marietto, Christian Marquand, Zia Mohyeddin, Jean-Paul Moulinot, Gregory Peck, Raymond Pellegrin, Perette Pradier, Anthony Quinn, Daniela Rocca, Alain Saury, Omar Sharif, Paolo Stoppa, Molly Urquhart, José Luis de Villalonga, Elisabeth Wiener.

Gregory Peck plays a famous guerrilla leader during the Spanish Civil War, who has lived 20 years since the war in exile in France. Anthony Quinn, a Spanish police officer, sets a trap to lure him back into Spain by letting it be known that his mother is sick. Although Peck is warned by Omar Sharif, his mother's priest, that it is a trap, he decides to visit his mother anyway.

The film is based on Emeric Pressburger's *Killing a Mouse on Sunday* (London: Reprint Society Ltd., 1963).

- The film contains actual footage from the Spanish Civil War.

BELL FOR ADANO, A

20th Century-Fox, 1945, b&w, 103 minutes.

Producers: Louis D. Lighton, Lamar Trotti; **Director:** Henry King; **Screenwriters:** John Hersey (novel), Norman Reilly Raine, Lamar Trotti; **Music:** Alfred Newman; **Distributor:** 20th Century-Fox; **Cast:** Mimi Aguglia, Luis Alberni, Henry Armetta, John Bagni, William Bendix, Roman Bohnen, Fortunio Bonanova, Harry Carter, Eduardo Ciannelli, Richard Conte, Marcel Dalio, Earl Easton, William Edmunds, Hugo Haas, Reed Hadley, John Hodiak, Frank Jaquet, Charles Judels, Frank Lackteen, Glenn Langan, Harry Morgan, Ed Mundy, Nino Pipitone Jr., Stanley Prager, Eva Puig, Roy Roberts, John Russell, Grady Sutton, Gene Tierney, Minerva Urecal, Yvonne Vautrot, Minor Watson.

John Hodiak is a U.S. Army major assigned to restore order to the war-torn Italian town of Adano. The people are distrustful of the Allied occupation forces, so he decides to win their confidence by gaining for them what they desire most: a new town bell.

The film is based on John Hersey's *A Bell for Adano*. (New York: Knopf, 1944).

BELLS GO DOWN, THE

Ealing Studios, 1943, b&w, 90 minutes.

Producers: Michael Balcon, S. C. Balcon; **Director:** Basil Dearden; **Screenwriters:** Stephen Black, Roger MacDougall; **Distributor:** Associated British Film Distributors; **Cast:** Grace Arnold, Alfie Bass, Lesley Brook, Frederick Culley, Finlay Currie, Meriel Forbes, Philip Friend, Leo Genn, Richard George, Muriel George, Leslie Harcourt, William Hartnell, Philippa Hiatt, Mervyn Johns, Stanley Lathbury, James Mason, Ralph Michael, Norman Pierce, Frederick Piper, John Salew, Johnnie Schofield, Tommy Trinder, Beatrice Varley, Julian Vedey, Charles Victor, H. Victor Weske.

Tommy Trinder is a member of the British wartime AFS (Auxiliary Fire Service), the dedicated band that keeps the fires under control during the Blitz and fire-bombings of London during World War II.

This movie is based on Stephen Black's *The Bells Go Down*. (London: Methuen & Co., 1942).

INTERESTING FACT

• Actor Tommy Trinder was a comedian.

BENT

Ask Kodansha Company Ltd., NDF Inc., Channel Four Films, Arts Council of England, 1997, color, 108 minutes.

Producers: Hisami Kuroiwa, Dixie Linder, Sean Mathias, Sarah Radclyffe, Martin Sherman, Michael Solinger; **Director:** Sean Mathias; **Screenwriter:** Martin Sherman; **Music:** Philip Glass; **Distributors:** Goldwyn Entertainment Company, Metromedia, Metro-Goldwyn-Mayer; **Filmed at:** Tring, England, London, Scotland; **Cast:** Crispian Belfrage, Suzanne Bertish, Paul Bettany, Lothaire Bluteau, Nikolaj Coster-Waldau, Claire Cunningham, Holly Davidson, Mary Davidson, Sadie Frost, Lou Gish, Rupert Graves, Simon Hammerstein, Shira Haviv, Filip Van Huffel, Mick Jagger, Johan Johnstone, Chris Karlitz, Johanna Kirby, Paul Kynman, Richard Laing, Jude Law, Sacha Lee, Ben Maher, Stefan Marling, Jane Mason, Ian McKellen, David Meyer, Mark Misauer, Gresby Nash, Clive Owen, Rupert Penry-Jones, David Phelan, Howard Sacks, Geraldine Sherman, Peter Stark, Mandy Stone, William Stone, Myer Taub, Daisy de Villeneuve, Jan de Villeneuve, Poppy de Villeneuve, Charlie Watts, Brian Webber, Rachel Weisz, Helen Whitehouse.

Because Max (Clive Owen) is gay, he is sent to Dachau concentration camp by the Nazis. He denies that he is gay and manages to get a yellow label (the one for Jews) instead of the pink label (reserved for gays). In prison he falls in love with his fellow prisoner Horst (Lothaire Bluteau), who wears his pink label with pride.

INTERESTING FACT

• Ian McKellen, who appears as Uncle Freddie in the film, starred in the role of Max in the original London West End theater production in 1979.

BEST OF ENEMIES, THE

Columbia Pictures Corporation, 1961, color, 104 minutes.

Director: Guy Hamilton; **Screenwriters:** Jack Pulman, Luciano Vincenzoni; **Cast:** Harry Andrews, Bruno Cattaneo, Bernard Cribbins, Robert Desmond, Giuseppe Fazio, Kenneth Fortescue, Ronald Fraser, Aldo Giuffrè, Noel Harrison, Duncan Macrae, Pietro Marascalchi, Tiberio Mitri, Amedeo Nazzari, Alessandro Ninchi, David Niven, David Opatoshu, Alberto Sordi, Michael Trubshawe, Michael Wilding.

During World War II, a comedy of errors occurs when blundering Italian and British combat units try to outwit each other in the North African desert.

BEST YEARS OF OUR LIVES, THE

Goldwyn Pictures Corporation, 1946, b&w, 172 minutes.

Producer: Samuel Goldwyn; **Director:** William Wyler; **Screenwriters:** MacKinlay Kantor, Robert E. Sherwood; **Distributor:** RKO Radio Pictures Inc.; **Cast:** Marlene Aames, Dorothy Adams, James Ames, Dana Andrews, Walter Baldwin, Don Beddoe, Roman Bohnen, Claire Du Brey, Hoagy Carmichael, Howland Chamberlain, Harry Cheshire, Steve Cochran, Ray Collins, Joyce Compton, Bert Conway, Clancy Cooper, Victor Cutler, Tom Dugan, Edward Earle, Blake Edwards, Ben Erway, Pat Flaherty, Gladys George, Minna Gombell, Michael Hall, Charles Halton, Earle Hodgins, Teddy Infuhr, Robert Karnes, Donald Kerr, Myrna Loy, Fredric March, Virginia Mayo, William Newell, Cathy O'Donnell, Norman Phillips Jr., Jack Rice, Harold Russell, Ruth Sanderson, Erskine Sanford, Ralph Sanford, Ray Teal, John Tyrrell, Dean White, Teresa Wright, Cathy Wyler, Judy Wyler.

Three American servicemen return home to Boone City after World War II to find their lives irrevocably changed by their military experience. Navy man Harold Russell has lost his hands and grows distant from his fiancée and family as he struggles to overcome his disability. Army sergeant Fredric March returns to a wife who has changed and children who have grown up during his three years overseas. Air Force captain Dana Andrews finds himself stuck in a lousy job and a loveless marriage, while at the same time falling in love with Fredric March's daughter. The film is based on MacKinlay Kantor's *Glory for Me.* (New York: Coward-McCann, Inc., 1945).

A moving scene depicts Dana Andrews, the U.S. Air Force captain, walking in an aircraft graveyard. Neither he nor the planes are needed anymore.

INTERESTING FACTS

- Gregg Toland, the cinematographer on this film, was commissioned a lieutenant in the U.S. Navy at the beginning of World War II and attached to John Ford's OSS Field Photographic. Toland's documentary on Pearl Harbor, entitled *December 7th,* was critical of the navy, which suppressed it.
- The producer, Samuel Goldwyn, said of this film: "I don't care if it doesn't make a nickel . . . I just want every man, woman, and child in America to see it."
- Harold Russell was appointed chairman in 1964 of the President's Council on Hiring the Handicapped. He appeared in Richard Donner's *Inside Moves* in 1980.

MILITARY SERVICE

- Fredric March, although he portrays a World War II sergeant in this film, was actually a veteran of World War I. This is an interesting switch, since actors usually play roles in wars fought before they were born. In World War I, he was a second lieutenant in the artillery.

QUOTE

Fredric March [recounting a cynical anecdote to his banking associates; he is drunk]: I want to tell you all that the reason for my success as a sergeant is due primarily to my previous training in the Cornbelt Loan and Trust Company. The knowledge I acquired in the good old bank I applied to my problems in the infantry. For instance, one day in Okinawa, a major comes up to me, and he says, "Stephenson, you see that hill?" "Yes, sir, I see it."

"All right," he said, "you and your platoon will attack said hill and take it." So I said to the major, "But that operation involves considerable risk. We haven't sufficient collateral." "I'm aware of that," said the major, "but the fact remains that there is the hill and you are the guys who are going to take it." So I said to him, "I'm sorry, Major. No collateral, no hill." So we didn't take the hill, and we lost the war."

AWARDS

Academy Awards, USA, 1946
Won: *Honorary, Award*—Harold Russell, "For bringing hope and courage to his fellow veterans through his appearance in *The Best Years of Our Lives.*" *Oscar, Best Actor,* Fredric March; *Best Director,* William Wyler; *Best Film Editing,* Daniel Mandell; *Best Music, Scoring of a Dramatic or Comedy Picture,* Hugo Friedhofer; *Best Picture,* Samuel Goldwyn; *Best Supporting Actor,* Harold Russell; *Best Writing, Screenplay,* Robert E. Sherwood
Nominated: *Oscar, Best Sound Recording,* Gordon Sawyer (Samuel Goldwyn SSD)

Bodil Festival, 1948
Won: *Bodil, Best American Film (Bedste amerikanske film),* William Wyler (director)

British Academy Awards, 1948
Won: *BAFTA Film Award, Best Film from any Source,* USA.

Golden Globes, USA, 1947
Won: *Golden Globe, Best Motion Picture—Drama; Special Award*—Harold Russell—*For Best Nonprofessional Acting*

Board of Review, USA, 1946
Won: *NBR Award, Best Director,* William Wyler

National Film Preservation Board, USA, 1989

National Film Registry

New York Film Critics Circle Awards, 1946
Won: *NYFCC Award, Best Director,* William Wyler; *Best Film.*

BETHUNE: THE MAKING OF A HERO

Filmline International Inc, 1990, color, 168 minutes.

Producers: Nicolas Clermont, Jacques Dorfmann, Pieter Kroonenburg, Xin-Gang Wang; **Director:** Phillip Borsos; **Screenwriter:** Ted Allan; **Distribu-**

tor: Ciné 360 Inc.; **Filmed at:** St. John's Wood, London; **Cast:** Iñaki Aierra, Anouk Aimée, Lorne Brass, Geoffrey Chater, Sophie Faucher, Colm Feore, Frank Fontaine, Ethel Gerstein, Peggy Goldberg, Rebecca Hogan, Beatrice Home, James Hong, Nicholas Kilbertus, Danute Kristo, Harrison Liu, Jack McGuigan, Helen Mirren, Linda O'Dwyer, James Pax, Ronald Pickup, Yvan Ponton, Helen Shaver, Donald Sutherland, Tan Zong-Yao, Leona Toppel, Zhang Ke-Yaw.

Donald Sutherland turns in an outstanding performance as real-life hero Norman Bethune, a Canadian-born physician who crusaded for socialized medicine in Montreal during the depression and treated the wounded during the Spanish Civil War. But Bethune is perhaps most famous for bringing modern medical care to the Far East during the brutal Japanese invasion of China during World War II.

The film is based on Ted Allan's *The Scalpel, the Sword; The Story of Dr. Norman Bethune* (New York: Monthly Review Press, 1973).

BETRAYED

Metro-Goldwyn-Mayer, 1954, color, 108 minutes.

Director: Gottfried Reinhardt; **Screenwriters:** George Froeschel, Ronald Millar; **Music:** Walter Goehr; **Filmed at:** Ypenburg Airfield, Rijswijk, Netherlands; **Cast:** Basil Appleby, Louis Calhern, Ian Carmichael, Roland Culver, Anton Diffring, Clark Gable, O. E. Hasse, Wilfrid Hyde-White, Lily Kann, Niall MacGinnis, Victor Mature, Reggie Nalder, Christopher Rhodes, Brian Smith, Nora Swinburne, Lana Turner, Leslie Weston.

Victor Mature is a resistance leader in the Dutch underground; he learns that his mother has been condemned by the underground for collaborating with the Nazis. To save her, he helps the Germans, which results in the death of other members of the Dutch resistance. His betrayal is ultimately uncovered by Clark Gable, and he is killed.

MILITARY SERVICE

• Victor Mature enlisted in the U.S. Coast Guard in July 1942 and served aboard an armed cutter on Atlantic convoy duty, the icebreaker USS *Storis*. After 14 months of escort duty, he transported troops to the Pacific via the Panama Canal aboard the transport USS *Admiral Mayo*.

BETWEEN HEAVEN AND HELL

20th Century-Fox, 1956, color, 94 minutes.

Producer: David Weisbart; **Director:** Richard Fleischer; **Screenwriters:** Harry Brown, Francis Gwaltney; **Music:** Hugo Friedhofer; **Distributor:** 20th Century-Fox Film Corporation; **Cast:** Ross Ackland, Tod Andrews, John Bardon, Amanda Barrie, Bernard Bresslaw, Ilene Brown, Irene Browne, Hugh Burden, Bart Burns, Erik Chitty, Ken Clark, Broderick Crawford, Scatman Crothers, Mark Damon, Aimée Delamain, Brad Dexter, Andrew Dove, Buddy Ebsen, Biff Elliot, Michael Elwyn, Darlene Fields, Frank Gerstle, Frank Gorshin, Lucy Griffiths, Deryck Guyler, Max Harris, Percy Herbert, Joan Hickson, Skip Homeier, Arthur Howard, L. Q. Jones, Robert Keith, Roy Kinnear, Jane Lapotaire, John Laurie, Harvey Lembeck, Angus Lennie, Peter Madden, Gregg Martell, Terry Moore, Brad Morrow, Scotty Morrow, Pixie Parkhurst, Richard Pearson, Jon Pertwee, Wensley Pithey, Natasha Pyne, Clive Revill, Anthony Sharp, Carl Alfalfa Switzer, Leonard Trolley, Robert Wagner, Max Wall, Holly Weir, Frank Williams.

Robert Wagner is the arrogant, callow, spoiled rich son of a Southern landowner whose National Guard unit is mobilized during World War II and sent to the Pacific to fight the Japanese. Wagner finds himself in the same company with the sharecroppers he scorned back home and is sent to a forward military camp run by a power-mad, vengeful officer (Broderick Crawford) who treats Wagner and his other troops with the same scorn that Wagner treated his sharecroppers back home. In the course of his military service, Wagner becomes best friends with Ebsen, a fellow soldier in the war, and also one of his sharecroppers back home. Wagner's experiences with his commander and Ebsen transform him into a better person, one who is going to treat his people differently when he returns home from the war.

The film is based on Francis Gwaltney's, *Between Heaven and Hell* (London: Brown, Watson, 1958).

MILITARY SERVICE

• Buddy Ebsen, a yachtsman, offered his sailboat and himself to the navy, but when they refused him a commission, he joined the U.S. Coast Guard. He was commissioned a lieutenant (j.g.) and trained in antisubmarine warfare. Assigned as the executive officer of the USS *Pocatello*, a sub chaser patrolling the Pacific, he was discharged as a full lieutenant at the end of the war.

BETWEEN WARS

Edgecliff Films, McElroy & McElroy, 1974, color, 100 minutes.

Producers: Hal McElroy, Michael Thornhill; **Director:** Michael Thornhill; **Screenwriter:** Frank Moorhouse; **Cast:** John Armstrong, David Bradley, Noel Brady, John Chance, Peter Collingwood, Graham Corry, Peter Cummins, Arthur Dignam, Betty Dyson, Stuart Finch, Neil Fitzpatrick, Reg Gillam, David Goddard, Ken Goodlet, Reg Gorman, Martin Harris, Melissa Jaffer, Brian James, Betty Lucas, Judy Lynne, Günter Meisner, Max Meldrum, John Morris, Judy Morris, Terence Peck, Robert Quilter, Corin Redgrave, Rob Steele, Martin Vaughan, Joan Winchester.

Dr. Trenbow (Corin Redgrave) is reluctantly caught up in various currents of political thought, including conservatism and fascism, during the period 1918–1941.

INTERESTING FACT

- This is one of the few Australian features to range over the sociopolitical landscape.

BEYOND THE CALL OF DUTY

Concorde–New Horizons, New Horizon Picture Corp., 1992, color, 85 minutes.

Producers: Joan Barnett, Jack Grossbart, Steven Rabiner, Cirio H. Santiago; **Director:** Cirio H. Santiago; **Screenwriters:** R. G. Davis, Beverly Gray; **Music:** Nonong Buencamino; **Cast:** Archie Adamos, Ronald Asinas, Bert Cayanan, Robert Ginnaven, Joanne Griffin, Eb Lottimer, Jillian McWhirter, Nick Nicholson, James Gregory Paolleli, Ruben Ramos, Ryan Redillas, Greg Rocero, Steve Rogers, Jett Sahara, Henry Strzalkowski, Totoy Torres, Vic Trevino, Jan-Michael Vincent.

While leading a maverick band of warriors on a high-speed gunboat behind enemy lines and through the treacherous Mekong Delta, a U.S. Army commander picks up a beautiful female American journalist, whom he must help while being pursued by a cunning Vietnamese enemy.

QUOTE

Lt. Sam Henderson: Well, now it's you and me and the barrel.

BEYOND VICTORY

Pathé, 1931, b&w, 70 minutes.

Producer: E. B. Derr; **Directors:** Edward H. Griffith, John S. Robertson (as John Robertson); **Screenwriters:** James Gleason, Horace Jackson; **Music:** Arthur Alexander; **Distributors:** RKO-Pathé; **Cast:** Lissy Arna, Max Barwyn, Wade Boteler, William Boyd, Edward Brady, E. H. Calvert, Mary Carr, Eddy Chandler, Lew Cody, Charles Coleman, Theodore von Eltz, James Gleason, Russell Gleason, Ethan Laidlaw, Zasu Pitts, Purnell Pratt, Frank Reicher, Hedwiga Reicher, Fred Scott, Marion Shilling.

During World War I, four battle-weary American soldiers are assigned to a rear-guard action to protect their unit's retreat. As they fight and die, they reflect on the women they left behind.

INTERESTING FACT

- The title is derived from the expression "Beyond victory lies the dream of man's desire."

BIG BLOCKADE, THE

Ealing Studios, 1942, b&w, 73 minutes.

Producers: Michael Balcon, Alberto Cavalcanti; **Director:** Charles Frend; **Screenwriters:** Charles Frend, Angus MacPhail, Frank Owen; **Distributor:** United Artists; **Cast:** Ronald Adam, Joss Ambler, Leslie Banks, David Bowes-Lyon, John Boxer, Frank Cellier, Cyril Chamberlain, Hugh Dalton, Mark Daly, Alfred Drayton, David Evans, Marius Goring, Morland Graham, Peter De Greef, Will Hay, Thora Hird, Leif Konow, Albert Lieven, Elliot Mason, George Merritt, Bernard Miles, John Mills, Charles Minor, Robert Morley, Frank Owen, Frederick Piper, Bernard Rebel, Michael Redgrave, Michael Rennie, Owen Reynolds, Quentin Reynolds, Ronald Shiner, John Stuart, Basil Sydney, Austin Trevor, Percy Walsh, Manning Whiley, Michael Wilding, George Woodbridge.

This film is wartime propaganda depicting the success of the economic blockade of Germany in the early years of the war.

INTERESTING FACTS

- The movie was made with the cooperation of the Ministry of Economic Warfare, the Royal Navy, and the Royal Air Force.

- Initially intended as an MOI (wartime Ministry of Information) two-reeler about economic warfare.

BIG PARADE, THE

Metro-Goldwyn-Mayer, 1925, b&w, 141 minutes.

Producer: Irving Thalberg; **Director:** King Vidor; **Screenwriters:** Harry Behn, Joseph Farnham, Laurence Stallings, King Vidor; **Filmed at:** San Antonio, Texas; **Cast:** Claire Adams, Renée Adorée, George Beranger, Hobart Bosworth, Frank Currier, Karl Dane, John Gilbert, Rosita Marstini, Claire McDowell, Tom O'Brien, Robert Ober.

The idle son of a rich businessman joins the army when the United States enters World War I. While fighting in France, he becomes friends with two working-class soldiers and falls in love with a French woman. He loses his leg in combat and returns home, where no one understands what he has been through in combat. Disillusioned, he returns to France and marries his French love.

In the scene of the troops advancing through the woods, they all march in unison. Director King Vidor had a metronome on the set and a big bass drum, which was pounded in unison with the metronome, keeping all of the soldiers in step with the same rhythm.

AWARDS

National Film Preservation Board, USA, 1992

Photoplay Awards, 1925
 Won: *Medal of Honor*—Irving Thalberg

San Sebastián International Film Festival, 1983
 Won: *OCIC Award—Honorable Mention*, King Vidor.

BIG RED ONE, THE

Lorimar Television, 1980, color, 113 minutes.

Producer: Gene Corman; **Director:** Samuel Fuller; **Screenwriter:** Samuel Fuller; **Distributors:** United Artists; **Filmed in:** Israel, Ireland; **Cast:** Stéphane Audran, Shimon Barr, Gregori Buimistre, Ken Campbell, Robert Carradine, Joseph Clark, Howard Delman, Bobby Di Cicco, Alain Doutey, Giovanna Galletti, Colin Gilbert, Mark Hamill, Perry Lang, Charles Macaulay, Serge Marquand, Maurice Marsac, Lee Marvin, Siegfried Rauch, Abraham Ronai, Galit Rotman, Marthe Villalonga, Kelly Ward, Doug Werner, Matteo Zoffoli.

Sergeant Lee Marvin leads a World War II squad of four longtime survivors who ignore the faceless replacements who continually arrive and die. The campaigns in which they are involved include Operation Torch (North African landings), the German counterattack at Kasserine Pass, Operation Husky (the invasion of Sicily), Operation Overlord (the Normandy landing), the Battle of the Bulge, and the liberation of a concentration camp in Germany.

A member of the squad (Mark Hamill) opens the door to the gas oven in which a Waffen SS concentration camp guard is hiding. The German fires, but his rifle is empty. The American then empties his entire clip into the German, with a haunting echo of the retort of the gunfire resounding in the metal oven with each shot. Into the middle of this scene walks Lee Marvin, who sees what is happening and hands him another ammunition clip.

INTERESTING FACTS

- Director Sam Fuller was an infantryman who served in the Big Red One in World War II.
- Most, if not all, of Sam Fuller's movies include a character named Griff. In this film, it is the soldier played by Mark Hamill (better known as Luke Skywalker in *Star Wars*).
- Lee Marvin was also a World War II veteran and was badly wounded.

MISTAKE

- When the Allies attack through France, a lone German soldier sets an ambush. As he retreats into the setting sun, the narrator comments on how the Germans are retreating back to Germany; if he were retreating back to Germany, he would be heading east, into a rising sun.

QUOTE

One of the members of the squad: Survival is the only glory in war.

AWARD

Cannes Film Festival, 1980
 Nominated: *Golden Palm*, Samuel Fuller.

BILOXI BLUES

Rastar Pictures, 1988, color, 106 minutes.

Producers: Joseph M. Caracciolo (executive), Marykay Powell (executive), Ray Stark; **Director:**

Mike Nichols; **Screenwriter:** Neil Simon (also play); **Music:** Georges Delerue; **Distributor:** Universal Pictures; **Cast:** Jeff Bailey, Matthew Broderick, Natalie Canerday, Michael Dolan, Markus Flanagan, Christopher Ginnaven, Michael R. Haley, Ben Hynum, Mark Evan Jacobs, Tom Kagy, Matthew Kimbrough, Dave Klenzie, Morris Mead, Penelope Ann Miller, Kirby Mitchell, Matt Mulhern, Park Overall, Corey Parker, Alan Pottinger, A. Collin Roddey, Norman Rose, Bill Russell, Virginia Sandifur, Casey Siemaszko, Scott Sudbury, Allen Turner, Christopher Walken, David Whitman, Andy Wigington.

Matthew Broderick is a New York City teenager who enlists in the U.S. Army in 1945, the last year of World War II. He is sent to basic training at Biloxi, Missis-sippi, where he must cope with a variety of fellow soldiers from all walks of life. He endures the whims of a mentally unstable drill sergeant.

INTERESTING FACT

- Based on Neil Simon's play of the same name, *Biloxi Blues* is the sequel to Simon's *Brighton Beach Memoirs*. It takes up the story of Eugene Jerome on his way to boot camp in Mississippi to train for World War II.

MISTAKES

- The closing scene with the steam locomotive is flipped horizontally.
- Although the film is set in 1945, a Corningware cup circa 1970 is visible on a shelf.

Biloxi Blues (RASTAR & UNIVERSAL PICTURES/AUTHOR'S COLLECTION)

- One night at boot camp, the recruits get into a scuffle. Sgt. Toomey enters to restore order and asks Hennessey what happened. Hennessey replies: "Nothing, Sir." No drill sergant would ever let pass such an "insult" as being referred to as "Sir."
- In the dance sequence with Eugene and Daisy during "How High the Moon," as they slowly dance in circles, you can see the shadow of the entire crew, camera, and boom against the back wall with each rotation!
- The scene where the troops are talking about what they would do with their last week on earth, Wykowski refers to "making it" with the queen of England. Because George VI was on the throne, his wife, later known as the Queen Mother, was queen of England.

QUOTES

Toomey: Epstein, Arnold B.
Epstein: Ho, ho!
Toomey: Are there two Arnold Epsteins in this company?
Epstein: No, sergeant.
Toomey: But I heard more than one ho.
Epstein: Yes, sergeant.
Toomey: Epstein, Arnold B.
Epstein: Ho!
Toomey: One more time.
Epstein: Ho!
Toomey: Do I make myself clear, Epstein?
Epstein: Ho!
Toomey: Do I make myself clear, Jerome?
Jerome: Ho, yes!
Toomey: Ho what?
Jerome: Ho nothing!
Toomey: Are you having trouble understanding me, Jerome?
Jerome: Ho no. I mean, no ho, sergeant. Just plain ho.

Eugene Morris Jerome: Man it's hot. It's like Africa hot. Tarzan couldn't take this kind of hot.

BLACK TENT, THE

J. Arthur Rank Films, 1956, color, 93 minutes.

Producer: William MacQuitty; **Director:** Brian Desmond Hurst; **Screenwriters:** Bryan Forbes, Robin Maugham; **Cast:** Anthony Bushell, Michael Craig, Anton Diffring, Paul Homer, Frederick Jaeger, André Morell, Donald Pleasence, Anna-Maria Sandri, Ter-ence Sharkey, Donald Sinden, Anthony Steele, Derek Sydney, Ralph Truman.

During a British retreat in the desert during World War II, Anthony Steele takes shelter with a Bedouin tribe and marries the sheik's daughter, Anna-Maria Sandri. When he tries to rejoin his regiment, however, he is killed.

BLOCKADE

Walter Wanger Productions, 1938, b&w, 85 minutes.

Producer: Walter Wanger; **Director:** William Dieterle; **Screenwriter:** John Howard Lawson; **Music:** Werner Janssen, Ann Ronell, Kurt Weill; **Distributor:** United Artists; **Filmed at:** Los Angeles River, California; **Cast:** Ricca Allen, Arthur Aylesworth, Paul Bradley, Edward Brady, George Byron, Leo Carrillo, Madeleine Carroll, William B. Davidson, Baby Maria De La Paz, Katherine DeMille, Guy D'Ennery, Reginald Denny, Carlos De Valdez, Roger Drake, Dolores Duran, Demetrius Emanuel, Henry Fonda, Mary Foy, Rosina Galli, Allan Garcia, Peter Godfrey, John Halliday, Herbert Heywood, George Houston, Fred Kohler, George Lloyd, Murdock MacQuarrie, John Skins Miller, Belle Mitchell, Hugh Prosser, Roman Ros, Evelyn Selbie, Harry Semels, Vladimir Sokoloff, Carl Stockdale, Nick Thompson, Lupita Tovar, Robert Warwick, Cecil Weston.

Henry Fonda is a simple soldier-peasant forced to take up arms to defend his farm during the Spanish Civil War. He falls in love with a Russian (Madeleine Carroll), whose father is an international spy.

INTERESTING FACTS

- The film was made while the Spanish Civil War was still raging.
- Although the film was cautious not to take sides, Loyalist or Fascist, it still caused a lot of controversy. The Hays Office, Hollywood's own built-in censor, suggested a lot of changes to avoid alienating any nations.
- The film was supported by American communists, but the Catholic press condemned it. Protesters from the Knights of Columbus boycotted the film at Radio City Music Hall.
- Ten years later, the film was used against screenwriter John Howard Lawson by the House Un-American Activities Committee when it investigated suspected communists in Hollywood.

Henry Fonda: Where is the conscience of the world that it allows the killing and maiming of civilians to go on?

BLOOD AND STEEL

20th Century-Fox, 1959, b&w, 63 minutes.

Producer: Gene Corman; **Director:** Bernard L. Kowalski; **Screenwriter:** Joseph C. Gilette; **Music:** Calvin Jackson; **Distributor:** 20th Century-Fox Film Corporation; **Cast:** John Brinkley, James Edwards, Brett Halsey, James Hong, Allen Jung, John Lupton, Bill Saito, Ziva Rodann.

Four American sailors, members of a U.S. Navy construction battalion (Seabees), are sent to reconnoiter a Japanese-held island as the site of a future American airbase. They evade the Japanese troops with the help of a native girl, who is killed.

INTERESTING FACTS

- The classic tribute to the navy's construction battalions is the film *THE FIGHTING SEABEES*.
- The name "Seabees" is actually a play on the initials for construction battalions, CBs.

BLOOD ON THE SUN

Cagney Productions, 1945, b&w, 98 minutes.

Producer: William Cagney; **Director:** Frank Lloyd; **Screenwriters:** Lester Cole, Nathaniel Curtis, Garrett Fort, Frank Melford; **Music**: Miklós Rózsa; **Distributor:** United Artists; **Cast:** Philip Ahn, Robert Armstrong, Hugh Beaumont, James Bell, James Cagney, Rosemary De Camp, Oy Chan, Dr. Hugh Ho Chang, John Emery, Wallace Ford, Gregory Gaye, Porter Hall, John Halloran, Joseph Kim, Grace Lem, Arthur Loft, Marvin Miller, George Paris, Frank Puglia, Sylvia Sidney, Leonard Strong, Emmett Vogan, Charlie Wayne, Rhys Williams.

James Cagney is a reporter working in Tokyo who refuses to toe the Japanese line on the expansionist policies of the Imperial government. When the Tanaka Memorial falls into his hands, Japanese agents try desperately to get it back before he can publish it in his newspaper.

The Tanaka Memorial was a real historical document. Released to the international press in 1927, it revealed Japanese plans, including maps and operational orders, to invade China and Manchuria. It also contained detailed plans to bomb the American naval base at Pearl Harbor. The plans were considered so fantastic that they were treated as fakes by the international community, and even when the Japanese began to execute the plan by invading China, the plans were still not given any credence.

Iris Hilliard: Japanese women aren't allowed to think. It's against the law.

BLUE MAX, THE

20th Century-Fox, 1966, color, 156 minutes.

Producers: Christian Ferry, Elmo Williams (executive); **Director:** John Guillermin; **Screenwriters:** Jack Hunter (novel) (as Jack D. Hunter), Ben Barzman (adaptation), Basilio Franchina (adaptation), David Pursall, Jack Seddon, Gerald Hanley; **Music:** Jerry Goldsmith; **Distributor:** 20th Century-Fox Film Corporation; **Filmed at:** Dublin, Ireland, Weston Aerodrome, Leixlip, County Kildare, Ireland, Wicklow Town, County Wicklow, Ireland; **Cast:** Ursula Andress, Ray Browne, Warren Crosby, Anton Diffring, Loni von Friedl, Jeremy Kemp, Ian Kingsley, Frederick Ledebur, James Mason, Derren Nesbitt, Derek Newark, Roger Ostime, Timothy Parkes, George Peppard, Carl Schell, Hugo Schuster, Alex Scott, Harry Towb, Karl Michael Vogler, Peter Woodthorpe.

During World War I, George Peppard is a German risen from the lower classes to become a fighter pilot. He now wants to be accepted by the aristocratic German officer corps. He covets Germany's highest medal for aviators, the Blue Max, which is awarded only to those with 20 confirmed kills. He hopes that attaining this medal will gain him acceptance in a world to which he was not born. However, his tactics in ruthlessly pursuing the award have the opposite effect, offending his aristocratic comrades.

The German award called the Blue Max was awarded at the beginning of the war to pilots who shot down eight enemy aircraft; this requirement was later raised to 16. However, the requirement was never 20 kills, as depicted in this film. This was obviously a device by the screenwriter to make the award even more unobtainable, not realizing that shooting down 16 enemy aircraft is quite a feat in itself.

INTERESTING FACTS

- "The Blue Max" took its name from Max Immelmann, a famous air ace.

The Blue Max (20TH CENTURY-FOX/AUTHOR'S COLLECTION)

- Camera operator Skeets Kelly was killed in a collision between two helicopters while filming this movie.
- In some scenes George Peppard was actually flying his plane.
- When Stachel climbs into the motorcycle sidecar in pouring rain, blue sky and sun shining on a hillside can be seen in the background. This phenomenon is not at all unheard of in France, so this is incorrectly regarded as a goof.

MISTAKES

- Willi is shown being killed when he accidentally flies into what appears to be a ruined church tower. In the next scene, Stachel tells Heidemann, "He hit the trees," and he has no reason to lie.
- German single-seat fighter aircraft in World War I did not carry bombs.
- The movie shows pilots firing their machine guns by reaching out and pulling back triggers on the guns themselves (in at least one scene, a pilot is shown with both hands on the guns, which of course means he is not flying his airplane). In fact, the guns were fired by levers located on the aircraft's joystick, allowing the pilot to fly and fire simultaneously.
- In two scenes of airplanes crashing, the wires suspending the aircraft mock-ups are clearly visible.
- Stachel's aircraft changes from a Pfalz to a Tiger Moth after he makes his first kill.
- Several British Tiger Moth training aircraft of 1930s vintage were used to represent German fighters. In addition, the "new monoplane" in which Stachel is killed was actually a French Morane Saulnier trainer, also dating from the 1930s.
- The Iron Cross national insignia on the German aircraft were incorrect for that period of World War I.
- The German artillery pieces being towed by horses bounce and vibrate too lightly, indicating that they are probably wooden mock-ups.
- In several scenes of burning aircraft, smoke can clearly be seen coming from charges mounted under the wings, rather than from the engine.
- Fokker DR1 triplanes never carried overall lozenge-pattern camouflage.

Willi von Klugermann: By the way, Stachel . . . there's an impression around that . . . you care more about your unconfirmed kill than you do about Fabian's death.

[long pause]

Bruno Stachel: Perhaps it's force of habit. In the trenches, we couldn't even bury the dead; there were too many of them. I've never had the time . . . to discuss them over a glass of champagne.

General Count von Klugermann: I'm afraid it's rather a small medal, Willi, but it's the highest Germany can give.

AWARDS

British Academy Awards, 1967
 Won: *BAFTA Film Award, Best British Art Direction (Color)*, Wilfred Shingleton
 Nominated: *BAFTA Film Award, Best British Cinematography (Color)*, Douglas Slocombe; *Best British Costume (Color)*, John Furniss; *Most Promising Newcomer to Leading Film Roles*, Jeremy Kemp.

BODY AND SOUL

Fox Film Corporation, 1931, b&w, 70 minutes.

Director: Alfred Santell; **Screenwriters:** Jules Furthman, Elliott White Springs (story "Big Eyes and Little Mouth"), A. E. Thomas (play "Squadrons"); **Music:** Peter Brunelli; **Distributor:** Fox Film Corporation; **Cast:** Humphrey Bogart, Dennis D'Auburn, Don Dillaway, Douglas Dray, Charles Farrell, Crauford Kent, Harold Kinney, Elissa Landi, Myrna Loy, Ian Maclaren, Pat Somerset, Bruce Warren.

Humphrey Bogart is an RAF pilot killed in combat during World War I during an attack on an observation balloon. After his death, one of his friends tries to return the letters Bogart received from a girl called "Pom-Pom." There are two possible letter writers: One is Bogart's widow, Elissa Landi, who is suspected of being a German spy, and the other is the real German spy, Myrna Loy.

BOLD AND THE BRAVE, THE

Filmakers Producing Organization, 1956, b&w, 87 minutes.

Producer: Hal E. Chester; **Director:** Lewis R. Foster; **Screenwriter:** Robert Lewin; **Distributor:** RKO Radio Pictures Inc., **Cast:** Stanley Adams, Wendell Corey, Race Gentry, Wright King, Nicole Maurey, Mickey Rooney, John Smith, Tara Summers, Don Taylor, Ralph Votrian, Bobs Watson.

Three soldiers fight in the Italian campaign during World War II. Mickey Rooney tries to win enough at craps to open a restaurant after the war but dies trying to protect his winnings. Wendell Corey is a pacifist who cannot deal with killing the enemy. Don Taylor is a religious fanatic who cannot consummate his relationship with a prostitute.

AWARDS

Academy Awards, USA, 1956
 Nominated: *Oscar, Best Supporting Actor*, Mickey Rooney; *Best Writing, Best Screenplay—Original*, Robert Lewin.

BOMBARDIER

RKO Radio Pictures Inc., 1943, b&w, 99 minutes.

Producer: Robert Fellows; **Director:** Richard Wallace; **Screenwriters:** Martin Rackin (story), John Twist (also story); **Music:** Roy Webb; **Distributor:** RKO Radio Pictures Inc.; **Cast:** Eddie Albert, Stanley Andrews, Joan Barclay, Hugh Beaumont, Abner Biberman, Charles D. Brown, John Calvert, James Craven, Eddie Dew, Bruce Edwards, Eugene L. Eubank, Martin Faust, Walter Fenner, Paul Fix, Charles Flynn, George Ford, Erford Gage, Bud Geary, Kirby Grant, Neil Hamilton, Herbert Heyes, Russell Hoyt, Lloyd Ingraham, John James, Joe King, Mike Lally, Harold Landon, Barton MacLane, Warren Mace, Richard Martin, Wayne McCoy, Robert Middlemass, John Miljan, Bert Moorhouse, James Newill, Pat O'Brien, Paul Parry, Edward Peil Sr., Joey Ray, Walter Reed, Charles Russell, Robert Ryan, Randolph Scott, John Sheehan, Anne Shirley, Lee Shumway, Margie Stewart, Leonard Strong, Russell Wade, Larry Wheat, Dick Winslow, Allen Wood.

During World War II, Pat O'Brien establishes a school for bombardiers and sets out to prove to the U.S. Army the superiority of high-altitude precision bombing. Randolph Scott is an aviator who insists that the pilot, not the bombardier, is the most important officer in a combat mission but finally comes to realize the critical importance of the bombardier.

The fact that almost every combat specialty during World War II has its own movie is no coincidence. It is a combination of two factors: The studios needed a large number of different story lines for the large number of movies they were making to support the war effort, and, secondly, the services were inundating the studios with requests to make films to increase recruiting in each combat specialty.

INTERESTING FACT

- Although the film, for dramatic effect, creates tension between the pilots and the bombardiers, in actuality the lines of authority have always been clear-cut. The pilots "drive the bus," the bombardiers control the flight path and the tactical mission. In fact, during the bombing run in World War II, the bombardiers were in complete control of every heading and every turn made by the aircraft.

MILITARY SERVICE

- The author, Robert Davenport, spent four years as a bombardier with the U.S. Navy.

QUOTES

Burton Hughes: You're quite an entomologist.
Sgt. Archie Dixon: Nope! But I know all about bugs.

AWARD

Academy Awards, USA, 1943
 Nominated: *Oscar, Best Effects, Special Effects,* Roy Granville, James G. Stewart (sound), Vernon L. Walker (photographic)

BOMBS OVER BURMA

Producers Releasing Corporation, 1943, b&w, 65 minutes.

Producers: Arthur Alexander, Alfred Stern; **Director:** Joseph H. Lewis; **Screenwriters:** Joseph H. Lewis, Milton Raison; **Music:** Lee Zahler; **Distributors:** Producers Releasing Corporation; **Cast:** Leslie Denison, Frank Lackteen, Richard Loo, Teala Loring, Noel Madison, Dan Seymour, Anna May Wong, Nedrick Young.

Anna May Wong is a Chinese girl who risks her life as a secret agent to stop the Japanese, who are trying to halt the flow of supplies on the Burma Road during World War II.

INTERESTING FACT

- During World War II, the Burma Road was the vital supply route by which the Allies kept the Chinese supplied in their fight against the Japanese invaders. The Japanese cut the road in April 1942, and supplies had to be sent by air for the next two years. In the winter of 1943–44, a combined British, American, and Chinese force, under Britain's Vice Admiral Louis Mountbatten and America's General Joseph Stilwell, slogged through the monsoon jungles and reopened the northern part of the Burma Road on January 27, 1945. The southern stretch was cleared of Japanese after three more months of fighting.

BOOT, DAS

Westdeutscher Rundfunk, Twin Bros. Productions, Radiant Productions, Süddeutscher Rundfunk, Bavaria Film, Westdeutscher Rundfunk, 1981, color, 210 minutes.

Producers: Michael Bittins, Mark Damon, Ortwin Freyermuth, Lutz Hengst, John W. Hyde, Edward R. Pressman, Günter Rohrbach; **Director:** Wolfgang Petersen; **Screenwriters:** Lothar G. Buchheim, Wolfgang Petersen, Dean Riesner; **Distributors:** Columbia TriStar, Columbia Pictures, Constantin Film, JMM Invest; **Filmed at:** Hamburg, Germany, the North Sea, Atlantic Ocean, La Rochelle, France, and Helgoland, in the North Sea; **Cast:** Roger Barth, Konrad Becker, Christian Bendomir, Hubertus Bengsch, Joachim Bernhard, Thomas Boxhammer, Rita Cadillac, Sky Dumont, Jan Fedder, Günther Franke, Norbert Gronwald, Herbert Grönemeyer, Martin Hemme, Heinz Hoenig, Jean-Claude Hoffmann, Arno Kral, Albert Kraml, Günter Lamprecht, Erwin Leder, Martin May, Maryline Moulard, Helmut Neumeier, Uwe Ochsenknecht, Peter Pathenis, Franz Pietsch, Wilhelm Pietsch, Jürgen Prochnow, Ralf Richter, Claude-Oliver Rudolph, Dirk Salomon, Otto Sander, Ferdinand Schaal, Lutz Schnell, Christian Seipolt, Martin Semmelrogge, Oliver Stritzel, Bernd Tauber, Rolf Weber, Klaus Wennemann, Lothar Zajicek.

This film is a detailed dramatization of the claustrophobic and terrifying world of a German U-boat crew hunting ships from under the sea during World War II.

When the submarine has to go down so deep that it is near crush depth, the rivets that hold the sub together begin to zing out of the metal plates and fly around the inside of the sub.

INTERESTING FACTS

- When one watches this film in German, the scene in which the crew sings "It's a Long Way to Tipperary" is poignant. After one listens to the film in German, one is startled, when the crew sings the song in English. The impact of this song is totally lost when one sees the film in English.

- The bulk of the film's $15 million budget was spent on constructing U-boats. Specifications for the original Type VII-C U-boat were found at the Chicago Museum of Science and Industry. The plans were taken to the original builders of the subs, who were commissioned to build a full-sized, seagoing replica, their first such assignment since the war ended. A second full-sized model was built for interior filming.

- Three scale models were built for the special effects. The first, a 35-foot remote-controlled model, could sail in high seas and dive; the other two, 18 feet and 8 feet in length, were used for underwater shots. Scale models of tankers, destroyers, and other ships were also built to complete the armada.

- To help his actors convey the claustrophobic conditions found on a real U-boat, director Wolfgang Petersen insisted on filming within the actual confines of the ship (scarcely wider than a man's outstretched arms) rather than removing the model's outer wall.

- While shooting scale models in the North Sea, photographers were disturbed by doves landing on the submarine.

- The submarine models built for *Das Boot* were also used in *RAIDERS OF THE LOST ARK* (1981).

- There was no Class VII-C submarine left from World War II, so the crew had to build the whole interior from scratch using original plans from that time. It was mounted on a large pivot to simulate a moving submarine. The cast received extensive drills on how to literally run through a submarine in order to shift its balance like an experienced crew.

- The cast was deliberately kept indoors continually during the shooting period in order to look as pale as a real submarine crew would on a mission at sea.

- The full-scale model was little more than a hollow shell with an engine and could be used only in calm waters. While it was being filmed in rougher weather, it cracked in two and sank. It was later recovered, patched with wood planks, and used for the final shots.

- Depth-charge explosion effects were created by detonating small explosives in a 5-meter-deep tank and filming them at 1500 frames per second.

- This is one of the few sympathetic portrayals of the war from the German side to be released in Western distribution.

- The movie is based on Lother G. Buchheim's *Das Boot* (New York: Knopf, 1975).

- Many of the original cast dubbed their own parts in the English-language version, released under the title *The Boat*.

- The film is available in alternate versions: a theatrical release 145 minutes long, edited down from a six-hour mini-series developed for German television; and a 210-minute director's cut released in the United States on April 4, 1997.

AWARDS

Academy Awards, USA, 1983
 Nominated: *Oscar, Best Cinematography*, Jost Vacano; *Best Director*, Wolfgang Petersen; *Best Effects, Sound Effects, Editing*, Mike Le Mare; *Best Film Editing*, Hannes Nikel; *Best Sound*, Milan Bor, Mike Le Mare, Trevor Pyke; *Best Writing, Screenplay, Based on Material from Another Medium*, Wolfgang Petersen

British Academy Awards, 1983
 Nominated: *BAFTA Film Award, Best Foreign Language Film*, Wolfgang Petersen—West Germany

Golden Globes, USA, 1982
 Nominated: *Golden Globe, Best Foreign Film*—West Germany.

BORN ON THE FOURTH OF JULY

Ixtlan Corporation, 1989, color, 145 minutes.

Producers: Lope V. Juban Jr., A. Kitman Ho, Joseph P. Reidy, Oliver Stone, Clayton Townsend; **Director:** Oliver Stone; **Screenwriters:** Ron Kovic, Oliver Stone; **Music:** John Williams; **Distributor:** Universal Pictures; **Filmed at:** Villa Dulce, Mexico, Philippines, Bronx Veterans Hospital, New York, SMU Campus, Dallas, Texas, Elmwood, Oak Cliff, Dallas, Texas (parade scenes, school, church); **Cast:** Paul Abbott, Bill Allen, Mel Allen, Seth Allen, Philip Amelio, Réal Andrews, Daniel Baldwin, Stephen Baldwin, William Baldwin, Lisa Barnes, Raymond J. Barry, Ryan Beadle, Cody Beard, Peter Benson, Tom Berenger, Anne Bobby, Edie Brickell, Claude Brooks,

R. D. Call, Rob Camilletti, David Carriere, Rocky Carroll, Reg E. Cathey, Frank Cavestani, Eagle Eye Cherry, Sami Chester, Holly Marie Combs, Michael Compotaro, Peter Crombie, Tom Cruise, Willem Dafoe, Lane R. Davis, Amanda Davis, Edith Diaz, Dale Dye, Josh Evans, John Falch, Markus Flanagan, Corkey Ford, Vivica A. Fox, Tony Frank, Dan Furnad, John William Galt, Geoff Garza, Jason Gedrick, Fred Geise, Erika Geminder, John Getz, Frank Girardeau, Cordelia González, Richard Grusin, Michael Smith Guess, Bob Gunton, Greg Hackbarth, Richard Haus, Jayne Haynes, David Herman, Abbie Hoffman, Elizabeth Hoffman, Michelle Hurst, Lucinda Jenney, Ed Jupp Jr., Ivan Kane, Caroline Kava, Jason Klein, Wayne Knight, William Hubbard Knight, Ron Kovic, Bryan Larkin, Samantha Larkin, Andrew Lauer, Ed Lauter, James LeGros, Damien Leake, Jerry Levine, Elbert Lewis, Jodi Long, Richard Lubin, Bruce MacVittie, William R. Mapother, Rick Masters, Gale Mayron, Annie McEnroe, Jack McGee, John C. McGinley, Sean McGraw, Kevin G McGuire, Michael McTighe, Mike Miller, Christopher W. Mills, Byron Minns, Willie Minor, Chip Moody, Liz Moore, Norma Moore, Lorraine Morin-Torre, Kevin Harvey Morse, Stacey Moseley, Mark Moses, Billie Neal, David Neidorf, Pamela S. Neill, Karen Newman, J. R. Nutt, Ken Osborne, Kristel Otney, Jenna von Oÿ, Richard Panebianco, Jimmy L Parker, Ellen Pasternack, Chris Pedersen, Anthony Pena, Chuck Pfeiffer, Johnny Pinto, Begonia Plaza, Richard Poe, Jessica Prunell, John Del Regno, Joseph P. Reidy, Melinda Ramos Renna, Eduardo Ricaro, Keri Roebuck, Paul Sanchez, Sergio Scognamiglio, Kyra Sedgwick, Tom Sizemore, Beau Starr, Mike Starr, Oliver Stone, Sean Stone, Michael Sulsona, Jamie Talisman, Brian Tarantina, Lili Taylor, Bob Tillotson, Alan Toy, Chris Walker, William Wallace, Mark Edward Walters, David Warshofsky, Jake Weber, Frank Whaley, Don Wilson, Norm Wilson, Michael Wincott, Harold Woloschin, Ben Wright, Joy Zapata.

Tom Cruise portrays Ron Kovic, who is paralyzed during the Vietnam War, feels betrayed by the country he

Born on the Fourth of July (UNIVERSAL PICTURES/AUTHOR'S COLLECTION)

fought for, and becomes an antiwar and pro–human rights political activist.

INTERESTING FACTS

- This is the true story of Vietnam veteran Ron Kovic.
- Star Tom Cruise was actually born on the third of July.
- The entire film was shot in shades of red, white, or blue, depending on the emotional level (battle scenes are all in reddish hues, dream sequences in white, sadness in blue).
- Abbie Hoffman is in a cameo as a war/draft protester.
- Ron Kovic is in a cameo as a World War II veteran in the parade at the beginning.
- Oliver Stone is in a cameo as the reporter interviewing the military official on television near the beginning of the film.

MILITARY SERVICE

- Dan Rowan, whose *Laugh In* TV show was featured in the film, was an Army Air Force fighter pilot during World War II. He was assigned to the Eighth Fighter Squadron, 49th Fighter Group of the Fifth Air Force in New Guinea, flying P-40 Curtis fighters. His military service included surviving a plane crash.

MISTAKES

- A 1957 Chevrolet convertible (released in the fall of 1956) is used in the 1956 Fourth of July parade.
- Ron's family watches JFK's inauguration in Washington, D.C., in January 1961. It is below freezing there. But outside the Kovic home in Long Island, N.Y., it appears to be early fall.
- Set in 1968–1969, the film includes the song *American Pie*, released in 1971.
- Reeboks (first made in 1978) are shown at a 1972 Republican convention.
- A "Jackie Gleason Blvd." street sign can be seen at the 1972 Republican National Convention in Miami Beach. The street wasn't so named until after Gleason's death in the late '80s.
- Tom Cruise and Willem Dafoe are in a Mexican bordello, but the prostitutes are not Hispanic; they are obviously Filipina. Credits indicate that part of the film was shot in the Philippines.

QUOTES

Mrs. Kovic: Don't say penis in this house!
Ron Kovic: Penis! Penis! Big fucking erect penis, ma!

Ron Kovic: People say that if you don't love America, then get the hell out. Well, I love America.

AWARDS

Academy Awards, USA, 1989
 Won: *Oscar, Best Director*, Oliver Stone; *Best Film Editing*, David Brenner, Joe Hutshing
 Nominated: *Oscar, Best Actor*, Tom Cruise; *Best Cinematography*, Robert Richardson; *Best Music, Original Score*, John Williams; *Best Picture*, A. Kitman Ho, Oliver Stone; *Best Sound*, Tod A. Maitland, Michael Minkler, Wylie Stateman, Gregory H. Watkins; *Best Writing, Screenplay, Based on Material from Another Medium*, Ron Kovic, Oliver Stone

American Cinema Editors, USA, 1990
 Nominated: *Eddie, Best Edited Feature Film*, David Brenner, Joe Hutshing

American Society of Cinematographers, USA, 1990
 Nominated: *ASC Award, Outstanding Achievement in Cinematography in Theatrical Releases*, Robert Richardson

Berlin International Film Festival, 1990
 Nominated: *Golden Berlin Bear*, Oliver Stone

British Academy Awards, 1991
 Nominated: *BAFTA Film Award, Best Actor*, Tom Cruise; *Best Adapted Screenplay*, Ron Kovic, Oliver Stone

Casting Society of America, USA, 1990
 Nominated: *Artios, Best Casting for Feature Film, Drama*, Risa Bramon Garcia, Billy Hopkins

Directors Guild of America, USA, 1990
 Won: *DGA Award, Outstanding Directorial Achievement in Motion Pictures*, Stephen Lim (first assistant director) (plaque); Joseph P. Reidy (first assistant director) (plaque); David Sardi (second assistant director) (plaque); Oliver Stone, Clayton Townsend (unit production manager) (plaque)

Golden Globes, USA, 1990
 Won: *Golden, Globe, Best Director—Motion Picture*, Oliver Stone; *Best Motion Picture—Drama; Best Performance by an Actor in a Motion Picture—Drama;* Tom Cruise; *Best Screenplay—Motion Picture*, Ron Kovic, Oliver Stone
 Nominated: *Golden Globe, Best Original Score—Motion Picture*

John Williams, Political Film Society, USA, 1991
 Won: *PFS Award, Democracy*

Writers Guild of America, USA, 1990
 Nominated: WGA, Best Screenplay Based on Material from Another Medium, Ron Kovic, Oliver Stone.

BOYS IN COMPANY C, THE

Columbia Pictures Corporation, 1978, color, 125 minutes.

Producers: Raymond Chow, Dennis Juban, André E. Morgan; **Director:** Sidney J. Furie; **Screenwriters:** Sidney J. Furie, Rick Natkin; **Filmed in:** Philippines; **Cast:** Joe Mari Avellana, Don Bell, Eazy Black, James Canning, Logan Clarke, Michael Cohen, Vic Diaz, Chuck Doherty, R. Lee Ermey, Parris Hicks, Karen Hilger, Scott Hylands, Stan Johns, Noel Kramer, Michael Lembeck, Bob Mallett, Frederick Matthews, Helen McNeely, Duane Mercier, Ken Metcalfe, Drew Michaels, Santos Morales, Rick Natkin, Peggy O'Neal, Cisco Oliver, Victor Pinzon, Stan Shaw, Fred Smithson, Andrew Stevens, Ray Wagner, Craig Wasson, Charles Waters, James Whitmore Jr., Noble Willingham, Claude Wilson.

Five young marines go through boot camp in 1967 and then leave for a tour in Vietnam, which quickly devolves into a hellish nightmare. Disheartened by futile combat, appalled by the corruption of their South Vietnamese ally, and constantly endangered by the incompetence of their company commander, the young men look for a way out of the war. They learn that if they can defeat a rival soccer team, they can spend the rest of their tour playing exhibition games behind the lines.

INTERESTING FACTS

- The drill instructor (DI) is played by R. Lee Ermey, a former DI with the U.S. Marines, who later played a similar role in *FULL METAL JACKET*.
- The original script was written by Rick Natkin for a film class at Yale University in 1973.
- There are several second-generation actors in the film. Andrew Stevens is the son of actress Stella Stevens. Michael Lembeck is the son of actor Harvey Lembeck. James Whitmore Jr. is the son of actor James Whitmore Sr.

QUOTES

Washington: Sergeant Loyce don't give a damn!
The Boys of Company C: Shipped our ass to Vietnam!
Washington: Good marines they never die!
The Boys of Company C: When they're hit they never cry!

BRASS TARGET

Metro-Goldwyn-Mayer, 1978, color, 111 minutes.

Producers: Berle Adams (executive), Arthur Lewis; **Director:** John Hough; **Screenwriters:** Frederick Nolan (novel, *Brass Target*), Alvin Boretz; **Music:** Laurence Rosenthal; **Distributor:** MGM/UA; **Filmed in:** Germany, Switzerland; **Cast:** Peter Armstrong, Heinz Bennent, Birgit Bergen, Ed Bishop, Hildegard Busse, Claudia Butenuth, John Cassavetes, Bob Cunningham, Bruce Davison, Lynn Ferren, Hal Galili, Brad Harris, Edward Herrmann, Wolfgang Hiller, Bernard Horsfall, Jimmy Jackson, John Junkin, George Kennedy, Dietrich Kerky, Richard Kley, Ray Le Clair, Sophia Loren, Drew Lucas, Patrick McGoohan, Lee Montague, Reinhold Olszewski, Yulian Panich, Osman Ragheb, Marshall Reynor, Rene Schoenberg, Sigfrit Steiner, Max von Sydow, Alan Tilvern, Robert Vaughn, Sissy Weiner, Ernst Zeiner.

Robert Vaughn is an American colonel, and Patrick McGoohan is head of the OSS. Together they conspire to steal Nazi gold at the end of World War II. George Kennedy is Gen. George S. Patton, who uncovers their plot and whom they must kill. The movie is based on Frederick Nolan's book, *Brass Target* (New York: Jove, 1978).

INTERESTING FACTS

- In real life, Gen. George S. Patton died as a result of an automobile accident in Germany soon after World War II, which had nothing to do with Nazi gold.
- In the novel, the investigator is not the real-life Gen. Patton but a fictional person. Because of the success of the film *PATTON* a few years earlier, the producers obviously thought this additional plot twist would help the film.

BRAVO TWO ZERO

Icon Entertainment International, 1999, color, 115 minutes.

Producers: Ruth Caleb, Gillian Pearson, Sudhir Pragjee, Anant Singh, Sanjeev Singh, Helena Spring, David M. Thompson; **Director:** Tom Clegg; **Screenwriters:** Troy Kennedy-Martin, Andy McNab; **Distributor:** Miramax Films; **Filmed at:** Upington, Northern Cape, South Africa; **Cast:** Caz Abrahams, Nick Ashby, Jamie Bartlett, Sean Bean, Barry Berk,

Julia Booth, Melissa Carter, Dimitri Cassar, Alison Coles, Kevin Collins, George Coutsoudis, Ian Curtis, Ernst Eloff, Arishaad Erreeff, Anthony Fridjohn, Richard Graham, Thomas Hall, Robert Hobbs, Graham Hopkins, Akram Ibrahim, Brent King, Maki Kossioris, Dehan Liebenberg, Tim Mahoney, Anna Meininger, Nissam Moalem, Steve Nicolson, Nicky Rebello, Louise Saint-Claire, Abdallah Sardi, Russel Savadier, Ron Senior Jr., Yvonne Van Den Berg, Rick Warden, Robert Whitehead.

The mission of this British patrol dropped behind enemy lines during the Gulf War was to take out the Scud missiles that Saddam Hussein was using to terrorize his enemies, as well as to sever strategic communication lines between Baghdad and northwestern Iraq. Dropped into Scud Alley carrying 210-pound packs, Sergeant McNab and his men soon find themselves surrounded by Saddam's army. Their radios don't work, the weather is brutally cold, and then they are spotted.

The film is based on Ryan Chris's *The One That Got Away* (Washington, D.C.: Brassey's, 1998).

INTERESTING FACTS

- This is the true story of the most highly decorated British patrol since the Boer War: an eight-man SAS team, commanded by Sergeant Andy McNab, that was behind Iraqi lines during the Gulf War in January 1991.
- For the SAS, the Bravo Two Zero patrol has always been regarded with mixed feelings. On the one hand, the patrol is a tale of remarkable endurance and heroism; on the other hand, only one of the eight-man patrol managed to escape, three were killed, and four were captured.

"BREAKER" MORANT

South Australian Film Corporation, 1980, color, 107 minutes.

Producer: Matt Carroll; **Director:** Bruce Beresford; **Screenwriters:** Bruce Beresford, Jonathan Hardy, Kenneth Ross, David Stevens; **Music:** Phil Cunneen; **Distributor:** Belle & Blade; **Filmed at:** Burra, South Australia, (prison scenes); **Cast:** Ray Ball, Vincent Ball, Wayne Bell, Hank Bernard, Bryan Brown, Alan Cassell, Halifa Cisse, Bridget Cornish, Norman Currer, Judy Dick, Terence Donovan, Ria Erskine, Lewis FitzGerald, Ian Gray, Chris Haywood, Dick Henderson, Sylvia Horseman, Russell Kiefel, Bruno Knez, Alan Lovett, Trevor Mann, Ray Meagher, Rod Mullinar, Jon Nicholls, Peter Osborn, Ron Peterson, John Pfitzner, Michael Procanin, Don Quin, Elspeth Radford, Maria Reed, Ron Rodger, Nellie Seidel, Chris Smith, Rob Steele, Jack Thompson, Charles Tingwell, Laurie Walton, John Waters, Barbara West, Frank Wilson, Edward Woodward.

During the Boer War, three Australian officers of the Bushveld Carabineers are on trial for shooting Boer prisoners. Although they acted under orders, they are being used as scapegoats by the general staff, who are trying to distance themselves from the irregular practices of the war and make a gesture to the Boers, as part of peace negotiations. The trial does not progress as smoothly as expected by the general staff, as the defense puts up a strong fight in the courtroom. To make things even harder on the court-martial board, the prison compound is attacked during the trial, and the three prisoners distinguish themselves by their bravery in defending their own prison.

The film delivers one of its most memorable scenes when the defense raises as an alibi the fact that one of the officers visited two different Boer wives that afternoon, for romantic liaisons. The prosecution is outraged, not only because of the indecency of the acts and the fact that they are married women, but also because they are the wives of enemy soldiers who are away fighting the British! Quite nonchalantly, the officer replies: "A slice cut from a cut loaf won't be missed."

INTERESTING FACTS

- The film is based on a true story.
- Lieutenant Morant was called "Breaker" because his occupation before joining the army was breaking horses.
- Mohandas K. Gandhi (1869–1948) served with the British medical corps as a stretcher-bearer in the Boer War.
- Sir Robert Baden-Powell (1857–1941), founder of the Boy Scouts, made his mark at Mafeking.
- Sir Arthur Conan Doyle (1859–1930), creator of Sherlock Holmes, ran an army hospital.
- Rudyard Kipling (1865–1936), poet and writer, worked on an army newspaper.
- Due to incompetence and neglect, 25,000 Boer civilians (mainly women and children) and 14,000 natives died in the infamous concentration camps invented by the British.
- Lieutenants Morant and Handcock were found guilty of murder and sentenced to death by firing

squad. Ironically, they share a grave in the same cemetery in Pretoria as President Paul Kruger and other leaders of the Transvaal Republic.

QUOTES

Lieutenant Harry Morant [just before he is executed]: Shoot straight, you bastards—don't make a mess of it!

Harry Morant: It's a new kind of war, George. It's a new war for a new century.

Breaker Morant's Poem [recited just before he is executed]:
But we bequeath a parting tip,
For sound advice as such men,
As come across in transport ship,
To polish off the Dutchmen!

If you encounter any Boers,
You really must not loot 'em,
And if you wish to leave these shores,
For pity's sake don't shoot 'em!

AWARDS

Academy Awards, USA, 1981
 Nominated: *Oscar, Best Writing, Screenplay Based on Material from Another Medium,* Bruce Beresford, Jonathan Hardy, David Stevens

Australian Film Institute, 1980
 Won: *AFI Award, Best Achievement in Cinematography,* Donald McAlpine; *Best Achievement in Costume Design,* Anna Senior; *Best Achievement in Editing,* William M. Anderson; *Best Achievement in Production Design,* David Copping; *Best Achievement in Sound,* Jeanine Chiavlo, Phil Judd, Gary Wilkins, Anderson, William; *Best Actor in a Lead Role,* Jack Thompson; *Best Actor in a Supporting Role,* Bryan Brown; *Best Director,* Bruce Beresford; *Best Film,* Matthew Carroll; *Best Screenplay, Original or Adapted,* Bruce Beresford, Jonathan Hardy, David Stevens
 Nominated: *AFI Award, Best Actor in a Lead Role,* Edward Woodward; *Best Actor in a Supporting Role,* Lewis Fitz-Gerald, Charles Bud Tingwell

Cannes Film Festival, 1980
 Won: *Best Supporting Actor,* Jack Thompson
 Nominated: *Golden Palm,* Bruce Beresford

Golden Globes, USA, 1981
 Nominated: *Golden Globe, Best Foreign Film, Australia.*

BREAKTHROUGH

Warner Bros., 1950, b&w, 91 minutes.

Producer: Bryan Foy; **Director:** Lewis Seiler; **Screenwriters:** Joseph I. Breen Jr., Bernard Girard, Ted Sherdeman; **Music:** William Lava; **Distributor:** Warner Bros.; **Cast:** John Agar, Danny Arnold, David Brian, William Campbell, Suzanne Dalbert, Ed Hinton, Eric Hoeg, Frank Lovejoy, Greg McClure, Richard Monahan, Howard Negley, Danny Sue Nolan, Edward Norris, Paul Picerni, William Self, Dick Wesson, Matt Willis.

An American infantry unit goes through basic training and becomes part of the Normandy landings during World War II.

INTERESTING FACT

• The film contains actual combat camera footage.

BRIDGE AT REMAGEN, THE

Wolper Pictures, 1969, color, 115 minutes.

Producers: Julian Ludwig, Theodore Strauss, David L. Wolper; **Director:** John Guillermin; **Screenwriters:** Roger O. Hirson, William Roberts, Richard Yates; **Distributor:** United Artists; **Filmed in:** Czechoslovakia; **Cast:** Hans Christian Blech, Zoanel Braunschlager, Matt Clark, Bradford Dillman, Peter van Eyck, Fritz Ford, Ben Gazzara, Anna Gaël, Joachim Hansen, Tom Heaton, Bo Hopkins, Rolf Jahnke, Rudolf Jelínek, Rudolf Kalina, Robert Logan, E. G. Marshall, Günter Meisner, Richard Münch, Václav Neuzil, Vít Olmer, Paul Prokop, Heinz Reincke, Steve Sandor, Jan Schánilec, George Segal, Pavel Solty, Robert Vaughn, Frank Webb, Sonja Ziemann.

A war-weary American unit is ordered to capture intact the last bridge left standing across the Rhine during the Allied drive toward Berlin, before the determined German defenders can blow it up. The Rhine River, even today, is a formidable obstacle, and the Allies desperately needed to capture at least one bridge or have their advance on Germany grind to a halt.

INTERESTING FACTS

• Filming in Czechoslovakia was interrupted by the Soviet invasion in August 1968. Cast and crew were

The Bridge at Remagen (UNITED ARTISTS/AUTHOR'S COLLECTION)

evacuated in a convoy of 28 taxis, and the movie had to be completed in Italy.

- The towers of the original bridge are still there at Remagen, in the beautiful Rhine River valley. The bridge was never rebuilt. As with most World War II sites, there are numerous military memorials covering what is left of the bridge.
- The film is based on the true story of the taking of the Remagen bridge during World War II. The U.S. Ninth Armored Division finally took the Remagen bridge on March 7, 1945, and although badly damaged, it remained standing for 10 more days, long enough to get a substantial number of American troops across the river and continue the offensive toward Berlin.

MISTAKES

- As the smoke clears from the failed attempt to blow up the bridge, several major elements of the super-structure of one of the main spans are shown destroyed at the handrail level, even though the explosives are located below road level.
- The superstructure is intact again in a general view of the bridge a few seconds later and in all subsequent scenes.
- The same overweight German soldier with his arm in a sling is seen to exit the tunnel at least five times.

QUOTES

Ben Gazzara [who spends most of the war removing rings and watches from Nazi soldiers]: Everyone makes a profit out of the war. Why shouldn't I?

Lt. Phil Hartman: How do you know Stadt Beckenheim isn't crawling with Germans? What if they unload on us?
Maj. Barnes: Then we'll know, won't we, Lieutenant?

BRIDGE ON THE RIVER KWAI, THE

Horizon Films, 1957, color, 155 minutes.

Producer: Sam Spiegel; **Director:** David Lean; **Screenwriters:** Pierre Boulle, Carl Foreman, Calder Willingham, Michael Wilson; **Distributor:** Columbia Pictures Corporation; **Filmed at:** Kitulgala, near Colombo, Sri Lanka. Openshaw, Manchester, England; **Cast:** John Boxer, M. R. B. Chakrabandhu, James Donald, Kannikar Dowklee, Harold Goodwin, Alec Guinness, Jack Hawkins, Sessue Hayakawa, Percy Herbert, William Holden, Geoffrey Horne, Keiichiro Katsumoto, André Morell, Henry Okawa, Javanart Punynchoti, Ann Sears, Vilaiwan Seeboonreaung, Ngamta Suphaphongs, Peter Williams.

British prisoners of war captured in the fall of Singapore during World War II are given the task by their Japanese captors of building a railway bridge in the harsh jungle of Thailand. Central to the story is the conflict between the ruthless camp commander, Col. Saito (Sessue Hayakawa), and the stubborn British commander, Col. Nicholson (Alec Guinness). It is Col. Saito's task to build a crucial bridge across the River Kwai with his prisoners. Nicholson refuses to cooperate because Saito wants officers to perform manual labor. The battle of wills between the two commanders is eventually won by Nicholson. The prisoners score a moral victory over the Japanese by building a better bridge than they could have done. In the meantime, Shears (William Holden) escapes and ends up leading a commando team back to the bridge to blow it up. Unfortunately, Nicholson has become so obsessed with the bridge that he actually defends it during the commando attack. At the last minute, he realizes his tragic error, and helps to destroy the bridge.

The film is based on Pierre Boulle's *Le pont de la rivière Kwai* (London:Secker & Warburg, 1954).

When William Holden is asked by Jack Hawkins to go with him into the jungle and destroy the bridge, Holden turns him down. It's then that Hawkins reveals that Shears isn't a navy commander at all; they know all about him, he's been impersonating an officer, and he's actually a seaman. Caught in a court-martial offense, Holden has no choice but to go on the mission, the classic reluctant hero.

Alec Guinness realizes that he is collaborating with the enemy by preventing the commandos from blowing up the bridge. With his classic line,"What have I done?" he falls onto the plunger with his final breath, which detonates the explosives, blowing up the bridge.

INTERESTING FACTS

- A ticket for a ride on the "Death Railway" can be purchased for a trip through the countryside on the actual tracks laid down by the prisoners.
- The reason for this bridge had nothing to do with Thailand; it was built by the Japanese to logistically support their operations in Burma by land, so that they didn't have to risk their supply ships on the high seas against the Royal Navy.
- A museum that shows the horrible working and living conditions that killed most of the prisoners, and a cemetery are maintained by the Thai government.
- Cary Grant was originally slated to star, but he withdrew due to other commitments and was replaced by William Holden.
- Howard Hawks was asked to direct, but he declined. After the box-office failure of *Land of the Pharaohs* (1955), he didn't want two failures in a row; he thought the critics would love this movie but the public would stay away. One particular concern was the all-male lead roles.
- Michael Wilson and Carl Foreman were on the blacklist of people with suspected communist ties at the time of the movie, and they were not credited. The sole writing credit, and so the Oscar for best-adapted screenplay, went to Pierre Boulle, who wrote the original French novel but did not even speak English.
- In 1984 the academy retrospectively awarded the Oscar to Wilson and Foreman. Wilson did not live to see this; Foreman died the day after it was announced. When the film was restored, their names were added to the credits.
- The bridge in the story was constructed by prisoners in two months; the one built in Ceylon by a British company for the filming (425 feet long and 50 feet above the water) took eight months, with the use of 500 workers and 35 elephants. It was demolished in a matter of seconds; the total cost was 85,000 pounds.
- The train had a small diesel engine at the rear to make sure all four coaches went off the bridge after the steam locomotive.
- The prisoners whistle the title song, the *Colonel Bogey March*, as they arrive in the prisoner of war camp, because the words to the real song are obscene. It won the Oscar for best score.

MISTAKES

- In the opening scene, the railway is five feet six inches (1.676 meters) broad gauge, as used in Ceylon (Sri Lanka), the filming location; but when we see tracks on the finished bridge, they're much narrower, about two feet (60 cm). Both scenes are wrong, the actual line would have been one meter gauge, as it connected existing Thai and Burmese one-gauge routes.
- Although the film is set in 1943, a 1946 Chrysler was shown as a military staff car.
- The movie credits have only one "n" in Alec Guinness's name.

QUOTES

Saito: Do not speak to me of rules. This is war! This is not a game of cricket!

Shears: You make me sick with your heroics. There's a stench of death about you. You carry it in your pack like the plague. Explosives and L-pills—they go well together, don't they? And with you it's just one thing or the other: destroy a bridge or destroy yourself. This is just a game, this war! You and Col. Nicholson, you're two of a kind, crazy with courage. For what? How to die like a gentleman . . . how to die by the rules . . . when the only important thing is how to live like a human being.

James Donald [summing up the insane turn of events at the end of the film]: "Madness! Madness!"

AWARDS

Academy Awards, USA, 1957

Won: *Oscar*, *Best Actor*, Alec Guinness; *Best Cinematography*, Jack Hildyard; *Best Director*, David Lean; *Best Film Editing*, Peter Taylor; *Best Music, Scoring*, Malcolm Arnold; *Best Picture*, Sam Spiegel; *Best Writing, Screenplay Based on*

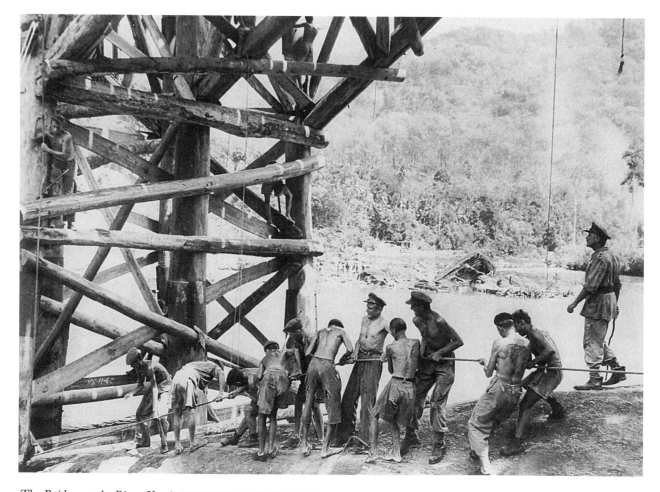

The Bridge on the River Kwai (COLUMBIA PICTURES/AUTHOR'S COLLECTION)

Material from Another Medium, Pierre Boulle, Carl Foreman, Michael Wilson

Nominated: *Oscar, Best Supporting Actor,* Sessue Hayakawa

British Academy Awards, 1958
Won: *BAFTA Film Award, Best British Actor,* Alec Guinness; *Best British Film; Best British Screenplay,* Pierre Boulle; *Best Film from Any Source*

British Society of Cinematographers, 1958
Won: *Best Cinematography Award,* Jack Hildyard

David di Donatello Awards, 1958
Won: David, *Best Foreign Production* (Migliore Produzione Straniera), Sam Spiegel

Directors Guild of America, USA, 1958
Won: *DGA Award, Outstanding Directoria Achievement in Motion Pictures,* Gus Agosti (assistant director) (plaque), David Lean, Ted Sturgis (assistant director) (plaque)

Golden Globes, USA, 1958
Won: *Golden Globe, Best Motion Picture—Drama; Best Motion Picture, Actor—Drama,* Alec Guinness; *Best Motion Picture,* Director, David Lean

National Board of Review, USA, 1957
Won: *NBR Award, Best Actor,* Alec Guinness; *Best Director,* David Lean; *Best Picture; Best Supporting Actor,* Sessue Hayakawa

National Film Preservation Board, USA, 1997

National Film Registry

New York Film Critics Circle Awards, 1957
Won: *NYFCC Award, Best Actor,* Alec Guinness; *Best Director,* David Lean; *Best Film.*

BRIDGES AT TOKO-RI, THE

Paramount Pictures, 1954, color, 102 minutes.

Producers: William Perlberg, George Seaton; **Director:** Mark Robson; **Screenwriters:** Valentine Davies, James Michener; **Distributor:** Paramount Pictures; **Cast:** Corey Allen, Nadine Ashdown, Keiko Awaji, Marshall U. Beebe, Willis Bouchey, Cheryl Lynn Callaway, Gene Hardy, William Holden, Earl Holliman, James Hyland, James Jenkins, Grace Kelly, Robert Kino, Paul Kruger, Fredric March, Charles McGraw, Rollin Moriyama, Gene Reynolds, Jack Roberts, Mickey Rooney, Richard Shannon, Robert A.

Sherry, Teru Shimada, Robert Strauss, Charles Tannen, Dennis Weaver.

Navy reserve fighter-pilot Harry Brubaker (William Holden), a veteran of World War II, is called to serve again in Korea, taking him away from his wife Nancy (Grace Kelly), two young children, and a successful law practice. When his plane goes down into the sea just short of the carrier, he bitterly questions the fairness of what he has been asked to do, while everyone back home is able to go on with the routine of their lives. Brubaker's wife and children join him in Japan, a brief respite, after which he must return to face his most formidable challenge, flying against the bridges at Toko-Ri, which could bring about a turning point in the war. Shot down, he dies fighting in a muddy ditch against overwhelming odds.

At the grim ending, William Holden and Mickey Rooney are killed fighting off North Koreans. There is nothing heroic about their end. First Holden's jet is shot down, as is Rooney's helicopter when he comes to pull him out. Eventually, their air cover has to leave, low on fuel. A seeming horde of communists are after them. As at the Alamo, they can't get all of the enemy, and they die, alone, in the bottom of a muddy ditch.

The film is based on James Michener's *The Bridges at Toko-Ri* (New York: Random House, 1953).

INTERESTING FACT

- The U.S. Navy's cooperation in making the movie included the use of 19 ships.

MILITARY SERVICE

- Holden wanted to make the movie in memory of his brother Robert, a naval aviator who was killed in action while flying a mission over Kavieng, New Ireland, in the South Pacific on January 1, 1944.

 Holden went through OCS and tried to get to flight training, but the military thought he was too valuable to risk in combat, and he ended up in the Army Air Force unit at the Hal Roach Studios in Culver City. He recalls taking an instant dislike to the unit's "martinet adjutant," Captain Ronald Reagan (future president of the United States), who had him stand at attention for 25 minutes while he recited regulations.

 Dennis Weaver, best known for his TV series *McCloud*, enlisted in the U.S. Naval Reserve at the age of 18. He served as an aviator and set records while on the navy track team. He was discharged with the rank of ensign, then attended the

The Bridges at Toko-Ri (PARAMOUNT PICTURES/AUTHOR'S COLLECTION)

University of Oklahoma as a drama major. He just missed qualifying for the 1948 Olympic track team.

QUOTE

Admiral Tarrant [at the end of the movie, pondering aloud]: Where do we get such men?

AWARDS

Academy Awards, USA, 1955
 Won: *Oscar, Best Special Effects*
 Nominated: *Oscar, Best Film Editing*, Alma Macrorie.

BRIDGE TOO FAR, A

United Artists, 1977, color, 176 minutes.

Producers: Joseph E. Levine, Richard P. Levine, John Palmer, Michael Stanley-Evans; **Director:** Richard Attenborough; **Screenwriters:** William Goldman, Cornelius Ryan; **Filmed at:** Bemmel, Brinkhorst, Gelderland, Deventer, Grave, Lent, Nijmegen, all in the Netherlands; **Cast:** Sebastian Abineri, Marlies van Alcmaer, Henry Alma, Alun Armstrong, Feliks Arons, David Auker, Michael Bangerter, Hartmut Becker, Tom van Beek, Tim Beekman, Stuart Blake, Dirk Bogarde, Hans von Borsody, Bertus Botterman, Ray Boyd, Andrew Branch, Michael Byrne, James Caan, Milton Cadman, Michael Caine, Nicholas Campbell, Simon Chandler, Erik Chitty, Stephen Churchett, Sean Connery, Paul Copley, Michael Graham Cox, Jon Croft, Hans Croiset, Ben Cross, Shaun Curry, Lex van Delden, Patrick Dickson, Harry Ditson, Donald Douglas, Keith Drinkel, Denholm Elliott, David English, Peter Faber, Colin Farrell, Edward Fox, Jack Galloway, Anthony Garner, Adrian Gibbs, Christopher Good, Peter Gordon, Elliott Gould, Michael Graves, Jason Gregory, Norman Gregory, Frank Grimes, Pieter Groenier, Stewart

Guidotti, Brian Gwaspari, Jonathan Hackett, Gene Hackman, Garrick Hagon, Patrick Hannaway, Brian Haughton, Brian Hawksley, Arthur Hill, Geoffrey Hinsliff, Anthony Hopkins, Ben Howard, Anthony Howden, George Innes, Frank Jarvis, Ray Jewers, John Judd, Edward Kalinski, Richard Kane, Jeremy Kemp, Neil Kennedy, David Killick, Adrienne Kleiweg, Walter Kohut, Hardy Krüger, Stanley Lebor, Ian Liston, Dan Long, Gerald Martin, Sean Mathias, Paul Maxwell, Barry McCarthy, Edward McDermott, Tony McHale, Jack McKenzie, Anthony Milner, Hilary Minster, Stephen Moore, Tim Morand, John Morton, Francis Mughan, Laurence Olivier, Richard Ommaney, Ryan O'Neal, Niall Padden, John Peel, Josephine Peeper, Donald Pickering, Wolfgang Preiss, Peter Quince, Paul Rattee, John Ratzenberger, Stephen Rayment, Philip Raymond, Robert Redford, Myles Reithermann, Georgette Reyevski, Dick Rienstra, Patrick Ryecart, Toby Salaman, John Salthouse, Maximilian Schell, Robin Scobey, Edward Seckerson, Peter Settelen, Anthony Pullen Shaw, Farrell Sheridan, Mark Sheridan, Gerald Sim, Mary Smithuysen, James Snell, Michael Stock, David Stockton, John Stride, Liv Ullmann, Paul Vaughan-Teague, Siem Vroom, James Wardroper, Jason White, Chris Williams.

The Allies develop a daring plan to capture a series of bridges across Holland to Germany in World War II (Operation Market Garden), in an effort to bring about a quick and decisive end to the war. The Germans have lost most of France, but the Allies are bogged down in their efforts to break out and get to Berlin. The plan is to drop thousands of paratroopers in Holland, on the key bridges along the line of advance, who will hold these positions until the tank column can work its way up the road to relieve them. But no one anticipated that the Dutch people would pour out onto the streets in throngs, thinking that they had been liberated, and bog down the advance of the armor. Intelligence about heavily equipped German Panzer units in the zone were ignored. Also, the plan allowed the Irish Guards (the armor) only one road on which to mount their all-important northward thrust.

Compare this film with the scene in *PATTON*, where George C. Scott complains that there is nothing between him and Berlin, that he has the perfect instrument at the perfect point in history—an opportunity to end the war, an opportunity that will last only a short time, and they're taking away his fuel and ammunition to give to Montgomery. Where were those supplies going? To Montgomery and his Operation Market Garden.

At the end of the film, all of the generals are on a tower from which they can see their objective, the final bridge, the bridge they just couldn't quite take. They each advance a reason why they couldn't make it: the road, the panzers, bad luck, etc. Finally, one of them, in a droll manner unique to the British, says, "We just tried to go a bridge too far." Ironically, this is the same officer who ignored the reconnaissance photographs of the Panzers.

INTERESTING FACTS

- The film is based on Cornelius Ryan's *A Bridge Too Far* (New York: Simon and Schuster, 1974) which is based on the true story of Operation Market Garden.
- The film illustrates very effectively the way in which the plan of Operation Market Garden developed its own momentum to destruction.
- It is easy now to point to the flaws in Operation Market Garden, but at the time it looked like a daring and viable alternative to slogging it out against the Siegfried Line.

QUOTES

Corp. Hancock [offers mug of tea]: Sir.
Maj. Gen. Urquhart: Hancock, I've got lunatics laughing at me from the woods. My original plan has been scuppered now that the jeeps haven't arrived. My communications are completely broken down. Do you really believe any of that can be helped by a cup of tea?
Corp. Hancock [Urquhart accepts his mug of tea]: Couldn't hurt, sir.

Brig. Gen. Gavin: What's the best way to take a bridge?
Maj. Julian Cook: Both ends at once.

Brig. Gen. Gavin: I'm sending two companies across the river by boat. I need a man with very special qualities to lead.
Maj. Julian Cook: Go on, sir.
Brig. Gen. Gavin: He's got to be tough enough to do it, and he's got to be experienced enough to do it. Plus one more thing. He's got to be dumb enough to do it. Start getting ready.
Junior Officer: What was all that about, major?
Maj. Julian Cook: Well someone's come up with a real nightmare. Real nightmare.

AWARDS

British Academy Awards, 1978
　　Won: *Anthony Asquith Award for Film Music*, John Addison; *BAFTA Film Award, Best Cinematography*, Geoffrey Unsworth; *Best Sound Track*,

Peter Horrocks, Gerry Humphreys, Simon Kaye, Robin O'Donoghue, Les Wiggins; *Best Supporting Actor*, Edward Fox

Nominated: *BAFTA Film Award, Best Direction*, Richard Attenborough; *Best Editing*, Antony Gibbs; *Best Film*; *Best Production Design/Art Direction*, Terence Marsh

Society of Cinematographers, 1977
Won: *Best Cinematography Award*, Geoffrey Unsworth

A Bridge Too Far (UNITED ARTISTS/AUTHOR'S COLLECTION)

National Society of Film Critics Awards, USA, 1978
 Won: *NSFC Award, Best Supporting Actor,* Edward
 Fox.

BRITISH AGENT

First National Pictures Inc., 1934, b&w, 81 minutes.

Director: Michael Curtiz; **Screenwriters:** Laird Doyle, R. H. Bruce Lockhart (novel *British Agent*); **Music:** Leo F. Forbstein, Bernhard Kaun, Heinz Roemheld; **Distributor:** Warner Bros.; **Cast:** Walter Armitage, Arthur Aylesworth, Thomas Braidon, Walter Byron, Alphonse Ethier, Mary Forbes, Kay Francis, William Gargan, Gregory Gaye, Winter Hall, Lew Harvey, Halliwell Hobbes, X. Tenen Holtz, Leslie Howard, Olaf Hytten, Marina Koshetz, Frank Lackteen, Doris Lloyd, Basil Lynn, J. Carrol Naish, George C. Pearce, Irving Pichel, Paul Porcasi, Philip Reed, Frank Reicher, Addison Richards, Cesar Romero, Ivan F. Simpson, Fred Walton, Robert Wilber.

Leslie Howard is the British consul-general to Russia during World War I, whose mission is to keep Russia in the war against Germany, as the Bolsheviks take over the country by revolt from within. He saves the life of Lenin's secretary, and she falls in love with him, even though they are separated by ideological differences.

 The movie is based on R. H. Bruce Lockhart's *British Agent* (New York and London: G. P. Putnam's Sons, 1933).

BRITISH INTELLIGENCE

Warner Bros., 1940, b&w, 62 minutes.

Producers: Bryan Foy, Mark Hellinger (associate); **Director:** Terry O. Morse; **Screenwriters:** Lee Katz, Anthony Paul Kelly (play *Three Faces East*); **Music:** Bernhard Kaun, Heinz Roemheld; **Cast:** Sidney Bracey, Louise Brien, Glen Cavender, Dennis D'Auburn, Clarence Derwent, Austin Fairman, Arno Frey, Frederick Giermann, Lawrence Grant, Carl Harbaugh, Winifred Harris, Gordon Hart, Holmes Herbert, Leyland Hodgson, Stuart Holmes, Boris Karloff, Willy Kaufman, Crauford Kent, Bruce Lester, Margaret Lindsay, Morton Lowry, Lester Matthews, Frank Mayo, Jack Mower, Leonard Mudie, Paul Panzer, Jack Richardson, Ferdinand Schumann-Heink, Hans Schumm, John Graham Spacey, Joe De Stefani, Bob Stevenson, John Sutton, Evan Thomas, David Thursby, Carlos De Valdez, Frederick Vogeding, Leonard Willey, Maris Wrixon, Henry von Zynda.

Boris Karloff is a German master spy who installs himself as the employee of a high-ranking British war official. Margaret Lindsay, a double agent, tries to ferret him out.

 The movie is based on the play *Three Faces East* (1918), by Anthony Paul Kelly.

INTERESTING FACTS

* This third version of the World War I play, made during World War II, includes a new character, a bumbling German corporal who looks like Adolf Hitler.
* The studios in this period were routinely remaking many of their successful silent films as talkies, with higher production values, new casts, and added plot twists.
* This is the third filmed version of the play; the other two are *Three Faces East* (1926 and 1930).

BURMA CONVOY

Universal Pictures, 1941, b&w, 72 minutes.

Director: Noel M. Smith; **Screenwriters:** Roy Chanslor, Stanley Rubin; **Music:** Heinz Roemheld, Hans J. Salter, Frank Skinner; **Distributor:** Universal Pictures; **Cast:** Frank Albertson, Evelyn Ankers, Turhan Bey, Charles Bickford, Truman Bradley, Ken Christy, Willie Fung, Chester Gan, Cecil Kellaway, Keye Luke, Harry Stubbs, Veola Vonn.

Truckers who carry vital supplies over the Burma Road from Rangoon to Chungking during the critical days of World War II are plagued by ambushes. When the leader of the operation learns that the leak was his younger brother, who was involved with enemy agents and then murdered, he sets out for revenge.

INTERESTING FACT

* A description of the Burma Road campaign is shown with the film *BOMBS OVER BURMA.*

CABARET

American Broadcasting Company, ABC Circle Films, 1972, color, 124 minutes.

Producers: Cy Feuer, Harold Nebenzal; **Director:** Bob Fosse; **Screenwriters:** Christopher Isherwood, Joe Masteroff, Jay Presson Allen, John Van Druten; **Music:** Ralph Burns, John Kander; **Distributor:** Allied Artists; **Filmed at:** Lübeck, Eutin, Schleswig-Holstein, Charlottenburg, Berlin, Dahlem, all in Germany; **Cast:** Marisa Berenson, Kathryn Doby, Joel Grey, Helmut Griem, Georg Hartmann, Inge Jaeger, Angelika Koch, Liza Minnelli, Estrongo Nachama, Elisabeth Neumann-Viertel, Louise Quick, Ricky Renée, Sigrid von Richthofen, Gitta Schmidt, Helen Velkovorska, Gerd Vespermann, Helen Vita, Fritz Wepper, Ralf Wolter, Michael York.

A female girlie-club entertainer, Liza Minnelli, romances two men while the Nazi Party rises to power around them. Berlin, only two years before Hitler came to power, is filled with poverty, drug and alcohol escapism, criminals, fighting in the streets, venereal disease, the prostitution of both sexes, the desperation to escape through the film industry, and the temporary escape from the harshness of life in "naughty" nightclubs like the Kit Kat Club. It's a bad scene and a good example of, perhaps, why so many Germans were seduced by the new order. There's not a single verbal reference to Hitler, and yet the growing Nazi movement all around these decadent misfits is ever present.

MILITARY SERVICE

- Director Bob Fosse enlisted in the U.S. Navy during World War II. He was assigned to an entertainment unit in the South Pacific, performing at Guam, Wake Island, and Okinawa, and was discharged in 1947.

QUOTES

Sally [singing]: Life is a cabaret, ol' chum, so come to the Cabaret.

Sally Bowles: Divine decadence, darling!

AWARDS

Academy Awards, USA, 1972
 Won: *Oscar*; *Best Actress*, Liza Minnelli; *Best Art Direction—Set Decoration*, Hans Jürgen Kiebach, Herbert Strabel, Rolf Zehetbauer; *Best Cinematography*, Geoffrey Unsworth; *Best Director*, Bob Fosse; *Best Film Editing*, David Bretherton; *Best Music, Scoring, Original Song Score, and/or Adaptation*, Ralph Burns; *Best Sound*, David Hildyard, Robert Knudson; *Best Supporting Actor*, Joel Grey

Nominated: *Oscar, Best Picture,* Cy Feuer; *Best Writing, Screenplay Based on Material from Another Medium,* Jay Presson Allen

American Cinema Editors, USA, 1973
Won: *Eddie, Best Edited Feature Film,* David Bretherton

Bodil Festival, 1973
Won: *Bodil, Best American Film* (Bedste amerikanske film), Bob Fosse (director)

British Academy Awards, 1973
Won: *BAFTA Film Award, Best Actress,* Liza Minnelli; *Best Art Direction,* Rolf Zehetbauer; *Best Cinematography,* Geoffrey Unsworth; *Best Direction,* Bob Fosse; *Best Film, Best Newcomer,* Joel Grey; *Best Sound Track,* David Hildyard, Robert Knudson, Arthur Piantadosi
Nominated: *BAFTA Film Award, Best Costume Design,* Charlotte Flemming; *Best Film Editing,* David Bretherton; *Best Screenplay,* Jay Presson Allen; *Best Supporting Actress,* Marisa Berenson

British Society of Cinematographers, 1972
Won: *Best Cinematography Award,* Geoffrey Unsworth

David di Donatello Awards, 1973
Won: *David, Best Foreign Actress* (Migliore Attrice Straniera), Liza Minnelli

Golden Globes, USA, 1973
Won: *Golden Globe, Best Motion Picture—Musical/Comedy; Best Motion Picture Actress—Musical/Comedy,* Liza Minnelli; *Best Supporting Actor—Motion Picture,* Joel Grey
Nominated: *Golden Globe, Best Director—Motion Picture,* Bob Fosse; *Best Original Song, unknown*—For the song "Mein Herr"—For the song "Money, Money," *Best Screenplay,* Jay Presson Allen; *Best Supporting Actress—Motion Picture,* Marisa Berenson; *Most Promising Newcomer—Female,* Marisa Berenson

National Board of Review, USA, 1972
Won: *NBR Award, Best Director,* Bob Fosse, *Best Picture—English Language; Best Supporting Actor,* Joel Grey (tied with Al Pacino for *The Godfather* [1972]); *Best Supporting Actress,* Marisa Berenson

National Film Preservation Board, USA, 1995

National Film Registry

National Society of Film Critics Awards, USA, 1973
Won: *NSFC Award, Best Supporting Actor,* Joel Grey (tied with Eddie Albert for *The Heartbreak Kid*

[1972]) **Writers Guild of America, USA, 1973**
Won: *WGA Screen Award, Best Comedy Adapted from Another Medium,* Jay Presson Allen.

CAINE MUTINY, THE

Columbia Pictures Corporation, 1954, color, 124 minutes.

Producer: Stanley Kramer; **Director:** Edward Dmytryk; **Screenwriters:** Michael Blankfort, Stanley Roberts, Herman Wouk; **Distributor:** Columbia Pictures; **Filmed at:** Treasure Island Naval Station, San Francisco, California. Yosemite National Park, California; **Cast:** Claude Akins, David Alpert, Don Anderson, Herbert Anderson, Warner Anderson, James Best, Whit Bissell, Humphrey Bogart, Robert Bray, Steve Brodie, Ted Cooper, Don Dillaway, Don Dubbins, Johnny Duncan, James Edwards, José Ferrer, Robert Francis, Arthur Franz, Joe Haworth, Van Johnson, Todd Karns, Don Keefer, Edward Laguna, Frank Losee Jr., Dayton Lummis, Kenneth MacDonald, Fred MacMurray, E. G. Marshall, Lee Marvin, Paul McGuire, Tyler McVey, Patrick Miller, Richard Norris, Jerry Paris, Steve Pendleton, Jay Richards, James Todd, John Tomeck, Tom Tully, Katherine Warren, May Wynn.

A ship gets a new captain during World War II, and the officers begin to suspect his sanity. Will he endanger them in combat? Will they have to remove him from command? Will they be charged with mutiny in time of war if they do? The first officer relieves Bogart of command during a typhoon when his actions endanger the ship, and faces court-martial for this act.

During the court-martial, Humphrey Bogart, as Captain Queeg, holds two silver metal balls in his hand. The more nervous he gets on the stand under cross-examination, the more he fidgets with those metal balls. Actors always like props to create something to do with their hands while they're saying their lines. This scene has become the classic hand prop of all time.

The film is based on Herman Wouk's *The Caine Mutiny* (Franklin Center, Pa.: Franklin Library, 1978).

INTERESTING FACTS

• When Humphrey Bogart broke bread into small pieces to symbolize the deteriorating state of Queeg's mental condition, a military adviser on the set told him that no naval officer would eat bread that way.
• Richard Widmark was chosen for the lead role, but producer Stanley Kramer wanted Humphrey Bogart.

The Caine Mutiny (COLUMBIA PICTURES/AUTHOR'S COLLECTION)

- Preparations for filming took 15 months.
- Actress Donna Lee Hickey adopted the name of her character in this movie, May Wynn, as her stage name, and made eight more films under that name. In the novel, May Wynn is itself a stage name.

MILITARY SERVICE

- Humphrey Bogart enlisted in the navy in May 1918 and served aboard the USS *Leviathan* (SP-1326), a captured German liner, and then aboard the USS *Santa Olivia* (SP-3125). He got his famous scar and lisp when a prisoner he was escorting fought him in an escape attempt, and Bogart had to shoot him to prevent his escape. He was discharged as a seaman second class on June 18, 1919.
- Stanley Kramer served with the U.S. Army Signal Corps during World War II, making orientation and training films in Astoria, New York. He was discharged as a first lieutenant.

- Herman Wouk served during World War II as an officer aboard the USS *Zane* (DMS-14) in the South Pacific. Wouk won a Pulitzer Prize for *The Caine Mutiny*.

MISTAKE

- When singing in the nightclub, presumably in 1944, May Wynn sings into a 1950s-design hand-held microphone.

QUOTES

Barney Greenwald: I don't want to upset you too much, but at the moment you have an excellent chance of being hanged.

Lt. Keith [Regarding Captain Queeg]: Well, he's certainly navy.
Lt. Keefer: Yeah . . . so was Captain Bligh.

Capt. Queeg: Ah, but the strawberries that's . . . that's where I had them. They laughed at me and made jokes, but I proved beyond the shadow of a doubt and with . . . geometric logic . . . that a duplicate key to the wardroom icebox did exist, and I'd have produced that key if they hadn't of pulled the *Caine* out of action. I, I, I know now they were only trying to protect some fellow officers.

AWARDS

Academy Awards, USA, 1954
 Nominated: *Oscar, Best Actor,* Humphrey Bogart; *Best Film Editing,* Henry Batista, William A. Lyon; *Best Music, Scoring of a Dramatic or Comedy Picture,* Max Steiner; *Best Picture,* Stanley Kramer; *Best Sound Recording,* John P. Livadary (Columbia, SSD); *Best Supporting Actor,* Tom Tully; *Best Writing, Screenplay,* Stanley Roberts

British Academy Awards, 1955
 Nominated: *BAFTA Film Awards, Best Film from any Source, Best Foreign Actor,* José Ferrer.

CANTERBURY TALE, A

The Archers, 1944, b&w, 124 minutes.

Producers: Michael Powell, Emeric Pressburger; **Directors:** Michael Powell, Emeric Pressburger; **Screenwriters:** Michael Powell, Emeric Pressburger; **Filmed at:** Valley of the Nailbourne, a.k.a. Little Stour, Kent, and Canterbury and Chilham, Kent, Rockefeller Center, New York City (American version), Chilmans Downs, Canterbury, England (scene where Alison and Colpepper hid in the grass), Chilham Mill, Chilham, Kent (boys' battle scene), Elbridge Farm, Fordwich, Kent (where Alison and Prudence load dung cart), George & Dragon, Fordwich, Kent (some shots of the Hand of Glory), The Red Lion, Wingham, Kent (other shots of the Hand of Glory), The Manor House, Fordwich, Kent (exteriors of the Colpepper Institute), Fordwich Parish Church, Fordwich, Kent (church attended by Bob and the Hortons), car park, George & Dragon, and football field in closing scene, Fordwich, Kent; **Cast:** Joss Ambler, Wally Bosco, Esma Cannon, Beresford Egan, Judith Furse, Harvey Golden, Michael Golden, Charles Hawtrey, Anthony Holles, Claude Horton, Neville Horton, Michael Howard, Kim Hunter, Freda Jackson, Jessie James, Betty Jardine, Parry Jones Jr., Esmond Knight, Maude Lambert, Mary Line, Kathleen Lucas, Eliot Makeham, H. F. Maltby, Raymond Massey, Eric Maturin, George Merritt, Jane Millican, Graham Moffatt, Charles Paton, Hay Petrie,

Eric Portman, Dennis Price, Edward Rigby, Margaret Scudamore, Jean Shepeard, Sheila Sim, John Slater, Leonard Smith, Winifred Swaffer, Charlie Tamsitt, James Tamsitt, Brian Todd, David Todd, Barbara Waring.

Three people arrive in a village in Kent in southern England in the early years of World War II. One is a London girl who is due to start working on a farm as a "Land Girl." Another is an Englishman conscripted into the army, taking a few days leave before going abroad. The third is a U.S. Army sergeant who wanted to go to Canterbury but got off the train in this town by mistake. As they walk into the village, Alison is attacked by "The Glue Man," a prankster who pours glue in women's hair. The three of them start to explore the area to discover and expose the Glue Man but then get engrossed in the history of the area and the tales of the Pilgrim's Way. The local magistrate is a local historian, an eccentric figure with a strange, mystical vision of the history of England in general and Canterbury in particular, who leads them further into the mystery.

INTERESTING FACTS

- Because Canterbury Cathedral's windows had been taken out to protect them from the air raids, the interior of the cathedral was rebuilt in Denham Studio.
- The cathedral bells seen in the opening and closing shots were a miniature replica of Canterbury's Bell Harry Tower to allow the camera to track up to and through them. The bells were rung by bell ringers from the cathedral who pulled the strings with finger and thumb to a playback of the real bells.
- The organ music had to be played on the St. Alban's Cathedral organ because the one at Canterbury Cathedral had been dismantled and stored away for the duration of the war.

MILITARY SERVICE

- Raymond Massey enrolled in the Canadian officer's training corps while at the University of Toronto. In 1915 he was commissioned a lieutenant in the Canadian field artillery. Sent to France in 1916, he was wounded at Ypres. After six months in hospital, he went to the United States to serve as a gunnery instructor at Yale and Princeton universities. He also served with the Expeditionary Force in Siberia from 1918 to 1919 and was discharged as a lieutenant in 1919. During World War II, after finishing filming on *ACTION IN THE NORTH ATLANTIC,* he applied to the U.S. Marines for a commission in intelligence but

was recalled to active service in his old regiment, as a major, and served until 1943 when he received a medical discharge.

QUOTE

Passerby [lost in a heavily bombed Canterbury]: It is an awful mess; I don't blame you for not knowing where you are. But you get a very good view of the cathedral now.

CAPTAIN EDDIE

20th Century-Fox, Eureka Productions, 1945, b&w, 107 minutes.

Producers: Winfield R. Sheehan, Christy Walsh; **Director:** Lloyd Bacon; **Screenwriter:** John Tucker Battle; **Music:** Cyril J. Mockridge; **Distributor:** 20th Century-Fox Film Corporation; **Cast:** Lynn Bari, Clem Bevans, Charles Bickford, Virginia Brissac, Spring Byington, Chick Chandler, George Chandler, Richard Conte, Richard Crane, Boyd Davis, Earle S. Dewey, Fred Essler, Elvin Field, Peter Garey, Don Garner, James Gleason, Winifred Glyn, Mary Gordon, Joseph J. Greene, Dwayne Hickman, Darryl Hickman, Olin Howlin, Fred MacMurray, Robert Malcolm, Gregory Marshall, Leila McIntyre, Peter Michael, Thomas Mitchell, George Mitchell, Lloyd Nolan, Mary Philips, Stanley Ridges, Nancy June Robinson, Charles Russell, Harry Shannon, David Spencer, Lotte Stein, Grady Sutton.

Fred MacMurray is World War I fighter ace Eddie Rickenbacker, who remembers his life in flashback while floating in a life raft in the South Pacific during World War II. Vignettes include his time as a car salesman, race car driver, fighter pilot in World War I, and airline industry executive.

The movie is based on the real-life story of aviator Capt. Eddie Rickenbacker (1890–1973), a member of the famous (Hat in the Ring) 94th Aero Squadron, who received the Congressional Medal of Honor and who shot down 26 enemy planes during World War I. Assigned during World War II to inspect U.S. air bases, he was shot down and survived a 23-day ordeal in a life raft.

MILITARY SERVICE

• The Medal of Honor Citation for Eddie Rickenbacker reads:

For conspicuous gallantry and intrepidity above and beyond the call of duty in action against the enemy near Billy, France, 25 September 1918. While on a voluntary patrol over the lines, 1st Lt. Rickenbacker attacked seven enemy planes (five Fokker type, protecting two Halberstadt type). Disregarding the odds against him, he dived on them and shot down one of the Fokkers. He then attacked one of the Halberstadts and sent it down also.

AWARD

Academy Awards, USA, 1945
 Nominated: *Oscar, Best Special Effects,* Sol Halperin (photographic), Roger Heman Sr. (sound), Harry M. Leonard (sound), Fred Sersen (photographic).

CAPTAINS OF THE CLOUDS

Warner Bros., 1942, color, 114 minutes.

Producers: William Cagney, Hal B. Wallis; **Director:** Michael Curtiz; **Screenwriters:** Roland Gillett, Arthur T. Horman, Richard Macaulay, Norman Reilly Raine; **Music:** Harold Arlen, Max Steiner; **Distributor:** Warner Bros.; **Cast:** Hardie Albright, Tod Andrews, Russell Arms, Benny Baker, Barry Bernard, Clem Bevans, W. A. Bishop, Walter Brooks, James Bush, James Cagney, Lucia Carroll, Owen Cathcart-Jones, Paul Cavanagh, Reginald Denny, Donald Dillaway, Roland Drew, Tom Dugan, Pat Flaherty, Willie Fung, John Gallaudet, Reginald Gardiner, Herbert Gunn, Alan Hale, Charles Halton, Carl Harbord, Winifred Harris, John Hartley, Louis Jean Heydt, Jack Hyde, Charles Irwin, John Kellogg, J. M. Kerrigan, Frank Lackteen, Morton Lowry, J. Farrell MacDonald, Miles Mander, Brenda Marshall, Edward McNamara, George Meeker, Ray Montgomery, Dennis Morgan, Gavin Muir, George Offerman, Patrick O'Moore, George Ovey, Charles Smith, James Stevens, Rafael Storm, George Tobias, Emmett Vogan, Roy Walker, Billy Wayne, Billy Wilkerson, Larry Williams, Frederick Worlock, Gig Young.

James Cagney is one of four young Canadian bush pilots who join the Royal Canadian Air Force (RCAF) right after Dunkirk and are given the job of training new young recruits. However, Cagney doesn't want to settle for such a mundane job, and his recklessness leads to his being dismissed from the RCAF. Undaunted, he gets a job as a civilian ferry pilot, flying new bombers to Britain. When a convoy of bombers is attacked by a German fighter, he saves the rest of them by flying his bomber into the fighter.

INTERESTING FACT

- Real-life World War I air ace William Bishop has a cameo awarding the new young fliers their hard-won wings.

QUOTE

Winston Churchill [at the end of the film]: We shall go on to the end. We shall fight on the seas and oceans. We shall fight with growing confidence and growing strength in the air. We shall fight in the fields and in the streets. We shall never surrender.

CAPTIVE HEARTS

Kurissama Productions, 1987, color, 97 minutes.

Producers: Milton Goldstein, John A. Kuri, Michael Nelson, Terry Spazek; **Director:** Paul Almond; **Screenwriters:** John A. Kuri, Patrick N. Morita, Sargon Tamimi; **Music:** Osamu Kitajima; **Distributor:** Metro-Goldwyn-Mayer; **Cast:** Dennis Akayama, Doug Funamoto, Kano Futurama, Kohachiro Ishii, Mas Ishimara, Roger Ito, George Kadowaki, Yo Kato, Laurence M. Makamua, Chris Makepeace, Pat Morita, Kim Nakashima, Frederick Y. Okimura, Seth Sakai, Michael Sarrazin, Mari Sato, Sho Togo.

An American soldier is shot down over Japan during World War II, is taken prisoner, and falls in love with a Japanese woman.

CAPTURED!

Warner Bros., 1933, b&w, 69 minutes.

Producer: Edward Chodorov; **Director:** Roy Del Ruth; **Screenwriters:** Edward Chodorov, Philip Gibbs; **Distributor:** Warner Bros.; **Cast:** Robert Barrat, John Bleifer, Joyce Coad, Harry Cording, Douglas Fairbanks Jr., Philip Faversham, Halliwell Hobbes, Arthur Hohl, Leslie Howard, Hans Joby, Margaret Lindsay, Paul Lukas, William Le Maire, J. Carrol Naish, Reginald Pasch, Frank Reicher, Bert Sprotte.

Douglas Fairbanks Jr. is captured and sent to a German prisoner-of-war camp during World War I. There he meets his friend Leslie Howard. While Howard was a POW, Fairbanks fell in love with Howard's wife. Fairbanks escapes from the prison camp, but on the same night a German girl is raped and killed by another prisoner. Leslie Howard, who has learned of his wife's affair, writes the British War Department and demands that Fairbanks be returned to the POW camp for trial on charges of rape and murder of the German girl. The British send him back to the POW camp, and he is put on trial, but at the last minute Leslie Howard obtains proof that he is innocent. After struggling with his conscience, Howard presents the evidence and saves his old friend, even though he has had an affair with his wife.

MILITARY SERVICE

- Douglas Fairbanks Jr. was already a lieutenant (j.g.) in the naval reserve at the outbreak of World War II. He was sent on a goodwill tour of South America, officially to counter German influence, but he also collected intelligence directly for Assistant Secretary of State Sumner Welles. After his return, he requested sea duty. He was assigned first to convoy duty off Newfoundland aboard the USS *Ludlow* (DD-438), and then as signal officer on board the battleship USS *Mississippi* (BB-41), which patrolled the North Atlantic and escorted convoys. He was then assigned as the executive officer of USS *Goldcress* (AM-80), a minesweeper, and then as aide to Admiral Giffens. He was flag lieutenant of the battleship USS *Washington* (BB-56), the flagship of Task Force 99. His next assignment was special duty aboard the carrier USS *Wasp* (CV-7), as part of a convoy ferrying planes and supplies to the besieged island of Malta and then similar duty aboard the cruiser USS *Wichita* (CA-45) en route to Murmansk to supply the Russians. He then participated in diversionary raids, setting troops ashore in Yugoslavia, Egypt, Tunisia, Italy, and southern France during the invasion in August 1944. His decorations include the Croix de Guerre, the British Distinguished Service Cross, the Legion of Merit with a "V" for valor, and the Silver Star. He finished the war as a lieutenant commander and retired from the naval reserve in 1969 as a captain.

CARVE HER NAME WITH PRIDE

Keyboard, 1958, b&w, 119 minutes.

Producer: Daniel M. Angel; **Director:** Lewis Gilbert; **Screenwriters:** Lewis Gilbert, Vernon Harris, Leo Marks, R. J. Minney; **Music:** William Alwyn; **Distributor:** Rank Film Distributors; **Filmed at:** Black Park Country Park, Buckinghamshire, England; **Cast:** Michael Caine, Michael Goodliffe, Denise Grey, Avice Landone, Harold Lang, Anne Leon, André Maranne, Virginia McKenna, William Mervyn, Bill Owen, Maurice Ronet, Alain Saury, Paul Scofield, Nicole

Stéphane, Sidney Tafler, Jack Warner, Billie Whitelaw, Noel Willman.

The daughter of an English father and a French mother, living in London in the early years of World War II, meets a handsome young French soldier, and they fall in love, marry, and have a baby girl. She receives the dreaded telegram informing her of his death in North Africa. Shortly afterwards, she is approached to join the SOE (Special Operations Executive) and must decide between duty to her country and her baby.

CASABLANCA

Warner Bros., 1942, b&w, 102 minutes.

Producers: Hal B. Wallis, Jack L. Warner (executive); **Director:** Michael Curtiz; **Screenwriters:** Murray Burnett (play *Everybody Comes to Rick's*), Joan Alison (play *Everybody Comes to Rick's*), Julius J. Epstein, Philip G. Epstein, Howard Koch, Casey Robinson; **Music:** M. K. Jerome (songs), Jack Scholl (songs), Max Steiner, nonoriginal music by Herman Hupfeld (song *As Time Goes By*); **Distributor:** Warner Bros.; **Filmed at:** Metropolitan Airport, Van Nuys, California (Strasser's arrival); **Cast:** Lotte Palfi Andor, Louis V. Arco, Leon Belasco, Ingrid Bergman, Trude Berliner, Oliver Blake, Monte Blue, Humphrey Bogart, Curt Bois, Gino Corrado, Franco Corsaro, Marcel Dalio, Helmut Dantine, George Dee, Jean Del Val, William Edmunds, Martin Garralaga, Gregory Gaye, Sydney Greenstreet, Ilka Grüning, Creighton Hale, Paul Henreid, Olaf Hytten, Leonid Kinskey, Charles La Torre, Madeleine LeBeau, George J. Lewis, Peter Lorre, Lou Marcelle, Michael Mark, George Meeker, Louis Mercier, Torben Meyer, Alberto Morin, Leo Mostovoy, Corinna Mura, Joy Page, Paul Porcasi, Frank Puglia, John Qualen, Claude Rains, Georges Renavent, Richard Revy, Richard Ryen, S. Z. Sakall, Dan Seymour, Ludwig Stössel, Hans Heinrich von Twardowski, Norma Varden, Conrad Veidt, Dooley Wilson, Wolfgang Zilzer.

In Casablanca, prior to America's entry into World War II, Humphrey Bogart, expatriate American with a mysterious past, runs the most popular nightspot in town, Rick's Café Américain. Casablanca is a critical way station for refugees escaping war-torn Europe, where only those with the proper exit visa can escape. The cynical Bogart comes into possession of two valuable letters of transit, visas that cannot be questioned. Into this gin joint walks Bogart's lost love, Ingrid Bergman, with a surprise of her own, her husband, Czech underground leader Paul Henreid, whom she had thought dead when she fell in love with Bogart some years before in Paris. Bogart can use these letters of transit to escape with Bergman. But in the end, Bogart does the noble thing and gives them to Ingrid Bergman so that she can leave Casablanca with her husband.

INTERESTING FACTS

- The script for Casablanca was adapted by Julius and Philip Epstein and Howard Koch from an unproduced play called *Everybody Comes to Rick's* by Murray Burnett and Joan Alison.

- No one knew right up until the filming of the last scene whether Ilsa would end up with Rick or Laszlo. During the course of the picture, when Ingrid Bergman asked director Michael Curtiz with which man her character was in love, she was told to "play it in between." Bergman complained that she didn't know who her character was supposed to be in love with.

- In the German version, the immortal line "Here's lookin' at you, kid" became "*Schau mir in die Augen, Kleines*," which in English means "Look in my eyes, kid."

- Producer Hal B. Wallis considered Hedy Lamarr for the role of Ilsa, but she was then under contract to MGM. Lamarr later portrayed Ilsa in a *Lux Radio Theater* 1944 radio show based on the movie script. At the time, both Bergman and Bogart were overseas entertaining the troops. Rick was played on radio by Alan Ladd. Hedy Lamarr turned down the film role of Ilsa as she did not want to work with an unfinished script.

- "Rick's Café Américain" was modeled after Hotel El Minzah in Tangiers.

- Conrad Veidt, who played Major Heinrich Strasser, was very well known for his hatred of the Nazis.

- Rick never says "Play it again, Sam." He says: "You played it for her, you can play it for me. Play it!" Ilsa says "Play it, Sam. Play *As Time Goes By*."

- Dooley Wilson (Sam) was a professional drummer who faked playing the piano. As the music was recorded at the same time as the film, the piano playing was actually a recording of a performance by Elliot Carpenter played behind a curtain.

- Producer Hal B. Wallis nearly made the character Sam a female. Hazel Scott, Lena Horne, and Ella Fitzgerald were tested for the role.

- Humphrey Bogart's wife, Mayo Methot, continually accused him of having an affair with Ingrid Bergman, often confronting him in his dressing room before a shot. Bogart would come onto the set in a rage.

Casablanca (WARNER BROS./AUTHOR'S COLLECTION)

- Wallis originally had Ronald Reagan and Ann Sheridan in mind for the lead roles. Another producer, then said he thought Bogart was Warner Bros.' most appealing star to women. Meanwhile, George Raft was angling for the part with Jack L. Warner, but Wallis eventually chose Bogart.
- Paul Henreid was loaned to Warner Bros. for the role of Victor Laszlo by Selznick International Pictures against his will. He was concerned that playing a secondary character would ruin his career as a leading romantic lead.
- Two endings were scheduled to be filmed, but the first one worked so well that they never filmed the other.
- The budget was so small they couldn't use a real plane in the background at the airport. Instead, it is a small cardboard cutout. To give the illusion that the plane was full-sized, they used midgets to portray the crew preparing the plane for take-off. This film was rewritten daily during filming, made on a shoestring budget, hastily released, and expected to bomb.

- Director Michael Curtiz's Hungarian accent often caused confusion on the set. He asked a prop man for a "poodle" to appear in one scene. The prop man searched high and low for a poodle while the entire crew waited. He found one and presented it to Curtiz, who screamed, "A poodle! A poodle of water!"
- Many of the actors who played the Nazis were Jewish.
- The timely real-life invasion of Casablanca was used to promote this film, and undoubtedly contributed to its success.
- Many of the shadows were painted onto the set.
- Wallis thought of the film's last line three weeks after shooting ended, and Bogart was called back to dub it.
- Capt. Renault's line "You like war. I like women" was changed from "You enjoy war. I enjoy women" in order to meet decency standards.
- Warner Bros. had intended to use *Horst Wessel*, the rallying song of the Nazi Party, during the "battle of

the anthems" sequence, but the copyright was controlled by a German company, and Warner dropped that anthem for the lesser *Die Wacht Am Rhein* rather than violate the rights.

- After shooting, Max Steiner spoke against using *As Time Goes By* as the song identifying Rick and Ilsa, saying he would rather compose an original song to qualify for royalties. But Hal Wallis replied that since filming had ended, Ingrid Bergman had cut her hair very short to film *FOR WHOM THE BELL TOLLS* (1943) at a distant locale and therefore could not re-shoot already-completed scenes that had used *As Time Goes By*.

- *As Time Goes By* was written by lifelong bachelor Herman Hupfeld and debuted in the Broadway show *Everybody's Welcome* (1931), sung by Frances Williams. It had been a personal favorite of playwright and high school teacher Murray Burnett who, seven years later, visited Vienna just after the Nazis had entered. Later, after visiting a café in southern France where a black pianist had entertained a mixed crowd of Nazis, French, and refugees, Burnett was inspired to write the melodrama *Everybody Comes to Rick's*, which was optioned for production by Martin Gabel and Carly Wharton and, later, Warners. After the film's release, *As Time Goes By* stayed on radio's *Hit Parade* for 21 weeks. However, because of the striking musicians' union recording ban, the 1931 Rudy Vallee version became the smash hit. (It contains the rarely sung introductory verse, not heard in the film.) Max Steiner, in a 1943 interview, admitted that the song "must have had something to attract so much attention."

- The scene of Maj. Strasser's arrival was filmed at Metropolitan Airport, now known as Van Nuys Airport, in Los Angeles. Bogart, Bergman, and Henreid later reprised their roles for a radio performance of *Casablanca* on the CBS radio program *The Screen Guild Players*, a war-benefit show.

- The film's success led to plans for a sequel, which was to be called *Brazzaville*. Ingrid Bergman was not available, so Geraldine Fitzgerald was considered for the part of Ilsa before the project was killed. It was not until the late 1990s and Michael Walsh's novel *As Time Goes By* that a true sequel ever came to pass.

- At the time of release, the film was banned in Germany because the story was considered to be anti-Nazi propaganda by the wartime censors. After the end of World War II, the picture was finally released in Germany, minus around 20 minutes of footage that removed all of Conrad Veidt's scenes and all references to Nazism.

MISTAKES

- A knight on the chessboard disappears momentarily in the opening chess game.
- The man who is shot escaping from police dies next to an arch where a woman suddenly appears.
- Rick's tie is suddenly knotted differently when he sees Ilsa in the bazaar.
- When Rick gets on the train after standing in the rain, his coat is completely dry.
- While chatting outside Café Américain, Rick lights his cigarette twice.
- There never was such a thing as a letter of transit.
- It sounds like Ugarte says that the letters of transit are signed by "General de Gaulle," leading to confusion because de Gaulle was on the other side, with the Free French. Ugarte (Peter Lorre) actually says, "General Weygand," but his accent makes it difficult to understand.
- The fact that Louis's fake phone call to the airport fools Rick shows that the letters of transit are meant to be used as exit documents. Yet in the end, the Laszlos board without anybody ever checking the documents. If, once Louis was a hostage, Rick could get the Laszlos around any exit check, why did Rick insist on the letters of transit being filled out? He did it to make it "even more official"; the Laszlos would be protected in case there was an unexpected document check later, on arrival either at Lisbon or at Casablanca.

QUOTES

Rick Blaine: I stick my neck out for nobody.

Rick Blaine: You know what I want to hear.
Sam [lying]: No, I don't.
Rick Blaine: You played it for her, you can play it for me!
Sam [lying]: Well, I don't think I can remember.
Rick Blaine: If she can stand it, I can! Play it!

Rick Blaine: Here's looking at you, kid.

Rick Blaine: Of all the gin joints in all the towns in all the world, she walks into mine.

Capt. Louis Renault: Maj. Strasser has been shot. Round up the usual suspects.

AWARDS

Academy Awards, USA, 1943

Won: *Oscar*, *Best Director*, Michael Curtiz; *Best Picture*, Hal B. Wallis; *Best Writing*,

Screenplay, Julius J. Epstein, Philip G. Epstein, Howard Koch

Nominated: *Oscar, Best Actor,* Humphrey Bogart; *Best Cinematography, Black-and-White,* Arthur Edeson; *Best Film Editing,* Owen Marks; *Best Music, Scoring of a Dramatic or Comedy Picture,* Max Steiner; *Best Supporting Actor,* Claude Rains

National Film Preservation Board, USA, 1989

National Film Registry

CASABLANCA EXPRESS

Surf Film, Dania Film, Globe Films, National Cinematografica, 1988, color, 85 minutes.

Producers: Pietro Innocenzi, Umberto Innocenzi; **Director:** Sergio Martino; **Screenwriters:** Ernesto Gastaldi, Roberto Leoni, Sergio Martino; **Music:** Luigi Ceccarelli; **Distributor:** Trylon Video; **Cast:** David Brandon, Jason Connery, John Evans, Glenn Ford, Manfred Lehmann, Luisa Maneri, Donald Pleasence, Augusto Poderosi, Francesco Quinn, Horst Schön, Jean Sorel, Jinny Steffan, Giovanni Tamberi, Giulia Urso, Marina Viro, Phillip Vye.

Jason Connery is a commando assigned in 1942 to protect Winston Churchill when it is learned that the Nazis are plotting to kidnap him.

INTERESTING FACT

- Jason Connery is the son of actor Sean Connery.

CASE OF SERGEANT GRISCHA, THE

RKO Radio Pictures, 1930, b&w, 91 minutes.

Producer: William LeBaron; **Director:** Herbert Brenon; **Screenwriters:** Elizabeth Meehan, Arnold Zweig (novel *Der Streit um den Sergeanten Grischa*); **Music:** Max Steiner; **Distributors:** RKO Radio Pictures Inc.; **Cast:** Percy Barbette, Betty Compson, Hal Davis, Alec B. Francis, Jean Hersholt, Leyland Hodgson, Paul McAllister, Frank McCormack, Chester Morris, Gustav von Seyffertitz, Bernard Siegel, Raymond Whitaker.

Chester Morris is an illiterate Russian soldier who escapes from a German prison camp during World War I in a futile attempt to see his mother. He is recaptured, and when he gives his captors the name of another soldier, ironically it is the name of a Russian spy. Despite his protestations of innocence, the spy is executed.

INTERESTING FACTS

- All copies of this film are presumed lost.
- This film was intended as an antiwar film, like *ALL QUIET ON THE WESTERN FRONT,* which was released the same year.

AWARD

Academy Awards, USA 1930
 Nominated: *Oscar, Best Sound Recording,* John E. Tribby.

CAST A GIANT SHADOW

Batjac Productions, Llenroc, Mirisch Company, 1966, color, 144 minutes.

Producers: Melville Shavelson, Michael Wayne; **Director:** Melville Shavelson; **Screenwriters:** Ted Berkman, Melville Shavelson; **Music:** Elmer Bernstein; **Distributor:** United Artists; **Filmed in:** Israel and Rome and Lazio, Italy; **Cast:** Luther Adler, Claude Aliotti, Michael Balston, Sean Barrett, Roland Bartrop, Senta Berger, Yul Brynner, Ken Buckle, Allan Cuthbertson, Rodd Dana, Samra Dedes, Angie Dickinson, Vera Dolen, James Donald, Kirk Douglas, Rina Ganor, Robert Gardett, Stathis Giallelis, Arthur Hansel, Shlomo Hermon, Michael Hordern, Gordon Jackson, Jeremy Kemp, Frank Latimore, Gary Merrill, Hillel Rave, Robert Ross, Michael Shagrir, Michael Shillo, Frank Sinatra, Dan Sturkie, Topol, John Wayne, Ruth White.

Kirk Douglas is an American army officer recruited to train a revolutionary army for the budding state of Israel. A native American, and unsure of his Jewishness, he nevertheless agrees to help Israel fight for its independence. Frank Sinatra, an aviator in the Jewish fight for independence, dies in an unequal dogfight between his light observation plane and a real Arab fighter plane.

Based on the true story of Colonel David (Mickey) Marcus.

INTERESTING FACTS

- Between 1947 and 1948 about 3500 volunteers from outside countries fought for Israel. An estimated 1000 came from the United States and another 250 from Canada. Most of the English-speaking

volunteers had, like Marcus, fought in World War II and wanted to put that combat experience at the service of the emerging Jewish state.

- Ironically, Col. Marcus, although he was a Jew, died because he did not speak Hebrew and could not understand the challenge from an Israeli sentry.
- The movie is based on Ted Berkman's *Cast a Giant Shadow: The Story of Mickey Marcus, Who Died to Save Jerusalem* (New York: Doubleday, 1962).

MILITARY SERVICE

- Mickey Marcus graduated from West Point with the class of 1924. His name has been honored at a playground in Brooklyn, a rest home for Israeli army personnel in Haifa, a housing development in Tel Aviv, a kibbutz, a memorial library at the command school in Israel, a lodge of B'nai B'rith, a lodge of the Knights of Pythias, a post of the Jewish War Veterans, and a chapter of the Disabled American Veterans. Marcus took the would-be country's tough but loose-knit guerrilla raiders, the Palmach, and instilled in them a sense of discipline and chain of command. He reorganized the forces into effective, quick-moving units capable of striking first in sustained attacks to harass, confuse, and halt the Egyptian tanks in the Negev. He played a significant role in offensives against Jordanians holding Latrun, a gateway to Jerusalem. His is the only grave at West Point for an American killed fighting beneath the flag of another country.

CASTLE KEEP

Filmways Pictures, 1969, color, 105 minutes.

Producers: John Calley, Martin Ransohoff; **Director**: Sydney Pollack; **Screenwriters:** William Eastlake, David Rayfiel, Daniel Taradash; **Music:** Michel Legrand; **Distributor:** Columbia Pictures Corporation; **Cast:** Jean-Pierre Aumont, Harry Baird, Tony Bill, Marja Allanen Bisera, Karen Blanguernon, Caterina Boratto, Ernest Clark, Michael Conrad, Marie Danube, Elizabeth Darius, Bruce Dern, Peter Falk, Al Freeman Jr., Jean Gimelo, Astrid Heeren, David Jones, Burt Lancaster, Anne Marie Moskovenko, Patrick O'Neal, James Patterson, Elisabeth Tessier, Eya Tuli, Scott Wilson.

Burt Lancaster commands a small company of American GIs who occupy an ancient Belgian castle near the end of World War II. At first, with no enemy in sight, the soldiers enjoy the facilities and the women that the castle has to offer. Lancaster has an affair with the countess, encouraged by the count, who is impotent and wants to have a son. When an overwhelming number of Germans arrive, the company must decide whether to defend the castle, which will put its priceless art masterpieces at risk. They decide to fight and are wiped out.

The movie is based on William Eastlake's *Castle Keep* (New York: Simon and Schuster, 1965).

MILITARY SERVICE

- Burt Lancaster was drafted in 1942 and assigned to the 21st Special Services Unit of the Fifth Army, charged with directing and acting in shows. He put on the show *Stars and Gripes* in North Africa, Sicily, Italy, and Austria. Although he was promoted to tech sergeant, he ended the war as a private due to insubordination. While in Italy, he met and married entertainer Norma Anderson.

QUOTES

The Count: You find me degenerate—or worse even, French.

Burt Lancaster [looking at the Volkswagen at the castle]: Someday, they are going to be everywhere.

CASUALTIES OF WAR

Columbia Pictures Corporation, 1989, color, 120 minutes.

Producers: Fred C. Caruso, Art Linson; **Director:** Brian De Palma; **Screenwriters:** Daniel Lang, David Rabe; **Music:** Ennio Morricone; **Filmed at:** Kanchanaburi (railroad bridge, river scenes) and Phuket, Thailand, San Francisco, California; **Cast:** Ennalls Berl, Darren E Burrows, J. Chalerm, Kristopher Dunn, Dale Dye, Michael J. Fox, Donal Gibson, Scott Gregory, Jack Gwaltney, Don Harvey, Sherman Howard, Shane Kerwin, Erik King, Steve Larson, Ba Thuan T. Le, Thuy Thu Le, John Leguizamo, John Linton, Dan Martin, Holt McCallany, Sean Penn, Wendell Pierce, Po Powpi, John C. Reilly, Ving Rhames, Sam Robards, Vyto Ruginis, Hataya Sarmount, Al Shannon, Shaun Shea, Vinh Than, Kady Tran, Maris Valainis.

During the Vietnam war, a young girl is taken from her village by five American soldiers. Four of the soldiers rape her, but the fifth (Michael J. Fox) refuses to participate. The girl is killed, and Fox is determined that the guilty soldiers brought to justice.

- This film is based on a true story.

QUOTES

Erikson: Pardon me sir, what's your point, sir?
Hill: There ain't no point, Erikson. I'm simply trying to illuminate the terrain in which we currently find ourselves deployed. You don't mind that, do you? And if you do, fuck you! You on my frequency?
Erikson: Yes sir!

AWARDS

Golden Globes, USA, 1990
 Nominated: *Golden Globe, Best Original Score—Motion Picture,* Ennio Morricone
 Motion Picture Sound Editors, USA, 1990
 Nominated: *Golden Reel Award, Best Sound Editing in Feature Film,* Maurice Schell

Political Film Society, USA, 1990
 Won: *PFS Award, Peace.*

CATCH-22

Paramount Pictures, 1970, color, 121 minutes.

Producers: John Calley, Martin Ransohoff, Clive Reed; **Director:** Mike Nichols; **Screenwriters:** Joseph Heller, Buck Henry; **Music:** Richard Strauss; **Distributor:** Paramount Pictures; **Filmed at:** San Carlos, Sonora, Mexico; **Cast:** Alan Alda, Alan Arkin, Bob Balaban, Martin Balsam, Richard Benjamin, Susanne Benton, Peter Bonerz, John Brent, Olimpia Carlisi, Marcel Dalio, Wendy D'Olive, Liam Dunn, Norman Fell, Art Garfunkel, Jack Gilford, Charles Grodin, Buck Henry, Bruce Kirby, Jon Korkes, Richard Libertini, Evi Maltagliati, Bob Newhart, Felice Orlandi, Collin Wilcox Paxton, Austin Pendleton, Anthony Perkins, Paula Prentiss, Jack Riley, Philip Roth, Gina Rovere, Martin Sheen, Fernanda Vitobello, Jon Voight, Orson Welles, Elizabeth Wilson.

During World War II, there is "catch-22": If you are crazy, you don't have to fly any more bombing

Catch-22 (PARAMOUNT PICTURES/AUTHOR'S COLLECTION)

missions, but if you don't want to fly missions, you must be sane and therefore you can't be crazy. That's the catch. Alan Arkin is a bombardier who desperately wants to be declared insane so that he doesn't have to fly any more missions. However, because of catch-22, he'll never be able to be declared insane, and that's driving him really insane.

Bob Newhart, whose character's name is Major, is promoted to major because someone in the army thought it would be funny if he was Maj. Major.

The movie is based on Joseph Heller's *Catch-22* (New York: Simon & Schuster, 1961).

INTERESTING FACT

- George C. Scott turned down the role of Col. Cathcart, saying he had effectively played the same part in *DR. STRANGELOVE OR HOW I LEARNED TO STOP WORRYING AND LOVE THE BOMB* (1964).

QUOTE

Yossarian: Let me see if I've got this straight: In order to be grounded, I've got to be crazy and I must be crazy to keep flying. But if I ask to be grounded, that means I'm not crazy any more and I have to keep flying.

CAUGHT IN THE DRAFT

Paramount Pictures, 1941, b&w, 82 minutes.

Producer: Buddy G. DeSylva; **Director:** David Butler; **Screenwriters:** Wilkie C. Mahoney, Harry Tugend; **Music:** Frank Loesser, Victor Young; **Cast:** Murray Alper, Irving Bacon, Marie Blake, Ferike Boros, Eddie Bracken, June Bryde, Jack Chapin, Heinie Conklin, Victor Cutler, Edgar Dearing, Johnny Dodd, Ellen Drew, Ray Flynn, Edward Hearn, Earlene Heath, Leonard Henry, Weldon Heyburn, Bob Hope, Paul Hurst, Jerry Jerome, Phyllis Kennedy, Clarence Kolb, Dorothy Lamour, Arthur Loft, Jack Luden, Peter Lynn, Arch MacNair, Frank Marlowe, George McKay, Frank Mitchell, Frances Morris, Ella Neal, Frank O'Connor, David Oliver, Lynne Overman, Rita Owen, Edward Peil Jr., Phyllis Ruth, Edwin Stanley, Eleanor Stewart, Andrew Tombes, Archie Twitchell, Gloria Williams, Dave Willock.

Bob Hope is a movie star who can't stand loud noises, like artillery shells screaming into his position. To evade the draft, he decides to get married but falls for a colonel's daughter. In basic training, Hope wants to

make a good impression on the fair lady and her father, and he saves his buddies during maneuvers.

QUOTES

Don Bolton [ogling Toni]: Mmmm, that's a bundle! She looks like Dorothy Lamour with clothes on.

Bert: I went out with a girl once that told me to go jump in the lake. . . . When I got back, she was gone.

CHE!

20th Century-Fox, Richard Fleischer, Sy Bartlett, 1969, color, 96 minutes.

Producer: Sy Bartlett; **Director:** Richard Fleischer; **Screenwriters:** Sy Bartlett (also story), David Karp (story), Michael Wilson; **Music:** Lalo Schifrin; **Distributor:** 20th Century-Fox Film Corporation; **Cast:** Richard Angarola, Paul Bertoya, Adolph Caesar, Cesare Danova, Rudy Diaz, Robert Loggia, Perry Lopez, Barbara Luna, Linda Marsh, Ray Martel, Jack Palance, Albert Paulsen, Paul Picerni, Omar Sharif, Frank Silvera, Abraham Sofaer, Woody Strode, Tom Troupe, Sarita Vara.

Omar Sharif is revolutionary Che Guevara, depicted as the architect behind Castro's communist takeover of Cuba.

INTERESTING FACT

- Dr. Ernesto Che Guevara (1928–1967) was educated as a physician. He became a communist, rioted against dictator Juan Perón in Argentina, and fought with revolutionary movements in Bolivia and Guatemala. He became Castro's number two man, was part of the revolution against Batista, and then held posts in Castro's Cuban regime. His book *Guerrilla Warfare* became a standard text for revolutionists. He then went to Bolivia, where he was killed fighting government troops. His personal diary was subsequently sold to Castro.

CHETNIKS

20th Century-Fox, 1943, b&w, 73 minutes.

Producer: Sol M. Wurtzel; **Director:** Louis King; **Screenwriters:** Jack Andrews, Edward E. Paramore Jr.; **Music:** Hugo Friedhofer; **Cast:** Louis V. Arco, Felix Basch, Philip Dorn, Arno Frey, Virginia Gilmore,

Martin Kosleck, Frank Lackteen, LeRoy Mason, Patricia Prest, Merrill Rodin, Anna Sten, Shepperd Strudwick.

Philip Dorn is Gen. Mihalovitch, who fights the Nazis, ambushes an Italian supply column, and finally captures an entire town held by the enemy to rescue his wife and child who are being held hostage.

INTERESTING FACT

- General Draja Mihalovitch and his Serbian guerrillas, known as Chetniks, fought against the Nazis during World War II in Yugoslavia. Unfortunately, they fell out of favor with the Allies, who transferred their support to Marshal Tito and his partisans.

CHINA

Paramount Pictures, 1943, b&w, 79 minutes.

Producer: Richard Blumenthal; **Director:** John Farrow; **Screenwriters:** Frank Butler, Archibald Forbes; **Music:** Victor Young; **Cast:** Philip Ahn, William Bendix, Tala Birell, Chester Gan, Alan Ladd, Ching Wah Lee, Richard Loo, Marianne Quon, Jessie Tai Sing, Irene Tso, Barbara Jean Wong, Beal Wong, Bruce Wong, Iris Wong, Soo Yong, Loretta Young, Victor Sen Yung.

Shortly before Pearl Harbor, American opportunist Alan Ladd and his partner William Bendix go to China to sell oil to the invading Japanese army. However, after Ladd sees three Japanese soldiers brutally rape a young girl, he kills them and changes sides. Now he's a one-man killing machine, sending hordes of the sons of Nippon straight to their ancestors.

MILITARY SERVICE

- Alan Ladd was eager to join up during World War II and enlisted in the U.S. Army Air Force. However, his career was cut short during basic training by a double hernia, and he received an honorable discharge after serving just a couple of weeks.

QUOTES

Mr. Jones: I knew a girl like you once. She had an act in a circus. Used to crack a whip and make lions jump through paper hoops.
Carolyn Grant: And you prefer the lipstick sort, huh?
Mr. Jones: Yes, mostly because I don't like jumping through paper hoops.

CHINA DOLL

Batjac Productions, Romina Productions, 1958, b&w, 85 minutes.

Producers: Frank Borzage, Victor Mature, Robert E. Morrison, John Wayne; **Director:** Frank Borzage; **Screenwriters:** Kitty Buhler, Thomas F. Kelly, James Benson Nablo; **Music:** "By" Dunham, Henry Vars; **Distributor:** United Artists; **Cast:** Tige Andrews, Tita Aragon, Don Red Barry, Gregg Barton, Ward Bond, Danny Chang, Elaine Curtis, Johnny Desmond, Li Li Hua, Bob Mathias, Victor Mature, Ann McCrea, Steve Mitchell, Barry O'Hara, Ann Paige, Ken Perry, Denver Pyle, Stuart Whitman.

In China, air force captain Victor Mature wakes up after a night of drinking to discover he has purchased the services of beautiful young Shu-Jen from her father. Disappointed by his drunken life-style, she leaves him, but he finds her and marries her in a traditional Chinese ceremony. They are happy until he returns from a supply-drop mission to find that she has been killed by Japanese bombers. He subsequently dies on a mission, and their young daughter is taken to the United States by his old service buddies.

INTERESTING FACT

- The combat sequences are mainly combat camera footage.

CHINA GATE

20th Century-Fox, 1957, b&w, 97 minutes.

Producer: Samuel Fuller; **Director:** Samuel Fuller; **Screenwriter:** Samuel Fuller; **Music:** Max Steiner, Victor Young, **Distributor:** 20th Century-Fox Film Corporation; **Cast:** Gene Barry, Paul Busch, Nat King Cole, Marcel Dalio, Angie Dickinson, Paul Dubov, George Givot, Sasha Hardin, James Hong, Walter Soo Hoo, William Soo Hoo, Warren Hsieh, Weaver Levy, Maurice Marsac, Gerald Milton, Neyle Morrow, Lee Van Cleef.

During the war in French Indochina, a group of French legionnaires travel through enemy territory to the Chinese border to blow up a secret communist arms depot. A Eurasian smuggler, Angie Dickinson, agrees to guide them in return for help in getting her son to America. The leader of the expedition, Gene Barry, had previously abandoned her when their boy was born with Asian features. Their love is rekindled on the mission, but she is killed when they blow up the ammo dump.

CHINA GIRL

20th Century-Fox, 1942, b&w, 95 minutes.

Producer: Ben Hecht; **Director:** Henry Hathaway; **Screenwriters:** Ben Hecht, Darryl F. Zanuck (as Melville Crossman) (story); **Music:** Hugo Friedhofer, Alfred Newman; **Cast:** Philip Ahn, Lynn Bari, Alan Baxter, Robert Blake, Paul Fung, Chester Gan, Allen Jung, Fred Kohler Jr., Myron McCormick, Victor McLaglen, Lal Chand Mehra, George Montgomery, Tom Neal, Ann Pennington, Sig Ruman, Gene Tierney, Kam Tong, Beal Wong, Bruce Wong.

During the Sino-Japanese War, newspaperman George Montgomery falls in love with a young Chinese woman who had gone to school in the United States. When she is killed by the Japanese in one of their brutal attacks against the Chinese civilian population, Montgomery joins the fight.

CHINA SKY

RKO Radio Pictures Inc., 1945, b&w, 78 minutes.

Producers: Maurice Geraghty, Jack J. Gross (executive); **Director:** Ray Enright; **Screenwriters:** Pearl S. Buck (novel), Joseph Hoffman, Brenda Weisberg; **Music:** Leigh Harline; **Cast:** Philip Ahn, Chin Kuang Chow, Ellen Drew, Benson Fong, Weaver Levy, Richard Loo, Ducky Louie, Kermit Maynard, Anthony Quinn, Randolph Scott, Carol Thurston, Layne Tom Jr. H. T. Tsiang, Ruth Warrick.

In a hill city of war-torn China, which is the headquarters of guerrilla leader Anthony Quinn against the ruthless Japanese invaders, the American mission hospital is run by two doctors, Randolph Scott and Ruth Warrick, who secretly loves Scott. When he returns from a fund-raising trip to the United States with a new wife, Ellen Drew, the two women are quickly at loggerheads.

The movie is based on Pearl S. Buck's *China Sky* (New York: Triangle Books, 1942).

CHINA'S LITTLE DEVILS

Monogram Pictures Corporation, 1945, b&w, 74 minutes.

Producer: Grant Withers; **Director:** Monta Bell; **Screenwriter:** Samuel Ornitz; **Music:** Dimitri Tiomkin; **Distributor:** Monogram Pictures Corporation; **Cast:** Philip Ahn, Harry Carey, Gloria Ann Chew, Jimmy Dodd, Hayward Soo Hoo, Paul Kelly, Ralph Lewis, "Ducky" Louie, H. T. Tsiang.

Harry Carey is a missionary whose Chinese orphans have become guerrilla fighters to resist the Japanese invaders during World War II. Working under the direction of Ducky Louie, a teenage orphan, they help rescue downed American fliers and fight the brutally inhuman Japanese war machine.

CHINA VENTURE

Columbia Pictures Corporation, 1953, b&w, 80 minutes.

Producer: Anson Bond; **Director:** Don Siegel; **Screenwriters:** Anson Bond, Richard Collins, George Worthing Yates; **Music:** Ross DiMaggio; **Cast:** Philip Ahn, James Anderson, Wong Artarne, Leon Askin, Jocelyn Brando, Leo Gordon, Dabbs Greer, Todd Karns, Richard Loo, Dayton Lummis, Alvy Moore, Edmond O'Brien, Rex Reason, Barry Sullivan, Guy Way, Frank Wilcox.

Marine captain Edmond O'Brien clashes with navy officer Barry Sullivan as they cross south China to capture a wounded Japanese admiral, Philip Ahn, who was shot down and is being held by Chinese guerrillas. They must fight both Japanese troops and the guerrillas to get their prisoner back for interrogation by the Allies.

CHUNUK BAIR

NFU Studios, Avalon Films, Daybreak Pictures, 1992, color, 106 minutes.

Producers: David Arnell, L. Grant Bradley; **Director:** Dale G. Bradley; **Screenwriters:** Grant Hinden Miller, Maurice Shadbolt; **Music:** Stephen Bell-Booth; **Filmed in:** New Zealand; **Cast:** Kim Andrews, Darryl Beattie, Tony Bertinshaw, Tim Bray, Jed Brophy, Chris Brougham, David Cole, Geoff Dolan, Crispin Field, John Fitzgerald, Norman Forsey, Richard Hanna, Jonathan Hendrey, Campbell Hey, Donald Holder, Stephen Hollins, Neil Holt, Peter Kaa, Murray Keane, Kevin Kelly, David Kettley, Andrew Laing, John Leigh, James MacLaurin, Tony Meinan, Danny Mulheron, Nigel Peacock, Damian Peters, Robert Powell, Des Ratima, Keith Richardson, Lewis Rowe, Des Stephens, Vlad Titov, Stewart Turner, Karl Urban, Stephen Ure, Kevin J. Wilson, John Wraight.

This is a World War I drama about faith, courage, and heroism amidst folly and betrayal at Gallipoli in 1915. New Zealand troops discover that British promises of support in the Gallipoli campaign are meaningless.

CIRCLE OF DECEPTION, A

20th Century-Fox, 1961, b&w, 100 minutes.

Producer: Tom Monohan; **Director:** Jack Lee; **Screenwriters:** Nigel Balchin, Robert Musil, Alec Waugh; **Cast:** Ronald Allen, Harry Andrews, Basil Beale, Maurice Belfer, Martin Boddey, Roland Brand, Jean Briant, A. J. Brown, Jacques Cey, Andre Charisse, Norman Coburn, Stephen Dartnell, John Dearth, Bradford Dillman, Tony Doonan, Frank Forsyth, Walter Gotell, Arthur Gross, Brian Hankins, Jean Harvey, Duncan Lamont, Richard Marner, George Mikell, Charles Lloyd Pack, Suzy Parker, Tony Quinn, Michael Ripper, Paul Rogers, Hennie Scott, John Serret, Michael Shaw, Richard Shaw, Robert Stephens, Meier Tzelniker, John Welsh, Theodore Wilhelm, Mickey Wood.

Bradford Dillman is an intelligence agent who goes into Germany on a dangerous mission during World War II but is captured and forced to reveal his mission.

COBRA MISSION

Fulvia Film, 1985, color, 90 minutes.

Producer: Fabrizio De Angelis; **Director:** Fabrizio De Angelis; **Screenwriters:** Gianfranco Clerici, Fabrizio De Angelis, Vincenzo Mannino; **Music:** Francesco De Masi; **Distributor:** Entertainment in Video; **Cast:** Manfred Berman, Enzo G. Castellari, Christopher Connelly, Ennio Girolami, Gordon Mitchell, Luciano Pigozzi, Donald Pleasence, John Steiner, Oliver Tobias, John Ethan Wayne.

Ethan Wayne is a Vietnam vet, 10 years after the end of the war, who meets up with two of his old war buddies. They decide to go back to Vietnam to free all the POWs still left there. They pick up another buddy from a mental institution, grab a load of guns and ammo, and head off to Vietnam.

The plotline is virtually identical to *UNCOMMON VALOR*, *MISSING IN ACTION*, and *RAMBO: FIRST BLOOD PART 2*.

INTERESTING FACT

- This film features John Ethan Wayne, the son of John Wayne.

COCKLESHELL HEROES, THE

Columbia Pictures Corporation, 1955, color, 110 minutes.

Producers: Irving Allen, Irwin Allen, Albert R. Broccoli, Phil C. Samuel; **Director:** José Ferrer; **Screenwriters:** Bryan Forbes, George Kent, Richard Maibaum; **Distributor:** Columbia Pictures Corporation; **Filmed in:** Portugal; **Cast:** Peter Arne, Jacques B. Brunius, Dora Bryan, Beatrice Campbell, Robert Desmond, Patric Doonan, John Fabian, José Ferrer, William Fitzgerald, Judith Furse, Gladys Henson, Percy Herbert, Trevor Howard, Christopher Lee, David Lodge, Victor Maddern, Andreas Malandrinos, Anthony Newley, Karel Stepanek, Graham Stewart, Sidney Tafler, John Van Eyssen, Yana.

José Ferrer leads a group of 10 Royal Marines on a maritime raid on Vichy France during World War II. First, the marines are taken by submarine to the mouth of the Gironde River, after which they journey upriver for three days by kayak to attack the unassailable port of Bordeaux. They attach limpet mines on five blockade runners, causing major devastation.

INTERESTING FACTS

- Apparently, the word *cockleshell* must be English slang for kayak, because the film centers almost completely on the kayak training and journey, and the film is not called "Kayak Heroes."
- The ending is puzzling, because some of the marines, who are taken prisoner by the Germans while wearing their English uniforms, are nevertheless shot as if they had been taken as spies.
- The screenwriters based the story on a real mission carried out by the Royal Marine Boom Patrol, forerunners of the Royal Marine Commandos Special Boat Mission, one of the most elite British military units.

 The movie is based on these books: Sparks, William (Munn, Michael), *The Last of The Cockleshell Heroes* (Glasgow: Blackie, 1971), and Phillips, C. E. Lucas, *Cockleshell Heroes* (London: Heinemann, 1957).

CODE NAME: WILD GEESE

Gico Cinematografica S.r.l., Ascot Film Berlin, 1984, color, 101 minutes.

Producer: Erwin C. Dietrich; **Director:** Antonio Margheriti; **Screenwriters:** Tito Carpi, Gianfranco Couyoumdjian, Michael Lester; **Music:** Ennio Morricone, Jan Nemec; **Distributor:** Starmaker Video; **Filmed at:** Pagsanjan, Luzon, Philippines, Hong Kong, China; **Cast:** Ernest Borgnine, Lewis Collins, Thomas

Danneberg, Mimsy Farmer, Frank Glaubrecht, Klaus Kinski, Manfred Lehmann, Hartmut Neugebauer, Wolfgang Pampel, Luciano Pigozzi, Lee Van Cleef.

The second sequel to the film THE WILD GEESE, this story focuses on the further adventures of this band of mercenaries as they work for the highest bidder.

COLDITZ STORY, THE

British Lion Film Corporation, 1955, b&w, 94 minutes.

Producer: Ivan Foxwell; **Director:** Guy Hamilton; **Screenwriters:** Ivan Foxwell, Guy Hamilton, William Douglas Home, P. R. Reid; **Distributor:** Republic Pictures Corp.; **Filmed at:** Colditz, Saxony, Germany; **Cast:** Douglas Argent, Jean Bacon, Leo Bieber, Theodore Bikel, A. Blichewicz, Terence Brook, Arthur Butcher, Ian Carmichael, Frank Coburn, Eric Corrie, John Corrie, Eugene Deckers, Guy Deghy, Anton Diffring, B. Dolinski, Jean Driant, Carl Dverny, Anthony Faramus, Bryan Forbes, John G. Heller, Lionel Jeffries, Eric Lander, Ludwik Lawinski, Guido Lorraine, Kenneth Midwood, John Mills, Peter Myers, Rudolph Offenbach, Eric Portman, Keith Pyott, Zygmunt Rewkowski, Christopher Rhodes, Claude Le Saché, Frederick Schiller, Denis Shaw, Witold Sikorski, Peter Swanwick, Frederick Valk, Richard Wattis, David Yates.

Colditz Castle in Saxony was used by the Nazis to hold incorrigible prisoners, those who regularly tried to escape from other camps. At all times the guards outnumbered the prisoners and, because some political prisoners were also held there, they were very strictly monitored. But if you put all those POWs into one place and they're all trying to escape, hilarity will ensue.

INTERESTING FACT

- This was one of the first war movies to play POW life for laughs, after the success of STALAG 17 two years earlier. In 1971 British TV tried to make *The Colditz Story* into a sitcom, to lukewarm results, unlike the successful *Stalag 17* TV spin-off, *Hogan's Heroes.*

 The film is based on P. R. Reid's *The Colditz Story* (Philadelphia:Lippincott, 1953).

COMBAT SHOCK

Troma Films, 1986, color, 92 minutes.

Producers: Carmine Giovinazzo, Michael Herz, Lloyd Kaufman; **Director:** Buddy Giovinazzo;

Screenwriter: Buddy Giovinazzo; **Music:** Rick Giovinazzo; **Distributors:** Prism Pictures, Troma; **Filmed at:** Port Richmond, Staten Island, New York; **Cast:** Martin Blank, Ginny Cattano, Jim Cooney, Mary Cristadoro, Tom Desantis, Tom Devito, Colette Geraci, Carmine Giovinazzo, Rick Giovinazzo, Claire Harnedy, Doo Kim, Lori Labar, Yan Lai, Asaph Livni, Joe Loach, Don Loftin, Leo Lunney, Mitch Maglio, Jeff Mathes, Jimmy May, Barry McBride, Dean Mercil, Bob Mireau, Howie Murphy, Nick Nasta, Ed Pepitone, Vincent Petrizzo, Ray Pinero, Janet Ramage, Arthur Saunders, Veronica Stork, Melissa Tait, Stacey Tait, Brendan Tesoriero, Michael Tierno, Leif Vetland, Nancy Zawada.

Ricky Giorinazzo is a veteran who is haunted by his part in a massacre when he was in Vietnam. His day-to-day existence back in the United States doesn't help him forget: He has no money, his wife is a nag, his friends are junkies, and he has a deformed baby.

COMBAT SQUAD

Columbia Pictures Corporation, 1953, b&w, 72 minutes.

Producer: Jerry Thomas; **Director:** Cy Roth; **Screenwriter:** Wyott Ordung; **Music:** Paul Dunlap; **Cast:** Tristram Coffin, Linda Danson, Robert Easton, Dick Fortune, Neva Gilbert, Don Haggerty, Myron Healey, David Holt, Eileen Howe, John Ireland, Paul Keast, Norman Leavitt, Hal March, Lon McCallister, Bob Peoples, George E. Stone.

During the Korean War, John Ireland, a hard-bitten sergeant, leads a platoon that includes Lon McCallister, whom he takes under his wing until he overcomes his fear, and George E. Stone, a medic fighting his third war.

COMING HOME

United Artists, 1978, color, 127 minutes.

Producers: Bruce Gilbert, Jerome Hellman; **Director:** Hal Ashby; **Screenwriters:** Nancy Dowd, Robert C. Jones, Waldo Salt, Rudy Wurlitzer; **Distributor:** United Artists; **Cast:** Jonathan Banks, Raul Bayardo, Tim Bell, Kimberly Binion, Louis Carello, Robert Carradine, Beeson Carroll, David Clennon, Olivia Cole, Pat Corley, Charles Cyphers, Gary Lee Davis, Bruce Dern, Gary Downey, Joey Faustine, Jane Fonda, Sally Frei, Bruce French, Robert

Ginty, Mary Gregory, Tresa Hughes, Mary Jackson, James E. Kindelon, Jim Klein, Ed Lang, Richard Lawson, Marc McClure, Penelope Milford, Kathleen Miller, Bill Nale, Bob Ott, Stacey Pickren, Kirk Raymond, James Richardson, George Roberts, Arthur Rosenberg, Dennis Rucker, Tony Santoro, Jan Michael Shultz, Rita Taggart, Danny Tucker, Willie Tyler, Marc Vahanian, Gwen Van Dam, Jon Voight, Claudie Watson, Ned Van Zandt.

Jane Fonda's husband, Bruce Dern, is a marine captain away in Vietnam. She goes to work as a volunteer nurse in a veterans hospital where she meets an old friend from high school, Jon Voight, who has returned from Vietnam a paraplegic and who chains his wheelchair to a fence as a protest against the war. As love between Fonda and Voight grows, she becomes a liberated woman and discovers orgasm. When her husband returns, also an embittered and disillusioned veteran, he ultimately walks into the ocean and commits suicide.

The film is based on a story by Nancy Dowd.

INTERESTING FACT

- Jane Fonda had a body double for her sex scene with Jon Voight.

QUOTE

Jon Voight: And now I'm here to tell you that I have killed for my country, or whatever, and I don't feel good about it 'cause there's not enough reason, man, to feel a person die in your hands or to see your best buddy get blown away. I'm here to tell you it's a lousy thing, man, I don't see any reason for it. And there's a lot of shit that I did over there that I find fucking hard to live with. And I don't want to see people like you, man, coming back and having to face the rest of your lives with that kind of shit. It's as simple as that. I don't feel sorry for myself. I'm a lot fucking smarter now than when I went. And I'm just telling you there's a choice to be made here.

AWARDS

Academy Awards, USA, 1978
Won: *Oscar, Best Actor,* Jon Voight; *Best Actress,* Jane Fonda; *Best Writing, Screenplay Written Directly for the Screen,* Nancy Dowd, Robert C. Jones, Waldo Salt
Nominated: *Oscar, Best Director,* Hal Ashby; *Best Film Editing,* Don Zimmerman; *Best Picture,* Jerome Hellman; *Best Supporting Actor,* Bruce Dern; *Best Supporting Actress,* Penelope Milford

Cannes Film Festival, 1978
Won: *Best Actor,* Jon Voight
Nominated: *Golden Palm,* Hal Ashby

Golden Globes, USA, 1979
Won: *Golden Globe, Best Motion Picture Actor—Drama,* Jon Voight; *Best Motion Picture Actress—Drama,* Jane Fonda
Nominated: *Golden Globe, Best Director—Motion Picture,* Hal Ashby; *Best Motion Picture—Drama; Best Motion Picture Actor in a Supporting Role,* Bruce Dern; *Best Screenplay—Motion Picture,* Robert C. Jones, Waldo Salt

Los Angeles Film Critics Association Awards, 1978
Won: *LAFCA Award, Best Actor,* Jon Voight; *Best Actress,* Jane Fonda, also for her performances in *Comes a Horseman* (1978) and *California Suite* (1978)

Best Picture, National Board of Review, USA, 1978
Won: *NBR Award, Best Actor,* Jon Voight, tied with Laurence Olivier for *The Boys from Brazil* (1978)

New York Film Critics Circle Awards, 1978
Won: *NYFCC Award, Best Actor,* Jon Voight

Writers Guild of America, USA, 1979
Won: *WGA Screen Award, Best Drama Written Directly for the Screen,* Robert C. Jones, Waldo Salt.

COMMAND DECISION

Metro-Goldwyn-Mayer, 1948, b&w, 112 minutes.

Producers: Sidney Franklin, Gottfried Reinhardt; **Director:** Sam Wood; **Screenwriters:** George Froeschel, William Wister Haines, William R. Laidlaw; **Music:** Miklós Rózsa; **Cast:** Warner Anderson, Edward Arnold, Gregg Barton, Charles Bickford, Ray Collins, Bruce Cowling, Brian Donlevy, Edward Earle, Sam Flint, Clark Gable, Don Haggerty, Henry Hall, Alvin Hammer, Holmes Herbert, John Hodiak, John James, Van Johnson, Marten Lamont, William Leicester, Peter Martin, John McIntire, James Millican, Cameron Mitchell, Barry Nelson, George Offerman, Moroni Olsen, William "Bill" Phillips, Walter Pidgeon, Richard Quine, John Ridgely, Michael Steele, Clinton Sundberg, Marshall Thompson, Mack Williams.

Clark Gable, a U.S. Army Air Force general in England during World War II, must order his planes deeper and deeper into Germany on daylight bombing raids to

prevent the production of German military jet planes. The high losses that result from the daylight precision bombing enrage both congressmen worried about the high losses among their constituents and his own chain of command. Meanwhile, the deaths of so many young men wear him down psychologically.

INTERESTING FACTS

- The Germans, always ahead of the power curve technologically during World War II, had developed an operational jet fighter prior to the end of the war. This was one of the "super weapons" that Hitler thought would save Germany at the final hour from destruction. As depicted in the film, the jet fighter wreaked havoc with both Allied fighters and bombers wherever it was utilized in the skies over Germany. However, because of production problems, and because it was developed so late in the war, the Nazis were never able to field the aircraft in sufficient numbers to affect the outcome of the war.
- The value of daylight precision bombing is that bombers at a high altitude at night will take fewer losses; however, bombing accuracy is low. Bombing from a low altitude in daylight, missions will be more accurate and greater damage will be inflicted. To inflict the same damage, more nighttime raids have to be flown than daylight raids. The two strategies were each employed during the war, and the relative effectiveness of these raids is still debated today.
- Clark Gable's role is mirrored by Gregory Peck in the film TWELVE O'CLOCK HIGH, which centers on the same issues that surrounded the air war over Germany during World War II.
- The film is based on a stage play by William Wister Haines.

MILITARY SERVICE

- Clark Gable enlisted in World War II after the death of his wife, Carole Lombard, in a plane crash during a war bond drive. The last words he received from his wife were in a telegram that read, "Hey Pappy, you'd better get in this man's army." He graduated from officer candidate school in the U.S. Army Air Force and flew five combat bombing missions over Germany, for which he received the Distinguished Flying Cross and the Air Medal. German Field Marshal Goering offered a $5000 bounty and immediate promotion to the pilot who shot down Gable. He was discharged at the end of the war with the rank of major.

COMMANDOS

CCC Filmkunst GmbH, G.G.I. SpA Rome, PIC, 1968, color, 82 minutes.

Producers: Artur Brauner, Alfonso Sansone; **Director:** Armando Crispino; **Screenwriters:** Dario Argento, Lucio Battistrada, Artur Brauner, Armando Crispino, Menahem Golan, Don Martin, Stefano Strucchi; **Music:** Mario Nascimbene; **Cast:** Giampiero Albertini, Pier Luigi Anchisi, Akim Berg, Gianni Brezza, Pier Paolo Capponi, Franco Cobianchi, Duilio Del Prete, Mario Feriazzo, Joachim Fuchsberger, Götz George, Jack Kelly, Mauro Lumachi, Emilio Marchesini, Marino Masé, Biagio Pelligra, Lorenzo Piani, Giacomo Piperno, Gianni Pulone, Romano Puppo, Heinz Reincke, Helmut Schmid, Giovanni Scratuglia, Ivano Staccioli, Otto Stern, Lee Van Cleef, Marilú Toló.

A group of Italian Americans are disguised as Italian soldiers in order to infiltrate a camp in North Africa. The commandos knife the Italian soldiers in their beds and then must hold the camp and its weapons until they are relieved by an American battalion.

INTERESTING FACT

- The original idea of an elite group of highly skilled fighters was first advanced in the British Army in 1938 by Maj. Holland and such a group was officially established on June 8, 1940. The name "commando" was taken from the Boer farmers of South Africa who had fought the British in the Boer War at the turn of the 20th century.

COMMANDOS STRIKE AT DAWN, THE

Columbia Pictures Corporation, 1943, b&w, 98 minutes.

Producer: Lester Cowan; **Director:** John Farrow; **Screenwriters:** C. S. Forester (story), Irwin Shaw; **Music:** Louis Gruenberg, John Leipold, Morris Stoloff; **Filmed at**: Heals Rifle Range, Saanich Peninsula, British Columbia, Canada (German base), Patricia Bay Aerodrome, Sidney, British Columbia, Canada (Allied airfield), Saanich Inlet, British Columbia, Canada (Norwegian fjord), Vancouver Island, British Columbia, Canada; **Cast:** Erville Alderson, Lloyd Bridges, Rod Cameron, Ann Carter, Ray Collins, Robert Coote, Rosemary De Camp, Richard Derr, Barbara Everest, Elisabeth Fraser, Lillian Gish, Cedric Hardwicke, Louis Jean Heydt, Elsa Janssen, Alexander Knox, Anna Lee, George Macready, Arthur Margetson, Paul Muni,

Ferdinand Munier, Walter Sande, John Arthur Stockton, Philip Van Zandt.

Paul Muni is a fishery observer who leads a quiet life in a small Norwegian town. But the abuses of the Nazi occupation lead Muni to form a resistance group from among his peaceful neighbors. When he discovers a secret German air base, he flees to England and returns to destroy it with a British commando raid.

AWARD

Academy Awards, USA, 1943
> **Nominated:** *Oscar, Best Music—Scoring of a Dramatic or Comedy Picture*, Louis Gruenberg, Morris Stoloff.

COMRADES IN ARMS

Cinema Sciences Corporation, 1991, color, 91 minutes.

Producers: Marc L. Bailin, J. Christian Ingvordsen, Steven Kaman, John Weiner; **Director:** J. Christian Ingvordsen; **Screenwriters:** J. Christian Ingvordsen, Steven Kaman, John Weiner; **Music:** Paul Avgerinos; **Distributor:** Republic Pictures Home Video; **Filmed at:** Ontario, Canada; **Cast:** Lyle Alzado, John Christian, Lorna Courtney, Parker Gentry, Lance Henriksen, Steven Kaman, Rick Washburn, John Weiner.

When a ruthless international drug cartel threatens to impose a new world order of its own, no-nonsense CIA chief Lance Henriksen calls an emergency summit with his KGB counterpart. The cold war is over, and Russia and America can join forces. As the cartel's terrorist army continues its march across international borders, it's up to Green Beret Rick Washburn to forge the Red Army Spetnatz commandos and the elite U.S. Delta Force into a fighting machine.

CONFESSIONS OF A NAZI SPY

First National Pictures Inc., 1942, b&w, 110 minutes.

Director: Anatole Litvak; **Screenwriters:** Leon G. Turrou (articles), Milton Krims, and John Wexley; **Distributor:** Warner Bros.; **Cast:** Louis Adlon, Rudolph Anders, Lotte Palfi Astor, Egon Brecher, Wilhelm von Brincken, Tommy Bupp, Frederick Burton, Alec Craig, John Deering, Lisa Golm, Creighton Hale, John Hamilton, Stuart Holmes, Selmer Jackson, Willy Kaufman, Edward Keane, Robert Emmett Keane, Martin Kosleck, Francis Lederer, Paul Lukas, Lya Lys, Eily Malyon, Frank Mayo, Lon McCallister, Walter Miller,

Jack Mower, Henry O'Neill, George Offerman, Lucien Prival, Hedwiga Reicher, John Ridgely, Edward G. Robinson, George Rosener, Bodil Rosing, Lionel Royce, Sig Ruman, George Sanders, Joe Sawyer, Charles Sherlock, Grace Stafford, James Stephenson, Frederic Tozere, Dorothy Tree, Charles Trowbridge, Hans Heinrich von Twardowski, Henry Victor, Emmett Vogan, Frederick Vogeding, Niccolai Yoshkin, Wolfgang Zilzer.

Edward G. Robinson is a G-man who investigates a huge Nazi spy ring in the United States and brings the spies to justice.

INTERESTING FACTS

- Hitler reportedly planned to execute the makers of this film upon winning the war.
- The movie is based on a series of articles by Leon Turrou, a former FBI agent who used materials from the spy trials of 1937 in which four spies were convicted.

QUOTE

Prosecutor: There are those who will say we have nothing to fear, that we are immune, that we are protected by vast oceans from the bacteria of aggressive dictatorships and totalitarian states. But we know and have seen the mirror of history in Europe this last year, the invasions of Poland, Norway, and Denmark by Nazi Germany and Russia. America is not simply one of the remaining democracies. America is democracy!

AWARD

National Board of Review, USA, 1939
> **Won:** *NBR Award, Best Picture—English Language.*

CONFIRM OR DENY

20th Century-Fox, 1941, b&w, 74 minutes.

Producer: Len Hammond; **Director(s):** Fritz Lang, Archie Mayo; **Screenwriters:** Samuel Fuller, Jo Swerling, Henry Wales; **Cast:** Claud Allister, Don Ameche, Joan Bennett, Billy Bevan, Eric Blore, Leonard Carey, Lumsden Hare, Dennis Hoey, Queenie Leonard, John Loder, Roddy McDowall, Roseanne Murray, Jean Prescott, Helene Reynolds, Stuart Robertson, Arthur Shields, Raymond Walburn.

Newspaperman Don Ameche, who has fallen in love with a beautiful English teletype operator during the London blitz, obtains secret information about Hitler's

invasion plans for England. He must decide whether to release his scoop, which will greatly displease the British, or to withhold the information.

INTERESTING FACT

- The blitz, a massive bombing campaign of the civilian population of London, was part of Hitler's plan to terrorize and subjugate England during World War II. He believed that the English people would surrender rather than suffer the destruction of their beloved London. Despite major devastation and a large number of casualties, the British never gave up hope, or even for a moment considered surrendering to the Nazis.

CONVOY

Ealing Studios, 1940, b&w, 90 minutes.

Producers: Michael Balcon, Sergei Nolbandov; **Director:** Pen Tennyson; **Screenwriters:** Patrick Kirwan, Pen Tennyson; **Music:** Ernest Irving; **Cast:** George Benson, John Boxer, Clive Brook, Judy Campbell, George Carney, John Carol, Edward Chapman, John Clements, Alec Clunes, Anton Diffring, Penelope Dudley-Ward, Derek Elphinstone, Charles Farrell, John Glyn-Jones, Stewart Granger, David Hutcheson, Allan Jeayes, Mervyn Johns, John Laurie, Edward Lexy, Albert Lieven, Al Millen, Nancy O'Neil, Hay Petrie, Edward Rigby, Harold Warrender, John Wengraf, Michael Wilding, Charles Williams.

Lieutenant Cranford lives the life of a playboy sportsman until the outbreak of World War II, when he joins the Royal Navy and is assigned to convoy duty. A German battleship targets his convoy, and a deadly game of cat and mouse ensues.

INTERESTING FACT

- The convoy was a part of the vital supply chain necessary for Britain to fight off the Nazi threat. Realizing that lone merchant marine ships were being picked off by submarines and pocket battleships at an alarming rate, the Allies developed the convoy system. Navy destroyers and merchant marine ships were combined into large flotillas, which were much more able to fight off enemy attacks at sea than single merchant ships. With complex signal systems, combined training, and by the development of effective tactics, the rate of loss of merchant tonnage due to enemy action was

greatly reduced by the convoy system. Although not considered glamorous duty by the active-duty navy, who were more interested in fighting the "navy war" in the Pacific, it was undoubtedly critical to the success of the Allied effort in the North Atlantic and European theater of operations.

MILITARY SERVICE

- Writer/director Pen Tennyson was in the RNVR (Royal Navy Volunteer Reserve) and was granted an exemption from service while he made this film. To gain some experience of convoy life, he served on HMS *Valorous* on convoy duty.

CORNERED

RKO Radio Pictures Inc., 1945, b&w, 102 minutes.

Producer: Adrian Scott; **Director:** Edward Dmytryk; **Screenwriters:** Ben Hecht, John Paxton, John Wexley; **Music:** Roy Webb; **Distributor:** RKO Pictures; **Cast:** Luther Adler, Carlos Barbe, Edgar Barrier, Paul Bradley, Egon Brecher, Beverly Bushe, Morris Carnovsky, Tanis Chandler, Micheline Cheirel, Martin Cichy, Richard Clarke, Ellen Corby, Jerry De Castro, Gloria De Guarda, Carl De Lora, Jean Del Val, Rod De Medici, Leslie Denison, Igor Dolgoruki, Joaquin Elizondo, Byron Foulger, Gregory Gaye, Steven Geray, Warren Jackson, Cy Kendall, Jack La Rue, Nelson Leigh, Jacques Lory, Michael Mark, Kenneth McDonald, Louis Mercier, Frank Mills, Belle Mitchell, Hans Moebus, Al Murphy, Nestor Paiva, Dick Powell, Stanley Price, Hugh Prosser, Georges Renavent, Walter Slezak, Nina Vale, Milton Wallace, Al Walton.

After being demobilized at the end of Word War II, a Canadian flyer returns to France to discover who ordered the killing of his new wife, along with a group of French Resistance fighters. He learns that the man responsible was a Vichy collaborator, who has tried to cover his escape by having himself declared dead. Uncovering the deception, he follows the trail of the Nazi to Argentina.

CORREGIDOR

Atlantis Pictures Corp., 1943, b&w, 73 minutes.

Producers: Edward Finney, Dixon R. Harwin, Peter R. Van Duinen; **Director:** William Nigh; **Screenwriters:** Doris Malloy, Alfred Noyes, Edgar G. Ulmer; **Music:** Leo Erdody; **Distributor:** Producers Releasing Corporation; **Cast:** Ted Adams, Ruby Dandridge, John

Grant, Frank Hagney, Eddie Hall, Gordon Hayes, Ted Hecht, Frank Jaquet, Frank Jenks, I. Stanford Jolley, Charles Jordan, Ian Keith, Otto Kruger, Elissa Landi, Wanda McKay, Jack Rutherford, Forrest Taylor, Rick Vallin, Jimmy Vilan, Donald Woods.

The heroic stand of the outnumbered American defenders against hopeless odds, as the Japanese attempt to take Corregidor, is the background of a love triangle between doctors Otto Kruger and Donald Woods as they compete for the affections of lovely Elissa Landi.

INTERESTING FACT

- Corregidor is a natural fortress island in Manila Bay, in the Philippines, that the U.S. Army converted into a military base following the acquisition of the islands after the Spanish-American War in 1898. After the fall of Bataan in 1942, this island became the symbol of resistance to the Japanese in the Far East. After 27 days, led by Lt. Gen. Jonathan Wainwright and under constant bombardment from air, land, and sea by Japanese forces, the island finally was forced to surrender on May 6, 1942. It remained in Japanese hands until the liberation of the Philippines in 1945.

CORVETTE K-225

Universal Pictures, 1943, b&w, 98 minutes.

Producer: Howard Hawks; **Director:** Richard Rosson; **Screenwriter:** John Rhodes Sturdy; **Music:** David Buttolph; **Filmed at:** University of King's College, Halifax, Nova Scotia, Canada; **Cast:** Murray Alper, Noah Beery Jr., James Brown, David Bruce, Andy Devine, John Diggs, Frank Faylen, Barry Fitzgerald, James Flavin, John Frederick, Thomas Gomez, Holmes Herbert, Fuzzy Knight, Richard Lane, Peter Lawford, Edmund MacDonald, Lester Matthews, Charles McGraw, Robert Mitchum, Gene O'Donnell, Oscar O'Shea, Ella Raines, Addison Richards, Walter Sande, Randolph Scott, Milburn Stone, Matt Willis, Ian Wolfe.

In 1943, Randolph Scott of the Canadian navy loses many of his men to a German torpedo that sinks his ship. While waiting for a new command, he falls in love with the sister of one of his dead officers. After the launching of the *Donnacola*, Scott takes command. The new crew includes his new girlfriend's younger brother, fresh out of the academy. They must now survive the hazardous run from Halifax to England, under attack from both the air and under the sea.

INTERESTING FACT

- The corvette was a British-Canadian warship used chiefly to support convoys to England during World War II and to protect the convoys from enemy submarines and aircraft. Their hull design was based on whaling ships, which could withstand the huge, pounding waves of the North Atlantic. Their armament included one large four-inch gun, anti-aircraft guns, and depth charges, as well as detection equipment such as sonar and radar.

QUOTE

Narrator [speaking of the ship]: She will carry on, and those who come after her, for her name is legion; and the legend of her and those who fight in her is an inspiration for all men who believe in courage and hope.

COUNTER-ATTACK

Columbia Pictures Corporation, 1945, b&w, 90 minutes.

Producer: Zoltan Korda; **Director:** Zoltan Korda; **Screenwriters:** John Howard Lawson, Mikhail Ruderman, Janet Stevenson, Philip Stevenson, Ilya Vershinin; **Music:** Louis Gruenberg; **Cast:** Louis Adlon, Rudolph Anders, Trevor Bardette, Roman Bohnen, Marguerite Chapman, Virginia Christine, Frank Darien, Ludwig Donath, Frederick Giermann, Richard Hale, George Macready, Harro Meller, Paul Muni, Larry Parks, Erik Rolf, Ivan Triesault, Philip Van Zandt, Matt Willis, Ian Wolfe, Wolfgang Zilzer.

Paul Muni is a Russian soldier trapped by an explosion in an underground room with a group of Nazi soldiers during World War II. With the help of Marguerite Chapman, also a Russian, who helps him hold the Germans prisoner, Muni engages in a battle of wits as he attempts to get from his enemies vital strategic information. First, he tricks them into revealing which of them is their officer. As the film unfolds, he works on their arrogance, using it against them to obtain the critical intelligence that he needs.

COUNTERPOINT

Universal Pictures, 1968, color, 107 minutes.

Producer: Richard Berg; **Director:** Ralph Nelson; **Screenwriters:** James Lee, Joel Oliansky, Alan Sillitoe; **Music:** Johannes Brahms, Bronislau Kaper, Franz

Schubert, Pyotr Ilyich Tchaikovsky, Ludwig van Beethoven; **Distributor:** Universal Pictures; **Cast:** Parley Baer, Linden Chiles, Cyril Delevanti, Anton Diffring, Dan Frazer, Mischa Hausserman, Kathryn Hays, Charlton Heston, Curt Lowens, Peter Masterson, Gregory Morton, Ralph Nelson, Leslie Nielsen, Neva Patterson, Ed Peck, Maximilian Schell.

Charlton Heston is an American symphony conductor who, along with his orchestra, is captured by the Germans during the Battle of the Bulge. The German commander (Maximilian Schell) is an admirer of Heston's work and wants to hear the orchestra play, but he is also under strict orders to kill all prisoners. Heston suspects the truth and does everything he can to delay the performance of his orchestra, afraid that it will be their last. At the last moment, they are rescued by a partisan attack.

The film is based on Alan Sillitoe's *The General* (London: W. H. Allen, 1960).

INTERESTING FACT

- In general, the Germans were well respected for their treatment of American POWs, who suffered only a 3 percent fatality rate at their hands during World War II, as compared with the Japanese treatment of prisoners, in which two of every three soldiers taken prisoner failed to survive the war due to brutal Japanese treatment. However, one of the great exceptions to the German record occurred during the Battle of the Bulge, when a group of American soldiers taken prisoner in the German counteroffensive were executed at a town called Malmedy, in Belgium, which is just north of Bastogne. This real-life massacre gives credence to the order to kill all prisoners, under which Maximilian Schell is operating during this film, which also takes place during the Battle of the Bulge.

COUNT FIVE AND DIE

Zonic Productions, 1958, b&w, 92 minutes.

Producer: Ernest Gartside; **Director:** Victor Vicas; **Screenwriters:** David Pursall, Jack Seddon; **Music:** John Wooldridge; **Distributor:** 20th Century-Fox Film Corporation; **Filmed at:** London, England; **Cast:** Philip Bond, Larry Burns, Otto Diamant, Annemarie Düringer, Wolf Frees, Arthur Gross, Jeffrey Hunter, Claude Kingston, David Kossoff, Rolf Lefebvre, Anthony Ostrer, Nigel Patrick, Peter Prouse, Robert Raglan, Philip Ray, Beth Rogan, Marianne Walla.

Jeffrey Hunter is an American undercover agent who works with the British to convince the Germans that the Allied invasion of Europe will be in Holland, not in Normandy.

COURAGE UNDER FIRE

Fox 2000 Pictures, 1996, color, 117 minutes.

Producers: Joseph M. Caracciolo, Debra Martin Chase, John Davis, David T. Friendly, Paul Neesan, Joseph Singer; **Director:** Edward Zwick; **Screenwriter:** Patrick Sheane Duncan; **Music:** James Horner; **Distributors:** 20th Century Fox Film Corporation, Cine Company, Filmes Castello Lopes; **Filmed at:** San Marcos, Texas, Fort Irwin, near Barstow, California, Bloomfield, Connecticut, southwest grounds of the Texas state capitol in Austin, Bastrop, El Paso, and Bertram, Texas (train/car head-on crash), and Barstow, Mojave Desert, California; **Cast:** Mark Adair-Rios, Robert Apisa, Peter Arnett, Sean Astin, Rory J. Aylward, Diane Baker, Julius Carter, Matt Damon, Armand Darrius, Michael Dolan, Reed Frerichs, Seth Gilliam, Scott Glenn, Daniel Gonzalez, Tim Guinee, Albert Hall, Amy Hathaway, Zeljko Ivanek, Ken Jenkins, Larry King, Lucky Luciano, Jamal A. Mays, James Ry McGee, Bruce McGill, David McSwain, Kyle Mickaelian, Michael Moriarty, James Paul Morse, Erica C. Newman, Manny Perez, Lou Diamond Phillips, Jimmy Ray Pickens, Bronson Pinchot, Ashlee Jordan Pryor, Tim Ransom, John Roarke, Meg Ryan, Tom Schanley, Matt Sigloch, Christina Stojanovich, Regina Taylor, Sean Patrick Thomas, Ned Vaughn, Richard Venture, Jeffrey Waid, Denzel Washington, Jack Watkins, Michole White, Kathleen Widdoes, Patrick Young.

During Desert Storm, the pilot of a rescue helicopter, Meg Ryan, dies shortly before her helicopter crew is rescued. It first appears that she made a spectacular rescue of a downed helicopter crew, then held her own crew together to fight off the Iraqis after her helicopter crashed. Lt. Col. Denzel Washington, who is struggling with his own demons from a tank battle in Desert Storm, is assigned to investigate her Medal of Honor recommendation. But conflicting accounts from her crew and soldiers in the area cause him to question whether she deserves to be the first woman ever to win the Medal of Honor.

The film is based on Patrick Sheane Duncan's *Courage Under Fire* (New York: G. P. Putnam's Sons, 1996).

INTERESTING FACTS

- The tanks are British Centurions, with sheet metal added to make them look like M1A1 Abrams tanks; they were shipped from Australia when the U.S. Department of Defense withdrew its cooperation.
- The White House rose garden set was destroyed twice: once by a tornado and once by a sandstorm.
- The basic concept of the movie is borrowed from *Rashomon* (1950).
- In some of the background scenes in the training camp, cadets from Texas A&M University were used as extras.
- The Iraqi battle scenes were filmed at the Indian Cliffs Ranch, located just outside El Paso, Texas. Many of the props were left there and became a tourist attraction.
- Capt. Karen Walden, the hero of this film, would not have been the first female to receive the Medal of Honor. Dr. Mary E. Walker was awarded the Medal of Honor for her actions during the Civil War. In 1917, the medal was taken away from

hundreds of recipients, including Mary Walker, in an attempt to "clean up" the award. The reason for taking it away from Walker, it was argued, was because she was an army contract doctor and therefore technically not in the army. However, whatever her actual military status, she was at the front treating soldiers, with such distinction that her contemporaries, male chauvinists one and all, awarded her the medal. In 1977 President Carter reinstated her Medal of Honor.

MISTAKES

- The M1A1 used by the Second ACR (Armored Cavalry Regiment), in which Col. Serling plays a part, fires a 120mm combustible case round. Only the aft end cap comes out of the breech after firing, not the whole casing. Also, the combustible case round is white, not silver.
- After the battle, Sgt. Monfriez is shown wearing a Combat Infantryman's Badge (awarded twice, as indicated by the star on top). During the firefight he

Courage Under Fire (20TH CENTURY-FOX/AUTHOR'S COLLECTION)

is shown with the single award (with the wreath around it) for the CIB. He is not authorized to wear the CIB (second award). He is only allowed to wear a CIB (one award) for service during Vietnam, Grenada, Panama, or Iraq (even if he served in more than one conflict).

- The first helicopter to crash was a Blackhawk by the dialogue, but a Huey in the scenes.
- Serling calls the Iraqi tanks T-72s in the battle scenes, but they are listed as T-54s on the blackboard behind him during his interview about killing Boylar.
- Medevacs don't carry door gunners and aren't used for over-flying advancing lines of tanks st the beginning of a major battle.
- When taping a conversation, Col. Serling depresses only the "play" button, not the "record" button.
- Boylar's insignia indicates that he is a captain, yet he is referred to as a lieutenant.
- Walden fires an M16A2 on full automatic. The M16A2 doesn't have full automatic fire. It fires either semi auto, or three-round bursts.
- Serling and Gen. Hershberg's unit patches are on the wrong shoulder; the patches are where the combat patch should be.
- The Capitol dome cannot be seen from Bethesda, Maryland (much as the Eiffel Tower cannot be seen from every hotel room in France).
- Walden shoots more than 100 rounds from the M-16's 30-round magazine.
- The Medal of Honor is never placed around the neck of anyone but the recipient of the award. And the medal hung around Walden's daughter's neck disappears during the flyover.
- In many indoor scenes, especially at Walden's parents' house, the boom mike is visible.
- Lt. Col. Serling tells Gen. Hershberg that the tank was "hit by a uranium spent projectile" rather than using the correct terminology, "spent uranium projectile."

QUOTES

Monfriez: Sir, if you get a hang fire on your weapon, what do you do? You wait, with your weapon pointed in a safe direction, 'cause sometimes the primer bursts, and if you open the chamber it blows up in your face. Leave this round in the chamber, sir.

Nathaniel Serling: Son, I work for the Pentagon, so I admit I'm a little slow on the uptake, but did you just threaten me?

AWARDS

Blockbuster Entertainment Awards, 1997
Won: *Blockbuster Entertainment Award, Favorite Supporting Actor—Adventure/Drama,* Lou Diamond Phillips

Image Awards, 1997
Won: *Image Award, Outstanding Lead Actor in a Motion Picture,* Denzel Washington
Nominated: *Image Award, Outstanding Motion Picture; Outstanding Supporting Actress in a Motion, Picture,* Regina Taylor

Lone Star Film & Television Awards, 1997
Won: *Lone Star Film & Television Award, Best Actor,* Denzel Washington; *Best Director,* Edward Zwick; *Best Film; Best Screenplay,* Patrick Sheane Duncan—tied with Robert Harling for *The Evening Star* (1996); *Best Supporting Actor,* Lou Diamond Phillips

Southeastern Film Critics Association Awards, 1997
Won: *SFCA Award, Best Actor,* Denzel Washington.

COURT-MARTIAL OF BILLY MITCHELL, THE

Warner Bros., 1955, color, 100 minutes.

Producer: Milton Sperling; **Director:** Otto Preminger; **Screenwriters:** Ben Hecht, Emmet Lavery, Milton Sperling, Dalton Trumbo, Michael Wilson; **Distributor:** Warner Bros.; **Cast:** Peter Adams, Phil Arnold, Griff Barnett, Ralph Bellamy, Charles Bickford, Robert Brubaker, Charles Chaplin Jr., Fred Clark, Gary Cooper, James Daly, Charles Dingle, William Forrest, William Fox, Peter Graves, Lars Hansen, William Henry, Herbert Heyes, Steve Holland, Edna Holland, C. Anthony Hughes, Edward Keane, Adam Kennedy, Mike Lally, Jack Lord, Dayton Lummis, Cy Malis, John Maxwell, George Mayon, Darren McGavin, Tom McKee, Ewing Mitchell, Elizabeth Montgomery, Al Page, Fred Perce, Jack Perrin, Stephen Roberts, Manning Ross, Jordan Shelley, Robert F. Simon, Joel Smith, Rod Steiger, Max Wagner, Gregory Walcott, Frank Wilcox, Robert Williams, Ian Wolfe, Will Wright, Carleton Young.

In spite of an impressive performance during World War I, the commanders of America's armed forces still think the airplane is little more then a carnival attraction. Even after sending an unsinkable captured German battleship to the bottom with air power, Billy Mitchell (Gary Cooper) sees funds dry up and friends die in the struggling air corps. He is court-martialed for questioning the loyalty of his superiors in allowing the air corps to deteriorate.

- The movie is based on the true story of Billy Mitchell, a pioneering crusader for the army's fledgling air corps.

 In 1946, after World War II proved Mitchell right about everything he said about air power, and because of his sacrifices in trying to alert the military about the realities of air power, he was awarded the Medal of Honor by a special act of Congress. The full text of that award reads: "An Act Authorizing the President of the United States to award posthumously in the name of Congress a Medal of Honor to William Mitchell. Be it enacted by the Senate and House of Representatives of the United States of America in Congress assembled, that the President of the United States is requested to cause a gold medal to be struck, with suitable emblems, devices, and inscriptions, to be presented to the late William Mitchell, formerly a Colonel, United States Army, in recognition of his outstanding pioneer service and foresight in the field of American military aviation. SEC. 2. When the medal provided for in section I of this Act shall have been struck, the President shall transmit the same to William Mitchell, Jr,, son of the said William Mitchell, to be presented to him in the name of the people of the United States."

 Actor Rod Steiger enlisted in the U.S. Navy and spent four years as a torpedoman on the destroyer USS *Taussig* (DD-746) in the South Pacific. The ship was involved in many of the major engagements of the Third and Fifth Fleets, including Okinawa and Iwo Jima. He received a medical discharge for an acute skin disease two weeks before the surrender of Japan.

AWARD

Academy Awards, USA, 1955
> Nominated: *Oscar, Best Writing, Story and Screenplay*, Emmet Lavery, Milton Sperling.

CRASH DIVE

20th Century-Fox, 1943, color, 106 minutes.

Producer: Milton Sperling; **Director:** Archie Mayo; **Screenwriters:** W. R. Burnett, Jo Swerling; **Music:** David Buttolph; **Distributor:** 20th Century-Fox Film Corporation; **Filmed at:** U.S. Navy Submarine Base, New London, Connecticut; **Cast:** Dana Andrews, Stanley Andrews, John Archer, David Bacon, Anne Baxter, Lulu Mae Bohrman, Paul E. Burns, Ben Carter, Frank Conroy, Frank Dawson, Steve Forrest, Chester Gan, James Gleason, Charley Grapewin, Thurston Hall, Sally Harper, George Holmes, Kathleen Howard, Florence Lake, Trudy Marshall, Leila McIntyre, Edward McWade, Hans Moebus, Harry Morgan, Tyrone Power, Gene Rizzi, Lionel Royce, Charles Tannen, Minor Watson, Cecil Weston, Dame May Whitty, Bruce Wong.

Against his wishes, PT boat commander Tyrone Power is made executive officer of the submarine USS *Corsair*, under the command of Dana Andrews. At sea, the men bond while fighting German Q-ships, heavily armed vessels disguised as merchant ships.

MILITARY SERVICE

- Tyrone Power was unable to get a navy commission, and he refused a commission in Darryl Zanuck's Culver City Commandos, so he enlisted as a private in the Marine Corps. He was immediately granted four months leave so that he could finish this film. After completing principal photography, he reported to flight training and was sent overseas to the Pacific as a marine transport pilot. He flew the Curtis R5C Commando with Transport Squadron VMR-353, seeing action at Saipan, where he flew in supplies under intense enemy fire, eventually logging more than 1,100 hours of flight time. He finished the war as a captain with the occupation forces in Japan.

CRIMSON ROMANCE

Mascot Pictures Corporation, 1934, b&w, 71 minutes.

Producer: Nat Levine; **Director:** David Howard; **Screenwriters:** Milton Krims, Sherman L. Lowe, Al Martin, Doris Schroeder; **Music:** Lee Zahler; **Distributor:** Mascot Pictures Corporation; **Cast:** Hardie Albright, Oscar Apfel, Eric Arnold, William Bakewell, Vince Barnett, Herman Bing, Wilhelm von Brincken, James Bush, Arthur Clayton, Brandon Hurst, Ben Lyon, Sari Maritza, Purnell Pratt, Jason Robards Sr., Bodil Rosing, Harry Schultz, Erich von Stroheim, Frederick Vogeding.

Ben Lyon and James Bush are young German Americans who, disgusted with anti-German hysteria before World War I, leave America and join the Luftwaffe. They both fall in love with the same woman, a young German ambulance driver. When America enters the war, James Bush remains in the Luftwaffe and

is killed in action, while Ben Lyon switches sides, flies for the Americans, and marries the German girl when the war is over.

CROSS OF IRON

Terra Filmkunst, Rapid Film, EMI Films Ltd., Radiant Productions, 1977, color, 133 minutes.

Producers: Wolf C. Hartwig, Arlene Sellers, Alex Winitsky; **Director:** Sam Peckinpah; **Screenwriters:** Julius J. Epstein, James Hamilton, Willi Heinrich, Walter Kelley; **Music:** Ernest Gold; **Distributors:** AVCO Embassy Pictures, EMI Films Ltd.; **Filmed in:** Yugoslavia; **Cast:** Senta Berger, Arthur Brauss, James Coburn, Burkhard Driest, Roger Fritz, Vadim Glowna, Klaus Löwitsch, James Mason, Michael Nowka, Maximilian Schell, Dieter Schidor, Fred Stillkrauth, Véronique Vendell, David Warner.

James Coburn, a disillusioned but highly skilled sergeant, leads a squad of seasoned German soldiers fighting on the Russian front during World War II. They receive a new commander, a traditional Prussian officer who wants only one thing from his command— an Iron Cross to maintain his family honor. The scene is set for a graphic portrayal of the horrors of war and of the conflict between two men of differing backgrounds as they fight to survive Soviet attacks.

INTERESTING FACT

- This sympathetic portrayal of the German side in World War II is not commonly seen in Hollywood films. However, the film was very popular in Germany.

QUOTES

Colonel Brandt: What will we do when we have lost the war?
Capt. Keisel: Prepare for the next one.

CROSS OF LORRAINE, THE

Metro-Goldwyn-Mayer, 1943, b&w, 90 minutes.

Producer: Edwin H. Knopf; **Director:** Tay Garnett; **Screenwriters:** Robert Aisner, Robert Hardy Andrews, Lilo Damert, Alexander Esway, Michael Kanin, Ring Lardner Jr.; **Distributor:** MGM; **Cast:** Jean-Pierre Aumont, Felix Basch, Joseph Calleia, Hume Cronyn, Donald Curtis, Emma Dunn, Jack Edwards Jr., Wallace Ford, Frederick Giermann, Cedric Hardwicke, Gene

Kelly, Jack Lambert, Peter Lorre, Billy Roy, Richard Ryen, Tonio Selwart, Richard Whorf.

Gene Kelly is a French soldier taken prisoner by the Germans after the fall of France during World War II. He is tortured by Peter Lorre, a sadistic German sergeant, after he resists collaborating with his Nazi captors, and his spirit is broken. Escaping, he heads for the border, where he can join the Free French forces fighting the Nazis. Once free, Kelly regains his fighting spirit and inspires the villagers where he is hiding to rise up and avenge themselves on their Nazi oppressors.

INTERESTING FACT

- Germany pledged fair treatment to those French soldiers who surrendered and accepted the armistice after the fall of France at the beginning of World War II. Instead, they were subjected to torture, starvation, and brainwashing. The incidents portrayed in this film are based on actual historical accounts of the experiences of these French soldiers.

MILITARY SERVICE

- Gene Kelly enlisted in the U.S. Navy after finishing the film *Anchors Aweigh* with Frank Sinatra in 1944. After being commissioned an ensign, he was assigned to make a movie about battle fatigue, which led to rumors that he had been in combat and was suffering from battle fatigue. He continued to make movies for the navy and was scheduled to participate in the invasion of Japan before the dropping of the atom bomb made an invasion unnecessary.

CRUEL SEA, THE

Ealing Studios, 1953, b&w, 126 minutes.

Producers: Michael Balcon, Leslie Norman; **Director:** Charles Frend; **Screenwriters:** Eric Ambler, Nicholas Monsarrat; **Distributors:** Universal-International, General Film Distributors; **Cast:** Warwick Ashton, Stanley Baker, Andrew Cruickshank, George Curzon, Meredith Edwards, Denholm Elliott, Walter Fitzgerald, Harold Goodwin, Fred Griffiths, Laurence Hardy, Dafydd Havard, Jack Hawkins, Gerard Heinz, Glyn Houston, Jack Howard, Harold Jamieson, Megs Jenkins, Kenn Kennedy, Sam Kydd, Barry Letts, Moira Lister, Alec McCowen, Virginia McKenna, Leo Phillips, Liam Redmond, Gaston Richer, Gerik Schjelderup, Bruce Seton, Don Sharp, Ronald Simpson,

Donald Sinden, John Singer, Anthony Snell, Barry Steele, John Stratton, June Thorburn, Herbert C. Walton, John Warner, Russell Waters.

At the start of World War II, Jack Hawkins is assigned to convoy escort duty as commander of the HMS *Compass Rose*, staffed with inexperienced officers and men just out of training. The winter seas make life miserable enough, but the men must also harden themselves to rescuing survivors of U-boat attacks, while at the same time rarely getting the opportunity to strike back.

The film is based on Nicholas Monsarrat's *The Cruel Sea* (New York: Knopf, 1951).

INTERESTING FACT

- The screenplay was nominated for an Oscar but lost out to that year's big hit, *FROM HERE TO ETERNITY*.

MISTAKE

- All depth charges are clearly labeled "Inert Filled."

QUOTES

Sub-Lt. Lockhart: If anyone else makes a noise, I'll have his guts for a necktie.

Jack Hawkins: For us, the Battle of the Atlantic was becoming a private war. If you were in it, you knew all about it. You knew how to keep watch on filthy nights and how to go without sleep; and how to bury the dead and how to die without wasting anyone's time.

CRY HAVOC

Metro-Goldwyn-Mayer, 1943, b&w, 98 minutes.

Producer: Edwin H. Knopf; **Director:** Richard Thorpe; **Screenwriters:** Allan Kenward, Jane Murfin, Paul Osborn; **Music:** Daniele Amfitheatrof; **Filmed at:** Pico, near Montebello, California; **Distributor:** Metro-Goldwyn-Mayer; **Cast:** Heather Angel, Morris Ankrum, Fay Bainter, George Beban Jr., William Bishop, Joan Blondell, Allan Byron, Bill Cartledge, Russ Clark, Richard Crane, Bill Cruz, Richard Derr, Roque Espiritu, Fely Franquelli, Frances Gifford, Connie Gilchrist, Gloria Grafton, Marsha Hunt, Victor Kilian, Diana Lewis, Joy Louie, Bob Lowell, Robert Mitchum, Dorothy Morris, Anna Q. Nilsson, Paul Oman, Ella Raines, Lorin Raker, Ann Sothern, Margaret Sullavan, James Warren.

The army nurses on Bataan need help badly, but when help arrives the replacements include a Southern belle, a waitress, and a stripper. As the situation becomes more hopeless, the nurses are given a chance to escape, but they vote to stay with the wounded men and ultimately end up surrendering to the Japanese.

The movie is based on a Broadway play entitled *Proof Thro' the Night*.

INTERESTING FACT

- The film *So Proudly We Hail!* also concerns the plight of military nurses during the fall of Bataan.

CRY OF BATTLE

Petramonte Productions, 1963, b&w, 99 minutes.

Producers: Eddie Romero, Joe Steinberg; **Director:** Irving Lerner; **Screenwriters:** Benjamin Appel, Bernard Gordon; **Music:** Richard Markowitz; **Distributor:** Allied Artists; **Filmed in:** Philippines; **Cast:** Sidney Clute, Van Heflin, Oscar Keesee Jr., James MacArthur, Liza Moreno, Rita Moreno, Marilou Muñoz, Michael Parsons, Oscar Roncal, Leopoldo Salcedo, Vic Solyin, Claude Wilson.

James MacArthur is a young American who arrives in the Philippines the day after the Japanese sneak attack on Pearl Harbor. When the Japanese invade the islands, he joins a guerrilla group.

QUOTE

Van Heflin's advice to James MacArthur: You fight when you have to, you get a dame when you can, that's it.

CUBA

Holmby, 1979, color, 122 minutes.

Producers: Denis O'Dell, Arlene Sellers, Alex Winitsky; **Director:** Richard Lester; **Screenwriter:** Charles Wood; **Music:** Patrick Williams; **Distributor:** United Artists; **Filmed in:** Spain; **Cast:** Brooke Adams, Martin Balsam, Earl Cameron, Maria Charles, Sean Connery, Danny De La Paz, Hector Elizondo, Denholm Elliott, Leticia Garrido, Walter Gotell, Ram John Holder, Stefan Kalipha, Dave King, Michael Lees, Roger Lloyd-Pack, Tony Matthews, Lonette McKee, Louisa Moritz, Wolfe Morris, John Morton, Raul Newney, Anna Nicholas, Pauline Peart, David Rappaport, Alejandro Rey, Chris Sarandon, Anthony Pullen Shaw, James Turner, Jack Weston.

During the Cuban Revolution, Sean Connery goes to Cuba to train those loyal to Batista, who are fighting Castro's rebel army. In Cuba he encounters an old love, who is now married. As Castro's army wins more and more engagements, their love is rekindled.

Batista had been in power for over 20 years when Fidel Castro, promising a democratic government, landed in Cuba in 1956 with 81 followers, among them Che Guevara, and started a guerrilla campaign against the entrenched government. By 1959, Batista realized that his position was untenable, and he fled the country. After a dispute with the United States over the nationalization of foreign property, Castro turned to the Soviet Union for funding and support, and fell under its sphere of influence.

DAD'S ARMY

Norcon, 1971, color, 95 minutes.

Producer: John R. Sloan; **Director:** Norman Cohen; **Screenwriters:** David Croft, Jimmy Perry; **Music:** Wilfred Burns; **Distributor:** Columbia Pictures Corporation; **Filmed at:** Chalfont St. Giles, England (exteriors); **Cast:** Bernard Archard, John Baskcomb, Colin Bean, James Beck, John D. Collins, Pat Coombs, Desmond Cullum-Jones, Paul Dawkins, Clive Dunn, David Fennell, Liz Fraser, Scott Fredericks, Frank Godfrey, Fred Griffiths, Alan Haines, George Hancock, Hugh Hastings, John Henderson, Michael Knowles, Sam Kydd, John Laurie, Ian Lavender, John Le Mesurier, Arthur Lowe, Roger Maxwell, Ingo Mogendorf, Derek Newark, Leslie Noyes, Bill Pertwee, Robert Raglan, Harriet Rhys, Arnold Ridley, George Roubicek, Anthony Sagar, Bernard Severn, Edward Sinclair, Franz Van Norde, Dervis Ward, Freddie White, Freddie Wiles, Frank Williams.

The home guard of Mainwaring Upon Sea save the day when the crew of a downed German aircraft take the vicar and villagers hostage in the church.

INTERESTING FACTS

- This film is based on the popular BBC-TV series *Dad's Army*. The film version is a prequel, demonstrating how the Warmington Upon Sea Home Guard (affectionately known as Dad's Army) was formed. Principal characters include Mainwaring, the bank manager; Fraser, the undertaker; and Jones, the butcher.
- The home guard was formed by the British War Office from those soldiers of World War I and others, who were too old for active service in World War II. Tasked with protecting the farms and villages of England, they took their duties very seriously.

DAM BUSTERS, THE

Associated British Picture Corporation, 1954, b&w, 119 minutes.

Producers: Robert Clark, W. A. Whittaker; **Director:** Michael Anderson; **Screenwriters:** Paul Brickhill, R. C. Sherriff; **Filmed at:** Howden & Derwent Dams, Dark Peak, Peak District National Park, England, and Peak National Park Reservoir Dam, Derbyshire, England; **Cast:** Basil Appleby, Peter Assinder, George Baker, Patrick Barr, Laidman Browne, Charles Carson, Ernest Clark, Anthony Doonan, Derek Farr, John Fraser, Harold Goodwin, Denys Graham, Raymond Huntley, Ursula Jeans, Bill Kerr, Richard Leech, Frederick Leister, Hugh Manning, Brewster Mason, Patrick McGoohan, Eric Messiter, David Morrell, Hugh Moxey, Laurence

Naismith, Brian Nissen, Frank Phillips, Michael Redgrave, Anthony Shaw, Robert Shaw, Harold Siddons, Ewen Solon, Nigel Stock, Edwin Styles, Basil Sydney, Colin Tapley, Richard Thorp, Richard Todd, Tim Turner, Stanley Van Beeres, Ronald Wilson.

Barnes Wallis (Michael Redgrave), the noted British engineer, ponders the central problem associated with bombing a dam. Any explosion in water (and direct hits on the dam wall are too much to expect) is cushioned by the fluidity of the water, and no structural damage results. Only if the bomb can be laid right beside the base of the dam will it be effective. Wallis, experimenting in his backyard, gets his brilliant idea: If a bomb can be delivered at the correct shallow trajectory and the right high speed, it will "skip" along the lake's surface like a pebble on a pond, strike the dam, and slide down the wall. A depth-sensitive trigger could then detonate the bomb where it would do the maximum damage. With the concept in place, the RAF develops the bomb, trains the crews, and attacks the Ruhr dams.

The scene of RAF training, when they start learning to skip the bomb over the surface of the water, is worth noting. Good use is made of genuine Air Ministry film of the bouncing-bomb tests.

INTERESTING FACTS

- The movie is based on the true story of "Operation Chastise." In spring 1942, the English design engineer Barnes Wallis suggested a new tactic for attacking Germany's industrial heartland. The great dams of western Germany were an important power source for the Nazi war effort. If the dams could be breached, then the loss of electrical energy and the collateral flooding would cripple German industry and shorten the war. Very-low-flying Lancaster aircraft of the Royal Air Force's 617 Squadron employed revolutionary five-ton bouncing bombs, developed expressly for this mission, to destroy the huge hydroelectric dams at Moehne, Sorbe, and Eder in the Ruhr Valley.
- The RAF supplied most of the aircraft, at a cost of £130 per hour. This expense consumed 10 percent of the film's budget.
- A cut of the film was spiced up for the American market. Additional scenes of a plane crashing were later removed after it was spotted that Warner Bros. had used World War II footage of a Flying Fortress (the RAF used Lancasters).

- The bombs shown in the movie were the wrong shape because the actual shape (a stubby cylinder) was still secret at the time.
- The film premiered 12 years to the day from the original raid.
- Dialogue among pilots in *Dam Busters* is almost word for word the dialogue of the Jedi pilots attacking the Death Star in the 1977 film *Star Wars*.
- Group Capt. Leonard Cheshire (awarded the Victoria Cross) was the much-decorated air ace who was a major pilot on the raid. He later became a peace and charity worker, founding the Cheshire Homes for the disabled (as well as becoming Lord Cheshire), and it is said he refused to be portrayed in the film because of the guilt he felt.
- Guy Gibson, who was killed later in the war, won a Victoria Cross for his part in the raid and for his leadership.

[handwritten: GUY GIBSON]

[handwritten: CHESHIRE NOT ON RAID.]

MISTAKES

- In the original edit of the film, the dog's name (a black Labrador) was a historically accurate but socially unacceptable "Nigger." One edit changed the spoken word to "Trigger" (the Morse code received in the Ops room was still Nigger), while another release cut all scenes with the offending word. As a result parts of the plot became unintelligible—the dog's name was one of the code words used during the attack.
- In U.S. prints, a Flying Fortress appears at least once in place of a Lancaster.
- The train being derailed by the flood is running on the left-hand track. British trains do run on the left (like their cars), but German ones run on the right.

QUOTES

Ministry official: You say you need a Wellington Bomber for test drops. They're worth their weight in gold. Do you really think the authorities will lend you one? What possible argument could I put forward to get you a Wellington?

Barnes Wallis: Well, if you told them I designed it, do you think that might help?

AWARDS

Academy Awards, USA, 1955
 Nominated: *Oscar, Best Special Effects*

British Academy Awards, 1956
 Nominated: *BAFTA Film Award, Best British Film; Best British Screenplay,* R. C. Sherriff; *Best Film from Any Source.*

DANGEROUSLY THEY LIVE

Warner Bros., 1942, b&w, 71 minutes.

Producers: Bryan Foy, Benjamin Stoloff; **Director:** Robert Florey; **Screenwriter:** Marion Parsonnet; **Cast:** Murray Alper, Tod Andrews, Arthur Aylesworth, Leah Baird, Swen Hugo Borg, Matthew Boulton, Sidney Bracey, Glen Cavender, Cliff Clark, Nancy Coleman, Esther Dale, Leslie Denison, Charles Drake, Roland Drew, John Garfield, Sol Gorss, Ilka Grüning, John Harmon, Audra Lindley, Raymond Massey, Lon McCallister, Adolph Milar, Jack Mower, Gavin Muir, Spec O'Donnell, Moroni Olsen, Paul Panzer, Lee Patrick, Frank Reicher, John Ridgely, Henry Rowland, Christian Rub, James Seay, Frank M. Thomas, Henry Victor, Ben Welden, Dick Wessel, Leo White, Joan Winfield.

John Garfield, a doctor, treats Nancy Coleman, a mysterious woman claiming to be a British secret agent on the run from German spies. He helps her escape, and together they convince the authorities that there is a secret German U-boat fleet off the coast of the United States.

The movie is based on Marion Parsonnet's *Remember Tomorrow* (no publication date is available).

DANGEROUS MOONLIGHT

RKO Radio British Productions, 1941, b&w, 94 minutes.

Producer: William Sistrom; **Director:** Brian Desmond Hurst; **Screenwriters:** Rodney Ackland, Terence Young; **Music:** Richard Addinsell; **Distibutor:** RKO Radio Pictures Inc.; **Cast:** Elwyn Brook-Jones, O.B. Clarence, Charles Farrell, Philip Friend, Leslie Gordon, Sally Gray, Kenneth Kent, John Laurie, John Lawson, Derrick De Marney, Guy Middleton, Cecil Parker, Percy Parsons, James Pirrie, Michael Rennie, J.H. Roberts, Marian Spencer, Frederick Valk, Anton Walbrook.

During the Nazi invasion of Poland, American reporter Carole Peters meets Polish airman Stefan Radetzky, who is also a piano virtuoso. Stefan is among the last to escape Warsaw. Months later, in New York, he and Carole meet again and marry. But the thought of his going back to fight is not only personally terrifying to Carole but also seems a great waste of his musical talent.

DANGER WITHIN

British Lion Film Corporation, 1959, b&w, 115 minutes.

Director: Don Chaffey; **Screenwriters:** Bryan Forbes, Michael Gilbert, Frank Harvey; **Music:** Francis Chagrin; **Cast:** Terence Alexander, Peter Arne, Richard Attenborough, Vincent Ball, Michael Caine, William Franklyn, Dino Galvani, Donald Houston, Bernard Lee, Dennis Price, Ronnie Stevens, Richard Todd, Michael Wilding.

In an Italian prisoner-of-war camp for Allied soldiers during World War II, a group of British soldiers find their plans for escape thwarted by a mysterious traitor in their midst.

DARBY'S RANGERS

Warner Bros., 1958, b&w, 121 minutes.

Producer: Martin Rackin; **Director:** William A. Wellman; **Screenwriter:** Guy Trosper; **Music:** Max Steiner; **Cast:** Corey Allen, Edward Ashley, Raymond Bailey, Willis Bouchey, Peter Brown, Edd Byrnes, Etchika Choureau, Joan Elan, James Garner, Murray Hamilton, Frieda Inescort, David Janssen, Andrea King, Reginald Owen, Venetia Stevenson, Torin Thatcher, Philip Tonge, Jack Warden, H. B. Warner, Bill Wellman Jr., Stuart Whitman, Adam Williams.

James Garner portrays real-life officer Lt. Col. William Darby, who formed this elite guerrilla fighting unit during World War II. After their special training, Darby leads his men on a series of missions in North Africa, Sicily, and northern Italy. Using lightning-fast surprise raids, they work behind enemy lines, and in Italy they attack the coastal defenses prior to the landing at Anzio.

INTERESTING FACTS

- The actual Darby's Rangers was formed in June 1942 as the First Ranger Battalion, after Gen. Lucien K. Truscott decided that the Americans needed a unit like the British commandos. Gen. Eisenhower decided on Col. William Darby (1911–1945), who was promoted to brigadier general and later killed in action in Italy, to select officers and men for the new unit. A group of 500 were selected from 2000 volunteers stationed in Northern Ireland.
- The first part of their name was obviously derived from Darby's surname; the second part was taken from Roger's Rangers (led by actor Spencer Tracy as

Capt. Richard Rogers in the film *Northwest Passage*), a real-life group of colonists who fought frontier style against Indians during the wars of 1755–1763. Several different ranger battalions were formed during World War II; they saw action in Sicily, Italy, France, and the South Pacific.

The film is based on Major James Altieri's *Darby's Rangers* (Arnold, Mo.: Ranger Book Committee, 1977).

MILITARY SERVICE

• James Garner was the first draftee inducted from Oklahoma for the Korean War. He was in Korea for 14 months, assigned to the Fifth Regimental Combat Team of the 24th Division (the Victory Division) and was wounded twice. The first wound was from shrapnel while he was on patrol. The second wound occurred when his unit was overrun by Chinese troops. During a night retreat, he was separated from his unit and with 30 other stragglers was mistaken for a concentration of enemy troops. A U.S. Navy jet attack on their position resulted in his being wounded in the buttocks by shrapnel, suffering phosphorus burns over his back and neck. Isolated and without a weapon, with only one South Korean soldier for company, Garner was able to fool the Chinese troops into thinking that he was the South Korean's prisoner and they were walking back to their own lines, with Garner holding his hands above his head the entire way. After his recovery, Garner was sent to Japan to a postal unit, where he used his talents as a scrounger and scavenger to equip his post office building with a bar, a theater, and hot showers.

DARK ANGEL, THE

Goldwyn Pictures Corp., 1935, b&w, 110 minutes.

Producer: Samuel Goldwyn; **Director:** Sidney Franklin; **Screenwriters:** Guy Bolton (play, as H. B. Trevelyan), Lillian Hellman, Mordaunt Shairp; **Music:** Alfred Newman; **Distributor:** United Artists; **Cast:** Katharine Alexander, Claud Allister, Andrew Arbuckle, Louise Bates, James C. Baxter, Janet Beecher, George P. Breakston, Jimmy Butler, Helena Byrne-Grant, Colin Campbell, Robert Carleton, Dennis Chaldecott, Fay Chaldecott, Phyllis Coghlan, Cora Sue Collins, Randolph Connelly, Edward Cooper, Henrietta Crosman, Phillip Dare, Roy Darmour, J. Gunnis Davis, Jack Deery, Vernon Downing, Sarah Edwards, Ann Fielder, Bud Geary, Douglas Gordon, Lawrence Grant, Robert Hale, John Halliday, Sam Harris, Holmes Herbert, Harold Howard, Olaf Hytten, Frieda Inescort, Colin Kenny, Claude King, Murdock MacQuarrie, Fredric March, Herbert Marshall, John Miltern, Tom Moore, Merle Oberon, Vesey O'Davoren, Albert Russell, Audrey Scott, Frederick Sewell, C. Montague Shaw, Doris Stone, Charles Tannen, Francis Palmer Tilton, David Torrence, Silvia Vaughan, Clare Verdera, Walt Voegeler, Carl Voss, Douglas Walton.

Fredric March is smitten with Merle Oberon, but the lovers are separated when he is ordered to France during World War I. On patrol in the no-man's land between the trenches, he is blinded by an explosion. Returning to England, he memorizes the location of everything in his room, so that Oberon will not discover that he is blind. He tries to convince her that he no longer wants her, that he wants to be let alone to pursue his career as a writer. However, she realizes that he is blind, and is determined that they will be together.

The film is based on a play by H. B. Trevelyan.

AWARDS

Academy Awards, USA, 1935
Won: *Oscar, Best Interior Direction,* Richard Day
Nominated: *Oscar, Best Actress,* Merle Oberon; *Best Sound Recording,* Thomas T. Moulton.

DAWN PATROL, THE

First National Pictures Inc., 1930, b&w, 105 minutes.

Producer: Robert North; **Director:** Howard Hawks; **Screenwriters:** Howard Hawks, Seton I. Miller, John Monk Saunders, Dan Totheroh; **Cast:** Jack Ackroyd, Harry Allen, Richard Barthelmess, Edmund Breon, Clyde Cook, Douglas Fairbanks Jr., James Finlayson, Neil Hamilton, Gardner James, William Janney, Frank McHugh, Dave O'Brien.

The commander of a World War I fighter squadron must send up his men each day to fight the enemy. Some kill the enemy, some are themselves killed, and each day, new replacements arrive. Soon, only two of the old veterans are left; the rest of the squadron are the replacements, who get younger and younger each day. Barely trained and straight out of flight school, they are no match for the veteran German pilots, and so they go up and they die. Ordering men to their deaths each day drives the commander to drink. He is criticized by the two old veterans, and when he is "kicked upstairs" to a staff job at headquarters, he is only too pleased to transfer command of the squadron to one of them, who is now faced with making these life-and-death decisions for the young replacement pilots.

- The command responsibility for a squadron has been the subject of a number of films. Enthusiasts should compare this film with John Wayne's *FLYING LEATHERNECKS* and Gregory Peck's *TWELVE O'CLOCK HIGH*, both of them excellent examples of this genre.
- Now overshadowed by its more famous remake with Errol Flynn, also entitled *THE DAWN PATROL*, this film is the original by directing legend Howard Hawks.

QUOTE

Hamilton, the commander: It's a slaughterhouse, that's what it is, and I'm the executioner. You send men up in rotten ships to die . . . they don't argue or revolt . . . they just say "right-o" and go out and do it.

DAWN PATROL, THE

Warner Bros., 1938, b&w, 103 minutes.

Director: Edmund Goulding; **Screenwriters:** Seton I. Miller, John Monk Saunders, Dan Totheroh; **Distributor:** Warner Bros.; **Cast:** Sidney Bracey, Hal Brazeale, Michael Brooke, James Burke, Melville Cooper, Donald Crisp, Carl Esmond, Herbert Evans, Burnett Fergrison, Barry Fitzgerald, Errol Flynn, Fred Graham, Stuart Hall, George Kirby, Morton Lowry, Anthony Marsh, David Niven, Leo Nomis, Wally Rairdon, Basil Rathbone, Jack Richardson, John Rodion, Tom Seidel, John Sutton, Gordon Thorpe, Charles Waldron Jr., Peter Willes, Norman Willis, Gilbert Wilson.

In 1915 France, Basil Rathbone commands the 39th Squadron of the Royal Flying Corps. Wartime commanders have the nasty job of sending men to their deaths every day. Rathbone gets telephone orders from the high command for the morning flights (the dawn patrols) and relays these to squadron commander Errol Flynn, who has the unenviable job of picking the young, untrained pilots for the job. Complaining about the men's inexperience and the rickety planes does no good, since it is their duty to do and die. In spite of the slaughter, morale is high, and one pilot who was not picked for the day's mission remarks, "Lucky devils," as the two who were picked leave the ready room. The men often sing a song with a last line ending "Hoorah for the next man who dies." As fate would have it, Flynn is promoted to flight commander and ordered to put every available man in the air to stave off a big push by the Germans. One of the new replacements is David Niven's kid brother, Morton Lowry, with only nine hours of flight time. Niven pleads with Flynn not to send his brother up, but there can be no exceptions. To make matters worse, the feared German flying ace, Von Richter (Norman Willis), waits up there in the sky. The death of his brother causes a deep rift between Niven and Flynn. When Niven volunteers for a near-suicide mission to fly alone and bomb a German armament dump 60 kilometers inside the German lines, Flynn gets Niven drunk and goes in his place. He gets the ammo dump, but three German planes, including one piloted by Von Richter, seal his fate.

QUOTES

[The camaraderie that existed between enemy fliers in World War I was unique. Flynn's face turns grim as he walks toward the man who he thought just killed his best friend. It looks like Flynn is going to take a poke at him, but he smiles, takes his hand, and drinks a toast with him. Only Peter Willes, whose two friends were just killed in combat, lets his true feelings surface and has to be forcibly restrained.]

Peter Willes [shouting at Flynn]: You laugh with him—joke with him—a man that just murdered your best friend. He's dead! You know that, don't you! Don't you! And so are Blaine and Madchen, my best friends. They're dead! They aren't coming home anymore!

DAYS OF GLORY

RKO Radio Pictures Inc., 1944, b&w, 86 minutes.

Producer: Casey Robinson; **Director:** Jacques Tourneur; **Screenwriters:** Melchior Lengyel, Casey Robinson; **Music:** Daniele Amfitheatrof; **Distributor:** RKO; **Cast:** Maria Bibikov, William Challee, Lou Crosby, Igor Dolgoruki, Gretl Dupont, Edward L. Durst, Erford Gage, Lowell Gilmore, Hugo Haas, Peter Helmers, Adolf E. Licho, Maria Palmer, Gregory Peck, Dena Penn, Alan Reed, Tamara Toumanova, Ivan Triesault, Glen Vernon, Joseph Vitale.

In late 1941, with the Germans advancing into Russia, the retreating Red Army leaves behind in the forest a band of guerrillas, led by Gregory Peck, to work behind enemy lines. They are joined by beautiful ballet dancer Tamara Toumanova; initially inept, a series of bitter lessons gradually makes her a seasoned soldier. They are ultimately all killed in the great Russian counterattack.

INTERESTING FACTS

- The director tried to give this film a sense of realism by casting unknowns in the lead roles, resulting in

the screen debut of actor Gregory Peck. Unfortunately, this lack of star names spelled death at the box office.

- During the war, as part of the war effort, the U.S. government encouraged the production of films such as this about our Russian ally. Later, during the McCarthy era, this same film was cited as evidence that Hollywood was part of the communist conspiracy.
- Tamara Toumanova played a ballet dancer in the film: she was a ballet dancer in real life.

DAY WILL DAWN, THE

General Film Distributors, 1942, b&w, 98 minutes.

Producer: Paul Soskin; **Director:** Harold French; **Screenwriters:** Anatole de Grunwald, Patrick Kirwan, Frank Owen, Terence Rattigan; **Distributor:** Paramount Pictures; **Cast:** Beckett Bould, John Boxer, George Carney, Roland Culver, Finlay Currie, Meriel Forbes, Philip Friend, Henry Hewitt, David Horne, Raymond Huntley, Griffiths Jones, Gerhard Kempinski, Deborah Kerr, Niall MacGinnis, Elizabeth Mann, Gus McNaughton, Patricia Medina, George Merritt, Bernard Miles, Olaf Olsen, Brefni O'Rorke, Henry Oscar, Roland Pertwee, Ralph Richardson, John Salew, Francis L. Sullivan, John Warwick, H. Victor Weske, Hugh Williams.

Hugh Williams is a foreign correspondent who seeks out a Nazi submarine base in Norway during World War II. Re-titled *The Avengers* when shown in the United States.

D-DAY THE SIXTH OF JUNE

20th Century-Fox, 1956, Color, 106 minutes.

Producer: Charles Brackett; **Director:** Henry Koster; **Screenwriters:** Harry Brown, Ivan Moffat, Lionel Shapiro; **Music:** Lyn Murray; **Distributor:** 20th Century-Fox Film Corporation; **Cast:** Richard Aherne, Parley Baer, Rama Bai, Marie Brown, Ashley Cowan, John Damler, Cyril Delevanti, Reggie Dvorak, Ross Elliott, Conrad Feia, Alex Finlayson, Joe Garcia, Robert Gist, Paul Glass, Dabbs Greer, Thomas Browne Henry, Queenie Leonard, Chester Marshall, Patricia McMahon, June Mitchell, Boyd "Red" Morgan, Edmond O'Brien, Damian O'Flynn, Jerry Paris, George Pelling, Howard Price, Grant Scott, Mickey Scott, Geoffrey Steele, Robert Taylor, Richard

Todd, Victoria Ward, John Williams, Ben Wright, Richard Wyler, Dana Wynter.

Special Force Six, consisting of U.S., Canadian, and English troops, is scheduled to hit Normandy ahead of the D-day invasion to knock out Nazi artillery positions. Robert Taylor and Richard Todd, two officers in the force, are both in love with the same woman, Dana Wynter. The problem is that Richard Todd is engaged to her, and Robert Taylor is already married to someone else. Todd is killed on the mission by a land mine, but Wynter pretends that he is still alive and tells Taylor that she is going to marry him, so that Taylor will return to his wife.

The film is based on Lionel S. B. Shapiro's *The Sixth of June* (New York: Doubleday, 1955).

INTERESTING FACTS

- Also related to the Normandy invasion are THE LONGEST DAY and SAVING PRIVATE RYAN.
- In probably the funniest and most obscure movie joke in film history (which makes it even funnier), in the film *Father of the Bride*, the date set for the wedding is the sixth of June.

DEADLINE

Norddeutscher Rundfunk, Creative Film GmbH, 1987, color, 100 minutes.

Producers: Michael Sharfshtein, Barnaby Thompson, Elisabeth Wolters-Alfs; **Director:** Nathaniel Gutman; **Screenwriter:** Hanan Peled; **Music:** Jacques Zwart; **Cast:** Etti Ankri, Shlomo Bar-Aba, Hywel Bennett, Shahar Cohen, Reuven Dayan, Sason Gabay, Moshe Ivgi, Amos Lavi, Marita Marschall, Nader Masraawi, David Menachem, Moni Moshonov, Yigal Naor, Gabi Shoshan, Shlomo Tarshish, Martin Umbach, Christopher Walken, Jerry Weinstock, Arnon Zadok.

Christopher Walken is an enterprising journalist operating behind the lines in war-torn Beirut. Initially jaded, he becomes increasingly personally involved in the Middle East situation.

DEAR RUTH

Paramount Pictures, 1947, b&w, 95 minutes.

Producer: Paul Jones; **Director:** William D. Russell; **Screenwriters:** Norman Krasna, Arthur Sheekman;

Music: Robert Emmett Dolan; **Distributor:** Paramount Pictures; **Cast:** Edward Arnold, Irving Bacon, Marietta Canty, Joan Caulfield, Jimmie Dundee, Mona Freeman, Jay Gerard, William Holden, Kenny O'Morrison, Mary Philips, Isabel Randolph, Ernö Verebes, Virginia Welles, Billy De Wolfe.

It's a normal day in the Wilkins household, ruled from the bottom by teenage political activist Miriam (Mona Freeman). Who should show up but a soldier pen pal, Lt. Bill Seacroft (William Holden), who has been corresponding with Miriam's older sister Ruth (Joan Caulfield) while he was overseas. The only problem is that Ruth has no idea that she has a pen pal. It seems Miriam used her sister's name and picture to build up wartime morale. Ruth reluctantly agrees to humor Bill for his two-day leave, even though she's just become engaged to her own stuffy suitor.

INTERESTING FACT

• J. D. Salinger got the name "Holden Caulfield" for his hero in *The Catcher in the Rye* from seeing the marquee for this film.

QUOTES

Miriam Wilkins [on phone]: I'll talk to you later. A prominent member of the last generation just walked in.

Judge Wilkins: I hope the young fellow that gets my blood doesn't need it too badly, because I have no confidence in it.

DEATHDREAM

Impact Films, Quadrant Films Ltd., 1972, color, 90 minutes.

Producers: Bob Clark, Gerald Flint-Shipman, Peter James, Geoffrey Nethercott, John Trent; **Director:** Bob Clark; **Screenwriter:** Alan Ormsby; **Music:** Carl Zittrer; **Distributor:** Entertainment International Pictures; **Filmed at:** Brooksville, Florida; **Cast:** Arthur Anderson, Edward Anderson, Richard Backus, Jeff Becker, Scott Becker, Arthur Bradley, Robert R. Cannon, Lynn Carlin, Virginia Cortez, Jane Daly, George De Vries, Henderson Forsythe, David Gawlikowski, Jeff Gillen, Bud Hoey, Mal Jones, John Marley, Michael Mazes, Raymond Michel, Robert Noble, Alan Ormsby, Anya Ormsby, Kevin Schweizer, Greg Wells.

A young soldier is killed in Vietnam. That same night, the soldier returns home, brought back to life by his mother's prayer that he not die. He sits in his room by day, refusing to see his friends or family, venturing out only at night. He is not really alive, he is just undead, a vampire with an insatiable need to live by drinking the blood of others.

DEATH FORCE

21st Century Film Corporation, 1978, Color, 96 minutes.

Producer: Robert E. Waters; **Director:** Cirio H. Santiago; **Screenwriter:** Howard R. Cohen; **Music:** Jaime Mendoza-Nava, Eddie Villanueva; **Filmed in:** Philippines, Los Angeles, California; **Cast:** Carmen Argenziano, Allen Arkus, Joe Mari Avellana, Tony Carrion, Ernie Carvajal, Vic Diaz, Ramon D'Salva, Armando Federico, Ellsworth Fortman-Waters, Elena Fortman-Waters, Joonee Gamboa, Darnell Garcia, Robert Gonzales, Tony Graziano, Jack Gregory, James Inglehart, Leon Isaac Kennedy, Jayne Kennedy, Tony Marino, Leo Martinez, Rocco Montalban, Bert Olivar, Arnie Parnell, Clay Platner, Cathy Sabino, Irene Waters, Dean Wein.

James Inglehart is left to die by his buddies during the Vietnam War. He is captured by Japanese soldiers still fighting World War II.

DECISION BEFORE DAWN

20th Century-Fox, 1951, b&w, 119 minutes.

Producers: Anatole Litvak, Frank McCarthy; **Director:** Anatole Litvak; **Screenwriters:** George Howe (novel, *Call It Treason*), Peter Viertel; **Music:** Franz Waxman; **Distributor:** 20th Century-Fox Film Corporation; **Cast:** C. A. Amos, Eva Marie Andres, Arno Assmann, Almut Bachmann, Richard Basehart, Harold Benedict, Heinrich Berg, Ulla Best, Dominique Blanchar, Hans Christian Blech, Bert Brandt, Ruth Brandt, H. W. Briggs, D. G. Devine, Don Devine, Jochen Diestelmann, L. E. Dixon, Erich Ebert, Ulrich Folkmar, Robert Freitag, Otto Friebel, Werner Fuetterer, Rainer Geldern, Elfe Gerhart, Jasper Gertzen, Aguste Hansen-Kleinmichel, O. E. Hasse, Rudolf Heimann, B. L. Hendrickson, Max Herbst, Loni Heuser, Alex Hohenlohe, Eva Maria Hoppe, Ernst Höchstötter, Walter Janssen, Erik Jelde, Katja Jobs, Klaus Kinski, Liselotte Kirschbaum, Gerhard Kittler, Hildegard Knef, D. Kogel, Sonja Kosta, Klaus W. Krause, Wolfgang Kuhnemann, Luitpold Kummer, Walter Ladengast, Maria Landrock, Egon Lippert,

Adolph Lodel, Ingeborg Luther, Peter Lühr, Kurt Marquardt, Gary Merrill, Elizabeth Millberg, Hans Mohrhard, S. I. Rice, Von Schmidel, Arnulf Schröder, Paul Schwed, Wilfried Seyferth, F. Slaman, Henriett Speidel, Gerhard Steinberg, Liselotte Steinweg, J. E. Stratton, Helen Thimig, Ruth Trumpp, George Tyne, Martin Urtel, Meta Weber, Oskar Werner, Clemens Wildemrod, Dieter Wilsing, Maria Wimmer, Harald Wolff.

World War II is all but over in Europe. Germany is in ruins, but the maniacal Hitler refuses to surrender. Oskar Werner, a German prisoner of war, is persuaded to act as a spy for the Allies. He hopes that his actions will help bring the war to a quicker end and save German lives. The scheme is risky; the Gestapo still has a terribly efficient network to identify and capture spies and deserters. Although he obtains the vital information, he is ultimately killed saving the life of Richard Basehart, an American officer.

INTERESTING FACT

- This was one of the first postwar films to depict anti-Nazi Germans risking their lives to fight against their country's policies. Later, many films would be made about the German resistance, including the plot to kill Hitler.

AWARDS

Academy Awards, USA, 1951
> Nominated: *Oscar, Best Film Editing,* Dorothy Spencer; *Best Picture,* Anatole Litvak, Frank McCarthy.

DEEP SIX, THE

Jaguar, 1957, color, 105 minutes.

Producers: George C. Bertholon, Alan Ladd, Martin Rackin; **Director:** Rudolph Maté; **Screenwriters:** Harry Brown, Martin Dibner, Martin Rackin, John Twist; **Distributor:** Warner Bros.; **Cast:** Ross Bagdasarian, William Bendix, Joey Bishop, Robert Clarke, Richard Crane, Ann Doran, Warren Douglas, Barbara Eiler, Dianne Foster, Peter Hansen, Alan Ladd, Carol Lee Ladd, Perry Lopez, Jerry Mathers, Morris Miller, Jeanette Nolan, Nestor Paiva, Walter Reed, Franz Roehn, Robert Whiteside, James Whitmore, Keenan Wynn, Efrem Zimbalist Jr.

Alan Ladd is a Quaker gunnery officer during World War II who has trouble coming to grips with his duty to kill the enemy. When he refuses to fire on an enemy aircraft, he is transferred to damage control duty, where he gains the respect of his crew when he disarms an unexploded bomb that threatens the ship. Later, manning a machine gun, the death of his Jewish shipmate William Bendix finally persuades him to kill the enemy.

The movie is based on Martin Dibner's *The Deep Six* (New York: Doubleday, 1953).

MILITARY SERVICE

- Joey Bishop was drafted during World War II and assigned to a special service unit at Ft. Sam Houston, Texas. He was discharged at the end of the war with the rank of sergeant.

QUOTE

William Bendix [as he dies and Alan Ladd starts killing Japanese with the machine gun]: I knew you had it in you all along.

DEER HUNTER, THE

Universal Pictures, EMI Films Ltd., 1978, color, 183 minutes.

Producers: Joann Carelli, Michael Cimino, Michael Deeley, John Peverall, Marion Rosenberg, Barry Spikings; **Director:** Michael Cimino; **Screenwriters:** Michael Cimino, Louis Garfinkle, Quinn K. Redeker, Deric Washburn; **Distributor:** Universal Pictures; **Filmed at:** Mill Creek Park, Youngstown, Ohio, Struthers, Ohio. Bangkok, Thailand. Cleveland and Mingo Junction, Ohio, Duquesne Heights and Pittsburgh, Pennsylvania, Lake Chelan, Washington, Weirton, West Virginia, Clairton, Pennsylvania; **Cast:** Rutanya Alda, Chuck Aspegren, Robert Beard, Tom Becker, Dale Burroughs, John Cazale, Krieng Chaiyapuk, Sapox Colisium, Christopher Colombi Jr., Paul D'Amato, Charlene Darrow, Robert De Niro, Frank Devore, Jane-Colette Disko, Joe Dzizmba, George Dzundza, Jiam Gongtongsmoot, Joe Grifasi, Mary Ann Haenel, Mana Hansa, Parris Hicks, John F. Buchmelter III, Sombot Jumpanoi, Mady Kaplan, Victoria Karnafel, Lynn Kongkham, Father Stephen Kopestonsky, Richard Kuss, Chok Chai Mahasoke, Phip Manee, Samui Muang-Intata, Charan Nusvanon, Ot Palapoo, Po Pao Pee, Chai Peyawan, Ding Santos, John Savage, Jack Scardino, Pierre Segui, Somsak Sengvilai, Shirley Stoler, Meryl Streep, Joe Strand, Nongnuj Timruang, Helen Tomko, Christopher Walken, Dennis Watlington, Vitoon Winwitoon, Michael Wollet, Amy Wright.

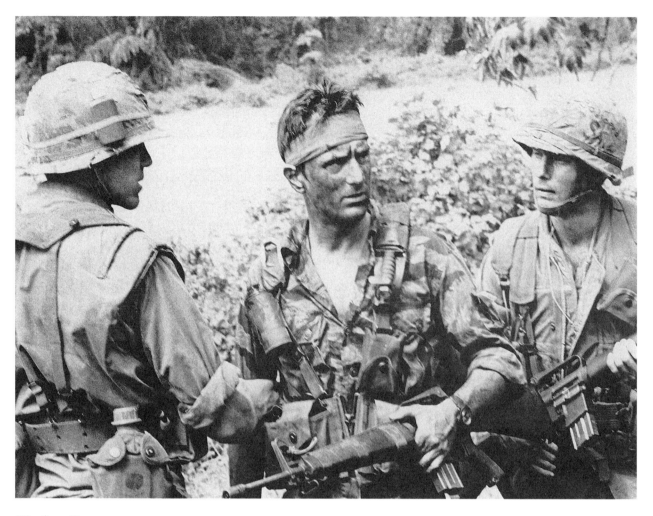

The Deer Hunter (UNIVERSAL PICTURES/AUTHOR'S COLLECTION)

Three young factory workers from western Pennsylvania are drafted to fight in Vietnam. As natives of western Pennsylvania, they are also deer hunters. Before they go to Vietnam, one of them gets married; the wedding party is also their farewell party. After many horrors the three friends fall into the hands of the Vietcong and are brought to a prison camp where they are forced to play Russian roulette. Finally escaping and returning home, they are faced with their own problems, created by their war service.

The Russian roulette scenes that make this film famous may be entirely fictitious, but it doesn't matter. Director Cimino presents it in such a realistic and powerful manner that you cannot help getting caught up in the scene. Particularly stressful is when they realize they must get more bullets into the gun if they are going to get out of there alive.

INTERESTING FACTS

- During the helicopter stunt, the runners caught on the ropes, and as the helicopter rose it threatened to seriously injure John Savage and Robert De Niro. The actors gestured and yelled furiously to the crew in the helicopter to warn them. Footage of this is included in the film.
- Robert De Niro claims this was his most physically exhausting film.
- John Cazale barely finished the film, dying of cancer soon after its completion.

MISTAKE

- The hunting scenes supposedly taking place in the Appalachian Range are obviously filmed elsewhere: The Appalachians are a smooth, rolling range, but the scenes show towering, jagged peaks. The

scenes were filmed in the Cascade Range, clear across the country.

QUOTE

Michael: One shot is what it's all about. A deer has to be taken with one shot.

AWARDS

Academy Awards, USA, 1978

Won: *Oscar, Best Director,* Michael Cimino; *Best Film Editing,* Peter Zinner; *Best Picture,* Michael Cimino, Michael Deeley, John Peverall, Barry Spikings; *Best Sound,* C. Darin Knight, William L. McCaughey, Richard Portman, Aaron Rochin; *Best Supporting Actor,* Christopher Walken

Nominated: *Oscar, Best Actor,* Robert De Niro; *Best Cinematography,* Vilmos Zsigmond; *Best Supporting Actress,* Meryl Streep; *Best Writing, Screenplay Written Directly for the Screen,* Michael Cimino, Louis Garfinkle, Quinn K. Redeker, Deric Washburn

American Cinema Editors, USA, 1979

Won: Eddie, Best Edited Feature Film, Peter Zinner

British Academy Awards, 1980

Won: *BAFTA Film Award, Best Cinematography,* Vilmos Zsigmond; *Best Editing,* Peter Zinner

Nominated: *BAFTA Film Award, Best Actor,* Robert De Niro; *Best Actress,* Meryl Streep; *Best Direction,* Michael Cimino; *Best Film; Best Screenplay,* Deric Washburn; *Best Soundtrack,* James J. Klinger, C. Darin Knight, Richard Portman; *Best Supporting Actor,* Christopher Walken

Directors Guild of America, USA, 1979

Won: *DGA Award, Outstanding Directorial Achievement in Motion Pictures,* Claude Binyon Jr. (unit production manager) (plaque), Michael Cimino, Michael Grillo (assistant director) (plaque), Charles Okun (assistant director) (plaque)

Golden Globes, USA, 1979

Won: *Golden Globe, Best Director—Motion Picture,* Michael Cimino

Nominated: *Golden Globe, Best Motion Picture—Drama; Best Motion Picture Actor—Drama,* Robert De Niro; *Best Motion Picture Actor in a Supporting Role,* Christopher Walken; *Best Motion Picture Actress in a Supporting Role,* Meryl Streep; *Best Screenplay—Motion Picture,* Deric Washburn

Los Angeles Film Critics Association Awards, 1978

Won: *LAFCA Award, Best Director,* Michael Cimino

National Film Preservation Board, USA, 1996— National Film Registry,

National Society of Film Critics Awards, USA, 1979

Won: *NSFC Award, Best Supporting Actress,* Meryl Streep

New York Film Critics Circle Awards, 1978

Won: *NYFCC Award, Best Film; Best Supporting Actor,* Christopher Walken

Writers Guild of America, USA, 1979

Nominated: *WGA Screen Award, Best Drama Written Directly for the Screen,* Michael Cimino, Louis Garfinkle, Quinn K. Redeker, Deric Washburn.

DESERT FOX: THE STORY OF ROMMEL, THE

20th Century-Fox, 1951, b&w, 88 minutes.

Producer: Nunnally Johnson; **Director:** Henry Hathaway; **Screenwriters:** Nunnally Johnson, Desmond Young; **Filmed at:** Imperial County, California; **Cast:** Luther Adler, John Alderson, Jack Baston, Richard Boone, Leo G. Carroll, Mary Carroll, Paul Cavanagh, Robert Coote, Don De Leo, Charles Evans, Peter van Eyck, Scott Forbes, Eduard Franz, John Goldsworthy, Cedric Hardwicke, Lumsden Hare, John Hoyt, Walter Kingsford, Freeman Lusk, George Macready, James Mason, Lester Matthews, Sean McClory, Dan O'Herlihy, Michael Rennie, William Reynolds, Everett Sloane, Jessica Tandy, Ivan Triesault, Philip Van Zandt, John Vosper, Trevor Ward, Victor Wood, Carleton Young, Desmond Young.

The film is about the life of Field Marshal Erwin Rommel (James Mason), including his defeats with the Afrika Korps, his work on the defenses of Fortress Europe, his part in the assassination attempt on Hitler, and his subsequent suicide.

Field Marshal Erwin Rommel (1891–1944) was Germany's most popular war hero and one of its best tactical generals. His reputation was so great that Allied troops fighting him were often demoralized to learn he was the German commanding general. He first made his reputation during World War I, where he became a popular hero fighting the Italians. An early advocate of the blitzkrieg tactic during World War II, he once again came into national prominence when he streaked across France at the head of the Seventh (Ghost) Panzer

Division. However, it was in the vast expanses of North Africa that he made his lasting reputation, as commander of the Afrika Korps, and earned his nickname "The Desert Fox." But no German general, no matter how brilliant, could have ultimately won that campaign. He was outnumbered, his supply lines were crippled by superior Allied air power, and all of his tactics were immediately known to the Allies because they had cracked the secret Enigma code. An honorable officer of the old school, he refused to allow any S.S. troops in his command, aware that they were often responsible for atrocities. Realizing that Hitler was destroying Germany, he joined the assassination plot, and when it failed, Hitler ordered him to commit suicide, which he did to save his wife and son from execution.

INTERESTING FACTS

- James Mason portrayed Rommel in this film and also in THE DESERT RATS.
- Other films that depict Rommel include FIVE GRAVES TO CAIRO (Erich von Stroheim) and THE LONGEST DAY (Werner Hinz).
- The film RAID ON ROMMEL, ironically, does not depict the German leader.

QUOTE

British Gen. Claude Auchinleck [read aloud to Allied troops, a historical quote]: There is a real danger that our friend Rommel will turn into a bogey man for our troops . . . He is not superhuman . . . it would be most undesirable for our soldiers to attribute superhuman powers to him.

DESERT HELL

20th Century-Fox, Regal Films Inc., 1958, b&w, 82 minutes.

Producer: Robert W. Stabler; **Director:** Charles Marquis Warren; **Screenwriter:** Charles Marquis Warren; **Music:** Raoul Kraushaar; **Filmed at:** Death Valley, California; **Cast:** Albert Carrier, Richard Denning, Johnny Desmond, Robert Etienne, Ron Foster, Richard Gilden, Charles D. Gray, Duane Grey, Barbara Hale, William Hamel, Brian Keith, Felix Locher, Patrick O'Moore, Michael Pate, Phillip Pine, Bert Rumsey, Richard Shannon, Bhogwan Singh, John Verros.

Brian Keith, a captain in the French Foreign Legion, must fight hostile Arab tribesmen while dealing with his wife's affair with his lieutenant.

DESERT LEGION

Universal-International Pictures, 1953, color, 84 minutes.

Producer: Ted Richmond; **Director:** Joseph Pevney; **Screenwriters:** Georges Arthur Surdez (novel, *The Demon Caravan*), Irving Wallace, Lewis Meltzer; **Music:** Frank Skinner; **Distributor:** Universal-International; **Cast:** Leon Askin, Asoka, Oscar Beregi Jr., Don Blackman, Anthony Caruso, Peter Coe, Richard Conte, Arlene Dahl, Elsa Edsman, Terry Frost, Ted Hecht, Alan Ladd, Pat Lane, Henri Letondal, George J. Lewis, David Sharpe, Sujata, Akim Tamiroff, Ivan Triesault.

Alan Ladd, an officer in the French Foreign Legion, is the sole survivor of an ambush by rebels. Badly wounded, he is found and taken to Medara, a Shangri-la in the remote Algerian mountains, where he is nursed back to health by the beautiful Arlene Dahl. The elderly leader of this utopia offers to make him his successor. Ladd declines his offer, deciding instead to return to headquarters, but ultimately he must save these peaceful people from the usurper.

INTERESTING FACT

- Most of the plot elements in this film will be found in *Lost Horizon*, a novel with two film versions. There are also similar elements in the Nick Nolte film FAREWELL TO THE KING, which contains a peaceful valley of people cut off from the outside world.

DESERT RATS, THE

20th Century-Fox, 1953, b&w, 88 minutes.

Producer: Robert L. Jacks; **Director:** Robert Wise; **Screenwriter:** Richard Murphy; **Cast:** John Alderson, Richard Burton, Charles Davis, Robert Douglas, Charles B. Fitzsimons, Arno Frey, Ray Harden, Charles R. Keane, James Lilburn, James Mason, Robert Newton, John O'Malley, Pat O'Morre, Michael Pate, Richard Peel, Frank Pulaski, Chips Rafferty, Albert Taylor, Torin Thatcher, Charles "Bud" Tingwell, John Wengraf, Ben Wright, Alfred Zeisler.

Rommel has the British in retreat on his way to the Suez Canal. All that stands in his way is Tobruk, held by an Allied force that he vastly outnumbers. Richard Burton leads Australian troops on daring raids against the Germans, keeping them off balance as they earn the nickname "The Desert Rats."

MISTAKE

- The first time the Australians sight the German tanks they report them as being at bearing 65 or about East-North-East, yet the commander plots them on the map as south of the observer's position and moving west.

QUOTE

Narrator: So, after 242 days, ended the siege of Tobruk, not the biggest action of the war and far from the last, but one in which a sweaty, dirty, hopelessly outnumbered garrison by stubborn courage won for itself an unforgettable place in the world's history of battles.

DESERT SANDS

Bel-Air Productions Inc., 1955, color, 87 minutes.

Producers: Howard W. Koch, Aubrey Schenck; **Director:** Lesley Selander; **Screenwriters:** Danny Arnold, George W. George, John Rob (novel *Punitive Action*), George F. Slavin; **Music:** Paul Dunlap (song *Desert Sands*); **Distributor:** United Artists; **Cast:** Peter Bourne, John Carradine, Albert Carrier, Terrence De Marney, Marla English, Bela Kovacs, Keith Larsen, Peter Mamakos, Ralph Meeker, Lita Milan, Mort Mills, Nico Minardos, J. Carrol Naish, Peter Norman, Ron Randell, Aaron Saxon, John Smith, Philip Tonge, Jarl Victor, Otto Waldis, Joseph Waring.

Ralph Meeker is a tough Legionnaire in command of a fort in the Sahara under siege by the Arabs. When the relief column is wiped out, he has to abandon their position. An Arab princess, Marla English, whose brother is the rebellious Arab chief, is in love with him, and she helps him defeat the tribesmen.

DESERT SONG, THE

Warner Bros., 1929, b&w, 123 minutes.

Director: Roy Del Ruth; **Screenwriters:** Harvey Gates (story), Oscar Hammerstein II (play), Otto A. Harbach (play), Frank Mandel (play), Laurence Schwab (play); **Music:** Sigmund Romberg; **Cast:** Johnny Arthur, John Boles, Lester Cole, Peggy Dale, Del Elliott, Louise Fazenda, Guzmán, Otto Hoffman, Carlotta King, Myrna Loy, Edward Martindel, John Miljan, Jack Pratt, Marie Wells.

John Boles is the son of a French general whose secret identity is the Red Shadow. He leads the Riffs across the desert sands in their fight against the French.

The movie is based on a 1920 operetta by Sigmund Romberg.

INTERESTING FACT

- Some of the scenes were shot in a primitive Technicolor. All such prints are lost; only the b&w copies made in the 1950s for TV have survived.

DESERT SONG, THE

Warner Bros., 1943, color, 90 minutes.

Producer: Robert Buckner; **Director:** Robert Florey; **Screenwriters:** Robert Buckner, Oscar Hammerstein II (play), Otto A. Harbach (play), Frank Mandel (play), Laurence Schwab (play); **Music:** Heinz Roemheld, Clifford Vaughan, Sigmund Romberg; **Filmed at:** Canyon de Chelly National Monument, Arizona, Gallup and McKinley, New Mexico; **Cast:** Felix Basch, Curt Bois, Egon Brecher, Bruce Cabot, Wallis Clark, Joseph Crehan, Marcel Dalio, William Edmunds, Faye Emerson, Victor Francen, Noble Johnson, Jack La Rue, Fritz Leiber, Gene Lockhart, Irene Manning, Gerald Mohr, Dennis Morgan, Alberto Morin, Sylvia Opert, Lynne Overman, Nestor Paiva, Duncan Renaldo, Georges Renavent.

In French Morocco, Nazi spies plan to build a railroad, using Riffs as slave laborers. Dennis Morgan, whom everyone believes is an American piano player, is in reality the Red Rider (his secret identity), and he leads the Riffs in a fight for freedom.

The movie is based on a 1920 operetta by Sigmund Romberg.

INTERESTING FACTS

- This second version of the operetta has Nazis (against whom the United States was at war) replacing the French (then U.S. allies) as the bad guys.
- The original songs are retained in this version of the operetta, along with four new songs.
- This film was remastered in the 1990s and shown for one week in New York City before suddenly being taken out of circulation. Apparently, there is a copyright problem over one song in the movie, which has caused Warner Bros./Turner Classic Movies to withhold release of this version from theatrical circulation and home video.

Academy Awards, USA, 1944
 Nominated: *Oscar, Best Interior Decoration, Color,* Jack McConaghy, Charles M. Novi.

DESERT SONG, THE

Warner Bros. 1953, color, 110 minutes.

Director: H. Bruce Humberstone; **Screenwriters:** Oscar Hammerstein II (play), Otto A. Harbach (play), Roland Kibbee, Frank Mandel (play), Laurence Schwab (play); **Music:** Max Steiner, Sigmund Romberg; **Cast:** Trevor Bardette, Steve Cochran, Ray Collins, William Conrad, Mark Dana, Frank DeKova, Kathryn Grayson, Gordon MacRae, Raymond Massey, Allyn Ann McLerie, Paul Picerni, Dick Wesson.

Gordon McRae is thought by all to be a mild-mannered anthropology student, but in reality he has a secret identity as El Khobar. He battles Raymond Massey, a ruthless sheik, who has the Riffs under his thumb.

 The movie, as before, is based on a 1920 operetta by Sigmund Romberg.

INTERESTING FACTS

- This is the third film version of this operetta. The script here returns faithfully to the original, although there are exceptions.
- Margot is now the general's daughter, as opposed to McRea being the general's son.
- Benny Kidd is back as Benjy Kidd.
- As with the 1944 pseudo-remake, only five songs are retained from the original operetta (*Riff Song, Romance, The Desert Song, One Flower, One Alone*), with two interpolated (*Gay Parisienne* and *Long Live The Night*).
- Azuri has a dance, but to different music than in the original.

DESPERATE JOURNEY

Warner Bros., 1942, b&w, 108 minutes.

Producers: Jack Saper, Hal B. Wallis; **Director:** Raoul Walsh; **Screenwriter:** Arthur T. Horman; **Music:** Max Steiner; **Distributor:** Warner Bros.; **Cast:** Frank Alten, Rudolph Anders, Louis V. Arco, Felix Basch, Elsa Basserman, Albert Bassermann, Barry Bernard, Walter Bonn, Swen Hugo Borg, Walter Brooke, Nancy Coleman, Harold Daniels, Helmut Dantine, Carl Ekberg, Errol Flynn, Richard Fraser, Arno Frey, Eugene Gericke, Ilka Grüning, Alan Hale, Ludwig Hardt, William Hopper, Charles Irwin, Kurt Katch, Arthur Kennedy, Bruce Lester, Harry Lewis, Rolf Lindau, Jack Lomas, Raymond Massey, Lester Matthews, Frank Mayo, Patrick O'Moore, Don Phillips, Ronald Reagan, Otto Reichow, Henry Rowland, Sig Ruman, Ferdinand Schumann-Heink, Hans Schumm, Lester Sharpe, Ronald Sinclair, Bob Stephenson, Sigfrid Tor, Philip Van Zandt, Roland Varno, Henry Victor, Douglas Walton.

Errol Flynn assumes command of his bomber after the plane commander is wounded on a mission over Europe during World War II. He takes the aircraft down for a better look at the damage inflicted on the target, and as a result, the bomber is hit and forced down. As the crew escapes and evades the Germans, they destroy a secret airplane factory and hijack a German airplane and fly it back to England.

QUOTES

Errol Flynn: Now for Australia, and a crack at those Japs.

Arthur Kennedy: I didn't get into this war for fun or adventure or because it was expected of me. I got into it because it was a hard, dirty job that has to be done. It's no bright game to me. It's just a job.

Young Woman of the German Underground: I must stay here. No one's share is done until the war is over. It's our job, the job of the underground. Tell the people in England that there are people like us left in Germany, still living, still hoping, still fighting.

DESTINATION GOBI

20th Century-Fox, 1953, color, 90 minutes.

Producer: Stanley Rubin; **Director:** Robert Wise; **Screenwriters:** Everett Freeman, Edmund G. Love; **Music:** Sol Kaplan, Alfred Newman; **Cast:** Rodolfo Acosta, Ross Bagdasarian, Edgar Barrier, Russell Collins, Judy Dan, William Forrest, Darryl Hickman, Earl Holliman, Richard Loo, Martin Milner, Alvy Moore, Bert Moorhouse, Anthony Numkena, Jack Raine, Stuart Randall, Max Showalter, Leonard Strong, Don Taylor, Murvyn Vye, Richard Widmark.

Richard Widmark leads a group of U.S. Navy weathermen sent to the Gobi Desert to take meteorological measurements during World War II (based on a real episode). When the Japanese attack

their weather station, the survivors are helped in their escape across the desert by Mongol nomads.

DESTINATION TOKYO

Warner Bros., 1943, b&w, 135 minutes.

Producer: Jerry Wald; **Director:** Delmer Daves; **Screenwriters:** Delmer Daves, Steve Fisher, Albert Maltz; **Music:** William Lava, Franz Waxman; **Cast:** John Alvin, George Anderson, Warner Anderson, Warren Ashe, Joy Barlow, Harry Bartell, Whit Bissell, Carlyle Blackwell, Danny Borzage, William Challee, Lane Chandler, Cliff Clark, Dane Clark, Bob Creasman, Warren Cross, Angelo Cruz, Deborah Daves, Michael Daves, Warren Douglas, Faye Emerson, Jimmy Evans, Benson Fong, Wing Foo, John Forrest, John Forsythe, John Garfield, Roland Got, Cary Grant, Kirby Grant, Herbert Gunn, Alan Hale, William Hudson, Tony Hughes, Bill Hunter, Robert Hutton, Ted Jacques, Bill Kennedy, Mary Landa, Paul Langton, Eddie Lee, James B. Leong, George Lloyd, Bob Lowell, Cy Malis, Lou Marcelle, Ralph McColm, Jack Mower, Maurice Murphy, Paul Parry, William Prince, Hugh Prosser, John Ridgely, George Robotham, Dorothy Schoemer, Bernard Sell, Charles Sherlock, Mark Stevens, Charles Sullivan, Ya Sing Sung, John Sylvester, Frank Tang, Charles S. Thompson, Tom Tully, Jay Ward, Pierre Watkin, Russ Whiteman, John Whitney, Peter Whitney, Alan Wilson, Bruce Wong, Duke York.

Cary Grant commands the USS *Copperfin*, which sails under secret orders on Christmas Eve (just after Pearl Harbor) for Tokyo Bay in the early days of World War II. The submarine's mission is to enter the bay undetected and put a landing party ashore to obtain information vital to the upcoming Doolittle Raid on Tokyo.

INTERESTING FACT

- The film *THIRTY SECONDS OVER TOKYO* details the Doolittle Raid.

DESTROYER

Columbia Pictures Corporation, 1943, b&w, 99 minutes.

Producer: Louis F. Edelman; **Director:** William A. Seiter; **Screenwriters:** Borden Chase, Lewis Meltzer, Frank Wead; **Music:** Anthony Collins; **Cast:** David

Alison, Warren Ashe, Dean Benton, Curt Bois, Lloyd Bridges, Edward Brophy, Edgar Buchanan, Eddy Chandler, Marguerite Chapman, Roger Clark, Edmund Cobb, Tristram Coffin, Eleanor Counts, Eddie Dew, Lester Dorr, Glenn Ford, Bud Geary, Leo Gorcey, Al Hill, Bobby Jordan, Charles McGraw, John Merton, Dennis Moore, Larry Parks, Paul Perry, Don Peters, Addison Richards, Edward G. Robinson, Virginia Sale, Regis Toomey, Dale Van Sickel, Eddy Waller, Pierre Watkin, Craig Woods.

Edward G. Robinson is a longtime petty officer who wants to serve his country in World War II but is considered too old for military service. Using his position in a shipyard, he is able to maneuver himself into a position as the chief bosun's mate on the new destroyer that he is building. However, things go wrong on their shakedown cruise, and the captain, afraid that Robinson is too old, replaces him with the younger Glenn Ford. In action, the ship is badly damaged by a Japanese air attack, but Robinson redeems himself when he saves the ship, puts it back into action, and then goes on to ram an enemy submarine.

MILITARY SERVICE

- This film could have been Edward G. Robinson's life story if he hadn't gone on to become an actor after his military service. He enlisted in the U.S. Navy during World War I and requested assignment to military intelligence. By the time his transfer came through and he had finished training, the war was over; he was discharged in 1919.

DEVIL'S BRIGADE, THE

Wolper Pictures, 1968, color, 130 minutes.

Producer: David L. Wolper; **Director:** Andrew V. McLaglen; **Screenwriters:** Robert H. Adleman, William Roberts, George Walton; **Distributor:** United Artists; **Cast:** Claude Akins, Norman Alden, Dana Andrews, Luke Askew, Paul Busch, Alan Caillou, Harry Carey Jr., James Craig, Richard Dawson, Vince Edwards, Donald Ein, Bill Fletcher, Don Fullmer, Gene Fullmer, Jerry Gatlin, William Holden, Wilhelm von Homburg, Paul Hornung, Richard Jaeckel, Patric Knowles, Rex Layne, Julian Ludwig, Don Megowan, Hal Needham, Carroll O'Connor, Andrew Prine, David Pritchard, Michael Rennie, Cliff Robertson, Rita Rogers, Dick Simmons, Jeremy Slate, Tom Stern, Alix Talton, Max Tarilli, Maggie Thrett, Tom Troupe, Jean-Paul Vignon, Patrick Waltz, Jack Watson, Gretchen Wyler.

During World War II, a special elite fighting unit is formed by combining a crack Canadian outfit with a conglomeration of U.S. Army misfits from military jails. After an initial period of conflict between the two groups, their enmity turns to respect and friendship, and the unit is sent overseas, where they distinguish themselves in the critical battle for Monte Cassino.

The movie is based on Robert H. Adleman's and George Walton's *The Devil's Brigade* (Philadelphia: Chilton Books, 1966).

INTERESTING FACTS

- The Devil's Brigade actually existed. Organized on July 9, 1942, its official name was the First Special Service Force.
- Originally it was assigned to the Aleutians to defend North America from Japanese invasion (1942). This 1800-man force (a brigade) of Canadians and Americans was very well trained. Not only did it successfully execute a mission to land on the island of Kiska in the Aleutians to rid the island of Japanese forces, it also went on special missions to destroy hydroelectric stations in Norway and northern Italy and oil fields in Romania.
- It was involved in missions in Italy, including the breakout of the Anzio beachhead to the south of Rome. The film is based on the brigade's capture of Monte La Difensa, a strategic target during the battle for Monte Cassino. Winston Churchill personally singled out the group for its acts of heroism.
- The brigade suffered a casualty rate of 39 percent, and was disbanded at the end of the war.
- Veterans of the Devil's Brigade have been meeting each year since 1945 in Montana at the former training facility depicted in the movie.

QUOTES

Cliff Robertson [the Canadian commander, talking to William Holden, the American commander]: Many of the Canadian unit fought at Dunkirk, so it might be possible that you may want to learn a lesson from their combat experience.
Holden: Yes, I might, if you had won at Dunkirk. You lost. I'm training this outfit to win. Good night, Major. (NO CANADIANS AT DUNKIRK)

DEVIL WITH HITLER, THE

Hal Roach Studios Inc., 1942, b&w, 44 minutes.

Producer: Hal Roach Jr.; **Director:** Gordon Douglas; **Screenwriters:** Cortland Fitzsimmons, Al Martin;

Music: Edward Ward; **Distributor:** United Artists; **Cast:** Sig Arno, Herman Bing, Joe Devlin, Douglas Fowley, Alan Mowbray, George E. Stone, Bobs Watson, Marjorie Woodworth.

The board of directors of Hell want to replace Alan Mowbray (the devil) with Bobby Watson (Adolf Hitler). To prevent that from happening, the devil tries to get Hitler to do a good deed, which will disqualify him from assuming the top post down under.

DIARY OF ANNE FRANK, THE

20th Century-Fox, 1959, b&w, 180 minutes.

Producers: George Stevens Jr. (associate), George Stevens; **Director:** George Stevens; **Screenwriters:** Anne Frank (diary, *Anne Frank: The Diary of a Young Girl*), Frances Goodrich and Albert Hackett (also play); **Distributor:** 20th Century-Fox Film Corporation; **Music:** Alfred Newman; **Cast:** Diane Baker, Richard Beymer, Robert Boon, Delmar Erickson, Gretchen Goertz, Dodie Heath, Gusti Huber, Lou Jacobi, William Kirschner, Millie Perkins, Joseph Schildkraut, Douglas Spencer, Frank Tweddell, Charles Wagenheim, Shelley Winters, Ed Wynn.

During World War II, the family of Anne Frank, and other Dutch Jews, hide from the Nazis in the attic of an Amsterdam factory owned by a good samaritan. They must all be quiet during the day or the workers below will hear them, and they will be turned in to the Gestapo. During the day, all they can do is read to pass the time, and Anne begins a diary. Forced to live at length in close quarters under such restrictive conditions, they inevitably get on each other's nerves. Lack of food, deprivation, and the fear of discovery only increases their stress. As the years drag by, the shut-ins become more miserable. Ultimately, after years of hiding, the Gestapo finds them, and they are all sent to a concentration camp.

INTERESTING FACTS

- The film is based on the true life story of Anne Frank and the diary she kept while in hiding, and on the successful stage play by Frances Goodrich and Albert Hackett. Although she and the others survive until after D day, they are ultimately arrested by the Gestapo and sent to a concentration camp.
- The sole survivor of the family was Otto Frank, Anne's father. The rest died at the hands of the Nazis.

Otto Frank: For the past two years we have lived in fear. Now we can live in hope.

Otto Frank: We don't need the Nazis to destroy us. We're destroying ourselves.

AWARDS

Academy Awards, USA, 1959

Won: *Oscar, Best Art Direction—Set Decoration, Black-and-White,* George W. Davis, Stuart A. Reiss, Walter M. Scott, Lyle R. Wheeler; *Best Cinematography, Black-and-White,* William C. Mellor; *Best Supporting Actress,* Shelley Winters

Nominated: *Oscar, Best Costume Design, Black-and-White,* Charles Le Maire, Mary Wills; *Best Director,* George Stevens; *Best Music, Scoring of a Dramatic or Comedy Picture,* Alfred Newman; *Best Picture,* George Stevens Jr.; *Best Supporting Actor,* Ed Wynn

Golden Globes, USA, 1960

Won: *Golden Globe, Best Film Promoting International Understanding*

Writers Guild of America, USA, 1960

Won: *WGA Screen Award, Best Written American Drama,* Frances Goodrich, Albert Hackett.

DIRTY DOZEN, THE

Metro-Goldwyn-Mayer, 1967, color, 144 minutes.

Producers: Raymond Anzarut, Kenneth Hyman; **Director:** Robert Aldrich; **Screenwriters:** Lukas Heller, Nunnally Johnson, E. M. Nathanson; **Distributor:** MGM; **Filmed at:** Chenies, England; **Cast:** Ernest Borgnine, Charles Bronson, Jim Brown, Tom Busby, Ben Carruthers, John Cassavetes, Stuart Cooper, John Hollis, Richard Jaeckel, George Kennedy, Trini López, Colin Maitland, Al Mancini, Lee Marvin, Ralph Meeker, Robert Phillips, Dora Reisser, George Roubicek, Robert Ryan, Telly Savalas, Donald Sutherland, Clint Walker, Robert Webber, Thick Wilson.

A dozen dangerous criminals—including thieves, murderers, rapists, and psychopaths—all serving life sentences, are offered a chance for a pardon if they take part in a hazardous commando mission during World War II. They are trained under the leadership of an insubordinate major (Lee Marvin) and dropped by parachute near Rennes in Brittany to destroy a heavily guarded and fortified château used as a recreational center for general staff officers.

Completely unsaid in this film is: Why does this mission have to be done by convicted criminals and not by a regular commando team? The reason is that, on a subtle level, this movie is an allegory for the crimes that the Nazis themselves committed. This mission is not just to take an enemy strong point or destroy some vital part of the industrial war machine. The mission is to assassinate, not just officers but also women or anyone else found in this army recreational facility (noncombatants under international law). The final scenes of this movie make it look a little too much like Auschwitz, with gasoline and grenades dropped down the tubes, just as the gas pellets were in the death camps. This kind of genocide is the work of criminals, says the movie, and thus it can be done only criminals.

The film is based on E. M. Nathanson's *The Dirty Dozen* (New York: Random House, 1965).

INTERESTING FACTS

- Although Aldrich had tried to purchase the rights to E. M. Nathanson's novel while it was still in outline form, it was MGM that successfully acquired the property in May 1963. The book became a best-seller upon publication in 1965.
- The French château in the film was constructed especially for the production by art director Bill Hutchinson and his crew of 85. One of the largest sets ever built, it stood 240 feet across and 50 feet high. Gardeners surrounded the building with 5400 square yards of heather, 400 ferns, 450 shrubs, 30 spruce trees, and six full-grown weeping willows.
- Construction of the faux château proved too good. The script called for it to be blown up, but the construction was so solid that 70 tons of explosives would have been needed to achieve the effect! Instead, the section to be blown up was built from cork and plastic.

MILITARY SERVICE

- Charles Bronson completed 25 missions as a tail gunner on B-29s in the Pacific and received the Purple Heart.
- Robert Ryan enlisted in the U.S. Marines and spent World War II as a marine drill instructor at Camp Pendleton, California. Seeing the casualties of war as they returned home later turned him into a pacifist.

QUOTES

Joseph Wladislaw: Killin' generals could get to be a habit with me.

The Dirty Dozen (MGM PICTURES/AUTHOR'S COLLECTION)

Maj. John Reisman: You've seen a general inspecting troops before, haven't you? Just walk slow, act dumb, and look stupid!

AWARDS

Academy Awards, USA, 1967
Won: *Oscar, Best Effects, Sound Effects,* John Poyner
Nominated: *Oscar, Best Film Editing,* Michael Luciano; *Best Sound; Best Supporting Actor,* John Cassavetes

American Cinema Editors, USA, 1968
Won: *Eddie, Best Edited Feature Film,* Michael Luciano

Golden Globes, USA, 1968
Nominated: *Golden Globe, Best Supporting Actor,* John Cassavetes

Photoplay Awards, 1967
Won: *Gold Medal.*

DIVE BOMBER

Warner Bros., 1941, color, 133 minutes.

Producers: Robert Lord, Hal B. Wallis; **Director:** Michael Curtiz; **Screenwriters:** Robert Buckner, Frank Wead; **Music:** Max Steiner; **Distributor:** Warner Bros.; **Filmed at:** San Diego, California; **Cast:** Herbert Anderson, James Anderson, Tod Andrews, Robert Armstrong, Ralph Bellamy, Garrett Craig, Ann Doran, Charles Drake, Tom Dugan, Errol Flynn, William Forrest, Sol Gorss, Creighton Hale, Alan Hale Jr., Louis Jean Heydt, Howard C. Hickman, Russell Hicks, Max Hoffman Jr., William Hopper, Allen Jenkins, Owen King, Harry Lewis, Alexander Lockwood, Fred MacMurray, George Meeker, Dennie Moore, Lyle Moraine, Cliff Nazarro, David Newell, Wedgwood Nowell, Moroni Olsen, Steve Pendleton, Jane Randolph, Addison Richards, Walter Sande, Tom Seidel, Tom Skinner, Garland Smith, Stanley Smith, Alexis Smith, Juanita Stark, Craig Stevens, Alix Talton, Regis Toomey, Richard Travis, Don Turner, Dick Wessel, Larry Williams, Charlotte Wynters, Gig Young.

Ralph Bellamy is an older flight surgeon taken off flight status because he's ruined his health on high-altitude experiments. Errol Flynn joins him to help solve the problem of blackouts at high altitude. They are opposed by Fred MacMurray, a pilot who doesn't have any use for flight surgeons but eventually becomes a convert and helps them test the new equipment they develop to combat the blackouts.

INTERESTING FACTS

- This was one of the first war films made in color; it features pre–World War II navy aircraft in full color.
- Released before Pearl Harbor, when many people were worried about the United States being ready for war, the scenes of large navy flight formations and combat-ready aviators did much to reassure the public.

QUOTE

Fred MacMurray: Thirty years ago the navy had one airplane and two pilots. Only 20 years ago a naval aviator was the first man to fly the Atlantic. In those few years the men who've learned to fly here have really built naval aviation. Now you're here to learn to fly and fight and become part of that heritage.

DOCTOR ZHIVAGO

Metro-Goldwyn-Mayer, Sostar S.A., 1965, color, 197 minutes.

Producers: Arvid Griffen (executive), David Lean, Carlo Ponti; **Director:** David Lean; **Screenwriters:** Boris Pasternak (novel), Robert Bolt; **Music:** Maurice Jarre; **Distributor:** Metro-Goldwyn-Mayer; **Filmed at:** Barajas, Madrid, and Granada, Spain, Joensuu, Punkaharju, and Punkasalmi, Finland; **Cast:** Luana Alcañiz, Assad Bahador, Jose Caffarel, José María Caffarel, Emilio Carrer, Geraldine Chaplin, Erik Chitty, Julie Christie, Adrienne Corri, Tom Courtenay, Mark Eden, Catherine Ellison, Pilar Gómez Ferrer, Wolf Frees, Alec Guinness, Inigo Jackson, Gerhard Jersch, Bernard Kay, Geoffrey Keen, Klaus Kinski, Jack MacGowran, Peter Madden, Maria Martin, Roger Maxwell, Siobhan McKenna, Lili Muráti, Gwen Nelson, José Nieto, Ricardo Palacios, Ingrid Pitt, Ralph Richardson, Jeffrey Rockland, Mercedes Ruiz, Omar Sharif, Tarek Sharif, Rod Steiger, Virgilio Teixeira, Gérard Tichy, Brigitte Trace, Rita Tushingham, María Vico, Lucy Westmore, Noel Willman.

Doctor Zhivago (Omar Sharif) is an upper-class physician-poet ill suited to the life into which he is thrust. As he witnesses World War I and then the Bolshevik Revolution, he is first married, then in love with Julie Christie, who is herself married to a Russian revolutionary general. He is taken away from his wife and mistress by Red partisans and serves as their medical officer until he can no longer take any more of the butchery. He returns from the war to find his old Russia gone.

INTERESTING FACTS

- At one point, the refugees come to a town that has been razed. They ask, who did this, White Russians or Red? The woman has only one answer: "Soldiers," dramatizing the suffering of civilians in war, who do not know or care which side is right or wrong.
- Later on in the film, Zhivago confronts the general responsible for the massacre. When he tells him he burned the wrong town, the general says: "It doesn't matter."
- The film is based on the novel by Boris Pasternak, which won a Nobel Prize (New York: Pantheon, 1958).

MISTAKES

- The Urals are gradually rising mountains, not snowcapped peaks visible from perfectly flat steppes.
- Director David Lean is reflected in a glass door as Yuri gets off a trolley and enters a house.

QUOTES

Komarovski: There are two kinds of women, and you, as we well know, are not the first kind. You, my dear, are a slut.

Komarovski: There are two kinds of men and only two. And that young man is one kind. He is high-minded. He is pure. He's the kind of man the world pretends to look up to, and in fact despises. He is the kind of man who breeds unhappiness, particularly in women. Do you understand?

AWARDS

Academy Awards, USA, 1965

Won: *Oscar, Best Art Direction—Set Decoration, Color;* John Box, Terence Marsh, Dario Simoni; *Best Cinematography, Color;* Freddie Young; *Best Costume Design, Color;* Phyllis Dalton; *Best Music,*

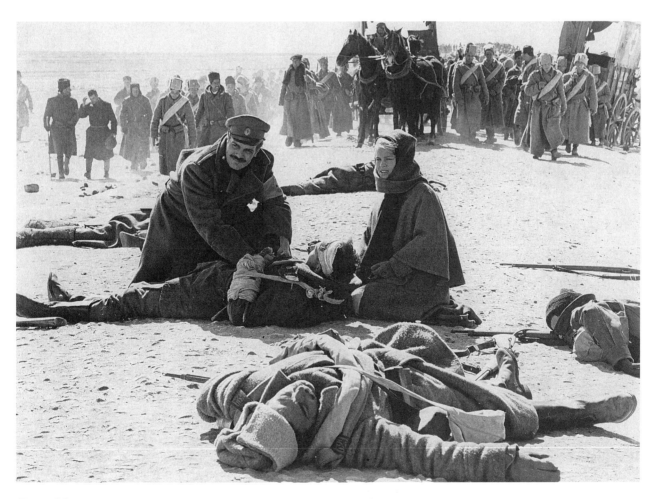

Doctor Zhivago (MGM PICTURES/AUTHOR'S COLLECTION)

Score—Substantially Original, Maurice Jarre; Best Writing, Screenplay Based on Material from Another Medium, Robert Bolt

Nominated: Oscar, Best Director, David Lean; Best Film Editing, Norman Savage; Best Picture, Carlo Ponti,; Best Sound, Franklin Milton (MGM SSD); A. W. Watkins (MGM British SSD), Best Supporting Actor, Tom Courtena

British Academy Awards, 1967

Nominated: BAFTA Film Award, Best British Actor, Ralph Richardson; Best British Actress, Julie Christie; Best Film from any Source, David Lean

British Society of Cinematographers, 1966

Won: Best Cinematography Award—Freddie Young

David di Donatello Awards, 1967

Won: David, Best Foreign Production (Migliore Produzione Straniera), Carlo Ponti

Golden Globes, USA, 1966

Won: Golden Globe, Best Motion Picture—Drama; Best Motion Picture Actor—Drama, Omar Sharif; Best Motion Picture Director, David Lean; Best Original Score, Maurice Jarre; Best Screenplay, Robert Bolt

Nominated: Golden Globe, Most Promising Newcomer—Female, Geraldine Chaplin (HFPA records do not specify a film)

Golden Screen, Germany, 1967

Won: Golden Screen

Grammy Awards, 1967

Won: Grammy, Best Original Score Written for a Motion Picture or Television Show, Maurice Jarre

National Board of Review, USA, 1965

Won: NBR Award, Best Actress, Julie Christie (also for her performance in Darling [1965])

People's Choice Awards, USA, 1988

Won: People's Choice Award, Favorite All-Time Motion Picture Song—My Love (Lara's theme).

DOGS OF WAR, THE

Juniper Films, 1980, color, 118 minutes.

Producers: Larry DeWaay, Norman Jewison, Patrick J. Palmer; **Director:** John Irvin; **Screenwriters:** Gary DeVore, Frederick Forsyth, George Malko; **Distributor:** United Artists; **Filmed in:** Belize; **Cast:** Pedro Armendáriz Jr., Christopher Asante, Thomas Baptiste, Tom Berenger, Robert Berger, Ilario Bisi-Pedro, Colin Blakely, Diana Bracho, Jim Broadbent, William Cain, Russell T. Carr, Erica Creer, Lawrence Davidson, Paul Freeman, Ernest Graves, George W. Harris, Kenny Ireland, Olu Jacobs, Jean-Pierre Kalfon, Jack Lenoir, Christopher Malcolm, Tony Mathews, Bruce McLane, Hugh Millais, Winston Ntshona, Ed O'Neill, André Penvern, Harlan Cary Poe, Hugh Quarshie, John Quentin, Jose Rabelo, Terence Rigby, Shane Rimmer, Sheila Ruskin, David Schofield, Maggie Scott, Jean-François Stévenin, Eddie Tagoe, Victoria Tennant, Kelvin Thomas, André Toffel, Robert Urquhart, Christopher Walken, JoBeth Williams.

Christopher Walken, an American mercenary, is hired to execute a coup in a small African country, to bring to power a dictator who will be friendly to a British multinational company. However, after he kills the original dictator, he unexpectedly dispatches the new puppet as well, and then redeems himself by installing a humane leader whom he had met earlier in prison and whom he knows will do good for the country.

The movie is based on Frederick Forsyth's The Dogs of War (Boston: G. K. Hall, 1974).

DONDI

Allied Artists Pictures Corporation, 1961, b&w, 80 minutes.

Director: Albert Zugsmith; **Screenwriters:** Gus Edson, Irwin Hasen; **Music:** Mort Garson, Earl Shuman; **Distributor:** Allied Artists; **Cast:** Gale Gordon, David Janssen, Susan Kelly, David Kory, John Melti, Patti Page, Dick Patterson, Louis Quinn, Bonnie Scott, Mickey Shaughnessy, Joan Staley, Arnold Stang, Robert Strauss, Nola Thorp, William Wellman Jr., Walter Winchell.

Dondi is an Italian waif who is adopted by a group of American GIs and brought to the United States.

The movie is based on the popular comic strip character "Dondi."

DOOMED BATTALION, THE

Universal Pictures, 1932, b&w, 95 minutes.

Director: Cyril Gardner; **Screenwriters:** Patrick Kearney, Paul Perez, Luis Trenker; **Distributor:** Universal Pictures; **Filmed at:** Austrian Tyrol; **Cast:** Henry Armetta, Tala Birell, Albert Conti, C. Henry Gordon, Ferdinand Gottschalk, Gibson Gowland, Gustav von Seyffertitz, Luis Trenker, Victor Varconi.

During World War I, an Austrian battalion holds a mountain stronghold against the attack of the Italian army. They have been ordered to hold their position at all costs, even at the risk of their own annihilation. However, the Italians are slowing tunneling under the mountain and plan to set off an explosion to destroy the stronghold, and the defenders with it.

INTERESTING FACTS

- A similar incident is portrayed in the 1936 World War I drama *THE ROAD TO GLORY*, directed by Howard Hawks.
- The incident portraying the undermining of the fortress and the blowing up of the defenders was based on a real incident, except that in the real battle, the victims of the explosion were Italians and the attackers were German.
- Luis Trenker portrays the scout who skis down the mountain in a last ditch attempt to discover the exact time that the Italians plan to set off the explosives.

DOUGHBOYS IN IRELAND

Columbia Pictures Corporation, 1943, b&w, 61 minutes.

Producer: Jack Fier; **Director:** Lew Landers; **Screenwriters:** Monte Brice, Howard J. Green; **Music:** Arthur Altman (song *All Or Nothing At All*); **Distributor:** Columbia Pictures; **Cast:** Harry Anderson, Kenny Baker, Guy Bonham, Wamp Carlson, James Carpenter, Jeff Donnell, Red Latham, Lynn Merrick, Robert Mitchum, Constance Purdy, Herbert Rawlinson, Neil Reagan, Syd Saylor, Muni Seroff, Harry Shannon, Larry Thompson, George Tyne, Dorothy Vaughan, Craig Woods.

Kenny Baker is a band leader and singer who falls in love while stationed in Ireland. An army ranger, he is wounded in a raid on the coast of Europe but is well enough to return to his Irish sweetheart.

DRAGONFLY SQUADRON

Allied Artists Pictures Corporation, 1953, b&w, 82 minutes.

Producer: John C. Champion; **Director:** Lesley Selander; **Screenwriter:** John C. Champion; **Cast:** Jess Barker, Bruce Bennett, Barbara Britton, Chuck Connors, Pamela Duncan, Benson Fong, John Hedloe, John Hodiak, Harry Lauter, John Lupton, Gerald Mohr, Fess Parker, Gene Wesson, Adam Williams.

John Hodiak is a major tasked with building an air force in South Korea before the expected attack of hordes of North Koreans. He drives his men to the breaking point, they are ready when the communist tanks drive south, and they decimate the enemy invasion.

DRAGON SEED

Metro-Goldwyn-Mayer, 1944, b&w, 145 minutes.

Producer: Pandro S. Berman; **Directors:** Harold S. Bucquet, Jack Conway; **Screenwriters:** Pearl S. Buck (novel), Jane Murfin, Marguerite Roberts; **Music:** Herbert Stothart; **Cast:** Philip Ahn, Lionel Barrymore, Turhan Bey, Abner Biberman, Robert Bice, Paul E. Burns, Anna Demetrio, Claire Du Brey, Benson Fong, Lee Tung Foo, Roland Got, Hurd Hatfield, Alex Havier, Ted Hecht, Katharine Hepburn, Al Hill, Walter Huston, Robbie Lee, Robert Lewis, Keye Luke, Charles Lung, Clarence Lung, Aline MacMahon, Abraham Mirkin, Agnes Moorehead, Leonard Mudie, J. Carrol Naish, Jay Novello, Frank Puglia, Frances Rafferty, Leonard Strong, Akim Tamiroff, Henry Travers, Philip Van Zandt, Jacqueline de Wit.

When the Japanese invade in 1937, a small Chinese village is subjected to a cruel and violent occupation. At first the villagers try passive resistance, but when they realize this is futile, they burn their crops, abandon their town, and become guerrillas.

The movie is based on Pearl S. Buck's *Dragon Seed* (New York: The John Day Company, 1942).

INTERESTING FACT

- During this period, the studio system still required Caucasian actors in Asian roles, which is why actors such as Katharine Hepburn and Walter Huston played Chinese villagers.

AWARDS

Academy Awards, USA, 1944
> **Nominated:** *Oscar, Best Cinematography, Black-and-White*, Sidney Wagner; *Best Supporting Actress*, Aline MacMahon.

DR. STRANGELOVE OR: HOW I LEARNED TO STOP WORRYING AND LOVE THE BOMB

Hawk Films, 1964, b&w, 93 minutes.

Producers: Stanley Kubrick, Victor Lyndon, Leon Minoff; **Director:** Stanley Kubrick; **Screenwriters:** Peter George, Stanley Kubrick, Terry Southern; **Music:**

Laurie Johnson; **Distributor:** Columbia Pictures; **Cast:** Glenn Beck, Frank Berry, Peter Bull, Jack Creley, Hal Galili, Sterling Hayden, Laurence Herder, James Earl Jones, John McCarthy, Robert O'Neil, Slim Pickens, Tracy Reed, Shane Rimmer, George C. Scott, Peter Sellers, Roy Stephens, Paul Tamarin, Gordon Tanner, Keenan Wynn.

Gen. Jack D. Ripper, USAF, goes completely mad and sends his bomber wing to destroy the Russians. He believes that the communists are conspiring to pollute the "precious bodily fluids" of the American people. The U.S. president meets with the Soviet ambassador, who tells him that if the USSR is hit by nuclear weapons, that will trigger a doomsday device, destroying all plant and animal life on earth. Peter Sellers portrays the three men who might avert this tragedy: Group Capt. Lionel Mandrake, the only person with access to the demented Gen. Ripper; President Merkin Muffley, whose best attempts to divert disaster depend on placating the drunken Soviet premier; and the former Nazi genius Dr. Strangelove, who concludes that such a doomsday device is not a very practical deterrent if the Russians kept it secret! Unfortunately, the bombers are not stopped in time, and the world is destroyed.

Major Kong (Slim Pickens), the commander of the only bomber to get through, waves his cowboy hat as he rides the bomb into oblivion, surely one of the most enduring images of the atomic era.

The film is based on Peter George's *Red Alert*, a.k.a. *Two Hours to Doom*, and Peter Bryant's *Red Alert* (New York: Ace Books, 1958).

Dr. Strangelove (COLUMBIA PICTURES/AUTHOR'S COLLECTION)

INTERESTING FACTS

- In the novel by Peter George the two H-bombs are named "Hi There!" and "Lolita." Two years earlier, Kubrick had directed *Lolita* (1962). The graffiti on the second bomb is "Dear John" in the movie.
- Sellers based Dr. Strangelove's strangled accent on the voice of Weegee (Arthur Felig), the famous German-born crime photographer of the 1950s whose nickname was bestowed by New York police due to his uncanny ability to show up at murder scenes before they did. Sellers heard Weegee talking during an on-set visit and adapted his strange German accent for the title character.
- Peter Sellers was cast in four roles but experienced problems when trying to develop a Texas accent for Maj. T. J. "King" Kong. After sending Kubrick a letter informing him he would be unable to play the part under any circumstances, he (fortunately) broke his leg while exiting his car. Despite doubts over the legitimacy of the injury, Kubrick was forced by the production's insurance company to find another actor. Convinced that nobody could have acted the part as well as Sellers, Kubrick decided to cast someone who naturally fit the role. Remembering his brief work on the Western film *One-Eyed Jacks* (1961), Kubrick cast Slim Pickens as Kong, the gung-ho hick pilot determined to drop his bombs at any cost. Pickens was never shown the script nor told it was a black comedy. Ordered by Kubrick to play it straight, he played the role as if it were a serious drama—with amusing results.
- Maj. Kong's comment about the survival kit ("a fella could have a pretty good weekend in Vegas with all

that stuff") originally referred to Dallas instead of Las Vegas; but was overdubbed after President Kennedy's assassination in Dallas.

- Maj. Kong's plane's primary target is an ICBM complex at Laputa. In Jonathan Swift's 1726 novel *Gulliver's Travels*, Laputa is a place inhabited by caricatures of scientific researchers.

- The photographic mural in Gen. Ripper's office, presumably showing an aerial view of Burpelson AFB, is actually a view of Heathrow Airport, London.

- Kubrick intended the film to end with a custard pie fight between the Russians and the Americans in the War Room (which is why we see a big table of food there). The footage was shot, but he decided not to use it because he considered it too farcical to fit in with the satirical nature of the rest of the film.

- Another reason for cutting the custard pie fight at the end of the film was that, at one point, President Muffley took a pie in the face and fell down, prompting Gen. Turgidson to cry, "Gentlemen! Our gallant young president has just been struck down in his prime!" Kubrick had already decided to cut the pie fight before the Kennedy assassination, but this line (or possibly even the whole sequence) would certainly have been cut due to its eerie similarity to real events.

- Gen. Turgidson (George C. Scott) was not scripted to fall over in the war room when he gets excited, but when it happened, Kubrick decided it was in character and left it in.

- When Strangelove is talking about the doomsday device, Turgidson says to Strangelove, "What is that, German?" The reply is "He changed his name; it was originally Merkwurdigliebe—which in German means 'Strangelove.'"

- Some references show the date of this film as 1963. Its world premiere was scheduled for December 12, 1963, but following John F. Kennedy's assassination on November 22, it was felt to be inappropriate to release such a film so soon afterward, so it was not shown until January 1964.

- The end sequence, in which Vera Lynn's *We'll Meet Again* is played over several shots of nuclear explosions, was suggested by Peter Sellers's fellow ex-Goon, Spike Milligan.

- The centerfold in Maj. "King" Kong's copy of *Playboy* is Gen. Turgidson's secretary, Miss Scott.

- Peter Sellers (at his most brilliant) as Dr. Strangelove is a crippled immigrant German scientist who keeps inadvertently calling the president "Mein Führer" and whose crippled arm has a life of its own, continually rising in a Nazi salute, a sardonic commentary on the many German scientists who were taken to the United States after World War II.

- The only reason the United States beat the Russians in the space race, it is often said, is because our German scientists were better than their German scientists.

- Dr. Strangelove was made shortly after the Cuban Missile Crisis, in which the United States and the Soviet Union came close to nuclear war. In the early 1960s the United States began a program to acquire enough long-range nuclear delivery devices to give it a first-strike capability and a four-to-one advantage over the Russians in nuclear missiles. At the end of the buildup, the United States had 1,000 Minuteman missiles, 32 Polaris submarines that could deliver 656 warheads, and 600 B-52 bombers that could carry nuclear bombs. The Soviets gambled that they could install intermediate-range missiles in Cuba undetected and redress the imbalance in nuclear forces without the necessity of building long-range delivery devices. The United States discovered this scheme before the missiles were operational and, in a tense week or so in which the whole country held its breath, forced the Soviets to dismantle the missiles and take them back to Russia. The Soviets, determined never to be caught short again, embarked on a massive nuclear arms buildup, and the arms race heated up again. It was in this climate that Dr. Strangelove was made.

MILITARY SERVICE

- James Earl Jones was in ROTC in college and was commissioned a second lieutenant on graduation. He was sent to Cold Weather Command in Colorado, where he did so well that he seriously considered making the army a career.

MISTAKES

- Burpelson Air Force Base is in daylight throughout the incident, and yet in Washington, D.C. it is 3 A.M.
- After the bomber is 10 miles from the target it takes almost 4 minutes to advance 3 miles more, giving an impossibly low speed of about 45 mph.
- Gen. Ripper holds a 50-caliber machine gun by its barrel. This would be almost impossible to do after 10 or 20 rounds were fired, because the barrel would be very hot.

QUOTES

Gen. Jack D. Ripper: I can no longer sit back and allow communist infiltration, communist indoctrination, communist subversion, and the international com-

munist conspiracy to sap and impurify all of our precious bodily fluids.

Gen. Buck Turgidson: Mr. President, I'm not saying we wouldn't get our hair mussed. But I do say no more than 10 to 20 million killed, tops. Uh, depending on the breaks.

President Merkin Muffley: You can't fight in here; this is the War Room!

Gen. Buck Turgidson: Gee, I wish we had one of them doomsday machines.

AWARDS

Academy Awards, USA, 1964
> **Nominated:** *Oscar, Best Actor,* Peter Sellers; *Best Director,* Stanley Kubrick; *Best Picture,* Stanley Kubrick; *Best Writing, Screenplay, Based on Material from Another Medium,* Peter George, Stanley Kubrick, Terry Southern

Bodil Festival, 1964
> **Won:** *Bodil, Best American Film (Bedste amerikanske film),* Stanley Kubrick (director)—award was given in this, category, even though it wa, produced in the UK.

British Academy Awards, 1965
> **Won:** *BAFTA Film Award, Best British Art Direction, (B/W),* Ken Adam; *Best British Film; Best Film from any Source*
> **Nominated:** *BAFTA Film Award, Best British Actor,* Peter Sellers; *Best British Screenplay,* Peter George, Stanley Kubrick, Terry Southern; *Best Foreign Actor,* Sterling Hayden

Hugo Awards, 1965
> **Won:** *Hugo, Best Dramatic Presentation*

Italian National Syndicate of Film Journalists, 1965
> **Won:** *Silver Ribbon, Best Director—Foreign Film, (Regista del Miglior Film, Straniero),* Stanley Kubrick

National Film Preservation Board, USA, 1989

National Film Registry

New York Film Critics Circle Awards, 1964
> **Won:** *NYFCC Award, Best Director,* Stanley Kubrick

Writers Guild of America, USA, 1965
> **Won:** *WGA Screen Award, Best Written American Comedy,* Peter George, Stanley Kubrick, Terry Southern.

DRUMS OF THE DESERT

Monogram Pictures Corporation, 1940, b&w, 64 minutes.

Director: George Waggner; **Screenwriters:** Dorothy Davenport, John T. Neville (story), George Waggner (as Joseph West); **Cast:** Ralph Byrd, Ann Codee, William Costello, Jean Del Val, Lorna Gray, Boyd Irwin, George Lynn, Neyle Marx, Mantan Moreland, Alberto Morin.

Ralph Byrd and George Lynn, paratroop officers in the French Foreign Legion, compete for the love of the same woman, Lorna Gray.

DUNKIRK

Ealing Studios, 1958, b&w, 134 minutes.

Producers: Michael Balcon, Michael Forlong (associate producer); **Director:** Leslie Norman; **Screenwriters:** J. S. Bradford (play), Ewan Butler (play), David Divine, Adam Hall (novel, *The Big Pickup*) (as Elleston Trevor), W. P. Lipscomb; **Music:** Malcolm Arnold; **Distributor:** Metro-Goldwyn-Mayer; **Cast:** Chesney Allen, Patrick Allen, Joss Ambler, Warwick Ashton, Richard Attenborough, Maxine Audley, Sean Barrett, Michael Bates, Eddie Byrne, Kenneth Cope, Roland Curram, Rodney Diak, Meredith Edwards, Bud Flanagan, Barry Foster, Denys Graham, Dan Gressy, Fred Griffiths, Michael Gwynn, Peter Halliday, Nicholas Hannen, Ronald Hines, John Horsley, Ray Jackson, Lionel Jeffries, Lloyd Lamble, Harry Landis, Bernard Lee, Victor Maddern, John Mills, Anthony Nicholls, Frederick Piper, Patricia Plunkett, Cyril Raymond, Christopher Rhodes, Michael Shillo, William Squire, Robert Urquhart, John Welsh.

John Mills is a reluctant corporal who becomes responsible for the lives of his men when their officer is killed. Trapped at Dunkirk, he has to get them back to Britain.

The Battle of Dunkirk was actually one of the greatest retreats in history, the rescue of the British army from the French coast in May 1940. At the outbreak of the hostilities that became World War II, England had sent a large army, an expeditionary force, to the European mainland to support its French allies against the Nazi advance. Utterly overwhelmed by the German blitzkrieg, or "lightning war," the British and French armies were surrounded and cut off from any hope of relief near the town of Dunkirk in northern France.

Code-named "Operation Dynamo," from May 26 to June 4, 1940, a fleet of 220 navy ships and 660 other vessels, including sloops and private yachts, in fact anything that the British could find that could float, was thrown across the channel to evacuate the 330,000 British, French, and other Allied troops trapped there. Many French units volunteered to stay behind as a rearguard, and they were eventually overwhelmed and captured by the Germans. The British lost a number of ships, including six destroyers sunk and 11 damaged, and they were forced to abandon all of their field equipment.

The movie is based on a novel, Elleston Trevor's *The Big Pick-Up* (London: Heinemann, 1955). The screenplay was the work of W. P. Lipscomb, with David Divine, a journalist experienced in military affairs and history. The script was by Ewan Butler.

INTERESTING FACT

- Other films that contain references to Dunkirk include *A YANK IN THE R.A.F.*, *MRS. MINIVER*, *CAPTAINS OF THE CLOUDS*, *THE LONGEST DAY*, and *THE DEVIL'S BRIGADE*.

DURING ONE NIGHT

Gala World Film, 1961, color, 77 minutes.

Producer: Sidney J. Furie; **Director:** Sidney J. Furie; **Screenwriters:** Sidney J. Furie, Anthony Gibbs; **Music:** Bill McGuffie; **Cast:** John Bloomfield, Don Borisenko, Tom Busby, Jackie Collins, Michael Golden, Graydon Gould, Susan Hampshire, Colin Maitland, Barbara Ogilvie, Roy Stephens, Sean Sullivan, Joy Webster.

During World War II, a wounded and traumatized American flyer becomes so obsessed with losing his virginity, lest he end up like a colleague who was castrated during a mishap on their last mission, that he goes AWOL. He eventually finds an obliging young streetwalker, but unfortunately stress and fear have rendered him impotent. He tries again with a kindly young woman, but at the crucial moment the MPs arrive and arrest him. However, a sympathetic chaplain eventually gets him released, and romance blooms when he returns to the young woman.

EAGLE AND THE HAWK, THE

Paramount Pictures, 1933, b&w, 68 minutes.

Producer: Bayard Veiller; **Directors:** Mitchell Leisen (associate), Stuart Walker; **Screenwriters:** Seton I. Miller, Bogart Rogers, John Monk Saunders (story, "Death in the Morning"); **Music:** Karl Hajos, Rudolph G. Kopp, John Leipold; **Cast:** Lane Chandler, Paul Cremonesi, Adrienne D'Ambricourt, Cary Grant, Virginia Hammond, Forrester Harvey, Leyland Hodgson, Kenneth Howell, Olaf Hytten, Jacques Jou-Jerville, Crauford Kent, Carole Lombard, Robert Manning, Fredric March, Jack Oakie, Dennis O'Keefe, Douglas Scott, Russell Scott, Yorke Sherwood, Guy Standing, John Stevens, Frank Tomick.

Fredric March is a pilot in an observation squadron of the Royal Flying Corps during World War I. As he becomes more and more successful in downing enemy aircraft, and his fellow pilots and observers die one by one, he becomes more and more morose, despite a liaison with beautiful Carole Lombard. Finally, his depression leads him to take his own life in his quarters. His body is discovered by Cary Grant, who puts him into his aircraft, crashes it, and riddles the plane with bullets, to give him a fitting death as a hero.

INTERESTING FACTS

- Aerial footage was used from *WINGS* (1927), *Lilac Time* (1928), and *THE DAWN PATROL* (1930).

- When he learns that Fredric March has committed suicide, Cary Grant takes him up in his plane, crashes it, and riddles it with bullets, making it look like he died a hero's death. Three years later, in the film *Suzy*, Franchot Tone recreates the exact same hero's death—for Cary Grant!

EAGLE HAS LANDED, THE

Associated General Films, 1976, color, 134 minutes.

Producers: David Niven Jr., Jack Wiener; **Director:** John Sturges; **Screenwriters:** Jack Higgins, Tom Mankiewicz; **Distributor:** American International Pictures; **Filmed in:** Finland, Mapledurham, Oxfordshire, England; **Cast:** Jenny Agutter, Tim Barlow, John Barrett, Kate Binchy, Keith Buckley, Michael Byrne, Michael Caine, Jeff Conaway, Robert Duvall, Anthony Forrest, Judy Geeson, David Gilliam, Larry Hagman, Joachim Hansen, Alexei Jawdokimov, Denis Lill, Jean Marsh, Jack McCulloch, Rick Parse, Donald Pleasence, Terence Plummer, Anthony Quayle, Siegfried Rauch, Robert G. Reece, Maurice Roëves, John Standing, Donald Sutherland, Sven-Bertil Taube, Asa Teeter, Léonie Thelen, Treat Williams, Richard Wren.

Michael Caine is a German officer during World War II who has been imprisoned for opposing genocide. He is released, on the condition that he take an assignment

to go to England and assassinate Winston Churchill. His group of loyal commandos dress as Polish soldiers and install themselves in a small English town, telling the villagers that they are on a training maneuver.

The movie is based on Jack Higgins's novel *The Eagle Has Landed* (London: Collins, 1975).

MILITARY SERVICE

- Michael Caine served in Korea as an infantryman.

MISTAKES

- There were no established German secret agents in Britain by 1943. All German attempts to set up secret agents there were quickly detected and the agents captured or, usually, turned to the British side.
- Father Verecker says he's figured out Steiner's plan to "assassinate" Churchill. Pamela overhears and flees, first to Joanna and then to the Americans. She tells Joanna that the Germans mean to "kidnap" Churchill, but tells the Americans that the plan is to kill him.
- When leaving the quay, having off-loaded the bodies of the dead German crew from the "suicide" boats, a man is first seen covered in blood (on his jacket) from his compatriots; a few seconds later while climbing stairs, he is perfectly clean.

QUOTES

Col. Max Radl [after watching Donald Sutherland calm a guard dog with a soft whistle and a pointing finger]: In the Middle Ages they'd have burned you for that.

Capt. Clark: Colonel, there's no such thing as death with honor. Just death.

Col. Kurt Steiner: I have no intention of dying now. But if I'm going to, allow me to choose where and how.

EAGLE SQUADRON

Universal Pictures, 1942, b&w, 109 minutes.

Producer: Walter Wanger; **Director:** Arthur Lubin; **Screenwriters:** C. S. Forester, Norman Reilly Raine; **Music:** Frank Skinner; **Distributor:** Universal Pictures; **Cast:** Eddie Albert, Evelyn Ankers, Howard Banks, Edgar Barrier, Diana Barrymore, Linda Bieber, Nigel Bruce, John Burton, Mary Carr, Paul Cavanagh, David Clyde, Gladys Cooper, Richard Crane, Richard Davies, Harold De Becker, James Eagles, Isobel Elsom, Leif Erickson, Jill Esmond, Richard Fraser, Peggy Ann Garner, Edmund Glover, Alan Hale Jr., Jon Hall, Carl Harbord, Olaf Hytten, Charles Irwin, Todd Karns,

Charles King, Harold Landon, Peter Lawford, Rex Lease, Queenie Leonard, Bruce Lester, John Loder, Audrey Long, Gavin Muir, Alan Napier, Tarquin Olivier, Frank Penny, Don Porter, Gene Reynolds, Quentin Reynolds, Stanley Ridges, James Seay, William Severn, Ivan F. Simpson, Stanley Smith, Robert Stack, Tom Stevenson, Clarence Straight, Donald Stuart, Robert Warwick, Rhys Williams, Ian Wolfe, Frederick Worlock.

Robert Stack is the leader of a group of American fighter pilots who volunteer to serve in the Royal Air Force during the Battle of Britain and who are formed into an all-American squadron appropriately named the "Eagle Squadron."

INTERESTING FACTS

- To make the film look authentic, the British government provided actual combat air footage.
- Quentin Reynolds, an American war correspondent, narrated the introduction, explaining why Americans, whose country had not entered the war at the time of the formation of the Eagle Squadron, volunteered to serve with the English in their fight against the Germans.
- This film is based on the exploits of the real-life Eagle Squadron, a squadron of Americans flying the standard British Spitfire. There were eventually three Eagle Squadrons formed in England by American aviators who were sympathetic to England's plight during the Battle of Britain and frustrated by the failure of the United States to enter the war in support of the British. The first squadron was formed in September 1940. The fliers wore an eagle patch to signify that they were American. Their battle record was impressive. In action over Europe and the Mediterranean the squadron shot down more than 70 German planes and sustained looses in excess of 100 aviators, including those killed, captured, or missing in action.
- With the arrival of the Americans into the war, all three squadrons were transferred to the Eighth Air Force in September 1942, but they were allowed to keep their British Spitfires.
- *LAFAYETTE ESCADRILLE* is also about the adventures of American aviation volunteers, in this instance fighting with the French in World War I.

EDGE OF DARKNESS

Warner Bros., 1942, b&w, 120 minutes.

Producer: Henry Blanke; **Director:** Lewis Milestone; **Screenwriters:** Robert Rossen, William Woods; **Music:** Franz Waxman; **Distributor:** Warner Bros.;

Filmed at: Monterey, California; **Cast:** Judith Anderson, John Beal, Monte Blue, Roman Bohnen, Henry Brandon, Morris Carnovsky, Glen Cavender, Virginia Christine, Nancy Coleman, Helmut Dantine, Charles Dingle, William Edmunds, Peter van Eyck, Tom Fadden, Errol Flynn, Richard Fraser, Frederick Giermann, Ruth Gordon, Kit Guard, Walter Huston, Kurt Katch, Richard Kipling, Kurt Kreuger, Vera Lewis, Rolf Lindau, Torben Meyer, Peter Michael, Francis Pierlot, Victor Potel, Henry Rowland, Tonio Selwart, Ann Sheridan, Art Smith, Helen Thimig, Dorothy Tree, Frank Wilcox, Lottie Williams.

Errol Flynn and Ann Sheridan are two leaders of the Resistance movement in a small fishing village in Norway. With the arrival of arms from England, they revolt against their oppressors, and when the German reinforcements arrive, all they find are the dead bodies of Nazi soldiers. The townspeople have disappeared, the women and children in fishing boats to England and the men into the hills to carry on the fight.

QUOTE

Franklin D. Roosevelt: If anyone wonders why this war is being fought, let him look to Norway. And if there's anyone who has doubt of the democratic will to win, again I say, let him look to Norway.

EIGHT IRON MEN

Columbia Pictures Corporation, 1952, b&w, 80 minutes.

Producer: Stanley Kramer; **Director:** Edward Dmytryk; **Screenwriter:** Harry Brown; **Music:** Leith Stevens; **Distributor:** Columbia Pictures; **Cast:** Mary Castle, Bonar Colleano, George Cooper, Nick Dennis, Arthur Franz, Richard Grayson, James Griffith, Douglas Henderson, Richard Kiley, Lee Marvin, David McMahon, Dickie Moore, Robert Nichols, Barney Phillips.

During World War II, a squad of GIs, fighting from an abandoned farmhouse, struggle to save their comrade, who is pinned down by machine-gun fire. The soldiers make futile attempts to rescue their friend, while at the same time exchanging stories and wisecracks. In the end, it is Bonar Colleano who goes out to rescue his buddy.

84 CHARLIE MOPIC

New Century/Vista, 1989, color, 95 minutes.

Producers: Stephen Hunter Flick, Jill Griffith, Michael Nolin; **Director:** Patrick Sheane Duncan; **Screenwriter:** Patrick Sheane Duncan, **Filmed in:** Southern California; **Cast:** Richard Brooks, Christopher Burgard, Nicholas Cascone, Sonny Carl Davis, Dale Dye, Jonathan Emerson, Joseph Hieu, Glenn Morshower, Glenn Plummer, Don Schiff, Michael Stokey, Byron Thames, Russ Thurman, Jason Tomlins.

A close-knit six-man reconnaissance squad undertakes a dangerous mission in Vietnam, accompanied by a combat cameraman.

INTERESTING FACTS

- In the title of the film, the term "Charlie" refers to the Vietcong; the term "Mopic" is an abbreviation for "Motion Picture." Although the film was released in 1989, it can only be presumed that "84" refers to the year it went into production, and that "84 Charlie Mopic" was a working title that stuck.
- This film is documentary style, told from the point of view of an army combat cameraman.

QUOTE

Easy [soon to be promoted to Pfc]: Private fucking civilian!

EL ALAMEIN

Columbia Pictures Corporation, 1953, b&w, 66 minutes.

Producer: Wallace MacDonald; **Director:** Fred F. Sears; **Screenwriters:** Horace McCoy, Herbert Purdom (also story), George Worthing Yates; **Cast:** Edward Ashley, Scott Brady, Peter Brocco, Robin Hughes, Peter Mamakos, Rita Moreno, Ray Page, Michael Pate, Henry Rowland, Benny Rubin.

Scott Brady, a civilian contractor who maintains tanks for the British army, gets lost in the desert with a tank crew, and together they stumble upon a Nazi supply depot. They manage to hold off Rommel's tanks and blow up the fuel dump before they are finally relieved.

INTERESTING FACTS

- This film is similar in plot to Humphrey Bogart's *SAHARA*, except that in Bogart's film the tank crew had water vital to the attacking Germans. In this film those holding the oasis have critical gasoline.
- In *BATTLE OF THE BULGE*, taking a fuel depot is a major plot point.

ELENI

CBS Entertainment Productions, 1985, color, 114 minutes.

Producers: Nicholas Gage, Nick Vanoff; **Director:** Peter Yates; **Screenwriters:** Nicholas Gage, Steve Tesich; **Music:** Bruce Smeaton; **Cast:** Noam Almaz, Dimitra Arliss, Oliver Cotton, Rosalie Crutchley, John Eastham, Stefan Gryff, Glenne Headly, Linda Hunt, Lisa Jakub, Alison King, Leon Lissek, John Malkovich, Arlene Mazerolle, Kate Nelligan, Ronald Pickup, Steve Plytas, Adrienne Pocock, Lisa Rose, Jon Rumney, Anthony Stamboulieh, Vic Tablian, Peter Woodthorpe, Michael Zelniker.

John Malkovich is a reporter who has waited 30 years for a posting in Greece so that he can investigate the death of his mother during the Greek civil war. What he discovers is that the communists executed his mother for helping children escape deportation and enslavement in the Soviet Union.

INTERESTING FACTS

- The Greek civil war (1944–1949) was the first of the cold war fights against communism that were to include Korea and Vietnam.
- Greece was liberated by the Allies on December 3, 1944, and almost immediately the communists attempted to take control. The British held a referendum, in which the people voted overwhelmingly for democracy, not surprising since ancient Greece is considered the birthplace of the concept. Not satisfied, the communists resumed combat, and the bitter fighting continued until 1949, when the communist rebel forces were finally defeated.
- Greeks are still bitter over the abduction and enslavement by the communists of young children, who were sent to the Soviet Union.
- Greece became a member of NATO; Nicholas Gage served with these Greek NATO forces in Kosovo.
- The fim is based on the nonfiction book by Nicholas Gage.

EMPIRE OF THE SUN

Amblin Entertainment, 1987, color, 154 minutes.

Producers: Kathleen Kennedy, Chris Kenny, Frank Marshall, Robert Shapiro, Steven Spielberg; **Director:** Steven Spielberg; **Screenwriters:** J. G. Ballard, Menno Meyjes, Tom Stoppard; **Music:** John Williams;

Distributor: Warner Bros.; **Filmed in:** Spain and England, Tiki Island, Texas; **Cast:** Hiro Arai, Christian Bale, Barbara Bolton, Tony Boncza, Ann Castle, Za Chuan Ce, Shirley Chantrell, Ray Charleson, Peter Copley, Michael Crossman, Tom Danaher, Nicholas Dastor, Jack Dearlove, Frank Duncan, Ronald Eng, Eric Flynn, Sheridan Forbes, Rupert Frazer, Peter Gale, Yvonne Gilan, James Greene, Paula Hamilton, Simon Harrison, Nigel Havers, Barrie Houghton, Masato Ibu, Guts Ishimatsu, Kieron Jecchinis, Marc de Jonge, Takatoro Kataoka, Bert Kwouk, Nigel Leach, Susan Leong, Guo Xue Liang, Francesca Longrigg, Sybil Maas, John Malkovich, Sylvia Marriott, Paul McGann, Ralph Michael, John Moore, David Neidorf, Joe Pantoliano, Gary Parker, Leslie Phillips, Emma Piper, Edith Platten, Shi Bui Qing, Ann Queensberry, Thea Ranft, Emily Richard, Miranda Richardson, Ralph Seymour, Zhai Nai She, Robert Stephens, Ben Stiller, Anna Turner, James Walker, Samantha Warden, Takao Yamada, Ge Tan Zhao.

A young boy's privileged life is turned upside down by the Japanese invasion of Shanghai on December 8, 1941. Separated from his parents, he is eventually captured and taken to Soo Chow concentration camp, next to a captured Chinese airfield. The spoiled, only child of an international British banker, he has no choice but to learn how to survive in the internment camp run by the Japanese. The young boy, the ultimate airplane enthusiast, is thrilled to see a P-51 Mustang fighter roar by as the pilot, the canopy open, waves at him.

The film is based on J. G. Ballard's *Empire of the Sun* (New York: Pocket Books, 1985), an autobiographical novel by a writer whose usual genre is science fiction.

INTERESTING FACTS

- "Suo Gan," the movie's theme song, is a lullaby sung in Welsh. Director Steven Spielberg chose it after casting Welsh actor Christian Bale as Jim. It was sung by James Rainbird.
- Ballard has a cameo at the party in the opening scenes.
- The Japanese Zero fighters are in fact North American–built Harvard trainers modified to look like the Zero.
- The B-29 Super Fortress seen in the film is in fact the last flying B-29 in the world ("FiFi"), flown by the "Confederate Air Force."

MILITARY SERVICE

- Writer J. G. Ballard was born November 15, 1930, in Shanghai, China. He joined the Royal Air Force. Both China and the air force influenced his book and this movie.

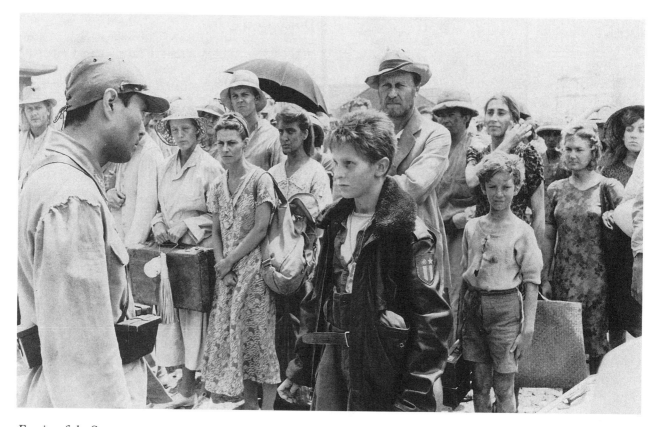

Empire of the Sun (WARNER BROS./AUTHOR'S COLLECTION)

QUOTES

Dainty: You want a Hershey Bar, kid?
Jim: Yeah.
Dainty: So do I, you got one?

Basie: Jim, didn't I teach you anything?
Jim: Yes! You taught me that people will do anything
for a potato.

Jim [when nurses attempt to wake a sickly man]: Can I
have his shoes when he's dead?
Dr. Rawlins: God, you're a pragmatist, Jim.

AWARDS

Academy Awards, USA, 1987
Nominated: *Oscar, Best Art Direction—Set Decoration*, Harry Cordwell, Norman Reynolds; *Best Cinematography*, Allen Daviau; *Best Costume Design*, Bob Ringwood; *Best Film Editing*, Michael Kahn; *Best Music, Original Score*, John Williams; *Best Sound*, John Boyde, Tony Dawe, Don Digirolamo, Robert Knudson

American Society of Cinematographers, USA, 1988
Won: *ASC Award, Outstanding Achievement in Cinematography in Theatrical Releases*, Allen Daviau

British Academy Awards, 1989
Won: *BAFTA Film Award, Best Cinematography*, Allen Daviau; *Best Score*, John Williams; *Best Sound*, Charles L. Campbell, Tony Dawe, Louis L. Edemann, Robert Knudson
Nominated: *BAFTA Film Award, Best Adapted Screenplay*, Tom Stoppard; *Best Costume Design*, Bob Ringwood; *Best Production Design*, Norman Reynolds

Directors Guild of America, USA, 1988
Nominated: *DGA Award, Outstanding Directorial Achievement in Motion Pictures*, Steven Spielberg

Golden Globes, USA, 1988
Nominated: *Golden Globe, Best Motion Picture—Drama; Best Original Score—Motion Picture*, John Williams

National Board of Review, USA, 1987
> **Won:** *NBR Award, Best Director,* Steven Spielberg; *Best Juvenile Performance,* Christian Bale

Best Picture—English Language, Young Artist Awards, 1989
> **Won:** *Young Artist Award, Best Family Motion Picture, Drama; Best Young Actor in a Motion Picture—Drama,* Christian Bale.

ENEMY AGENTS MEET ELLERY QUEEN

Columbia Pictures Corporation, 1942, b&w, 64 minutes.

Producers: Ralph Cohn, Larry Darmour; **Director:** James P. Hogan; **Screenwriter:** Eric Taylor; **Cast:** Felix Basch, James Burke, Ernst Deutsch, Ludwig Donath, William Gargan, Charley Grapewin, John Hamilton, Margaret Lindsay, Netta Packer, Gilbert Roland, Sig Ruman, James Seay, Gale Sondergaard, Minor Watson, Dick Wessel.

Ellery Queen (William Gargan) is a modern-day Sherlock Holmes who thwarts a Nazi spy ring that is after industrial diamonds, vital to the production of precision instruments during World War II.

ENEMY AT THE GATES

Mandalay Pictures, 2000, color, 131 minutes.

Producers: Jean-Jacques Annaud, Alain Godard, John D. Schofield, Alisa Tager; **Director:** Jean-Jacques Annaud; **Screenwriters:** Jean-Jacques Annaud, Alain Godard; **Distributor:** Paramount Pictures; **Filmed in:** Potsdam, Brandenburg, Berlin, Bavaria, Germany; **Cast:** Joseph Fiennes, Ed Harris, Jude Law, Ron Perlman, Rachel Weisz.

During the siege of Stalingrad in World War II, a savvy political officer, Joseph Fiennes, makes a young Russian sharpshooter, Jude Law, the hero of his propaganda campaign. Their friendship is threatened when both men fall in love with a beautiful female soldier, Rachel Weisz. As the battle rages, Jude Law faces his ultimate challenge when the Nazi command dispatches its most elite marksman, Ed Harris, to hunt him down and kill him, to remove him as a symbol of hope for the city.

The movie is based on a true story of Russian war hero Vassili Zaitsev.

ENEMY BELOW, THE

20th Century-Fox, 1957, color, 98 minutes.

Producer: Dick Powell; **Director:** Dick Powell; **Screenwriters:** Wendell Mayes, D. A. Rayner; **Cast:** Frank Albertson, Jimmy Bates, Thomas Beyl, Theodore Bikel, David Blair, Robert Boon, Joe Brooks, Russell Collins, Roger Cornwell, Dale Cummings, Jeff Daley, Peter Dane, Vincent Deadrick, Alan Dexter, Joe Di Reda, Maurice Doner, Biff Elliot, Richard Elmore, Sasha Hardin, David Hedison, Curd Jürgens, Jack N. Kramer, Kurt Kreuger, Arthur La Ral, Ralph Manza, Doug McClure, Michael McHale, Robert Mitchum, Frank Obershall, Ted Perritt, David Post, Ralph Reed, Werner Reichow, Ronnie Rondell Jr., Robert Whiteside, Lee J. Winters.

During World War II, a destroyer commanded by Robert Mitchum plays a deadly game of cat and mouse with Curt Jürgens's U-boat. The captains are equally matched and ultimately they destroy each other. The U-boat torpedoes the destroyer, the destroyer rams the submarine, and both vessels sink.

The movie is based on D. A. Rayner's *The Enemy Below* (London: Collins, 1956).

QUOTES

Lieutenant Ware (The ship has just avoided two torpedoes) The Miami yacht races were never like this.

Doctor: I guess you're finding the sun kind of hard to take, after the North Atlantic.
Capt. Murrell: Oh, it doesn't matter. It's always either too cold or too hot, wherever there's a war on.

Capt. Murrell: I have no idea what he is, what he thinks. I don't want to know the man I'm . . . trying to destroy.

ENEMY GENERAL, THE

Columbia Pictures Corporation, 1960, b&w, 74 minutes.

Producer: Sam Katzman; **Director:** George Sherman; **Screenwriters:** Dan Pepper, Burt Picard; **Cast:** Jean-Pierre Aumont, Paul Bonifas, Dany Carrel, Edward Fleming, Van Johnson, Gérard Landry, Jacques Marin, Paul Müller, Hubert Noël, Françoise Prévost, John Van Dreelen.

OSS agent Van Johnson is assigned to bring a defecting Nazi officer safely out of Europe. The German's crimes include the murder of Johnson's fiancée and innocent French citizens. When Johnson discovers that the Nazi is actually a counterintelligence double agent who plans to send secret Allied information back to the Nazis, he kills him.

INTERESTING FACT

- The OSS, the Office of Strategic Services, was America's response to the obvious need for a counterintelligence service while fighting the Japs and the Nazis during World War II. Founded by "Wild" Bill Donovan, a Medal of Honor winner from World War I, it evolved after the war into the CIA, the Central Intelligence Agency.

ENEMY OF WOMEN

W. R. Frank Productions, Monogram Pictures Corporation, 1944, b&w, 72 minutes.

Producer: W. R. Frank; **Director:** Alfred Zeisler; **Screenwriters:** Herbert O. Phillips, Alfred Zeisler; **Distributor:** Monogram Pictures Corporation; **Cast:** Robert Barrat, Lester Dorr, Claudia Drake, Byron Foulger, Sigrid Gurie, Charles Halton, Ralph Morgan, Marin Sais, Gloria Stuart, Emmett Vogan, Beryl Wallace, H. B. Warner, Crane Whitley, Donald Woods, Wolfgang Zilzer.

In the 1920s, Goebbels (Wolfgang Zilzer) is unsuccessful as a playwright; he also fails to win the affections of struggling actress Maria Brandt (Claudia Drake). As the Nazi Party rises to absolute power, Goebbels's power also increases, and he uses it to advance the acting career of his unrequited love. When she discovers the identity of her mentor, she flees to Austria to be free of his influence and marries her true love. Goebbels tries to influence her even there, but she is killed in an air raid.

INTERESTING FACT

- This is not an accurate biography of Joseph Goebbels, Hitler's minister of propaganda during World War II.

ESCAPE

Metro-Goldwyn-Mayer, 1940, b&w, 98 minutes.

Producers: Mervyn LeRoy, Lawrence Weingarten; **Directors:** George Cukor (additional scenes), Mervyn LeRoy; **Screenwriters:** Arch Oboler, Marguerite Roberts, Grace Zaring Stone (novel) (as Ethel Vance); **Music:** Daniele Amfitheatrof, C. Bakaleinikoff, Franz Waxman, Eugene Zador; **Distributor:** Metro-Goldwyn-Mayer; **Cast:** Lotte Palfi Andor, Edit Angold, Edgar Barrier, Elsa Basserman, Albert Bassermann, Walter Bonn, Felix Bressart, Helmut Dantine, Albert D'Arno, Kay Deslys, Ernst Deutsch, Philip Dorn, Gretl Dupont, William Edmunds, Arno Frey, Frederick Giermann, Lisa Golm, Bonita Granville, Hans Joby, Erwin Kalser, Howard Lang, Florine McKinney, Adolph Milar, Marianne Mosner, Alla Nazimova, Maria Ray, Henry Rowland, Gerta Rozan, Hans Schumm, Janet Shaw, Norma Shearer, Ann Sheldon, Anya Taranda, Robert Taylor, Conrad Veidt, Henry Victor, Frederick Vogeding, Marek Windheim, Fred Wolff, William Yetter Sr., Blanche Yurka, Wolfgang Zilzer.

Norma Shearer, the mistress of a Nazi general, helps Robert Taylor's mother, who is awaiting execution in a concentration camp, to escape from Germany.

The movie is based on Ethel Vance's best-seller *Escape* (1939).

INTERESTING FACTS

- Author Grace Zaring Stone used a pen name when her book was published to protect relatives living in Europe from Nazi retribution. Similarly, no composer credit was given in the film for the same reason, and some of the actors used fictitious names.
- German Conrad Veidt had fled Germany with his Jewish wife in 1929, and then, ironically, made a career out of playing Nazis.

ESCAPE IN THE DESERT

Warner Bros., 1945, b&w, 79 minutes.

Producers: Alex Gottlieb, Jack L. Warner (executive); **Director:** Edward A. Blatt; **Screenwriters:** Marvin Borowsky, Thomas Job, Robert E. Sherwood (play, *The Petrified Forest*); **Music:** Adolph Deutsch; **Distributor:** Warner Bros.; **Filmed at:** Death Valley, California; **Cast:** Rudolph Anders, Trevor Bardette, Oliver Blake, Monte Blue, Al Bridge, Charles Cane, Cliff Clark, Helmut Dantine, Philip Dorn, Alan Hale, Samuel S. Hinds, Selmer Jackson, Bill Kennedy, Victor Kilian, Kurt Kreuger, Blayney Lewis, Irene Manning, Hans Schumm, Robert Shayne, Jean Sullivan.

Nazi prisoners of war escape from a POW camp in Nevada and find their way to a remote motel resort in the desert.

ESCAPE TO GLORY

Columbia Pictures Corporation, 1940, b&w, 74 minutes.

Director: John Brahm; **Screenwriters:** Sidney Biddell, (story), Fredric M. Frank (story), P. J. Wolfson; **Music:** Sidney Cutner, Werner R. Heymann, Ben Oakland, Alfred Newman (stock music); **Cast:** Franz von Altenberger, Frank Baker, Alan Baxter, Don Beddoe, Constance Bennett, Bruce Bennett, Frank Benson, Edgar Buchanan, Jessie Busley, Melville Cooper, Leslie Denison, David Dunbar, Arno Frey, Marjorie Gateson, Douglas Gordon, Bobby Hale, John Halliday, Olaf Hytten, Erwin Kalser, Jimmie Kilgannon, Stanley Logan, Paul Michael, Hans von Morhart, Arthur Mulliner, Pat O'Brien, Francis Pierlot, Rex Post, Jean Prescott, Dick Rich, Norbert Schiller, Hans Schumann, Wyndham Standing, Frank Sully, Fred Wolff.

While they are at sea, Americans on their way home from Europe learn that the United States has entered World War II. When they are attacked by a Nazi submarine, one of the passengers, a fugitive murderer, forces a double-crossing district attorney to load a lifeboat with explosives, and then together they ram and blow up the submarine, saving the ship.

ESPIONAGE AGENT

Warner Bros. 1939, b&w, 83 minutes.

Producers: Louis F. Edelman (associate), Hal B. Wallis (executive); **Director:** Lloyd Bacon; **Screenwriters:** Frank Donaghue, Warren Duff, Michael Fessier; **Music:** Adolph Deutsch; **Cast:** Eddie Acuff, Louis Adlon, Rudolph Anders, George Bancroft, Fern Barry, Granville Bates, Sidney Bracey, Egon Brecher, Nana Bryant, Howard C. Hickman, Lois Chenney, Alice Connors, Jean De Briac, Sarah Edwards, Arno Frey, Eddie Graham, John Hamilton, Winifred Harris, Grace Hayle, Hickman, Stuart Holmes, William Hopper, Lloyd Ingraham, George Irving, Selmer Jackson, Martin Kosleck, Glenn Langan, Vera Lewis, Rolf Lindau, Frederick Lindsley, Al Lloyd, Jeffrey Lynn, Brenda Marshall, Chris-Pin Martin, Billy McClain, Joel McCrea, Alex Melesh, Lucien Prival, George Reeves, Addison Richards, Stanley Ridges, Lionel Royce, Sally Sage, Edwin Stanley, James Stephenson, Hans Heinrich von Twardowski, Dorothy Vaughan, Henry Victor, Emmett Vogan, Frederick Vogeding, Nella Walker, Lottie Williams, William Worthington, Wolfgang Zilzer, Henry von Zynda.

When Joel McCrea discovers that his new bride is an enemy agent, he resigns from the diplomatic service to go undercover, where he flushes out a German espionage ring planning to destroy American industrial capacity.

ETERNAL SEA, THE

Republic Pictures Corporation, 1955, b&w, 103 minutes.

Director: John H. Auer; **Screenwriters:** William Wister Haines, Allen Rivkin; **Distributor:** Republic Pictures; **Cast:** Morris Ankrum, James Best, Willis Bouchey, Ben Cooper, Richard Crane, Frank Ferguson, Virginia Grey, Sterling Hayden, Louis Jean Heydt, Dean Jagger, Douglas Kennedy, Harry Lauter, John Maxwell, William Phipps, Tom Powers, Richard Reeves, Hayden Rorke, Robert Shayne, Alexis Smith, Arthur Space, Robert Williams.

During World War II, naval officer John M. Hoskins (Sterling Hayden) loses a leg when the aircraft carrier USS *Princeton* goes down in the Pacific. Fighting to stay in the navy, although people believe that he should be medically discharged, he obtains command of the newly commissioned aircraft carrier *Princeton*. He helps to develop the new jet fighters on carriers, and follows through with the concept of successful baptism under fire during the Korean War.

INTERESTING FACT

- This movie tells the true story of a real-life hero, Adm. John M. Hoskins.

MILITARY SERVICE

- Sterling Hayden traveled to England before Pearl Harbor and trained as a commando in Scotland in the British army. He broke his ankle during a parachute jump and was discharged. He returned to the United States and enlisted in the U.S. Marines. After officer candidate school, he joined the OSS (Office of Strategic Services, precursor to the CIA). He had worked for OSS director "Wild Bill" Donovan, collecting information before the war. He

served in Cairo, Egypt, and then in Yugoslavia, where under Tito he assumed command of 400 Yugoslavian partisans. Because of his sailing experience, he was put in charge of 22 schooners, ketches, and brigs running the German blockade across the Adriatic to the island of Vis off the coast of German-occupied Dalmatia. He landed supplies and captured Italian war matériel. After that, he was part of the intelligence section of the First Army in Europe. He performed clandestine missions in Italy, Germany, and other parts of Europe. He was discharged as a captain, with a Silver Star and a medal from Marshal Tito.

EVE OF ST. MARK, THE

20th Century-Fox, 1944, b&w, 96 minutes.

Producer: William Perlberg; **Director:** John M. Stahl; **Screenwriters:** Maxwell Anderson, George Seaton; **Cast:** Murray Alper, John Archer, Robert Bailey, Anne Baxter, Jimmy Clark, Roger Clark, Ray Collins, Joann Dolan, Blake Edwards, David Essex, William Eythe, Toni Favor, Reed Hadley, Arthur Hohl, Milton Kibbee, George Mathews, Dickie Moore, Henry Morgan, Ruth Nelson, Michael O'Shea, Stanley Prager, Vincent Price, Joven E. Rola, Harry Shannon, George Tyne.

A young man has a perfect life on his farm before his call to duty after Pearl Harbor. Sent overseas, he becomes part of the force fighting to hold the island fortress of Corregidor, in the Philippines, against the brutal onslaught of the Japanese invasion.

The movie is based on Maxwell Anderson's play *The Eve of St. Mark* (Washington, D.C.: Anderson House, 1942).

INTERESTING FACT

• In the original stage play, the hero and his company are killed in the delaying action in the Philippines; the film, however, suggests that they will survive.

MISTAKE

• The Japanese invasion of the Philippines followed closely after the bombing of Pearl Harbor on December 7, 1941, and Corregidor finally fell on May 6, 1942. While it is possible that a young soldier could enlist after Pearl Harbor, finish basic training, and arrive in the Philippines in time to fight at Corregidor, it is not likely.

EXODUS

Carlyle, Alpha, 1960, color, 212 minutes.

Producer: Otto Preminger; **Director:** Otto Preminger; **Screenwriters:** Dalton Trumbo, Leon Uris; **Music:** Ernest Gold; **Distributor:** United Artists; **Filmed in:** Jerusalem and Acre, Israel, Cyprus; **Cast:** Abi, Felix Aylmer, Dahn Ben Amotz, Martin Benson, Marc Burns, Lee J. Cobb, John Crawford, John Derek, Joseph Fürst, Marius Goring, Hugh Griffith, Philo Hauser, Jill Haworth, Peter Lawford, Peter Madden, Victor Maddern, George Maharis, Martin Miller, Sal Mineo, Paul Newman, Esther Ofarim, David Opatoshu, Zipora Peled, Gregory Ratoff, Esther Reichstadt, Ralph Richardson, Eva Marie Saint, Samuel Segal, Paul Smith, Mary Ann Spencer, Paul Stassino, Paul Stevens, Alexandra Stewart, Ralph Truman, Michael Wager, Betty Walker, Michael Wynne.

Paul Newman is the leader of a Jewish resistance group called the Irgun, which is working toward establishing the new state of Israel by peaceful means, while other groups use violence, such as blowing up the Hotel David and killing British officers. A ship arrives filled with Jewish immigrants, whom the British refuse to allow to disembark in Palestine. Their hunger strike turns public opinion against the British, who finally allow them to land.

The film is based on Leon Uris's *Exodus* (New York: Doubleday, 1958).

INTERESTING FACTS

• Director Otto Preminger helped to end the stigma of the Hollywood blacklist by hiring Dalton Trumbo to adapt the screenplay for the film.
• After World War I, Palestine was taken from the defeated Turks and placed under the control of Great Britain as a League of Nations mandate. The British Balfour Declaration encouraged Zionism and the immigration of Jewish settlers; but until the rise of Adolf Hitler, only a small trickle of idealistic settlers were interested in leaving Europe for this desert wasteland. However, with the end of World War II, it became a final destination for the exodus of displaced Jews of Europe who survived the Holocaust.
• In the film, and actually, the large influx of Jewish settlers breeds resentment among the Arab inhabitants, and the British try to solve the problem by limiting immigration. When this turns out to be impossible, as depicted in the film, they throw up their hands, and turn the problem over to the United

Nations. Ultimately, over Arab objections, the United Nations partitioned Palestine, thereby creating the modern Jewish state of Israel.

EXPENDABLES, THE

Premiere Productions, 1988, color, 89 minutes.

Producers: Anna Roth, Christopher R. Santiago; **Director:** Cirio H. Santiago; **Screenwriter:** Philip Alderton; **Cast:** Vic Diaz, Kevin Duffis, Anthony Finetti, Jeff Griffith, Eric Hahn, Loren Haynes, Don Holtz, David Light, Jim Moss, Leah Navarro, Peter Nelson, Janet Price, Greg Rocero, Corwin Sperry, William Steis, Don Wilson.

A tough captain, assigned a squad of misfit soldiers, trains them into a fighting powerhouse. They risk their lives to cross into Cambodia and rescue American hostages.

EXTRAORDINARY SEAMAN, THE

Metro-Goldwyn-Mayer, 1969, color, 80 minutes.

Producer: Edward Lewis; **Director:** John Frankenheimer; **Screenwriters:** Hal Dresner, Phillip Rock; **Cast:** Alan Alda, Jack Carter, John Cochran, Faye Dunaway, Jerry Fujikawa, Richard Guizon, Juano Hernandez, Barry Kelley, David Niven, Mickey Rooney, Leonard O. Smith, Manu Tupou.

David Niven is a World War I ghost doomed to linger about his old ship until he clears his family honor.

MILITARY SERVICE

- Mickey Rooney wanted to enlist during World War II, but studio boss Louis B. Mayer didn't want to lose the star of his popular Andy Hardy films. It wasn't until 1944 that Rooney finally got his way and enlisted. He completed chemical warfare training at Camp Siebert, Alabama, before being transferred to Special Services. Assigned to the 5817th Special Service Battalion, he served in Europe as a part of a "jeep show," a three-man team that entertained troops on the front lines. On more than one occasion he came under enemy fire. He finished the war as a staff sergeant and was awarded the Bronze Star.

Director John Frankenheimer applied for and was accepted in the Motion Picture Squadron of the Air Force, where he realized his natural talent to handle a camera. After his military discharge, he began a TV career in 1953, convincing CBS to hire him as an assistant director, which consisted mainly in working as a cameraman.

EYE OF THE EAGLE

Concorde-New Horizons, New Horizon Picture Corp., 1986, color, 84 minutes.

Producer: Cirio H. Santiago; **Director:** Cirio H. Santiago; **Screenwriter:** Joseph Zucchero; **Music:** Marita Manuel; **Cast:** David Anderson, Tony Beso, Brett Baxter Clark, Ed Crick, Mel Davidson, Vic Diaz, Jerry Hart, David Light, Rey Malonzo, Mike Monty, Jim Moss, Nick Nicholson, Robert Patrick, William Steis, Henry Strzalkowski, Cec Verrell, Willie Williams.

The "Lost Command," a bunch of notorious renegades, AWOLs, and MIAs, terrorizes South Vietnam. The army sends its best man to hunt them down and stop their killing spree.

EYE OF THE EAGLE 2: INSIDE THE ENEMY

Concorde-New Horizons, 1989, color, 78 minutes.

Producers: Catherine Santiago, Cirio H. Santiago; **Director:** Carl Franklin; **Screenwriters:** Carl Franklin, Dan Gagliasso; **Music:** Justin Lord, Jody C. Robinson; **Cast:** Archie Adamos, Butch Aguas, Cris Albert, Le Whoung Thung Copruz, Gyuyen Alex Dulay, Leif Erlandson, John Falch, Todd Field, Carl Franklin, Geronimo Holandez, Paul Holmes, Val Iglesias, Ken Jacobson, Adrianne Joseph, Ronald William Lawrence, Dardo Lungsod, Leo Martinez, Warren McLean, Louanne Mercado, Mike Monty, Le Mai Phung, Janet Price, Shirley Tesoro, Le Thanh Van, Tracy Westmoreland, Andy Wood, Nge Lang Yu, Christy Yu.

When soldier Anthony Glenn (Todd Field) discovers that Mai (Shirley Tesoro) is missing, he sets out to rescue her from the corrupt Maj. Sorenson (Andy Wood), pitting soldier against soldier in a bloody game of honor.

FACE IN THE RAIN

Embassy Pictures Corporation, Filmways Pictures, 1963, b&w, 81 minutes.

Producer: John Calley; **Director:** Irvin Kershner; **Screenwriters:** Hugo Butler, Jean Rouverol; **Music:** Richard Markowitz; **Distributor:** Embassy Pictures Corporation; **Cast:** Marina Berti, Rory Calhoun, Massimo Giuliani, Niall MacGinnis, Danny Ryais, Peter Zander.

Rory Calhoun is an American agent who parachutes behind enemy lines and is pursued by Nazis.

FAIL-SAFE

Columbia Pictures Corporation, 1964, b&w, 112 minutes.

Producers: Sidney Lumet (co-executive), Charles H. Maguire (associate), Max E. Youngstein; **Director:** Sidney Lumet; **Screenwriters:** Eugene Burdick and Harvey Wheeler (novel), Walter Bernstein; **Distributor:** Columbia Pictures; **Cast:** Frieda Altman, Nancy Berg, Ed Binns, Sorrell Booke, Russell Collins, John Connell, Dom DeLuise, Dana Elcar, Henry Fonda, Stewart Germain, Larry Hagman, William Hansen, Russell Hardie, Louise Larabee, Walter Matthau, Dan O'Herlihy, Frank Overton, Hildy Parks, Frank Simpson, Charles Tyner, Janet Ward, Fritz Weaver.

A technical malfunction in the Pentagon's strategic control system causes an erroneous order to be sent to a B-58 squadron on a routine training mission. Ordered to fly beyond their "fail safe" distance, standard procedures call for the flight crew to cease communications and bomb Moscow. The president, Henry Fonda, tries several solutions, including helping the Russians to shoot down the bombers, but one determined and well-trained crew gets through. In order to avoid global nuclear war, he decides on a drastic solution: Drop an atomic bomb on New York City as a symbol of American good faith.

INTERESTING FACTS

- With one exception, all shots of U.S. Air Force Vindicator bombers are views of the same Convair B-58 Hustler, taken from a stock piece of film after the Department of Defense declined to cooperate with the filmmakers.
- *DR. STRANGELOVE OR: HOW I LEARNED TO STOP WORRYING AND LOVE THE BOMB* (1964) has a remarkably similar premise, and was being made by Stanley Kubrick at the same time. Kubrick threatened legal action, claiming plagiarism. The issue was settled when Columbia Pictures agreed to push Kubrick's film at the expense of *Fail-Safe* (1964), which subsequently bombed at the box office.

MISTAKES

- In scenes intended to be simultaneous, the time is 5:30 A.M. in New York, Washington, Omaha, and Anchorage. Consideration of sunrise times shows that 5:30 A.M. Eastern Time must have been what was meant.
- The fighters sent after the bombers have already been airborne for some time and hence are low on fuel. From the map display, the distance from them to the bombers is a large fraction (like 4/5) of that from Anchorage to the bombers. There must have been other fighters available at Anchorage or another base that could have been sent out fully fueled, and this would be well known to the people involved.
- The Vindicator bombers in the film are portrayed using a Convair B-58 Hustler, except during the final attack on Moscow, when the Vindicator briefly appears as a North American F-86 Sabre Jet instead.
- Many errors are evident in the map displays. For example, Bering Strait is shown too narrow and twisty, with part of Russia extending north of the Seward Peninsula; and in the first two scales of map shown, Hudson Strait is too narrow, and a nonexistent island appears southeast of Baffin Island.
- The UFO is reported initially "near Hudson's Bay" and its course is given (both in dialogue and on text superimposed on the map display) as 196, heading for Detroit. But according to the map display itself, it initially appears near the Labrador coast, more than 500 miles from Hudson Bay; and while it is heading for Detroit, its course from there is to the southwest, about 225.
- The fim is based on a novel by Eugene Burdick and Harvey Wheeler.

FALLEN SPARROW, THE

RKO Radio Pictures Inc., 1943, b&w, 94 minutes.

Director: Richard Wallace; **Screenwriters:** Warren Duff, Dorothy B. Hughes (novel); **Music:** Roy Webb; **Distributor:** RKO; **Cast:** John Banner, Hugh Beaumont, Symona Boniface, Patti Brill, Jack Carr, André Charlot, William Edmunds, Bruce Edwards, Edith Evanson, Jim Farley, Martin Faust, Fely Franquelli, Erford Gage, Rosina Galli, John Garfield, Bud Geary, Sam Goldenberg, Rita Gould, Babe Green, Mary Halsey, Joe King, Mike Lally, Margaret Landry, Stella LeSaint, George Lloyd, Charles Lung, Miles Mander, John Miljan, Billy Mitchell, Patricia Morison, Martha O'Driscoll, Maureen O'Hara, Nestor Paiva, Lee Phelps, Russ Powell, Stanley Price, Al Rhein, George Sherwood, Walter Slezak, Margie Stewart, Russell Wade, Lillian West, Eric Wilton, Jane Woodworth.

John Garfield is a member of the Lincoln Brigade during the Spanish Civil War who is captured and tortured by the Nazis; they want to discover what happened to one of their battle flags. Hoping that he will lead them to it, they allow him to escape and send beautiful Maureen O'Hara to seduce the information out of him. When he discovers that she is a Nazi agent, he turns her over to the FBI.

QUOTE

John Garfield (as he turns Maureen O'Hara over to the FBI): Another sparrow has fallen.

AWARD

Academy Awards, USA, 1943
Nominated: *Oscar, Best Music, Scoring of a Dramatic or Comedy Picture,* C. Bakaleinikoff, Roy Webb.

FAREWELL TO ARMS, A

Paramount Pictures, 1932, b&w, 80 minutes.

Producer: Edward A. Blatt; **Director:** Frank Borzage; **Screenwriters:** Oliver H. P. Garrett, Benjamin Glazer, Ernest Hemingway; **Cast:** Alice Adair, Henry Armetta, Agostino Borgato, Robert Cauterio, Gary Cooper, Peggy Cunningham, Gilbert Emery, Mary Forbes, Blanche Frederici, Helen Hayes, George Humbert, Doris Lloyd, Fred Malatesta, Adolphe Menjou, Inez Palange, Mary Philips, Paul Porcasi, Tom Ricketts, Jack La Rue.

American Gary Cooper enlists in the Italian army during World War I as an ambulance driver. When he is wounded, he falls in love with his English nurse, Helen Hayes. After he returns to the front, he realizes the futility of the war during the Italian army's retreat from Caporetto. He deserts and rejoins his love, who dies in childbirth.

The movie is based on Ernest Hemingway's *A Farewell to Arms* (New York: Scribner's, 1929).

INTERESTING FACTS

- This was considered by many to be Helen Hayes's best film performance.
- The Italian ambassador protested the depiction of the Italian army during its disastrous retreat from Caporetto.
- A related film, IN LOVE AND WAR, with Chris O'Donnell, is based directly on Ernest Hemingway's experiences during the war, rather than on the novel.

MILITARY SERVICE

- Ernest Hemingway enlisted in a Red Cross ambulance unit in World War I. Commissioned a second lieutenant, he was wounded in the leg in Italy and awarded Italy's Silver Medal of Military Valor. Hemingway remained in Europe after the war and reported from the front during the Spanish Civil War. During World War II, he patrolled the waters around Cuba on board his yacht *Pilar* on antisubmarine duty. Later, he flew as an observer on missions with the U.S. Army Air Force and the Royal Air Force. In spring 1944, he was a correspondent for *Collier's* and was awarded a Bronze Star in 1947 for meritorious service as a war correspondent, in spite of the fact that he almost lost his accreditation from the army for leading a Free French unit during the liberation of Paris, a violation of his noncombatant status as a correspondent.

QUOTE

Adolphe Menjou: What if we take the mountains to the north? Behind them are more mountains and behind these are more mountains yet.

FAREWELL TO ARMS, A

20th Century-Fox, 1957, color, 152 minutes.

Producers: Arthur Fellows (associate), David O. Selznick; **Directors:** John Huston, Charles Vidor; **Screenwriters:** Ben Hecht, Ernest Hemingway (novel); **Music:** Mario Nascimbene; **Distributor:** 20th Century-Fox Film Corporation; **Filmed at:** Italian Alps, Rome, Lazio, Venzone (first 20 minutes), all in Italy; **Cast:** Luigi Barzini, Georges Bréhat, Memmo Carotenuto, Patrick Crean, Albert D'Amario, Vittorio De Sica, Victor Francen, Angelo Galassi, Guidarino Guidi, Johanna Hofer, Oskar Homolka, Rock Hudson, Peter Illing, Franco Interlenghi, Vittorio Jannitti, Jennifer Jones, Kurt Kasznar, Diana King, Eva Kotthaus, Sam Levine, Carlo Licari, Eduard Linkers, Franco Mancinelli, Guido Martufi, Clelia Matania, Gisella Mathews, Mercedes McCambridge, José Nieto, Alex Revides, Umberto Sacripanti, Joan Shawlee, Alberto Sordi, Umberto Spadaro, Elaine Stritch, Leopoldo Trieste.

This film has the same plot as the earlier version, made in 1932, but with Rock Hudson as the ambulance driver and Jennifer Jones as the nurse.

During the retreat from Caporetto, Rock Hudson and his friend Vittorio De Sica are captured as deserters. De Sica, half out of his mind and rambling incoherently about the stupidity of war, is ordered shot by a hastily convened court-martial, despite Rock Hudson's pleading with the court that his friend is mentally unbalanced. De Sica's performance is superb, and this single scene is probably what earned him his Oscar nomination.

INTERESTING FACTS

- This was the last film produced by David O. Selznick.
- This film is considered to be more faithful to the novel than the 1932 version, but despite its high production values and all-star cast, it was not considered a critical success.
- This film is based on *A Farewell to Arms*, by Ernest Hemingway (New York: Scribner's, 1929).

AWARD

Academy Awards, USA, 1957
 Nominated: *Oscar, Best Supporting Actor,* Vittorio De Sica.

FAREWELL TO THE KING

Cine Location Services, 1989, color, 115 minutes.

Producers: Charles Hannah, Gopala Krishnan, Ralph Marshall, André E. Morgan; **Director:** John Milius; **Screenwriters:** John Milius, Pierre Schoendoerffer; **Music:** Basil Poledouris; **Filmed in:** Malaysia; **Cast:** Aki Aleong, James Fox, Nigel Havers, Gerry Lopez, Frank McRae, Richard Morgan, Michael Nissman, Nick Nolte, Elan Oberon, John Bennett Perry, Wayne Pygram, Marilyn Tokuda, Marius Weyers, Choy Chang Wing, William Wise.

An American sailor (Nick Nolte) escapes the execution of his comrades by Japanese soldiers in Borneo during World War II and creates an empire for himself among the native people. It is an idyllic existence, until he is approached by British soldiers who want him to rejoin the fight against the Japanese troops, who have become cannibals. He refuses, until the Japanese attack his tribe, and then he leads the remnants of his warriors in a campaign of vengeance.

INTERESTING FACT

- This film is akin to *The Man Who Would Be King* and *Lord Jim*, not only because it centers on a white man who becomes king of a native people but also because of its underlying themes of loyalty, redemption, and personal integrity.

FEAR AND DESIRE

Kubrick, 1953, b&w, 68 minutes.

Producers: Stanley Kubrick, Martin Perveler; **Director:** Stanley Kubrick; **Screenwriters:** Stanley Kubrick, Howard Sackler; **Music:** Gerald Fried; **Distributor:** Joseph Burstyn Inc.; **Cast:** David Allen, Steve Coit, Kenneth Harp, Virginia Leith, Paul Mazursky, Frank Silvera.

Four soldiers survive the crash landing of their plane to find themselves in a forest six miles behind enemy lines. The group, led by Lt. Corby (Kenneth Harp), decides to make its way to a nearby river, build a raft, and under cover of night float back to friendly territory. Their plans for getting back safely are sidetracked by a young woman who stumbles across them as they hide in the woods, and by the nearby presence of an enemy general whom one member of the group is determined to kill.

QUOTES

Lt. Corby: We spend our lives running our fingers down the lists in directories, looking for our real names, our permanent addresses. No man is an island? [chuckles softly] Perhaps that was true a long time ago, before the Ice Age. The glaciers have melted away, and now we're all islands—parts of a world made of islands only . . .

Narrator: There is war in this forest. Not a war that has been fought, or one that will be, but any war. And the enemies who struggle here do not exist, unless we call them into being. This forest, then, and all that happens now is outside history. Only the unchanging shapes of fear—and doubt— and death—are from our world. These soldiers that you see keep our language and our time but have no other country but the mind.

FIELD OF FIRE

Concorde-New Horizons, 1991, color, 96 minutes.

Producers: Roger Corman, Christopher R. Santiago; **Directors:** Cirio H. Santiago; **Screenwriter:** Thomas McKelvey Cleaver; **Cast:** Joe Mari Avellana, Don Barnes, David Carradine, Tonichi Fructuoso, Eb Lottimer, Ken Metcalfe, Jim Moss, Archie Ramirez, Ruben Ramos, David Anthony Smith, Henry Strzalkowski, José Torres, Scott Utley, Joseph Zucchero.

Sgt. Thomas Duncan (Ed Lottimer) takes his men behind enemy lines to recover a secret government fighter helicopter and its pilot. However, behind their backs, a traitor is sending messages to the enemy side.

INTERESTING FACT

- David Carradine's character is named Gen. Corman, after B-movie mogul Roger Corman, director Cirio H. Santiago's longtime business partner.

QUOTE

Sgt. Duncan: It's your life. I can't teach you the bush overnight.

55 DAYS AT PEKING

Samuel Bronston, 1963, color, 150 minutes.

Producers: Samuel Bronston, Alan Brown, Michael Waszynski; **Directors:** Guy Green, Andrew Marton, Nicholas Ray; **Screenwriters:** Ben Barzman, Bernard Gordon, Philip Yordan; **Music:** Dimitri Tiomkin; **Distributor:** Allied Artists; **Filmed at:** Las Matas and Madrid, Spain; **Cast:** Harry Andrews, Lucy Appleby, Geoffrey Bayldon, Carlos Casaravilla, Michael Chow, Félix Dafauce, Andrea Esterhazy, Joseph Fürst, Ava Gardner, Leo Genn, Walter Gotell, Robert Helpmann, Charlton Heston, Andy Ho, John Ireland, Juzo Itami, Mervyn Johns, Kurt Kasznar, Dong Kingman, Mitchell Kowall, Philippe Leroy, Soong Ling, Paul Lukas, Alfred Lynch, Alfredo Mayo, Martin Miller, Conchita Montes, Lynne Sue Moon, John Moulder-Brown, José Nieto, David Niven, Eric Pohlmann, Nicholas Ray, Milton Reid, Flora Robson, Fernando Sancho, Elizabeth Sellars, Massimo Serato, Jacques Sernas, Aram Stephan, Kenji Takaki, Jerome Thor, John A. Tinn, Robert Urquhart, George Wang, Stephen Young.

Diplomats, soldiers, and other representatives of a dozen nations endure the 55-day siege of the International Compound in Peking during the 1900 Boxer Rebellion. The disparate interests unite for survival despite competing factions, overwhelming odds, delayed relief from their home governments, and tacit support of the Boxers by the dowager empress of China, who realizes that this might be her only way of ridding her country of foreign domination.

In a dramatic scene, the Boxers attack the high wall of the diplomats' compound. This is one of those big

budget Hollywood set pieces we are unlikely to ever see again in the movies. Thousands of fully costumed extras attack down a large ramp on the compound wall and almost succeed in overwhelming the defenders until Charlton Heston, leading his marines, counterattacks and drives them off the wall.

INTERESTING FACT

• Director Nicholas Ray walked off the set and never worked again in Hollywood. Andrew Marton and Guy Green finished the film.

AWARDS

Academy Awards, USA, 1964
 Nominated: *Oscar, Best Music Score—Substantially Original*, Dimitri Tiomkin; *Best Music, Song*, Dimitri Tiomkin (music), Paul Francis Webster (lyrics)—for the song *So Little Time*.

FIGHTER ATTACK

Allied Artists Pictures Corporation, 1953, color, 80 minutes.

Producer: William A. Calihan Jr.; **Director:** Lesley Selander; **Music:** Marlin Skiles; **Distributor:** Allied Artists; **Cast:** David Bond, Arthur Caruso, Tony Dante, Frank DeKova, Paul Fiero, James Flavin, John Fontaine, Sterling Hayden, Maurice Jara, Harry Lauter, David Leonard, Louis Lettieri, Joel Marston, J. Carrol Naish, Joy Page, Kenneth Tobey.

Sterling Hayden is an airman forced to bail out over Italy on a raid from his base in Corsica during World War II. After a narrow escape from capture by enemy soldiers, he is picked up by Italian partisans who take him to their mountain retreat. He convinces them to help him destroy a concealed German supply dump, and then he makes his way successfully back to his own lines.

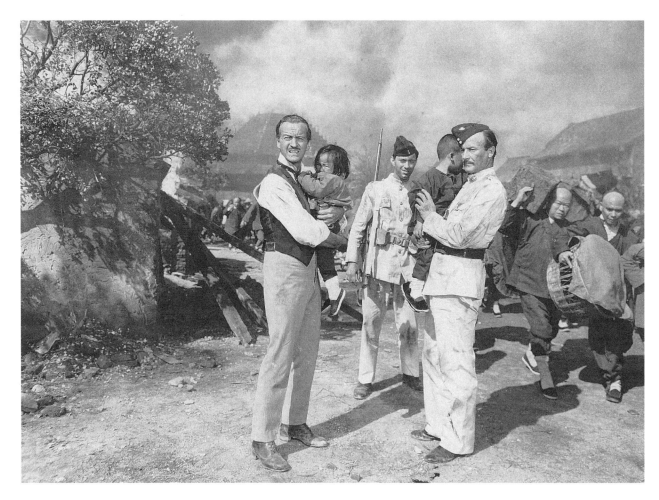

55 Days at Peking (ALLIED ARTISTS PICTURES/AUTHOR'S COLLECTION)

FIGHTER SQUADRON

Warner Bros., 1948, color, 96 minutes.

Producer: Seton I. Miller; **Director:** Raoul Walsh; **Screenwriters:** Seton I. Miller, Martin Rackin; **Music:** Max Steiner; **Cast:** George Adrain, Joel Allen, George Backus, William Cabanne, Tom D'Andrea, Elliott Dare, Jean Fenwick, Jack Grant, Carl Harbaugh, Hallene Hill, James Holden, Rock Hudson, Henry Hull, Guy Kingsford, Jack Larson, Charles Lind, Robert Manning, Frank Marlowe, Mickey McCardle, John McGuire, Harry McKim, William McLean, John Morgan, Patricia Northrop, Edmond O'Brien, George Offerman, Dick Paxton, Don Phillips, Walter Reed, Geza Remy, Jeff Richards, John Rodney, John Royce, Arthur Space, Robert Stack, Shepperd Strudwick, Gilchrist Stuart, Willy Wickerhauser, William Yetter Jr.

Edmund O'Brien is an insubordinate ace fighter pilot. When he is promoted to squadron commander, the shoe is on the other foot; he can't be the rebel any more. Not only does he have to change his wicked ways, he also has to make everyone else follow the rules.

INTERESTING FACT

- This was Rock Hudson's first screen appearance, in the role of one of the squadron's pilots.

QUOTE

Pilot: [as he strafes an enemy train]: I've been working on the railroad.

FIGHTING COAST GUARD

Republic Pictures Corporation, 1951, b&w, 86 minutes.

Producer: Joseph Kane; **Director:** Joseph Kane; **Screenwriters:** Kenneth Gamet, Charles Marquis Warren; **Music:** David Buttolph; **Distributor:** Republic Pictures; **Cast:** Morris Ankrum, Steve Brodie, Brian Donlevy, James Flavin, Olin Howlin, Richard Jaeckel, Martin Milner, William Murphy, Hugh O'Brian, Damian O'Flynn, Eric Pedersen, Jack Pennick, Tom Powers, Ella Raines, Roy Roberts, John Russell, Emil Sitka, Sandra Spence, Forrest Tucker.

A group of shipyard workers, angry over the sneak Japanese attack on Pearl Harbor, promptly enlist in the U.S. Coast Guard. After basic training, they ship out for the South Pacific. Although he tries to get through officer training, Forrest Tucker, one of the workers, washes out, but he sticks with the military as an enlisted sailor and ultimately proves his worth in action.

INTERESTING FACT

- Many of the battle scenes use actual combat camera footage from World War II.

FIGHTING SEABEES, THE

Republic Pictures Corporation, 1944, b&w, 100 minutes.

Producer: Albert J. Cohen; **Director:** Edward Ludwig; **Screenwriters:** Borden Chase, Aeneas MacKenzie; **Cast:** Abdullah Abbas, Roy Barcroft, Charles D. Brown, Jean Fenwick, Paul Fix, William Forrest, William Frawley, Terry Frost, Bud Geary, Ernest Golm, William Hall, Alex Havier, Susan Hayward, Herbert Heyes, Reed Howes, John James, J. M. Kerrigan, Leonid Kinskey, Nora Lane, Tom London, Adele Mara, Frank Marlowe, LeRoy Mason, Forbes Murray, Jay Norris, Dennis O'Keefe, Jack O'Shea, Paul Parry, Hugh Prosser, Duncan Renaldo, Addison Richards, Chief Thundercloud, Charles Trowbridge, Wally Wales, John Wayne, Ben Welden, Crane Whitley, Grant Withers.

Construction workers in the Pacific are needed to build military sites, but the job is dangerous and the workers don't trust the army to protect them from the Japanese. The navy realizes that something has to be done and gets Donovan (John Wayne) to create something new, fighting navy construction workers, the Seabees.

INTERESTING FACTS

- As pointed out in the film, the name "Seabees" is derived from the initials of their previous official name, Construction Battalions—"C.B.s."
- While the average age of a marine rifleman in World War II was 19, the typical Seabee was 34. This gave rise to one of the marines' favorite expressions: "Be kind to a Seabee, he might be your father."
- Well past draft age, and working in critical civilian occupations that would defer them from serving even if they were of draft age, these Seabees gave up their well-paying civilian jobs and deferments and volunteered to accept the hardships and sacrifices of military life in the spirit of patriotism and the desire to contribute directly to America's war effort.

- Rear Adm. Ben Moreell, chief of the navy's Bureau of Yards and Docks, realized that when war came, civilian construction workers, who were doing the bulk of the navy's overseas building, had no place in a combat zone. By international law, these workers could not be armed, and thus had no way to defend themselves. Moreell's vision of civilian construction workers trapped in a combat zone tragically came true with the workers who were captured in the fall of Wake Island. They were forced to complete their projects and then executed by firing squad, even though they were never armed, clearly weren't spies, and posed no threat to the Japanese garrison on the island. After Wake Island, Moreell was finally given the go-ahead to form a military unit composed of construction specialists who would also be able to defend themselves and the construction site against attack. More than 325,000 men served with the Seabees in World War II, fighting and building on six continents and more than 300 islands. In the Pacific, where most of the construction work was needed, the Seabees landed with the marines and built every airstrip, bridge, road, warehouse, and hospital needed by the soldiers.

- Seabees were not generally impressed with rank, a primary reason being that most Seabees were quite a bit older than many of the officers they encountered. One night on guard duty, so the story goes, a Seabee saw someone approaching his post.

 "Who goes there, friend or foe?" came the challenge. "Friend," came the reply.

 "Well, advance friend, and come on over here," said the Seabee.

 The individual approaching the post asked, "Do you know who I am?"

 "Nope," replied the 'Bee.

 He was told, "I'm the admiral commanding this operation."

 "Well," said the 'Bee, mulling this bit of information, "that's a pretty important job, Bub, don't louse it up."

QUOTE

Lt. Cdr. Yarrow [Dennis O'Keefe]: We're not fighting men anymore, we're fighting animals.

AWARD

Academy Awards, USA, 1944
 Nominated: *Oscar, Best Music, Scoring of a Dramatic or Comedy Picture*, Walter Scharf, Roy Webb.

FIGHTING 69TH, THE

Warner Bros., 1940, b&w, 90 minutes.

Producers: Louis F. Edelman, Hal B. Wallis, Jack L. Warner; **Director:** William Keighley; **Screenwriters:** Fred Niblo Jr., Norman Reilly Raine, Dean Riesner; **Filmed at:** Warner's Calabasas Ranch, California; **Cast:** Eddie Acuff, Herbert Anderson, John Arledge, Trevor Bardette, Jack Boyle Jr., George Brent, James Cagney, Nat Carr, Richard Clayton, Frank Coghlan Jr., Sammy Cohen, Joseph Crehan, John Daheim, Eddie Dew, Tom Dugan, Ralph Dunn, Edgar Edwards, Frank Faylen, James Flavin, Jerry Fletcher, Dick Foran, Arno Frey, Edmund Glover, Sol Gorss, Alan Hale, Creighton Hale, John Harron, William Hopper, J. Anthony Hughes, Layne Ireland, George Kilgen, John Litel, Jacques Lory, Wilfred Lucas, William Lundigan, Jeffrey Lynn, Frank Mayo, Frank McHugh, Frank Melton, Dennis Morgan, Jack Mower, Elmo Murray, Byron Nelson, Pat O'Brien, George O'Hanlon, Henry O'Neill, Jack Perrin, George Reeves, John Ridgely, Benny Rubin, Harvey Stephens, Frank Sully, Charles Trowbridge, Roland Varno, Emmett Vogan, Frank Wilcox, Guinn Williams, Jack Wise.

James Cagney is an undisciplined soldier in New York's 69th Infantry Regiment. Despite his bravado, his true character as a coward is revealed when the regiment comes under fire. Court-martialed and sentenced to death, he is freed from his prison by a stray artillery shell. He goes back to the front and saves his regiment, giving his life to save his fellow soldiers.

INTERESTING FACTS

- Priscilla Lane was cast as a girl back home. The part was cut before shooting.
- William Gargan was originally cast as John Wynn.
- A statue was erected to Father Duffy (Patrick O'Brien) in New York's Times Square.
- Another character in the film is real-life poet Joyce Kilmer (Jeffrey Lynn), who wrote the poem *Trees*. Kilmer was killed in action during an attack by the 69th on the Circq River on July 30, 1918, while serving as an adjutant to Maj. William "Wild Bill" Donovan, who later became the founder of the CIA. Kilmer was posthumously awarded the Croix de Guerre by the French government.
- This is one of a series of patriotic war films released prior to the U.S. entry into World War II, as part of FDR's campaign to get America ready for war.
- Seventy Jews served in the 69th, many of them born in Ireland.

The Fighting 69th (WARNER BROS./AUTHOR'S COLLECTION)

- The sets were so authentic at Calabasas Ranch in California that one French critic thought that the movie was filmed in France.
- The film is based on the real story of New York's 69th "Fighting Irish" Regiment. The 69th started out as a militia regiment in 1851 in New York, and first became famous in 1860 when it refused, as Irishmen, to parade before Edward, Prince of Wales (the future king of England), when he visited America. During World War I, the regiment was part of the Rainbow Division's 165th Infantry from New York. Well known for its ferocious fighting style, in World War II it fought at Saipan and Okinawa, and today it is the 69th Infantry (mechanized) of the New York National Guard.
- The conflict between the 69th and the southern units that were attached to the Rainbow Division portrayed in the movie are based on fact. Among the

infantry regiments that joined the 69th at Camp Mills to form the 42nd Division was the 69th's Civil War adversary, the Fourth Alabama, now the 167th Infantry. Apparently, on several occasions members of these two regiments refought some of the old battles.

FIGHT TO THE LAST

Chinese Film Co., 1938, b&w, 54 minutes.

Director: Y. C. Cheng; **Music:** C. R. Sheng; **Distributor:** Garrison Film Distributors Inc.; **Cast:** T. S. He, F. K. Ho, Kao Chan-Fei, Lily Lee, F. Ling, Yeh Ping, P. Wong.

The plot is about the fate of one Chinese family amid the atrocities of the Japanese invasion.

- When this film was being made in 1938, Pearl Harbor was three years away and Poland had not yet been invaded. However, World War II was raging in Asia, where the Japanese inflicted ghastly horrors on conquered populations.

FINEST HOUR, THE

21st Century Film Corporation, 1991, color, 105 minutes.

Producer: Menahem Golan; **Director:** Shimon Dotan; **Screenwriters:** Shimon Dotan, Stuart Schoffman; **Distributor:** Lauren Film; **Filmed at:** San Diego, California; **Cast:** Erik Degn, Daniel Dieker, Baruch Dror, Michael Fountain, Uri Gavriel, Tracy Griffith, Ava Haddad, Gale Hansen, Evyatar Lazar, Eb Lottimer, Rob Lowe, Natan Sgan-Cohen, Ari Sorko-Ram, Gilya Stern, Gregory Tal, Jack Widerker.

Gale Hansen and Rob Lowe become best friends during the intense training to become navy SEALS. But after a woman comes between them, it takes a war to bring them back together again.

FIRST COMES COURAGE

Columbia Pictures Corporation, 1943, b&w, 88 minutes.

Producer: Harry Joe Brown; **Director:** Dorothy Arzner; **Screenwriters:** Elliott Arnold, Melvin Levy, Lewis Meltzer, George Sklar; **Music:** Ernst Toch; **Cast:** Louis Adlon, Brian Aherne, Erville Alderson, Conrad Binyon, Swen Hugo Borg, Frederic Brunn, Gordon Clark, Leslie Denison, John Elliott, Isobel Elsom, Fern Emmett, Carl Esmond, Eric Feldary, Byron Foulger, Arno Frey, Greta Granstedt, Ethel Griffies, Louis Jean Heydt, Lloyd Ingraham, Charles Irwin, Guy Kingsford, Marten Lamont, Paul Langton, Fritz Leiber, Nelson Leigh, Rolf Lindau, Miles Mander, William Martin, Robert McKenzie, Hans von Morhart, Pat Moriarity, Merle Oberon, Larry Parks, William Phillips, Paul Power, Otto Reichow, Erik Rolf, Henry Rowland, John Royce, Reinhold Schünzel, Pietro Sosso, Tom Stevenson, Walter Thiele, Evan Thomas, Hans Heinrich von Twardowski, Rex Williams, Lewis Wilson.

Merle Oberon is a beautiful Norwegian spy who literally sleeps with the enemy when she marries a Nazi officer as part of her scheme to obtain vital war information and transmit it to England. When a British commando officer is captured, who was a friend of Merle Oberon's before the war, he kills her husband and escapes back to England with a British commando raiding party. She remains in Norway to continue as a spy, with an even better cover as the widow of a Nazi officer.

The movie is based on Elliot Arnold's *The Commandos* (New York: Duell, 1942).

FIRST TO FIGHT

Warner Bros., 1967, color, 92 minutes.

Producer: William Conrad; **Director:** Christian Nyby; **Screenwriter:** Gene L. Coon; **Music:** Fred Steiner; **Cast:** Claude Akins, Norman Alden, Robert Austin, James Best, Marilyn Devin, Chad Everett, Gene Hackman, Wings Hauser, Dean Jagger, Ray Reese, Clint Ritchie, Stephen Roberts, Ron Stokes, Ken Swofford, Bobby Troup, Robert Watson.

Chad Everett, the sole survivor of his squad in the fight for Guadalcanal, is sent back to the United States to receive the Medal of Honor and to go on a war-bond tour. Anxious to return to combat, he arrives in the Pacific in time for the invasion of Saipan, but he freezes in battle. Labeled a coward by his comrades, he is finally able to overcome his fear and once again become a hero.

FIRST YANK INTO TOKYO

RKO Radio Pictures Inc., 1945, b&w, 82 minutes.

Producer: J. Robert Bren; **Director:** Gordon Douglas; **Screenwriters:** Gladys Atwater, J. Robert Bren; **Music:** Leigh Harline; **Cast:** Harry Anderson, Spencer Chan, Keye Chang, Bo Ching, Bob Chinn, Peter Chong, Wallis Clark, Robert Clarke, Marc Cramer, Gwen Crawford, Dorothy Curtis, Bruce Edwards, Benson Fong, Paul Fung, Betty Gillette, Edmund Glover, Aline Goodwin, Frances Haldern, Barbara Hale, John Hamilton, Russell Hicks, Selmer Jackson, Jimmy Jordan, Joseph Kim, Bobbie La Salle, Albert Law, George Lee, Noreen Lee, Tommy Lee, James B. Leong, Weaver Levy, Richard Loo, Eddie Luke, Keye Luke, Clarence Lung, Tom Neal, Eden Nicholas, Gerald Pierce, Ione Reed, Michael St. Angel, Ralph Stein, Johnny Strong, Leonard Strong, Chet Voravan, Richard Wang, Artarne Wong, Larry Wong, Thomas Quon Woo.

Army intelligence selects Tom Neal for a secret mission into World War II Japan because he lived there before

the war, and he knows the language and the people. After plastic surgery to make him look Japanese, he's sent in to rescue a captured American engineer who knows the secret of the atomic bomb. The undercover agent not only brings out the engineer but also manages to rescue an army nurse who has been a POW since the fall of the Philippines.

INTERESTING FACT

- In the original film, shot near the end of the war, the engineer has only the plans for a new type of gun that will bring the war to a faster end. Before the film's release, however, the Allies dropped the atomic bomb on Japan, and the war ended. Some quick surgery on the film turned the secret the engineer is carrying into that of the atomic bomb, and a shot of an atomic bomb exploding was quickly grafted onto the end of the movie, making this the first war film in history to deal with the atomic bomb.

5 BRANDED WOMEN

Paramount Pictures, 1960, b&w, 106 minutes.

Producer: Dino De Laurentiis; **Director:** Martin Ritt; **Screenwriters:** Paul Jarrico, Ivo Perilli, Ugo Pirro, Michael Wilson; **Music:** Angelo Frances Lavagnino; **Cast:** Richard Basehart, Barbara Bel Geddes, Guido Celano, Sidney Clute, Bob Cunningham, Franca Dominici, Cyrus Elias, Steve Forrest, Vera Fusek, Pietro Germi, Carla Gravina, Harry Guardino, Van Heflin, Gérard Herter, Carlo Hinterman, Gérard Landry, Silvana Mangano, Nona Medici, Vera Miles, Tiberio Mitri, Jeanne Moreau, Alex Nicol, Teresa Pellati, Linda Rogers, Giacomo Rossi-Stuart, Tonio Selwart, Aldo Silvani, Erwin Strahl, Romolo Valli.

This movie follows the classic World War II film formula "resistance band fights guerrilla warfare against Nazis in the snowy woods," but with an interesting twist: The players are all women, decked out in leather bomber jackets and crew cuts and equipped with machine guns. Jeanne Moreau, Barbara Bel Geddes, Silvana Mangano, Carla Gravina, and Vera Miles—all shaved, humiliated, and thrown out of their peasant villages for sleeping with the enemy—have taken arms against that enemy, but the "real" resistance fighters don't want them. These women must fight both the men who are against them and the men who are supposedly on their side.

The film is based on the book *5 Branded Women* by Ugo Pirro (New York: Permabooks, 1960).

MILITARY SERVICE

- Van Heflin was a second lieutenant of artillery during World War II before being transferred to a position as a combat cameraman with the 9th Air Force in Europe.

FIVE GATES TO HELL

20th Century-Fox, 1959, b&w, 98 minutes.

Producer: James Clavell; **Director:** James Clavell; **Screenwriter:** James Clavell; **Music:** Paul Dunlap; **Cast:** Neville Brand, Greta Chi, Benson Fong, Gerry Gaylor, Shirley Knight, Nancy Kulp, Irish McCalla, Nobu McCarthy, Dolores Michaels, John Morley, Patricia Owens, Ken Scott, Linda Wong.

Neville Brand is a warlord in French Indochina prior to the Vietnam War. Most of his victims are beautiful Red Cross nurses who fall into his evil hands.

FIVE GRAVES TO CAIRO

Paramount Pictures, 1943, b&w, 96 minutes.

Producer: Charles Brackett; **Director:** Billy Wilder; **Screenwriters:** Lajos Biró, Charles Brackett; **Music:** Miklós Rózsa; **Cast:** Philip Ahlm, Kenneth Anspach, Anne Baxter, Fortunio Bonanova, Roger Creed, Leslie Denison, John Erickson, Peter van Eyck, Bud Geary, Frederick Giermann, Clyde Jackman, Ian Keith, Miles Mander, Hans Moebus, Bill Mussetter, Fred Nurney, Peter F. U. Pohlney, Otto Reichow, John Royce, Konstantin Shayne, Erich von Stroheim, Akim Tamiroff, Franchot Tone, Sam Waagenaar.

The British army, in its retreat from the victorious Nazis, leaves behind in the desert the lone survivor of a tank crew, Franchot Tone, who finds refuge at a remote hotel on the Egyptian border. As he hides out by impersonating a bartender, the hotel ironically becomes the German headquarters of Gen. Rommel. The German general's code name for his secret strategy is "five graves." The fate of the British in North Africa hangs on whether a humble corporal can penetrate this secret and get it to the British lines in time.

INTERESTING FACTS

- This film was released during Field Marshal Montgomery's westward march across North Africa. Because the movie was so timely, it was a box-office success.

- Although the premise of this film is not historical fact, because Montgomery did not receive his vast intelligence about the Desert Fox at the battle of El Alamein from a spy, there is a grain of truth in this film: Much of Monty's success against Rommel is credited not to his skill as a general but to the remarkable military intelligence he received from those who cracked the Nazi code. Allied intelligence had broken the supersecret "Ultra" system used by the Germans, and Monty was privy to Rommel's communications with his army. In light of the fact that the Allies had broken the German code and that this was the reason for Monty's victory in the desert, it's remarkable that someone in the War Office didn't suggest that this film be placed on the shelf until after the war, for fear that the movie might tip the Germans to the fact that we had broken their code.

QUOTES

Mouche: I'm not afraid of generals.
Lt. Schwegler: You're not?
Mouche: It's lieutenants I'm afraid of.

Italian General [speaking about his German allies]: Can a nation that belches understand a nation that sings?

Gen. Rommel [Erich von Stroheim]: I have an aversion to women in the morning.

FIXED BAYONETS

20th Century-Fox, 1951, b&w, 92 minutes.

Producer: Jules Buck; **Director:** Samuel Fuller; **Screenwriters:** John Brophy, Samuel Fuller; **Cast:** Richard Basehart, George Conrad, James Dean, John Doucette, Gene Evans, Patrick Fitzgibbon, Bill Hickman, Craig Hill, Pat Hogan, Skip Homeier, Richard Hylton, Tony Kent, Henry Kulky, Richard Monahan, Neyle Morrow, Al Nego, Wyott Ordung, Don Orlando, Michael O'Shea, Mel Pogue, Paul Richards, Kayne Shew, William Thourlby, George Wesley, David Wolfson.

Richard Basehart, a corporal who does not have the stomach for a fight, ends up in command after everyone else in his patrol is killed. He is forced by circumstances to overcome his fears and become a leader of men.
The movie is based on John Brophy's *Fixed Bayonets.*

INTERESTING FACT

- This was director Sam Fuller's second film about the Korean War; the first was *THE STEEL HELMET.*

QUOTES

General: Morale is high, but ammo is low.

Soldier [looking at a dead soldier]: Strip him of everything we can use, roll him in a blanket, and bury him.

FLAG LIEUTENANT, THE

British & Dominions Film Corporation, Gaumont, 1933, b&w, 85 minutes.

Producer: Herbert Wilcox; **Director:** Henry Edwards; **Screenwriter:** Joan Wentworth Wood; **Cast:** Joyce Bland, O. B. Clarence, Tully Comber, Henry Edwards, Peter Gawthorne, Louis Goodrich, Michael Hogan, Sam Livesey, Anna Neagle, Peter Northcote, Abraham Sofaer.

Accused of cowardice under fire, Henry Edwards is ostracized by his peers. The only person who knows that he is actually a hero is his superior officer, the major (Fred Raynham). Unfortunately, the major is suffering from amnesia and cannot come to his defense. It is up to the heroine to uncover the truth.

INTERESTING FACTS

- Produced on a grand scale, *The Flag Lieutenant* was deemed worthy of an American release, a rarity in the British film industry in those days.
- This is a remake of the 1919 and 1926 versions of the "stiff upper lip" drama *Flag Lieutenant.*

FLAT TOP

Monogram Pictures Corporation, 1952, color, 83 minutes.

Producer: Richard V. Heermance; **Director:** Lesley Selander; **Screenwriters:** Steve Fisher, Walter Mirisch; **Music:** Marlin Skiles; **Distributor:** Republic Pictures; **Cast:** James Best, John Bromfield, Richard Carlson, Phyllis Coates, Walter Coy, Sterling Hayden, Todd Karns, Keith Larsen, William Phipps, William Schallert, Dave Willock.

Sterling Hayden is a strict, by-the-book commander of an aircraft carrier during World War II, in counterpoint to the command style of his executive officer. They clash when a naval aviator, who was waved off by the deck officer, ignores the signal and lands anyway. Hayden grounds him for disobeying a direct order, and his exec disagrees vehemently with the decision. The

carrier steams to the South Pacific, where the squadron is tasked with supporting MacArthur's return to the Philippines. While the squadron is in the air, flying air cover for the invasion, the carrier is attacked by the Japanese, and the aviator who has been grounded and left behind, Keith Larsen, heroically takes to the skies in his fighter to protect the flattop.

INTERESTING FACT

- The disagreement between Hayden and his executive officer over styles of leadership is very similar to the clash between John Wayne and his exec in the film *The Flying Leathernecks*, which had been released the year before.

FLIGHT COMMAND

Metro-Goldwyn-Mayer, 1940, b&w, 116 minutes.

Producer: J. Walter Ruben; **Director:** Frank Borzage; **Screenwriters:** Harvey S. Haislip, Wells Root, John Sutherland; **Music:** Franz Waxman; **Cast:** Donald Douglas, Pat Flaherty, Lee Tung Foo, Reed Hadley, John Hamilton, Marsha Hunt, Ruth Hussey, Paul Kelly, Jack Luden, Forbes Murray, Nat Pendleton, Steve Pendleton, Walter Pidgeon, Dick Purcell, John Raitt, Addison Richards, Red Skelton, Stanley Smith, William Stelling, Shepperd Strudwick, William Tannen, Robert Taylor, Dick Wessel.

Pensacola (Robert Taylor), straight out of flight training, is sent to join a Hellcat squadron at the naval air station at North Island, the replacement for a recently killed pilot. When he arrives, he almost meets a similar fate: The field is socked in, and after one unsuccessful pass at the field, he is forced to bail out before his aircraft crashes into the ocean. When another one of the pilots develops a radio-guided signal for landing in bad weather, and is killed testing it, Pensacola continues with its development, installs it in his own plane, and uses it to save the entire squadron when they get caught in bad weather returning from maneuvers.

INTERESTING FACTS

- One of the USMC pilots in the air scenes was Lt. Greg (Pappy) Boyington, famous as the leader of the Black Sheep Squadron on which the television series starring Robert Conrad was based.
- North Island was the perfect place to set this film. North of Seattle, Washington, in the Puget Sound basin, the weather is always bad, and thus a perfect place to develop this device.

MILITARY SERVICE

- This film must have inspired Robert Taylor. First, he became a civilian pilot. Then, with the coming of World War II, he insisted on becoming a naval aviator and got his gold wings on January 11, 1944. Although he repeatedly requested combat, he was too old, and he spent the war as a flight instructor.

 Red Skelton wanted to enlist in World War II (despite his enormous salary at that time), but he was automatically deferred because he was married. As soon as his divorce was final, he went into the service. He later remarked that he was the only major film star to finish the war as a buck private.

AWARD

Academy Awards, USA, 1941
> **Nominated:** *Oscar*, *Best Special Effects*, A. Arnold Gillespie (photographic), Douglas Shearer (sound).

FLIGHT FOR FREEDOM

RKO Radio Pictures Inc., 1943, b&w, 102 minutes.

Producer: David Hempstead; **Director:** Lothar Mendes; **Screenwriters:** Horace McCoy (story), Jane Murfin (adaptation), Oliver H. P. Garrett, S. K. Lauren; **Music:** Roy Webb; **Cast:** Ed Agresti, Ernie Alexander, Stanley Andrews, Martin Ashe, Hugh Beaumont, Jack Carr, Jack Cheatham, Eduardo Ciannelli, Eddie Dew, Don Dillaway, Tom Dugan, James Eagles, Bruce Edwards, Kathleen Ellis, Theodore von Eltz, William Forrest, Walter Kingsford, Isabel La Mal, Shirley Lew, Richard Loo, Charles Lung, Fred MacMurray, Herbert Marshall, Matt McHugh, Malcolm McTaggart, Frank Mills, Forbes Murray, Damian O'Flynn, Gerald Pierce, Rosalind Russell, Byron Shores, Paul Stanton, Clarence Straight, Ann Summers, Mary Treen, Buddy Williams.

Rosalind Russell is aviation pioneer Amelia Earhart (here called Tonie Carter). She mysteriously disappears in the Pacific in the tense years before World War II when the Japanese were building their Pacific empire.

INTERESTING FACTS

- This film popularized the theory that Amelia Earhart's disappearance on her round-the-world flight was connected with top-secret work for the U.S. Navy.
- Amelia Earhart (1896–1937) was a military nurse during World War I, and after the war she qualified as a pilot. She was the first woman to cross the

Atlantic by air in 1928 as a passenger, and then the first woman to fly solo across the Atlantic as a pilot in 1932. In 1937, on a round-the-world flight, she and her copilot, Lt. Cmdr. Fred Noonan (USN), disappeared along with their twin-engine Lockheed somewhere in the Pacific. Speculation at the time was that she was shot down by the Japanese after flying over and observing something that she shouldn't have.

QUOTES

Paul Turner: Besides, fliers aren't good for women—ever.
Tonie Carter: Oh, I know. Every flier's married to his plane.
Paul Turner: Not quite that bad. But they never know what's going on inside of other people. How can they? They live 10,000 feet up in a world entirely their own. Any girl's safer to leave them there.
Tonie Carter: Dad always used to say, when you're safe . . . you're dead.

AWARD

Academy Awards, USA, 1943
 Nominated: *Oscar, Best Interior Decoration, Black-and-White,* Carroll Clark, Albert S. D'Agostino, Harley Miller, Darrell Silvera.

FLIGHT FROM ASHIYA

Daiei Motion Picture Co., Harold Hecht Films, 1964, color, 100 minutes.

Producer: Harold Hecht; **Director:** Michael Anderson; **Screenwriters:** Elliot Arnold, Waldo Salt; **Music:** Frank Cordell; **Distributor:** United Artists; **Filmed in:** Japan; **Cast:** Yul Brynner, George Chakiris, Joe Di Reda, Danièle Gaubert, Andrew Hughes, E. S. Ince, Shirley Knight, Suzy Parker, June Shelley, Mitsuhiro Sugiyama, Eiko Taki, Richard Widmark.

Members of the Air Rescue Service recall their pasts while searching for survivors.

The movie is based on Elliot Arnold's *Flight from Ashiya* (New York: Knopf, 1959).

FLIGHT NURSE

Republic Pictures Corporation, 1953, b&w, 90 minutes.

Producer: Herbert J. Yates; **Director:** Allan Dwan; **Screenwriter:** Alan Le May; **Music:** Victor Young; **Cast:** Morris Ankrum, Hal Baylor, James Brown, Ben Cooper, Richard Crane, Jeff Donnell, Arthur Franz,

Thomas Browne Henry, James Holden, Harry Lauter, Joan Leslie, Kristine Miller, Maria Palmer, Robert Shayne, Dick Simmons, Forrest Tucker, Dick Wessel.

Joan Leslie is a U.S. Air Force nurse during the Korean War who must choose between marriage and her career in the military. Her two romantic interests are Arthur Franz, a helicopter pilot, and Forrest Tucker, a C-47 pilot who evacuates the wounded. In the end, she decides to forgo her romantic entanglements and devote her life to the military and the care of the wounded.

FLIGHT OF THE INTRUDER

Paramount Pictures, 1990, color, 115 minutes.

Producers: John McTiernan, Mace Neufeld, Robert Rehme, Ralph Winter; **Director:** John Milius; **Screenwriters:** Stephen Coonts, Robert Dillon, John Milius, David Shaber; **Music:** Basil Poledouris; **Filmed in:** Kauai, Hawaii; **Cast:** Rosanna Arquette, Eddie Badiang, Adam Biesk, Reb Brown, J. Kenneth Campbell, Connie B. Canales, Jared Chandler, John Corbett, Willem Dafoe, Rick Dano, Minh Huu Do, Richard Fancy, Dann Florek, Alison Furrevig, Danny Glover, Brad Johnson, Grove E. Johnson, Mike Jolly, Brian Khaw, Tom Kriss, Madison Mason, Duane Matthews, J. Patrick McNamara, Dr. Akio Mitamura, Hugo Napier, Adam Nelson, Jeff O'Haco, James O'Neel, Jonnie C. Pangyarihan Sr., David Glyn Price, Ving Rhames, Christopher Rich, Douglas Roberts, David Schwimmer, Ernie Seliceo, Peter Sherayko, Tom Sizemore, Scott N. Stevens, Fred Dalton Thompson, Justin Williams, Ken Wright.

After his copilot is killed, Jake Grafton (Brad Johnson), a carrier-based Intruder pilot, questions the purpose of navy bombing missions. He finds an ally for his cynicism in Virgil Cole (Willem Dafoe), a weapons officer on his third tour of duty, and together they hatch a scheme to pull off one unsanctioned mission downtown, to knock out the concentration of surface-to-air missiles (SAMs) at "SAM City" in North Vietnam.

The movie is based on Stephen Coonts's *Flight of the Intruder* (Annapolis: Naval Institute Press, 1986).

FLYING FORTRESS

Warner Bros., 1942, b&w, 110 minutes.

Director: Walter Forde; **Producer:** Max Milner; **Screenwriters:** Edward Dryhurst, Gordon Wellesley, Brock Williams; **Cast:** Joss Ambler, Robert Beatty, John Boxer, Peter Croft, Tommy Duggan, Richard Greene, Hubert Gregg, William Hartnell, Charles Heslop,

Sidney King, Carla Lehmann, Andreas Malandrinos, Percy Parsons, Basil Radford, Edward Rigby, John Slater, Donald Stewart, Betty Stockfeld, John Stuart, Frank Wilcox, Gerry Wilmot.

The movie is about a B-17 Flying Fortress and its bombing raids over Berlin.

INTERESTING FACTS

- The are some exceptional scenes of the damage caused during the first London blitz of World War II.
- This film was shot so early in the war that the navigator is still using celestial fixes as the primary means of navigation.

FLYING LEATHERNECKS

RKO Radio Pictures Inc., 1951, color, 102 minutes.

Producer: Edmund Grainger; **Director:** Nicholas Ray; **Screenwriters:** Kenneth Gamet, James Edward Grant; **Music:** Roy Webb; **Distributor:** RKO Pictures; **Cast:** James Bell, Janis Carter, Ralph Cook, Gail Davis, Michael Devery, James Dobson, Sam Edwards, James Flavin, Jay C. Flippen, Gordon Gebert, William Harrigan, Douglas Henderson, Maurice Jara, Barry Kelley, Brett King, Keith Larsen, Harry Lauter, John Mallory, Brit Norton, Melville Robert, Robert Ryan, Michael St. Angel, Lynn Stalmaster, Milburn Stone, Don Taylor, Harlan Warde, John Wayne, Dick Wessel, Adam Williams, Mack Williams, Adam York, Carleton Young.

John Wayne, who commands the Wildcat squadron at the Battle of Guadalcanal, tries to convince his superiors of the value of close air support to ground troops. Wayne is tougher on his pilots than his executive officer, Robert Ryan, thinks is necessary. But in the end, Wayne proves that harsh discipline and close air support are vital for Marine Corps aviation.

INTERESTING FACTS

- "Leatherneck" is a nickname for a marine and makes for a more colorful title than "Flying Marines." They received this nickname because of the stiff leather collar used on early Marine Corps uniforms.
- In an example of life imitating film, the Marine Aviation Museum is now called the Flying Leatherneck Aviation Museum.
- The film was offered the use of the navy's aircraft carrier *Bataan*, but the offer had to be withdrawn when the carrier went on active duty off the coast of Korea.

- The film uses contemporary Korean war combat camera footage to substitute for World War II footage.
- In World War II, marine aviation was trying to convince the high command of the value of close air support; today that is the major argument in favor of keeping marine aviation. The marines argue that this job cannot be left to the air force or the navy; they can't be trusted to do it right and, in most situations, can't be counted on to do it at all. Marines, as a result, are the only ground troops in the U.S. military with reliable, consistent air support.

QUOTE

Mud Marine: Any closer and those guys will be using bayonets instead of propellers.

FLYING TIGERS

Republic Pictures Corporation, 1942, b&w, 102 minutes.

Producer: Edmund Grainger; **Director:** David Miller; **Screenwriters:** Kenneth Gamet, Barry Trivers; **Music:** Victor Young; **Distributors:** Republic Pictures; **Filmed in:** New Mexico; **Cast:** Gregg Barton, David Bruce, John Carroll, Mae Clarke, Richard Crane, Jimmy Dodd, Willie Fung, Chester Gan, John James, Gordon Jones, Paul Kelly, Charles Lane, Anna Lee, Richard Loo, Edmund MacDonald, Malcolm McTaggart, Tom Neal, Addison Richards, Tom Seidel, Bill Shirley, John Wayne.

Capt. Jim Gordon (John Wayne) commands a unit of mercenary fighter pilots who fight the Japanese in China before America's entry into World War II. Wayne must send his outnumbered band of fighter pilots out against overwhelming odds, while juggling the disparate personalities and problems of the flyers. In particular, he must handle the difficulties created by a reckless hot-shot pilot named Woody Jason (John Carroll), who is in it only for the bounty paid on each Japanese plane he shoots down, and who is trying to waltz off with Wayne's girlfriend.

INTERESTING FACTS

- Actual Flying Tigers Lawrence Moore and Kenneth Sanger were technical advisers for this film.
- Some clips of the dogfights and Japanese ack-ack guns were from confiscated Japanese newsreels.
- No scene of the interior of the airplane could be shown for security reasons. The instrument boards shown were fake.

- This movie broke all box-office records for Republic Pictures by a large margin and was one of the top-grossing movies of the year.
- The recruiter was a retired captain and a veteran of the Lafayette Escadrille (see the movie of the same name), Richard Aldworth, vice president of the company that was hiring mercenary pilots for China.
- The set was an authentic reproduction of the AVG facility, but set on a California studio ranch.
- The very odd bomber is the only Capelis XC-12 "Safety Aircraft Transport" built.
- A videotape version of *Flying Tigers* is now colorized.
- The Flying Tigers was a real unit of the Chinese Air Force, the American Volunteer Group authorized by FDR and put together by Claire Chennault in November 1941 (right before Pearl Harbor) and disbanded in April 1942 (the time of the Doolittle Raid). FDR also authorized sending the P-40s that had been earmarked for England and, in addition, authorized the recruitment of American reserve pilots from the army and air force, with a guarantee that when America entered the war, they could return to their parent service with full rank restored

MISTAKE

- When the burning cargo plan is waved off at the Rangoon Airport, it has only the right landing gear down. Moments later the pilots are shown raising the left landing gear.

QUOTE

[Hap got shot down while filling in for Woody, who was off the base on a date.]

Jim Gordon: I hope you two had a good time, 'cause Hap just paid the check.

AWARDS

Academy Awards, USA, 1943
 Nominated: *Oscar; Best Special Effects,* Daniel J. Bloomberg (sound), Howard Lydecker (photographic); *Best Score, Scoring of a Dramatic or Comedy Picture,* Victor Young; *Best Sound Recording,* Daniel J. Bloomberg (Republic, SSD).

FORCE OF ARMS

Warner Bros., 1951, b&w, 99 minutes.

Producer: Anthony Veiller; **Director:** Michael Curtiz; **Screenwriters:** Orin Jannings, Richard Tregaskis, **Music:** Max Steiner; **Filmed at:** Santa Susana Mountains, California; **Cast:** Argentina Brunetti, Francesco Cantania, Philip Carey, Amelia Cova, Anna Demetrio, Gene Evans, Ross Ford, Donald Gordon, Ron Hagerthy, William Holden, Henry Kulky, Lea Lamedico, Frank Lovejoy, Andy Mariani, John McGuire, Bob Ohlen, Nancy Olson, Adriana Page, Paul Picerni, Jay Richards, Robert Roark, Mario Siletti, Virgil S. Taylor, Katherine Warren, Dick Wesson, Joan Winfield.

William Holden is pulled out of the line after his platoon is decimated by the Germans as the Americans try to advance in the mountains of Italy during the winter of 1943. While on leave in Naples, he meets Nancy Olson, who is with the WACs (Women's Army Corps). Initially, she is cool toward him, but she starts to warm up during an air raid, and they are eventually married. He is periodically sent back to the line, but as a married man he is much more cautious, and he gets his men killed. Ultimately, he is captured, and his wife, who is afraid that he is dead, finds him only when the Germans release a number of prisoners of war.

INTERESTING FACTS

- The film includes combat camera footage of the Italian front during World War II.
- Both the title and the plot are similar to Hemingway's *A FAREWELL TO ARMS.*

QUOTES

Sgt. Joe Peterson: You mean you were a civilian once?
Lt. Eleanor MacKay: Oh, if you consider schoolteachers civilians.
Sgt. Joe Peterson: You, honest?
Lt. Eleanor MacKay: Mm-hmm.
Sgt. Joe Peterson: Well, and me without an apple!

FORCE 10 FROM NAVARONE

Marwi, Mundo, Navarone, TBC, American International Pictures, Open Road, 1978, color, 118 minutes.

Producers: David W. Orton, John R. Sloan, Anthony B. Unger, Oliver A. Unger; **Director:** Guy Hamilton; **Screenwriters:** Robin Chapman, Carl Foreman, Alistair MacLean; **Music:** Ron Goodwin; **Filmed at:** Malta, Jersey (Channel Islands), and Yugoslavia; **Cast:** Jürgen Andersen, Dicken Ashworth, Barbara Bach, Alan Badel, Jonathan Blake, Petar Buntic, Michael Byrne, Graeme Crowther, Jim Dowdall, Nick Ellsworth, Harrison Ford, Edward Fox, Robert Gillespie, David Gretton, Richard Hampton, Paul Humpoletz, Paul Jerrico, Michael

Josephs, Hans Kahler, Wolf Kahler, Edward Kalinski, Richard Kiel, Anthony Langdon, Philip Latham, Angus MacInnes, Christopher Malcolm, Frances Mughan, Franco Nero, Michael Osborne, Roger Owen, Ramiz Pasic, Edward Peel, Leslie Schofield, Robert Shaw, Michael Sheard, Mike Sirett, Carl Weathers.

During World War II, a mission is sent into Yugoslavia to destroy a bridge before German troops can cross it, to save Yugoslav forces under Marshal Tito. However, they are betrayed by a spy, the plane and equipment are destroyed, and they save the mission only by destroying a dam, and using the force of the cascading water to destroy the bridge.

INTERESTING FACTS

- It took *GUNS OF NAVARONE* producer Carl Foreman a decade to get the *Force 10* project off the ground, and Gregory Peck and David Niven were both out of the picture by the time the film was ready to go.
- Ironically, while Marshal Tito was a U.S. ally during World War II, after the war he would become the communist enemy.

 The film is based on Alistair MacLean's *Force 10 from Navarone*.

MISTAKE

- Near the end of the movie, an electric locomotive is visible. The model was not manufactured until the late 1960s.

QUOTES

Mallory: I don't suppose they taught you German at that awful school of yours?
Miller: What, instead of Latin? Heaven forbid, old boy.

Miller: Don't worry, old chap. Been handling this stuff ever since I blew up the nursery with my first chemistry set. Poor old Nanny.

FOREIGN CORRESPONDENT

Walter Wanger Productions, 1940, b&w, 120 minutes.

Producer: Walter Wanger; **Director:** Alfred Hitchcock; **Screenwriters:** Robert Benchley, Charles Bennett, Harold Clurman, Joan Harrison, Ben Hecht, James Hilton, John Howard Lawson, John Lee Mahin, Richard Maibaum, Budd Schulberg; **Music:** Alfred Newman; **Distributor:** United Artists; **Cast:** Samuel Adams, Meeka Aldrich, Jack Alfred, Albert Bassermann, Bunny Beatty, Robert Benchley, Frank Benson, Barry Bernard, Billy Bester, Henry Blair, Rebecca Bohannen, Louis Borel, Barbara Boudwin, Betty Bradley, Louise Brien, Ronald Brown, John Burton, Horace B. Carpenter, Frances Carson, William Castello, George Cathrey, Wheaton Chambers, Ken Christy, Eduardo Ciannelli, E. E. Clive, Eddie Conrad, Gino Corrado, Harry Davenport, Jack Dawson, Laraine Day, Harry Depp, Elspeth Dudgeon, Carl Ekburg, Helena Phillips Evans, Herbert Evans, James Finlayson, Robert Fischer, George B. French, Bill Gavier, John George, Roy Gordon, Douglas Gordon, Alexander Granach, Edmund Gwenn, Charles Halton, Richard Hammond, Holmes Herbert, Alfred Hitchcock, Gertrude Hoffman, Otto Hoffman, Billy Horn, Colin Kenny, Crauford Kent, Martin Kosleck, Marten Lamont, Joan Leslie, Gwendolyn Logan, Eily Malyon, Ted Mapes, Herbert Marshall, Joel McCrea, Jackie McGee, John Meredith, Hermina Milar, Thomas Mizer, Hans von Morhart, Leonard Mudie, John T. Murray, Jane Novak, Joe O'Brien, George Offerman, Lawrence Osman, Emory Parnell, Barbara Pepper, Hilda Plowright, Thomas Pogue, Jack Rice, Loulette Sablon, George Sanders, Harry Semels, Raymond Severn, Frederick Sewell, Ernie Stanton, William Stelling, Donald Stuart, Paul Sutton, Ferris Taylor, Dorothy Vaughan, Jack Voglin, Charles Wagenheim, Bert White, Ian Wolfe, William Yetter Sr., Mary Young.

Joel McCrea, a crime reporter on a New York newspaper, is appointed the paper's European correspondent because the editor says that a crime is being committed over there. McCrea's first assignment is to get the inside scoop on a secret treaty between two European countries, and this gets him entangled in a spy ring.

INTERESTING FACTS

- Robert Benchley was allowed to write his own lines.
- Director Alfred Hitchcock wanted Gary Cooper for the lead instead of Joel McCrea, but Cooper wasn't interested in doing a thriller.
- Shooting was completed on May 29, 1940, after which Hitchcock made a visit to England. He returned on July 3 with word that the Germans were expected to start bombing at any time. Ben Hecht was hurriedly called in and wrote the tacked-on final scene set at a London radio station; it was filmed on July 5, and the real-life bombing started on July 10.
- Albert Bassermann (who played the Dutch diplomat Van Meer) couldn't speak a word of English and learned all his lines phonetically.
- Alfred Hitchcock has a cameo early in the movie, walking past Johnny Jones's hotel reading a newspaper.

- After the release of the film, the British government asked Hitchcock to stay in Hollywood and continue to make anti-Nazi films.

MISTAKES

- Despite the explicit dialogue and written appearances of the name that make it clear that the character Scott ffolliott's surname has no capital F, the name still appears as Ffolliott in the end credit cast list.
- The window shadow on Johnny's jacket changes while he is in his boss's office.
- Johnny's raincoat lapel is folded, then flat, then folded while he is on the steps in the rain.
- The ladder appears and disappears beside the windmill door.
- The taxi rear-window view shows that they drive up the same street twice.
- Johnny takes the police to a completely different windmill than the one he entered before.
- The film is reversed left-to-right during the chess game at the police station.

QUOTES

Johnny Jones: I'm in love with you, and I want to marry you.

Carol Fisher: I'm in love with you, and I want to marry you.

Johnny Jones: Hmm . . . that cuts down our love scene quite a bit, doesn't it?

Johnny Jones [Radio broadcast from London]: Hello, America. I've been watching a part of the world being blown to pieces. A part of the world as nice as Vermont, and Ohio [siren sounds], and Virginia, and California, and Illinois lies ripped up and bleeding like a steer in a slaughterhouse, and I've seen things that make the history of the savages read like Pollyanna legends. I've seen women . . .
[bombs begin exploding]

English announcer: It's a raid; we shall have to postpone the broadcast.

Johnny Jones: Oh, postpone nothing! Let's go on as long as we can.

English announcer: Madam, we have a shelter downstairs.

Johnny Jones: How about it, Carol?

Carol Fisher: They're listening in America, Johnny.

Johnny Jones: Okay, we'll tell 'em, then. I can't read the rest of the speech I had, because the lights have gone out, so I'll just have to talk off the cuff. All that noise you hear isn't static—it's death, coming to

London. Yes, they're coming here now. You can hear the bombs falling on the streets and the homes. Don't tune me out, hang on a while —this is a big story, and you're part of it. It's too late to do anything here now except stand in the dark and let them come . . . as if the lights were all out everywhere, except in America. Keep those lights burning, cover them with steel, ring them with guns, build a canopy of battleships and bombing planes around them. Hello, America, hang on to your lights: they're the only lights left in the world!

AWARDS

Academy Awards, USA, 1940
 Nominated: *Oscar, Best Interior Decoration, Black-and-White,* Alexander Golitzen; *Best Cinematography, Black-and-White,* Rudolph Maté; *Best Special Effects,* Paul Eagler (photographic), Thomas T. Moulton (sound); *Best Picture,* Walter Wanger; *Best Supporting Actor,* Albert Bassermann; *Best Writing, Original Screenplay,* Charles Bennett, Joan Harrison.

FOREMAN WENT TO FRANCE, THE

Ealing Studios, 1942, b&w, 87 minutes.

Producers: Michael Balcon, Alberto Cavalcanti; **Director:** Charles Frend; **Screenwriters:** Leslie Arliss, John Dighton, Angus MacPhail, J. B. Priestley; **Filmed in:** Cornwall, England; **Cast:** Ronald Adam, Mrs. Blewett, Bill Blewitt, Paul Bonifas, John Boxer, Constance Cummings, Clifford Evans, Thora Hird, Gordon Jackson, Mervyn Johns, Ernest Milton, Robert Morley, Anita Palacine, Owen Reynolds, Francis L. Sullivan, Tommy Trinder, Charles Victor, John Williams.

As the Germans invade France at the start of World War II, a British aviation firm sends a foreman to the continent to steal a piece of specialized machinery.

INTERESTING FACT

- The movie is based on the true story of Melbourne Johns, an aircraft factory foreman sent to France to prevent the Nazis from getting hold of vital equipment.

FOR THE MOMENT

John Aaron Features II Inc., 1994, color, 120 minutes.

Producers: Jack Clements, Aaron Kim Johnston, Joseph MacDonald, Ches Yetman; **Director:** Aaron

Kim Johnston; **Screenwriter:** Aaron Kim Johnston; **Music:** Victor Davies; **Filmed at:** Grand Beach, Winnipeg, Brandon, all at Manitoba, Canada; **Cast:** Alistair Abell, John Bekavac, Bruce Boa, Roxanne Boulianne, Sean Bowie, Wanda Cannon, Ari Cohen, David Cowie, Russell Crowe, Grant Dilworth, Christianne Hirt, Katelynd Johnston, Scott Kraft, Riel Langlois, Sara McMillan, Clement Nelson, Peter Outerbridge, Kelly Proctor, Curtis Sali, Robert G. Slade, Guy Stewart, Glen Thompson, David Warburton, Tyler Woods, Steve James Young.

Three airmen go to Manitoba, Canada, during World War II: Russell Crowe and Peter Outerbridge, a pair of young daredevils out to earn their wings as bomber pilots, and Scott Kraft, a grizzled veteran of two European tours of duty, who is their flight instructor.

FORT SAGANNE

Albina Productions, Films A2, SFP Cinéma, 1984, color, 180 minutes.

Producer: Samuel Bronston; **Director:** Alain Corneau; **Screenwriters:** Alain Corneau, Louis Gardel, Bernard Gordon, Henri de Turenne, Philip Yordan; **Music:** Philippe Sarde; **Cast:** Mohamed Djamal Allam, Saïd Amadis, Daniel Aubert, Teddy Bilis, Nicole Camus, Med Salah Cheurfi, René Clermont, Jean-Laurent Cochet, Catherine Deneuve, Gérard Depardieu, Phillippe Deplanche, Michel Duchaussoy, Roger Dumas, Hippolyte Girardot, Sophie Grimaldi, Helga Hertzog, El Kébir, Grégoire Lavollay-Porter, Laurent Lavollay-Porter, Dahbia Maouch, Sophie Marceau, Charles Marosi, Hadrami Ould Meidah, Philippe Noiret, Florent Pagny, Myriam Perigois, Robin Renucci, Catherine Rethi, Jean-Louis Richard, Ernest von Rintelen, Zakia Tahiri, Lounès Tazairt, Salah Teskouk, Pierre Tornade, Tatiana Vialle.

Saganne (Gérard Depardieu) is of French peasant stock, a man of courage and forceful will. In 1911, he volunteers for the military and is posted to the Sahara Desert, where he serves under the aristocratic Col. Dubreuilh (Philippe Noiret) and catches the eye of Madeline (Sophie Marceau), the daughter of the regional administrator. In the desert, Saganne is a leader, with the respect of Arabs, including Amajan (Saïd Amadis), an independent warrior. After winning several resourceful campaigns, Saganne is sent on a diplomatic mission to Paris, where he has an affair with a journalist. Back in Africa, he leads a gallant defense against the sultan, is awarded the Grand Cross of the Legion of Honor, and marries Madeline. Then the Great War puts at risk all of his success and happiness.

The movie is based on Louise Gardel's *Fort Saganne*.

FORTY-NINTH PARALLEL

Ministry of Information, Ortus Films, 1941, b&w, 123 minutes.

Producers: George H. Brown, Roland Gillett, Michael Powell; **Director:** Michael Powell; **Screenwriters:** Rodney Ackland, Emeric Pressburger; **Music:** Ralph Williams; **Distributor:** General Film Distributors; **Filmed at:** Wolstenholme, Québec, Corner Brook, Newfoundland, Lake O'Hara, British Columbia (Philip Armstrong Scott segment), Banff, Alberta, and Niagara Falls, all in Canada; **Cast:** Basil Appleby, Robert Beatty, Elisabeth Bergner, Eric Berry, John Chandos, Eric Clavering, Finlay Currie, Leslie Falardeau, O. W. Fonger, Richard George, Lionel Grose, Leslie Howard, Jack Hynes, Glynis Johns, Stuart Latham, Raymond Lovell, Niall MacGinnis, Raymond Massey, Vincent Massey, Tawera Moana, Peter Moore, Laurence Olivier, Ley On, Frederick Piper, Eric Portman, Charles Rolfe, Theodore Salt, Charles Victor, Anton Walbrook.

A damaged U-boat is sunk by the Royal Canadian Air Force in a Canadian bay in the early years of World War II, before the United States has entered the war. The fanatical Nazi captain and the other five survivors of his crew must reach the neutral United States before they are captured by the Canadians. Along the way they meet a variety of characters, each with their own views on the war and nationalism. Of particular interest is a Hutterite community of pacifists who have fled Nazi Germany. When one of the German group decides to remain with the expatriate community, the other U-boat crew members kill him. One by one, the survivors die, until the captain is the only one left. He is captured when he tries to cross into the United States.

INTERESTING FACTS

- Powell forgot that Newfoundland was a Crown colony and not a part of Canada, and when the studio moved the full-sized submarine model to Newfoundland it was impounded by Customs & Excise, which demanded that import duty be paid. The matter was finally resolved when Powell appealed to the governor of Newfoundland, citing their work for the war effort. Newfoundland became a Canadian province in 1949.
- The film was edited by future director David Lean.

- The film was conceived by the British government as a propaganda piece to convince the United States to enter the war on the British side.

MISTAKE

- Despite the title, no scene in the movie is set at the 49th parallel of north latitude, which forms most of the the United States/Canadian border.

AWARD

Academy Awards, USA, 1942

Screenwriter Emeric Pressburger won an Oscar for best original story; in the United States, film was titled *The Invaders*.

40,000 HORSEMEN

Goodwill Pictures, 1941, b&w, 100 minutes.

Producer: Charles Chauvel; **Director:** Charles Chauvel; **Distributor:** Goodwill; **Screenwriter:** Elsa Chauvel; **Cast:** Harry Abdy, Harvey Adams, Kenneth Brampton, Betty Bryant, Edna Emmett, John Fleeting, Joy Hart, Vera Kandy, Iris Kennedy, Theo Lianos, Roy Mannix, Norman Maxwell, Pat Penny, Chips Rafferty, Eric Reiman, Grant Taylor, Claude Turton, Pat Twohill, Joe Valli, Albert C. Winn, Charles Zoll.

The movie is an accurate account of the Australian Light Horse in the Sinai Desert campaign of World War I. (Another excellent film on the Australian Light Horse in World War I is THE LIGHTHORSEMEN.)

INTERESTING FACTS

- Director/producer Charles Chauvel was the nephew of the commander of the Australian Light Horse in World War I, General Sir Harry Chauvel.
- Director Chauvel gave Chips Rafferty his first major screen role.
- This film was appropriate for the times; it was a popular success in Australia, England, and the United States.
- The desert marches and the climactic action scenes were filmed in the Cronulla sand hills.

FOR WHOM THE BELL TOLLS

Paramount Pictures, 1943, color, 170 minutes.

Producers: Buddy G. DeSylva, Sam Wood; **Director:** Sam Wood; **Screenwriters:** Ernest Hemingway, Dudley Nichols; **Music:** Walter Kent, Victor Young; **Filmed in:** Sonora, California; **Cast:** Maxine Ardell, Ingrid Bergman, John Bleifer, Fortunio Bonanova, Dick Botiller, Leo Bulgakov, Joseph Calleia, Yakima Canutt, Yvonne De Carlo, Feodor Chaliapin Jr., Eduardo Ciannelli, Gary Cooper, Harry Cording, Pedro de Cordoba, Franco Corsaro, George Coulouris, Arturo de Córdova, Michael Dalmatoff, Marjorie Deanne, William Edmunds, Eric Feldary, Martin Garralaga, Alexander Granach, Lynda Grey, Soledad Jiménez, Christopher King, Alice Kirby, Adia Kuznetzoff, Louise LaPlanche, Frank Lackteen, Manuel López, Antonio Vidal Molina, Ernesto Morelli, Alberto Morin, John Mylong, Mayo Newhall, Manuel París, Katina Paxinou, Marcella Phillips, Frank Puglia, Mikhail Rasumny, Pedro Regas, Duncan Renaldo, Tito Renaldo, Luis Rojas, Armand Roland, Konstantin Shayne, Leonid Snegoff, Vladimir Sokoloff, George Sorel, Robert Tafur, Akim Tamiroff, José Luis Tortosa, Jean Del Val, Victor Varconi, Trini Varela, Michael Visaroff, Lilo Yarson.

The Spanish Civil War of the 1930s is the place to be for a man of action like Gary Cooper. He is given a high-risk assignment in the mountains, to destroy a bridge that is vital to an upcoming battle. During the course of this mission, he falls in love with partisan Ingrid Bergman. The partisans blow up the bridge, but in the escape, Cooper is critically wounded and must remain behind, manning the machine gun in a doomed rear-guard action.

This film is based on Ernest Hemingway's *For Whom the Bell Tolls* (New York: Scribner's, 1940).

INTERESTING FACTS

- Ernest Hemingway, the author of the book, insisted on the casting of Gary Cooper and Ingrid Bergman, whom he said he had in mind when he was writing the book.
- This film ends the way a lot of other films of the 1940s end, with the American on a machine gun, blasting away at the enemy, his fate certain as hordes of the enemy attack. Other films with this ending include BATAAN and WAKE ISLAND.
- In the Spanish Civil War, Gary Cooper is shown taking the side that appealed most to idealists, like Ernest Hemingway, of that era.

MISTAKE

- People have complained about Ingrid Bergman's blonde hair in the film. Blonde hair, while not common, is not unknown in Spain. She is different from the other partisans, and blonde hair helps accentuate her unique status.

QUOTE

One of the old soldiers [when told he must kill a young boy who is a sentry]: I will kill the sentry, yes. Considering the necessity of the bridge. But if I live later, I would try to live in such a way, doing no harm to anyone, that it will be forgiven.

AWARDS

Academy Awards, USA, 1943
 Won: *Oscar, Best Supporting Actress,* Katina Paxinou
 Nominated: *Oscar, Best Actor,* Gary Cooper; *Best Actress,* Ingrid Bergman; *Best Interior Decoration, Color,* Haldane Douglas, Hans Dreier, Bertram C. Granger; *Best Cinematography, Color,* Ray

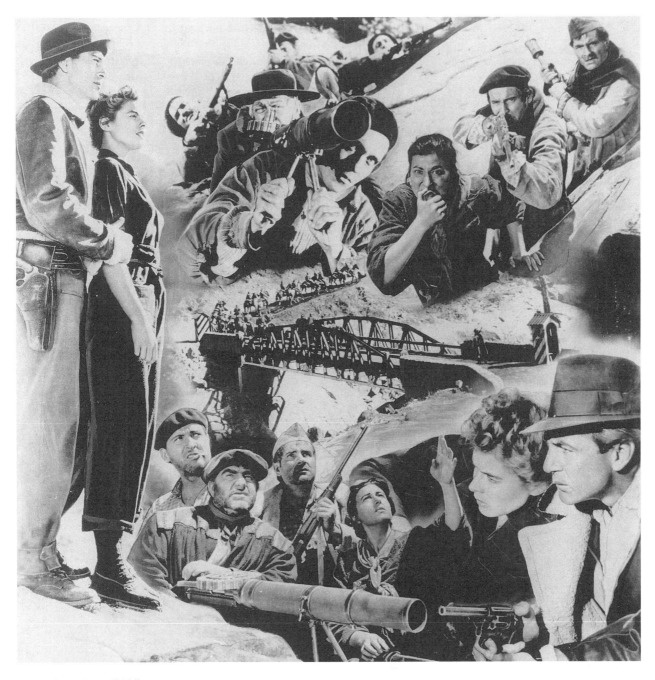

For Whom the Bell Tolls (PARAMOUNT PICTURES/AUTHOR'S COLLECTION)

Rennahan; *Best Film Editing*, John F. Link Sr., Sherman Todd; *Best Score, Scoring of a Dramatic or Comedy Picture*, Victor Young; *Best Picture*; *Best Supporting Actor*, Akim Tamiroff

Golden Globes, USA, 1944
Won: *Golden Globe, Best Supporting Actor*, Akim Tamiroff; *Best Supporting Actress*, Katina Paxinou.

FOUR JILLS IN A JEEP

20th Century-Fox, 1944, b&w, 68 minutes.

Director: William A. Seiter; **Screenwriters:** Robert Ellis, Helen Logan, Fred Niblo Jr. (story), Froma Sand (story), Snag Werris; **Music:** Harold Adamson (songs), Jimmy McHugh (songs), Leo Robin (songs), Harry Warren (songs); **Cast:** Eddie Acuff, Kirk Alyn, Martin Black, Ralph Byrd, Lester Dorr, Jimmy Dorsey, Alice Faye, Mary Field, James Flavin, Alice Faye, Mary Field, James Flavin, Kay Francis, Betty Grable, Alec Harford, Winifred Harris, John Harvey, Paul Harvey, Dick Haymes, George Jessel, Crauford Kent, Mike Killian, Carole Landis, Glenn Langan, Miles Mander, Jimmy Martin, Lester Matthews, Mitzi Mayfair, Carmen Miranda, Frances Morris, Alex Pollard, B. S. Pulley, Martha Raye, Bernard Sell, Mary Servoss, Mel Shubert, Phil Silvers, George Tyne, Dave Willock, Gordon Wynn.

During World War II, a United Service Organization (USO) goes on tour to entertain the troops as the Allies fight their way across Europe from Normandy to Berlin.

INTERESTING FACTS

- Kay Francis, Carole Landis, Martha Raye, and Mitzi Mayfair play themselves in this film.
- This movie was the high-water mark for the four leading actresses. Mitzi Mayfair never made another movie. Kay Francis made only three more before retiring. Carole Landis would suffer personal problems and die a few years later. Martha Raye moved on to a successful career in 1950s television and 20 years later would entertain troops in Vietnam. Another film based loosely on her life was Bette Midler's *For the Boys*.
- The movie is loosely based on the true story of a real USO unit headed by Kay Francis.

FOXHOLE IN CAIRO

Omnia Films, 1961, b&w, 80 minutes.

Producers: Steven Pallos, Donald Taylor; **Director:** John Llewellyn Moxey; **Screenwriters:** Leonard Mosley,

Donald Taylor; **Music:** Douglas Gamley, Kenneth V. Jones, Wolfram Röhrig; **Distributors:** Paramount; **Cast:** John Blythe, Michael Caine, Storm Durr, Peter van Eyck, Fenella Fielding, Adrian Hoven, James Robertson Justice, Albert Lieven, Niall MacGinnis, Howard Marion-Crawford, Neil McCallum, Lane Meddick, Gloria Mestre, Lee Montague, Nancy Nevinson, Anthony Newlands, Henry Oscar, Robert Urquhart, Richard Vernon, John Westbrook, Jerome Willis.

British intelligence officers trail a German agent to Cairo. He has been sent by Field Marshal Rommel to gather information on Field Marshal Montgomery's plan to defeat him in the desert during the North African campaign in World War II.

FRENCH LEAVE

Welwyn, 1937, b&w, 86 minutes.

Producer: Warwick Ward; **Director:** Norman Lee; **Screenwriters:** Reginald Berkeley, Vernon Clancey; **Cast:** Edmund Breon, Frederick Burtwell, Arthur Hambling, John Longden, Betty Lynne, Michael Morel, Oliver Wakefield, John Wickham, Margaret Yarde.

In France during World War I, the wife of an army lieutenant, in order to be with her husband, pretends to be her husband's friend. This is complicated by two unforeseen problems: Her husband's colonel falls in love with her, and she is accused of being an enemy spy. To save her, her husband must finally tell everyone the truth.

FROGMEN, THE

20th Century-Fox, 1951, b&w, 96 minutes.

Producer: Samuel G. Engel; **Director:** Lloyd Bacon; **Screenwriters:** John Tucker Battle, Oscar Millard; **Cast:** Robert Adler, Richard Allan, Dana Andrews, Parley Baer, William Bishop, Frank Donahue, Harry Flowers, James Gregory, Harry Hamada, Russell Hardie, Jeffrey Hunter, Ray Hyke, Peter Leeds, Harvey Lembeck, Norman McKay, Gary Merrill, William N. Neil, Robert Patten, Robert Rockwell, Fay Roope, Henry Slate, Sydney Smith, Warren Stevens, Robert Wagner, Jack Warden, Richard Widmark, Rush Williams, George Yoshinaga.

Richard Widmark is sent to take charge of a squad of U.S. Navy frogmen in the Pacific during World War II when their former commander is killed in action. At

first Widmark is resented by the men in the squad; they change their opinion of him when he disarms a Japanese torpedo that has lodged itself, unexploded, in the hull of the ship in the middle of the hospital ward. They then follow him on a dangerous underwater mission to blow up a Japanese submarine base.

FROM HERE TO ETERNITY

Columbia Pictures Corporation, 1953, b&w, 118 minutes.

Producer: Buddy Adler; **Director:** Fred Zinnemann; **Screenwriters:** James Jones, Daniel Taradash; **Music:** George Duning, Fred Karger; **Filmed in:** Hawaii; **Cast:** Claude Akins, Vicki Bakken, Margaret Barstow, Harry Bellaver, Ernest Borgnine, Willis Bouchey, John Bryant, Mary Carver, John L. Cason, Mack Chandler, Montgomery Clift, John Davis, John Dennis, Don Dubbins, Moana Gleason, Robert Healy, Douglas Henderson, James Jones, Robert Karnes, Arthur Keegan, Deborah Kerr, Manny Klein, Edward Laguna, Burt Lancaster, Carey Leverette, Weaver Levy, William Lundmark, Freeman Lusk, Tyler McVey, Patrick Miller, Kristine Miller, Barbara Morrison, Philip Ober, Robert Pike, Allen Pinson, Donna Reed, George Reeves, Joe Roach, Fay Roope, Tim Ryan, Delia Salvi, Louise Saraydar, Alvin Sargent, Joseph D. Sargent, Mickey Shaughnessy, Joan Shawlee, Frank Sinatra, Angela Stevens, Brick Sullivan, Merle Travis, John Veitch, Jack Warden, Guy Way, Norman Wayne, Robert J. Wilke, Jean Willes, Carleton Young.

Robert E. Lee Prewitt (Montgomery Clift) has been transferred to Schofield Barracks in Hawaii. His new captain has heard he is a great boxer and wants him to represent the company in the championships. However, "Prew" is adamant that he will not box again, so the captain orders his sergeants to make his life a living hell. Meanwhile, Sgt. Warden (Burt Lancaster) starts seeing the captain's wife (Deborah Kerr), who has a history of seeking extracurricular activities. Prew's friend Maggio (Frank Sinatra) has a few altercations with the sadistic stockade sergeant, "Fatso" Judson (Ernest Borgnine), and Prew begins falling in love with "social club" employee Lorene (Donna Reed). All of these personal stories come to a head with the Japanese sneak attack on Pearl Harbor.

The most poignant scene occurs on the ship taking Montgomery Clift's girlfriend, Donna Reed, back to the states, as she talks about her fiancé. "They're very fine people, southern people. In fact, he's named after a famous general. His name was Robert E. Lee Prewitt." What she says is obviously a lie, about how he was a

pilot, and was killed trying to take his plane off during the Pearl Harbor attack. The surprised look on the face of Deborah Kerr, who knows all about Prewitt the boxer/bugler/deserter, says it all.

The film is based on James Jones's *From Here to Eternity* (New York: Scribner's, 1951).

INTERESTING FACTS

- Eli Wallach accepted the role of Angelo Maggio, but then turned it down without ever giving a reason.
- Joan Crawford refused a role because she abhorred the costumes.
- Studio executive Harry Cohn wanted Aldo Ray to play Prewitt and Joan Crawford for the Karen Holmes role. Director Fred Zinnemann opted for less familiar screen personalities.
- The scene in which Prew meets Maggio and Lorene in the bar after he walks off guard duty was actually Frank Sinatra's screen test for the part of Maggio. To impress director Fred Zinnemann, he did an ad-lib using olives as dice and pretending to shoot craps. The entire sequence was kept as is and used in the picture.

MILITARY SERVICE

- Ernest Borgnine enlisted in the U.S. Navy in October 1935 and served as a seaman apprentice aboard the USS *Lamberton* (DD-119), then as a gunner's mate aboard destroyers in both the Atlantic and Pacific fleets before World War II. He was discharged in October 1941, right before Pearl Harbor. During this time, he was a boxer, a strange turn of events, considering his future role in *From Here to Eternity*. After Pearl Harbor, he went back into the navy and served as a gunner's mate first class, primarily on the USS *Sylth* (PY-12), a patrol gunboat on the East Coast.

QUOTES

Robert E. Lee "Prew" Prewitt: Nobody ever lies about being lonely.

Pvt. Prewitt: A man don't go his own way, he's nothing.
Sgt. Milton Warden: Maybe back in the days of the pioneers a man could go his own way, but today you got to play ball.

Alma: Sit down and — and get comfortable. I'll make you a martini and see what's to cook for dinner.
Pvt. Prewitt: Hey, this is like being married, ain't it?
Alma: It's better.

Karen Holmes: You certainly chose a lovely spot for our meeting. I've had three chances to be picked up in the last five minutes.

Best Line in the Movie: You know, the funny thing is, there isn't going to be any boxing competition this year [because of the war].

AWARDS

Academy Awards, USA, 1953
Won: *Oscar, Best Cinematography, Black-and-White,* Burnett Guffey; *Best Director,* Fred Zinnemann; *Best Film Editing,* William A. Lyon; *Best Picture,* Buddy Adler; *Best Sound Recording,* John P. Livadary (Columbia, SSD); *Best Supporting Actor,* Frank Sinatra; *Best Supporting Actress,* Donna Reed; *Best Writing, Screenplay,* Daniel Taradash

Nominated: *Oscar, Best Actor,* Montgomery Clift, Burt Lancaster; *Best Actress,* Deborah Kerr; *Best Costume Design, Black-and-White,* Jean Louis; *Best Music, Scoring of a Dramatic or Comedy Picture,* George Duning, Morris Stoloff

British Academy Awards, 1954
Nominated: *BAFTA Film Award, Best Film from any Source—USA*

Cannes Film Festival, 1954
Won: *Special Award—*Fred Zinnemann

Directors Guild of America, USA, 1954
Won: *DGA Award, Outstanding Directorial Achievement in Motion Pictures,* Earl Bellamy (assistant, director) (plaque), Fred Zinnemann

Golden Globes, USA, 1954
Won: *Golden Globe, Best Motion Picture Director,* Fred Zinnemann; *Best Supporting Actor,* Frank Sinatra

New York Film Critics Circle Awards, 1953
Won: *NYFCC Award, Best Actor,* Burt Lancaster; *Best Director,* Fred Zinnemann

Best Film, Photoplay Awards, 1953
Won: *Gold Medal*

Writers Guild of America, USA, 1954
Won: *WGA Screen Award, Best Written American Drama,* Daniel Taradash.

FULL METAL JACKET

Warner Bros., 1987, color, 116 minutes.

Producers: Jan Harlan, Michael Herr, Philip Hobbs, Stanley Kubrick; **Director:** Stanley Kubrick;

Screenwriters: Gustav Hasford, Michael Herr, Stanley Kubrick; **Distributor:** Warner Bros.; **Music:** Vivian Kubrick; **Filmed at:** Parris Island, South Carolina, and Bassingbourn Barracks, Cambridgeshire, Dorset, Beckton Gasworks, and Isle of Dogs, London (the last four in England); **Cast:** Martin Adams, Kevin Albridge, Del Anderson, Philip Bailey, Adam Baldwin, Louis Barlotti, John Beddows, Patrick Benn, Bruce Boa, Steve Boucher, Adrian Bush, Tony Carey, Gary Cheeseman, Costas Dino Chimona, Wayne Clark, Tim Colceri, Chris Cornibert, Danny Cornibert, John Curtis, Marcus D'Amico, Harry Davies, John Davis, Kevin Day, Vincent D'Onofrio, Gordon Duncan, Peter Edmund, Phil Elmer, Colin Elvis, R. Lee Ermey, Hadrian Follett, Tan Hung Francione, Sean Frank, David George, Laurie Gomes, Brian Goodwin, Nigel Goulding, Tony Hague, Steve Hands, Dorian Harewood, Chris Harris, Bob Hart, Derek Hart, Barry Hayes, Tony Hayes, Kenneth Head, Robin Hedgeland, Duncan Henry, Keith Hodiak, Liam Hogan, Leanne Hong, Arliss Howard, Kevyn Major Howard, Tony Howard, Steve Hudson, Kieron Jecchinis, Gil Koppel, Vivian Kubrick, Sean Lamming, Dan Landin, Ngoc Le, Tony Leete, Sal Lopez, Nigel Lough, Terry Lowe, Chris Maybach, Frank McCardle, Peter Merrill, Gary Meyer, Brett Middleton, Gary Landon Mills, David Milner, Sean Minmagh, Tony Minmagh, Matthew Modine, Jon Morrison, Russell Mott, John Ness, Robert Nichols, Herbert Norville, Ed O'Ross, David Palffy, David Perry, Nguyen Hue Phong, Peter Rommely, Pat Sands, Jim Sarup, Al Simpson, Russell Slater, Gary Smith, Roger Smith, Tony Smith, Papillon Soo, Jon Stafford, Anthony Styliano, Duc Hu Ta, Kirk Taylor, John Terry, Bill Thompson, Mike Turjansky, Ian Tyler, Dan Weldon, Dennis Wells, Michael Williams, John Wilson, John Wonderling.

Marine recruits go through basic training under the command of a punishing sergeant, and one of them commits suicide. They are sent to Vietnam, and one of those recruits, Private Joker (Matthew Modine), covers the war as a correspondent for *Stars and Stripes* during the Tet offensive.

The film is based on Gustav Hasford's *The Short Timers.*

INTERESTING FACTS

• Mickey Mouse is referred to at the end of both segments: When Hartmann enters the head to confront Joker and Pyle, he cries, "What is this Mickey Mouse shit?" Joker and others sing the theme from the Mickey Mouse Club as they march through

Full Metal Jacket (WARNER BROS./AUTHOR'S COLLECTION)

the burning city. A third Mickey Mouse reference is in the press room: A Mickey Mouse figure can be seen near the window behind Pvt. Joker.

- Vincent D'Onofrio gained 70 pounds for his role as Pvt. Pyle.
- Former U.S. Marine drill Instructor R. Lee Ermey was hired as a consultant on how to drill USMC style. He performed a demonstration on videotape in which he yelled obscene insults and abuse nonstop for 15 minutes without repeating himself or even flinching—despite being continuously pelted with tennis balls and oranges. Director Stanley Kubrick was so impressed that he cast Ermey as Sgt. Hartmann, ordered a transcript of the audition tape (it came to 250 pages), and exclusively used Ermey's insults in the script.
- R. Lee Ermey hardly blinks at all in any scene.
- Ermey was involved in a jeep accident during the making of the movie. At 1 A.M., he skidded off the road, breaking all his ribs on one side. He refused to pass out, and kept flashing his car lights until a motorist stopped. In some scenes, he does not move one of his arms at all.
- The scenes of the ruined city of Hue were shot at a dockyard on the Isle of Dogs, London, that was scheduled for demolition. In some shots there is a rock in the background that looks very much like the monolith from Kubrick's *2001: A Space Odyssey* (1968). Kubrick says it wasn't intentional, but it was noticed when the rushes were viewed.
- As Joker prepares to kill the sniper, his chest turns as he raises the gun—hiding his peace symbol button from view.
- Toward the end of the movie, when Cowboy uses the radio to request tank support, the voice of Murphy,

to whom he is speaking, is probably none other than Stanley Kubrick.

- The inscription "I Am Become Death" is written on Animal Mother's helmet. This is a quotation from the *Bhagavad-Gita*, spoken by J. Robert Oppenheimer after the explosion of the first atomic bomb at Alamogordo.
- Stanley Kubrick's daughter Vivian makes a cameo appearance during a scene in Vietnam in which Joker and Rafterman encounter an open mass grave. Vivian can be seen wielding a motion picture camera, shooting into the open grave for a few moments.
- At the end of the film, the troops once more move forward. As they march, they sing the Mickey Mouse theme, "Who's the leader of the club, that's made for you and me. M-I-C, K-E-Y, M-O-U-S-E." This song sums up the futility of this war, in which the general officers, much like in *PATHS OF GLORY* (another Stanley Kubrick film), are totally out of tune with the men they are leading. In *Paths*, there was a strict class division between the men and their officers. In *Full Metal Jacket*, it's the generation gap between the soldiers and their generals. In Vietnam, for the most part, the senior leadership was from the World War II generation, whereas the soldiers were baby boomers. Nothing could have been a more appropriate anthem for these boomers than the theme of the Mickey Mouse club, a show that was watched by an entire generation.

MISTAKES

- Hartmann's ribbons are incorrect—the P.U.C. (Presidential Unit Citation) is upside down: The blue horizontal stripe should be on top.
- Hartmann gives his recruits a minimum time to complete an obstacle, berating them for doing it too quickly.
- Road markings indicate the filming location as England and not Parris Island.
- The characters are in an old Sea Cow helicopter, but the shadow on the jungle canopy indicates a Jet Ranger.
- Animal's aimless shots blow away parts of the My Toan sign, but it is later seen intact.
- During the assault on the Leyna building, the windows that are blown out by the grenade launcher reappear.
- An anachronism is evident from a cell phone tower in a shot of a helicopter taking off after troops enter the city and it is being strafed by the tanks. This occurs

during the scene of troops being filmed by the film crew while they are sitting down waiting for orders.

QUOTES

Joker: The dead know only one thing: It's better to be alive.

Joker: Are those . . . live rounds?
Pyle: Seven-six-two millimeter. Full metal jacket.

Joker: I am so happy that I am alive, in one piece and short. I'm in a world of shit . . . yes. But I am alive. And I am not afraid.

Joker: I wanted to meet stimulating and interesting people of an ancient culture, and kill them. I wanted to be the first kid on my block to get a confirmed kill.

Door Gunner: Anyone who runs is V.C. Anyone who stands still is well-disciplined V.C.

Marines [chanting]: This is my rifle [grabbing their crotches]. This is my gun. This is for fighting, and this is for fun.

AWARDS

Academy Awards, USA, 1987
 Nominated: *Oscar, Best Writing, Screenplay, Based on Material from Another Medium,* Gustav Hasford, Michael Herr, Stanley Kubrick

Boston Society of Film Critics Awards, 1988
 Won: *BSFC Award, Best Director,* Stanley Kubrick; *Best Supporting Actor,* R. Lee Ermey

British Academy Awards, 1988
 Nominated: *BAFTA Film Award, Best Sound,* Nigel Galt, Andy Nelson, Edward Tise; *Best Special Effects,* John Evans

Golden Globes, USA, 1988
 Nominated: *Golden Globe, Best Performance by an Actor in a Supporting Role in a Motion Picture,* R. Lee Ermey

Writers Guild of America, USA, 1988
 Nominated: *WGA Screen Award, Best Screenplay Based on Material from Another Medium,* Gustav Hasford, Michael Herr, Stanley Kubrick.

GALLANT BESS

Metro-Goldwyn-Mayer, 1946, color, 100 minutes.

Producer: Harry Rapf; **Director:** Andrew Marton; **Screenwriter:** Jeanne Bartlett; **Music:** Rudolph G. Kopp; **Filmed at:** Advance Naval Base, Hueneme, California; **Cast:** Murray Alper, Clem Bevans, Johnny Bond, John Burford, Wally Cassell, Donald Curtis, Jim Davis, Marshall Thompson, George Tobias, Chill Wills.

A young orphan farm boy has dreams of building a ranch with his horse Bess. But it's World War II, and he must join the navy and leave Bess behind. While on patrol in the jungle, he finds a wounded horse, which he nurses back to health. This new Bess not only becomes the unit mascot but also saves the life of her new master.

GALLANT HOURS, THE

Cagney-Montgomery Productions, 1960, b&w, 115 minutes.

Producers: James Cagney, Robert Montgomery; **Director:** Robert Montgomery; **Screenwriters:** Frank D. Gilroy, Beirne Lay Jr.; **Music:** Roger Wagner; **Distributor:** United Artists; **Cast:** Raymond Bailey, Robert Burton, James Cagney, James Cagney Jr., Richard Carlyle, Ward Costello, Art Gilmore, James T. Goto, Selmer Jackson, Richard Jaeckel, Harry Landers, Nelson Leigh, Leon Lontoc, Herbert Lytton, Maggie Magennio, John McKee, Tyler McVey, Robert Montgomery Jr., Carl Benton Reid, Walter Sande, William Schallert, Sydney Smith, Karl Swenson, Vaughn Taylor, Les Tremayne, Dennis Weaver, James Yagi, Carleton Young, John Zaremba.

The film is about five weeks in the life of Rear Adm. William F. "Bull" Halsey Jr. (James Cagney), from his assignment to command of U.S. naval operations in the South Pacific during World War II to the Allied victory at Guadalcanal. A poignant scene involves Admiral Halsey's understated pain in ordering only a "routine" search for his missing son, although he has at his disposal the entire U.S. Navy in the Pacific during World War II.

MILITARY SERVICE

- Admiral William F. "Bull" Halsey Jr. (1882–1956) received the Navy Cross in World War I.

 At sea on the aircraft carrier *Enterprise* during the sneak Japanese attack on Pearl Harbor, he retaliated several months later when his task force launched the Doolittle Raid against Tokyo.

 An aggressive and successful commander, he was also the subject of controversy. During the Battle of Leyte Gulf, he was criticized for allowing his ships to be decoyed, resulting in other Japanese warships slipping through the San Bernardino Straits. For this

episode, he faced a court of inquiry. Another inquiry concerned his ships caught in typhoons, which resulted in the loss of lives and ships.

QUOTE

Fleet Adm. William F. "Bull" Halsey Jr.: There are no great men, only great challenges that ordinary men are forced by circumstances to meet.

GALLIPOLI

R&R Films, 1981, color, 110 minutes.

Producers: Martin Cooper, Ben Gannon, Patricia Lovell, Francis O'Brien, Robert Stigwood; **Director:** Peter Weir; **Screenwriters:** Peter Weir, David Williamson; **Music:** Tomaso Albinoni, Georges Bizet, Jean-Michel Jarre, Brian May; **Distributor:** Belle & Blade; **Filmed at:** Adelaide, Port Lincoln, and Quorn, South Australia, Egypt; **Cast:** Brian Anderson, David Argue, Harold Baigent, Saltbush Baldock, Don Barker, Clive Bennington, Phyllis Burford, Diane Chamberlain, Les Dayman, Steve Dodd, Graham Dow, Reg Evans, Peter Ford, Robyn Galwey, Mel Gibson, Jack Giddy, Ian Govett, Ronny Graham, Stan Green, Robert Grubb, Heath Harris, Giles Holland-Martin, Harold Hopkins, Peter R. House, Bill Hunter, Marjorie Irving, Moshe Kedem, Bill Kerr, Peter Lawless, Mark Lee, Paul Linkson, Jenny Lovell, Tim McKenzie, John Morris, John Murphy, Gerda Nicolson, Geoff Parry, Dane Peterson, Don Quin, Paul Sonkkila, Max Wearing, Kiwi White, Charles Yunupingu.

A promising track star (Mel Gibson) interrupts his career when Australia enters World War I. Although he is an excellent candidate for the Olympics, he nonetheless abandons his track pursuits to do the patriotic thing and join the ANZAC (Australian and New Zealand Army Corps). The young Australians are sent to Gallipoli, where they are slaughtered in the ill-conceived British invasion. The ANZACs are ordered to charge the Turkish trenches, but their officers don't synchronize their watches. As a result, the artillery barrage ends, allowing precious minutes to go by before the soldiers charge out of the trenches. During this delay, the Turks come out of their bunkers and set up their machine guns for the slaughter. After the first wave fails, another mistake occurs when the British commander receives erroneous information that marker flags have been seen in the enemy trenches. Based on this bad information, he sends another wave of soldiers to their deaths.

The Gallipoli campaign, advocated by Winston Churchill, was one of the great disasters of World War

I. Once Turkey had allied itself with the Central Powers, an Anglo-French fleet tried to push through the Dardanelles to help the Russians, who needed access to the Mediterranean from the Black Sea. When the naval attack failed, it was decided to send an Allied expeditionary force to seize the forts guarding the Dardanelles; it landed on April 25, 1915.

The ANZACs gained immortal fame storming the heights above the beach on which they had been mistakenly landed, and the British 29th Division suffered terrible losses while landing in broad daylight at the tip of the peninsula. The campaign that followed was characterized by deeds of heroism and endurance, appalling generalship, and a Turkish defense under the inspired leadership of Mustafa Kemal (Ataturk), who later founded modern Turkey. The cost in human terms was horrific: 252,000 Allied troops were killed, wounded, missing, prisoners, or victims of disease.

AWARDS

Australian Cinematographers Society, 1982
 Won: *Cinematographer of the Year*—Russell Boyd

Australian Film Institute, 1981
 Won: *AFI Award, Best Achievement in Cinematography*, Russell Boyd; *Best Achievement in Editing*, William M. Anderson; *Best Achievement in Sound*, Greg Bell, Don Connolly, Peter Fenton; *Best Actor in a Lead Role*, Mel Gibson; *Best Actor in a Supporting Role*, Bill Hunter; *Best Director*, Peter Weir; *Best Film*, Patricia Lovell, Robert Stigwood; *Best Screenplay, Original or Adapted*, David Williamson
 Nominated: *AFI Award, Best Achievement in Costume Design*, Terry Ryan, Wendy Weir; *Best Achievement in Production Design*, Herbert Pinter, Wendy Weir; *Best Actor in a Lead Role*, Mark Lee; *Best Actor in a Supporting Role*, Bill Kerr

Golden Globes, USA, 1982
 Nominated: *Golden Globe, Best Foreign Film*—Australia.

GARDENS OF STONE

TriStar Pictures, Zoetrope Studios, ML Delphi Premier Productions, 1987, color, 112 minutes.

Producers: Francis Ford Coppola, Jay Emmett, Michael I. Levy, Fred Roos, David Valdes, Stan Weston; **Director:** Francis Ford Coppola; **Screenwriters:** Ronald Bass, Nicholas Proffitt; **Music:** Carmine Coppola, Franz Schubert; **Distributor:** TriStar Pictures; **Filmed at:**

National Capital Region, District of Columbia; **Cast:** Steve Barcanic, Sam Bottoms, James Caan, Terrence Currier, Grant Lee Douglass, Penny B. Ernst, Lisa-Marie Felter, Laurence Fishburne, Terry Foster, Mark Frazer, Robert Frerichs, Carlin Glynn, Arthur V. Gorman Jr., Bill Graham, Terry Hinz, Erik Holland, Anjelica Huston, James Earl Jones, Elias Koteas, Peter Masterson, Mary Stuart Masterson, Lonette McKee, Hajna O. Moss, Louis Rangel, Joseph A. Ross Jr., Casey Siemaszko, Marshall Sizemore, Dean Stockwell, Daniel R. Suhart, D. B. Sweeney, Dick Anthony Williams, William Williamson.

James Caan is a colonel in charge of the burial detail at Arlington National Cemetery during the Vietnam War. He would rather save lives than bury dead soldiers, but his request for transfer to a training command is denied. He tries to help one young soldier, the friend of an old army buddy, but he too returns from Vietnam in a coffin.

The film is based on Nicholas Proffitt's *Gardens of Stone*.

INTERESTING FACTS

- The parents of Mary Stuart Masterson's character are played by her real-life parents, Peter Masterson and Carlin Glynn.
- The title *Gardens of Stone* refers to the rows of tombstones in Arlington National Cemetery.
- This film was produced in cooperation with the U.S. Army.

MISTAKE

- Hazard leaves his Combat Infantry Badge on Willow's coffin, but it is back on his uniform when he goes back outside.

QUOTES

Goody Nelson: Well, here's to us and those like us.
Clell Hazard: Damn few left.

Clell Hazard: I am not a peacenik, Captain; I just don't agree with the reasons behind this particular war, and I feel if we're gonna fight it we oughtta god-damn fight it right.

GERMANS

Rubicon Film Productions, 1998, color, 93 minutes.

Producers: Eva Kaminski, Zbigniew Kaminski, Kazimierz Rozwalka; **Director:** Zbigniew Kaminski;

Screenwriters: Zbigniew Kaminski, Leon Kruczkowski; **Music:** Maciej Zielinski; **Filmed at:** Wroclau, Poland; **Cast:** Scott Cleverdon, Mark Folger, Per Oscarsson, Eric Parkinson, Matthew Sullivan, Peter Thoemke, Vivian Schilling, Beth Tegarden, Beata Tyszkiewicz.

Joachim Peters (Matthew Sullivan) escapes from a Nazi concentration camp in 1944 and seeks refuge with his wealthy German friends. Torn between their duty as German citizens and their greater humanitarian sensibilities, the family is divided in how to deal with his presence.

The movie is based on the award-winning play *Germans*, by Leon Kruczkowski.

GHOST OF THE CHINA SEA

Columbia Pictures Corporation, 1958, b&w, 79 minutes.

Producer: Charles B. Griffith; **Director:** Fred F. Sears; **Screenwriter:** Charles B. Griffith; **Music:** Alexander Laszlo; **Distributor:** Columbia Pictures; **Cast:** Gene Bergman, Lynette Bernay, David Brian, Harry Chang, Jaime Del Rosario, Kam Fong, Jonathan Haze, Bud Pente, Mel Prestige, Dan Taba, Norman Wright.

David Brian and his compatriots flee from the Japanese as they invade the Philippines.

QUOTES

Justine Woolf: Well, you look 1000 percent better today.
Martin French: I feel better.
Justine Woolf: That's wonderful! For as long as I've known you you've never even felt good. Why the big improvement?
Martin French: Aw, I suppose it's 'cause we're past the problem of Larry.
Justine Woolf: Problem? That's a funny way to put it.
Martin French: Well, it *was* a problem. Larry's become important to me. It's a strange thing; no one's ever been important to me before. Now Larry is and, in a way, so is everyone on the boat.
Justine Woolf: I figured you would warm up one day.
Martin French: No, you don't understand. I could've come and gone and never cared what happened to any one of you, but . . .
Justine Woolf: Palo Alma was too much for you . . .
Martin French: That's right. You see, what happened back there in one day suddenly made me want to know those men. The things they did they just shouldn't have done. I had to know why. And the

only people who knew were dead. Darby and Hito died forever the day they came to life; I won't try to explain that. You know what I mean. Larry almost died, I expected him to, and then somehow they all changed. They became new men. Men worth knowing. But they only lived that single day. Do you get what I'm driving at?

GLORY BRIGADE, THE

20th Century-Fox, 1953, b&w, 82 minutes.

Producer: William Bloom; **Director:** Robert D. Webb; **Screenwriter:** Franklin Coen; **Cast:** Nick Dennis, Richard Egan, Russell Evans, David Gabai, Frank Gerstle, Jonathan Hale, John Haretakis, Lamont Johnson, Henry Kulky, Archer MacDonald, Peter Mamakos, Gregg Martell, Lee Marvin, Victor Mature, George Michaelides, Nico Minardos, Alvy Moore, Costas Morfis, Alberto Morin, Stewart Nedd, Father Patrinakos, Roy Roberts, George Saris, Alexander Scourby, John Verros, Carleton Young.

During the Korean War, Victor Mature volunteers to take his platoon with Greek troops on a reconnaissance mission behind communist lines. Because of his Greek heritage, Mature is initially proud to accompany the Greek contingent, but his feelings change to scorn and mistrust when what he believes is cowardice shown by the Greek soldiers results in the near annihilation of his own platoon. However, after further combat, the Americans develop a newfound respect for their Greek allies.

GOD IS MY CO-PILOT

Warner Bros., 1945, b&w, 90 minutes.

Producer: Robert Buckner; **Director:** Robert Florey; **Screenwriters:** William Faulkner, Abem Finkel, Peter Milne, Robert L. Scott (book); **Music:** Franz Waxman; **Cast:** Phyllis Adair, Philip Ahn, Joel Allen, Murray Alper, Paul Brooke, Clark Burroughs, William Challee, Frances Chan, Dane Clark, Sanders Clark, George Cleveland, Warren Douglas, Dan Dowling, James Flavin, William Forrest, Art Foster, Joel Friedkin, Paul Fung, Alan Hale, Andrea King, Richard Loo, Raymond Massey, Don McGuire, John Miles, Dennis Morgan, Clarence Muse, Gigi Perreau, Addison Richards, John Ridgely, Stanley Ridges, Bernard Sell, Charles Smith, Tom Steele, Craig Stevens, Mark Stevens, Frank Tang, Dale Van Sickel, Minor Watson.

Colonel Robert Lee Scott (Dennis Morgan), a fighter pilot with the Flying Tigers, has his faith in religion restored by a missionary priest.

INTERESTING FACTS

- The film is based on the true-life story of Col. Robert Lee Scott.
- The historical Flying Tigers are depicted in the film *THE FLYING TIGERS*.

MILITARY SERVICE

- Author Col. Robert L. Scott, who wrote the best-selling *God Is My Co-Pilot* (London: Hodder, 1944), was a Flying Tiger with 13 confirmed combat kills, including downing the infamous Japanese air ace "Tokyo Joe." A graduate of West Point, he was a mail pilot prior to joining the Tigers. When the United States entered the war, he was given command of the 23rd Fighter Group.

QUOTE

Missionary: Son, you're not up there alone. You have the greatest copilot in the world.

GO FOR BROKE

Metro-Goldwyn-Mayer, 1951, b&w, 92 minutes.

Producer: Dore Schary; **Director:** Robert Pirosh; **Screenwriter:** Robert Pirosh; **Music:** Alberto Colombo; **Cast:** Richard Anderson, Warner Anderson, John Banner, Hugh Beaumont, Gianna Maria Canale, Tony Christian, Mark W. Clark, Ann Codee, Edward Earle, Akira Fukunaga, Henry Guttman, Don Haggerty, Harry Hamada, Toru Iura, Van Johnson, Freeman Lusk, Louis Mercier, George Miki, Henry Nakamura, Tsutomu Paul Nakamura, Lane Nakano, Frank Okada, Ken K. Okamoto, Henry Oyasato, Walter Reed, Jack Reilly, Dan Riss, Mario Siletti, George Tanaguchi, Frank Wilcox.

Van Johnson, a Caucasian, returns from officer candidate school to discover that he is not going back to his Texas national guard unit; he has been assigned to a Japanese-American unit formed to fight the Nazis. Once they are in combat, his prejudices evaporate with the dawning realization that his men are better soldiers than he.

The U.S. 442nd Regimental Combat Team, formed in February 1943 by presidential permission with Japanese-American volunteers from concentration camps in Hawaii and the mainland, fought in Italy and

France. They received four distinguished unit citations, 18,000 personal decorations, and more than 10,000 of the soldiers were casualties.

INTERESTING FACTS

- According to the FBI, not one act of espionage or sabotage can be attributed to Japanese Americans during World War II.
- The cast includes many of the Nisei who actually fought with the 442nd.

AWARD

Academy Awards, USA, 1952
> **Nominated:** *Oscar, Best Story and Screenplay*, Robert Pirosh.

GOING HOME

Opix Films Ltd. 1987, color, 100 minutes.

Producers: Ray Marshall, Terence Ryan; **Director:** Terence Ryan; **Filmed in:** North Wales, UK; **Cast:** William Armstrong, Peter Banks, Bernard Brown, Nicholas Campbell, Milan Cheylov, Meredith Edwards, William Hope, Bradley Lavelle, Eugene Lipinski, Sioned Mair, Ian Morton, Clyde Pollitt, Albert Schultz, Peter Whitman.

At the front during World War I, a platoon of Canadian soldiers get shabby treatment from their high command. When they return home from Europe, they face another struggle—dealing with their post-traumatic stress.

GOOD LUCK, MR. YATES

Columbia Pictures Corporation, 1943, b&w, 70 minutes.

Producer: David Chatkin; **Director:** Ray Enright; **Screenwriters:** Lou Breslow, Adele Commandini, Sam Rudd, Hal Smith; **Cast:** Henry Armetta, Jess Barker, Albert Bassermann, Scotty Beckett, Conrad Binyon, Edgar Buchanan, Tommy Cook, Rosina Galli, Bobby Larson, Douglas Leavitt, Tom Neal, Billy Roy, Frank Sully, Claire Trevor, Rudy Wissler.

Jess Barler is a teacher in a military academy during World War II. He is despised by his students because he is not in uniform, despite the fact that he is medically unfit because of a punctured eardrum. He leaves the school, takes a job in a shipyard, and becomes a hero during a fire.

GOOD MORNING, VIETNAM

Silver Screen Partners III, Touchstone Pictures, 1987, color, 119 minutes.

Producers: Harry Benn, Larry Brezner, Mark Johnson, Ben Moses; **Director:** Barry Levinson; **Screenwriter:** Mitch Markowitz; **Filmed in:** Thailand; **Cast:** Suvit Abakaz, Wichien Chaopramong, Kien Chufak, Richard Edson, John Goyer, Louis Hood, Danny Aiello III, J. J. Boonchai Jakraworawut, Bruno Kirby, Gregg T. Knight, Uikey Kuay, Tuan Lai, Peter Mackenzie, Jonathan MacLeod, Christopher Mangan, James McIntire, Lerdcharn Namkiri, Cu Ba Nguyen, Hanh Hi Nguyen, Hoa Nguyen, Tim O'Hare, Kenneth Pitochelli, Richard Portnow, Sangad Sangkao, Vanlap Sangko, Juney Smith, Don Stanton, Chintara Sukapatana, Ralph Tabakin, Prasert Tangpantarat, No Tran, Tung Thanh Tran, Joe B. Veokeki, Floyd Vivino, J. T. Walsh, Forest Whitaker, Robin Williams, Noble Willingham, Panas Wiwatpanachat, Robert Wuhl.

Adrian Cronauer (Robin Williams) is a U.S. Air Force disc jockey shipped from Crete to bring some humor to Armed Forces Radio in Vietnam. He turns the studio on its ear and becomes wildly popular with the troops, but he runs afoul of middle management, who do not think he is GI enough.

Adrian Cronauer was a real DJ in Vietnam, and the author, Robert Davenport, used real footage of him in the 225th Army Birthday Video, of which he was writer/producer/director. Adrian Cronauer has gone on record as saying that Robin Williams is a lot funnier than he was. He is now a communications lawyer in Washington, D.C., vice chairman of the Vietnam Veteran's Institute, and a board member of the National Vietnam Veterans Coalition and the Citizen's Flag Alliance, which supports the constitutional amendment to protect the U.S. flag.

INTERESTING FACTS

- Robin Williams ad-libbed all of Adrian Cronauer's broadcasts.
- In order to give the trailers a more military feel, scenes of Cronauer on the air in military fatigues were shot specifically for the trailers.

MISTAKES

- Jeeps used in the Vietnam War did not have ignition keys.
- When Cronauer first goes to see the Vietnamese village with Tuan, he is wearing a white shirt, but

Good Morning, Vietnam (TOUCHSTONE PICTURES/AUTHOR'S COLLECTION)

he wears a plaid shirt in the close-up when they enter the village.

• In the bathroom, Cronauer misbuttons his shirt, but in the next shot the shirt is fine.

• Louis Armstrong did not record *What a Wonderful World* until two years after the movie takes place.

• When Adrian Cronauer leaves Vietnam, we see a propeller starting in his plane, but in the next shot of the plane it has jet engines.

QUOTES

Adrian Cronauer: Goooooooood morning, Vietnam! Hey, this is not a test! This is rock and roll! Time to rock it from the Delta to the DMZ!

Dickerson: This is not military issue, airman. What sort of uniform is that?
Cronauer: Cretan camouflage, sir. If you want to blend in with a bunch of drunken Greeks there's nothing better.
Dickerson: That is humor. I recognize that. I also recognize your brand of soldier.

Lt. Hauk : Sir, in my heart, I know I'm funny.

[Lt. Steven Hauk uses army jargon to refer to a press conference to be given by former vice president Nixon.]
Adrian Cronauer: Excuse me, sir. Seeing as how the VP is such a VIP, shouldn't we keep the PC on the QT? 'Cause of the leaks to the VC, he could end up MIA, and then we'd all be put out in KP.

Adrian Cronauer: You know, you're more in need of a blow job than any other white man in the history of the human race.

AWARDS

Academy Awards, USA, 1987
 Nominated: *Oscar, Best Actor,* Robin Williams

American Comedy Awards, USA, 1988
 Won: *American Comedy Award, Funniest Actor in a Motion Picture (Leading Role),* Robin Williams

British Academy Awards, 1989
 Nominated: *BAFTA Film Award, Best Actor,* Robin

Williams; *Best Sound*, Bill Phillips, Terry Porter, Clive Winter

Golden Globes, USA, 1988
Won: *Golden Globe, Best Performance by an Actor in a Motion Picture—Comedy/Musical*, Robin Williams

Political Film Society, USA, 1989
Won: *PFS Award, Peace Special Award.*

GO TELL THE SPARTANS

Spartan Productions, 1978, color, 114 minutes.

Producers: Allan F. Bodoh, Mitchell Cannold, Jess Corallo, Michael Leone; **Director:** Ted Post; **Screenwriters:** Daniel Ford, Wendell Mayes; **Music:** Dick Halligan; **Cast:** Ralph Brannen, Mark Carlton, David Clennon, Phong Diep, Jonathan Goldsmith, Hilly Hicks, James Hong, Tad Horino, Dennis Howard, Evan C. Kim, Denice Kumagai, Clyde Kusatsu, Burt Lancaster, John Megna, Marc Singer, Dolph Sweet, Joe Unger, Craig Wasson.

Burt Lancaster, playing a veteran of two past wars, heads a unit of American military advisers assisting Vietnamese soldiers holding the town of Muc Wa. When the situation becomes hopeless, they are ordered to abandon the Vietnamese soldiers, but Burt Lancaster stays behind and dies with them.

The movie is based on Daniel Ford's *Incident at Muc Wa* (Garden City: Doubleday, 1967).

INTERESTING FACTS

- The initial American involvement in Vietnam was not with combat troops but with military advisers. Their mission was as instructors to the South Vietnamese regulars in their fight against the Vietcong insurgents.
- This film draws a parallel between the fight of these Americans and the French who had fought at the same location a decade earlier. The French Indochina War (1946–1954) had ended in defeat for France and a pullout from Vietnam.
- The Geneva Accords of 1954 split Vietnam at the 17th parallel, with the communist regime in the north and the American-backed democratic republic in the south. The number of American military forces was limited by the accords to 700, of which these advisers were part.
- The movie title refers to the Spartans who died at the Battle of Thermopylae in 480 B.C. They defended Greece for three days against a Persian

invasion force of 180,000 soldiers before they were wiped out to the last man. The film made about this heroic battle is *300 Spartans*.

QUOTES

[Sign over French soldiers' graveyard]: Stranger, when you find us here, go tell the Spartans we obeyed their orders.

GREAT ESCAPE, THE

Mirisch Company, 1963, color, 169 minutes.

Producers: James Clavell, John Sturges; **Director:** John Sturges; **Screenwriters:** Paul Brickhill, W. R. Burnett, James Clavell; **Distributor:** United Artists; **Filmed at:** Füssen (motorcycle scenes) and Munich (stalag camp), Germany; **Cast:** Tom Adams, Karl-Otto Alberty, Richard Attenborough, Ulrich Beiger, Charles Bronson, James Coburn, Robert Desmond, James Donald, Robert Freitag, James Garner, Robert Graf, Gordon Jackson, Til Kiwe, Angus Lennie, John Leyton, David McCallum, Steve McQueen, Hannes Messemer, George Mikell, Lawrence Montaigne, Donald Pleasence, Hans Reiser, Harry Riebauer, William Russell, Nigel Stock, Jud Taylor, Heinz Weiss.

The Nazis, exasperated at the number of escapes from their prison camps by a relatively small number of Allied prisoners, relocate all of their "bad apples" into a high-security escape-proof camp, where they hope the prisoners will sit out the remainder of the war. Undaunted, the prisoners plan one of the most ambitious escape attempts of World War II. First, they secretly dig four escape tunnels. After 76 of them escape at the same time, there is a massive effort by the Gestapo to track them down, and in the end the Gestapo recaptures and shoots 50 of them.

The film is based on Paul Brickhill's *The Great Escape* (London: Faber and Faber, 1951).

INTERESTING FACTS

- The individual incidents in the film are mostly true but were rearranged as to both the timing and the people involved. A note at the start of the film acknowledges this. For instance, of the 76 who escaped, three got away and 50 were killed in reprisal, but the murders occurred in small groups, not all at once. (Fourteen Germans were executed after the war for their part in these executions.)
- The real-life escape preparations involved 600 men working for well over a year. The escape did have the

desired effect of diverting German resources, including an ongoing effect in that the number of guards was doubled after the Gestapo took over the camp from the Luftwaffe.

- The real-life escape was on the night of March 24, 1944; the ground was snow-covered. The German town near the prison camp, called Neustadt in the film, was really Sagan (now Zagan, Poland).

- For the train sequences, a railroad engine was rented and two condemned cars were purchased and modified to house the camera equipment. Scenes were shot on the single rail line between Munich and Hamburg, and a railroad representative was on hand to advise the filmmakers when to pull aside to avoid hitting scheduled oncoming trains.

- During the climactic motorcycle chase, Sturges allowed McQueen to ride (in disguise) as one of the pursuing German soldiers, so that in the final sequence, through the magic of editing, he's actually chasing himself.

- Charles Bronson, who portrays the chief tunneler, brought his own expertise to the set: He had been a coal miner before turning to acting and gave director Sturges advice on how to move the earth.

- Although McQueen did his own motorcycle riding, there was one stunt he did not perform: the hair-raising 60-foot jump over a fence. This was done by McQueen's friend Bud Ekins, who was managing a Los Angeles–area motorcycle shop when recruited for the stunt. It was the beginning of a new career for Elkins, as he later doubled for McQueen in *Bullitt* (1968) and did much of the motorcycle riding on the television series *CHiPs* (1977).

- Hilts (Steve McQueen) strings a wire across the road to obtain a motorcycle. McQueen himself performed the stunt where the rider hits the wire.

The Great Escape (UNITED ARTISTS/AUTHOR'S COLLECTION)

- The motorcycle ridden by Steve McQueen is the same motorcycle ridden by Henry Winkler as Fonzie in *Happy Days* (1974).
- The motorcycle scenes were not based on real life but were added at McQueen's suggestion. The airplane theft was also fictitious.
- McQueen also personally attempted the jump across the border fence, but crashed. The jump was successfully performed by Bud Ekins.
- The gold medallion Steve McQueen wears throughout the film was a present from his wife.
- The nationality of many of the prisoners in the story was changed, emphasizing American soldiers, and de-emphasizing Commonwealth and other Allied soldiers.
- The film was shot entirely on location in Europe, with a complete camp resembling Stalag Luft III built near Munich, Germany. Exteriors for the escape sequences were shot in the Rhine country and areas near the North Sea, and Steve McQueen's motorcycle scenes were filmed in Fussen (on the Austrian border) and the Alps. All interiors were filmed at the Bavaria Studio in Munich.
- When the Bavaria Studio's back lot proved to be too small, the production team obtained permission from the German government to shoot in a national forest adjoining the studio. After the end of principal photography, the company restored (by reseeding) some 2,000 small pine trees that had been damaged in the course of shooting.

MILITARY SERVICE

- Paul Brickhill piloted a Spitfire aircraft that was shot down over Tunisia in March 1943. He was taken to Stalag Luft III in Germany, where he assisted in escape preparations.
- Several cast members were actual POWs during World War II. Donald Pleasence was held in a German camp, Hannes Messemer in a Russian camp, and Til Kiwe and Hans Reiser were prisoners of the Americans.
- Wally Floody, the real-life tunnel king (he was transferred to another camp just before the escape), served as a consultant to the filmmakers, almost full-time, for more than a year.

MISTAKES

- In the opening sequence, during which Allied POWs arrive at the camp and disembark from trucks, Luftwaffe guards are holding Schmeisser MP-40 9mm machine pistols, except for one who's clearly holding a U.S.-issue M-3.45-caliber grease gun, a weapon no German soldier was issued.
- The head Luftwaffe sergeant greets the British group captain by introducing himself as "Hauptscharführer." This was not a Luftwaffe rank but a senior enlisted rank of the SS.
- Although there were Americans in the camp when the escape preparations were begun, in real life none of them was among the 76 who escaped, because they had all been transferred to another camp.
- The movie is set in July, and the United States and Germany are both at war only in the summers of 1942, 1943, or 1944. However, in none of those years was there a new moon during the period July 7–9 as is stated twice in the dialogue.
- The railway logo is incorrect.
- Traffic signs are clearly postwar.
- The motorcycle that Hilts uses in his escape attempt is a 1960s British Triumph 650.
- Motorcycles change in close-up shots.
- Sedgwick is shown reading *Liberation*, a newspaper not published during the German occupation of France.

QUOTES

Sedgwick Manufacturer: Danny, you speak Russian?
Danny Velinski "Tunnel King": A little, but only one sentence.
Sedgwick Manufacturer: Well, let me have it, mate!
Danny Velinski "Tunnel King": Ya vei lublo.
Sedgwick Manufacturer: Ya vei lublo. Ya vei lublo. What's it mean?
Danny Velinski "Tunnel King": I love you.
Sedgwick Manufacturer: I love you! What bloody good is that?
Danny Velinski "Tunnel King": I don't know, I wasn't going to use it myself.

AWARDS

Academy Awards, USA, 1963
 Nominated: *Oscar, Best Film Editing,* Ferris Webster

Writers Guild of America, USA, 1964
 Nominated: *WGA Screen Award, Best Written American Drama,* W. R. Burnett, James Clavell.

GREAT IMPERSONATION, THE

Universal Pictures, 1942, b&w, 70 minutes.

Producer: Paul Malvern; **Director:** John Rawlins; **Screenwriters:** Scott Darling (as W. Scott Darling),

E. Phillips Oppenheim (novel); **Music:** Ralph Freed, Richard Hageman, Werner R. Heymann, Charles Maxwell, Hans J. Salter, Frank Skinner; **Distributor:** Universal Pictures; **Cast:** Rudolph Anders, Evelyn Ankers, Sylvia Arslan, Ralph Bellamy, Charles Coleman, Marcelle Corday, Henry Daniell, Yvette Duguay, Rex Evans, Charles Flynn, Mary Forbes, Frederick Giermann, Henry Guttman, Hans Herbert, Olaf Hytten, Charles Irwin, Audrey Long, Aubrey Mather, Hans von Morhart, Edward Norris, Napoleon Simpson, Val Stanton, Ludwig Stössel, Kaaren Verne, Frederick Vogeding, Eric Wilton, Victor Zimmerman.

Ralph Bellamy plays both an Englishman and a German who meet in Africa before the war. One of them assumes an important post in England during World War II, but the audience is left guessing which one it is, the Englishman or the German. We finally learn that he is the true Englishman, and he turns over false information to the Germans.

The movie is based on E. Phillips Oppenheim's *The Great Impersonation* (Boston: Little, Brown, and Company, 1920), and was also filmed in 1921 and 1935.

GREEN BERETS, THE

Batjac Productions, 1968, color, 141 minutes.

Producer: Michael Wayne; **Directors:** Ray Kellogg, John Wayne; **Screenwriters:** James Lee Barrett, Robin Moore; **Distributor:** Warner–Seven Arts; **Filmed at:** Fort Benning, Georgia; **Cast:** Yodying Apibal, Luke Askew, Charles Bail, Bruce Cabot, Vincente Cadiente, Eddy Donno, Jason Evers, Edward Faulkner, Mike Henry, Jim Hutton, David Janssen, Craig Jue, Frank Koomen, Cliff Lyons, William Olds, Richard Pryor, Aldo Ray, Rudy Robbins, Chuck Roberson, Raymond St. Jacques, Bill Shannon, Jack Soo, Laird Stuart, George Takei, Irene Tsu, John Wayne, Patrick Wayne, Bach Yen.

Colonel Mike Kirby (John Wayne) leads the Green Berets on combat missions in South Vietnam, which include kidnapping a North Vietnamese general critical to the war effort.

The movie is based on Robin Moore's *The Green Berets.*

INTERESTING FACTS

• Much of the film was shot in 1967 at Fort Benning, Georgia, hence the large pine forests in the background rather than tropical jungle trees.

• Some of the Vietnamese village sets were so realistic they were left intact and were later used by the army to train troops destined for Vietnam.

• The colonel who ran the jump school was the real jump school commandant and a legendary commander of U.S. paratroopers.

• *The Ballad of the Green Berets*, a song by Sgt. Barry Sadler, is probably the best part of the film, and is still a classic among the Special Forces community.

Fighting soldiers, from the sky,
Fearless men, who jump and die,
Men who mean just what they say,
The brave men of the Green Beret.

Silver wings upon their chest,
These are men, America's best.
One hundred men we'll test today,
But only three win the Green Beret.

Trained to live off nature's land,
Trained in combat, hand to hand,
Men who fight by night and day,
Courage deep from the Green Beret.

Silver wings upon their chest,
These are men, America's best.
One hundred men we'll test today,
But only three win the Green Beret.

Back at home, a young wife waits,
Her Green Beret has met his fate.
He has died for those oppressed,
Leaving her, this last request:

Put silver wings on my son's chest,
Make him one of America's best.
He'll be a man they'll test one day,
Have him win the Green Beret.

MISTAKES

• When Kirby smashes the M-16 against a tree, you can see a speaker in the stock, indicating that it is probably a toy gun.

• Late in the movie John Wayne can be seen to wrap his rappelling rope through a carabineer the wrong way. Called a fatal hookup in the army, this would result in an immediate fall once weight was applied.

QUOTE

John Wayne: Out here, due process is a bullet.

GUADALCANAL DIARY

20th Century-Fox, 1943, b&w, 93 minutes.

Producers: Islin Auster, Bryan Foy; **Director:** Lewis Seiler; **Screenwriters:** Jerome Cady, Richard Tregaskis, Lamar Trotti; **Music:** David Buttolph; **Cast:** Eddie Acuff, John Archer, Warren Ashe, William Bendix, Martin Black, Ralph Byrd, Harry Carter, Richard Conte, Tom Dawson, Walter Fenner, Robert Ford, Preston Foster, Paul Fung, Reed Hadley, Louis Hart, George Holmes, Russell Hoyt, Selmer Jackson, Richard Jaeckel, Allen Jung, Charles Lang, Jack Luden, Miles Mander, Lloyd Nolan, David Peters, Anthony Quinn, Roy Roberts, Robert Rose, Lionel Stander, Larry Thompson, Minor Watson.

A war correspondent goes through the training, landing, and campaign on Guadalcanal during World War II.

The film is based on Richard Tregaskis's *Guadalcanal Diary* (New York: Random House, 1943).

INTERESTING FACT

- The Battle of Guadalcanal (August 7, 1942, to February 19, 1943) was the first counterattack in America's island-hopping campaign toward Japan. Vicious and brutal fighting centered on control of the unfinished Japanese airfield on the island, which the Marines completed and renamed Henderson Field. The ultimate cost to both sides was high: The Japanese lost 25,000 men, 600 airplanes, and 24 ships. The Americans lost 1490 dead, 5000 wounded, and 24 ships sunk.

QUOTE

William Bendix: I ain't no hero. I'm just a guy. I'm here because someone sent me and I just want to get it over with and go home as soon as I can.

GUERRILLA GIRL

Liberty Bell Motion Pictures Inc., 1953, b&w, 82 minutes.

Producer: John Christian; **Director:** John Christian; **Screenwriters**: John Byrne, William Koch, William Kyriakis, Ben Parker; **Music:** Bernard Bossick; **Distributor:** United Artists; **Cast:** Rene Champlin, Helmut Dantine, Ray Julian, Gerald Lee, Charlotte Paul, Sidney Paul, Michael Vale, Dora Weissman.

Helmut Dantine is a Greek officer who flees Athens when the Nazis invade his country. He is helped to escape by a beautiful gypsy girl and her band, and in the course of the escape they have an affair. When he returns to the city after the Germans are expelled from the country, the new enemy is communists determined to take over Greece. He is on the communists' death list, and when his gypsy lover learns this, she tries to warn him, but they are both captured and shot together, dying in a final embrace.

GUNG HO!

Universal Pictures, 1943, b&w, 88 minutes.

Producer: Walter Wanger; **Director:** Ray Enright; **Screenwriters:** Joseph Hoffman, Lucien Hubbard, W. S. LeFrançois; **Music:** Frank Skinner; **Distributor:** Universal Pictures; **Filmed at:** Camp Pendleton Marine Corps Base, and Oceanside, California; **Cast:** Irving Bacon, Noah Beery Jr., David Bruce, Rod Cameron, Peter Coe, Alan Curtis, Joe Haworth, Louis Jean Heydt, Chet Huntley, John James, Robert Kent, Harold Landon, Richard Lane, Sam Levene, Grace McDonald, Robert Mitchum, J. Carrol Naish, Walter Sande, Randolph Scott, Milburn Stone, Harry Strang, Carl Vernell.

Seven weeks after Pearl Harbor, volunteers form the new Second Marine Raider Battalion, whose purpose is to raid Japanese-held islands. Under the command of Colonel Thorwald (Randolph Scott), they are trained in all imaginable forms of combat. Then, after a perilous submarine journey, they face a daunting first mission: to annihilate the much larger Japanese garrison on Makin Island.

INTERESTING FACTS

- This is the true story of Carlson's Raiders and their World War II attack on Makin Island. Randolph Scott portrays Evans F. Carlson (1896–1947), who served as technical adviser for the film. He had been an observer with the Chinese communist Eighth Route Army for a year in 1937 fighting the Japanese. After that experience, he recommended that a special U.S. Marine unit be formed, similar to the British commandos. The Second Marine Raider Battalion was nicknamed Carlson's Raiders and was originally composed of 200 men.
- Actor Harold Landon, who plays Frankie Montana in the film, related that the actors who played Japanese soldiers were really Filipino and Chinese actors.

- Colonel Carlson learned the term "Gung Ho" while serving with Mao's army in China; it is a Chinese phrase that means, roughly, "work together." He added this word to the English language at a time when the United States was allied with two communist countries, China and Russia, against the Axis powers.

GUN RUNNERS, THE

Seven Arts, 1958, b&w, 83 minutes.

Producer: Clarence Greene; **Director:** Don Siegel; **Screenwriters:** Ben Hecht, Ernest Hemingway (novel, *To Have and Have Not*), Daniel Mainwaring, Paul Monash; **Music:** Joe Lubin (song), Leith Stevens; **Distributor:** United Artists; **Cast:** Eddie Albert, Paul Birch, Edward Colmans, Jack Elam, Gita Hall, John Harding, Ted Jacques, Richard Jaeckel, Lita Leon, Peggy Maley, Audie Murphy, Patricia Owens, Steven Peck, John Qualen, Freddie Roberto, Carlos Romero, Everett Sloane.

Audie Murphy is a charter boat skipper who is forced by circumstances to run guns to Cuba for gangster Eddie Albert, in order to pay off his debts. However, he reforms, turns on the gun runners, and kills all of them.

INTERESTING FACT

- The film is set against the backdrop of the real 1930s revolt against Cuban dictator Machado. It is based on *To Have and Have Not*, by Ernest Hemingway (New York: Scribner's, 1937).

GUNS AT BATASI

20th Century-Fox, 1964, b&w, 103 minutes.

Producer: George H. Brown; **Director:** John Guillermin; **Screenwriters:** Robert Holmes, Leo Marks, C. M. Pennington-Rich, Marshall Pugh; **Music:** John Addison; **Distributor:** 20th Century-Fox Film Corporation; **Cast:** Richard Attenborough, Richard Bidlake, Alan Browning, Earl Cameron, Mia Farrow, Jack Hawkins, Percy Herbert, Patrick Holt, Bernard Horsfall, Ric Hutton, Horace James, Errol John, Joseph Layode, John Leyton, David Lodge, John Meillon, Bloke Modisane, Cecil Parker, Flora Robson, Graham Stark.

Richard Attenborough is a sergeant major stationed in Africa in the 1960s who becomes involved in a violent revolt by the natives against the British, whom they regard as their oppressors.

The movie is based on Robert Holmes's *The Siege of Battersea* (London: M. Joseph, 1962).

QUOTE

Sgt. Maj. Lauderdale: I have seen Calcutta. I have eaten camel dung. My knees are brown, my navel is central, my conscience is clear, and my will is with my solicitors, Short and Curly.

GUNS OF NAVARONE, THE

Highroad, Columbia Pictures Corporation, Open Road, 1961, color, 158 minutes.

Producers: Leon Becker, Cecil F. Ford, Carl Foreman; **Director:** J. Lee Thompson; **Screenwriters:** Carl Foreman, Alistair MacLean; **Filmed at:** Rhodes, Greece; **Cast:** Stanley Baker, Victor Beaumont, Allan Cuthbertson, James Darren, Carl Duering, Bryan Forbes, Walter Gotell, Richard Harris, Percy Herbert, James Robertson Justice, Tutte Lemkow, Albert Lieven, George Mikell, David Niven, Nicholas Papakonstantino, Irene Papas, Gregory Peck, Anthony Quayle, Anthony Quinn, Christopher Rhodes, Gia Scala, Cleo Scouloudi, Michael Trubshawe, Norman Wooland.

During World War II, a commando team is put together to destroy two large German naval guns on the Greek island of Navarone. The guns control a vital water route in the Mediterranean, making the evacuation of endangered British troops on a neighboring island impossible. Air attack fails, so a team of six Allied and Greek agents is put ashore to meet up with partisans and dynamite the guns. As if the mission is not perilous enough, the team is plagued by leaks and can stay only one step ahead of the Germans as they move on the fortress. David Niven plants his "safety" demolition charge at the bottom of the lift used to bring munitions up to the naval guns. He rigs two wires on the runner, the connection for detonation being made by the lift coming down and completing the connection. As he covers the wires with grease to hide them, he says, "This is the one I'm counting on." The Germans disarm the other explosives, and the lift keeps coming down, not quite far enough to reach the wires. Finally, the lift goes down far enough and the guns are blown up.

The film is based on Alistair MacLean's *The Guns of Navarone* (Garden City: Doubleday, 1957).

INTERESTING FACTS

- Anthony Quayle spent part of World War II in Albania organizing guerrilla forces.
- William Holden asked for $750,000 plus 10 percent of the gross to play Mallory. He was turned down and Gregory Peck was cast.
- One of the Rhodian locations used in the film was renamed Anthony Quinn Bay after the actor was reported to have bought property nearby.
- The plot went through so many twists that Gregory Peck finally submitted his own version to Foreman: David Niven really loves Tony Quayle, and Gregory Peck loves Anthony Quinn. Tony Quayle breaks a leg and is sent off to hospital. Tony Quinn falls in love with Irene Papas, and David Niven and Peck catch each other on the rebound and live happily ever after.

MISTAKES

- German soldiers are seen operating vehicles manufactured in the United States by Dodge.

- In the opening sequence, a Lancaster bomber is about to crash. The bomber that is on fire flies by another Lancaster bomber that is just sitting in the sky not moving.

QUOTES

Mallory: Someone's got to take the responsibility if the job's going to get done. Do you think that's easy?

Miller: Captain, I'm concerned about this vessel. It's taking on water.
Mallory: Why does that concern you?
Miller: I can't swim.

Mallory: Are you sure it will work?
Miller: There's no guarantee, but the theory's perfectly feasible.

AWARDS

Academy Awards, USA, 1961
 Won: *Oscar, Best Special Effects*, Chris Greenham (audible), Bill Warrington (visual)

The Guns of Navarone (COLUMBIA PICTURES/AUTHOR'S COLLECTION)

Nominated: *Oscar, Best Director,* J. Lee Thompson; *Best Film Editing,* Alan Osbiston; *Best Music, Scoring of a Dramatic or Comedy Picture,* Dimitri Tiomkin; *Best Picture,* Carl Foreman; *Best Sound,* John Cox (Shepperton, SSD); *Best Writing, Screenplay Based on Material from Another Medium,* Carl Foreman

British Academy Awards, 1962
Nominated: *BAFTA Film Award, Best British Screenplay,* Carl Foreman

Golden Globes, USA, 1962
Won: *Golden Globe, Best Motion Picture—Drama; Best Motion Picture Score,* Dimitri Tiomkin.

HAIL THE CONQUERING HERO

Paramount Pictures, 1944, b&w, 101 minutes.

Producer: Preston Sturges; **Director:** Preston Sturges; **Screenwriter:** Preston Sturges; **Music:** Werner R. Heymann; **Cast:** George Anderson, Eddie Bracken, Al Bridge, Georgia Caine, Chester Conklin, Jimmy Conlin, James Damore, William Demarest, Pauline Drake, Jimmie Dundee, Bill Edwards, Dot Farley, Jim Farley, Franklyn Farnum, Maxine Fife, Miriam Franklin, Julie Gibson, Kenneth Gibson, Stephen Gregory, Mildred Harris, Harry Hayden, Len Hendry, Esther Howard, Arthur Hoyt, Philo McCullough, Tom McGuire, George Melford, Torben Meyer, Charles R. Moore, Frank Moran, Marjean Neville, Jack Norton, Franklin Pangborn, Elizabeth Patterson, Paul Porcasi, Victor Potel, Ella Raines, Dewey Robinson, Merrill Rodin, John Sinclair, Freddie Steele, Raymond Walburn, Robert Warwick.

Eddie Bracken wants to join the marines, but he can't pass the physical. Too embarrassed to go home, he has friends send postcards from every theater of World War II. When he returns and realizes that his hometown thinks he is a hero, some sympathetic marines he meets on the train help him to keep up the deception.

AWARD

Academy Awards, USA, 1944
 Nominated: *Oscar, Best Writing, Original Screen-play*, Preston Sturges.

HALLS OF MONTEZUMA

20th Century-Fox, 1950, color, 113 minutes.

Producer: Robert Bassler; **Director:** Lewis Milestone; **Screenwriter:** Michael Blankfort; **Music:** Sol Kaplan; **Cast:** Philip Ahn, Richard Allan, Richard Boone, Neville Brand, Harry Carter, Howard Chuman, Fred Coby, George Conrad, Fred Dale, Chris Drake, Bert Freed, Reginald Gardiner, Helene Hatch, William Hawes, Don Hicks, Skip Homeier, Richard Hylton, Frank Kumagai, Jack Lee, Paul Lees, Karl Malden, Marion Marshall, Roger McGee, Harry McKim, Bob McLean, Martin Milner, Rollin Moriyama, Ralph Nagai, Jack Palance, Michael Road, Clarke Stevens, Robert Wagner, Jack Webb, Richard Widmark.

Richard Widmark leads his marines against the Japanese on a Pacific island. He must use more than just his war-fighting skills as he tries to determine the location of an enemy rocket site, which entails outsmarting an American-educated Japanese officer that he is interrogating.

HAMBURGER HILL

RKO Radio Pictures Inc., 1987, color, 112 minutes.

Producers: James Carabatsos, Marcia Nasatir; **Director:** John Irvin; **Screenwriter:** James Carabatsos; **Music:** Philip Glass; **Filmed in:** Philippines and the Vietnam Veterans Memorial, Washington, D.C.; **Cast:** Anthony Barrile, Michael Boatman, Don Cheadle, Kieu Chinh, Michael Dolan, Doug Goodman, Don James, Dylan McDermott, Michael A. Nickles, Harry O'Reilly, Daniel O'Shea, J. C. Palmore, Timothy Patrick Quill, Tommy Swerdlow, Courtney B. Vance, J. D. Van Sickle, Steven Weber, Tegan West.

A squad of 14 soldiers of the 101st Airborne struggles to fight its way up Hamburger Hill. When they get to the top, only four of them are left alive.

It took three battalions of the 101st Airborne, with ARVN support, to take Hamburger Hill. The battle lasted for 10 days, from May 10 until May 20, 1969. The mountain, in the Ashau Valley of Vietnam, was actually named Dong Ap Bia. It was marked on the maps as hill 937 (it was 937 meters high). The defenders, the 28th North Vietnamese Regiment, were virtually wiped out. About one month after the battle, the 101st Airborne left the Ashau Valley, and the North Vietnamese were free to use Hill 937 once again. Critics charged that the battle to take Hamburger Hill wasted American lives and exemplified the irrelevance of American tactics in Vietnam. Defending the operation, the division commander of the 101st acknowledged that the hill's only significance was that the enemy occupied it. "My mission," he said, "was to destroy enemy forces and installations. We found the enemy on Hill 937, and that is where we fought them."

INTERESTING FACTS

- After the final battle, Dylan McDermott as Sgt. Frantz vehemently tells an army photographer who shows up to "Unass my AO!" In the condensed language of GI slang, it is an order to move his ass out of the sergeant's area of operations, and in this context it expresses the infantry GI's contempt for soldiers who don't fight.
- When the men were strafed by their own gunships in the real attack on Hamburger Hill, the battalion commander, Lieutenant Colonel Honeycutt, sent a message to the division staff: "I want you to make sure that everybody gets this. And I mean the artillery people and the gunship pilots and the liaison officers, everybody. I don't want them out here if they can't shoot the enemy instead of us. I'm tired of taking more casualties from friendlies than from the enemy. The next goddamn son of a bitch who comes out here and shoots us up, we're gonna shoot his fucking ass down. And that's final. Now you go back and tell 'em that."
- The hill was given the nickname "Hamburger Hill" because it chewed up soldiers like chopped meat.

QUOTES

Worcester: We had a short-timer once. Johnny I-forget-his-name. He wore a flak jacket, two helmets, and armor underwear. Ashau Valley . . . your time's up, your time is up.

Galvan: We're Airborne. We don't start fights, we finish 'em!

HANGMEN ALSO DIE

Arnold Pressburger, 1943, b&w, 140 minutes.

Producers: Fritz Lang, Arnold Pressburger; **Director:** Fritz Lang; **Screenwriters:** Bertolt Brecht, Fritz Lang, John Wexley; **Music:** Sam Coslow, Hanns Eisler, Richard Wagner; **Distributor:** United Artists; **Cast:** Erville Alderson, William Benedict, Walter Brennan, Nana Bryant, James Bush, Ludwig Donath, Brian Donlevy, Ralph Dunn, Virginia Farmer, William Farnum, Byron Foulger, Arno Frey, Dwight Frye, Alexander Granach, William Haade, Jonathan Hale, George Irving, Anna Lee, Gene Lockhart, Arthur Loft, Emmett Lynn, Edmund MacDonald, Philip Merivale, Charles Middleton, Dennis O'Keefe, Sarah Padden, Otto Reichow, Billy Roy, Reinhold Schünzel, Tonio Selwart, Lester Sharpe, Lionel Stander, Hans Heinrich von Twardowski, Philip Van Zandt, Emmett Vogan, Eddy Waller, Harry Wilson, Margaret Wycherly.

As the Czech people are put to the sword in increasing numbers in retaliation for their refusal to give up the killer who assassinated Nazi "gauleiter" Reinhard Heydrich, a plan evolves to provide the Nazis with a "assassin," who is actually a Czech traitor that the resistance wants killed.

INTERESTING FACTS

- The film is based on the true story of the assassination of Reinhard Heydrich. On May 27, 1942, the Nazi Reichsprotector of Bohemia/

Moravia, Reinhard Heydrich, known as "The Hangman," died from the bullets of unidentified Resistance fighters.

- This was Bertolt Brecht's only comparatively successful Hollywood project. The money he received allowed him to write *The Visions of Simone Marchand*, *Schwyk in the Second World War* and his adaptation of Webster's *The Duchess of Malfi*.
- *Hitler's Hangman*, also called HITLER'S MADMAN, OPERATION DAYBREAK, and *Hangmen Also Die* are all films that deal with Reinhard Heydrich.

AWARDS

Academy Awards, USA, 1943
 Nominated: *Oscar, Best Music, Scoring of a Dramatic or Comedy Picture*, Hanns Eisler; *Best Sound Recording*, Jack Whitney (Sound Service Inc.).

HANNA'S WAR

Golan-Globus, 1988, color, 148 minutes.

Producers: Carlos Gil, Yoram Globus, Menahem Golan; **Director:** Menahem Golan; **Screenwriters:** Menahem Golan, Stanley Mann, Yoel Palgi, Hanna Senesh; **Music:** Dov Seltzer; **Distributor:** Cannon Films; **Filmed in:** Hungary and Israel; **Cast:** Anthony Andrews, Rami Baruch, Balazs Blasko, Ellen Burstyn, Patsy Byrne, Laura Bökönyi, Peter Czajowski, Magda Darvas, Maruschka Detmers, George Dillon, Yehuda Efroni, Serge El-Baz, Joe El Dror, Christopher Fairbank, Magda Faluhelyi, Tamás Farkas, Shimon Finkel, Jeff Gerner, György Gonda, Eli Gorenstein, Nigel Hastings, István Hunyadkürthy, József Incze, Rob Jacks, Avi Korein, Miodrag Krivokapic, Árpád Ladányi, István Lakatos, Jozsef Lakky, Barry Langford, Emma Lewis, Ági Margittay, Patrick Monkton, Miklos Nagy, Csaba Pethes, Tamas Philippovich, Ingrid Pitt, Donald Pleasence, Russell Porter, Zsuzsa Pálos, Vincenzo Ricotta, Jon Rumney, Rade Serbedzija, Dorota Stalinska, John Stride, Imre Szalai, Mordechai Tenenbaum, Teri Tordai, Jon Varady, Gábor Váradi, Teréz Várhegyi, David Warner.

Hanna Senesh (Maruschka Detmers) is a Jewish patriot who fights during World War II for the freedom of Palestine and who is subsequently executed as a spy in Hungary.

INTERESTING FACT

- The film is based on the true story of Hanna Senesh.

HANOI HILTON, THE

Cannon Group, Golan-Globus, 1987, color, 126 minutes.

Producers: Yoram Globus, Menahem Golan; **Director:** Lionel Chetwynd; **Screenwriter:** Lionel Chetwynd; **Cast:** James Acheson, Aki Aleong, Ron Barker, Mark Brennan, Bill Cakmis, Gloria Carlin, Jesse Dabson, Stephen Davies, Brian Demonbreun, John Diehl, Bruce Fairbairn, Rick Fitts, Nicolas Freccia, Peter Gray, Tony Gray, Gary Guidinger, Joseph Hieu, Leslie Hung, Jeffrey Jones, Mark Kemble, Elizabeth Reiko Kubota, Augustine Lam, Bill Lee, Glen Lee, Kevin Lee, Paul Le Mat, Robert Ligouri, Marii Mak, Tony Markes, Michael Moriarty, Peter Pan, Lawrence Pressman, Michael Russo, Scotty Sachs, Doug Savant, John Edwin Shaw, David Anthony Smith, David Soul, D. Paul Thomas, April Tran, Janet Travers, Le Tuan, John Vargas, Ken Wright.

Aki Aleong, the commandant of the Hanoi Hilton, is determined to wring confessions of fictitious war crimes out of the POWs who are at his mercy. His first target is Lawrence Pressman, an American colonel who finally dies at the hands of his tormentors. His next target is Michael Moriarty, whom he is determined to break. The horror of their existence is temporarily halted by the visit of an American actress and political activist who is sympathetic to the North Vietnamese, and who tries to get them to collaborate with the enemy.

The character portrayed by Gloria Carlin is based on the real-life activities of actress-turned-political-activist Jane Fonda. Jane Fonda traveled to North Vietnam during the war, and her activities as a nondiplomatic civilian with an enemy of the United States in time of war are a matter of controversy to this day. She is still the target of enmity by veterans groups, and a popular bumper sticker is "Vietnam Vets are not Fonda Jane." Her nickname among Vietnam veterans is "Hanoi Jane," and her movie sets have often been the scenes of anti–Jane Fonda protests. Ironically, while she felt very strongly that she had the right to protest the Vietnam War, she has no trouble calling in the police to arrest those who are peacefully protesting her.

INTERESTING FACTS

- The "Hanoi Hilton" was the nickname given to the Hao Lo prisoner-of-war camp in Hanoi used to imprison American soldiers captured by the North Vietnamese communists during the Vietnam War.
- Because of the nature of the war, the majority of prisoners taken by the North Vietnamese were

aviators captured when they were forced to bail out of their fighter and bomber aircraft, usually over enemy-held territory. However, unlike World War II aviators in Europe who were grouped together in POW camps and allowed complete freedom to meet together inside the camp, the Hanoi Hilton focused on complete isolation of the individual prisoner. Communication was possible only by Morse code, the "tap" code used to communicate from cell to cell. Brutally beaten, tortured, and starved to the brink of death, aviators miraculously survived up to seven years of this treatment, a true testament to the American fighting man.

HEARTBREAK

Fox Film Corporation, 1931, b&w, 63 minutes.

Director: Alfred L. Werker; **Screenwriters:** William M. Conselman, Leon Gordon; **Cast:** Hardie Albright, John Arledge, Paul Cavanagh, Albert Conti, Theodore von Eltz, Madge Evans, Charles Farrell, Claude King, John St. Polis.

Charles Farrell is an American aviator serving in Italy during World War I. His girlfriend, an Austrian countess (Madge Evans), is on the other side of the war. When he shoots down and kills her brother, he steals an airplane and flies into Austria to visit her behind enemy lines. When his superiors learn what he has done, they court-martial him and he is sent to prison. The lovers are reunited after the armistice.

HEARTBREAK RIDGE

Malpaso Company, 1986, color, 130 minutes.

Producers: Clint Eastwood, Fritz Manes; **Director:** Clint Eastwood; **Screenwriters:** James Carabatsos, Joseph Stinson; **Music:** Clint Eastwood, Lennie Niehaus; **Distributor:** Warner Bros.; **Filmed at:** Camp Pendelton and Agua Dulce (roadside cafe), California, and Vieques, Puerto Rico; **Cast:** Alex M. Bello, John Brewer, John Eames, Clint Eastwood, Tom Ellison, Timothy Fall, Ramón Franco, Boyd Gaines, John Gallagher, Trish Garland, Mike Gomez, Moses Gunn, Steve Halsey, Eileen Heckart, Rodney Hill, John Hostetter, Vincent Irizarry, Peter Jason, Peter Koch, Dutch Mann, Marsha Mason, Michael Maurer, Everett McGill, Christopher Michael, Lloyd Nelson, Annie O'Donnell, Jon Pennell, Rebecca Perle, Begonia Plaza, J. C. Quinn, Elizabeth Ruscio, John Sasse, Thom Sharp, Holly Shelton-Foy, Arlen Dean Snyder, Bo Svenson,

Darwyn Swalve, Mario Van Peebles, Richard Venture, Tom Villard, Nicholas Worth.

Sergeant Tom Highway (Clint Eastwood), a hardened, tough veteran with a Medal of Honor from "Heartbreak Ridge" in Korea, returns to the United States for his last tour of duty with the U.S. Marine Corps. He is assigned to train a raw recon unit. Their trendy and "hippy" approach to military life is a reminder to him that he is, in the words of his general, an anachronism—useful only in case of war. Conveniently, a war starts (the invasion of Grenada in October 1983) and successfully tests both his usefulness and the training he has given his new recruits.

INTERESTING FACTS

- The attack by U.S. forces on Grenada is historically accurate, but it was the U.S. Army Rangers that took the university medical school, not U.S. Marines Recon.
- Heartbreak Ridge (in Korea) was not a U.S. Marine Corps action. The 23rd Infantry, attached to the Army Second Indianhead Division, captured Heartbreak Ridge (Hill 931).
- Heartbreak Ridge today is 600 yards inside the demilitarized zone and flanked by a South Korean minefield on the North Korean side. The top of the ridge houses a South Korean observation post.
- The Medal of Honor was awarded to two enlisted soldiers at Heartbreak Ridge, both of them army.

MILITARY SERVICE

- Clint Eastwood was drafted during the Korean War and spent the duration as a swimming instructor at Fort Ord, California. After the war, he used his GI Bill to study acting at Los Angeles City College.

MISTAKES

- Sergeant Highway's cigar gains length during the prison fight.
- When Highway orders his platoon out the first time, it is supposedly 5 o'clock, yet the sun stands high above, casting short shadows.
- When Highway and his platoon attack the hill at the end of the movie, a tank is blown up by a helicopter, but in the next shot it's still intact.
- The final scene is supposed to be at Cherry Point, MCAS, North Carolina, but you can see hills in the distance; Cherry Point has just pine trees.
- When the platoon is forced to take cover in an abandoned building at the end, the radio operator

is killed and his radio destroyed so that they have to call for help via phone. Later on, when the platoon takes the hill, someone else lies down with an intact radio on his back.

- When Highway is in a bar near the beginning of the movie, he watches a performance of "the Ayatollah of Rock & Rollah." However, the "Ayatollah," whose singing is amplified and who plays an electric guitar, is neither miked nor amped. In fact, there's no amp cord even connecting his guitar to the sound system.

QUOTES

Gunnery Sergeant Highway: With all due respect, sir, you're beginning to bore the hell out of me.

Highway: Improvise. Adapt. Overcome.

Highway: It's a cluster fuck, Sir.

Highway: Be advised, I eat concertina wire and piss napalm. I can put a round through a flea's ass at 300 yards.

Highway: The United States Marines is lookin' for a few good men—you ain't it.

AWARD

Academy Awards, USA, 1986
 Nominated: *Oscar, Best Sound,* Richard Alexander (as Dick Alexander), Les Fresholtz, William Nelson, Vern Poore.

HEAVEN & EARTH

Le Studio Canal+, Alcor Films, Regency Enterprises, Warner Bros., 1993, color, 140 minutes.

Producers: Risa Bramon Garcia, Mario Kassar, A. Kitman Ho, Robert Kline, Arnon Milchan, Christina Rodgers, Richard Rutowski, Oliver Stone, Clayton Townsend, Randy Miller; **Director:** Oliver Stone; **Screenwriters:** James Hayslip, Le Ly Hayslip, Oliver Stone, Jay Wurts; **Filmed in:** Bangkok, Thailand; **Cast:** Catherine Ai, Scott Barkwill, Marshall Bell, Robert John Burke, Lan Nguyen Calderon, Timothy Carhart, Michael Paul Chan, Joan Chen, Dave Cooper, Vinh Dang, Chau Mao Doan, Yeung Yong Dumda, Peter Duong, Dale Dye, Conchata Ferrell, Kevin Gallagher, Lester Gopaoco, Tim Guinee, Le Ly Hayslip, Brian Helmick, Don Ho Jr., Mai Le Ho, Somsak Hormsombat, Tran Huy, Tommy Lee Jones,

Hiep Thi Le, Michelle Vynh Le, Phuong Huu Le, Thuan Le, Michael Lee, Tom Nam Ly, Robert Marshall, Annie McEnroe, Chitra F. Mojtabai, Marianne Muellerleile, Willie Nark-Orn, Phil Neilson, Irene Ng, Haing S. Ngor, Dustin Nguyen, Huynh Cao Nguyen, Long Nguyen, Mai Nguyen, Thuan K. Nguyen, Vu Anh Phan, Supak Pititam, Stephen Polk, Brad Rea, Andy Reeder, Melinda Renna, Debbie Reynolds, George Roarke, Term Saefam, Bussaro Sanruck, Jennifer Low Sauer, Keith Smith, Aron Starrat, Vivien Straus, Gina Sheri Tavizon, Khiem Thai, Tai Thai, Thuc-Hanh Tran, Tuan Tran, Thanh Vo, Hieu Van Vu, Toby Vu, Liem Whatley, Vivian Wu.

A young Vietnamese girl flees the violence of the Vietcong by leaving her farming village for Saigon. After disgracing herself by becoming pregnant, she moves in with her sister. While hustling American troops, she meets up with a U.S. Marine (Tommy Lee Jones). They become lovers and, encouraged by his promises, she agrees to return with him to the strange but wonderful land of America.

INTERESTING FACT

- This is the third movie in Oliver Stone's Vietnam trilogy, the other two films being *PLATOON* and *BORN ON THE FOURTH OF JULY.*

HEAVEN KNOWS, MR. ALLISON

20th Century-Fox, 1957, color, 108 minutes.

Producers: Buddy Adler, Eugene Frenke; **Director:** John Huston; **Screenwriters:** John Huston, John Lee Mahin, Charles Shaw (novel); **Music:** Georges Auric; **Distributor:** 20th Century-Fox Film Corporation; **Filmed at:** Tobago, West Indies; **Cast:** Deborah Kerr, Robert Mitchum.

Marine corporal Robert Mitchum washes ashore on a desolate Pacific island during World War II. The only person on the island is a novice nun, Deborah Kerr, who is also stranded. The pure nun and the rough-and-ready soldier, total opposites, gradually fall in love. Because she has not yet taken her final vows, she could marry Mitchum instead of God. Forced to survive in close quarters in a cave when the Japanese set up a weather station on the island, they become even more intimate, but in the end she chooses God.

 The movie is based on Charles Shaw's *Heaven Knows, Mr. Allison* (New York: Crown Publishers, 1952).

- The director and the explosives expert were reportedly left hanging onto an elevated platform after a short-circuit in special-effects wiring unexpectedly set off all of some 30 planted detonation devices at one time.

AWARDS

Academy Awards, USA, 1957
 Nominated: *Oscar, Best Actress,* Deborah Kerr; *Best Screenplay Based on Material from Another Medium,* John Huston, John Lee Mahin

British Academy Awards, 1958
 Nominated: *BAFTA Film Award, Best Film from Any Source—USA, Best Foreign Actor,* Robert Mitchum—USA.

New York Film Critics Circle Awards, 1957
 Won: *NYFCC Award, Best Actress,* Deborah Kerr

Writers Guild of America, USA, 1958
 Nominated: *WGA Screen Award, Best Written American Drama,* John Huston, John Lee Mahin.

HELL AND HIGH WATER

20th Century-Fox, 1954, color, 103 minutes.

Producer: Raymond A. Klune; **Director:** Samuel Fuller; **Screenwriters:** Samuel Fuller, David Hempstead (story), Jesse Lasky Jr. (as Jesse L. Lasky Jr.); **Music:** Alfred Newman; **Distributor:** 20th Century-Fox Film Corporation; **Cast:** Robert Adler, Wong Artarne, Stephen Bekassy, Leslie Bradley, Harry Carter, Bella Darvi, Harry Denny, Gene Evans, Victor Francen, John Gifford, Henry Kulky, Richard Loo, Edo Mita, Cameron Mitchell, Rollin Moriyama, Neyle Morrow, Don Orlando, Peter Scott, Tommy Walker, Harlan Warde, David Wayne, John Wengraf, Richard Widmark, Ramsay Williams, Robert Williams, William Yip.

Richard Widmark is captain of an American submarine tracking a Chinese communist sub in the Arctic. They must ultimately shoot down a stolen American bomber carrying a nuclear device, which would have precipitated an international nuclear incident.

AWARD

Academy Awards, USA, 1955
 Nominated: *Oscar, Best Special Effects.*

HELL BELOW

Metro-Goldwyn-Mayer, 1933, b&w, 105 minutes.

Director: Jack Conway; **Screenwriters:** Laird Doyle, Raymond L. Schrock, John Lee Mahin (dialogue), John Meehan (dialogue); **Music:** William Axt; **Distributor:** Metro-Goldwyn-Mayer; **Filmed at:** Honolulu, Hawaii; **Cast:** Anna Demetrio, James Donlan, Jimmy Durante, Maude Eburne, Madge Evans, Herbert Evans, Eddie Hart, Sterling Holloway, Walter Huston, Charles Irwin, Henry Kolker, Babe London, John Lee Mahin, Frank Marlowe, Matt McHugh, Robert Montgomery, Herbert Mundin, David Newell, Bradley Page, Eugene Pallette, James Parrish, Paul Porcasi, Syd Saylor, Edwin Styles, Charles Sullivan, Robert Young.

During World War I, Robert Montgomery becomes enraged at his captain when he takes down their submarine and thereby kills his friend who is left topside. In his anger at his commander's action, he fires all four of their torpedoes. While some find their target, others miss, and the action brings the submarine under attack from German destroyers, resulting in the deaths of some of the submariners. He is court-martialed for his actions and dishonorably discharged from the service. To make matters worse, Montgomery is in love with his commander's daughter, who is already married to another officer. To redeem himself, Montgomery pilots a submarine filled with explosives in an attack on the enemy.

- The plot device in which a commander has to abandon a man topside and dive the submarine to save it was repeated in the film *OPERATION PACIFIC,* the difference being that in that film, the scene was based on the actions of a real World War II Medal of Honor recipient, while this film, made before the war, is totally fictional.

HELL BOATS

Oakmont Productions, 1970, b&w, 95 minutes.

Producer: Lewis J. Rachmil; **Director:** Paul Wendkos; **Screenwriters:** Derek Ford, Donald Ford, S. S. Schweitzer, Anthony Spinner; **Music:** Frank Cordell; **Distributor:** United Artists; **Filmed in:** Malta; **Cast:** Ronald Allen, Reuven Bar-Yotam, Sean Barrett, Peter Burton, Bernard Davies, Takis Emmanuel, James Franciscus, John G. Heller, Mark Hawkins, John G. Heller, Drewe Henley, Inigo Jackson, Moultrie Kelsall,

Magda Konopka, Philip Madoc, Andreas Malandrinos, David Savile, Elizabeth Shepherd.

James Franciscus, an American commander under Royal Navy command and control during World War II, is ordered to destroy a Nazi supply depot in Sicily. His plan is to use a captured German "E-boat" to sneak through enemy lines and blow up the arsenal. Crew member Ronald Allen, though he has personal differences with his commander, volunteers to pilot the small torpedo boat and help complete the mission.

INTERESTING FACT

- The movie, based on S. S. Schweitzer's *Hell Boats*, (no publication data is available) shows splendid views of Malta, the island fortress in the Mediterranean.

HELLCATS OF THE NAVY

Columbia Pictures Corporation, 1957, b&w, 82 minutes.

Producer: Charles H. Schneer; **Director:** Nathan Juran; **Screenwriters:** Hans Christian, Bernard Gordon, David Lang, Charles A. Lockwood; **Music:** Mischa Bakaleinikoff; **Cast:** Robert Arthur, Nancy Davis, Arthur Franz, Michael Garth, Thomas Browne Henry, Selmer Jackson, Don Keefer, Harry Lauter, William Leslie, Maurice Manson, William Phillips, Ronald Reagan, Joe Turkel.

In World War II, submarine commander Ronald Reagan, on an important mission in the Tsushima Straits and the Sea of Japan to chart minefields, is forced to abandon a navy frogman to save the ship from being detected. However, the crew believes that the commander had personal reasons for wanting the death of the crew member.

INTERESTING FACT

- This is the only movie that Ronald and Nancy (Davis) Reagan made together. She plays a navy nurse who provides the romantic interest for submarine commander Ronald Reagan.

HELL IN THE HEAVENS

Fox Film Corporation, 1934, b&w, 79 minutes.

Producer: Al Rockett; **Director:** John G. Blystone; **Screenwriters:** Byron Morgan, Ted Parsons, Herman Rossman, Jack Yellen; **Cast:** Rudolph Anders, Johnny Arthur, Vince Barnett, Warner Baxter, Vincent Carato, Andy Devine, Arno Frey, Russell Hardie, Conchita Montenegro, Ralph Morgan, Herbert Mundin, J. Carrol Naish, William Stack, William Stelling, Frank Tomick.

Spads and Fokkers clash in the sky over France as Warner Baxter, an American in the French Flying Corps, combs the sky for the Baron, a German ace who is cutting a swath through the ranks of Baxter's compatriots. He captures the Baron and then returns to romancing a local French maiden, Conchita Montenegro.

HELL IN THE PACIFIC

Selmur Pictures, 1968, color, 101 minutes.

Producers: Reuben Bercovitch, Henry G. Saperstein, Selig J. Seligman; **Director:** John Boorman; **Screenwriters:** Eric Bercovici, Reuben Bercovitch, Alexander Jacobs; **Music:** Lalo Schifrin; **Distributor:** Cinerama Releasing Corporation; **Filmed in:** Palau Islands; **Cast:** Lee Marvin, Toshiro Mifune.

During World War II, a solitary Japanese soldier (Toshiro Mifune) guarding a remote Pacific island is confronted by an American serviceman (Lee Marvin) who washes up on the beach. Lee Marvin is a brash, violent man who cannot defer gratification, whereas Toshiro Mifune is methodical, dutiful, and somewhat unimaginative. Enemies who lack a common language, the two men must decide whether to continue the vendettas of a distant civilization, or cooperate in order to survive.

The movie is based on William Golding's *Pincher Martin* (London: Faber and Faber, 1956).

MILITARY SERVICE

- Lee Marvin enlisted in the U.S. Marines at the beginning of World War II and served in I Company, Third Battalion, 25th Marines, Fourth Marine Division. He saw action in Saipan, the Marianas, and the Marshall Islands. He was involved in the capture of several small islands as part of a reconnaissance unit and was almost killed twice. In the battle for Saipan in June 1944, he was wounded in the back by Japanese fire, which severed his sciatic nerve. He was invalided, spent 13 months in a naval hospital, and then was put into vocational rehabilitation by the Veterans Administration, to train him for the job of actor.
- Toshiro Mifune was also a veteran of World War II, on the Japanese side.

HELL IS FOR HEROES

Paramount Pictures, 1962, b&w, 90 minutes.

Producer: Henry Blanke; **Director:** Don Siegel; **Screenwriters:** Richard Carr, Robert Pirosh; **Music:** Leonard Rosenman; **Distributor:** Paramount Pictures; **Filmed at:** Cottonwood, California; **Cast:** Nick Adams, James Coburn, Bobby Darin, Harry Guardino, Don Haggerty, Joseph Hoover, L. Q. Jones, Mike Kellin, Steve McQueen, Michele Montau, Bill Mullikin, Bob Newhart, Fess Parker.

Steve McQueen leads a 10-man squad holding their section of the Siegfried Line against overwhelming odds during World War II. After a number of attempts to destroy an enemy pillbox fail, the soldiers manage to get a satchel charge within a few feet of the mouth of a machine gun spilling death from the narrow slit. McQueen, mortally wounded, jumps onto the explosives and rolls into the pillbox, exploding the charge, killing himself, and saving his squad.

INTERESTING FACT

- This is Bob Newhart's film debut. His previous comedy routine had been based on talking on the telephone; this routine was incorporated in a hilarious segment in an otherwise serious war movie. The squad discovers an enemy microphone planted in one of their bunkers, to eavesdrop on their strategic telephone calls. However, since Bob Newhart knows about the plant, he plays the Germans for suckers, with lines on the field telephone like "Don't send up any more men, we have too many, we keep sending them back, and besides, we're completely out of foxholes."

HELL RAIDERS

Azalea Pictures, 1968, color, 80 minutes.

Director: Larry Buchanan; **Distributor:** American International Pictures; **Filmed in:** Dallas, Texas; **Cast:** John Agar, Joan Huntington, Bill Thurman, Richard Webb.

During World War II, a group of soldiers in the Philippines are recruited for the dangerous mission of destroying an American base to keep strategic papers out of enemy hands when the Japanese forces invade.

This movie is a remake of *SUICIDE BATTALION* (1958).

HELL'S ANGELS

Caddo Company, 1930, b&w and color, 127 minutes.

Producer: Howard Hughes; **Director:** Howard Hughes; **Screenwriters:** Harry Behn, Howard Estabrook, Joseph Moncure March, Marshall Neilan; **Distributor:** United Artists; **Cast:** William B. Davidson, Wilhelm von Brincken, Stephen Carr, Thomas Carr, Frank Clark, Hank Coffin, Ross Cooke, John Darrow, Jack Deery, Douglas Gilmore, J. Granville-Davis, Carl von Haartman, James Hall, Evelyn Hall, Jean Harlow, Hans Joby, Ben Lyon, Marian Marsh, Lena Melana, Maurice Murphy, Stewart Murphy, Leo Nomis, Lucien Prival, Ira Reed, Ferdinand Schumann-Heink, Harry Semels, Pat Somerset, Wyndham Standing, Gertrude Sutton, Frank Tomick, Roscoe Turner, Al Wilson, Roy Wilson, Jane Winton.

Two brothers attending Oxford enlist in the Royal Flying Corps at the outbreak of World War I. Roy (James Hall) and Monte Rutledge (Ben Lyon) have very different personalities. Monte is a freewheeling womanizer, even with his brother's girlfriend. He also proves to have a yellow streak when it comes to his night patrol duties. Roy is made of stronger moral fiber and tries to keep his brother in line. Both volunteer for an extremely risky two-man bombing mission, but for different reasons. Monte wants to lose his cowardly reputation, Roy wants to protect his brother. Their assignment to knock out a strategic German munitions facility is a success, but when they are captured, Roy realizes that his cowardly brother won't survive under torture, and he is forced to kill him to keep him from talking.

INTERESTING FACTS

- Director Howard Hughes had all of the prints tinted and hand-colored before releasing them for general distribution.
- This film cost $3.8 million, so expensive that it made no profit on its first release.

AWARD

Academy Awards, USA, 1929-30
 Nominated: *Oscar, Best Cinematography*, Tony Gaudio, Harry Perry.

HELL'S HORIZON

Columbia Pictures Corporation, 1955, b&w, 78 minutes.

Producer: Wray Davis; **Director:** Tom Gries; **Screenwriter:** Tom Gries; **Music:** Heinz Roemheld;

Distributor: Columbia Pictures; **Cast:** Stanley Adams, Chet Baker, Hugh Beaumont, Don Burnett, Wray Davis, Kenne Duncan, Marla English, John Ireland, Paul Levitt, John Murphy, Jerry Paris, Larry Pennell, William Schallert, Mark Scott, Bill Williams.

John Ireland commands a bombing mission on a vital bridge over the Yalu River during the Korean War. As the crew fights their way to the bridge and back through enemy fighters, tension grows among the crew as we learn the different reasons why they dislike their plane commander.

HELL SQUAD

Rhonda Productions, 1958, b&w, 64 minutes.

Producer: Burt Topper; **Director:** Burt Topper; **Screenwriter:** Burt Topper; **Distributor:** American International Pictures (AIP); **Cast:** Cecil Addis, John Amos, Ben Bigelow, Wally Campo, Brandon Carroll, Don Chambers, Gordon Edwards, Fred Gavlin, Jim Hamilton, Joe Hampton, Jack N. Kramer, Curtis Loser, Leon Schrier, Larry Shuttleworth, Jack B. Sowards, Gregg Stewart, Dick Walsh, Bob Weston, Bob Williams.

In the Tunisian desert during World War II, Wally Campo, the sole survivor of an American patrol, is wounded and surrounded by mines. He has his rifle trained on a German officer who has a map of the minefield and who is out of water.

INTERESTING FACT

• The old World War II films were always very technically accurate, even when their budgets, like that for this film, were minuscule. This was probably because the cast and crew had all served in the military during the war, in effect creating a film set in which everyone on the set was a military technical adviser.

HELL TO ETERNITY

Atlantic Pictures, 1960, b&w, 131 minutes.

Producers: Irving H. Levin, Lester A. Sansom; **Director:** Phil Karlson; **Screenwriters:** Gil Doud, Walter Roeber Schmidt, Ted Sherdeman; **Music:** Leith Stevens; **Distributor:** Allied Artists; **Filmed at:** Okinawa, Japan; **Cast:** Tsuru Aoki, Nicky Blair, Vic Damone, Richard Eyer, Richard Gardner, Sessue Hayakawa, Jeffrey Hunter, David Janssen, Michi Kobi, John Larch, George Matsui, Bob Okazaki, Patricia Owens, Reiko Sato, George Shibata, Miiko Taka, George Takei, Paul Togawa, Bill Williams.

Jeffrey Hunter is a Hispanic-American U.S. Marine who speaks Japanese like a native because he was brought up in the home of a Japanese-American family in Los Angeles. During World War II, his language skills help him kill Japanese soldiers in the South Pacific. During the bloody fight for the island of Saipan, he single-handedly convinces an entire battalion of Japanese to surrender.

This film was based on the true-life story of Guy Gabaldon, a Hispanic Los Angeles orphan who was raised in the 1930s by a Japanese-American foster family. When his foster parents and his Nisei siblings were interned in an American concentration camp for Japanese Americans, he enlisted in the U.S. Marines.

The movie is based on Edward S. Aarons's *Hell to Eternity* (London: Frederick Muller, 1960).

INTERESTING FACTS

• Guy Gabaldon was recommended for the Medal of Honor, but because of Marine Corps racism during World War II, he received only the Silver Star. This was upgraded, years later, to a Navy Cross.
• The casting of Jeffrey Hunter in itself reflects the racial attitudes of the time, since he looks more like a Viking than a Hispanic American from East Los Angeles.

HERE COME THE JETS

20th Century-Fox, 1959, b&w, 72 minutes.

Producer: Richard Einfeld; **Director:** Gene Fowler Jr.; **Screenwriter:** Louis Vittes; **Music:** Paul Dunlap; **Cast:** Steve Brodie, Jean Carson, Mark Dana, John Doucette, Vikki Dougan, Joseph Hamilton, B. B. Hughes, I. Stanford Jolley, Tiger Joe Marsh, Walter Maslow, Gloria Moreland, Glenn Morgan, Lyn Thomas, Joe Turkel, Carleton Young.

Steve Brodie is an alcoholic Korean War veteran who is given a chance to turn his life around as a test pilot of jet planes. However, he suffers an emotional breakdown on a flight simulator. Overcoming his personal problems, he is instrumental in the launch of a new jet plane.

HEROES DIE YOUNG

Allied Artists Pictures Corporation, 1960, b&w, 76 minutes.

Producer: Gerald Shepard; **Director:** Gerald Shepard; **Screenwriter:** Gerald Shepard; **Music:** Al Pellegrini;

Cast: Chick Bilyeu, Scott Borland, Bill Browne, Jack Card, Robert Getz, Don Joslyn, Erika Peters, Malcolm Smith, James Strother, Arthur Tenen.

James Strother, an American soldier, and Erika Peters, the Rumanian daughter of a man killed by the Allies, lead a group of eight soldiers behind enemy lines during World War II. Their mission is to infiltrate the Ploesti oil fields and set up flares to guide the Allied air raid. At first Peters is hostile toward her comrades but gradually she falls in love with Scott Borland, who is killed when the Allies bomb the oil fields.

This film is set against a historical event, the raid on the Ploesti oil fields by Allied bombers during World War II. The theory of the Allied high command was that the destruction of this source of fuel for the German war machine would bring the war to a more rapid end. Although the raid successfully accomplished its mission, devastating the oil fields, it was at the cost of unacceptably high casualties among the bombers. While military theorists and historians can argue about the ultimate strategic value of the raid, this film should be compared with *THE BATTLE OF THE BULGE*, in which the central premise is that the German counter-offensive in the Argonne, in the winter of 1944, depended on the German panzers reaching an Allied fuel depot for resupply. When they fail, the German war machine, quite literally out of gas, rolls to a stop, and they are forced to walk back to Germany.

HEROES OF TELEMARK, THE

Bruton Film Productions, Rank Organisation, 1965, color, 108 minutes.

Producer: Benjamin Fisz; **Director:** Anthony Mann; **Screenwriters:** Ben Barzman, Ivan Moffat; **Distributor:** Columbia Pictures; **Filmed at:** Rjukan, Norway; **Cast:** Annette Andre, Grace Arnold, Robert Ayres, Victor Beaumont, Sebastian Breaks, Faith Brook, Robert Bruce, Jan Conrad, Pamela Conway, David Davies, Maurice Denham, Anton Diffring, Roy Dotrice, Howard Douglas, Kirk Douglas, Wolf Frees, John Golightly, Elvi Hale, Paul Hansard, Richard Harris, Philo Hauser, Gerard Heinz, Jennifer Hilary, Alan Howard, Brian Jackson, Ulla Jacobsson, Mervyn Johns, Alf Joint, Barry Jones, Patrick Jordan, Geoffrey Keen, William Marlowe, Ralph Michael, George Murcell, Terence Plummer, Eric Porter, Joe Powell, Michael Redgrave, Karel Stepanek, Russell Waters, David Weston, Brook Williams.

During World War II, with Norway under Nazi occupation, a factory producing "heavy water" (a key ingredient in the manufacture of atomic weapons) is under the control of the German army. Knut Straud (Richard Harris), a leading figure in the Norwegian underground, joins forces with scientist Dr. Rolf Pederson (Kirk Douglas), who is working with British intelligence agents to destroy the factory in hopes of keeping the atomic bomb out of Axis hands. Although Straud and Pederson are only to infiltrate the factory as a reconnaissance force and await British commandos, the British army is forced to abandon its plans, leaving to the Norwegians the task of destroying the factory and scuttling a shipment of the heavy water.

The film was inspired by a true story. Allied efforts to interrupt heavy-water production at the Norsk hydro plant near Rjukan in German-occupied Norway included a failed glider assault by 34 British commandos in November 1942 (Operation Freshman) and the blowing up of a portion of the plant by a team of Norwegians on February 27, 1943 (Operation Gunnerside). The heavy-water plant was subsequently rebuilt, and an Eighth Air Force bombing raid was sent on November 16, 1943, which destroyed the power station and the adjacent plant. On February 20, 1944, the Hydro ferry, carrying practically all of the remaining supply of heavy-water concentrate, was sunk on Lake Tinnsjø by the Norwegian Resistance, which ended the battle for heavy water on Norwegian soil. These operations cost the lives of 40 Britons, 36 Norwegians, and 20 Germans.

INTERESTING FACT

- The sinking of the Hydro ferry is the high point of the film. As the ship sinks into the fjord, the train carrying the heavy water slides off the ferry, to great dramatic effect.

MISTAKE

- As Kirk Douglas rushes out of his photo lab at the University of Oslo, he rips the door off its hinges. From his reaction, you can tell it is unintentional, and the picture fades quickly.

HIDING PLACE, THE

World Wide Pictures, 1975, color, 150 minutes.

Producer: Frank R. Jacobson; **Director:** James F. Collier; **Screenwriters:** Lawrence Holben, Allan Sloane, Corrie Ten Boom; **Cast:** Tom van Beek, Jeannette Clift, Janet Davies, David De Keyser, Lex van

Delden, John Gabriel, Carol Gillies, Julie Harris, Broes Hartman, Nigel Hawthorne, Eileen Heckart, Paul Henley, Janette Legge, Arthur O'Connell, Irene Prador, Robert Rietty, Cyril Shaps, Pamela Sholto, Lillias Walker, Richard Wren.

Jeannette Clift and Julie Harris are middle-aged Dutch sisters who work in their father's watchmaker shop. Their uneventful lives are disrupted when the Nazis invade their hometown of Haarlem. Caught hiding Jews in their attic, they are sent to a concentration camp, where their Christian faith helps them overcome despair and bitterness.

INTERESTING FACTS

- This film was financed by the Billy Graham Evangelical Association.
- The film is based on the true story of Corrie ten Boom, as told in her autobiography. Corrie was the only member of the family to survive the concentration camp.

HILL, THE

Seven Arts Productions, 1965, b&w, 121 minutes.

Producers: Raymond Anzarut, Kenneth Hyman; **Director:** Sidney Lumet; **Screenwriters:** R. S. Allen, Ray Rigby; **Distributor:** Metro-Goldwyn-Mayer; **Cast:** Harry Andrews, Ian Bannen, Norman Bird, Tony Caunter, Sean Connery, Ossie Davis, Howard Goorney, Ian Hendry, Roy Kinnear, Alfred Lynch, Neil McCarthy, Michael Redgrave, Jack Watson.

During World War II, a British disciplinary barracks located in the Libyan desert has one major feature, a large, artificial dirt hill whose primary purpose is to punish the prisoners, who include Sean Connery and Ossie Davis. The main architect of their torture is Staff Sergeant Williams (Ian Hendry), who makes them climb the hill again and again under the heavy sun.

HILL IN KOREA, A

British Lion Film Corporation, Wessex Film Productions Ltd., 1956, b&w, 80 minutes.

Producers: Ian Dalrymple, Anthony Squire; **Director:** Julian Amyes; **Screenwriters:** Max Catto, Ian Dalrymple, Ronald Spencer, Anthony Squire; **Distributor:** British Lion Film Corporation; **Cast:** Harry Andrews, George Baker, Stanley Baker, Stephen

Boyd, Robert Brown, Michael Caine, Eric Corrie, Percy Herbert, Harry Landis, Charles Laurence, Ronald Lewis, Barry Lowe, Victor Maddern, Michael Medwin, David Morrell, Robert Shaw.

During the Korean War, the Allies retreat south from the Yalu River, pursued by overwhelming Chinese forces. A small unit of British troops is sent to reconnoiter a Korean village and gets caught by two advancing Chinese battalions.

INTERESTING FACT

- A very young Michael Caine plays Private Lockyer, lamenting the death of Corporal Ryker (Stanley Baker).

HITLER—DEAD OR ALIVE

Ben Judell, 1943, b&w, 70 minutes.

Producers: Ben Judell (producer), Herman E. Webber (associate producer) (as Herman Webber); **Director:** Nick Grinde; **Screenwriters:** Karl Brown, Sam Neuman (also story); **Music:** Leo Erdody; **Distributor:** Ben Judell; **Cast:** Felix Basch, Ward Bond, Eddie Coke, Ed Cook, Bruce Edwards, Paul Fix, Jack Gardner, Frederick Giermann, Kenneth Harlan, Russell Hicks, Warren Hymer, Myra Marsh, George Sorel, Dorothy Tree, Faye Wall, Bobby Watson.

Three criminals impersonate musicians to get close to Hitler, so that they can kill him and claim a $1 million reward for his death.

INTERESTING FACTS

- Bob Watson was cast as Adolf Hitler in more films than any other actor. The films include *Hitler: Dead or Alive*, THE HITLER GANG, *Miracle of Morgan's Creek*, THAT NAZTY NUISANCE, *On the Double*, *The Story of Mankind*, *The Whip Hand*, *A Foreign Affair*, *The Heavenly Body*, and THE DEVIL WITH HITLER.
- The film is inspired by a true story. In 1942, an American millionaire advertised in the newspapers that he would pay a $1 million reward to any person who killed Hitler.

HITLER GANG, THE

Paramount Pictures, 1944, b&w, 101 minutes.

Producer: Buddy G. DeSylva; **Director:** John Farrow; **Screenwriters:** Frances Goodrich, Albert

Hackett; **Cast:** Walter Abel, Felix Basch, Roman Bohnen, Ray Collins, Albert Dekker, Ludwig Donath, Poldy Dur, Alexander Granach, Walter Kingsford, Fritz Kortner, Martin Kosleck, Arthur Loft, Fred Nurney, Alex Pope, Frank Reicher, Lionel Royce, Sig Ruman, Richard Ryen, Reinhold Schünzel, Tonio Selwart, Helen Thimig, Ivan Triesault, Luis Van Rooten, Victor Varconi, Ernst Verebes, Bobby Watson.

The movie is about the life of Adolf Hitler, starting with his service as a corporal in World War I, through his rise to dictator of Germany.

INTERESTING FACTS

* Some of the character actors in this film were German refugees from Nazi Europe.
* Except for some minor inaccuracies the basic historical facts in this film are correct.

QUOTES

Röhm: Gerlich has shot himself.
Streicher: He's the first man who shot himself in the head six times.

HITLER'S MADMAN

Producers Releasing Corporation/Metro-Goldwyn-Mayer, 1943, b&w, 84 minutes.

Producers: Rudolf Joseph, Seymour Nebenzal; **Director:** Douglas Sirk; **Screenwriters:** Peretz Hirschbein, Albrecht Joseph, Melvin Levy, Emil Ludwig, Bart Lytton, Doris Malloy, Edgar G. Ulmer; **Music:** Karl Hajos, Eric Zeisl; **Distributor:** MGM; **Cast:** Chet Brandenberg, Budd Buster, John Carradine, Jimmy Conlin, Alan Curtis, Lester Dorr, Natalie Draper, Howard Freeman, Ava Gardner, Leatrice Joy Gilbert, Ernst Hausman, Johanna Hofer, Betty Jaynes, Edgar Kennedy, Victor Kilian, Tully Marshall, Dennis Moore, Ralph Morgan, Patricia Morison, Frances Rafferty, Jorja Rollins, Lionel Royce, Elizabeth Russell, Hans Schumm, Al Shean, Ludwig Stössel, Richard Talmadge, Celia Travers, Sam Waagenaar, Blanche Yurka, Wolfgang Zilzer.

John Carradine is Reinhard Heydrich, the cruel Nazi ruler of Czechoslovakia, known as Heydrich the Hangman. Alan Curtis plays a resistance leader who parachutes into the village of Lidice to convince the villagers to rise up against their oppressors. At first they are afraid, but then Heydrich kills the local priest. In retaliation, they assassinate Heydrich. The Nazis, in retribution, then enter the town and round up everyone. The men are shot, the women are sent to slave labor camps, and the children are deported. Then the Germans completely level the village.

The film, also known as *Hitler's Hangman,* is based on Bart Lytton's *Hangman's Village* (no publication data available).

INTERESTING FACTS

* Eleanor Roosevelt heard about the destruction of the village and suggested that this true story be made into a feature film.
* Poet Edna St. Vincent Millay contributed several verses that she wrote specifically for the film. The last scene in the film portrays the ghosts of those killed, and each one recites lines of the poem:

> I'm telling you not to eat or drink,
> One morsel of food, one swallow of drink,
> Before you think, before you think,
> What is best for your country.
> Keep your country free from the foe you hate,
> Catch him, catch him, do not wait.

* On May 27, 1942, the Nazi Reichsprotector of Bohemia/Moravia, Reinhard Heydrich (the Hangman), died from the bullets of unidentified resistance fighters. Nazi reprisals led to the complete destruction of the village of Lidice.

HOLD BACK THE NIGHT

Allied Artists Pictures Corporation, 1956, b&w, 80 minutes.

Producer: Hayes Goetz; **Director:** Allan Dwan; **Screenwriters:** Walter Doniger, Pat Frank, John C. Higgins; **Music:** Hans J. Salter; **Distributor:** Allied Artists; **Cast:** Nicky Blair, Stanley Cha, Chuck Connors, John Craven, Audrey Dalton, Robert Easton, Mona Freeman, Peter Graves, Nelson Leigh, Edward J. McCraw, Robert Nichols, John Payne, John Wilder.

John Payne leads the U.S. Marines through combat in Korea behind enemy lines, carrying a bottle of scotch he has been lugging around since World War II, waiting for a very special occasion. He offers it to his company as a reward if they can fight their way back to their own lines. The liquor becomes a symbol of their goal.

The movie is based on Pat Frank's *Hold Back the Night* (Philadelphia: Lippincott, 1952).

HOMECOMING

Metro-Goldwyn-Mayer, 1948, b&w, 113 minutes.

Producers: Sidney Franklin, Gottfried Reinhardt (associate producer); **Director:** Mervyn LeRoy; **Screenwriters:** Sidney Kingsley (story), Jan Lustig, Paul Osborn; **Music:** Bronislau Kaper; **Distributor:** MGM; **Cast:** John Albright, Frank Arnold, Peggy Badley, Art Baker, Gregg Barton, Anne Baxter, Honor Blackman, Francine Bordeaux, Olga Borget, Thomas E. Breen, James Bush, Wally Cassell, Wheaton Chambers, Dorothy Christy, David Clark, Ray Collins, Louise Colombet, Edwin Cooper, Gladys Cooper, Jeff Corey, Joseph Crehan, Danielle Day, Leslie Denison, Vernon Downing, Mimi Doyle, Phil Dunham, Fern Eggen, Mary Jo Ellis, William Forrest, Clark Gable, Lisa Golm, Jessica Grayson, Alan Hale Jr., Eloise Hardt, John Hodiak, Jerry Jerome, J. Louis Johnson, Virginia Keiley, Michael Kirby, Jeanne Lafayette, Nolan Leary, Queenie Leonard, Hobart Manning, Kay Mansfield, Alphonse Martell, Frank Mayo, Charles Meredith, Charles F. Miller, Cameron Mitchell, Ralph Montgomery, Roger Moore, Bert Moorhouse, Anne Nagel, David Newell, Jay Norris, Arthur O'Connell, Broderick O'Farrell, George Offerman, Steve Pendleton, Albert Pollet, Frances Pyle, Dan Quigg, William Self, George Sherwood, Robert Skelton, Lew Smith, Arthur Space, James Taggart, William Tannen, Marshall Thompson, Lana Turner, Lurene Tuttle, Leo Vandervelde, Geraldine Wall.

Self-absorbed doctor Clark Gable enlists in the army medical corps during World War II, more out of a feeling that it is the right thing to do than any deep-seated patriotism. On his first day, he is put in his place by Lana Turner, a sassy and attractive nurse. Their initial antagonism blossoms into romance, although he does feel some pangs of guilt over being unfaithful to his wife who is waiting for him back home. Their affair lasts from North Africa to the Battle of the Bulge, where Turner is killed.

HOME OF THE BRAVE

Screen Plays Corp., 1949, b&w, 88 minutes.

Producer: Stanley Kramer; **Director:** Mark Robson; **Screenwriters:** Carl Foreman, Arthur Laurents (play); **Music:** Dimitri Tiomkin; **Distributor:** United Artists; **Cast:** Lloyd Bridges, Steve Brodie, Cliff Clark, Jeff Corey, Douglas Dick, James Edwards, Frank Lovejoy.

James Edwards is a black soldier during World War II who returns from a dangerous mission in a state of shock. The psychiatrist who examines him learns that he has been subjected to intense racial abuse, followed by the death of the one white soldier who had been his friend.

INTERESTING FACT

- The original play by Arthur Laurents had a Jewish, instead of a black, soldier, but this was changed at the insistence of producer Stanley Kramer.

QUOTE

T.J.: Yeah, I'll never forget the first letter I got from my wife. It started, "My darling, darling, darling, I'll never again use the word love without thinking only of you." And I remember the last one I got from her. It started "Dear T.J. This is the hardest letter I've ever had to write."

AWARD

Writers Guild of America, USA, 1950
 Nominated: *WGA Screen Award, The Robert Meltzer Award (Screenplay Dealing Most Ably with Problems of the American Scene)*, Carl Foreman.

HOOK, THE

Metro-Goldwyn-Mayer, 1963, b&w, 98 minutes.

Producer: William Perlberg; **Director:** George Seaton; **Screenwriters:** Henry Denker, Vahé Katcha; **Cast:** Nick Adams, John Alderson, Anders Andelius, John Bleifer, Kirk Douglas, Barnaby Hale, Enrique Magalona, Mark Miller, Nehemiah Persoff, Frank Richards, Robert Walker Jr.

During the Korean War, three American soldiers on a Finnish freighter—Kirk Douglas, Nick Adams, and Robert Walker—are ordered to kill a prisoner. At sea, far removed from any battle, the soldiers are unable to carry out their brutal assignment. While they are wrestling with their consciences, they learn that the war is over, but almost simultaneously, their prisoner escapes, intent on setting fire to the ship. Kirk Douglas finally corners him but can't make him understand that the war is over. Finally, he is forced to kill him with his own razor. After he dies, they are finally able to make out his last words, "I couldn't do it."

The movie is based on Vahé Katcha's *L'Hamecon* (Paris: Plon, 1957).

HOPE AND GLORY

Columbia Pictures Corporation, Goldcrest Films, Nelson Entertainment, 1987, color, 113 minutes.

Producers: John Boorman, Michael Dryhurst, Jake Eberts, Edgar F. Gross; **Director:** John Boorman; **Screenwriter:** John Boorman; **Music:** Peter Martin; **Distributor:** Columbia Pictures Corporation; **Filmed at:** Middlesex, Surrey, Sussex, and Croydon, all in England; **Cast:** Jodie Andrews, William S. Armstrong, Nicholas Askew, Jill Baker, Ian Bannen, Jean-Marc Barr, Andrew Bicknell, Charley Boorman, Katrine Boorman, Jamie Bowman, Amelda Brown, Susan Brown, Imogen Cawrse, Arthur Cox, Christine Crowshaw, Colin Dale, Sammi Davis, Shelagh Fraser, David Hayman, Colin Higgins, Peter Hughes, Gerald James, Sara Langton, Annie Leon, Sarah Miles, Geraldine Muir, Derrick O'Connor, David Parkin, Barbara Pierson, Sebastian Rice-Edwards, Carlton Taylor, Nicky Taylor, Ann Thornton, Susan Wooldridge.

A nine-year-old boy grows up in London during the blitz in World War II. For him, this time in history is not a world war; it is not the struggle of humanity against a totalitarian evil, rather it is an adventure, a total upheaval of order, restrictions, and discipline—in other words, a great time. World War II is seen totally through this young boy's eyes. The blitz is seen as the world's greatest fireworks display. Going to school is an excellent opportunity to collect shrapnel. The gang of kids to which he belongs specializes in smashing windows and other debris left of houses in their neighborhood after they are bombed, until the reality sets in when it's his house that burns down and his friends show up to smash the windows. He perceives Hitler as someone who blew up his school, and now he doesn't have to go. One kid exclaims, "Thank you, Adolf!"

INTERESTING FACT

• Director John Boorman was a young boy during the blitz, and this film is in large part an autobiographical work.

QUOTES

[A teacher in a classroom under constant bombardment from Hitler's airplanes points to a map of the world in which the British Empire countries are colored pink.]
"What's the significance of the pink bits?" the teacher asks the class.

The young hero hesitantly suggests, "They're ours?" "That's right! They're ours!" the teacher shouts back. "And that's what our men are fighting and dying in this bloody war for: to make sure we keep holding on to those pink bits, for you ungrateful little twerps!"

AWARDS

Academy Awards, USA, 1987
Nominated: *Oscar; Best Art Direction—Set Decoration*, Anthony Pratt, Joanne Woollard; *Best Cinematography*, Philippe Rousselot; *Best Director*, John Boorman; *Best Picture*, John Boorman; *Best Writing, Screenplay Written Directly for the Screen*, John Boorman

Boston Society of Film Critics Awards, 1988
Won: *BSFC Award, Best Film*

British Academy Awards, 1988
Won: *BAFTA Film Award, Best Actress in a Supporting Role*, Susan Wooldridge
Nominated: *BAFTA Film Award, Best Actor in a Supporting Role*, Ian Bannen; *Best Actress*, Sarah Miles; *Best Cinematography*, Philippe Rousselot; *Best Costume Design*, Shirley Russell; *Best Direction*, John Boorman; *Best Editing*, Ian Crafford; *Best Film*, John Boorman; *Best Make Up Artist*, Anna Dryhurst; *Best Original Screenplay*, John Boorman; *Best Production Design*, Anthony Pratt; *Best Score*, Peter Martin; *Best Sound*, Ron Davis, Peter Handford, John Hayward

British Society of Cinematographers, 1987
Won: *Best Cinematography Award*, Philippe Rousselot

Golden Globes, USA, 1988
Won: *Golden Globe, Best Motion Picture—Comedy/Musical*
Nominated: *Golden Globe, Best Director—Motion Picture*, John Boorman; *Best Screenplay—Motion Picture*, John Boorman

Independent Spirit Awards, 1988
Nominated: *Independent Spirit Award, Best Foreign Film*, John Boorman—UK

Los Angeles Film Critics Association Awards, 1987
Won: *LAFCA Award, Best Director*, John Boorman; *Best Picture; Best Screenplay*, John Boorman

National Society of Film Critics Awards, USA, 1988
Won: *NSFC Award, Best Cinematography*, Philippe Rousselot; *Best Director*, John Boorman; *Best Screenplay*, John Boorman

Tokyo International Film Festival, 1987
 Won: *Best Artistic Contribution Award*—John Boorman

Writers Guild of America, USA, 1988
 Nominated: *WGA Screen Award, Best Screenplay Written Directly for the Screen,* John Boorman

Young Artist Awards, 1989
 Nominated: *Young Artist Award, Best Family Motion Picture—Drama; Best Young Actor in a Motion Picture—Drama,* Sebastian Rice-Edwards.

HORIZONTAL LIEUTENANT, THE

Metro-Goldwyn-Mayer, 1962, color, 90 minutes.

Producer: Joe Pasternak; **Director:** Richard Thorpe; **Screenwriters:** Gordon Cotler, George Wells; **Cast:** Jim Backus, Argentina Brunetti, Jack Carter, Jim Hutton, Marty Ingels, Lloyd Kino, Lee Krieger, Charles McGraw, Paula Prentiss, Yuki Shimoda, Miyoshi Umeki, Linda Wong, Yoshio Yoda.

Jim Hutton, a rather pathetic excuse for an officer, is ordered to bring in the last surviving Japanese soldier resisting on an island in the South Pacific during World War II.

The movie is based on Gordon Cotler's *The Bottletop Affair* (New York: Simon and Schuster, 1959).

HORNET'S NEST

Triangle Productions, 1970, color, 110 minutes.

Producer: Stanley S. Canter; **Directors:** Franco Cirino, Phil Karlson; **Screenwriters:** Stanley Colbert, S. S. Schweitzer; **Music:** Ennio Morricone; **Distributor:** United Artists; **Cast:** Andrea Bosic, Giuseppe Cassuto, Amedeo Castracane, Alain Chammas, Mark Colleano, Giancarlo Colombaioni, Ronald Colombaioni, Valerio Colombaioni, Giuseppe Coppola, Luigi Criscuolo, Rod Dana, Gaetano Danaro, Vincenzo Danaro, Amos Davoli, Daniel Dempsey, Larry Dolgin, Mino Doro, Bondy Esterhazy, Sergio Fantoni, Tom Felleghy, John Fordyce, Anna-Luisa Giacinti, Bruno Marco Gobbi, Mauro Gravina, Gérard Herter, Rock Hudson, Daniel Keller, Sylva Koscina, Mauro Orsi, Giacomo Rossi-Stuart, Jacques Sernas, Jacques Stany, Hardy Stuart, Max Tarilli, Maurizio-Fabriz Tempio, Freddie Unger, Jean Valmont.

Rock Hudson is an American paratrooper sent into Italy to blow up a strategic dam during World War II. He enlists the help of a guerrilla band made up exclusively of children whose parents have been killed by the Germans.

HOSTAGES

Paramount Pictures, 1943, b&w, 88 minutes.

Producer: Sol C. Siegel; **Director:** Frank Tuttle; **Screenwriters:** Frank Butler, Lester Cole, Stefan Heym; **Music:** Victor Young; **Cast:** Louis Adlon, Felix Basch, William Bendix, Hans Conried, Arturo de Córdova, Eric Feldary, Frederick Giermann, Oskar Homolka, Jack Lambert, Paul Lukas, John Mylong, Kurt Neumann, Katina Paxinou, Luise Rainer, Mikhail Rasumny, Richard Ryen, Philip Van Zandt, Roland Varno, Michael Visaroff, Rex Williams.

A group of 26 Czechoslovakian citizens are jailed until a reward of 50,000 crowns offered by the Gestapo uncovers the supposed killer of a Nazi officer who was found drowned, although virtually everyone suspects that the killer in fact committed suicide. The hostages include the leader of the underground resistance movement (William Bendix), whose cover is that of a washroom attendant in the nightclub where the victim was last seen alive. Motives are even more obscured by the fact that several of the Nazis hope to share the wealth of one of the wealthy prisoners after he is shot for killing the officer.

The novel on which the film is based, Stefan Heym's *Hostages* (New York: G. P. Putnam's Sons, 1942), was inspired by actual historical incidents.

HOTEL BERLIN

Warner Bros., 1945, b&w, 98 minutes.

Producer: Louis F. Edelman; **Director:** Peter Godfrey; **Screenwriters:** Vicki Baum (novel), Alvah Bessie, Jo Pagano; **Music:** Paul Dessau, Franz Waxman; **Distributor:** Ruth Albu, George Coulouris, Henry Daniell, Helmut Dantine, Faye Emerson, Steven Geray, Alan Hale, Elsa Heiis, Erwin Kalser, Andrea King, Kurt Kreuger, Peter Lorre, Raymond Massey, Torben Meyer, John Mylong, Jay Novello, Paul Panzer, Frank Reicher, Lotte Stein, Helen Thimig, Richard Tyler, Peter Whitney, Wolfgang Zilzer.

Near the end of World War II, a member of the German underground escapes from the Gestapo and takes shelter at the Hotel Berlin. The hotel is a hotbed of Nazis, refugees, spies, and ordinary

Germans trying to survive until the inevitable defeat of Nazi Germany.

The film is based on Vicki Baum's *Hotel Berlin* (Garden City: Doubleday, Doran & Company, Inc., 1944).

INTERESTING FACT

- The crumbling hotel, damaged by repeated Allied air attacks, is the author's metaphor for the physical state of Germany, which is in the final stages of collapse. The elevators don't work, the electricity is out, and the basement is used as an air raid shelter. The people seeking refuge in the hotel represent a cross section of society.

QUOTE

[scrolling at the end of the film, over an air raid]: Our purpose is not to destroy the German people, but we are determined to disband all German armed forces, bring all war criminals to just and swift punishment, and wipe out the Nazi Party and Nazi laws. Germany must never again disturb the peace of the world.

HOTEL IMPERIAL

Paramount Pictures, 1939, b&w, 67 minutes.

Director: Robert Florey; **Screenwriters:** Lajos Biró (story, *Színmü négy felvonásban*), Gilbert Gabriel, Robert Thoeren; **Music:** Ralph Freed (songs), Richard Hageman, Frederick Hollander (songs); **Distributor:** Paramount Pictures; **Cast:** Bull Anderson, Stanley Andrews, William Bakewell, Curt Bois, Agostino Borgato, Arthur W. Cernitz, Spencer Charters, Davison Clark, Betty Compson, Sheila Darcy, Paula DeCardo, Albert Dekker, Richard Denning, Paul Everton, Robert Frazer, Norah Gale, Russell Hicks, Harry Holman, Judith King, Jack Knoche, Bob Kortman, Paul Kruger, Ethan Laidlaw, Gene Lockhart, George MacQuarrie, George Magrill, Joseph Marievsky, Andre Marsaudon, Robert Middlemass, Ray Milland, Isa Miranda, J. Carrol Naish, Reginald Owen, Norman Phillips Jr., Bert Roach, Bodil Rosing, Gustav von Seyffertitz, Lee Shumway, Harry Tenbrook, Ernst Verebes, Henry Victor, Luana Walters, Michel Werboff, Marek Windheim, Wolfgang Zilzer.

Ray Milland is an Austrian officer hiding in the Hotel Imperial, who falls in love with Isa Miranda, a chambermaid seeking revenge for the death of her sister. Milland escapes back to his own lines, bringing his army vital information for a counterattack, and then returns to his love when the town is retaken.

INTERESTING FACTS

- The hotel depicted is on the Austro-Hungarian border, where the Russians and the Austrians fought over Galicia during World War I. It was overrun and occupied by the Russians in 1914. After the war, it was declared independent by the Ukraine, but then it was almost immediately annexed by Poland.
- This troubled film was many years in production, with numerous cast, director, and title changes.
- Actor Ray Milland was seriously injured while making this film. Playing a cavalry officer, Milland was leading a "charge" through a village. As they rounded a corner he saw that someone had left a camera on a tripod in the middle of the street. There was no time to try to pull around it or stop his horse, so Milland, an experienced horseman, tried to get the horse to jump over it. The horse cleared the camera, but the saddle girth snapped. Milland was thrown from the saddle, bounced off the wall of a building, and landed in a pile of debris and broken masonry. He was unconscious for almost 24 hours and was hospitalized for two weeks.
- Three actresses were cast as Anna. The first, Marlene Dietrich, was constantly at loggerheads with then-director Henry Hathaway; he wanted to deglamorize her. After some rewriting by Grover Jones, she finally quit, and production was frozen. Margaret Sullavan was then brought in as Anna and shooting resumed, but while clowning around with Ray Milland on the set between takes (she was squirting him with a concealed water pistol), she fell on her arm and fractured it. She refused to do the rest of the movie in a sling as the studio heads demanded and also quit. At this point Dietrich offered to come back, but Paramount refused and instead brought in Italian sex symbol Isa Miranda. However, Miranda knew no English and had to have all her dialogue supplied phonetically.

HOW I WON THE WAR

United Artists, Petersham Pictures, 1967, color, 109 minutes.

Producer: Richard Lester; **Director:** Richard Lester; **Screenwriters:** Patrick Ryan, Charles Wood; **Music:** Ken Thorne; **Distributor:** United Artists; **Cast:** Fanny Carby, Norman Chappell, Kenneth Colley,

James Cossins, Michael Crawford, Paul Daneman, Mick Dillon, Charles Dyer, Bill Dysart, Gretchen Franklin, Peter Graves, Sheila Hancock, Robert Hardy, Jack Hedley, Ewan Hooper, Michael Hordern, John Junkin, Roy Kinnear, Alexander Knox, Ronald Lacey, John Lennon, Jack MacGowran, Jack May, Lee Montague, Dandy Nichols, Richard Pearson, Bryan Pringer, John Ronane, Pauline Taylor, John Trenaman, Karl Michael Vogler.

Former Beatle John Lennon and Roy Kinnear are ill-fated enlisted men under the inept command of Lt. Earnest Goodbody (Michael Crawford), an incompetent officer who commands one of the worst units in the army.

The movie is based on Patrick Ryan's *How I Won the War* (London: F. Muller, 1963).

HUNTERS, THE

20th Century-Fox, 1958, color, 105 minutes.

Producer: Dick Powell; **Director:** Dick Powell; **Screenwriters:** Wendell Mayes, James Salter; **Cast:** Chiyoko Tota Baker, Jimmy Baya, May Britt, John Caler, Vinnie De Carlo, John Doucette, Richard Egan, John Gabriel, Stacy Harris, Jay Jostyn, Whamok Kim, Frank Kumagai, Candace Lee, Mabel Lim, Leon Lontoc, Mae Maeshire, Ralph Manza, Nobu McCarthy, Robert Mitchum, Alena Murray, Bob Olen, Lee Philips, Robert Reed, Nina Shipman, Mary Song, Rachel Stephens, Frank Tang, Larry Thor, Kam Tong, Robert Wagner, James Yagi, Victor Sen Yung.

Robert Mitchum is "The Iceman," a veteran World War II pilot commanding a jet fighter squadron in Korea. While his planes fly missions against communist airfields near the Yalu River, he falls in love with the wife of one of his pilots. When her husband is shot down during a mission, Mitchum joins him on the ground, and together they fight their way back to their own lines.

The movie is based on James Salter's *The Hunters* (New York: Harper, 1956).

INTERESTING FACTS

- The film features flying sequences with F-86 Sabre jets.
- Because of the short interval between World War II and Korea, all of the senior pilots were veterans of the previous conflict. Although initially trained as regular fixed-wing fighter pilots, the military, using captured German jet aircraft, had quickly begun a transition after World War II, and the older pilots had been trained in the new jet fighters.

ICE-COLD IN ALEX

Associated British Pictures Corporation, 1958, b&w, 129 minutes.

Producer: W. A. Whittaker; **Director:** J. Lee Thompson; **Screenwriters:** Christopher Landon, T. J. Morrison; **Music:** Leighton Lucas; **Filmed in:** Libya; **Cast:** Harry Andrews, Peter Arne, Diane Clare, Allan Cuthbertson, Walter Gotell, Basil Hoskins, Frederick Jaeger, Richard Leech, David Lodge, Richard Marner, John Mills, Michael Nightingale, Anthony Quayle, Liam Redmond, Paul Stassino, Sylvia Syms.

An ambulance crew, which includes nurses, commanded by an intoxicated commander, John Mills, attempts a dangerous and arduous trek across the deserts of North Africa during World War II. What keeps him going is the thought of an ice-cold beer when they reach Alexandria.

I COVER THE WAR

Universal Pictures, 1937, b&w, 68 minutes.

Producers: Trem Carr, Paul Malvern (associate producer); **Director:** Arthur Lubin; **Screenwriters:** Bernard McConville (story), George Waggner; **Music:** Sam Perry, David Raksin, Heinz Roemheld, Edward Ward, Franz Waxman; **Filmed at:** Alabama Hills and Lone Pine, California; **Cast:** Abdulla, Arthur Aylesworth, Don Barclay, Charles Brokaw, James Bush, Gwen Gaze, Sam Harris, Keith Hitchcock, Earle Hodgins, Olaf Hytten, Frank Lackteen, Cactus Mack, Franklin Parker, Pat Somerset, Richard Tucker, John Wayne.

Newsreel cameraman John Wayne heads to Iraq to cover an Arab revolt, romances the niece of a British officer, saves a company of lancers from being wiped out by the insurgents, and unmasks the leader of the uprising.

The film is set during the Iraqi rebellion of 1935. The modern nation of Iraq was created by the treaty ending World War I, in lands that were part of the defeated Ottoman Empire. The British were given a League of Nations mandate, which ended in 1932 when the country became independent under King Faisal. Revolts broke out against this new government in 1935, but they were soon suppressed.

MISTAKE

- Although the country was officially called Iraq by the time period of this film, the actors still refer to it by its prewar name of Mesopotamia.

I DEAL IN DANGER

20th Century-Fox Television, 1966, color, 90 minutes.

Producers: Walter Grauman, Buck Houghton; **Director:** Walter Grauman; **Screenwriter:** Larry

Cohen; **Music:** Josep Mullendore, Lalo Schifrin; **Distributor:** 20th Century-Fox Film Corporation; **Cast:** John Alderson, Alexander Allerson, Manfred Andrae, Peter Capell, Christine Carère, Dieter Eppler, Horst Frank, Paul Glawion, Robert Goulet, Donald Harron, Dieter Kirchlechner, Werner Peters, Eva Pflug, Osman Ragheb, Hans Reiser, Margit Saad, Christiane Schmidtmer, John Van Dreelen.

Robert Goulet, an American correspondent, pretends to go over to the Nazis during World War II but is instead working for the officially neutral United States against Hitler.

INTERESTING FACT

- The movie is a feature version of the TV series *Blue Light*.

ILL MET BY MOONLIGHT

Vega Film Productions, Rank Organisation, 1957, b&w, 104 minutes.

Producers: Michael Powell, Emeric Pressburger, Earl St. John, Sydney Streeter; **Directors:** Michael Powell, Emeric Pressburger; **Screenwriters:** W. Stanley Moss, Michael Powell, Emeric Pressburger; **Music:** Mikis Theodorakis; **Filmed at:** French Riviera and Alpes Maritimes, France, Alpes Maritimes, Italy; **Cast:** Dimitri Andreas, Adeeb Assaly, Peter Augustine, Roland Bartrop, Dirk Bogarde, John Cairney, Cyril Cusack, George Eugeniou, Takis Frangofinos, Marius Goring, Michael Gough, John Houseman, Phyllia Houseman, Christopher Lee, Andreas Malandrinos, David McCallum, Theo Moreas, Wolfe Morris, David Oxley, Laurence Payne, Christopher Rhodes, Paul Stassino, Brian Worth.

During World War II, a team of British officers and local partisans kidnap a German general from under the very nose of his own army on the occupied island of Crete. Once they have him, they have to get him back to Cairo, all the while dodging an intense air and land search.

The film is based on a true story and a book by W. Stanley Moss, *Ill Met by Moonlight* (London: Sphere, 1968).

MISTAKE

- The fully illuminated side of the moon always points toward the sun, but when we first see the moon at night, the illuminated side is higher.

IMITATION GENERAL

Metro-Goldwyn-Mayer, 1958, b&w, 88 minutes.

Producer: William B. Hawks; **Director:** George Marshall; **Screenwriter:** William Bowers; **Distributor:** Metro-Goldwyn-Mayer; **Cast:** Tige Andrews, Red Buttons, Taina Elg, Glenn Ford, Dean Jones, Kent Smith, Ralph Votrian, John Wilder.

Glenn Ford plays a sergeant who impersonates his fallen general, boosting the morale of his troops in France in 1944. As the general tells Ford before he dies, it inspires the men to see a general fighting with the soldiers in the field. There is one soldier (Tige Andrews) who knows that Ford is a sergeant, not a general. As a result Ford has to constantly invent ways to avoid him. As a fake general (he puts on the helmet with the star), Ford inspires the men, and together they stop the Nazi advance.

INTERESTING FACTS

- Impersonating a superior officer is a serious offense under Article 134 of the Uniform Code of Military Justice, and that's what Glenn Ford does, despite repeated warnings from his friend Red Buttons that they are going to be shot for what they are doing.
- At one point, an observant soldier notices that Glenn Ford, while he is wearing a general's helmet, also has sergeant's stripes on his field jacket. This requires Ford, with the help of his sidekick Red Buttons, to launch into a lengthy and ridiculous explanation. This same situation was later played for laughs in an episode of TV's *M*A*S*H*.

MILITARY SERVICE

- Glenn Ford enlisted in the U.S. Marine Corps during World War II and became a photographic specialist. Despite printed statements that Ford served with the OSS or liberated Dachau, he actually spent the entire war in the United States. In 1958, he enlisted in the naval reserves, and was commissioned a lieutenant commander. He served as a public relations officer for the 11th Naval District and was ultimately promoted to captain. During the Vietnam War, he served for a month in a forward combat area. He advised marine combat camera teams filming a marine corps documentary in the Mekong Delta. For his actions he was awarded the Navy Commendation Medal and was decorated with the Vietnamese Legion of Merit First Class by Premier Nguyen Cao Ky.

IMMORTAL SERGEANT

20th Century-Fox, 1943, b&w, 91 minutes.

Producer: Lamar Trotti; **Director:** John M. Stahl; **Screenwriters:** John Brophy, Lamar Trotti; **Music:** David Buttolph; **Cast:** John Banner, Wilson Benge, Gordon Clark, Melville Cooper, James Craven, Italia DeNubila, Bramwell Fletcher, Henry Fonda, Reginald Gardiner, Bud Geary, Frederick Giermann, Henry Guttman, Charles Irwin, Allyn Joslyn, Guy Kingsford, Peter Lawford, Robert Lowery, Morton Lowry, Anthony Marsh, Bob Mascagno, John Meredith, Thomas Mitchell, Hans von Morhart, Maureen O'Hara, Donald Stuart, David Thursby, Leslie Vincent, Sam Waagenaar, John Whitney, Eric Wilton.

Henry Fonda is a Canadian corporal fighting in the Libyan desert against the Germans. He must take command of their patrol after his sergeant and mentor, a veteran of World War I, is killed. With his "Immortal Sergeant" as inspiration, he is able to get the remnants of the unit back to their own lines, blowing up a German camp along the way.

The movie is based on John Brophy's *Immortal Sergeant* (New York: Harper, 1942).

IMPOSTOR, THE

Universal Pictures, 1944, b&w, 92 minutes.

Producer: Julien Duvivier; **Director:** Julien Duvivier; **Screenwriters:** Marc Connelly, Julien Duvivier; **Cast:** Warren Ashe, Peter Cookson, William B. Davidson, Ellen Drew, Peter van Eyck, John Forrest, Jean Gabin, George Irving, Allyn Joslyn, Fritz Leiber, Charles McGraw, Dennis Moore, Ralph Morgan, John Philliber, John Qualen, Eddie Quillan, Grandon Rhodes, Milburn Stone, Ernest Whitman, Richard Whorf, Frank Wilcox, Ian Wolfe.

During World War II, a patriotic French criminal escapes from prison during an air raid, steals a uniform off a dead soldier, and distinguishes himself in a battle with the Italians in the North African desert. When he tells his superiors in the Free French army that he is really an escaped prisoner, he is broken in rank. In a subsequent battle, he once again distinguishes himself, this time by attacking a machine-gun nest and saving his battalion.

INCHON

One Way Productions, 1982, color, 140 minutes.

Producers: Mitsuhari Ishii, Sun Myung Moon; **Director:** Terence Young; **Screenwriters:** Laird Koenig, Robin Moore, Paul Savage; **Music:** Jerry Goldsmith; **Distributor:** Metro-Goldwyn-Mayer; **Filmed at:** Inchon, South Korea; **Cast:** Jacqueline Bisset, Peter Burton, Anthony Dawson, Gabriele Ferzetti, Ben Gazzara, Dorothy James, David Janssen, Karen Kahn, Mickey Knox, Nakhoon Lee, Lydia Lei, Toshiro Mifune, Rion Morgan, Laurence Olivier, John Pochna, Rex Reed, Richard Roundtree, Sabine Sun, James T. Goto, Nam Goon Won, Kwang Nam Young.

General Douglas MacArthur (Laurence Olivier) is the mastermind behind the brilliant and successful invasion of Inchon during the Korean War.

INTERESTING FACTS

- The recreation of the Inchon lighthouse was destroyed by a typhoon during filming and had to be rebuilt.
- The climactic scene of the fleet coming into harbor had to be reshot, at an expense of several million dollars, when an assistant director misinterpreted his instructions and ordered the ships to head out of camera range.
- The film was cofinanced by the Rev. Sung Myung Moon's Unification Church, which explains the emphasis on religion in the film.

IN ENEMY COUNTRY

Universal Pictures, 1968, color, 107 minutes.

Producer: Harry Keller; **Director:** Harry Keller; **Screenwriters:** Edward Anhalt, Sy Bartlett; **Music:** William Lava; **Distributor:** Universal Pictures; **Cast:** Tige Andrews, Ivor Barry, Tom Bell, Lee Berger, Paul Busch, Virginia Christine, Anjanette Comer, Michael Constantine, Jim Creech, Gene Dynarski, Anthony Franciosa, Émile Genest, Mischa Hausserman, Paul Hubschmid, Patric Knowles, Harry Landers, John Marley, Murray Matheson, Gerald Michenaud, Norbert Schiller, Simon Scott, Milton Selzer, Guy Stockwell, Harry Townes.

A team of special agents—including Tony Franciosa, a French intelligence officer; Guy Stockwell, an American air force officer; Tom Bell, a British explosives expert;

and Anjanette Comer, a French spy—join forces with the French underground to learn the secret of a new Nazi torpedo. They get into the secret German torpedo plant, steal one of the torpedoes to take back to England for analysis, and then call in an Allied air strike to destroy the factory.

INFORMER, THE

RKO Radio Pictures Inc., 1935, b&w, 91 minutes.

Producers: John Ford, Cliff Reid (associate producer); **Director:** John Ford; **Screenwriters:** Dudley Nichols, Liam O'Flaherty (novel); **Music:** Max Steiner; **Distributor:** RKO Pictures; **Cast:** Heather Angel, May Boley, Ward Bond, Barlowe Borland, Eddy Chandler, Clyde Cook, D'Arcy Corrigan, Neil Fitzgerald, Wallace Ford, Francis Ford, Preston Foster, Margot Grahame, Frank Hagney, Grizelda Harvey, Robert Homans, Cornelius Keefe, J. M. Kerrigan, Frank Marlowe, Leo McCabe, Arthur McLaglen, Victor McLaglen, Donald Meek, Frank Moran, Pat Moriarity, Jack Mulhall, Una O'Connor, Denis O'Dea, Anne O'Neal, Robert Parrish, Steve Pendleton, Bob Perry, Joe Sawyer, Pat Somerset, Harry Tenbrook.

In 1922 Dublin, Victor McLaglen is in desperate need of money. When he discovers that his equally destitute sweetheart has been reduced to prostitution, he succumbs to temptation and betrays an IRA comrade, who is wanted by the British, for the reward. Not too bright and wracked with guilt, he immediately begins wildly spending the money, giving himself away as the traitor. In the course of one gloomy, foggy night, retribution inexorably closes in on him. He is caught and tried by the IRA, escapes, and is ultimately tracked down and mortally wounded.

The film is based on Liam O'Flaherty's *The Informer* (New York: Knopf, 1925).

INTERESTING FACTS

- The £20 reward given to Victor McLaglen for his betrayal is a reference to the 30 pieces of silver that Judas was paid for betraying Jesus. Director John Ford uses other religious references in the film, and McLaglen ultimately dies in a church. This is an appropriate backdrop for a conflict that is ultimately a religious war, between the protestant British rulers and the Catholic IRA insurgents.
- Since its original release, the UK prints of this film have omitted all references to the IRA, but a 1998 release on a budget video label restores these cuts for the first time.

AWARDS

Academy Awards, USA, 1935
 Won: *Oscar, Best Actor,* Victor McLaglen; *Best Director,* John Ford; *Best Music Score,* Max Steiner (also head of department); *Best Writing, Screenplay,* Dudley Nichols
 Nominated: *Oscar, Best Film Editing,* George Hively; *Best Picture*

National Board of Review, USA, 1935
 Won: *NBR Award, Best Picture*

New York Film Critics Circle Awards, 1935
 Won: *NYFCC Award, Best Director,* John Ford; *Best Film*

Venice Film Festival, 1935
 Nominated: *Mussolini Cup*—John Ford.

IN HARM'S WAY

Paramount Pictures, Sigma Productions, 1965, b&w, 165 minutes.

Producer: Otto Preminger; **Director:** Otto Preminger; **Screenwriters:** James Bassett, Wendell Mayes; **Music:** Jerry Goldsmith; **Distributor:** Paramount Pictures; **Filmed in:** Hawaii; **Cast:** Dana Andrews, Tod Andrews, Barbara Bouchet, Bruce Cabot, Dort Clark, Brandon De Wilde, Kirk Douglas, Henry Fonda, Christopher George, Jerry Goldsmith, Larry Hagman, Christian Haren, Jill Haworth, Stanley Holloway, George Kennedy, Richard LePore, Phil Mattingly, Don McCurry, Burgess Meredith, James Mitchum, Stewart Moss, Patricia Neal, Hugh O'Brian, Carroll O'Connor, Patrick O'Neal, Slim Pickens, Paula Prentiss, Chet Stratton, Franchot Tone, Tom Tryon, John Wayne, Soo Yong.

Capt. Rockwell Torrey (John Wayne) and Cmdr. Paul Eddington (Kirk Douglas), after weathering the Japanese sneak attack at Pearl Harbor, help lead the navy's island-hopping campaign across the Pacific. Torrey is romantically involved with nurse Maggie Haynes (Patricia Neal), while at the same time trying to restore his relationship with his estranged son, a young naval officer. To make the romantic entanglements even more complex, his son is in love with a young nurse, also being pursued by Kirk Douglas, whose unfaithful wife died in the Pearl Harbor attack. These human dramas play out against a backdrop of the war as the navy engages the Japanese at sea and the para-marines fight them on land.

In Harm's Way (PARAMOUNT PICTURES/AUTHOR'S COLLECTION)

The film is based on James Bassett's *Harm's Way* (Cleveland: World Pub. Co., 1962).

INTERESTING FACTS

- The *St. Louis* was the only capital ship to clear the harbor during the Pearl Harbor attack.
- The naval battle sequences were done with models that were so large in scale (for the sake of greater detail) that they could be operated from the inside.
- The title *In Harm's Way* derives from a quote by John Paul Jones, the Revolutionary War naval hero: "I wish to have no connection with any ship that does not sail fast, for I intend to go in harm's way."

MILITARY SERVICE

- Kirk Douglas enlisted in the U.S. Navy, was sent to OCS, and was commissioned an ensign on February 27, 1943. He was assigned as a communications officer in an antisubmarine unit aboard Patrol Craft #1139, a submarine chaser stationed in Algiers. He was injured by the premature detonation of a depth charge on February 24, 1944, which resulted in internal injuries, and after five months in the hospital, he received a medical discharge.

MISTAKE

- The film shows a U.S. Navy Albatross, not built until after the end of World War II.

AWARDS

Academy Awards, USA, 1965
 Nominated: *Oscar, Best Cinematography, Black and White,* Loyal Griggs

British Academy Awards, 1966
 Won: *BAFTA Film Award, Best Foreign Actress,* Patricia Neal.

IN LOVE AND WAR

20th Century-Fox, Jerry Wald Productions, 1958, color, 111 minutes.

Producer: Jerry Wald; **Director:** Philip Dunne; **Screenwriters:** Edward Anhalt, Anton Myrer; **Music:** Hugo Friedhofer; **Distributor:** 20th Century-Fox Film Corporation; **Filmed at:** Monterey, Oakland, Stanford University in Palo Alto and San Francisco, all in California; **Cast:** Edith Barrett, James Bell, Sebastian Cabot, Tap Canutt, Veronica Cartwright, Buck Class, Paul Comi, Brian Corcoran, Bradford Dillman, Joe Di Reda, Steven Gant, Jeffrey Hunter, Hope Lange, Nelson Leigh, Frank Murphy, Sheree North, France Nuyen, Mary Patton, Mort Sahl, Harvey Stephens, Murvyn Vye, Robert Wagner, Dana Wynter.

Three marines take shore leave in San Francisco during World War II: Robert Wagner is from a dysfunctional lower-class family, Jeffrey Hunter has a pregnant fiancée (Hope Lange), and the upper-class intellectual Bradford Dillman discovers that his fiancée has become a high-living, hard-drinking party girl. Wagner drowns his troubles in alcohol; Hunter marries his fiancée but realizes he may not survive the war to see his child; Dillman sheds his decadent girlfriend for a pure-hearted Hawaiian nurse. Sent into combat, Jeffrey Hunter is killed knocking out an enemy tank. Robert Wagner, previously a coward, saves a fellow marine and is decorated for bravery. Brad Dillman becomes increasingly disillusioned by the war. Returning home, Robert Wagner visits Hope Lange and tells her of her husband's death; there is a possibility that he will continue to take care of her.

The film is based on Anton Myrer's *The Big War* (New York: Appleton-Century-Crofts, 1957).

QUOTE

Mort Sahl [answering the army field telephone]: Good morning, World War II.

IN LOVE AND WAR

Dimitri Villard Productions, New Line Cinema, 1997, color, 115 minutes.

Producers: Richard Attenborough, Janis Rothbard Chaskin, Diana Hawkins, Chris Kenny, Sara Risher, Dimitri Villard; **Director:** Richard Attenborough; **Screenwriters:** James Nagel, Anna Hamilton Phelan, Allan Scott, Clancy Sigal, Dimitri Villard, Henry S. Villard; **Music:** George Fenton, Giuseppe Verdi; **Distributors:** New Line Cinema, Warner Bros.; **Filmed in:** Italy, Québec, and Mineola, Long Island, New York; **Cast:** MacKenzie Astin, Rodger Barton, Alan Bennett, Richard Blackburn, Giuseppe Bonato, Emilio Bonucci, Lauren Booth, Nick Brooks, Sandra Bullock, Kaethe Cherney, Rebecca Craig, Carlo Croccolo, Todd Curran, Allegra Di Carpegna, Valeria Fabbri, Gil Filar, Richard Fitzpatrick, Colin Fox, Roseline Garland, Tom Goodman-Hill, Kay Hawtrey, Tracy Hostmyer, Tara Hugo, Ian Kelly, Ingrid Lacey, Philippe Leroy, Bruce Lidington, Joseph Long, Bruno Majean, Doreen Mantle, Laura Martelli, Tim McDonnell, Laura Nardi, Vincenzo Nicoli, Chris O'Donnell, Wendi Peters, Maria Petrucci, Reno Porcaro, Rocco Quarzell, Mindy Lee Raskin, Noah Reid, Vincenzo Ricotta, Frances Riddelle, Quinto Rolman, Milan Rosandic, George Rossi, Terence Sach, Avery Saltzman, Matthew Sharp, Evan Smirnow, Margot Steinberg, Colin Stinton, Sam Stone, Cyril Taylor, Raph Taylor, Gigi Vivan, Diane Witter, Grahame Wood.

Chris O'Donnell portrays Ernest Hemingway during his time as an ambulance driver in Italy during World War I. When he is injured in the line of duty, he ends up in a hospital where he falls in love with his nurse, Sandra Bullock.

INTERESTING FACTS

- Several scenes were filmed in or near the Italian village of Vittorio Veneto, including the battle scenes. Many of the extras playing the soldiers in the movie were airmen from the nearby U.S. Air Force base at Aviano who volunteered to be in the movie.
- Comparable to this film are two filmed versions of *A FAREWELL TO ARMS*, films based on Ernest Hemingway's novel of the same name, which the author based on his experiences as an ambulance driver during World War I.

IN OUR TIME

Warner Bros., 1944, b&w, 110 minutes.

Producer: Jerry Wald; **Director:** Vincent Sherman; **Screenwriters:** Howard Koch, Ellis St. Joseph; **Music:** Mario Castelnuovo-Tedesco, Franz Waxman; **Cast:** Alex Akimoff, Lotte Palfi Andor, Sylvia Arslan, John Bleifer, Mary Boland, Michael Chekhov, Nancy Coleman, Gino Corrado, Victor Francen, Mici Goty, Paul Henreid, Mary Landa, Sonia Lefkova, Ida Lupino,

Alla Nazimova, Ryszard Ordynski, Frank Reicher, Shimen Ruskin, Hector Sarno, Leonid Snegoff, Ivan Triesault, Michael Visaroff, Max Willenz, Marek Windheim, Wolfgang Zilzer.

In early 1939, Ida Lupino goes to Poland to buy antiques for her business in London. She meets Paul Henreid, an aristocratic count. They marry, but over the objections of his class-conscious family. Together they modernize his family farm with equipment such as tractors and increase production, only to be faced by the German blitzkrieg into Poland. They set fire to their fields to leave the enemy nothing, knowing that one day they will return to their land and that it will bloom again.

INTERESTING FACTS

- After the WB (Warner Bros.) logo appears at the end of the movie, the letters W and B are separated and letters added to form the words "Buy War Bonds."
- While World War I gave European class distinctions a hard kick in the teeth, World War II was the coup de grâce. This film reflects that final breakdown of the class system.

INTERNATIONAL SQUADRON

Warner Bros., 1941, b&w, 85 minutes.

Directors: Lothar Mendes, Lewis Seiler; **Screenwriters:** Kenneth Gamet, Barry Trivers, Frank Wead; **Music:** William Lava; **Cast:** Jean Ames, Tod Andrews, Frank Baker, Julie Bishop, Olympe Bradna, Sonny Bupp, Shirley Coates, Eddie Conrad, Helmut Dantine, Leslie Denison, Reginald Denny, Ann Edmonds, Cliff Edwards, Frank Faylen, Gerald Gavin, Frederick Giermann, Brenda Henderson, Holmes Herbert, Leyland Hodgson, William Hopper, Hugh Huntley, Charles Irwin, Selmer Jackson, Crauford Kent, Knud Kreuger, Marten Lamont, Ernest Lennart, Harry Lewis, Doris Lloyd, William Lundigan, John Meredith, Ivan Molnar, Ottola Nesmith, Pat O'Hara, Joan Perry, Ronald Reagan, Addison Richards, John Ridgely, Henry Rowland, Tom Skinner, James Stephenson, Tom Stevenson, Cyril Thornton, David Thursby, Richard Travis, Marjorie Whatley.

Ronald Reagan is a no-account ferry pilot running Lockheeds across the Atlantic to England during World War II, whose reckless attitude is responsible for the deaths of two other pilots. He joins the Royal Air Force and finds redemption by destroying a German munitions dump in France, although he is killed in accomplishing the mission.

IN THE ARMY NOW

Hollywood Pictures, 1994, color, 91 minutes.

Producers: Nicholas Hassitt, Michael Rotenberg, Cyrus I. Yavneh; **Director:** Daniel Petrie Jr.; **Screenwriters:** Fax Bahr, Jeff Buhai, Robbie Fox, Ken Kaufman, Stu Krieger, Daniel Petrie Jr., Adam Small, Steve Zacharias; **Music:** Robert Folk; **Distributor:** Buena Vista Pictures; **Filmed at:** Imperial County, California, Fort Sill, Oklahoma; **Cast:** Richard Assad, Beau Billingslea, Coleen Christie, Keith Coogan, Ryan Cutrona, Andy Dick, Christopher B. Duncan, Brian Fenwick, Kirk Fox, Brendan Fraser, David Alan Grier, Anthony H. Humphreys, Howard J. von Kaenel, Kenneth O. Kilgo, Art LaFleur, John Larsen, Vincent Marotta, Paul Mooney, Esai Morales, Glenn Morshower, Earl M. Nicholson, Barry Nolan, Daniel Petrie Jr., Lori Petty, Maurice Sherbanee, Pauly Shore, Justin Simons, Peter Spellos, Allen R. Stokes, Daniel C. Striepeke, Fabiana Udenio, Tom Villard, Matthew Walker, Lynn Whitfield, Carlton Wilborn, Dan Wolfe, Derek C. Zackery.

Two misguided youths (Pauly Shore and Andy Dick) join the army reserve to make some money after they are fired from their jobs at an electronics store. Trained as water purification specialists, no sooner have they finished basic training than are they called up to do their part to save the free world in the Gulf War. They get lost in the desert, and soon they are in combat, blowing up a vital Iraqi base in the desert.

INTERESTING FACTS

- This film was loosely based on an actual historical incident. There really was an army reserve water purification unit in Southern California that was mobilized for the Gulf War. Because Europe and Korea both have abundant natural water supplies, the unit was firmly convinced it was never going to be called up. The chances of a desert war, it believed, were a million to one.
- Link was played by Brendan Fraser, who played a character with the same name in *Encino Man* (1992).

QUOTE

One of the water purification specialists: Dude, this is gonna be so easy, my brother was a pool boy. . . . All we gotta do is make dirty water clean. And even

if there's a big war, what are we gonna make . . . *water balloons*!

IN THE MEANTIME, DARLING

20th Century-Fox, 1944, b&w, 72 minutes.

Producer: Otto Preminger; **Director:** Otto Preminger; **Screenwriters:** Arthur Kober, Michael Uris; **Cast:** Eddie Acuff, Heather Angel, Bonnie Bannon, Lee Bennett, Lillian Bronson, Janet Burston, Cliff Clark, Roger Clark, Ruth Clifford, William Colby, Ann Corcoran, Jeanne Crain, Marvin Davis, Blake Edwards, Reed Hadley, Paul Harvey, Don Hayden, Charles Hayes, Olin Howlin, Milton Kibbee, Glenn Langan, Frank Latimore, Lee March, Mae Marsh, Marjorie Massow, Mary McCarty, Frank McClure, Doris Merrick, Evelyn Mulhall, Clarence Muse, Mary Nash, Eugene Pallette, Stanley Prager, B. S. Pulley, Jane Randolph, Elisabeth Risdon, Gale Robbins, Merrill Rodin, Sonny Tufts, Geraldine Wall, Frank Wilcox, Cara Williams.

A young bride from a rich family has a hard time adjusting to life in a boardinghouse with other soldiers and their wives. Her spoiled ways cause resentment from the other wives and problems with her husband.

IN WHICH WE SERVE

Two Cities Films Ltd., British Lion Film Corporation, 1942, b&w, 115 minutes.

Producers: Noel Coward, Anthony Havelock-Allan; **Directors:** Noel Coward, David Lean; **Screenwriter:** Noel Coward; **Music:** Noel Coward; **Distributor:** United Artists; **Cast:** Mickey Anderson, Richard Attenborough, Franklyn Bennett, Ballard Berkeley, John Boxer, Chimmo Branson, Joyce Carey, George Carney, Kenneth Carten, Gerald Case, Charles Compton, Noel Coward, James Donald, Penelope Dudley-Ward, Leslie Dwyer, Derek Elphinstone, Kenneth Evans, Walter Fitzgerald, Philip Friend, Everley Gregg, Hubert Gregg, Dora Gregory, Lionel Grose, Kathleen Harrison, Geoffrey Hibbert, Leslie Howard, Roddy Hughes, Celia Johnson, Daniel Massey, Bernard Miles, John Mills, Juliet Mills, Robert Moreton, Lesley Osmond, Wally Patch, Eileen Peel, Norman Pierce, Frederick Piper, Charles Russell, Robert Sansom, Trixy Scales, Johnnie Schofield, John Singer, Ann Stephens, Jill Stephens, John Varley, Kay Walsh, Barbara Waring, Caven Watson, Josie Welford, Michael Whittaker, Michael Wilding, Kay Young.

This "life story of a ship," the British destroyer HMS *Torrin*, is told in flashbacks by survivors as they cling to a life raft.

INTERESTING FACTS

- The Hays Office tried to delete the words *God*, *hell*, *damn*, and *bastard* from the American release. Uproar from England forced the office to back down on everything except *bastard*.
- This film is David Lean's first directing credit.
- This is the film debut of Celia Johnson, Richard Attenborough, young Daniel Massey, and infant Juliet Mills.

AWARD

Written, codirected, and scored by costar Noel Coward, who was given a special Oscar "for his outstanding production achievement."

IRON EAGLE

TriStar Pictures, 1986, color, 117 minutes.

Producers: Kevin Elders, Lou Lenart, Ron Samuels, Joe Wizan; **Director:** Sidney J. Furie; **Screenwriters:** Kevin Elders, Sidney J. Furie; **Music:** John Deacon, Brian May, Freddie Mercury, Basil Poledouris, Roger Taylor; **Cast:** Michael Alldredge, Tony Becker, Debbie Bloch, Michael Bowen, Christopher Bradley, Jacque Lynn Colton, Kevin Elders, Jay Footlik, Tom Fridley, Rob Garrison, Uri Gavriel, Jason Gedrick, Louis Gossett Jr., David Greenlee, Heather Haase, Melora Hardin, Jerry Hyman, Bobby Jacoby, Will Jeffries, Michael Kehoe, Kevin King, Caroline Lagerfelt, Lance LeGault, Jerry Levine, David Menachem, Roger Nolan, F. William Parker, Steve Rabin, Paul O'Brien Richards, Robbie Rist, Albert R. Schara, Larry B. Scott, Joseph Shiloach, Shawnee Smith, David Suchet, Max Thayer, Tim Thomerson, Kathy Wagner, David Ward, Chino Williams, Terry Wills, Arnon Zadok.

When a young man's father, an air force pilot, is shot down by MIGs belonging to a radical Middle East state, the son is determined to rescue his father. He finds Lou Gossett Jr., an air force colonel who is intrigued by the son's idea of stealing an F-16 and using it for the rescue.

MISTAKES

- The cockpit and controls of a real F-16 are nothing like they appear in this movie.
- In the opening scenes, the F-16s keep switching from single-seat versions to two-seat trainers. They keep losing their wing fuel tanks, and they keep switching the type of weapons.
- Mac is supposedly adjusting the carburetor on a Cessna 150 through the top access hatch, but it is only accessible from underneath.
- The plane's flaps are clearly at least 20 degrees down, showing that the aircraft is being deliberately slowed to avoid overtaking the motorcycle.
- The MIGs flown by the enemy are Israeli Kfir fighter planes.
- When Doug lands after dropping the Hades bomb, it can still be seen hanging under his aircraft.
- The F-16's Vulcan cannon does not have a lock.
- The brief aerial view of the oil refinery actually shows a sewage plant.
- When the enemy planes explode, they are clearly wooden models that splinter rather than fragment, as metal would.
- When Doug's dad is chewing him out, Doug says, "Come on, Dad!" His dad, obviously meaning to say "Don't 'come on Dad' me!" answers instead with "Don't come on me Dad!"
- Several enlisted personnel, including Hazel the administrative sergeant and the maintenance supervisor in the hangar, are grossly beyond air force body fat standards.
- Many of the external shots of the aircraft during flight clearly show that these are remote-controlled scale models. This is evident by the jumpy flight characteristics. Full-size aircraft do not behave in such an erratic manner.

IRON EAGLE II

Carolco Pictures, Harkot Productions, Alliance Entertainment, 1988, color, 105 minutes.

Producers: Asher Gat, Andras Hamori, Sharon Harel, John Kemeny, Jacob Kotzky, Stephane Reichel; **Director:** Sidney J. Furie; **Screenwriters:** Kevin Elders, Sidney J. Furie; **Music:** Amin Bhatia; **Filmed in:** Israel; **Cast:** Jason Blicker, Sharon Brandon, Maury Chaykin, Jesse Collins, Nicolas Coucos, Colm Feore, Uri Gavriel, Louis Gossett Jr., Mark Humphrey, Jery Hyman, Mark Ivanir, Clark Johnson, Janine Manatis, Stuart Margolin, Neil Munro, Azaria Rapaport, Gary Reineke, Michael J. Reynolds, Alan Scarfe, Douglas Sheldon.

Louis Gossett puts together a mixed Soviet and U.S. force to perform a surgical strike on a massively defended nuclear missile site in the Middle East. Gossett learns that he has two problems: Someone in the Pentagon is actively sabotaging his mission, and a nuclear strike has been ordered should they fail, which will hit his forces at the airfield, at ground zero.

MISTAKES

- The MIGs flown by the Soviets during the final assault are actually U.S. F-4 aircraft.
- When the two planes move to intercept, he identifies them as MIG-29s. However, these two planes (as well as two others seen later) are actually F-4 Phantoms.

QUOTES

Graves: Hey, Downs, what do you do for a living?
Downs: I blow up things, especially people. Bend over, captain, I'll give you a demonstration.

Sinclair: Those fools in the tower know exactly what they're doing, which is more than I can say for you bunch of idiots.

IRON EAGLE IV

Trimark Pictures, Norstar Entertainment Inc., 1995, color, 96 minutes.

Producers: Mark Amin, Joseph Newton Cohen, Peter R. Simpson; **Director:** Sidney J. Furie; **Screenwriters:** Joel Chernoff, Michael Stokes; **Music:** Paul Zaza; **Distributors:** Norstar Entertainment Inc., Trimark Pictures; **Filmed at:** Oshawa, Ontario, Canada; **Cast:** Rachel Blanchard, Jason Blicker, Jason Cadieux, Matt Cooke, Aidan Devine, David Fraser, Karen Gayle, Matthew Godfrey, Louis Gossett Jr., David Hemblen, Kevin Hicks, Ross Hull, Amy E. Jacobson, Chas Lawther, Ron Lea, Marilyn Lightstone, Anne Marie Loder, Sean McCann, Dean McDermott, Brad Milne, Jack Nicholsen, Miklos Perlus, Max Piersig, Jeff Pustil, Rino Romano, Victoria Snow, Joanne Vannicola, Al Waxman, Dominic Zamprogna.

When Louis Gossett Jr. is saddled with a bunch of misfits and delinquents at his flight school, he turns to his protégé Jason Cadieux to help him get them into shape for an important competition. However, more critical than the competition is a group of subversive air force officers who are dealing in toxic waste.

IRON TRIANGLE, THE

Scotti Brothers Pictures, 1989, color, 91 minutes.

Producers: John A. Bushelman, Angela P. Schapiro, Ben Scotti, Fred Scotti, Tony Scotti; **Director:** Eric Weston; **Screenwriters:** John A. Bushelman, Larry Hilbrand, Eric Weston; **Filmed at:** Openshaw, Manchester, England; **Cast:** Iilana B'tiste, Beau Bridges, François Chau, Glen Chin, Johnny Hallyday, Jim Ishida, Bobby McGee, Allan Moore, Haing S. Ngor, Jack Ong, Joe Seely, Sophie Trang, Arsenio Trinidad, Richard Weygint, Liem Whatley, Ping Wu.

Whatley is a Vietcong soldier who captures American captain Beau Bridges. Because Bridges did not kill Whatley when he had the chance, a bond begins to build between them as the Vietcong soldier treks his prisoner north to prison. Ultimately, the Vietcong soldier just melts into the jungle, leaving his captive free to return home.

INTERESTING FACT

- This film was based on the diary of a real Vietcong soldier.

QUOTE

Beau Bridges: We couldn't have been more different . . . but maybe we couldn't have been more alike.

IS PARIS BURNING?

Marianne Productions, Seven Arts Productions, Transcontinental Films, 1966, color and b&w, 133 minutes.

Producer: Paul Graetz; **Director:** René Clément; **Screenwriters:** Larry Collins (book), Dominique Lapierre (book), Gore Vidal, Francis Ford Coppola, Marcel Moussy (additional material for French scenes), Beate von Molo (additional material for German scenes); **Music:** Maurice Jarre; **Distributor:** Paramount; **Filmed at:** Paris, France; **Cast:** Karl-Otto Alberty, Jean-Paul Belmondo, Michel Berger, Georges Bidault, Gerhard Bormann, Charles Boyer, Colette Brosset, Georges Béreux, Leslie Caron, Jean-Pierre Cassel, George Chakiris, Georges Claisse, Pierre Collet, Paul Crauchet, Bruno Cremer, Claude Dauphin, Suzy Delair, Alain Delon, Kirk Douglas, Pierre Dux, Doc Erickson, Michel Etcheverry, Pascal Fardoulis, Glenn Ford, Germaine de France, Bernard Fresson, Billy Frick, Gert Fröbe, Ernst Fritz Fürbringer, Clara Gansard, Charles de Gaulle, Konrad Georg, Michel Gonzalès, Daniel Gélin, Georges Géret, Joachim Hansen, Claus Holm, Jean-Pierre Honoré, Peter Jacob, Billy Kearns, Pierre Koenig, Hubert de Lapparent, Joëlle LaTour, Jacques Leclerc, Michael Lonsdale, Roger Lumont, Maria Machado, Aimé de March, E. G. Marshall, Félix Marten, Paloma Matta, Günter Meisner, Hannes Messemer, Harry Meyen, Pierre Mirat, Yves Montand, Francis Nani, Del Negro, Jean Négroni, Peter Neusser, Alexandre Parodi, Anthony Perkins, Michel Piccoli, Sascha Pitoëff, Sébastien Poitrenaud, Georges Poujouly, Wolfgang Preiss, Michel Puterflam, Albert Rémy, Claude Rich, Christian Rode, Serge Rousseau, Jean-Michel Rouzière, Michel Sardou, Helmuth Schneider, Simone Signoret, Robert Stack, Georges Staquet, Otto Stern, Hénia Suchar, Tony Taffin, Jean-Louis Trintignant, Yves le Trocquer, Jean Valmont, Pierre Vaneck, Claude Vernier, Marie Versini, Skip Ward, Joe Warfield, Orson Welles, Dominique Zardi, Jean-Pierre Zola.

As the Allies advance on Paris during World War II, various French Resistance factions fight to regain Paris from the Germans, who control the city. The Nazi general in charge of the city (Gert Fröbe) is under direct orders from Hitler to burn the city rather than let it fall to the advancing Allied troops. As the Resistance fighters gradually take over the city, the German general decides not to destroy it but to let it fall intact to the liberators.

The film is the true story of the last days before the liberation of Paris. Adolf Hitler sent one of his most trusted generals, Dietrich von Choltitz, to destroy Paris. In a remarkable act of courage, he disobeyed repeated direct orders from the Fuhrer to destroy the city, because he believed that burning it would serve no useful military purpose. Had the general fallen back into Nazi hands, Hitler would certainly have had him shot for his flagrant disobedience of a direct order.

The film is based on Larry Collins and Dominique Lapierre's book.

INTERESTING FACTS

- The title of the film comes from the incessant telephone calls made by Adolf Hitler to his general in Paris, which always started with the phrase "Is Paris burning?"
- Notice the mascot names of the tanks in General Leclerc's Free French armored division. Many had Spanish names such as "Madrid," "Teruel," and "Zaragosa," and were manned by anti-Fascist Spanish refugee fighters, who played an important yet mostly unacknowledged part in the liberation.

- The film was shot in black and white, which many think was to allow the editing the of film with real-life footage. Actually, the main reason for the black and white was the Nazi flags. The French authorities refused to allow the movie company to fly red-and-black Nazi flags in Paris. They would agree only to black-and-gray versions of the Nazi swastika flag, which looked authentic when filmed in black and white.
- Gert Fröbe, the actor who played the German general in charge of destroying Paris, is better known to film audiences as James Bond's Goldfinger.
- The short vignettes of characters who appear in the film only for a few minutes are all based on true stories of real-life Resistance fighters.
- There were so many different Resistance factions operating in Paris at the time of the liberation that it is difficult to keep them straight while watching the movie. Reading Larry Collins and Dominique Lapierre's *Is Paris Burning* (New York: Simon and Schister, 1965) gives you a much better perspective on the part each faction played in the liberation.
- The French and German dialogue was dubbed in English, and many of the actors did their own English dubbing.

AWARDS

Academy Awards, USA, 1966
 Nominated: *Oscar, Best Art Direction–Set Decoration, Black-and-White*, Marc Frédérix, Pierre Guffroy, Willy Holt; *Best Cinematography, Black-and-White*, Marcel Grignon

Golden Globes, USA, 1967
 Nominated: *Golden Globe, Best Original Score*, Maurice Jarre.

IT'S IN THE AIR

A.T.P. Studios Ltd., 1938, b&w, 74 minutes.

Producers: Basil Dean, Jack Kitchin; **Director:** Anthony Kimmins; **Screenwriter:** Anthony Kimmins; **Music:** Fred E. Cliffe, George Formby, Harry Gifford; **Distributor:** Associated British Film Distributors; **Cast:** Esma Cannon, O. B. Clarence, Joe Cunningham, George Formby, Hal Gordon, Jack Hobbs, Frank Leighton, Eliot Makeham, Garry Marsh, Jack Melford, Julien Mitchell, Michael Shepley, Ilena Sylva, Polly Ward, C. Denier Warren.

George Formby is a humble army private mistaken for a dashing RAF pilot.

INTERESTING FACTS

- George is George Formby, the toothy little chappy with the ukulele whose films made oodles of money in the 1930s and 1940s.
- One of the cameramen was future director Ronald Neame.
- The original British title of this musical farce was *George Takes the Air*.

I WAS A MALE WAR BRIDE

20th Century-Fox, 1949, b&w, 103 minutes.

Producer: Sol C. Siegel; **Director:** Howard Hawks; **Screenwriters:** Charles Lederer, Henri Rochard, Leonard Spigelgass, Hagar Wilde; **Music:** Cyril J. Mockridge; **Cast:** André Charlot, Russ Conway, Patricia Cutts, Eugene Gericke, Alex Gerry, Cary Grant, Paul Hardtmuth, Joe Haworth, Gil Herman, Carl Jaffe, Lillie Kann, Harry Lauter, Alfred Linder, Mike Mahoney, Marion Marshall, William McLean, David McMahon, Martin Miller, William Murphy, William Neff, Barbara Perry, Ben Pollock, William Pullen, Otto Reichow, William Self, John Serret, Lester Sharpe, Ann Sheridan, Robert Stevenson, Randy Stuart, Kenneth Tobey, Ruben Wendorf, John Whitney, William Yetter Jr., Kay Young, John Zilly.

Capt. Henri Rochard (Cary Grant) of the French army, and Lt. Catherine Gates (Ann Sheridan) of the WACs, are assigned a mission in which they have to work together to stop a black marketer in postwar Germany. They start out hating each other but end up falling in love. Lieutenant Gates goes to her superiors in the army for permission to get married, and that's the beginning of their bureaucratic hassles. When Catherine's unit gets called back to the states, the only way they can stay together is by invoking a law allowing the spouse of American army personnel to enter the country—the War Brides Act. Zany gender-bending hilarity ensues as Captain Rochard tries to return to America as a war bride, under a law designed for women. Cary Grant dresses up as an army nurse (female) for the sole purpose of getting on the war brides ship. With a horse's mane on his head for hair, and taller than any other nurse in sight, he'd fool only people in a movie.

It's been a long time since World War II, and no one would remember the War Brides Act (which Cary Grant quotes every five minutes in the film) if it weren't for this movie. War brides were a big business for the American military, in both the European and the Asian theaters of war. Send millions of young American men

overseas for four years, and you can bet that a lot of them are going to return with wives—in fact, 120,000 of them. As is evident from the film, it was such a big business that whole military transports were dedicated to getting them to the United States.

QUOTE

Cary Grant constantly quotes the War Brides Act. "Yes," he says, "I'm a war bride, traveling under the authority of the War Brides Act of the United States Congress." "But you're a man," they always say, and his reply is also always the same: "Yes, I know, but nevertheless, I am the spouse of an American serviceman traveling under the authority of the War Brides Act of the United States Congress."

AWARD

Writers Guild of America, USA, 1950
Nominated: *WGA Screen Award, Best Written American Comedy*, Charles Lederer, Leonard Spigelgass, Hagar Wilde.

I WAS AN AMERICAN SPY

Allied Artists Pictures Corporation, 1951, b&w, 85 minutes.

Producer: David Diamond; **Director:** Lesley Selander; **Screenwriters:** Myron B. Goldsmith and Claire Phillips (novel, *Manila Espionage*), Samuel Roeca; **Music:** Arthur Hammerstein (songs), Edward J. Kay, Dudley Wilkinson (songs); **Cast:** Leo Abbey, Philip Ahn, Wong Artarne, Nadine Ashdown, Richard Bartlett, E. Baucin, Lane Bradford, Chabing, Howard Chuman, Kei Thin Chung, Angelo Cruz, John Damler, Ann Dvorak, Gene Evans, Lisa Ferraday, George Fields, Harold Fong, Jerry Fujikawa, Harry Hamada, Bret Hamilton, Gil Herman, Riley Hill, Frank Iwanaga, Remedos Jacobe, Frank Jenks, Douglas Kennedy, Eddie Lee, James B. Leong, Weaver Levy, Sung Li, Leon Lontoc, Richard Loo, Andres Lucas, Celeste Madamba, Marya Marco, Dennis Moore, Toshi Nakaki, Lane Nakano, Fred Revelala, Jack Reynolds, Ed Sojin Jr., William Tannen, William Yip, William Yokota.

After her husband is killed on the Bataan Death March, Ann Dorvak (Claire Phillips) pretends to be Italian, so that she can safely open and run a nightclub in Manila. She uses the club to gather intelligence from the Japanese, which she passes on to Filipino guerrillas. When she is exposed and sentenced to death, she is rescued by her guerrilla friends.

Based on the true-life espionage activities of Claire Phillips during World War II, for which she received the Medal of Freedom. The film is also based on Claire Phillips and Myron B. Goldsmith's, *Manila Espionage* (Portland: Binfords & Mont, 1947).

The theme song is *Because of You*.

I WAS MONTY'S DOUBLE

Associated British Pictures Corporation, 1958, b&w, 100 minutes

Producers: John Palmer, Maxwell Setton; **Director:** John Guillermin; **Screenwriters:** M. E. Clifton-James, Bryan Forbes; **Music:** John Addison; **Distributor:** Associated British-Pathé Limited; **Cast:** Patrick Allen, Alfie Bass, Victor Beaumont, Diana Beaumont, Michael Bell, Steven Berkoff, Douglas Blackwell, David Browning, Max Butterfield, Maureen Connell, Patrick Connor, Allan Cuthbertson, David Davies, Vera Day, John Dunbar, George Eugeniou, Bryan Forbes, Harry Fowler, Eric Francis, Otto Fries, John Gale, Marius Goring, Walter Gotell, Gordon Harris, James Hayter, John G. Heller, Geoffrey Hibbert, Barbara Hicks, Patrick Holt, Michael Hordern, Frederick Jaeger, Sid James, Edward Judd, Sam Kydd, Duncan Lamont, John Le Mesurier, M.E. Lifton-James, David Lodge, Victor Maddern, Marne Maitland, Alfred Maron, John Mills, Bill Nagy, Michael Oliver, MacDonald Parke, Cecil Parker, Leslie Phillips, Desmond Roberts, Anthony Sagar, Martin Shaban, Ronnie Stevens, Ernst Walder, Kenneth J. Warren, Brian Weske, Ronald Wilson.

This incredible but true story of how an actor was recruited and trained to impersonate Field Marshal Montgomery, primarily to mislead the Germans about Monty's campaign in North Africa, is based on M. E. Clifton-James's *I Was Monty's Double* (London: New York: Rider, 1954).

JET ATTACK

Catalina Productions, 1958, b&w, 68 minutes.

Producers: Israel M. Berman, Alex Gordon; **Director:** Edward L. Cahn; **Screenwriters:** Orville H. Hampton, Mark Hanna; **Music:** Ronald Stein; **Distributor**: American International Pictures; **Cast:** John Agar, Nicky Blair, Hal Bogart, Robert Carricart, George Cisar, James Dobson, Madeline Foy, Bob Gilbreath, Joseph Hamilton, Weaver Levy, Stella Lynn, Paul Power, Guy Prescott, Leonard Strong, Audrey Totter, Gregory Walcott, Victor Sen Yung.

John Agar is a jet pilot who is shot down behind enemy lines during the Korean War. He not only manages to evade his captors and escape back to his own lines, but he is also able to rescue a U.S. scientist, flying them both back to their own lines in a captured communist plane.

JOHNNY FRENCHMAN

Ealing Studios, 1945, b&w, 112 minutes.

Producers: Michael Balcon, S. C. Balcon; **Director:** Charles Frend; **Screenwriter:** T. E. B. Clarke; **Music:** Clifton Parker; **Distributors:** Eagle-Lion Film Distributors; **Filmed at:** Mevagissey, Cornwall, England; **Cast:** Grace Arnold, Jean-Marie Balcon, Alfie Bass, Franklyn Bennett, Bill Blewitt, Henri Bollinger, Paul Bonifas, Paul Dupuis, Bernard Fishwick, Judith Furse, Richard George, Louis Gournay, Denver Hall, Arthur Hambling, James Harcourt, Leslie Harcourt, Richard Harrison, George Hirste, Vincent Holman, Charles Jezequel, James Knight, Joseph Menou, Ralph Michael, Jean-Marie Nacry, Carol O'Connor, Stanley Pasken, Frederick Piper, Patricia Roe, Françoise Rosay, John Stone, Herbert Thomas, Beatrice Varley, Tom Walls, Drusilla Wills.

Cornish fishermen have a friendly rivalry with the fishermen (and one formidable woman) from a French port. However, World War II forces them to rethink all of their petty differences.

JOHNNY GOT HIS GUN

Cinemation, 1971, b&w, 111 minutes.

Producers: Bruce Campbell, Tony Monaco, Christopher Trumbo; **Director:** Dalton Trumbo; **Screenwriter:** Dalton Trumbo; **Music:** Jerry Fielding; **Distributor:** Cinemation; **Cast:** Milton Barnes, Don Barry, Timothy Bottoms, Craig Bovia, Peter Brocco, Judy Howard Chaikin, Eric Christmas, Kendell Clarke, Robert Cole, Maurice Dallimore, Robert Easton, Kathy Fields, Larry Fleischman, Eduard Franz, Anthony Geary, Ed Gilbert, Ben Hammer, Lynn Hanratty, Wayne Heffley, Marsha Hunt, Ernestine Johnston,

Joseph Kaufmanm, Mike Lee, Kerry MacLane, Charles McGraw, William Mims, Byron Morrow, Alice Nunn, Marge Redmond, Jason Robards, Jodean Russo, David Soul, Donald Sutherland, Diane Varsi, Peter Virgo Jr., Gigi Vorgan, Jeffrey Walker, Bruce Watson, Margaret Williams, Sandy Brown Wyeth.

A young American soldier, hit by a shell on the last day of World War I, lies in a hospital bed, a quadruple amputee who has also lost his eyes, ears, mouth, and nose. Conscious and able to reason, he is finally able to communicate with his nurse by tapping out letters in Morse code with his head. He wants to leave the hospital, but the military, unwilling to let this testimony to the horrors of war be seen by the public, locks him away.

The film is based on Dalton Trumbo's *Johnny Got His Gun* (New York: J. B. Lippincott, 1939).

INTERESTING FACTS

- Dalton Trumbo was blacklisted by the studios after he was suspected of being a communist, having been investigated by the House Un-American Activities Committee.
- Marsha Hunt, another actor, was also blacklisted.
- This film, with its depressing subject matter, could not get made until America was embroiled in the Vietnam War.

QUOTES

Johnny: Inside me I'm screaming, nobody pays any attention. If I had arms, I could kill myself. If I had legs, I could run away. If I had a voice, I could talk and be some kind of company for myself. I could yell for help, but nobody would help me.

Johnny: I don't know whether I'm alive and dreaming or dead and remembering.

JOURNEY'S END

Gainsborough Pictures, Tiffany Productions, 1930, b&w, 120 minutes.

Producer: George Pearson (supervising producer); **Director:** James Whale; **Screenwriters:** Joseph Moncure March, R. C. Sherriff (play); **Distributor:** Tiffany Pictures; **Cast:** Robert Adair, Billy Bevan, Anthony Bushell, Colin Clive, Charles K. Gerrard, Werner Klingler, Ian Maclaren, David Manners, Jack Pitcairn, Leslie Sketchley, Tom Whiteley.

Colin Clive is an officer who has been mentally destroyed by three years of sending men to their deaths in the trenches during World War I. David Manners arrives in the dugout, proud to be serving under his boyhood idol, until he realizes that the war has turned him into a hopeless and cynical alcoholic.

INTERESTING FACTS

- The film is based on R. C. Sherriff's stage play and directed by James Whale, both of whom had front-line experiences during World War I.
- Its original form, as a stage play, hampers this film adaptation, which almost never leaves the confines of the dugout where the play was set. This can be attributed to the fact that James Whale directed both the play in London and the film in Hollywood.

JOURNEY TOGETHER

RAF Film Unit, 1946, b&w, 95 minutes.

Director: John Boulting; **Screenwriters:** John Boulting, Terence Rattigan; **Music:** Dr. Gordon Jacob; **Distributor:** RKO; **Cast:** Ronald Adam, Richard Attenborough, Jack Baker, Arthur Bolton, Bromley Challenor, George Cole, Norval D. Crutcher Sr., Stuart Dick, Jerry Fitzgerald, Rex Harrison, John Justin, Stuart Latham, Bessie Love, Miles Malleson, Fletcher Markle, Murray Matheson, Michael McNeile, Peter Naylis, Hamish Nichol, Leslie Nixon, Z. Peremowski, Sidney Rider, Edward G. Robinson, Sebastian Shaw, Ronald Squire, Nick Stuart, David Tomlinson, Tommy Tomlinson, Patrick Waddington, Hugh Wakefield, Jack Watling, Eric Worth.

Prospective Royal Air Force pilots Richard Attenborough and Jack Watling go through flight training in England and the United States during World War II.

The movie is based on a story by Terence Rattigan.

INTERESTING FACT

- Most of those involved with the film's production were Royal Air Force members.

JUDGMENT AT NUREMBERG

Roxlom, 1961, b&w, 178 minutes.

Producers: Stanley Kramer, Philip Langner (associate producer); **Director:** Stanley Kramer; **Screenwriter:** Abby Mann (story); **Music:** Ernest Gold, Norbert

Schultze (songs); **Distributor:** United Artists; **Cast:** Alan Baxter, Joseph E. Bernard, Ed Binns, Martin Brandt, Sheila Bromley, Paul Busch, Howard Caine, Virginia Christine, Montgomery Clift, Joseph Crehan, Marlene Dietrich, Olga Fabian, Judy Garland, Bernard Kates, Werner Klemperer, Burt Lancaster, Kenneth MacKenna, Torben Meyer, Maximilian Schell, William Shatner, Rudy Solari, Karl Swenson, Jana Taylor, Ray Teal, Spencer Tracy, Otto Waldis, John Wengraf, Richard Widmark, Ben Wright.

Spencer Tracy, a retired New England judge, is asked to be a judge at Nuremberg, three years after the most important Nazi leaders have already been convicted. The four new Nuremberg defendants are unique in that the men on trial are themselves judges who misused their judicial powers to help the Nazi regime carry out their evil policies. For example, one of the judges ordered the sterilization of Montgomery Clift because he was feebleminded. Another ordered Judy Garland imprisoned for having an affair with a Jew. However, Spencer Tracy's task is complicated by the fact that the cold war is heating up, and the Allies, who want the help and support of the German people, want the trials to end. In spite of this pressure, Spencer Tracy does the right thing and convicts all four defendants.

MISTAKES

* While it is true that there was a gas chamber at Dachau, it was never used. Prisoners died from maltreatment or from execution by means other than gas. Dachau, located outside Munich, now has a museum the author has visited, and some of the barracks have been reconstructed.
* Zyklon-B gas was not released with a lever.
* The archival film footage does not show "paintings" made on human skin. It shows tattooed skin. Buchenwald prisoners with unusual tattoos were killed, then their skin was preserved for the tattoo collection of convicted war criminal Ilse Koch, the "Bitch of Buchenwald." Buchenwald is also open to the public, and present-day German officers are required, as part of their training, to go there and listen to lectures on the evils of the Holocaust.
* When Colonel Lawson begins his filmed presentation of the conditions in the concentration camps, he is standing between the projector and the screen on which the film is being shown. Despite this, Lawson doesn't cast a shadow on the screen, which is probably a rear projection.

QUOTES

[Referring to the Holocaust, after Burt Lancaster's conviction]
Ernst Janning (Burt Lancaster): These millions of people. I never know it would come to that.
Judge Dan Haywood (Spencer Tracy): It came to that the first time you first sentenced a man to death you knew to be innocent.

AWARDS

Academy Awards, USA, 1961
Won: *Oscar, Best Actor,* Maximilian Schell; *Best Writing, Screenplay Based on Material from Another Medium,* Abby Mann
Nominated: *Oscar, Best Actor,* Spencer Tracy; *Best Art Direction—Set Decoration, Black-and-White,* George Milo, Rudolph Sternad; *Best Cinematography, Black-and-White,* Ernest Laszlo; *Best Costume Design, Black-and-White,* Jean Louis; *Best Director,* Stanley Kramer; *Best Film Editing,* Frederic Knudtson; *Best Picture,* Stanley Kramer; *Best Supporting Actor,* Montgomery Clift; *Best Supporting Actress,* Judy Garland

American Cinema Editors, USA, 1962
Nominated: *Eddie, Best Edited Feature Film,* Frederick Knudtson

Bodil Awards, 1962
Won: *Bodil, Best American Film (Bedste amerikanske film),* Stanley Kramer (director)

British Academy Awards, 1962
Nominated: *BAFTA Film Award, Best Film from any Source—USA; Best Foreign Actor,* Montgomery Clift, Maximilian Schell—USA

David di Donatello Awards, 1962
Won: *David, Best Foreign Film (Miglior Film Straniero),* Stanley Kramer

Golden Globes, USA, 1962
Won: *Golden Globe, Best Motion Picture Actor—Drama,* Maximilian Schell; *Best Motion Picture Director,* Stanley Kramer

Italian National Syndicate of Film Journalists, 1962
Won: *Silver Ribbon, Best Director—Foreign Film (Regista del Miglior Film Straniero),* Stanley Kramer

New York Film Critics Circle Awards, 1961
Won: *NYFCC Award, Best Actor,* Maximilian Schell

Writers Guild of America, USA, 1962
Nominated: *WGA Screen Award, Best Written American Drama,* Abby Mann.

JUMP INTO HELL

Warner Bros., 1955, b&w, 92 minutes.

Producer: David Weisbart; **Director:** David Butler; **Screenwriter:** Irving Wallace; **Music:** David Buttolph; **Cast:** Patricia Blair, Peter Bourne, George Chan, Marcel Dalio, Lawrence Dobkin, Norman Dupont, Harold Dyrenforth, Peter van Eyck, Kurt Kasznar, Leon Lontoc, Maurice Marsac, Louis Mercier, Lisa Montell, Alberto Morin, Arnold Moss, Jack Scott, Jacques Sernas, Roger Valmy.

Jacques Sernas, Kurt Kasznar, Peter van Eyck, and Norman Dupont are among the French paratroopers who volunteer to jump into the French fortress of Dienbienphu and lift the siege. However, their attempt to discourage the communist attack fails, and Sernas and Dupont are the only survivors of those who escape the fall of the fortress.

The film is based on the true story of the siege of Dienbienphu. The battle of Dienbienphu was the critical turning point in the French Indochina War, in which French army paratroopers attempted to save this garrison of 10,000 French troops, under siege for 56 days, from being overrun by the communists. The defeat at Dienbienphu led to the withdrawal of France from Vietnam and set the stage for the American Vietnam War less than a decade later.

INTERESTING FACTS

- A description of the French Indochina War (1945–54) is shown in the film *THE QUIET AMERICAN*.
- Actual combat footage was used to add realism to the battle sequences.

JUNGLE PATROL

20th Century-Fox, 1948, b&w, 71 minutes.

Producer: Frank N. Seltzer; **Director:** Joseph M. Newman; **Screenwriters:** William Bowers, Francis Swann; **Music:** Arthur Lange, Emil Newman, Al Rinker; **Distributor:** 20th Century-Fox Film Corporation; **Cast:** Pat Collins, Ross Ford, Arthur Franz, Richard Jaeckel, Mickey Knox, Harry Lauter, Kristine Miller, William Murphy, Tommy Noonan, Gene Reynolds.

At a remote airstrip in the South Pacific near Port Moresby during World War II, eight American fighter pilots struggle to hold back the Japanese until a larger and more permanent airstrip can be constructed. Tensions mount as each aviator wonders how much longer he can survive against overwhelming odds.

KEEP, THE

Paramount Pictures, 1983, color, 96 minutes.

Producers: Colin M. Brewer, Gene Kirkwood, Howard W. Koch Jr.; **Director:** Michael Mann; **Screenwriters:** Michael Mann, F. Paul Wilson; **Distributor:** Paramount; **Filmed at:** North Wales, UK; **Cast:** Yashaw Adem, Sean Baker, Timothy Block, Philip Bloomfield, Benedick Blythe, Gabriel Byrne, David Cardy, Michael Carter, Rosalie Crutchley, John Eastham, Scott Glenn, Peter Guinness, Stephen Jenn, Jona Jones, Phillip Joseph, Wolf Kahler, Renny Krupinski, Robin Langford, Ian McKellen, Bruce Payne, Jürgen Prochnow, Robert Prosky, Lan Ruskin, William Morgan Sheppard, Royston Tickner, John Vine, Frederick Warder, Alberta Watson, Stephen Whittaker.

During World War II, a detachment of the German army is sent to guard a mysterious Rumanian citadel located on a strategic mountain pass. One of the soldiers unwittingly releases an unknown force trapped within the walls. As the soldiers are mysteriously murdered, the SS arrives to deal with what is thought to be partisan activity. What the SS finds, however, is an evil force trapped within the keep, a force that will do anything to escape. With no way of fighting the menace, the Nazis have no option but to seek the aid of a Jewish man and his daughter, who are both knowledgeable about the keep and who can translate manuscripts vital to combating the force.

The film is based on F. Paul Wilson's *The Keep* (New York: Morrow, 1981).

INTERESTING FACTS

- Some television versions include additional footage after the original downbeat ending. Alberta Watson (Eva Cuza) finds the body of Scott Glenn (Glaeken) dead after the final battle with Michael Carter (Molasar). She hugs him and revives him with the power of her love.
- Another TV version features an ending in which Glaeken is seen carrying the dead Molasar in his arms in the inner chamber of the keep.
- A strangely edited version that appeared on Channel 39 in Houston, Texas, around 1989 had a scene in which Glenn is telling Eva that it has been so long that he can't remember what he looks like anymore. That version ends with Glenn alive at the bottom of the gorge, wounded after his battle with Molasar and crawling to the stream and seeing his reflection.
- The upbeat ending showing Eva and Glaeken alive together is close to the ending in the novel.

MISTAKE

- The camera assistant is visible directing a camera pan when the German soldiers are firing into the air as the evil force is released.

KEEP YOUR POWDER DRY

Metro-Goldwyn-Mayer, 1945, b&w, 93 minutes.

Producer: George Haight; **Director:** Edward Buzzell; **Screenwriters:** George Bruce, Mary C. McCall Jr.; **Music:** David Snell; **Distributor:** MGM; **Cast:** Dorothy Ackers, Jess Barker, Judi Blacque, Marie Blake, Early Cantrell, Marjorie Davies, Laraine Day, Rita Dunn, Rex Evans, Jeanne Francis, Jean French, Charlotte Hunter, Bill Johnson, Margaret Kays, Michael Kirby, Edith Leach, Ruth Lee, Marta Linden, June Lockhart, Mary Lord, Agnes Moorehead, Tim Murdock, Henry O'Neill, Jetsy Parker, Lee Patrick, Shirley Patterson, George Peters, Susan Peters, Jane Ray, Beth Renner, Claire Rochelle, Sondra Rodgers, Elizabeth Russell, Natalie Schafer, Barbara Sears, Melba Snowden, Ray Teal, Lana Turner, Geraldine Wall, Pierre Watkin, Claire Whitney, Bobbie Woods.

Lana Turner and Laraine Day join the Women's Army Corps (WACs) during World War II. Socialite Lana Turner enlists only to receive an inheritance and is always at odds with the military system, whereas Laraine Day is highly motivated; she comes from a military family, and she is totally squared away. They bicker constantly, but in the end, Lana Turner becomes the better soldier and helps keep Laraine Day from being washed out of officer candidate school.

INTERESTING FACTS

- This was Susan Peters's last film. She was injured in a hunting accident shortly after the film was completed and was never able to walk again.
- Lana Turner and Laraine Day also bickered off the set for real. This probably enhanced their screen performance.

KELLY'S HEROES

Avala Film, Metro-Goldwyn-Mayer, 1970, color, 149 minutes.

Producers: Sidney Beckerman, Gabriel Katzka, Irving L. Leonard; **Director:** Brian G. Hutton; **Screenwriter;** Troy Kennedy-Martin; **Music:** Lalo Schifrin; **Distributor:** MGM; **Filmed in:** Yugoslavia; **Cast:** Phil Adams, Karl-Otto Alberty, Dick Balduzzi, Hal Buckley, Michael Clark, Gene Collins, Richard Davalos, Hugo De Vernier, Clint Eastwood, Ross Elliott, George Fargo, Frank J. Garlotta, Harry Goines, David Gross, John G. Heller, David Hurst, Sandy Kevin, Len Lesser, Perry Lopez, Gavin MacLeod, Robert MacNamara, Vincent Maracecchi, Stuart Margolin, James McHale, Reed Morgan, Jeff Morris, Carroll O'Connor, Fred Pearlman, Dee Pollock, Don Rickles, Shepherd Sanders, George Savalas, Telly Savalas, Tom Signorelli, Harry Dean Stanton, Donald Sutherland, Tom Troupe, Donald Waugh, Tony Wheeler.

During World War II, Clint Eastwood (Kelly) learns of a bank located behind enemy lines containing $16 million in Nazi gold. His platoon has three days of rest and recreation coming, so they decide to spend their time off robbing the bank. With the aid of a corrupt supply sergeant (Don Rickles), a very bizarre tank commander (Donald Sutherland) with three souped-up Sherman tanks, and an entire army band, Eastwood leads his off-beat task force deep into enemy territory. In the process, they open up a whole new front, and the American army attacks through the break they have created in the German lines.

QUOTES

Oddball: We play music very loud. It kind of calms us down.

Oddball [referring to paint canister ammunition]: We have our own ammunition. When we fire it, it paints beautiful pictures.

Oddball: Why don't you knock it off with them negative waves? Why don't you dig how beautiful it is out here? Why don't you say something righteous and hopeful for a change?

Oddball: Crazy! I mean like so many positive waves maybe we can't lose! You're on!

Oddball: To a New Yorker like you, a hero is some sort of weird sandwich, not some nut that takes on three Tigers.

Big Joe: If I hear any more threats against the captain's life, or any more rumors about going down to headquarters and assassinating the general, or raping the nurses at the field hospital, I'm going to strangle the guy with my bare hands! Got it?
Oddball: A Sherman tank can give you an . . . edge.

Oddball: I'm drinking some wine, eating some cheese, and catching some rays, you know . . .

Oddball [sees that the bridge he wants to cross is intact and is pleased with himself]: Still up!

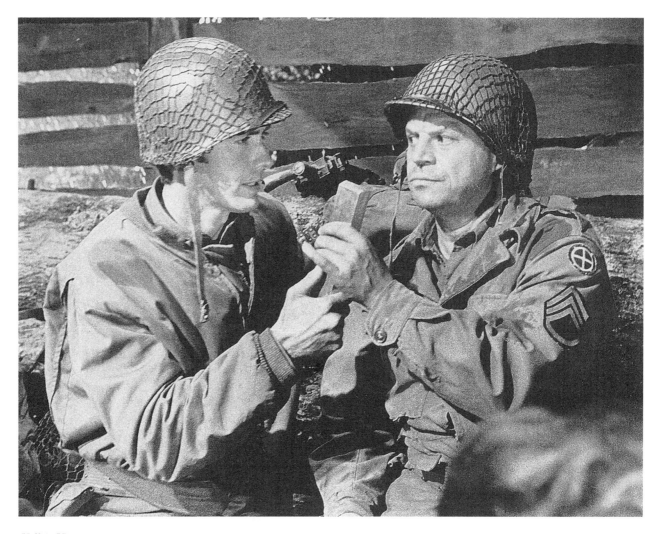

Kelly's Heroes (MGM/AUTHOR'S COLLECTION)

[A plane flies over the bridge and bombs it . . . direct hit]
Oddball: No it ain't.

Oddball: Arf arf arf . . . That's my other dog impression.
[The lone obstacle to the sought-after gold is a solitary tank guarding the bank.]
Crapgame: Try making a *deal*!
Big Joe: What kind of *deal*?
Crapgame: A *deal*, *deal*! Maybe he's a Republican. You know, "Business is business."

Oddball: Crapgame, who is that guy?
Crapgame: Him? Name's Kelly. Used to be a lieutenant, until somebody gave the order to attack the wrong hill. Wiped out a half a company of GIs. Somebody had to get blamed and he got picked.

Big Joe: Now take that underwear off your head. Enough's enough.

INTERESTING FACTS

- Director Brian G. Hutton was forced to make a number of cuts to suit MGM boss James Aubrey.
- Donald Sutherland became seriously ill during filming on location in Yugoslavia.
- John Landis was a production assistant on this film. He appears as an extra. (He was one of the three nuns.)
- Mike Curb, who wrote the lyrics to the *Kelly's Heroes* theme song *Burning Bridges*, served as lieutenant governor of California between 1978 and 1982.
- *Burning Bridges* (theme song) is sung by the Mike Curb Congregation, lyrics by Mike Curb, music by Lalo Schifrin. *Sunshine* is sung by Hank Williams Jr.

MISTAKES

- Boxes of gold bars weigh more than indicated.
- German tanks of World War II indeed had hydraulic turrets and gasoline engines.
- The "Tiger" tanks depicted are really disguised Russian T-34 tanks. You can tell by the treads and wheels.
- When fighting the Germans at the minefield, you can't hear Kelly's voice over the gunfire, but Big Joe's is perfectly clear.
- While the U.S. Air Force did not exist as a separate unit until 1947, beginning in 1941 its precursor was known as the U.S. Army Air Force, which is similar enough to "Air Force" to be known as such.
- The typefaces used in the "liberation" signs for the town weren't available until the late 1950s.
- Oddball's hair style and beard are nonregulation for the era.
- Big Joe drives off to try and get some "dirty movies" to entertain the men. He returns with a chaplain, goes inside, and gets distracted by other developments. No further mention is made of the chaplain sitting outside, presumably needing a ride back to HQ.
- An old video release has a very quick scene involving Germans trying to jump over a truck (after the group crosses the minefield). This scene isn't in the 1999 video; however, a scene with one of the American machine-gun crews right after the deleted scene is inserted.

KEY, THE

Warner Bros., 1934, b&w, 71 minutes.

Producer: Robert Presnell Sr.; **Director:** Michael Curtiz; **Screenwriters:** Laird Doyle, R. Gore Brown (play), J. L. Hardy (play); **Music:** Mort Dixon (song), Allie Wrubel (song); **Distributor:** Warner Bros.; **Cast:** Arthur Aylesworth, Edna Best, Hobart Cavanaugh, Colin Clive, Edward Cooper, Luke Cosgrave, Donald Crisp, Lowin Cross, Maxine Doyle, John Elliott, Eddie Fetherston, Douglas Gordon, Aggie Herring, Halliwell Hobbes, Robert Homans, Olaf Hytten, Charles Irwin, Lew Kelly, J. M. Kerrigan, Dixie Loftin, Mary MacLaren, James May, Henry O'Neill, William Powell, Phil Regan, Ralph Remley, Desmond Roberts, Anne Shirley, Gertrude Short, Pat Somerset, Wyndham Standing, David Thursby, Arthur Treacher, Kathrin Clare Ward.

In 1920, William Powell is a British army captain assigned to the Black and Tans during the Irish Rebellion. He finds in Ireland an old flame, Edna Best, and they resume their affair, despite the fact that she is now married to an officer in British intelligence, Colin Clive. When Clive discovers the affair, he goes on a drinking spree, and while drunk he is taken hostage by the Irish Republican Army. They demand the return of one of their leaders, who is scheduled to be executed, as the price of his safe return.

KILLING FIELDS, THE

Warner Bros., Goldcrest Films, International Film Investors, Enigma, 1984, color, 141 minutes.

Producers: David Puttnam, Iain Smith; **Director:** Roland Joffé; **Screenwriter:** Bruce Robinson; **Filmed in:** New York City, Bangkok, Railway Hotel, Hua Hin, and Phuket, Thailand, Toronto, Canada; **Cast:** Jay Barney, Tom Bird, Nell Campbell, Edward Entero Chey, Katherine Krapu Chey, Lambool Dtangpaibool, Athol Fugard, Spalding Gray, Joan Harris, David Henry, Sayo Imaba, Graham Kennedy, Mow Leng, Mark Long, Patrick Malahide, John Malkovich, Joanna Merlin, Craig T. Nelson, Haing S. Ngor, Neevy Pal, Bill Paterson, Oliver Pierpaoli, Julian Sands, Chinsaure Sar, Monirak Sisowath, Thach Suon, Hout Ming Tran, Sam Waterston, Ira Wheeler.

A *New York Times* journalist, assisted by native Dith Pran, covers the tragedy and madness of the Cambodian civil war. As an American, the journalist doesn't have any trouble when he later decides to leave the country, but the situation is different for Pran. As a local, there is a good chance he could end up as another victim of the Khmer Rouge.

INTERESTING FACTS

- Dictator Pol Pot's plan was to turn Cambodia into an agrarian utopia. The cities were emptied of their citizens, and over 2 million Cambodians, considered "enemies of the state," were systematically slaughtered by the Khmer Rouge.
- The film is based on Sidney Schanberg's "The Death and Life of Dith Pran: A Story of Cambodia" (published in *The New York Times Magazine* on January 20, 1980).

QUOTE

Dith Pran [in his journal while imprisoned]: The wind whispers of fear and hate. The war has killed love. And those that confess to the Angka are punished, and no one dare ask where they go. Here only the silent survive.

Academy Awards, USA, 1984
Oscar, Best Supporting Actor—Ngor, an amateur actor.

KILL ZONE

Concorde-New Horizons, New Horizon Picture Corp, 1993, color, 81 minutes.

Producers: Roger Corman, Steven Rabiner, Cirio H. Santiago; **Director:** Cirio H. Santiago; **Screenwriter:** Frederick Bailey; **Music:** Nonong Buencamino; **Filmed in:** Philippines; **Cast:** Archie Adamos, Ronald Asinas, Geno Bolda, David Carradine, Tony Dorsett, Francis Evaristo, Eddie Gaerlan, Ned Hourani, Bob Larson, Ken Metcalfe, Jim Moss, Nick Nicholson, James Gregory Paolleli, Steve Rogers, Roxanne Silverio, Vic Trevino, Vivian Velez, Cesar Villanueva, Richard White, Rob Youngblood.

David Carradine is an American colonel who will pay any price to defeat the Vietcong. When his unauthorized fighting force in Cambodia is discovered, he becomes a one-man army, fighting a war of his own.

KING AND COUNTRY

BHE Films, Landau/Unger, 1964, b&w, 86 minutes.

Producers: Joseph Losey, Norman Priggen; **Director:** Joseph Losey; **Screenwriters:** James Lansdale Hodson, Evan Jones, John Wilson; **Music:** Larry Adler; **Distributor:** Allied Artists; **Cast:** Richard Arthure, Dirk Bogarde, Raymond Brody, Keith Buckley, David Cook, Peter Copley, Dan Cornwall, Tom Courtenay, Barry Foster, James Hunter, Barry Justice, Vivian Matalon, Leo McKern, Terry Palmer, Derek Partridge, Jonah Seymour, Jeremy Spenser, Larry Taylor, Brian Tipping, James Villiers.

A sensitive private is put on trial for desertion during World War I and is defended by a captain convinced of his innocence.

KING RAT

Coleytown, 1965, b&w, 133 minutes.

Producer: James Woolf; **Director:** Bryan Forbes; **Screenwriters:** James Clavell, Bryan Forbes; **Music:** John Barry; **Distributor:** Columbia Pictures; **Cast:** Todd Armstrong, Edward Ashley, John Barclay, Geoffrey Bayldon, Larry Conroy, Tom Courtenay, Richard Dawson, James Donald, Roy Duane, Hamilton Dyce, Denholm Elliott, Anthony Faramus, William Fawcett, James Fox, David Frankham, Brian Gaffikin, David Haviland, Dale Ishimoto, Dick Johnson, Wright King, Michael Lees, John Levingston, Reg Lye, Arthur Malet, Hedley Mattingly, John Merivale, John Mills, Louis Neervort, Patrick O'Neal, John Orchard, George Pelling, Sammy Reese, John Ronane, Leonard Rossiter, George Segal, Teru Shimada, Gerald Sim, John Standing, Michael Stroka, Joe Turkel, John Warburton, Alan Webb.

During World War II, Allied soldiers are held by the Japanese in the Changi POW camp near Singapore. There are no escape attempts here, only survival; the prisoners are preoccupied with just trying to stay alive. One soldier comments that they scurry around like a colony of rats. Corporal King (George Segal), an unlikable con artist, take merciless advantage of his fellow prisoners, living a life of luxury and power among men who are starving. He is the King Rat. His life is perfect, until the camp is liberated. Then the King is toppled from his throne, and he becomes just one more GI.

The movie is based on James Clavell's *King Rat* (Boston: Little, Brown, and Company, 1962).

Academy Awards, USA, 1965
 Nominated: *Oscar, Best Art Direction—Set Decoration, Black-and-White,* Robert Emmet Smith, Frank Tuttle; *Best Cinematography, Black-and-White,* Burnett Guffey

British Academy Awards, 1966
 Nominated: *UN Award*—Brian Forbes—USA.

KINGS GO FORTH

Frank Ross, Eton, 1958, b&w, 109 minutes.

Producer: Frank Ross; **Director:** Delmer Daves; **Screenwriters:** Joe David Brown, Merle Miller; **Music:** Elmer Bernstein; **Distributor:** United Artists; **Cast:** Jacques Berthe, Pete Candoli, Ann Codee, Tony Curtis, Leora Dana, Marie Isnard, Red Norvo, Eddie Ryder, Frank Sinatra, Karl Swenson, Natalie Wood.

Two soldiers, Tony Curtis and Frank Sinatra, are both attracted to the same woman, Natalie Wood. However, she prefers Tony Curtis, who has an abundance of good looks and charm. He takes advantage of that, until he

learns that Natalie is half black, at which point he instantly and cruelly turns his back on her. When Curtis and Sinatra are sent together on a mission into a German town, Curtis is mortally wounded, and Sinatra, realizing the Nazis are going to pull out and escape, calls in an air strike on his own position. He loses his arm, but in the end he gets the girl.

The movie is based on Joe David Brown's *Kings Go Forth* (New York: Morrow, 1956).

KISS THEM FOR ME

Jerry Wald Productions, 20th Century-Fox, 1957, color, 105 minutes.

Producer: Jerry Wald; **Director:** Stanley Donen; **Screenwriters:** Luther Davis, Julius J. Epstein, Frederic Wakeman; **Music:** Carroll Coates, Lionel Newman; **Distributor:** 20th Century-Fox Film Corporation; **Filmed at:** San Francisco, California; **Cast:** Isabel Analla, Hal Baylor, Larry Blyden, Jane Burgess, Harry Carey Jr., Harry Carter, Sue Collier, Richard Deacon, John Doucette, Leif Erickson, Linc Foster, Michael Fox, Kathleen Freeman, Nathaniel Frey, Barbara Gould, Cary Grant, Jonathan Hale, Deborah Kerr, Kip King, Werner Klemperer, Nancy Kulp, Peter Leeds, Larry Lo Verde, Mike Mahoney, Jayne Mansfield, Jack Mather, Ann McCrea, Ray Montgomery, Jack Mullaney, Frank Nelson, Suzy Parker, William Phipps, Maudie Prickett, Jan Reeves, Michael Ross, Robert St. Angelo, Richard Shannon, Robert Sherman, Rachel Stephens, James Stone, Bill Suiter, Ray Walston, Ben Wright, Caprice Yordan.

Cary Grant, Leif Erickson, and Ray Walton are decorated navy pilots who finagle a four-day leave in San Francisco. They procure a posh suite at the best hotel and fill it with party people. A public affairs lieutenant tries to get the pilots to make speeches at a war plant to rally the home front, but they are tired of the war and just want to have fun. However, when they hear that their carrier has been sunk, they realize that even though they have already done more than their part, they must return to the war.

INTERESTING FACTS

- The screenwriter, to remind the audience of the hell endured by these pilots, injected a poignant character, a critically injured Medal of Honor winner who had served in the Pacific with Cary Grant and now has only a matter of weeks to live. His war wounds are a vivid reminder that for every pilot at the party, there is another one who didn't make it.
- The desire to return to war at the end of this film is reminiscent of *ALL QUIET ON THE WESTERN FRONT*. In both films, the soldiers realize that they have more in common with their comrades at the front than with the people back home, who can't even begin to understand what they are going through.
- The film is based on Frederick Wakeman's *Shore Leave* (New York: Triangle Books, 1944). The novel was made into a play before it became a feature film.

KOREA PATROL

Jack Schwarz Productions, 1951, b&w, 59 minutes.

Producers: Jack Schwarz, Walter Shenson; **Director:** Max Nosseck; **Screenwriters:** Kenneth G. Brown, Walter Shenson; **Music:** Alexander Gerens; **Distributor:** Eagle-Lion; **Cast:** Wong Artarne, Richard Barron, John Close, Danny Davenport, Teri Duna, Al Eben, Richard Emory, Benson Fong, Harold Fong, Sung Li.

Richard Emory's patrol, guided by a South Korean scout, takes heavy losses in knocking out a strategic enemy bridge.

L

LADIES COURAGEOUS

Universal Pictures, 1944, b&w, 88 minutes.

Producer: Walter Wanger; **Director:** John Rawlins; **Screenwriters:** Virginia Cowles, Doris Gilbert, Norman Reilly Raine; **Music:** Dimitri Tiomkin; **Distributor:** Universal Pictures; **Cast:** Evelyn Ankers, Diana Barrymore, Steve Brodie, David Bruce, Chester Carlisle, Lois Collier, Gwen Crawford, Blake Edwards, Geraldine Fitzgerald, Richard Fraser, Anne Gwynne, Marie Harmon, Fay Helm, Samuel S. Hinds, Frank Jenks, Doris Linden, Don McGill, Matt McHugh, Dennis Moore, Dorothy Moore, Grandon Rhodes, Kane Richmond, Ruth Roman, Janet Shaw, Phillip Terry, June Vincent, Billy Wayne, Loretta Young.

Loretta Young is the serious-minded leader of a squadron of WAFS. She must deal not only with the personal problems of her young female pilots but also fight the Washington bureaucracy to accept her squadron as military pilots.

The WAFS, the Women's Auxiliary Ferry Service, were female civilian pilots who were hired to ferry completed military aircraft from the war plants where they were manufactured, across the United States, and overseas to where they were critically needed. This service was created because every available male civilian pilot had already joined the U.S. Army or the Navy Air Corps.

Ferry pilots had to be qualified in every aircraft they flew, and they accumulated thousands of flight hours in many different types of aircraft. As a result, by the end of the war, these women were among the most proficient pilots in the American arsenal.

LADY FROM CHUNGKING

Producers Releasing Corporation, 1943, b&w, 66 minutes.

Producer: Arthur Alexander; **Director:** William Nigh; **Screenwriters:** Milton Raison, Sam Robins; **Distributor:** Producers Releasing Corporation; **Cast:** Paul Bryar, Mae Clarke, Ludwig Donath, Archie Got, Ted Hecht, Walter Soo Hoo, Harold Huber, James B. Leong, Rick Vallin, Anna May Wong.

During the Sino-Japanese war, Anna May Wong, a sexy Chinese guerrilla leader, uses her feminine wiles to seduce the Japanese commander and then turn the information she obtains against their oppressors.

LAFAYETTE ESCADRILLE

Warner Bros. 1958, b&w, 93 minutes.

Producer: William A. Wellman; **Director:** William A. Wellman; **Screenwriters:** Aaron Sidney Fleischman, William A. Wellman; **Music:** Leonard

Rosenman; **Distributor:** Warner Bros.; **Cast:** Raymond Bailey, Etchika Choureau, Marcel Dalio, Dennis Devine, Clint Eastwood, Paul Fix, Brett Halsey, Robert Hover, Tab Hunter, Will Hutchins, David Janssen, Tom Laughlin, Maurice Marsac, Jody McCrea, Maurice Millard, Henry Nakamura, George Nardelli, Veola Vonn, William A. Wellman, William Wellman Jr.

Tab Hunter is an American who goes to Paris and falls in love with a French prostitute (Etchika Choureau) before joining the American volunteers in the French air force. He assaults a French officer and is thrown in prison, but he is sprung by his fellow pilots and is able to rejoin the fight.

The Lafayette Escadrille was made up of American pilots based in France who fought against the Jagdstaffeln (German Air Force) prior to the U.S. entry into World War I. Originally called the Escadrille Americaine, this group is perhaps as well remembered for their actions in the officer's club as their success in the skies. The acquisition of two lion cubs named "Whiskey" and "Soda" as squadron mascots added to the unit's hard-drinking reputation.

The Lafayette Escadrille had 38 American pilots who rotated to other squads within the Lafayette Flying Corps, a part of the French Air Service. They were based at Luxeuil and supported the Verdun campaign. In all, 65 Lafayette Escadrille and Lafayette Flying Corps members perished during the air war, before the Lafayette Escadrille was absorbed by the United States Air Service (early U.S. Army Air Corps) in 1918.

INTERESTING FACT

- *Escadrille* is French for "squadron." Their official name was Escadrille No. 124.

MILITARY SERVICE

- Director William Wellman's nickname was "Wild Bill." He went to France in 1917 as an ambulance driver, then enlisted in the French Foreign Legion, where he served as a pilot with the Lafayette Flying Corps, a French aviation unit. He was shot down in combat and injured his back. He then returned to the United States and was commissioned a first lieutenant in the U.S. Army Signal Corps Aviation Section. He was awarded the Croix de Guerre. This film is supposedly based on his own experiences flying with the French.

LAST BLITZKRIEG, THE

Columbia Pictures Corporation, 1958, b&w, 84 minutes.

Producer: Sam Katzman, **Director:** Arthur Dreifuss; **Screenwriter:** Lou Morheim; **Distributor:** Columbia Pictures; **Filmed in:** De Veluwe, Netherlands; **Cast:** Leon Askin, Chris Baay, Han Bentz van den Berg, T. Bolland, Robert Boon, Lise Bourdin, Steye van Brandenberg, Ton van Duinhoven, Pieter Goemans, John T. Greene, Herb Grika, Hans Hagemeyer, Brett Halsey, Howard Jaffe, Van Johnson, Jack Kelling, Carl Kent, Ron Landweer, Robsen Assenbroek Mach, Kerwin Mathews, Fred Oster, Charles Rosenblum, Larry Storch, Gijsbert Tersteeg, Jan Verkoren, Dick York.

Van Johnson plays the leader of an elite group of German soldiers during the Battle of the Bulge in World War II. Because they all speak perfect English and are dressed in American uniforms, they are able to infiltrate the American lines.

This film was inspired by a true story. Realizing the havoc that they could cause behind enemy lines, German soldiers who had been brought up in the United States were recruited. They could speak excellent "American." Dressed as military police in the U.S. Army, whose task it was to mark routes and to direct units in the proper direction, they were able to cause a lot of confusion and misdirection by their actions. Ultimately, most of them were detected, and because they were caught wearing the wrong uniform, they were shot as spies. After this, American soldiers were wary of each other; mutual trust was no longer established by a uniform and an American accent. Questions used for challenges quickly became recent "Americana" that only an American fresh from the United States would know, like "Who won the World Series?"

INTERESTING FACT

- German soldiers appearing as U.S. military police provide a major secondary story in the film *BATTLE OF THE BULGE.*

LAST ESCAPE, THE

United Artists, 1970, color, 90 minutes.

Producer: Irving Temaner; **Director:** Walter Grauman; **Screenwriters:** John C. Champion, Herman

Hoffman; **Cast:** Richard Abbott, Paul Bentley, Pinkas Braun, Johnny Briggs, Don Brodie, John Collin, Harald Dietl, Greta Granstedt, Frank Guarente, Helmut Heisler, Michael Hinz, Paul Hurst, Martin Jarvis, Patrick Jordan, Robert Emmett Keane, Dorothea Kent, Samuel Lee, Andrew Lodge, Günther Neutze, Andy Pap, Edward Raquello, Margit Saad, Albert Shaw, Christian Skrobek, Chuck Stanford, David Taylor, Kent Taylor, Charles Trowbridge, Gerd Vespermann, Stuart Whitman.

At the end of World War II, Allied forces enter a well-guarded German rocket base and capture a German rocket scientist. When they try to get away, they are pursued by Germans and Russians, both of whom want the scientist.

LAST GRENADE, THE

Cinerama, 1970, color, 94 minutes.

Producer: Josef Shaftel; **Director:** Gordon Flemyng; **Screenwriters:** James Mitchell, John Sherlock, Kenneth Ware; **Cast:** Richard Attenborough, Stanley Baker, Honor Blackman, Ray Brooks, A. J. Brown, Alex Cord, Paul Dawkins, Julian Glover, Rafer Johnson, Andrew Keir, Philip Latham, Gerald Sim, Pamela Stanley, Kenji Takaki, John Thaw, Neil Wilson.

In the Far East, war and revenge are mixed with an affair between soldier Stanley Baker and Honor Blackman, the wife of a general.

LAST STAND AT LANG MEI

Concorde-New Horizons, New Horizon Picture Corp., 1990, color, 90 minutes.

Producer: Roger Corman, Christopher R. Santiago; **Director:** Cirio H. Santiago; **Screenwriters:** Carl Franklin, Dan Gagliasso, M. A. Solomon; **Music:** Justin Lord; **Filmed in:** Philippines; **Cast:** Frederick Bailey, Marilyn Bautista, Ramon D'Salva, Carl Franklin, Tonichi Fructuoso, Joonee Gamboa, Robert Ginnaven, Jeff Griffith, Eric Hahn, Steve Kanaly, Leo Martinez, Jim Moss, Peter Nelson, Monty Obieta, Archie Ramirez, Steve Rogers, John Vargas, Ken Wright, Joseph Zucchero.

In Vietnam, army headquarters has written off the captain and his men who are missing in action, cut off deep behind the enemy positions. They must fight their own way back to their lines.

INTERESTING FACT

- This film is based on a true story; it is also known as *Eye of the Eagle III.*

LAST TIME I SAW ARCHIE, THE

Mark VII Ltd., Talbot Productions Inc., 1961, b&w, 93 minutes.

Producer: Jack Webb; **Director:** Jack Webb; **Screenwriter:** William Bowers; **Music:** Frank Comstock; **Distributor:** United Artists; **Cast:** Richard Arlen, Art Balinger, Claudia Barrett, Theona Bryant, Marilyn Burtis, Dick Cathcart, Robert Clarke, Elaine Davis, Martin Dean, Joe Flynn, Phil Gordon, Martha Hyer, Bill Kilmer, Don Knotts, Nancy Kulp, Harvey Lembeck, Jimmy Lydon, Eugene McCarthy, Howard McNear, Robert Mitchum, James Mitchum, Del Moore, John Nolan, France Nuyen, Louis Nye, Robert Strauss, Jack Webb.

Robert Mitchum (Private Archie Hall) is a schemer who manages to convince everyone around him that he is a general from military intelligence on an undercover assignment to unmask a Japanese agent. Thus they all treat him with great respect. Jack Webb is his sidekick. Private Bill Bowers (the screenwriter) is the buddy who goes along for the ride. Archie is a master of avoiding all of the mundane duties of military life: He has a girlfriend, an unrestricted pass, and a private jeep.

INTERESTING FACTS

- This film was based on a true-life situation in a stateside camp consisting of leftovers from a program designed to train pilots too old for combat duty during World War II. The program was canceled because the war was coming to an end. William Bowers, the screenwriter, based this film on his own experiences during World War II.
- The real Archie, on whom the film was based, sued the studio.
- The film was Jack Webb's most expensive production, costing about $2 million. It was also his biggest flop, grossing about $1.2 million. Webb would never again make a theatrical feature. Five years later, he'd be back on television, playing Sergeant Joe Friday of *Dragnet.*

LAST WARRIOR, THE

Incorporated Television Company, Label Productions, Martin Wragge Production, 1989, color, 94 minutes.

Producer: Keith Watkins; **Director:** Martin Wragge; **Screenwriter:** Martin Wragge; **Cast:** Sheryl Burton, John Carson, Peggy Champion, Victoria Cooper, Eva Davis, Pippa Duffy, Ingrid Emsley, Gary Graham, Maria Holvoe, Steven Ito, Al Karaki, Cary-Hiroyuki Tagawa.

The Japanese destroyer *Yamato* is badly damaged in a sea battle and must be repaired at a small island in the Pacific inhabited only by an American observer, some aborigines, a priest, and a novice nun.

LATINO

Lucasfilm Ltd., 1985, color, 105 minutes.

Producer: Benjamin Berg; **Director:** Haskell Wexler; **Screenwriter:** Haskell Wexler; **Music:** Diane Louie; **Cast:** Robert Beltran, Annette Charles, Américo González, Michael Goodwin, Ricardo López, Walter Marin, Julio Medina, Juan Carlos Ortiz, Tony Plana, Luis Torrentes.

Uncle Sam's plan to train the Contras is evil, and the Sandinistas are the good guys. Unfortunately, the bad guys turn out to be much more interesting than the heroes.

LAWRENCE OF ARABIA

Horizon Pictures, 1962, color, 216 minutes.

Producer: Sam Spiegel; **Director:** David Lean; **Screenwriters:** Robert Bolt, T. E. Lawrence, Michael Wilson; **Music:** Maurice Jarre, **Distributor:** Columbia Pictures; **Filmed at:** Cobham, England (where Lawrence falls off motorcycle), El Jafr, Jebel Tubeiq, and Wadi Rumm, Jordan, Quarzazate, Morocco, Almería, and Sevilla, Spain; **Cast:** Bruce Beeby, Fred Bennett, John Bennett, Robert Bolt, Peter Burton, Basil Dignam, John Dimech, José Ferrer, Kenneth Fortescue, Harry Fowler, Alec Guinness, Jack Gwyllim, Jack Hawkins, Jack Hedley, I. S. Johar, Arthur Kennedy, Howard Marion-Crawford, Hugh Miller, Zia Mohyeddin, Clive Morton, Henry Oscar, Peter O'Toole, Bryan Pringle, Anthony Quayle, Anthony Quinn, Claude Rains, Gamil Ratib, Michel Ray, Norman Rossington, John Ruddock, Fernando Sancho, Stuart Saunders, Omar Sharif, Roy Stevens, Donald Wolfit.

T. E. Lawrence (Peter O'Toole) is a young maladjusted lieutenant in the British army in Arabia during World War I. Unhappy with his assignment coloring maps, Lawrence manages to get a job as the British army observer with Prince Faisal, the leader of an Arab tribal army, in his campaigns against the Turks. His adventures are detailed by Jackson Bentley (Arthur Kennedy), a journalist who makes him famous. He quickly transitions from a position of observer and military adviser to that of commander of the Arab army that he builds. He helps to defeat the Turks and to forge the modern country of Saudi Arabia. The concept of Arab unity was something advocated by Lawrence, a concept that had to be learned by most Arabs. As Lawrence states in the film: "So long as the Arabs fight tribe against tribe, they will be a little people."

INTERESTING FACTS

- Director David Lean originally wanted Albert Finney for the title role. Katherine Hepburn urged producer Sam Spiegel to cast Peter O'Toole.
- This film has no women in speaking roles.
- While preparing for many of the train sabotage scenes, which were all shot on location, Lean's team found wreckage from the original trains Lawrence had blown up.
- The 1989 version was restored by Robert A. Harris, who produced a new 65mm preservation interpositive from the original camera negative (including outtakes and alternate shots) and color separations. The camera negative was in its final months of usability.
- The motorcyclist who hails Lawrence from across the Suez Canal with the line "Who are you? Who are you?" is director David Lean.
- One of Lawrence's brothers, Arnold Lawrence, a professor of archaeology at Cambridge University in England, found this film's portrayal of his brother "pretentious and false." According to Arnold Lawrence, T. E. Lawrence was kind, and "one of the most exhilarating people I've known."
- T. E. Lawrence was a real historical figure, well known at the time because of newspaper stories. While the film is generally accurate, there is no evidence that T. E. Lawrence was present at the massacre of the Turks, one of the central scenes in the movie.
- The empire of the Ottoman Turks extended throughout most of Arabia; it sided with Germany during the war. Promising the Arabs independence after the war, the British and French governments encouraged the Arabs to revolt. Lawrence and Prince Faisal carried out a successful guerrilla campaign against Turkish rail supply lines. The

Arabs, accompanied by Lawrence, conquered the city of Damascus in 1918.

- Following British policy at the time, Lawrence assured the Arabs that if they revolted against the Turks they would be rewarded with their independence after the war. The British and French governments never intended to keep this promise, but Lawrence didn't know this. After the war, Lawrence lobbied British politicians and attended the Versailles peace conference in an unsuccessful effort to get the Allies to grant Arab independence. After World War I the Middle East was divided between the French and the British empires.

- T. E. Lawrence was a student and archaeologist before World War I. At college, Lawrence was an oddball ascetic; a serious student who did not participate in sports and who ate bread and water for lunch. He wrote his senior thesis on Crusader forts in the Middle East, gathering information by walking more than 1000 miles in what was then the Ottoman Empire. On this trip he became acquainted with the area, learned Arabic, and came to love Arab culture. After graduation he supervised Arab workers on several archaeological digs in the Middle East. When Britain needed intelligence officers for the Middle East during World War I, T. E. Lawrence was an ideal choice.

- Many incidents in the film are taken from actual events. Lawrence was forced to personally execute a Bedouin who had killed another man. If he had not, the expedition would have disintegrated into a round of revenge killings. After killing the man by shooting him three times, Lawrence was so upset that he had to be carried onto his camel. While on a reconnaissance patrol, Lawrence was captured, and then flogged and raped by the Turks.

- Lawrence was made famous by an American newspaper reporter, Lowell Thomas, who accompanied Lawrence and his Bedouin soldiers for eight days. After the war, Lawrence could have used his popularity to run for office, but he refused all of the honors offered to him.

- Lawrence was a deeply private man who distrusted his own "passion for distinction." For this reason and, perhaps, because of his disgust at his own role in the British betrayal of the Arabs, he retired from public life, joining the Royal Tank Corps and the Royal Air Force under assumed names. He served from 1923 to 1935, never accepting any promotion and avoiding the press but keeping up a correspondence with many distinguished friends.

- Lawrence translated *The Odyssey* for an American publishing company and wrote a critically acclaimed book, *The Mint*, about his experiences in the RAF. Lawrence's book *The Seven Pillars of Wisdom* (1926) describes his wartime experiences and his personal philosophy.

- Lawrence was killed in a motorcycle accident in 1935.

- Many characters in the movie are historical. The character of Faisal is a combination of Emir Hussain and his son, Prince Faisal. It was Lawrence's close relationship with Faisal that permitted such close British/Arab cooperation.

- Edmund Allenby was a British general who lead a brilliant campaign against the Turks in World War I and captured Palestine and Syria.

- Shortly after the premiere, which took place in London in December 1962, 20 minutes were deleted from the film. The film was rereleased in 1971 after 15 more minutes were deleted. In 1989 the restored version was released at 216 minutes.

MISTAKES

- On the way to Faisal's camp, Lawrence's desert guide offers him food from a mess tin. To prove he is at one with the Arabs and thus will eat what they eat, Lawrence takes it—but with the fingers of his left hand, and twice. The guide would have thrown the food away, because among Arabs the left hand is reserved exclusively for cleaning oneself in the toilet.

- The Browning air-cooled machine guns used by the director in the train ambush scene had not yet been invented when the actual events took place.

QUOTES

Lawrence: My friends, we have been foolish. Auda will not come to Aqaba. Not for money . . .
Auda Abu Tayi: No.
Lawrence: for Faisal . . .
Auda Abu Tayi: No!
Lawrence: nor to drive away the Turks. He will come . . . because it is his pleasure.
Auda Abu Tayi [pausing]: Thy mother mated with a scorpion.

Lawrence: I killed two people. One was yesterday. He was just a boy, and I led him into quicksand. The other was . . . well . . . before Aqaba. I had to execute him with my pistol, and there was something about it that I didn't like.
Allenby: That's to be expected.
Lawrence: No, something else.
Allenby: Well, then let it be a lesson.
Lawrence: No . . . something else.

Allenby: What then?
Lawrence: I enjoyed it.

General Allenby: I'm promoting you, major.
T. E. Lawrence: I don't think that's a very good idea.

Col. Harry Brighton: Look, sir, we can't just do nothing.
General Allenby: Why not? It's usually best.

AWARDS

Academy Awards, USA, 1962
 Won: *Oscar, Best Art Direction—Set Decoration, Color,* John Box, Dario Simoni, John Stoll; *Best Cinematography, Color,* Freddie Young; *Best Director,* David Lean; *Best Film Editing,* Anne V. Coates; *Best Music Scoring—Substantially Original,* Maurice Jarre; *Best Picture,* Sam Spiegel; *Best Sound,* John Cox (Shepperton SSD)
 Nominated: *Oscar, Best Actor,* Peter O'Toole; *Best Supporting Actor,* Omar Sharif; *Best Writing, Screenplay Based on Material from Another Medium,* Robert Bolt

American Cinema Editors, USA, 1963
 Nominated: *Eddie, Best Edited Feature Film,* Anne V. Coates

British Academy Awards, 1963
 Won: *BAFTA Film Award, Best British Actor,* Peter O'Toole; *Best British Film; Best British Screenplay,* Robert Bolt
 Nominated: *BAFTA Film Award, Best Foreign Actor,* Anthony Quinn

British Society of Cinematographers, 1962
 Won: *Best Cinematography Award*—Freddie Young

David di Donatello Awards, 1964
 Won: *Best Foreign Film (Miglior Film Straniero),* Sam Spiegel

Directors Guild of America, USA, 1963
 Won: *DGA Award, Outstanding Directorial Achievement in Motion Pictures,* David Lean, Roy Stevens (assistant director, plaque)

Golden Globes, USA, 1963
 Won: *Golden Globe, Best Cinematography—Color,* Freddie Young; *Best Motion Picture—Drama; Best Motion Picture, Director,* David Lean; *Best Supporting Actor,* Omar Sharif

Italian National Syndicate of Film Journalists, 1964
 Won: *Silver Ribbon, Best Director—Foreign Film (Regista del, Miglior Film Straniero),* David Lean

National Board of Review, USA, 1962
 Won: *NBR Award, Best Director,* David Lean

National Film Preservation Board, USA, 1991— National Film Registry

LEATHERNECKS HAVE LANDED, THE

Republic Pictures Corporation, 1936, b&w, 66 minutes.

Producer: Ken Goldsmith; **Director:** Lew Ayres, Howard Bretherton; **Screenwriters:** James Gruen (story), Seton I. Miller, Wellyn Totman (story); **Music:** Arthur Kay, Leon Rosebrook, Sam H. Stept; **Distributor:** Republic Pictures Corporation; **Cast:** Lew Ayres, Ward Bond, James Burke, Clay Clement, Ray Corrigan, John Webb Dillon, James Ellison, Maynard Holmes, Isabel Jewell, Claude King, Lal Chand Mehra, Henry Mowbray, J. Carrol Naish, Paul Porcasi, Leon Rosebrook, Christian Rub, Joe Sawyer, C. Montague Shaw, Sam H. Stept, Robert Strange, Frank Tang, Louis Vincenot, Beal Wong, Victor Wong.

Lew Ayres is held responsible for the death of a friend and dishonorably discharged from the U.S. Marine Corps. He starts running guns to rebel forces in Shanghai and rescues a group of Americans from Chinese bandits.

LETTER TO EVIE, A

Metro-Goldwyn-Mayer, 1945, b&w, 89 minutes.

Producer: William H. Wright; **Director:** Jules Dassin; **Screenwriters:** Blanche Brace (story, *The Adventure of a Ready Letter Writer*), Alan Friedman, DeVallon Scott; **Music:** George Bassman; **Cast:** Ernie Adams, Pamela Britton, Spring Byington, John Carroll, Hume Cronyn, Donald Curtis, Esther Howard, Marsha Hunt, Norman Lloyd, Therese Lyon, Sharon McManus, Cameron Mitchell, Robert Emmett O'Connor, William Phillips, Robin Raymond, Ray Teal, Percival Vivian, Arthur Walsh, Lynn Whitney.

While working in a uniform factory during World War II, Evie (Marsha Hunt) slips a letter into a shirt marked 16 ½, hoping that size uniform is going to eventually belong to someone tall, dark, and handsome. It's received by GI John Carroll, who immediately throws it away, but his sensitive, dreaming, plain, and short buddy, Hume Cronyn, snags it and begins a correspondence with Evie, pretending to be his handsome friend. But things get complicated when Evie

wants to meet her soldier. And even more complicated when John Carroll sees Evie, and likes what he sees. He's a cad, and it's up to Cronyn to save her from his buddy the wolf.

LIFE AND DEATH OF COLONEL BLIMP, THE

The Archers, 1943, color, 163 minutes.

Producers: Michael Powell, Emeric Pressburger, Richard Vernon; **Directors:** Michael Powell, Emeric Pressburger; **Screenwriters:** Michael Powell, Emeric Pressburger; **Distributor:** United Artists; **Cast:** Muriel Aked, Yvonne Andre, Dennis Arundell, Felix Aylmer, Frith Banbury, Captain W. Barrett, John Boxer, Edward Cooper, Roland Culver, Helen Debroy, Valentine Dyall, Ian Fleming, Marjorie Greasley, Robert Harris, Vincent Holman, David Hutcheson, Carl Jaffe, Ursula Jeans, Deborah Kerr, James Knight, John Laurie, Albert Lieven, Roger Livesey, Neville Mapp, Diana Marshall, A. E. Matthews, Eric Maturin, Ferdy Mayne, James McKechnie, Jane Millican, Phyllis Morris, Peter Murray, Peter Noble, Thomas Palmer, Wally Patch, Norman Pierce, Norris Smith, Joan Swinstead, Reginald Tate, Waleen Tidy, Spencer Trevor, Jan Van Loewen, John Varley, Anton Walbrook, David Ward, Harry Welchman, Arthur Wontner, George Woodbridge, Count Zichy.

Colonel Clive Candy (Roger Livesey) fought in the Boer War and World War I. He still believes he can win any fight with honor and gentlemanly conduct. It takes an old German friend of his to point out that the rules do not apply when you are fighting the Nazis.

The irony of Clive Candy's counterpropaganda mission to Berlin during the South African War is that the enemy's "lies" were true—the British army had departed from the rules of war and it was in the Boer War that the British invented the concentration camp.

Colonel Blimp was a newspaper cartoon character created by David Low, an Englishman with a patriotic bent. Blimp was a little slow and inflexible, but he was certain of his moral position and was entirely fearless. He enshrined the British national character and stood as a reassuring emblem for the British people during the dark days of World War II. In this film, the character of General Wynne-Candy is loosely based on Blimp.

INTERESTING FACTS

- Director Michael Powell originally wanted Wendy Hiller to play Blimp's ideal woman, but she was unavailable, so the part was given to Deborah Kerr.

- Michael Powell's golden cocker spaniels, Erik and Spangle, make their second appearance on film as Clive and Barbara return from their honeymoon.
- The tapestry seen in the opening credits was made by the members of the Royal College of Needlework.
- Winston Churchill hated the film and wanted it banned.
- Director Michael Powell was intrigued by how second-unit cameraman Jack Cardiff was filming the animal heads and gave Jack his first big break as the cinematographer on his next film, *A Matter of Life and Death* (1946).
- Three-quarters of the Germans in the crowd at the POW camp are "carefully painted and positioned" plaster models.

QUOTES

Clive Candy [Blimp has just been told by his German friend there's no place for him in the modern army]: Are you mad? I know what war is!

Theo Kretschmar-Schuldorff: I don't agree. I read your broadcast up to the point where you describe the collapse of France. You commented on Nazi methods, foul fighting, bombing refugees, machine-gunning hospitals, lifeboats, lightships, bailed-out pilots, by saying that you despised them, that you would be ashamed to fight on their side, and that you would sooner accept defeat than victory if it could only be won by those methods.

Clive Candy: So I would.

Theo Kretschmar-Schuldorff: Clive! If you let yourself be defeated by them, just because you are too fair to hit back the same way they hit at you, there won't be any methods *but* Nazi methods! If you preach the "rules of the game" while they use every foul and filthy trick against you, they will laugh at you! They think you're weak, decadent! And if you lose there won't be a return match next year, perhaps not even for a hundred years! [He pats Clive's shoulder.] You mustn't mind me, an old alien, saying all this. But who can describe hydrophobia better than one who has been bitten—and is now immune.

LIFEBOAT

20th Century-Fox, 1944, b&w, 96 minutes.

Producer: Kenneth Macgowan; **Director:** Alfred Hitchcock; **Screenwriters:** Ben Hecht, John Steinbeck, Jo Swerling; **Music:** Hugo Friedhofer; **Filmed in:** studio water tank; **Distributor:** 20th Century-Fox Film; **Cast:** Mary Anderson, Heather Angel, Tallulah

Bankhead, William Bendix, Hume Cronyn, Alfred Hitchcock, John Hodiak, Henry Hull, Canada Lee, Walter Slezak, William Yetter Jr.

Eight individuals are stranded in a 20-foot wooden lifeboat in the middle of the Atlantic Ocean during World War II, after their transport ship is destroyed by a German U-boat, which also sinks. To make matters worse—as if being adrift in the middle of the ocean, minus food and water, in a damaged boat isn't bad enough—one of the eight survivors is the captain of the German submarine (Walter Slezak). The seven Americans rationalize that if they refuse to help him, they would be lowering their principles to those of the Nazis. Thus, in an effort to hold the moral high ground, they allow Slezak to remain on board. Slezak hoards water, conceals pertinent information, and kills one of the survivors. When the other castaways realize what he has done, they turn on him, and he is killed.

The film is based on a short story by John Steinbeck.

INTERESTING FACTS

- Alfred Hitchcock called in Ben Hecht to read the final script and to rewrite the ending.
- Much of the cast caught pneumonia after constant exposure to cold water.
- During filming, several of the crew complained that Tallulah Bankhead was not wearing underwear. This was apparent to them when she climbed in and out of the lifeboat. When told of the situation, director Alfred Hitchcock replied, "I don't know if this is a matter for the costume department or the hairdresser."
- Alfred Hitchcock, in a director's cameo, appears in before-and-after pictures in a newspaper advertisement for Reduco the Obesity Slayer. The pictures were genuine, as he had just been on a crash diet (although not with the fictional Reduco).

QUOTE

Connie Porter: Dying together's even more personal than living together.

AWARDS

Academy Awards, USA, 1944
 Nominated: *Oscar, Best Cinematography, Black-and-White,* Glen MacWilliams; *Best Director,* Alfred Hitchcock; *Best Writing, Original Story,* John Steinbeck

New York Film Critics Circle Awards, 1944
 Won: *NYFCC Award, Best Actress,* Tallulah Bankhead.

LIGHTHORSEMEN, THE

RKO Pictures, 1987, color, 131 minutes.

Producers: Antony I. Ginnane, Ian Jones, Simon Wincer, **Director:** Simon Wincer; **Screenwriter:** Ian Jones; **Distributor:** Belle & Blade; **Filmed at:** Corryong, Melbourne, Queenscliff, Yarra Glen, Wallan, and Geelong, Victoria, Port Lincoln and Hawker, South Australia, Geelong, Western Australia; **Cast:** Anthony Andrews, Steve Bastoni, Jon Blake, Tony Bonner, David Bracks, Scott Bradley, Shane Briant, Terry Brittingham, Peter Browne, Ashley Cooper, Ralph Cotterill, Stephen Crockett, Peter Douglas, Graham Dow, Jason Dunn, Brendan Egan, Patrick Frost, Steve Harrison, Anthony Hawkins, John Heywood, Lou Horvarth, Adrian Ireland, John Kelly, Gerard Kennedy, Bill Kerr, William Kerr, Michael Kitsche, John Larking, Serge Lazareff, Kingsley MacDonald, Tony Mack, Kevin May, Tim McKenzie, Peter Merrill, Tom Mudge, Ricky Noble, Tom O'Brien, Di O'Connor, Vic O'Neal, Simon Palomares, Peter Phelps, Grant Piro, Mark Pretti, Johnny Raaen, Matthew Randell, David Sadler, Leo Scanders, Anne Scott-Pendlebur, Jon Sidney, Robert Simper, Bill Stacey, Gary Stalker, Barry Stephan, Milton Stevens, Richard Stevens, Iain Strutt, Gary Sweet, Tamas Szegedi, Sigrid Thornton, John Walton, Nick Waters, Brenton Whittle, Jim Willoughby, Adrian Wright, James Wright.

In Palestine during World War I, the British advance has been stopped by the Turks at Gaza. Following the bloody debacle at Gallipoli, the Australian Lighthorse is given another impossible mission, to move across the waterless desert and attack the heavily armed Turkish post at Beersheba. This time, however, instead of a horrible slaughter, the Australians win the day. This is a true story, and very faithfully rendered by the movie.

For days after the charge at Beersheba, it was the talk of the camps and messes; the Australian Light Horse had galloped into history. South Australians can be proud of the Battle of Beersheba. "A" Squadron Third/Ninth South Australian Mounted Rifles has today inherited the honors of the Australian Light Horse.

AWARDS

Australian Film Institute, 1988
 Won: *AFI Award, Best Achievement in Sound,* Peter Burgess, Lloyd Carrick, Craig Carter, James Currie, Phil Heywood, Peter D. Wood; *Best Original Music Score,* Mario Millo

Nominated: AFI Award, *Best Achievement in Cinematography*, Dean Semler.

LIGHT THAT FAILED, THE

Paramount Pictures, 1939, b&w, 97 minutes.

Producer: William A. Wellman; **Director:** William A. Wellman; **Screenwriters:** Robert Carson, Rudyard Kipling (novel); **Music:** Victor Young; **Cast:** Muriel Angelus, Jimmy Aubrey, Clara Blore, Ferike Boros, George Chandler, Joe Collings, Ronald Colman, Clyde Cook, Harry Cording, Pedro de Cordoba, Ernest Cossart, Barbara Denny, Dudley Digges, Barry Downing, Harold Entwistle, Sam Harris, Fay Helm, Halliwell Hobbes, Walter Huston, Charles Irwin, Colin Kenny, Connie Leon, Ida Lupino, Francis McDonald, George Melford, Pat O'Malley, George Regas, Cyril Ring, Wilfred Roberts, Gerald Rogers, Ronald Sinclair, Hayden Stevenson, Colin Tapley, Carl Voss, Blue Washington, Sarita Wooton.

Ronald Colman, an artist and war correspondent going blind from an injury, struggles to complete his masterpiece, a portrait of Ida Lupino, a cockney girl in London, before his eyesight fails him. Deciding that he cannot stand life as a blind artist, he journeys to the Sudan where the British are fighting the Mahdi and intentionally exposes himself to enemy fire, thereby committing suicide.

The movie is based on Rudyard Kipling's *The Light That Failed* (London: New York: Macmillan, 1891).

LIMBO

Filmmakers Group, Omaha, Orange, Universal Pictures, 1972, color, 112 minutes.

Producer: Linda Gottlieb; **Director:** Mark Robson; **Screenwriters:** James Bridges, Joan Micklin Silver (also story); **Music:** Anita Kerr; **Distributor:** Universal Pictures; **Cast:** Mike Bersell, Dick Callinan, Kate Jackson, Andrew Jarrell, Katherine Justice, Ken Kornbluh, Laura Kornbluh, Frank Logan, Stuart Margolin, Charles Martin, Hazel Medina, Joan Murphy, Kim Nicholas, Kathleen Nolan, Mike Phillips, Russell Wiggins.

Kate Jackson is the wife of an American aviator shot down and taken prisoner by the Vietnamese. Married only two weeks before he went overseas, she has an affair while waiting for him to return. She bonds with other air force wives on the base whose husbands are also missing in action over Vietnam and who have their own problems.

This movie is also known as *Women in Limbo*. Other movies that have dealt with Vietnam MIAs are *RAMBO: FIRST BLOOD PART II* and *MISSING IN ACTION*.

LION OF THE DESERT

Falcon International, 1980, color, 162 minutes.

Producers: Moustapha Akkad, Nahila May Al-Jabri; **Director:** Moustapha Akkad; **Screenwriter:** H. A. L. Craig; **Music:** Maurice Jarre; **Distributor:** United Film Distribution Company; **Filmed in:** Libya; **Cast:** Massimiliano Baratta, Victor Baring, Gianfranco Barra, Loris Bazoki, Rodolfo Bigotti, Pietro Brambila, Lino Capolicchio, Claudio Cassinelli, Luciano Catenacci, Mark Colleano, Filippo Degaras, Sky Dumont, Takis Emmanuel, Franco Fantasia, Mario Feliciani, Scott Fensome, Piero Gerlini, John Gielgud, Claudio Gora, Andrew Keir, Adolfo Lastretti, Alec Mango, Gastone Moschin, Irene Papas, Stefano Patrizi, Anthony Quinn, Oliver Reed, Ewen Solon, Eleonora Stathopoulou, Rod Steiger, George Sweeney, Pietro Tordi, Raf Vallone, Ihab Werfali.

Anthony Quinn is the charismatic Islamic Libyan fighter Omar Mukhtar, who commits himself to a lifetime war against Italian colonialism ("We have stood against you for 20 years and with the help of God we will stay with you till your end!"). Enraged by the Bedouin patriots, the arrogant Mussolini (Rod Steiger) orders his new military governor, the ruthless Rodolfo Graziani (Oliver Reed), to crush and silence the Bedouin rebellion by "whatever means" and to capture their great leader Omar Mukhtar. The "means" include a massive killing rampage by the Italians in Kufra, a primitive village attacked with planes, tanks, artillery, and machine guns. The Italian army stops at nothing in its fight against the rebels: holding the helpless population in concentration camps, isolating the warriors from their families, setting fire to their fields, closing their wells, raping their women, destroying their homes, hanging old men and women, and shooting innocent civilians.

INTERESTING FACTS

- Omar el-Mukhtar was the instigator, organizer, and spirit of the longest war of resistance ever conducted in the Maghreb. In 1912, Turkey signed the Treaty of Ouchy in Lausanne, delivering Libya into the hands of the Italians.

- Part of el-Mukhtar's appeal was his status as a fervent follower of the Senoussia Brotherhood and an associate of Idriss el-Senouussi, who would later be crowned king of Libya. At the time he had been forced into exile by illness and the Italians' breach of their promises. Senoussia, a religious renaissance movement formed under the Ottoman Empire, was recognized by the population as the repository of religious and nationalist legitimacy.
- Under the sway of fascism, Il Duce, Benito Mussolini, decided to make Libya a natural extension of Italy around the *mare nostrum* of the Mediterranean, "our sea." The tone was set in 1921 by Giuseppe Volpi, a businessman named governor, who declared that he would "fight for Italy's rights with blood."
- The military chief of the operation was Rodolfo Graziani. Known as "the butcher," Graziani spared nothing in attacking the supporters of el-Mukhtar. These included scorched-earth tactics, deportations, concentration camps, and random bombardments. Ever elusive, el-Mukhtar returned the attacks blow for blow.
- At one point more than 400,000 Italian troops fought to secure control of a country that at the time had barely 1 million inhabitants. In the end, the combat was unequal. Omar el-Mukhtar was captured after the fall of the Koufra Oasis and was hanged in public on September 16, 1931. A Pax Romana was installed in Libya, but the legend of el-Mukhtar survived. Because of his wartime exploits and tactical genius, he became a national hero to a younger generation, including Col. Muammar Qadhafi.
- This film, a box-office failure, was bankrolled by Libya's Colonel Qadhafi.
- The film was directed by Mustapha Akkad, a Syrian-born filmmaker.

LONG AND THE SHORT AND THE TALL, THE

Associated British Picture Corporation, 1960, b&w, 85 minutes.

Producer: Michael Balcon; **Director:** Leslie Norman; **Screenwriters:** Willis Hall, Wolf Mankowitz; **Cast:** Ronald Fraser, Richard Harris, Laurence Harvey, David McCallum, John Meillon, John Rees, Kenji Takaki, Richard Todd.

A squad of British soldiers are sent to record troop noises in the jungle so that the sounds can be played back later to divert the enemy. As they progress, they find themselves farther and farther from their own lines, until the only channel they can clearly receive is Japanese. When they take a Japanese soldier prisoner, the true colors of each man come to the surface.

LONG DAY'S DYING, THE

Junction Films Limited, Paramount Pictures, 1968, color, 95 minutes.

Producers: Michael Deeley, Harry Fine; **Director:** Peter Collinson; **Screenwriters:** Alan White, Charles Wood; **Cast:** Tony Beckley, Tom Bell, Alan Dobie, David Hemmings.

Three privates and their German prisoner are caught in the no-man's-land between the trenches during World War I.

The movie is based on Alan White's *The Long Day's Dying* (London: Hodder and Stoughton, 1965).

LONGEST DAY, THE

20th Century-Fox, 1962, b&w, 180 minutes.

Producers: Elmo Williams, Darryl F. Zanuck; **Director:** Ken Annakin, Andrew Marton, Gerd Oswald; **Screenwriters:** Romain Gary, James Jones, David Pursall, Cornelius Ryan, Jack Seddon; **Filmed in:** Pointe du Hoc and Ste.-Mère Eglise, Normandy, France; **Cast:** Eddie Albert, Paul Anka, Arletty, Patrick Barr, Jean-Louis Barrault, Michael Beint, Richard Beymer, Hans Christian Blech, Bourvil, Lyndon Brook, Richard Burton, Red Buttons, Vicco von Bülow, Wolfgang Büttner, Pauline Carton, Bryan Coleman, Sean Connery, John Crawford, Mark Damon, Ray Danton, Jo D'Avra, Eugene Deckers, Irina Demick, Fred Durr, Peter van Eyck, Fabian, Mel Ferrer, Frank Finlay, Henry Fonda, Steve Forrest, Harry Fowler, Robert Freitag, Gert Fröbe, Leo Genn, Harold Goodwin, Henry Grace, John Gregson, Daniel Gélin, Paul Hartmann, Ruth Hausmeister, Jack Hedley, Peter Helm, Michael Hinz, Werner Hinz, Donald Houston, Jeffrey Hunter, Karl John, Curd Jürgens, Til Kiwe, Alexander Knox, Simon Lack, Peter Lawford, Fernand Ledoux, Christopher Lee, Wolfgang Lukschy, Howard Marion-Crawford, Christian Marquand, Dewey Martin, Neil McCallum, Roddy McDowall, Michael Medwin, John Meillon, Kurt Meisel, Sal Mineo, Robert Mitchum, Kenneth More, Louis Mounier, Richard Münch, Bill Nagy, Edmond O'Brien, Kurt Pecher, Rainer Penkert, Leslie Phillips, Siân Phillips, Maurice Poli, Wolfgang Preiss,

Ron Randell, Hartmut Reck, Trevor Reid, Heinz Reincke, Madeleine Renaud, Georges Rivière, John Robinson, Françoise Rosay, Norman Rossington, Paul Edwin Roth, Robert Ryan, Tommy Sands, Dietmar Schönherr, Ernst Schröder, George Segal, Jean Servais, Heinz Spitzner, Rod Steiger, Nicholas Stuart, Alice Tissot, Richard Todd, Serge Tolstoy, Tom Tryon, Robert Wagner, Richard Wattis, John Wayne, Stuart Whitman, Georges Wilson.

The film is about the D day invasion of Normandy in World War II. The Allies storm five separate invasion beaches and drop paratroopers inland to take key towns and bridges. The Germans still expect the invasion at Calais, and Hitler refuses to believe this is the main invasion.

The film is based on Cornelius Ryan's *The Longest Day* (New York: Simon and Schuster, 1959).

In 1942 General Eisenhower, Supreme Allied Commander, warned Germany: "Beware the fury of an aroused democracy." On D day, June 6, 1944, the Allies mounted the largest amphibious assault in history and made good on Eisenhower's warning. The invasion force consisted of more than 5,000 ships, 1,200 warships, and 13,000 airplanes. Some 90,000 U.S., British, Canadian, and Free French troops landed on the beaches of Normandy and about 20,000 more came by parachute or glider.

Hitler is reported to have said: "The destruction of the enemy's landing is the sole decisive factor in the whole conduct of the war." But the Germans couldn't push the invasion back into the sea. Because of the excellent counterintelligence work done by the Allies, the German High Command was extremely confused during the early hours of the invasion. Hitler refused to commit Panzer reserves to the battle until the beachhead was already established. By June 11, 1944, the Allied forces had linked up and made a solid front, ensuring that they would not be thrown back into the sea.

The Longest Day (20TH CENTURY-FOX/AUTHOR'S COLLECTION)

INTERESTING FACTS

- The American cemetery at Omaha beach is shown in *SAVING PRIVATE RYAN*. At Ste.-Mère Eglise, a mannequin in a parachute is positioned on the church tower, just where Red Buttons (and the real soldier) actually hung, and there is a museum to the men of the 101st and 82nd Airborne.
- Pointe Du Hoc is still as it was on D day, with all of the bunkers (most of them blown up) left there as a shrine.
- Darryl F. Zanuck was quoted in an interview as saying that he didn't think much of actors forming their own studio, citing John Wayne's *The Alamo* (1960) project as a failure of such ventures. Wayne found out about this interview before being approached by Zanuck and refused to be in this movie unless he was paid $250,000 for his role (when the other famous actors were being paid $25,000 for the same movie). Wayne got his requested salary.
- Henry Grace was not an actor when he was cast as Dwight D. Eisenhower; his remarkable resemblance to Eisenhower got him the role.
- Sean Connery, who made his debut as James Bond in 1962, the year the film was released, acted in the movie along with Gert Fröbe and Curt Jurgens—two future Bond villains.
- Former U.S. president Dwight D. Eisenhower was considered for the role of himself in the film, and he indicated his willingness. However, it was decided that makeup artists couldn't make him appear young enough to play his World War II self.
- Red Buttons was cast in the film after he ran into Darryl F. Zanuck in a Paris café.
- Due to the massive cost overruns on the film *Cleopatra* (which was filming contemporaneously), Zanuck had to agree to a fixed filming budget. After he had spent the budgeted amount he started using his own money to pay for the production.

MILITARY SERVICE

- Richard Todd (Major Howard of the British Sixth Airborne) was himself in Normandy on D day and participated as Lieutenant Todd of the British Sixth Airborne in the glider assault on the Orne River Bridge.

 As a 22-year-old private, Joseph Lowe landed on Omaha Beach on D day with the Fifth Ranger Battalion and scaled the cliffs at Pointe Du Hoc. He scaled those hundred-foot cliffs all over again for the cameras, some 17 years later, acting as a member of the 505th Infantry Battle Group.

MISTAKES

- The shots that kill Private Martini occur too quickly in succession to have been fired from the indicated bolt-action rifle.
- A compound fracture of the ankle would show blood and/or protruding bones, of which Vandervoort's ankle had none. It also would have been impossible to put any weight on the ankle.
- The shadow of the dolly against the smoke of battle during the invasion of Omaha beach indicates that it was filmed in the afternoon, not at dawn.
- The film shows LCM-8s, which weren't built until 1954.
- Germany's Gen. Max Pemsel says: "*Wir haben starke RADAR-störungen*," but the Germans didn't have radar.
- During the final scenes of the movie when an American general is on Omaha beach, it's actually Juno beach, where the Canadians landed.
- When two German planes strafe Gold-Juno beaches, the airborne camera overruns the set, exposing the empty beach ahead, which has neither vehicles nor men.
- Before Oberstleutnant Priller and Unteroffizier Wodarczyk attack the Allies, there is some stock footage of Me-109s. Priller and Wodarczyk flew FW-190s on that mission.
- The Pegasus bridge had not been rigged for demolition.
- The German defenses on Omaha beach were not blown up and frontally assaulted. This was the original plan, but the bulldozers and tanks that were to carry out the assault did not make it to the beach. The junior officers and NCOs took charge of the situation, infiltrating their men behind the enemy fortifications, taking them from the rear.

QUOTES

Flight Officer David Campbell: I don't mind being one of the few; trouble is we keep getting fewer.

Brig. Gen. Norman Coda: Two kinds of people are staying on this beach: the dead and those that are going to die!

Lt. Col. Benjamin Vandervoort: Don't give the enemy a break. Send him to hell.

David Campbell: He's dead. I'm crippled. You're lost. Do you suppose it's always like that . . . in a war?

Academy Awards, USA, 1962

Won: *Oscar, Best Cinematography, Black-and-White,* Jean Bourgoin, Walter Wottitz; *Best Special Effects,* Robert MacDonald (visual), Jacques Maumont (audible)

Nominated: *Oscar, Best Art Direction—Set Decoration, Black-and-White,* Gabriel Béchir, Léon Barsacq, Ted Haworth, Vincent Korda; *Best Film Editing,* Samuel E. Beetley; *Best Picture,* Darryl F. Zanuck

American Cinema Editors, USA, 1963

Won: *Eddie, Best Edited Feature Film,* Samuel E. Beetley

David di Donatello Awards, 1963

Won: *David, Best Foreign Film (Miglior, Film Straniero),* Darryl F. Zanuck

Golden Globes, USA, 1963

Won: *Golden Globe, Best Cinematography—Black and White,* Jean Bourgoin, Henri Persin, Walter Wottitz

National Board of Review, USA, 1962

Won: *NBR Award, Best Picture—English Language.*

LONG VOYAGE HOME, THE

Walter Wanger Productions, Argosy Productions, 1940, b&w, 105 minutes.

Producer: Walter Wanger; **Director:** John Ford; **Screenwriters:** Dudley Nichols, Eugene O'Neill; **Distributor:** United Artists; **Filmed in:** San Pedro, California; **Cast:** Billy Bevan, Ward Bond, Danny Borzage, Mary Aiken Carewe, Bing Conley, Lita Cortez, Jane Crowley, Carmen D'Antonio, Lowell Drew, Barry Fitzgerald, James Flavin, Constant Franke, Soledad Gonzales, David Hughes, Ian Hunter, J. M. Kerrigan, Guy Kingsford, Wilfrid Lawson, Judith Linden, Elena Martínez, Cyril McLaglen, Tina Menard, Art Miles, Thomas Mitchell, Carmen Morales, Mildred Natwick, Rafaela Ottiano, Lionel Pape, Jack Pennick, Bob Perry, John Qualen, Luanne Robb, Ky Robinson, Maureen Roden-Ryan, Constantine Romanoff, Joe Sawyer, Arthur Shields, Lee Shumway, Leslie Sketchley, Wyndham Standing, Roger Steele, Sammy Stein, Harry Tenbrook, Douglas Walton, Blue Washington, John Wayne, Harry Woods.

The freighter *Glencairn* is transporting high explosives from the West Indies to the United States during World War II. One of the sailors is John Wayne, who is saving his money to buy a farm in Sweden. The men smuggle women and booze on board to help them battle their greatest enemies: fear, loneliness, and suspicion. They fight with each other, spy on each other, comfort each other in the face of death, and rescue each other from danger. They survive an attack by a Nazi aircraft and an attempt to rob them in a waterfront bar, before they finally get their dangerous cargo to port.

The movie is based on Eugene O'Neill's *The Long Voyage Home; Seven Plays of the Sea* (New York: Modern Library, 1940).

INTERESTING FACT

- John Wayne was asked by director John Ford to play the part of Ole Olson, a Swede. Wayne wasn't sure he could pull off the Swedish accent and was worried that the audience would laugh. Ford persuaded Wayne to take the role.

LOST COMMAND

Columbia Pictures Corporation, Red Lion, 1966, color, 129 minutes.

Producer: Mark Robson; **Director:** Mark Robson; **Screenwriters:** Nelson Gidding, Jean Lartéguy; **Music:** Franz Waxman; **Cast:** Grégoire Aslan, Simon Benzakein, Jean-Claude Berq, Manuel de Blas, Marie Burke, Claudia Cardinale, Emilio Carrer, Mario De Barros, Alain Delon, Howard Hagan, René Havard, Gordon Heath, Walter Kelly, Bert Kwouk, Syl Lamont, Jacques Marin, Armand Mestral, Andrés Monreal, Michèle Morgan, Jean-Paul Moulinot, Al Mulock, Félix de Pomés, Anthony Quinn, Héctor Quiroga, Georges Rigaud, Roberto Robles, Maurice Ronet, Aldo Sambrell, Maurice Sarfati, George Segal, Jean Servais, Albert Simono, Robert Sutton, Carmen Tarrazo.

Anthony Quinn is a French paratroop commander who must surrender his surrounded and outnumbered command in Indochina. He is then sent to Algeria where France is once again fighting against rebel insurgents. George Segal is an Algerian who served with Quinn in Indochina and has returned to his native Algeria to fight with the rebels (and thus against his old comrade Quinn) after his parents are killed by French soldiers.

The war in Algeria (1954–1962) followed directly on the heels of the Indochina War (1946–1954) and the defeat at Dienbienphu, which resulted in France's losing Vietnam. The French were unwilling to lose a second colony and sent in more and more troops to combat the

National Liberation Front, a coalition of Algerian Muslim rebel groups that had rebelled against French rule. Finally, in 1962, France agreed to grant them their independence.

The movie is based on Jean Lartéguy's *The Centurions* (Paris: Presses de la Cité, 1960).

LOST PATROL, THE

RKO Radio Pictures Inc., 1934, b&w, 74 minutes.

Producers: Merian C. Cooper, John Ford, Cliff Reid; **Director:** John Ford; **Screenwriters:** Garrett Fort, Philip MacDonald, Dudley Nichols; **Filmed in:** Yuma, Arizona; **Cast:** Billy Bevan, Neville Clark, Reginald Denny, Francis Ford, Wallace Ford, Alan Hale, Paul Hanson, Brandon Hurst, Boris Karloff, J. M. Kerrigan, Victor McLaglen, Sammy Stein, Douglas Walton, Howard Wilson.

During World War I, a British army patrol crosses the Mesopotamian desert. Their commanding officer, the only one who knows their destination, is killed by a bullet fired by unseen bandits. Victor McLaglen, their sergeant, keeps them heading north on the assumption that they will run into their brigade. They stop for the night at an oasis and awake the next morning to find their horses stolen, their sentry dead, and the oasis surrounded. One by one, they are picked off. Only McLaglen is left alive when the relief column arrives.

The film is based on Philip MacDonald's *Patrol* (New York: Harper, 1928).

INTERESTING FACT

- The 1929 version of this film, instead of starring Victor McLaglen, starred his brother Cyril McLaglen.

MILITARY SERVICE

- Victor McLaglen actually served with the British Army in Mesopotamia during World War I, so he was very familiar with the setting and the action in this film.

LOST PLATOON, THE

Action International Pictures, 1989, color, 89 minutes.

Producer: Kimberley Casey; **Director:** David A. Prior; **Screenwriters:** David A. Prior, Ted Prior; **Distributor:** Action International Pictures; **Filmed in:** Alabama; **Cast:** William Knight.

An American reporter covering the civil war in Nicaragua comes across four young soldiers. He discovers that they are World War II veterans, but they haven't aged over the years, because they are now vampires.

MACARTHUR

Universal Pictures, 1977, color, 130 minutes.

Producer: Frank McCarthy; **Director:** Joseph Sargent; **Screenwriters:** Hal Barwood, Matthew Robbins; **Music:** Jerry Goldsmith; **Cast:** Lane Allan, Robert V. Barron, Ivan Bonar, Barry Coe, Everett Cooper, Ward Costello, Nicolas Coster, Charles Cyphers, Manuel DePina, Jesse Dizon, Warde Donovan, Marj Dusay, Ed Flanders, Art Fleming, John Fujioka, Jerry Holland, Russell Johnson, Philip Kenneally, Sandy Kenyon, Robert Mandan, John McKee, Walter O. Miles, Allan Miller, Dan O'Herlihy, Dick O'Neill, Gregory Peck, Gerald Peters, Eugene Peterson, Addison Powell, Beulah Quo, Branscombe Richmond, Alex Rodine, Tom Rosqui, Yuki Shimoda, Shane Sinutko, G. D. Spradlin, Fred Stuthman, Kenneth Tobey, Harvey Vernon, Garry Walberg, William Wellman Jr.

The film dramatizes the career of Gen. Douglas MacArthur (Gregory Peck), including his recall in 1942 from the Philippines by Franklin Roosevelt, his triumphant return to liberate that country from the Japanese as the Supreme Allied Commander, his influence on the Allies' postwar policies in Japan, his volatile relationship with Harry Truman, and finally his experiences as the U.N. commander during the Korean War, which resulted in his dismissal from the army by Truman.

INTERESTING FACTS

- It is inevitable that *MacArthur* would be compared to *PATTON*, the other military biopic produced by Frank McCarthy. *Patton* is a much more succinct, less ambitious film than *MacArthur*. It concentrates on its colorful, mercurial main character during a comparatively brief two-year period between the American defeat at Kasserine Pass in early 1943 to Patton's death in late 1945. *MacArthur* is a much more ambitious film, covering nearly a decade from the fall of Bataan in early 1942 to MacArthur's dismissal in 1951.
- Douglas MacArthur, and his father Arthur MacArthur, are the only instance of a father and son recipient of the Medal of Honor. His father received his during the Civil War.

QUOTE

General Douglas MacArthur (responding to restrictive attack orders): In all my 50 years of military service, I have never learned how to bomb HALF a bridge!

AWARD

Golden Globes, USA, 1978
 Nominated: *Golden Globe, Best Motion Picture Actor—Drama*, Gregory Peck.

MAD PARADE, THE

Liberty Pictures, 1931, b&w, 63 minutes.

Producer: M. H. Hoffman; **Director:** William Beaudine; **Screenwriters:** Frank Roland Conklin, Doris Malloy (also story, *Women Like Men*), Henry McCarty (as Henry McCarthy), Gertrude Orr (also story, *Women Like Men*); **Distributor:** Paramount; **Cast:** Evelyn Brent, June Clyde, Marceline Day, Louise Fazenda, Elizabeth Keating, Helen Keating, Irene Rich, Fritzi Ridgeway, Lilyan Tashman.

Eight nurses do their duty to help soldiers wounded in the trenches of World War I. One nurse commits suicide, another is killed by a fellow nurse she was harassing, and two others fight over the same man.

The movie is based on Gertrude Orr's story *Women Like Men* (New York: The Macaulay Company, 1926).

MALAYA

Metro-Goldwyn-Mayer, 1949, b&w, 98 minutes.

Producer: Edwin H. Knopf; **Director:** Richard Thorpe; **Screenwriters:** Manchester Boddy (story), Frank Fenton; **Music:** Malcolm Arnold, Bronislau Kaper; **Cast:** Joel Allen, Besmark Auelua, Lionel Barrymore, George M. Carleton, Silan Chan, Spencer Chan, Valentina Cortese, Joseph Crehan, Luther Crockett, Jack Davis, Carl Deloro, Carli Elinor, Roque Espiritu, David Fresco, Sydney Greenstreet, Vic Groves, Ben Hagerty, Herbert Heywood, John Hodiak, Anthony Jochim, DeForest Kelley, George Khoury, Paul Kruger, Eddie Lee, Uluao Letuli, Weaver Levy, Leon Lontoc, Richard Loo, Ian MacDonald, Peter Mamakos, Lester Matthews, Charles Meredith, Matt Moore, Anna Q. Nilsson, James O'Gatty, Alex Pope, Gilbert Roland, William Self, Jack Shea, Paul Singh, James Somers, James Stewart, Leon Stewart, Leonard Strong, James Todd, Spencer Tracy, Kula Tutiama, Robert Williams, Roland Winters.

Newspaperman Jimmy Stewart brings to the U.S. government his foolproof plan to obtain rubber by smuggling it out of Japanese-held Malaya, and convinces the government to let convicted smuggler James Cagney out of prison to help. At the beginning of World War II, the U.S. military war effort was desperate for rubber. While taking out the last load, Stewart is killed, and Cagney, even though he is wounded, finishes the job. The movie is based on a true story.

QUOTE

Jimmy Stewart (referring to his dead brother): He got stopped at Wake Island. I thought I'd take it the rest of the way.

MALTA STORY, THE

Theta, Rank Organisation, 1953, b&w, 97 minutes.

Producer: Peter De Sarigny; **Director:** Brian Desmond Hurst; **Screenwriters:** Nigel Balchin, William Fairchild; **Filmed in:** Malta; **Cast:** Ronald Adam, Renée Asherson, Ivor Barnard, Peter Bull, Hugh Burden, Rosalie Crutchley, Jerry Desmonde, Alec Guinness, Jack Hawkins, Victor Maddern, Michael Medwin, Muriel Pavlow, Flora Robson, Harold Siddons, Anthony Steel, Nigel Stock, Reginald Tate, Ralph Truman, Noel Willman.

In 1942, Britain clings to the island of Malta under the relentless attack of the Luftwaffe. During this campaign, a Royal Air Force reconnaissance photographer, whose job is to plot enemy movements, romances a local girl.

During World War II, the British defense of the 95-square-mile crown colony of Malta was critical, because from this island it was possible for the British, via the Royal Air Force, to control the central Mediterranean and to keep open critical Allied supply lines to North Africa.

MAN AT LARGE

20th Century-Fox, 1941, b&w, 70 minutes.

Producer: Ralph Dietrich; **Director:** Eugene Forde; **Screenwriter:** John Larkin; **Music:** Emil Newman; **Distributor:** 20th Century-Fox Film Corporation; **Cast:** George Chandler, Spencer Charters, George Cleveland, Jimmy Conlin, Elisha Cook Jr., Hal K. Dawson, Richard Derr, John Dilson, William Edmunds, Steven Geray, Ethel Griffies, Frank Hagney, Kurt Katch, Lenita Lane, Richard Lane, Lucien Littlefield, Spec O'Donnell, Milton Parsons, Barbara Pepper, George Reeves, Dick Rich, George Riley, Jack Roper, Bodil Rosing, Frank Thomas, Minerva Urecal, Marjorie Weaver.

During World War II, a German flier escapes from a POW camp in Canada and is pursued by a female newspaper reporter and an FBI agent.

MAN CALLED SARGE, A

Cannon Pictures, 1990, color, 88 minutes.

Producers: Gene Corman, Yoram Globus, Itzik Kol, Christopher Pearce; **Director:** Stuart Gillard; **Screenwriter:** Stuart Gillard; **Distributor:** Cannon Pictures; **Cast:** Josef Bee, Andrew Bumatai, Howard Busgang, Peter Dennis, Bobby Di Cicco, Yehuda Efroni, Chris England, Gretchen German, Andy Greenhalgh, Lior Hashin, Bruce Jenner, Zafrir Kohanovsky, Gary Kroeger, Don LaFontaine, Natasha Leon, Amikam Levi, Aviva Marks, Travis McKenna, Michael Mears, Alexander Peleg, Jennifer Runyon, Ofer Shikartsi, Gabi Shoshan, Marc Singer, Yuval Vill, Jeffry Wickham, Tomer Yoseph.

During World War II, a group of half-witted soldiers, led by a slightly smarter sergeant, battle the Germans in the desert.

MANCHURIAN CANDIDATE

M.C. Productions, 1962, b&w, 126 minutes.

Producers: George Axelrod, John Frankenheimer, Howard W. Koch (executive producer); **Director:** John Frankenheimer; **Screenwriters:** George Axelrod, Richard Condon (novel), John Frankenheimer; **Music:** David Amram; **Distributor:** United Artists; **Filmed at:** 67 Riverside Drive, 79th Street, New York City (Shaw's apartment interiors/exteriors); **Cast:** Joe Adams, Frank Basso, Mary Benoit, Whit Bissell, Nicky Blair, Merritt Bohn, Nick Bolin, Robert Burton, Evelyn Byrd, Lloyd Corrigan, Lana Crawford, Ray Dailey, Khigh Dhiegh, Mimi Dillard, Joan Douglas, James Edwards, Estelle Etterre, Mickey Finn, Bess Flowers, Lee Tung Foo, John Francis, Paul Frees, Ralph Gambina, Joe Gray, James Gregory, Tom Harris, Laurence Harvey, Maggie Hathaway, Douglas Henderson, Maye Henderson, Sam Kid Hogan, Harry Holcombe, John Indrisano, Miyoshi Jingu, Barry Kelley, Rita Kenaston, Helen Kleeb, Lou Krugg, Angela Lansbury, John Lawrence, Janet Leigh, Richard LePore, Tom Lowell, Mike Masters, John McGiver, Marquita Moll, Reggie Nalder, Frances E. Nealy, Karen Norris, Richard Norris, Leslie Parrish, Albert Paulsen, Julie Payne, Robert Riordan, Anna Shin, Henry Silva, Frank Sinatra, Ray Spiker, Madame Spivy, Irving Steinberg, Anton von Stralen, William Thourlby, Raynum K. Tsukamoto, Jean Vaughn, James Yagi.

After Laurence Harvey returns home from the Korean War with the Medal of Honor, the other members of his platoon cannot remember what he did to win his medal. Frank Sinatra starts having recurring nightmares about Korea, and this leads him to investigate Harvey's current activities. He discovers that Harvey has been brainwashed by the communists and programmed to carry out assassinations on command. At the last minute, Sinatra is able to stop him from killing a progressive candidate for president.

The film is based on Richard Condon's *The Manchurian Candidate* (New York: McGraw-Hill, 1959).

INTERESTING FACTS

- Senator Iselin's plane in real life was owned by Frank Sinatra.
- One scene was filmed at the bar and grill that Frank Sinatra's friend Jilly Rizzo owned in New York City.
- Jilly Rizzo played a cameo as bartender.
- Frank Sinatra broke one of his fingers in the fight sequence with Henry Silva.
- Angela Lansbury plays the lead character's mother, even though she is only three years older than him.
- All the members of the platoon in Korea are named after the cast and crew of *The Phil Silvers Show*, (1955).
- It took a full week to film the opening dream sequence. Director John Frankenheimer rushed a rough edit of the sequence to Sinatra, then decided to keep the cut in the final movie unchanged.
- In the scene where Frank Sinatra gives the all-queens deck of cards to Laurence Harvey, Sinatra is out of focus. Sinatra had trouble recreating his performance, so director John Frankenheimer left the footage as is. Audiences weren't bothered; they interpreted it as Laurence Harvey's blurred perspective.
- Images of Abraham Lincoln are everywhere (busts, paintings, portraits), alluding to the assassination.
- JFK was shot soon after this film was released, and the movie was pulled from circulation for over 20 years out of sensitivity.
- Frank Sinatra wanted Lucille Ball for the Angela Lansbury role.
- The film was considered too fantastic when it was released, but the subsequent assassinations of John F. Kennedy, Martin Luther King, and Robert Kennedy have made it all too probable.

QUOTES

Raymond Shaw: There are two kinds of people in this world: Those that enter a room and turn the televi-

sion set on, and those that enter a room and turn the television set off.

Dr. Yen Lo: His brain has not only been washed, as they say . . . it has been dry cleaned.

Dr. Yen Lo: I'm sure you've all heard the old wives' tale that no hypnotized subject may be forced to do that which is repellent to his moral nature, whatever that may be. Nonsense, of course.

AWARDS

Academy Awards, USA, 1962
Nominated: *Oscar, Best Film Editing*, Ferris Webster; *Best Supporting Actress*, Angela Lansbury

British Academy Awards, 1963
Nominated: *BAFTA Film Award, Best Film from Any Source—USA*

Golden Globes, USA, 1963
Won: *Golden Globe, Best Supporting Actress*, Angela Lansbury

National Board of Review, USA, 1962
Won: *NBR Award, Best Supporting Actress*, Angela Lansbury—also for her performance in *All Fall Down* (1962)

National Film Preservation Board, USA, 1994

National Film Registry

MAN FROM YESTERDAY, THE

Paramount Pictures, 1932, b&w, 71 minutes.

Director: Berthold Viertel; **Screenwriters:** Neil Blackwell, Roland G. Edwards, Oliver H. P. Garrett; **Cast:** Frank Atkinson, Yola d'Avril, Charles Boyer, Clive Brook, Emile Chautard, Claudette Colbert, Ronnie Cosby, George Davis, Andy Devine, Marie Donn, Boyd Irwin, Barbara Leonard, Greta Meyer, Alan Mowbray, Dennis O'Keefe, Reginald Pasch, Christian Rub, Donald Stuart, Barry Winton.

Clive Brook, who marries Claudette Colbert after a whirlwind romance right before leaving for the trenches of World War I, is captured and sent to a prisoner-of-war camp. Colbert, told that he was killed in action, meets a doctor to whom she becomes engaged. When Brook returns, he realizes that she is really in love with the doctor and nobly bows out of the picture.

MAN HUNT

20th Century-Fox, 1941, b&w, 105 minutes.

Producer: Kenneth Macgowan; **Director:** Fritz Lang; **Screenwriters:** Geoffrey Household (novel, *Rogue Male*), Dudley Nichols; **Music:** Alfred Newman; **Distributor:** 20th Century-Fox; **Cast:** Charles Bennett, Joan Bennett, Frank Benson, Walter Bonn, Swen Hugo Borg, Egon Brecher, John Carradine, Cyril Delevanti, Carl Ekberg, Herbert Evans, Richard Fraser, Arno Frey, Douglas Gerrard, William Haade, Bobbie Hale, Holmes Herbert, Keith Hitchcock, Olaf Hytten, Roger Imhof, Hans Joby, Kurt Krüger, Bruce Lester, Adolf E. Licho, Eily Malyon, Lester Matthews, Roddy McDowall, Virginia McDowall, Adolph Milar, Carl Ottmar, Walter Pidgeon, Lucien Prival, Otto Reichow, John Rogers, George Sanders, Clifford Severn, Bob Stephenson, Ludwig Stössel, Heather Thatcher, Frederick Vogeding, Frederick Worlock.

Walter Pidgeon plays a big-game hunter who enters Bavaria on vacation and gets Hitler in his sights, just to prove to himself that he can do it. He is concentrating so much on the gun sight that he doesn't notice the guards coming up behind him. He is captured, beaten, and tortured, but they don't believe his story. He escapes back to England, where the tables are turned; he is now the hunted, not the hunter. Finally eluding the Nazi agents who are after him, he heads back to Germany, to finish the job.

The movie is based on Geoffrey Household's *Rogue Male* (Boston: Little, Brown and Company, 1939).

MAN I KILLED, THE

Paramount Pictures, 1932, b&w, 76 minutes.

Director: Ernst Lubitsch; **Screenwriters:** Reginald Berkeley, Samson Raphaelson, Maurice Rostand (play), Ernest Vajda; **Music:** W. Franke Harling; **Distributor:** Paramount Pictures; **Cast:** Lionel Barrymore, George Bickel, Nancy Carroll, Louise Carter, George Davis, Tom Douglas, Emma Dunn, Ed Eberle, Lillian Elliott, Henry Fifer, Julia Swayne Gordon, Phillips Holmes, George Irving, Lucien Littlefield, Tully Marshall, Rod McLennan, Torben Meyer, Reginald Pasch, ZaSu Pitts, Frank Sheridan, Joan Standing, Marvin Stephens, Anton Vaverka.

A young French soldier in World War I is overcome with guilt when he kills a German soldier, who, like himself, is a musically gifted conscript. They had both

attended the same musical conservatory in France. The fact that the incident occurred in battle does not assuage his feelings of remorse. He travels to Germany to meet the man's family, but he tells them only that he knew their son; he doesn't reveal that he is the one that killed him. The father (Lionel Barrymore) in particular feels guilty, because he was caught up in the glory of the waving flags and the marching bands, and encouraged his son to march off to war. When their son's fiancée, who now lives with them, discovers the truth, she urges him not to tell the parents, since his visit has brought the grief-stricken family some relief. When a firebrand in town, a rejected suitor of the fiancée, tries to stir up resentment against the young visitor, Lionel Barrymore comes to his defense, arguing pointedly that this sort of prejudice is what started the last war and resulted in the loss of so many young men. The movie is also known as *Broken Lullaby*.

MILITARY SERVICE

- Ironically, Phillips Holmes, who played the young French soldier in this pacifist film, was killed in action in 1942 during World War II, while serving with the Royal Canadian Air Force.

MANILA CALLING

20th Century-Fox, 1942, b&w, 81 minutes.

Producer: Sol M. Wurtzel; **Director:** Herbert I. Leeds; **Screenwriter:** John Larkin; **Distributor:** 20th Century-Fox Film Corporation; **Cast:** Ralph Byrd, Ken Christy, Elisha Cook Jr., James Gleason, Louis Jean Heydt, Harold Huber, Martin Kosleck, Carole Landis, Lester Matthews, Lloyd Nolan, Ted North, Rudy Robles, Charles Tannen, Cornel Wilde, Victor Sen Yung.

Lloyd Nolan leads a group of American and Filipino guerrillas fighting the Japanese during World War II. He helps Cornel Wilde set up a radio transmitter to counteract the invader's propaganda.

MAN I MARRIED, THE

20th Century-Fox, 1940, b&w, 77 minutes.

Producers: Raymond Griffith (associate producer), Darryl F. Zanuck; **Director:** Irving Pichel; **Screenwriters:** Oscar Schisgall (novel, *Swastika*), Oliver H. P. Garrett; **Music:** David Buttolph; **Distributor:** 20th Century-Fox; **Cast:** Rudolph Anders, Joan Bennett, Walter Bonn, Eugene Borden, Egon

Brecher, Glen Cavender, Harry Depp, Ernst Deutsch, Diane Fisher, Arno Frey, Carl Freybe, Rudy Frolich, Albert Geigel, John Hiestand, Leyland Hodgson, Charles Irwin, Willy Kaufman, Otto Kruger, Francis Lederer, Greta Meyer, Thomas Mizer, Hans von Morhart, Lloyd Nolan, Maria Ouspenskaya, Lillian Porter, Ragnar Qvale, Frank Reicher, Lionel Royce, Johnny Russell, Hans Schumm, John Stark, Anna Sten, Ludwig Stössel, Frederick Vogeding, Eleanor Wesselhoeft, Lillian West, William Yetter Sr.

Joan Bennett travels to prewar Nazi Germany with her husband and young son. She is repulsed by what she sees, but her husband, a German-American, is enthralled and decides to join the party and raise their child as a Nazi. She decides to escape the country with her young son.

MAN IN THE GRAY FLANNEL SUIT, THE

20th Century-Fox, 1956, color, 153 minutes.

Producer: Darryl F. Zanuck; **Director:** Nunnally Johnson; **Screenwriters:** Nunnally Johnson, Sloan Wilson (novel); **Music:** Bernard Herrmann; **Distributors:** 20th Century Fox Film Corporation; **Cast:** Dorothy Adams, Leon Alton, Mary Benoit, Robert Boon, Jim Brandt, John Breen, Alfred Caiazza, Alexander Campbell, Ruth Clifford, Lee J. Cobb, Tristram Coffin, John Crawford, Henry Daniell, Sandy Descher, Connie Gilchrist, Paul Glass, Roy Glenn, Phyllis Graffeo, Lee Graham, Jerry Hall, Ann Harding, Michael Jeffries, Jennifer Jones, DeForest Kelley, Harry Lauter, Gene Lockhart, King Lockwood, Mickey Maga, Fredric March, Nan Martin, Portland Mason, Jack Mather, Arthur O'Connell, Marisa Pavan, Gregory Peck, Gigi Perreau, Dorothy Phillips, William Phillips, William Phipps, Otto Reichow, Mario Siletti, Lomax Study, Joseph Sweeney, Kenneth Tobey, Renata Vanni, Geraldine Wall, Frank Wilcox, Raymond Winston, Keenan Wynn.

Gregory Peck's experiences as a paratrooper are told in flashback as he struggles to succeed on Madison Avenue. The stress of combat in World War II resulted in a romance with a young Italian girl (Marisa Pavan), who bore him a son, the revelation of which causes conflict in his marriage to Jennifer Jones. However, his wartime experiences have also made him a tough negotiator, and he is ultimately able to land a prestigious and well-paying job with a major broadcasting company. Despite his detractors within the company, he is able to impress the president, Fredric March, with his abilities.

Cannes Film Festival
 Won: *OCIC Award—Special Mention*, Nunnally Johnson.

MAN IN THE MIDDLE

Belmont, Pennebaker Productions, Talbot Productions Inc., 1964, b&w, 94 minutes.

Producer: Max E. Youngstein; **Director:** Guy Hamilton; **Screenwriter:** Howard Fast; **Music:** John Barry, Lionel Bart; **Distributor:** 20th Century-Fox Film Corporation; **Cast:** Jared Allen, David Bauer, Glenn Beck, Ed Bishop, Julian Burton, Gary Cockrell, Terence Cooper, Michael Goodliffe, Trevor Howard, Errol John, Alexander Knox, Howard Marion-Crawford, Paul Maxwell, Robert Mitchum, Lionel Murton, Russell Napier, Robert Nichols, France Nuyen, Barry Sullivan, Edward Underdown, Sam Wanamaker, Al Waxman, Keenan Wynn.

An American lieutenant, who could be insane, shoots and kills a British sergeant in India at the end of World War II.
 The movie is based on Howard Fast's *The Winston Affair* (New York: Crown Publishers, 1959).

MAN WHO NEVER WAS, THE

Sumar Film, 1956, color, 103 minutes.

Producer: André Hakim, Bob McNaught; **Director:** Ronald Neame; **Screenwriters:** Nigel Balchin, Ewen Montagu; **Distributor:** 20th Century-Fox; **Cast:** Ronald Adam, Gordon Bell, Stephen Boyd, Michael Brill, Robert Brown, D. A. Clarke-Smith, Cyril Cusack, Allan Cuthbertson, Robert Flemyng, Wolf Frees, Gloria Grahame, Everley Gregg, Josephine Griffin, Joan Hickson, Michael Hordern, Geoffrey Keen, Moultrie Kelsall, Lloyd Lamble, Terence Longdon, Miles Malleson, Gibb McLaughlin, Ewen Montagu, André Morell, Laurence Naismith, Brian Oulton, Cicely Paget-Bowman, Gerhard Puritz, William Russell, Peter Sellers, William Squire, Richard Wattis, Clifton Webb, John Welsh, Peter Williams.

During World War II, British intelligence wants to trick the German high command into believing that the upcoming Allied invasion, which the Nazis know is in preparation because of the massive buildup, is not going to happen in Sicily but is actually going to occur in a different theater of operations. They obtain a dead body, dress it in the uniform of a British officer, create personal papers to make the body seem authentic, and plant on the body documents that will convince the Germans that the Allies are preparing to invade Sardinia and Greece. They then throw the body into the sea off the coast of Spain, knowing that after it floats ashore the Spanish authorities will pass the papers on to the Germans.
 This film is based on a book, the true story of Operation Mincemeat: Ewen Montagu's *The Man Who Never Was* (Philadelphia: Lippincott, 1954).

INTERESTING FACT

- Ewen Montagu, the real-life officer who was in charge of Operation Mincemeat, has a small cameo role as an air marshal.

QUOTES

Lt. George Acres [watching a display of dropping supplies by parachute]: Monty, that parachute that didn't open . . . suppose we were to drop a fellow out of a plane over enemy territory, with papers on him saying we were going to invade Greece, and his parachute didn't open. The Germans would find him dead, and the papers, and aha, they'd say, look at this. Officer with secret papers, parachute didn't open . . . they're going to invade Greece.
Lt. Cmdr. Ewen Montagu: Do we tell the man who jumps that the parachute doesn't work, or is it a sort of practical joke that he finds out on the way down?
Lt. George Acres: Well, of course it would have to be somebody you didn't mind much about.
Lt. Cmdr. Ewen Montagu: Are you volunteering? No, George, it wouldn't work.
Lt. George Acres: What about using a man already dead?
Lt. Cmdr. Ewen Montagu: The autopsy would show he was dead before he hit the ground. Let's get back to the office and think again.

Lt. Cmdr. Ewen Montagu: Suppose I wanted to put a dead body in the sea and let it float ashore, and have it accepted by the people who find it as the victim of an air crash at sea. What sort of body would I need?

MARCH OR DIE

March or Die Associates, Incorporated Television Company, 1977, color, 104 minutes.

Producers: Jerry Bruckheimer, Dick Richards; **Director:** Dick Richards; **Screenwriters:** Edward Di Lorenzo, David Zelag Goodman; **Music:** Maurice Jarre; **Distributor:** Columbia Pictures; **Filmed at:** Imperial County, California; **Cast:** Paul Antrim, Maurice Arden, Luis Barboo, Gigi Bonos, Marcel Bozzuffi, Eve Brenner, Jean Champion, Guy Deghy, Catherine Deneuve, Arnold Diamond, Vernon Dobtcheff, Walter Gotell, Gene Hackman, Terence Hill, Ian Holm, Wolf Kahler, Lila Kedrova, Guy Mairesse, Marne Maitland, Guy Marly, Ernest Misko, Margaret Modlin, Elisabeth Mortensen, Jack O'Halloran, André Penvern, Jean Rougerie, Liliane Rovère, Leila Shenna, Paul Sherman, Max von Sydow, François Valorbe, Catherine Wilmer, Albert Woods.

Major William Sherman Foster (Gene Hackman) was kicked out of West Point but then rose in the French Foreign Legion to obtain a command of Legionnaires after the end of World War I. His troops have been ordered to accompany an archaeological expedition traveling to Morocco, headed by Francois Marneau (Max von Sydow). Foster's motley band includes an on-the-lam cat burglar named Marco Segrain (Terence Hill), an ex-guardsman from the deposed Russian monarchy named Ivan (Jack O'Halloran), an adventure-seeking aristocrat named Fred Hastings (Paul Sherman), and an alluring beauty named Simone Picard (Catherine Deneuve). As the band makes its way to Morocco, they cross paths with the fervid and bloodthirsty Arab leader El Krim (Ian Holm), who vows to unite his people to expel foreigners from their land. Foster's command occupies a small village where the archaeologists believe they've found a burial site sacred to the Arabs. The Arab leader (Holm) uses this alleged affront to unite the tribes in jihad and attacks the tiny garrison of Legionnaires at the dig.

The French Foreign Legion was founded on March 10, 1831. Composed exclusively of volunteers aged between 18 and 40, with or without means of identification, the Legion was immediately involved in the conquest of Algeria. No knowledge of French is required to join. Since 1831, 902 officers, 3176 NCOs, and over 30,000 Legionnaires have died for France, one-third of them while fighting directly for the defense of the country. Foreigners by birth, the Legionnaires have become Frenchmen by the blood they have spilled. Although the Legion has served in every French war and in every part of the world, from Mexico to Indochina to Norway, it is most closely associated in the public mind with desert campaigns.

MARINE RAIDERS

RKO Radio Pictures Inc., 1944, b&w, 90 minutes.

Producer: Robert Fellows; **Director:** Harold D. Schuster; **Screenwriter:** Warren Duff; **Music:** Roy Webb; **Cast:** Robert Anderson, Harry Brown, Cliff Clark, William Forrest, Edmund Glover, Ruth Hussey, Selmer Jackson, Barton MacLane, Richard Martin, Frank McHugh, Pat O'Brien, Stanley Price, Robert Ryan, Michael St. Angel, John Sheehan, Martha Vickers, Russell Wade.

Pat O'Brien is a major and Robert Ryan a captain of the First Raider Battalion in the fight for Guadalcanal. Sent to Australia to retrain and refit, Ryan falls in love with Ruth Hussey, but O'Brien disapproves and tries to break up the romance. In spite of the superior officer's efforts, Ryan and Hussey are able to marry. The two officers are reconciled when they go back into combat to take another Japanese-held island.

Relevant to this movie is the description of the battle of Guadalcanal in the film *GUADALCANAL DIARY*. *Marine Raiders* is loosely based on the exploits of Merritt A. "Red Mike" Edson, leader of the First Raider Battalion and First Parachute Battalion. On September 13, 1942, he and his unit stood firm against a Japanese attack on Guadalcanal that threatened to throw the American invasion back into the sea. He later made assaults on Japanese-held islands in the Pacific.

MARINES, LET'S GO

20th Century-Fox, 1961, color, 103 minutes.

Producer: Raoul Walsh; **Director:** Raoul Walsh; **Screenwriters:** John Twist, Raoul Walsh; **Distributor:** 20th Century-Fox Film Corporation; **Cast:** Steve Baylor, David Brandon, Adoree Evans, Fumiyo Fujimoto, David Hedison, Linda Hutchins, Hideo Inamura, Peter Miller, Henry Okawa, Tom Reese, Barbara Stuart, Tom Tryon, William Tyler, Vince Williams.

A war-weary platoon of U.S. Marines is pulled out of the front lines during the Korean War and sent to Japan for rest and recreation. Rejuvenated, they return to the front lines and a major battle.

MARINES ARE COMING, THE

Mascot Pictures Corporation, 1935, b&w, 70 minutes.

Producer: Nat Levine; **Director:** David Howard; **Screenwriters:** Colbert Clark, James Gruen, John

Rathmell; **Cast:** Smiley Burnette, Allan Cavan, Gino Corrado, Joe Dominguez, William Haines, Hale Hamilton, Dell Henderson, Edgar Kennedy, Yancey Lane, Frank Leyva, Chris-Pin Martin, Conrad Nagel, Broderick O'Farrell, Esther Ralston, George Regas, Harry Semels, Michael Visaroff, Wes Warner.

William Haines loses his commission in the U.S. Marine Corps, and he promptly reenlists as a private. When his unit is sent to Nicaragua to fight the rebel leader Sandino, he encounters the captain who was responsible for his disgrace and who has also become his rival for the love of a girl.

The movie refers to the Nicaraguan civil war of 1925–1933. After a coup d'état on October 25, 1925, which deposed the democratically elected officials in Nicaragua, Gen. Augusto Sandino lead a revolution to restore the freely elected government. However, when the revolutionaries seized American property, the United States responded by sending in gunboats and marines to restore order. Soon, Sandino was fighting both the government in power and America, a combined alliance he could not defeat. After the United States imposed an election, which brought the liberal Moncada to power, Sandino was offered amnesty, and when he returned to Nicaragua, he was murdered in 1934. In this film, he is erroneously portrayed as a bandit; in reality he was a revolutionary.

MARINES ARE HERE, THE

Monogram Pictures Corporation, 1938, b&w, 60 minutes.

Producer: Scott R. Dunlap; **Director:** Phil Rosen; **Screenwriters:** J. Benton Cheney, Jack Knapp, Charles Logue (story), Edwin C. Parsons (story); **Cast:** Wade Boteler, Ronnie Cosby, Billy Dooley, Earl Douglas, Edward Earle, Pat Gleason, Marjorie Kane, Gordon Oliver, John Picorri, Harry Semels, June Travis, Ray Walker, Charles Williams, Guinn Williams, Duke York, Carleton Young.

Gordon Oliver is a U.S. Marine who must change his ways in order to succeed in the corps, while his unit battles a bandit stronghold.

MARINES COME THRU, THE

Astor Pictures Corporation, 1943, b&w, 65 minutes.

Producer: George A. Hirliman; **Director:** Louis J. Gasnier; **Screenwriters:** Jack Kofoed, D. S. Leslie,

Lawrence Meade; **Distributor:** Astor Pictures Corporation; **Cast:** Bill Baird, Michael Doyle, Roy Elkins, Wallace Ford, Beth Hayes, Don Lanning, Sheila Lynch, Thomas McKeon, James Neary, Frank Rasmussen, William Tubby Rives, Toby Wing, Grant Withers.

Wallace Ford is a U.S. Marine who stops evil Nazi agents from stealing a top-secret bomb sight.

MARINES FLY HIGH, THE

RKO Radio Pictures Inc., 1940, b&w, 68 minutes.

Producers: Lee S. Marcus (executive producer) (as Lee Marcus), Robert Sisk; **Directors:** George Nichols Jr., Benjamin Stoloff (as Ben Stoloff); **Screenwriters:** A. J. Bolton (as Lt. Cmdr. A. J. Boulton), Jerome Cady (as Jerry Cady), A.C. Edington (story); **Music:** Louis Betancourt (native music); **Distributor:** RKO; **Cast:** Lucille Ball, Abner Biberman, Richard Dix, Steffi Duna, John Eldredge, Kirby Grant, Paul Harvey, Dick Hogan, Selmer Jackson, Ethan Laidlaw, Horace McMahon, Chester Morris, Nestor Paiva, John Sheehan, Ann Shoemaker.

Richard Dix leads U.S. Marines who are sent to Nicaragua, where a band of outlaws roam the countryside robbing, killing, and fomenting revolution. When a new marine pilot, Chester Morris, arrives at the camp, he competes with Dix for the attentions of beautiful Lucille Ball, who lives at a nearby cocoa plantation. When she is captured by the bandits, the marines must go into action to rescue her.

This movie relates to the Nicaraguan civil war of 1925–1933 as shown in *THE MARINES ARE COMING*. The "outlaws" are actually the revolutionary forces under General Sandino.

INTERESTING FACT

- Ben Stoloff took over direction of the film when George Nicholls Jr. was killed in an automobile accident during production.

M*A*S*H

Ingo Preminger Productions, 20th Century-Fox, Aspen Productions, 1970, color, 116 minutes.

Producers: Leon Ericksen, Ingo Preminger; **Director:** Robert Altman; **Screenwriters:** Richard Hooker,

Ring Lardner Jr.; **Music:** Mike Altman, Johnny Mandel; **Distributor:** 20th Century-Fox Film Corporation; **Cast:** Stephen Altman, David Arkin, Indus Arthur, Kim Atwood, Rene Auberjonois, Roger Bowen, Timothy Brown, Tommy Brown, Buck Buchanan, Gary Burghoff, Jack Concannon, Michael Consoldane, Cathleen Cordell, Bud Cort, Dawne Damon, Ben Davidson, J. B. Douglas, Robert Duvall, Tom Falk, Corey Fischer, Danny Goldman, Carl Gottlieb, Elliott Gould, Sumi Haru, Susan Ikeda, Dale Ishimoto, Jerry Jones, Sally Kellerman, Ted Knight, Harvey Levine, Weaver Levy, John Mamo, Marvin Miller, Michael Murphy, John Myers, H. Lloyd Nelson, Monica Peterson, Jo Ann Pflug, Ken Prymus, Masami Saito, John Schuck, Samantha Scott, Tom Skerritt, Noland Smith, Donald Sutherland, Fran Tarkenton, Bobby Troup, Diane Turley, Sal Viscuso, Hiroko Watanabe, Tamara Wilcox-Smith, Howard Williams, Fred Williamson, G. Wood, Tom Woodeschick, Yoko Young.

MASH is the U.S. Army acronym for Mobile Army Surgical Hospital. Korea was the first war in which the army had the helicopter available for battlefield evacuation of wounded soldiers. That's where two young, crack surgeons, but lousy officers, Trapper John (Elliott Gould) and Hawkeye (Donald Sutherland), end up during the Korean War. They deal on a daily basis with the carnage of the war, which they relieve by a series of hijinks. Their escapades include getting rid of the idiotic Major Burns, helping the camp dentist to commit suicide, making a trip to Tokyo to operate on a congressman's son and play a little golf, and unearthing the secret of whether the head nurse (Hot Lips Houlihan) is a natural blonde.

The real-life MASH unit on which the movie was based continued to serve in Korea until the 1990s. A special ceremony was held when it was decommissioned, and Larry Gelbart, the producer of the television series (and the author's mentor), traveled to Korea for the ceremony.

*M*A*S*H* (20TH CENTURY-FOX/AUTHOR'S COLLECTION)

The film is based on Richard Hooker's *M*A*S*H** (New York: Morrow, 1968). The author served with a MASH unit in Korea.

INTERESTING FACTS

- Gary Burghoff played the same character, Radar O'Reilly, in both the film and television series.
- Roger Bowen, who played Lt. Col. Henry Blake, died of a heart attack on February 16, 1996. The day before that, February 15, McLean Stevenson, who played Lt. Col. Henry Blake on the TV series, died of the same cause.
- Robert Altman's son, Mike Altman, wrote the lyrics to the theme song at age 14. The song *Suicide Is Painless*, is sung with words in the film, but only the musical score is used in the television show.
- Note the scene in which Painless the dentist is contemplating suicide and Hawkeye and the gang throw him a farewell supper. Watch this scene and hold up a copy of Da Vinci's the *Last Supper*; you'll notice that the scene is a spoof of Christ's last meal.

MILITARY SERVICE

- Director Robert Altman trained as an army bomber pilot during World War II and flew 46 missions in the Dutch East Indies. He stated in an interview that it never occurred to him that he was killing people, and he doubted that it would have bothered him if it had.

MISTAKES

- Note the cars on a freeway in the background of the football game.
- Trapper John can be heard as a surgeon in the O.R. prior to his arrival at the camp.
- Lieutenant Dish can be seen in the jeep at the chopper pad ready to leave when Hot Lips first arrives, even though she appears in a later sequence.

QUOTES

Major Houlihan: I wonder how such a degenerated person ever reached a position of authority in the Army Medical Corps!
Father Mulcahy: He was drafted.

Hot Lips Houlihan [yelling at Colonel Blake]: This isn't a hospital! It's an insane asylum! And it's your fault!

Last line of the film, delivered by a disgusted soldier: God damn army.

AWARDS

Academy Awards, USA, 1970
Won: *Oscar, Best Writing, Screenplay Based on Material from Another Medium*, Ring Lardner Jr.
Nominated: *Oscar, Best Director*, Robert Altman; *Best Film Editing*, Danford B. Greene; *Best Picture*, Ingo Preminger; *Best Supporting Actress*, Sally Kellerman

American Cinema Editors, USA, 1971
Nominated: *Eddie, Best Edited Feature Film*, Danford B. Greene

British Academy Awards, 1971
Won: *UN Award*
Nominated: *BAFTA Film Award, Best Actor*, Elliott Gould; *Best Direction*, Robert Altman; *Best Film*; *Best Film Editing*, Danford B. Greene; *Best Sound Track*, David Dockendorf, Bernard Freericks, Don Hall

Cannes Film Festival, 1970
Won: *Golden Palm*—Robert Altman

Golden Globes, USA, 1971
Won: *Golden Globe, Best Motion Picture—Musical/Comedy*
Nominated: *Golden Globe, Best Motion Picture Actor—Musical/Comedy*, Elliott Gould, Donald Sutherland; *Best Motion Picture Director*, Robert Altman; *Best Screenplay*, Ring Lardner Jr.; *Best Supporting Actress*, Sally Kellerman

National Film Preservation Board, USA, 1996

National Film Registry

National Society of Film Critics Awards, USA, 1971
Won: *NSFC Award, Best Film*

Writers Guild of America, USA, 1971
Won: *WGA Screen Award, Best Comedy Adapted from Another Medium*, Ring Lardner Jr.

MASTER RACE, THE

RKO Radio Pictures Inc., 1944, b&w, 95 minutes.

Producers: Edward A. Golden, Robert Golden; **Director:** Herbert J. Biberman; **Screenwriters:** Herbert J. Biberman, Anne Froelich, Rowland Leigh; **Distributor:** RKO Radio Pictures Inc.; **Cast:** Axel Anderson, Helen Beverly, George Blagoi, Sammy Blum, Ernst Brengt, Lloyd Bridges, Morris Carnovsky,

Harry Clay, Naum Coster, George Coulouris, Jack Davis, Ludwig Donath, Carl Esmond, Eric Feldary, Nancy Gates, Paul Guilfoyle, Hans Hopf, Russell Hopton, Virgil Johanson, Jimmy Jordan, Paul Kruger, Charles Legneur, Gabriel Lenoff, Max Linder, Marie Lund, Eric Mack, William Martin, Osa Massen, Frank Mayo, Rene Mimieux, Bert Moorhouse, Gavin Muir, John Mylong, Richard Nugent, Gigi Perreau, Stanley Ridges, Jason Robards Sr., Albin Robeling, Bob Robinson, Merrill Rodin, Herbert Rudley, Walter Soderling, Fred O. Sommers, Bob Stevenson, Helen Thimig, Alan Ward, Bryant Washburn.

When Allied troops liberate the small battle-scarred Belgian town of Kolar in 1944, the Americans do all they can to help the war-weary people back on their feet. There are mental and physical wounds to heal, fields to plow, a church to rebuild. But a top Nazi, knowing the war is lost, has infiltrated the town posing as a patriot and is fostering hatred, dissent, and disunity. He is one of a large coterie of Nazi officers who have gone into hiding to promote their ideology in postwar Europe. However, he and his evil plot are exposed.

INTERESTING FACT

- This film was completed soon after D day and paints a picture of the future in which Nazi Germany is quickly defeated. From a historical perspective, it is interesting to see this perception of the American people at this point in history. There was no conception that the Nazis would launch their major counteroffensive, now know as the Battle of the Bulge, or that they would hold out until Berlin was in ruins.

MATA HARI

Cannon Group, 1985, color, 103 minutes.

Producers: Yoram Globus, Menahem Golan, Rony Yacov; **Director:** Curtis Harrington; **Screenwriter:** Joel Ziskin; **Music:** Wilfred Josephs; **Distributors:** U.G.C. Worldwide Distribution, Cannon Films, Metro-Goldwyn-Mayer; **Filmed in:** Hungary; **Cast:** Michael Anthony, Brian Badcoe, Márta Bakó, Emese Balogh, László Baranyi, János Bata, Ferenc Bencze, Teréz Bod, Gaye Brown, Christopher Cazenove, Erzsi Cserhalmi, Julia Cziraky, Magda Darvas, Vernon Dobtcheff, Ágnes Dávid, Laszlo Farkas, William Fox, Erzsi Galambos, Odon Gyalog, István Hunyadkürthy, Vilmos Izsóf, Csaba Jakab, Gottfried John, Vilmos Kolba, Laszló Konter, Sylvia Kristel, Géza Laczkovich, Victor Langley, Tutte Lemkow, Derek de Lint, Georg Maday, Lajos Mezey, Ildikó Molnár, András Márton, Gábor Nagy, Anthony Newlands, László Németh, Ferenc Némethy, Gábor Reviczky, Neil Robinson, Tobias Rolt, Taylor Ryan, Nicholas Selby, Carlos Sutton, Székely, Malcolm Terris, Oliver Tobias, László Ujlaky, Mátyás Usztics, Károly Vogth.

After beautiful dancer Mata Hari is framed for a murder on the train to Berlin, the Germans force her to spy for them during World War I. She is subsequently arrested by the French in Paris, and they turn her into a double agent. When the French catch her in a plot to blow up important French military officers, she is executed by a firing squad.

The movie is about the most famous female spy of World War I. Mata Hari's (1876–1917) real name was Margaretha Zelle. As a Dutch dancer in Paris, she became the confidante of many top-ranking officers and passed vital military information she acquired to the Germans. When the French discovered her secret, she was executed as a spy.

McCONNELL STORY, THE

Warner Bros., 1955, color, 106 minutes.

Producer: Henry Blanke; **Director:** Gordon Douglas; **Screenwriters:** Sam Rolfe, Ted Sherdeman (also story); **Music:** Max Steiner; **Cast:** June Allyson, Willis Bouchey, Robert Ellis, Frank Faylen, Frank Ferguson, Frank Gerstle, Dabbs Greer, Alan Ladd, Perry Lopez, Vera Marshe, John Pickard, Edward Platt, Sarah Selby, Tito Vuolo, Gregory Walcott, O. P. Weyland, James Whitmore.

Alan Ladd plays an unlikely hero. Despite washing out of medical school and nearly being bounced out of navigator school for being AWOL during World War II, it is only with the onset of the Korean War and his qualification as a jet pilot that he rises to become the first triple ace (you become an ace with five confirmed victories) for the United States.

This is the true story of Captain Joseph McConnell Jr., America's first triple jet ace. Starting in the medical corps as an enlisted soldier during World War II, he eventually became a navigator and flew 25 combat missions. It is only in Korea that he flew as a pilot. After the war, he became a military test pilot and was killed while testing an experimental jet plane at Edwards Air Force Base.

INTERESTING FACT

- In Korea, America learned that the only edge it had in aerial combat was in numbers and training. The MiG-15 was superior to anything the United States had developed at that time. Modern audiences may find it difficult to believe that America was actually behind the power curve in jet design and performance in the early 1950s.

MISTAKE

- During World War II, a character disembarks from a C-47 transport that is clearly marked USAF. The United States Air Force was not created until 1947, two years after the war ended.

McHALE'S NAVY

Universal Pictures, 1964, color, 93 minutes.

Producers: Edward Montagne, Si Rose; **Director:** Edward Montagne; **Screenwriters:** George Carleton Brown, Frank Gill Jr., Si Rose; **Music:** Jerry Fielding; **Filmed in:** Barra de Navidad and Manzanillo, Mexico; **Cast:** Carl Ballantine, Ernest Borgnine, Tim Conway, Joe Flynn, Bob Hastings, Marcel Hillaire, Dale Ishimoto, George Kennedy, Claudine Longet, Gavin MacLeod, John Mamo, Billy Sands, Edson Stroll, Gary Vinson, Jean Willes, John Wright, Yoshio Yoda.

The crew of *PT-73* get into trouble when they back the wrong horse in a race. Now they have to come up with a way to raise the money to pay off the winners.

INTERESTING FACT

- This film reunites the cast of the popular TV series *McHale's Navy* in a feature-length film.

McHALE'S NAVY

Sheinberg Productions, The Bubble Factory, 1997, color, 108 minutes.

Producer: Tom Arnold, Conrad Hool, Lance Hool, Perry Katz, Bill Sheinberg, Jonathan Sheinberg, Sid Sheinberg; **Director:** Bryan Spicer; **Screenwriters:** Peter Crabbe, Andy Rose; **Music:** Dennis McCarthy; **Distributor:** Universal Pictures; **Cast:** Tom Arnold, Tom Ayers, Anthony Azizi, Ernest Borgnine, Bruce Campbell, Eric Champnella, Henry Cho, Tommy Chong, Scott Cleverdon, Alex Cole, Anthony Jesse Cruz, Tim Curry, David Alan Grier, Brian Haley,

Luisa Huertas, Joe Keyes, Tomás Leal, Luis Lemus, Honorato Magaloni, Francisco Mauri, Debra Messing, Joe Minjares, Lucy Moreno, Mineko Mori, Fima Noveck, John Pyper-Ferguson, Juan Rebolledo, Alejandro Reyes, Eduardo López Rojas, Guillermo Ríos, Robert Schuch, Bryan Spicer, French Stewart, Dean Stockwell, Danton Stone, Diego Vasquez.

Retired Lt. Cmdr. Quinton McHale (Tom Arnold) spends his days puttering around the Caribbean in the old *PT-73* selling home-brew, ice cream, and swimsuit calendars. He's brought out of retirement when his old nemesis, Major Vladikov (Tim Curry), takes over the island of San Moreno and starts building a nuclear launch silo. With help from his old crew and hindrance from the annoying Capt. Wallace B. Binghampton (Dean Stockwell), McHale sets out to stop Vladikov.

INTERESTING FACT

- This is another film based on the popular TV series *McHale's Navy*, but this time it was done many years later and without the original cast.

QUOTES

Capt. Wallace B. Binghampton: Did we wake you up?
Willie: No sir, we've been up since the crack of noon.
Lt. Cmdr. Quinton McHale: Remember to try tonight's drink special: Stolen Vodka Surprise. We stole Vladikov's vodka. Surprise!

McHALE'S NAVY JOINS THE AIR FORCE

Universal Pictures, 1965, color, 90 minutes.

Producers: Edward Montagne, Si Rose; **Director:** Edward Montagne; **Screenwriters:** William J. Lederer, John Fenton Murray; **Music:** Jerry Fielding; **Distributor:** Universal Pictures; **Cast:** Andy Albin, Jacques Aubuchon, Henry Beckman, Jack Bernardi, Ted Bessell, Willis Bouchey, Tim Conway, Henry Corden, Joe Flynn, Tony Franke, Jean Hale, Berkeley Harris, Bob Hastings, Norman Leavitt, Len Lesser, Gavin MacLeod, Cliff Norton, Joe Ploski, Billy Sands, Susan Silo, Edson Stroll, Clay Tanner, Tom Tully, Gary Vinson, John Wright, Yoshio Yoda.

Tim Conway plays an idiot in the U.S. Air Force.

INTERESTING FACT

- This second sequel to the popular TV series *McHale's Navy* was made without Ernest Borgnine.

McKENZIE BREAK, THE

Gramercy Pictures, 1970, color, 108 minutes.

Producers: Arthur Gardner, Jules Levy; **Director:** Lamont Johnson; **Screenwriters:** William W. Norton, Sidney Shelley; **Distributor:** Metro-Goldwyn-Mayer; **Filmed in:** Ireland; **Cast:** John Abineri, Eric Allan, Alexander Allerson, Constantine Gregory, Helmut Griem, Ian Hendry, Horst Janson, Brian Keith, Tom Kempinski, Mary Larkin, Ingo Mogendorf, Caroline Mortimer, Patrick O'Connell, Gregg Palmer, Michael Sheard, Jack Watson.

Brian Keith, the commandant of a POW camp in Scotland, must deal with U-boat captain Helmut Griem, the leader of the POWs and an expert strategist who has turned the camp into a miniature Nazi Germany, complete with anti-Semitic demonstrations. Keith allows Griem and some of his men to escape, hoping that they will lead him to a German submarine.

The movie is based on Sidney Shelley's *The McKenzie Break* (New York: Delacorte Press, 1968).

QUOTE

Captain Jack Connor [last line]: Willi, looks like we're both in the shithouse.

ME AND THE COLONEL

Columbia Pictures Corporation, 1958, b&w, 109 minutes.

Director: Peter Glenville; **Screenwriters:** S. N. Behrman, George Froeschel, Franz Werfel; **Music:** George Duning; **Distributor:** Columbia Pictures; **Cast:** Eugene Borden, Alain Bouvette, Gérard Buhr, Albert Godderis, Clément Harari, Martita Hunt, Curd Jürgens, Danny Kaye, Karen Lenay, Celia Lovsky, Maurice Marsac, Nicole Maurey, Liliane Montevecchi, Franz Roehn, Françoise Rosay, Alexander Scourby, Ludwig Stössel, Akim Tamiroff.

When the Germans invade Paris in 1940, two unlikely traveling companions are thrown together. Danny Kaye is a Jewish refugee with a valuable asset: a car. Hitching a ride from him is an aristocratic and anti-Semitic Polish officer, Curt Jurgens. Danny Kaye must constantly figure out clever schemes as they elude their Nazi pursuers. In the end, his passenger comes to recognize that Jews are not all that bad.

The movie is based on a play by Franz Werfel.

QUOTE

Curt Jurgens [at end of film, speaking of Danny Kaye]: I think I like that fellow Jacobowsky.

MEDAL FOR THE GENERAL

British National Films, 1944, b&w, 100 minutes.

Producer: Louis H. Jackson; **Director:** Maurice Elvey; **Screenwriters:** Elizabeth Baron, James Ronald; **Cast:** Rosalyn Boulter, Jeanne De Casalis, Petula Clark, Mabel Constanduros, Patric Curwen, Morland Graham, Irene Handl, John Laurie, H. F. Maltby, Gerald Moore, Janette Scott, Godfrey Tearle, Thorley Walters, Brian Weske.

A retired general helps out the war effort by sheltering evacuees during World War II.

The movie is based on James Ronald's *Medal for the General* (London: Hodder & Stoughton, 1943).

MEMPHIS BELLE

Enigma Films, Warner Bros., 1990, color, 107 minutes.

Producers: David Puttnam, Eric Rattray, Catherine Wyler; **Director:** Michael Caton-Jones; **Screenwriter:** Monte Merrick; **Music:** George Fenton; **Filmed at:** Imperial War Museum, Duxford, RAF Binbrook, Lincolnshire, and London, all in England; **Cast:** Sean Astin, Paul Birchard, Ben Browder, Greg Charles, Harry Connick Jr., Bill Cullum, Reed Diamond, Tate Donovan, Keith Edwards, Steve Elm, Courtney Gains, Neil Giuntoli, Jane Horrocks, Bradley Lavelle, John Lithgow, Eric Loren, Steven Mackintosh, Mac McDonald, Martin McDougal, Matthew Modine, Cathy Murphy, Jason Salkey, Morag Siller, Eric Stoltz, David Strathairn, D. B. Sweeney, Mitch Webb, Jodie Wilson, Billy Zane.

The 10-man crew of the B-17 *Memphis Belle* has only one more bombing mission before they finish their tour of duty and can go home. Since they would be the first crew to finish all 25 missions in the Eighth Air Force, there are already plans to make them big stars back home, selling bonds for the war effort. In the briefing before their last flight, on May 18, 1943, the crew discovers that the target for the day is a heavily defended city that invariably inflicts many casualties. The target is heavy in surface-to-air artillery; the flak will be deadly. With bad weather and shot nerves, the crew, designated the lead plane in the squadron, flies a

Memphis Belle (WARNER BROS./AUTHOR'S COLLECTION)

frantic mission before finally returning home, alive, to their airfield.

The *Memphis Belle* was a real bomber, and its crew was in fact one of the first bomber crews to attain the 25-mission requirement, which under USAAF rules allowed them to rotate back to the states. The 25-mission requirement was instituted because of the high fatality rates in the bomber command. Without this ceiling on missions, crews knew it was only a matter of time before their number was up. With the implementation of this limit, aircrews knew that they had a chance of surviving the war. The rotation also had another positive effect on the war effort, besides raising the morale of the bomber crews. Those aviators rotated home became flight instructors in the training command pipeline, which was the largest aviation training program in history. This also had the beneficial effect of exposing airmen in flight training to flyers who had been on actual missions only weeks before, therefore allowing them to learn real-life, up-to-date, effective tactics. The Axis powers, on the other hand, never adopted this policy. As a result, all of the top-scoring aces of World War II are German and Japanese aviators, because those who survived flew the entire war. But this meant that they did not have the best instructors in their flight programs. And this, combined with the fact that the Axis powers never really understood the value of a huge pipeline, meant that Germany and Japan ran out of flyers by the end of the war, whereas we had them waiting in line for planes.

INTERESTING FACTS

- The *Memphis Belle* was named after the girlfriend of the pilot, Robert Morgan.
- The film was based on the World War II documentary *Memphis Belle*, directed by William Wyler, then a lieutenant colonel.

MISTAKES

- The wrong number of blades is shown on the propeller of the first damaged B-17 returning to base.
- The film features P-51 Mustangs in May 1943, several months before they were introduced into the European theater.

- The farmland around the airfield on which the B-17s are based is shown to have light rail lines in the grain crops. Light rail was not used in British farms at the time of World War II.
- The film is set in May. A farmer can be seen harvesting crops normally done in late summer.
- On its last mission, the *Memphis Belle* was not damaged, none of the crew was injured, it had no trouble finding the target, and it did not crash upon landing.
- After the *Memphis Belle* drops her bombs, Dennis pulls on the stick to close the bomb-bay doors. Then you see Val close the bomb-bay doors.
- The plane that lands still has the ball turret.
- None of the names of the crew members in the film are even similar to the names of the *Belle's* actual crew.
- Once in the air, at altitude, the crew is continually taking off their gloves and oxygen masks. With the temperature around 20 to 40 degrees below zero, their hands would not only stick to the guns, they would also suffer frostbite almost immediately. Also the crew would pass out in a matter of seconds due to lack of oxygen.
- The crew interaction during the mission was totally Hollywood . . . the bickering and fighting among the crews, especially over enemy territory, was not accurate. They depended on one another for survival, and that meant being alert at all times.
- In May 1943, the "Little Friends" escorting the bombers couldn't have been P-51s. The main escort for B-17s and B-24s at this time was the P-47 "Thunderbolt."
- Crews had parachutes on well before the point in the movie when they put them on. Aircrews are lucky to be able to get to the door and jump, much less have time to scramble around looking for a parachute.

QUOTES

Luke Sinclair: Fuel gauge is shot. How long can we fly on one engine?
Dennis Dearborn: I don't know. I guess we'll find out.

AWARDS

British Academy Awards, 1991
 Nominated: *BAFTA Film Award, Best Original Film Score*, George Fenton

Fantasporto, 1991
 Nominated: *International Fantasy Film Award, Best Film*, Michael Caton-Jones.

MEN IN WAR

Security Pictures, 1957, b&w, 102 minutes.

Producers: Sidney Harmon, Anthony Mann; **Director:** Anthony Mann; **Screenwriters:** Ben Maddow, Van Van Praag, Philip Yordan; **Music:** Elmer Bernstein; **Distributor:** United Artists; **Cast:** James Edwards, Race Gentry, L. Q. Jones, Robert Keith, Walter Kelley, Adam Kennedy, Scott Marlowe, Michael Miller, Vic Morrow, Robert Normand, Nehemiah Persoff, Phillip Pine, Aldo Ray, Anthony Ray, Robert Ryan, Victor Sen Yung.

In Korea, Robert Ryan's war-weary platoon finds itself isolated in enemy-held territory after a general retreat. Exhausted, they come across a sergeant who is driving his catatonic colonel to a field hospital, and they appropriate his jeep. Ryan and the sergeant can't stand each other, but together they get the survivors to Hill 465, hoping that it is still battalion headquarters, but it's been overrun by the enemy. They join forces to retake the hill.

This movie is based on Van Van Praag's *Day Without End* (New York: W. Sloane, 1949).

MEN OF THE FIGHTING LADY

Metro-Goldwyn-Mayer, 1954, color, 79 minutes.

Producer: Henry Berman; **Director:** Andrew Marton; **Screenwriters:** Harry A. Burns (story, *The Case of the Blind Pilot*), Art Cohn, James Michener (story, *The Forgotten Heroes of Korea*); **Music:** Miklós Rózsa; **Distributor:** MGM; **Cast:** Ann Baker, Louis Calhern, George Cooper, Bert Freed, Jonathan Hale, Robert Horton, Teddy Infuhr, Van Johnson, Ronald Lisa, Frank Lovejoy, Dewey Martin, Lewis Martin, Jerry Mathers, Dorothy Patrick, Walter Pidgeon, John Rosser, Steve Rowland, Sarah Selby, Dick Simmons, Paul Smith, Bucko Stafford, Ronald Stafford, Ed Tracy, Chris Warfield, Keenan Wynn.

Navy jet pilots fly mission after mission from their carrier, *Fighting Lady*, in endless support of the U.N. troops fighting on the Korean Peninsula. Van Johnson is a fighter pilot who flies on the wing of a blinded pilot and talks him down to a successful landing on the aircraft carrier.

This movie is based on a series of magazine articles by James Michener, *The Forgotten Heroes of Korea* (Louis Calhern plays Michener in the film, looking for good stories for his articles), and on *The Case of the Blind Pilot*, by Cmdr. Harry A. Burns, USN.

INTERESTING FACTS

- A blurb (from the *Blockbuster Entertainment Guide*) on the video jacket claims that the movie has dogfights, when in fact it does not (they get flak from the ground, but no bogies).
- *THE BRIDGES AT TOKO-RI* is another film that deals with navy fighter pilots flying bombing runs in Korea.

QUOTES

Walter Pidgeon: A man has to do what he has to do.

Officer [slaps a jet with his hand]: What good are ya? What good are ya without men?

Pilot [after knocking out a train]: Due to technical difficulties, the Wonton Limited will be a few minutes late.

MERRILL'S MARAUDERS

United States Pictures, 1962, color, 98 minutes.

Producer: Milton Sperling; **Director:** Samuel Fuller; **Screenwriters:** Samuel Fuller, Charlton Ogburn Jr., Milton Sperling; **Music:** Howard Jackson, Max Steiner, Franz Waxman; **Distributor:** Warner Bros.; **Filmed in:** Philippines; **Cast:** Claude Akins, Charlie Briggs, Peter Brown, Jeff Chandler, Andrew Duggan, Ty Hardin, Chuck Hayward, Chuck Hicks, John Hoyt, Will Hutchins, Pancho Magalona, Chuck Roberson, Luz Valdez, Jack C. Williams, Vaughan Wilson.

Brig. Gen. Frank D. Merrill (Jeff Chandler) leads his Marauders behind enemy lines from Burma to Myitkyina, pushing his men beyond their physical and psychological limits to keep them moving and fighting. As they hit critical strategic enemy targets, they help the British hold back the Japanese juggernaut bent on world conquest through India.

The 5307th Composite Provisional Unit, known as "Merrill's Marauders," was organized by Brig. Gen. Frank D. Merrill (1903–1955) from volunteers in the South Pacific. After training in India, during 1944 the 3000 men in this unit conducted numerous operations and were cited for their successful capture of the Japanese airfield dramatized in the film. Despite their success, they were disbanded in August 1944 and reorganized into an infantry regiment that served until August 1945. Although Merrill dies in the film, urging his men forward, in fact he survived the war.

INTERESTING FACT

- This was Jeff Chandler's last film, and he died before the film was released.

QUOTE

Merrill's commanding general: Your job is to do the impossible.

MERRY CHRISTMAS, MR. LAWRENCE

Asahi National Broadcasting Company, Cineventure Productions London, Oshima Productions, Recorded Pictures Company, 1983, color, 124 minutes.

Producers: Terry Glinwood, Masato Hara, Joyce Herlihy, Geoffrey Nethercott, Eiko Oshima, Larry Parr, Jeremy Thomas; **Director:** Nagisa Oshima; **Screenwriters:** Paul Mayersberg, Nagisa Oshima, Laurens Van der Post; **Distributor:** Universal Pictures; **Filmed in:** Auckland, New Zealand, and Rarotonga, Cook Islands; **Cast:** Richard Adams, Geoff Allen, Michael Baxter-Law, Mark Berg, David Bowie, Grant Bridger, Chris Broun, Alistair Browning, Marcus Campbell, Geoff Clendon, Tom Conti, Barry Dorking, Colin Francis, Richard Hensby, Richard Hoare, Yuji Honma, Martin Ibbertson, Daisuke Iijima, Yoichi Iijima, Tamio Ishikura, Satoshi Ito, Rob Jayne, Ryunosuke Kaneda, Takeshi Kitano, Kunihide Kuruma, Masaki Kusakabe, James Malcolm, Akihiro Masuda, Tokuhisa Masuda, Hiroshi Mikami, Kan Mikami, Ian Miller, Richard Mills, Hideo Murota, Takeshi Nagasawa, Takashi Naito, Takashi Odashima, Masanori Okada, Johnny Okura, Mark Penrose, Arthur Ranford, Ryuichi Sakamoto, Shoetsu Sato, Masamichi Shibasaki, Rintaro Shibata, Kaname Shimura, Kenzo Shirahama, Steve Smith, Don Stevens, Hisao Takeda, Stephen Taylor, Jack Thompson, Hidenobu Togo, Rokko Toura, Yuya Uchida, Atsuo Yamashita, Heiwa Yoshihara, Takeshi Yu, Richard Zimmerman.

David Bowie plays an Australian major captured while on a commando raid in 1942. He is sent to a Japanese prisoner-of-war camp in Java. Tom Conti is the title character, Mr. Lawrence, unpopular with his fellow prisoners because he tries to explain to them the warped Japanese way of thinking: They treat their prisoners brutally and as nonhuman because they consider the Allied POWs cowards and unworthy of respect because they surrendered instead of committing suicide.

The film is based on Laurens Van der Post's book *The Seed and the Sower* (New York: W. Morrow, 1963).

INTERESTING FACTS

- The actors playing POWs use their actual names in the hospital roll-call scene.
- David Bowie is a rock musician.

QUOTES

Captain Yunoi: To be or not to be, that is the question.
Colonel Lawrence: God, I wish they'd stop hitting me.

MIDNIGHT CLEAR, A

A&M Films, Beacon, 1991, color, 107 minutes.

Producers: Marc Abraham, Armyan Bernstein, Bill Borden, Margaret Hilliard, Dale Pollock, Tom Rosenberg; **Director:** Keith Gordon; **Screenwriters:** Keith Gordon, William Wharton **Distributor:** Sovereign Pictures; **Filmed in:** Utah; **Cast:** Peter Berg, Matt Bohling, Robert Chynoweth, Kevin Dillon, Kelly Gately, Rachel Griffin, Arye Gross, Ethan Hawke, David Jensen, Larry Joshua, Andre Lamal, Curt Lowens, John C. McGinley, Bill Osborn, Timothy S. Shoemaker, Gary Sinise, Frank Whaley.

During World War II, an American intelligence unit is posted to a remote location of the Ardennes Forest on the eve of the Battle of the Bulge. The American soldiers receive a message from a German army unit that it wants to surrender. However, the Germans want it to appear that they were overwhelmed to make sure there will be no reprisals to their families in Germany. But the plan goes wrong: American soldiers are killed and the German unit is wiped out. The film is based on William Wharton's *A Midnight Clear* (New York: Knopf, 1982).

The Battle of the Bulge was the last major German offensive on the western front. Under Hitler's direct orders, the German army transferred men and matériel from the eastern front, permitting the Russians to gain ground at the rate of 100 miles a day. The plan was to break through the Allied lines and push to the sea at Antwerp and Lieges. The attack began on December 16, 1944. The Germans broke through in the Ardennes Forest, making a huge bulge in the Allied lines. The Allies were not able to turn the Germans back until January 16, 1945. The Battle of the Bulge cost 77,000 Allied casualties and 220,000 German casualties.

QUOTE

Will Knott: I'm not exactly sure what country we're in. Could be Belgium, Luxembourg, France, or even Germany. I don't know what day it is. I have no watch, so I don't know what time it is. I'm not even sure of my name. The next thing you know, they'll be making me a general.

MIDNIGHT MENACE

Grosvenor, 1937, b&w, 79 minutes.

Producers: Angus MacLeod, Harcourt Templeman; **Directors:** Michael Hankinson, Sinclair Hill; **Screenwriter:** D. B. Wyndham-Lewis; **Music:** John Reynders; **Distributors:** Film Alliance of the United States; **Cast:** Reynes Barton, Billy Bray, Monti DeLyle, Wallace Evennett, Charles Farrell, Arthur Finn, Dino Galvani, Arthur Gomez, Danny Green, Laurence Hanray, Evan John, Sydney King, Fritz Kortner, Raymond Lovell, Andreas Malandrinos, Dennis Val Norton, Terence O'Brien, Victor Tandy, Margaret Vyner.

In the years before World War II, a reporter is murdered: He has uncovered a plot by a secret group of military industrialists to destroy an upcoming peace conference and to incite war. They have developed a fleet of radio-controlled airplanes that they plan to send over London carrying powerful bombs. The movie is also known as *Menace at Midnight* and *Bombs Over London*.

MIDWAY

Mirisch Company, 1976, color, 132 minutes.

Producer: Walter Mirisch; **Director:** Jack Smight; **Screenwriter:** Donald S. Sanford; **Music:** John Williams; **Distributor:** Universal Pictures; **Filmed in:** Pensacola, Florida, and Terminal Island Naval Base, Los Angeles; **Cast:** Edward Albert, Phillip R. Allen, Beeson Carroll, James Coburn, Dabney Coleman, Noel Conlon, Glenn Corbett, Larry Csonka, Kevin Dobson, Don Dolan, Erik Estrada, Henry Fonda, Glenn Ford, Paul Frees, John Fujioka, Sean Garrison, Christopher George, Kurt Grayson, Anthony Herrara, Charlton Heston, David Hirokane, Hal Holbrook, James Ingersoll, Jim Ishida, Dale Ishimoto, Robert Ito, Steve Kanaly, Lloyd Kino, Christina Kokubo, Clyde Kusatsu, David Macklin, Monte Markham, Biff McGuire, Sandy McPeak, Toshiro Mifune, Robert Mitchum, Pat Morita, Chuck Morrell, Ed Nelson, Kip

Midway (UNIVERSAL PICTURES/AUTHOR'S COLLECTION)

Niven, Bennett Ohta, Frank Parker, Ken Pennell, John Bennett Perry, Michael Richardson, Clint Ritchie, Cliff Robertson, Dennis Rucker, Mitch Ryan, Seth Sakai, Richard Sanders, Richard Sarradet, Tom Selleck, James Shigeta, Yuki Shimoda, Sab Shimono, Alec Smight, Susan Sullivan, Miiko Taka, Robert Wagner, Gregory Walcott, Robert Webber, William Wellman Jr., Alfie Wise, Conrad Yama.

This is a very accurate studio film about the World War II Battle of Midway, complete with captions to identify major historical characters. The film diverges from this main story line only to delve into a subplot involving Charlton Heston and his son's Nisei fiancée, exploring the fate of Japanese Americans during the war.

The Battle of Midway occurred just six months after the Japanese attack on Pearl Harbor. Midway is an atoll located northwest of Hawaii. In World War II it was a naval base and an airfield from which reconnaissance could be made over a large part of the Pacific. In late 1940, the United States cracked the Japanese military code, and in April 1942, military intelligence picked up messages about a location referred to as "AF." The U.S. Navy thought that "AF" was Midway Island but was not sure. To be certain, the Americans sent a false message, in a way that would be intercepted by the Japanese, that the water purification machinery at Midway had broken down. Two days later a Japanese message was intercepted, reporting that "AF" was short of water. On May 25, 1942, U.S. intelligence picked up messages giving the units, ships, captains, courses, and times for the Japanese attack on Midway. Based on this intelligence, Admiral Nimitz sent his ships to the scene. The Japanese had expected that the American carriers would come toward Midway only after the battle had begun. They were completely surprised when the American fleet and its planes appeared at close range at the beginning of the attack. The Japanese committed 11 battleships, eight aircraft carriers, 22 cruisers, 65 destroyers, 21 submarines, and more than 700 war planes to the Battle of Midway. Facing them was a much smaller American force of three carriers, eight cruisers, 18 destroyers, 25 submarines, and 524 planes (including the land-based planes on Midway). However, Japanese strategy negated Japanese strength by separating forces into five groups that were far apart and unable to support or reinforce each other. This allowed the American forces to concentrate their power and engage each group separately.

In the first engagements of the battle, on June 4, 1942, the American attacks on the Japanese ships were unsuccessful. In these early attacks, a very high percentage of American planes were shot down and their pilots lost. Then, at about 10 A.M., within a space of five minutes, two squadrons of U.S. dive bombers, in the right place at the right time, destroyed three Japanese aircraft carriers, the backbone of the vaunted Japanese First Air Fleet. In total, four Japanese aircraft carriers and a heavy cruiser were sunk, 322 planes were destroyed, and 3500 Japanese military personnel were killed, including 100 first-line pilots. The U.S. Navy lost a carrier, a destroyer, 150 planes, and 307 lives. Because of the water temperature, the survival rate for the crews of downed planes was virtually zero. The Japanese navy never recovered from the blow, and the strategic initiative passed to the Americans. It stopped further Japanese attacks on Pearl Harbor, prevented Japanese raids on the U.S. West Coast, and gave the Allies the breathing room to pursue the "Germany First" policy.

INTERESTING FACTS

- The film was originally shown in Sensurround, a system that had special low-pitch woofers for sound effects.
- For the opening credits, footage was taken directly from the classic film *THIRTY SECONDS OVER TOKYO* (1944), to represent the B-25 bombing of Tokyo.
- Most dogfight sequences come from 1942 newsreels, with considerable cropping due to the need to adapt the images to Panavision framing.
- Most sequences of the Japanese air raids on Midway are stock shots from 20th Century-Fox's *TORA! TORA! TORA!* (for instance, the jeep thrown into a wall by a bomb blast).
- Several action scenes, including the one in which a Zero slams into the *Yorktown's* bridge, were taken from *AWAY ALL BOATS* (1956).
- The Japanese blamed their loss at Midway on "victory disease." Until the battle, the war in the Pacific had been a string of victories for the Japanese. Pre-attack Japanese war games of the battle had successfully predicted an American victory, but the Japanese navy, flush with success and overconfident, ignored this warning.

MILITARY SERVICE

- Henry Fonda actually was on Admiral Nimitz's staff at Guam.
- Glenn Ford was on a U.S. Coast Guard forward picket at the real Battle of Midway.
- Charlton Heston went overseas in March 1944 and spent two years assigned as a radioman aboard B-25s serving with the 77th Bombardment Squadron of the 11th Air Force on Attu in the Aleutian Islands. The

77th attacked the Japanese islands of Shumushu and Parmushiri, as well as Japanese shipping. Near the end of the war, his unit transitioned to B-29s, and they were getting ready for the invasion of Japan, "Operation Downfall," when his life was saved by the dropping of the atomic bomb on Japan. During Vietnam, he twice went there to entertain troops, often traveling right up to the front lines.

- Hal Holbrook was a graduate of Culver Military Academy in Ohio and enlisted in the U.S. Army during World War II, serving with the Corps of Engineers in Newfoundland. It was there that he became interested in theater, acting in amateur theater groups.

MISTAKES

- Several shots identifying the American and Japanese carriers are actually those of Korean War–era American Essex-class carriers.
- American carriers did not have angled flight decks until after World War II.
- The footage of American fighters taking off from Midway to repel the Japanese (Hellcats and P-40s), shows planes that were not present on Midway at the time.
- The fighter escort for the *Yorktown*'s bombers consisted of only four planes, not the many more shown in the film.
- Kamikaze attacks did not begin until late 1944, more than two years after the Battle of Midway.
- Garth's spectacular crash is in a Hellcat, not the Wildcat that he should have been flying.
- Utility poles are visible in the scene of the Japanese aircraft carrier launching planes for the first attack on Midway.
- The same Forrestal-class carrier ('60s vintage, with slant decks and full radar suites) is used as the *Hiryu* and *Soryu*, one of which is simply the same film turned left-to-right, including the backward hull number painted on the flight deck.
- In virtually every shot of the flight deck looking up at the fighters and bombers overhead, the anti-aircraft guns show the red paper caps of blanks rather than pointed bullets.
- During the Japanese bombing of Midway you clearly see, briefly, battleship masts in the background, because of recycled footage from *Tora! Tora! Tora!*

QUOTES

Captain Garth: Can I ask you something personal? Very personal?
Commander Rochefort: Sure.

Captain Garth: You know, it really stinks down here. How often do some of your people take a bath?
Commander Rochefort: Bath?! Hell, I don't know. What day is it?

Captain Garth: How much can you decipher?
Commander Rochefort: 15 percent.
Captain Garth: Really decipher?
Commander Rochefort: 10 percent.
Captain Garth: That's 1 word in 10, Joe! You're guessing!
Commander Rochefort: We like to call it analysis.

MINESWEEPER

Paramount Pictures, 1943, b&w, 67 minutes.

Producers: William H. Pine, William C. Thomas; **Director:** William A. Berke; **Screenwriters:** Edward T. Lowe Jr., Maxwell Shane; **Cast:** Richard Arlen, Charles D. Brown, Chick Chandler, Emma Dunn, Frank Fenton, Douglas Fowley, Russell Hayden, Robert Mitchum, Bill Nelson, Jean Parker, Ralph Sanford, Guinn Williams.

Richard Arlen plays a former naval officer who has destroyed his life with chronic gambling. When Pearl Harbor is attacked, he finds a chance for redemption. He enlists under an assumed name as a lowly seaman, then proves that he's still made of "the right stuff" by single-handedly seeking out and destroying a new type of Japanese mine.

MIRACLE OF THE WHITE STALLIONS

Walt Disney Productions, 1963, color, 93 minutes.

Producer: Peter V. Herald; **Director:** Arthur Hiller; **Screenwriters:** A. J. Carothers, Alois Podhajsky; **Music:** Richard M. Sherman, Robert B. Sherman, Paul J. Smith; **Distributor:** Buena Vista Pictures; **Filmed in:** Vienna, Austria; **Cast:** Philip Abbott, Eddie Albert, Larry Billman, Robert Dietl, James Dobson, Margarethe Dux, Fritz Eckhardt, Douglas Fowley, James Franciscus, Hal Galili, Günther Haenel, Max Haufler, Philo Hauser, Brigitte Horney, Harry Hornisch, Kurt Jager, Helmut Janatsch, Michael Janisch, Peter Jost, Curd Jürgens, Josef Krastel, John Larch, Hugo Lindinger, Lilli Palmer, Herbert Prikopa, Charles Régnier, Erik Schumann, Robert Taylor, Michael Tellering, Olaf Tschierschke, Fritz Wepper.

In World War II Austria, a German colonel, Robert Taylor, must protect his beloved Lipizzaner stallions and

ensure that they are surrendered into the right hands. The colonel knows that General Patton is a horse fancier and might help, if he sees the stallions perform.

MISFIT BRIGADE, THE

Manley, Panorama, 1987, color, 101 minutes.

Producers: Just Betzer, Benni Korzen; **Director:** Gordon Hessler; **Screenwriters:** Nelson Gidding, Sven Hassel; **Distributor:** Trans World Entertainment; **Cast:** David Carradine, Bruce Davison, David Patrick Kelly, Boris Komnenic, Annie Korzen, Gordana Les, Andrija Maricic, D. W. Moffett, Lidija Pletl, Irena Prosen, Oliver Reed, Jay O. Sanders, Slavko Stimac, Keith Szarabajka.

Prisoners are recruited from German prisons by Nazi officers who need fighting men.

Also known as *Wheels of Terror*, the movie is based on Sven Hassel's *Wheels of Terror* (London: Souvenir Press, 1959).

MISSING IN ACTION

Cannon Group, 1984, color, 101 minutes.

Producers: Yoram Globus, Menahem Golan, Lance Hool, Avi Kleinberger; **Director:** Joseph Zito; **Screenwriters:** James Bruner, Lance Hool; **Music:** Jay Chattaway; **Distributor:** Metro-Goldwyn-Mayer; **Filmed in:** Philippines; **Cast:** Erich Anderson, Gil Arceo, Stephen Barbers, Omar Camar, Joseph Carberry, Deanna Crowe, James Crumrine, Jessie Cuneta, Roger Dantes, Protacio Dee, Sabatini Fernandez, Bella Flores, Joonee Gamboa, James Hong, Lenore Kasdorf, Avi Kleinberger, Juliet Lee, Kim Marriner, Pierrino Mascarino, Jeff Mason, Renato Morado, Chuck Norris, Ernie Ortega, Jack Pereza, Ric Segreto, David Tress, Augusto Victa, M. Emmet Walsh, Willie Williams.

Chuck Norris escapes from a POW camp after 10 years. He returns to Vietnam with a committee to find other MIAs, but the Vietnamese deny there are any more POWs still in captivity. He tracks down the prisoner-of-war camp, rescues the prisoners, and delivers them to the meeting room just as a Vietnamese spokesman is swearing that there are no MIAs still being held prisoner in Vietnam.

MILITARY SERVICE

- Chuck Norris, who is half Indian, enlisted in the U.S. Air Force in 1958. After air police school at

Lackland Air Force Base in Texas, he was sent to Korea with the 6314th Air Police Squadron. When, as an MP, he was unable to arrest an aggressive drunk, he became interested in the martial arts, and by the time he was discharged, he had earned his black belt in Tang So Do, a type of karate.

MISSING IN ACTION 2: THE BEGINNING

Cannon Films, 1985, color, 96 minutes.

Producers: Yoram Globus, Menahem Golan; **Director:** Lance Hool; **Screenwriters:** Steve Bing, Larry Levinson, Arthur Silver; **Music:** Brian May; **Filmed in:** Jalapa, Mexico, and Georgetown, Colorado; **Cast:** Christopher Cary, David Chung, Cosie Costa, Dean Raphael Ferrandini, Mischa Hausserman, Joseph Hieu, Pierre Issot, Randon Lo, Andrea Lowe, Nancy Martin, Chuck Norris, Soon-Tek Oh, Bennett Ohta, John Otrin, Professor Toru Tanaka, Michiyo Tanaka, Joe Michael Terry, John Wesley, Steven Williams.

Chuck Norris is an army colonel whose helicopter is shot down on a routine mission. Captured by the Vietcong, for years he is subjected to torture by a sadistic camp commandant who attempts to get Norris to sign a "confession" about the atrocities he committed as an American soldier against the Vietnamese people. Norris is finally able to escape and takes revenge on his tormentor.

INTERESTING FACT

- The film opens with real-life newsreel footage of President Reagan talking about those missing in action in Vietnam.

QUOTE

President Ronald Reagan [newsreel footage]: We write no last chapters, we close no books, we put away no final memories. An end of America's involvement in Vietnam cannot come before we have achieved the fullest possible accounting of those missing in action.

MISSION BATANGAS

Diba Productions, 1969, color, 100 minutes.

Producer: Keith Larsen; **Director:** Keith Larsen; **Screenwriter:** Lew Antonio; **Distributor:** Manson Distributing Corp. (USA); **Cast:** Vic Diaz, Tony Dun-

gan, Fred Galang, Ernesto La Guardia, Keith Larsen, Vera Miles, Bruno Punzalan, Pol Salcedo, Helen Thompson, Dennis Weaver.

Dennis Weaver plays an American pilot on a mission to save the national gold treasury of the Philippines from the invading Japanese. To accomplish this mission, he must traverse a jungle full of headhunters to reach an aircraft, then bomb the barge containing the gold.

MISSION OVER KOREA

Columbia Pictures Corporation, 1953, b&w, 85 minutes.

Director: Fred F. Sears; **Music:** George Antheil, Mischa Bakaleinikoff, Joseph Dubin, George Duning, W. Franke Harling; **Cast:** John Derek, John Hodiak, Todd Karns, Maureen O'Sullivan.

John Derek and John Hodiak argue about their jobs in Korea, then later reveal their true characters to each other.

MISSION TO MOSCOW

Warner Bros. 1943, b&w, 123 minutes.

Producer: Robert Buckner; **Director:** Michael Curtiz; **Screenwriters:** Joseph E. Davies (book), Howard Koch; **Music:** Max Steiner; **Cast:** Walter Huston, Ann Harding, Oskar Homolka, George Tobias, Gene Lockhart, Eleanor Parker, Richard Travis, Helmut Dantine, Victor Francen, Henry Daniell, Barbara Everest, Dudley Field Malone, Roman Bohnen, Maria Palmer, Moroni Olsen, Minor Watson, Vladimir Sokoloff, Maurice Schwartz, John Abbott, Ernie Adams, Alex Akimoff, Demetrius Alexis, Elizabeth Archer, Louis V. Arco, Herbert Ashley, Hooper Atchley, Robert Baikoff, Felix Basch, Nino Bellini, Nina Biagio, Oliver Blake, Monte Blue, Eugene Borden, Egon Brecher, Barbara Brown, Alexander Campbell, George M. Carleton, Maurice Cass, Nikolai Celikhovsky, Feodor Chaliapin Jr., Luke Chan, Cyd Charisse, Virginia Christine, Wallis Clark, Donald Clayton, Edmund Cobb, Harry Cording, Gino Corrado, Jerome Cowan, Noel Cravat, Joseph Crehan, Oliver Cross, Albert D'Arno, Jacqueline Dalya, William B. Davidson, Joseph E. Davies, George Davis, Jean De Briac, Igor Dega, Jean Del Val, John Dilson, Warren Douglas, Eugene Eberle, Ben Erway, Fred Essler, Frank Faylen, Frank Ferguson, Robert Fischer, James Flavin, Lee Tung Foo, Ross Ford, William Forrest Jr., Patricia Fung, Jack Gardner, Gene Gary, Art Gilmore, George Glebeff, Sam Goldenberg, Ernest Golm, Lisa Golm, Gregory Golubeff, Peter Goo Chung, Christine Gordon, William Gould, Alexander Granach, Henry Guttman, John Hamilton, Lumsden Hare, Ernest Hauserman, Alex Havier, Frank Hemphill, Yvonne Hendricks, Louis Jean Heydt, Herbert Heyes, David Hoffman, Mauritz Hugo, Olaf Hytten, Frieda Inescort, Ted Jacques, Frank Jaquet, Allen Jung, Erwin Kalser, Joseph Kamaryt, Eddie Kane, Zoia Karabanova, Kurt Katch, Edward Keane, Bill Kennedy, Jack Kenney, Manart Kippen, Nicholas Kobliansky, Al Kunde, Adia Kuznetzoff, Charles La Torre, Ivan Lebedeff, Gabriel Lenoff, George Lessey, Marion Lessing, Adolf E. Licho, Rolf Lindau, Doris Lloyd, Kathleen Lockhart, Arthur Loft, Bill Louie, Rosa Margot, Michael Mark, John Maxwell, Mike Mazurki, Alex Melesh, Marie Melish, Tina Menard, Peter Michael, Howard M. Mitchell, Clive Morgan, Forbes Murray, Martin Noble, Pat O'Malley, Daniel Ocko, Michael Panaieff, Emory Parnell, Irene Pedrini, Frank Penny, Francis Pierlot, René Plaissetty, Frank Puglia, Emil Rameau, Frank Reicher, Duncan Renaldo, Georges Renavent, Vera Richkova, Betty Roadman, Nico Romoff, Lionel Royce, Dick Ryan, Loulette Sablon, Tanya Samova, Sam Savitsky, Ferdinand Schumann-Heink, Hans Schumm, Irina Semochenko, Konstantin Shayne, Robert Shayne, Tamara Shayne, Evelynne Smith, Leonid Snegoff, George Sorel, Rudolf Steinbeck, Glenn Strange, Mark Strong, Paula Terry, Zina Torchina, Ivan Triesault, Charles Trowbridge, Mike Tulligan, Tom Tully, Olga Uljanovskaja, Edward Van Sloan, Sandor Varga Szabo, Henry Victor, Michael Visaroff, Ray Walker, Pierre Watkin, Peggy Watts, Frank Wayne, John Wengraf, Mischa Westfall, Leigh Whipper, Marek Windheim, Joan Winfield, Isabel Withers, Jean Wong, Victor Wong, Jack Young, Alfred Zeisler, Esther Zeitlin.

A sympathetic picture of communist Russia depicted through the eyes of Walter Huston, the U.S. ambassador to the Soviet Union. Stalin is pictured as a benevolent leader, and the purges are explained away by showing that those executed were actually agents of Germany and Japan seeking to weaken the Russian military capacity.

The movie is based on the memoirs of former U.S. ambassador Joseph E. Davies.

INTERESTING FACTS

- *Mission to Moscow* was made at the behest of F.D.R. in order to garner more support for the Soviet

Union and to soften the image of Stalin in the minds of the American public during World War II.

- Because the movie presents Stalin's Russia in such a favorable light, it was cited years later by the House Un-American Activities Committee and was largely responsible for the screenwriter Howard Koch being blacklisted in 1951.
- Even at the time it was released, the movie was recognized by most people as a false and distorted view of the realities of communist Russia.

AWARD

Academy Awards, USA, 1943
 Nominated: *Oscar, Best Interior Decoration, Black-and-White,* George James Hopkins, Carl Jules Weyl.

MISTER ROBERTS

Warner Bros., 1955, color, 123 minutes.

Producer: Leland Hayward; **Directors:** John Ford, Mervyn LeRoy, Joshua Logan; **Screenwriters:** Thomas Heggen, Joshua Logan, Frank S. Nugent; **Music:** Franz Waxman; **Filmed in:** Midway Islands and Kaneohe, Hawaii; **Cast:** Nick Adams, Frank Aletter, Tige Andrews, Ward Bond, Danny Borzage, George Brangier, James Cagney, Philip Carey, Harry Carey Jr., Francis Connor, Ken Curtis, Mimi Doyle, Shug Fisher, James Flavin, Henry Fonda, Fritz Ford, Clarence E. Frank, William Henry, William Hudson, Duke Kahanamoku, Buck Kartalian, Stubby Kruger, Jack Lemmon, Perry Lopez, Martin Milner, Jim

Mister Roberts (WARNER BROS./AUTHOR'S COLLECTION)

Moloney, Jim Murphy, Maura Murphy, Jeanne Murray, Denny Niles, Kathleen O'Malley, Betsy Palmer, Jack Pennick, Lonnie Pierce, William Powell, Robert Roark, Harry Tenbrook, Carolyn Tong, Gregory Walcott, Patrick Wayne.

Mister Roberts (Henry Fonda) is an officer aboard a U.S. cargo ship, USS *Reluctant*, in the Pacific during World War II. He'd do anything to leave the quiet of the ship to join in the action. The trouble is that the captain of the ship isn't willing to sign Roberts's transfer request. Also on board is Ensign Pulver (Jack Lemmon), who avoids work as best he can, while living off the profits of his buying and selling. Roberts and the crew are constantly at odds with the captain, who is a petty tyrant.

The most famous and memorable scene, in which Mister Roberts throws the captain's palm tree overboard, actually happened. Although no one knows who threw the captain's tree overboard, the captain did lose his prized palm. The scene in which members of the crew look through binoculars at nurses at the island's hospital also happened on the *Virgo*. In addition, Heggen used names of some of his fellow crew members in his book. For example, Olson is the man put in charge of finding the captain a new palm tree.

INTERESTING FACTS

- This is William Powell's last film.
- Henry Fonda reprises the title role that he originated on Broadway (for which he won a Tony Award in 1948).
- Scientology founder L. Ron Hubbard claimed to have been the model for Mr. Roberts and that the ship in the film portrayed his assignment aboard the USS *Algol*.

MILITARY SERVICE

- Thomas Heggen, the author of the novel that inspired the film, based the story on his adventures in the U.S. Navy during World War II. Although the characters Mister Roberts and Ensign Pulver are fictional, many of the other members of the crew are recognizable as members of the USS *Virgo*.
- Jack Lemmon entered the U.S. Navy's V-12 training program and received the lowest marks of any officer commissioned at Harvard's ROTC program. He was assigned to the aircraft carrier USS *Lake Champlain*, for the time it took her to sail home and be mothballed at the end of the war. Somehow, like his counterpart Ensign Pulver and without any awards or decorations, he had himself assigned to a desk job in Washington.

QUOTES

Doug Roberts: I looked down from our bridge and saw our captain's palm tree! Our trophy for superior achievement! The Admiral John J. Finchley award for delivering more toothpaste and toilet paper than any other navy cargo ship in the safe area of the Pacific.

Ensign Pulver [last line]: Captain, it is I, Ensign Pulver, and I want you to know that I just threw your stinkin' palm tree overboard. Now what's all this crap about no movie tonight?

AWARDS

Academy Awards, USA, 1955
 Won: *Oscar, Best Supporting Actor,* Jack Lemmon
 Nominated: *Oscar, Best Picture,* Leland Hayward; *Best Sound Recording,* William A. Mueller (Warner Bros.)

British Academy Awards, 1956
 Nominated: *BAFTA Film Award, Best Foreign Actor,* Jack Lemmon—USA

Writers Guild of America, USA, 1956
 Won: *WGA Screen Award, Best Written American, Comedy,* Joshua Logan, Frank S. Nugent.

MOON IS DOWN, THE

20th Century-Fox, 1943, b&w, 90 minutes.

Producer: Nunnally Johnson; **Director:** Irving Pichel; **Screenwriters:** Nunnally Johnson, John Steinbeck (novel); **Music:** Alfred Newman; **Cast:** Louis V. Arco, E. J. Ballantine, John Banner, Trevor Bardette, Swen Hugo Borg, Dorris Bowdon, Lee J. Cobb, Harry Cording, Jeff Corey, Ernst Deutsch, Peter van Eyck, Gibson Gowland, Cedric Hardwicke, Ernst Hausman, Kurt Kreuger, Mae Marsh, Charles McGraw, John Mylong, Dorothy Peterson, Irving Pichel, William Post Jr., William Prince, Otto Reichow, Henry Rowland, Hans Schumm, Helen Thimig, Henry Travers, Vesey Walker, Violette Wilson, Ian Wolfe, Natalie Wood, Margaret Wycherly.

Sir Cedric Hardwicke is a Nazi colonel who deals with acts of sabotage against his occupation of a Norwegian town by executing hostages. However, he begins to realize that for each person he kills, he creates more determined members of the underground, and the resistance increases.

The film is based on John Steinbeck's *The Moon Is Down* (Garden City, New York: Sun Dial, 1943), a novel that was also adapted into a stage play.

- The character of George Corell, played by E. J. Ballantine, was based on the real pro-Nazi Norwegian traitor Vidkun Quisling.
- The resistance of Norwegians against the Nazi occupation was well known to audiences at the time because of newspaper reports.

MORITURI

20th Century-Fox, Arcola Pictures, Colony Productions, 1965, 123 minutes.

Director: Bernhard Wicki; **Screenwriters:** Werner Jörg Lüddecke (novel), Daniel Taradash; **Cast:** Martin Benrath, Oscar Beregi, Hans Christain Blech, Eric Braeden, Marlon Brando, Martin Brandt, La Chapman, Wally Cox, Charles De Vries, Carl Esmond, Max Haufler, Klaus Kinski, Martin Kosleck, William Redfield, Walter Richter, Norbert Schiller, Sigmar Schneider, Carl Heinz Schroth, Robert Sorrells, Gilchrist Stuart, Rick Traeger, Ivan Triesault.

During World War II, Yul Brynner is the captain of a German freighter bringing rubber to Germany from the Orient. Marlon Brando is a German pacifist forced to work for British intelligence. The British threaten to tell the Nazis he is Jewish unless he agrees to spy for them.

The movie is based on Werner Jörg Lüddecke's *Morituri* (Greenwich: Fawcett/Ballantine Publishers, 1965).

MILITARY SERVICE

- Wally Cox was hospitalized with heat stroke while in training at Camp Walters, Texas, during World War II and received a medical discharge.

AWARD

Academy Awards, USA, 1965
 Nominated: *Oscar*, *Best Cinematography, Black-and-White*, Conrad L. Hall.

MOROCCO

Paramount Pictures, 1930, b&w, 90 minutes.

Producer: Hector Turnbull; **Director:** Josef von Sternberg; **Screenwriters:** Jules Furthman, Benno Vigny (novel, *Amy Jolly*); **Music:** Karl Hajos; **Filmed in:** Imperial County, California; **Cast:** Emile Chautard, Juliette Compton, Albert Conti, Gary Cooper, Thomas A. Curran, Marlene Dietrich, Theresa Harris, Ullrich Haupt, Francis McDonald, Adolphe Menjou, Paul Porcasi, Harry Schultz, Eve Southern, Michael Visaroff.

Marlene Dietrich journeys from Paris to Morocco to sing in a café, rejecting along the way Adolphe Menjou, who can offer her money and security if she becomes his mistress. While doing her act, she becomes infatuated with a handsome French Legionnaire, Gary Cooper, whom she ultimately follows into the desert, barefoot, when the Legionnaires depart.

The movie is based on Benno Vigny's *Amy Jolly* (Berlin-Friedenau: Weltbücher-verlag, 1927).

INTERESTING FACTS

- The infamous scene where Marlene Dietrich kisses another woman—which was added to the script at Dietrich's suggestion—was saved from being cut by the censors by Dietrich herself. She came up with the idea of taking a flower from the woman before kissing her and then giving the flower to Gary Cooper, explaining that if the censors cut the kiss, the appearance of the flower would make no sense.
- At the time of filming, Dietrich knew virtually no English; thus her lines in each scene were kept to a minimum and fed to her phonetically.
- *Morocco* is Marlene Dietrich's first movie in the United States.
- Von Sternberg made seven films with Dietrich, giving rise to rumors of a Svengali relationship between the two.

QUOTES

Tom Brown: I'd sit down if I were you.

Amy Jolly: You are pretty brave . . . with women.

Amy Jolly: You'd better go now. I'm . . . beginning to like you.

AWARDS

Academy Awards, USA, 1930-31
 Nominated: *Oscar*, *Best Actress*, Marlene Dietrich; *Best Art Direction*, Hans Dreier; *Best Cinematography*, Lee Garmes; *Best Director*, Josef von Sternberg

National Film Preservation Board, USA, 1992

National Film Registry

MOSQUITO SQUADRON

Oakmont Productions, 1969, color, 90 minutes.

Producer: Lewis J. Rachmil; **Director:** Boris Sagal; **Screenwriters:** Joyce Perry, Lewis J. Sanford; **Music:** Frank Cordell; **Distributor:** United Artists; **Cast:** Michael Anthony, David Buck, David Dundas, Charles Gray, Brian Grellis, Nicky Henson, Dinsdale Landen, John Landry, Michael Latimer, George Layton, Bryan Marshall, David McCallum, Suzanne Neve, Vladek Sheybal, Derek Steen, Gordon Stone, Patrick Tull, Robert Urquhart.

David McCallum plays a Canadian-born RAF pilot who undertakes a crucial behind-the-lines mission to destroy Germany's ultimate weapon project.

MOUNTAIN ROAD, THE

Columbia Pictures Corporation, 1960, b&w, 102 minutes.

Producer: William Goetz; **Director:** Daniel Mann; **Screenwriters:** Alfred Hayes, Theodore White; **Cast:** Alan Baxter, James Best, Rudy Bond, Leo Chen, Peter Chong, Glenn Corbett, Eddie Firestone, Mike Kellin, P. C. Lee, Lisa Lu, Frank Maxwell, Harry Morgan, Bill Quinn, Frank Silvera, James Stewart.

In war-torn China in 1944, Jimmy Stewart is an American combat engineer, assigned to slow down the Japanese advance by blowing up bridges and mountain passes to delay the enemy.

Based on Theodore White's *The Mountain Road* (New York: W. Sloane Associates, 1958).

QUOTE

Superior Officer: Do you know what command is?
Jimmy Stewart: The book says...
Superior Officer: Command is power.

MOUSE THAT ROARED, THE

Open Road, 1959, color, 83 minutes.

Producers: Carl Foreman, Jon Penington, Walter Shenson; **Director:** Jack Arnold; **Screenwriters:** Roger MacDougall, Stanley Mann, Leonard Wibberley; **Distributor:** Columbia Pictures; **Cast:** Timothy Bateson, Jacques Cey, Charles Clay, Harry De Bray, Bill Edwards, Richard Gatehouse, Colin Gordon, William Hartnell, Harold Kasket, David Kossoff, Monty Landis, George Margo, Leo McKern, Bill Nagy, MacDonald Parke, Stuart Saunders, Peter Sellers, Ken Stanley, Austin Willis, Jean Seberg, Mavis Villiers.

The entire economy of the world's smallest country, the duchy of Grand Fenwick, is based on its wine, Pinot Grand Fenwick. When a competitor in America bottles a cheaper version, Pinot Grand Enwick, bankruptcy rears its ugly head for the tiny duchy, which decides that the only way to get out of its economic woes is to declare war on the United States, lose, and then accept foreign aid. They send an invasion force to New York (in medieval chain mail, armed with longbows), which arrives during a nuclear drill that has cleared the streets. Wandering about the empty city, they discover a scientist with a special ultimate weapon that can destroy the earth. They capture the bomb and unexpectedly win the war.

The film is based on Leonard Wibberley's *The Mouse That Roared* (Boston: Little, Brown, and Company, 1955).

MRS. MINIVER

Metro-Goldwyn-Mayer, 1942, b&w, 134 minutes.

Producers: Sidney Franklin, William Wyler; **Director:** William Wyler; **Screenwriters:** George Froeschel, James Hilton, Jan Struther, Claudine West, Arthur Wimperis; **Music:** Herbert Stothart; **Distributor:** Metro-Goldwyn-Mayer; **Cast:** John Abbott, Harry Allen, Sybil Bacon, Charles Bennett, Florence Benson, Billy Bevan, John Burton, Walter Byron, Colin Campbell, Leonard Carey, Herbert Clifton, David Clyde, Tom Conway, Alec Craig, Helmut Dantine, Marie De Becker, Mary Field, Brenda Forbes, Greer Garson, Douglas Gordon, Bobby Hale, Forrester Harvey, Charles Irwin, Peter Lawford, Connie Leon, Eric Lonsdale, Thomas Louden, Miles Mander, Aubrey Mather, Ottola Nesmith, Richard Ney, Reginald Owen, Walter Pidgeon, Clara Reid, Clare Sandars, Paul Scardon, Christopher Severn, Gerald Oliver Smith, Henry Travers, Ben Webster, Dame May Whitty, Henry Wilcoxon, Rhys Williams, Arthur Wimperis, Ian Wolfe, Teresa Wright.

The Miniver family experiences life in England during World War II while dodging Hitler's bombs in the blitz. Mrs. Miniver captures a downed German pilot whom she tries to help, only to be rewarded with a diatribe about how the Germans are going to level

London with their bombs. Her husband (Walter Pidgeon) takes the family yacht and helps soldiers off the beach at Dunkirk. Her son joins the Royal Air Force, but it is his wife, "safe" back home, who is killed in an air raid.

The film is based on Jan Struther's *Mrs. Miniver* (New York: Harcourt, Brace and Company, 1940).

For historical notes on the blitz, see the *BATTLE OF BRITAIN*. In this movie, Mrs. Miniver's husband participates in the Dunkirk evacuation. Dunkirk is a seaport in northern France, where in late May 1940, the British army was trapped between the advancing German army and the sea. The Royal Navy mobilized every available boat, public and private, on England's Channel coast and evacuated 337,000 troops between May 27 and June 4, 1940. Dunkirk has gone down in history as a brilliant military retreat.

In the movie, the Belham family is the local aristocracy. Beginning with the Norman Conquest in 1066, a rigid class system prevailed in Britain. At the top was the king and the royal family, then came the aristocracy, and finally, with the fewest rights, the common people. Over the centuries, the British class system was gradually dismantled. However, its vestiges were still very evident during World War II. For example, the vast majority of officers, such as Mrs. Miniver's son, still came from the aristocracy.

INTERESTING FACTS

- Winston Churchill once said that this film had done more for the war effort than a flotilla of destroyers.
- Greer Garson's best actress acceptance speech lasted an incredible 5 ½ minutes, making it a Hollywood record.
- After first-choice Norma Shearer rejected the title role (she refused to play a mother), Greer Garson was cast. Although she didn't want the part either, she was contractually bound to take it, and she won an Academy Award for her performance.
- Greer Garson married Richard Ney, who played her son in the movie.
- President Roosevelt was so impressed with the final speech in this film that he ordered it printed onto leaflets and dropped over occupied Europe.

MILITARY SERVICE

- Director William Wyler was commissioned a major in the U.S. Army Air Force early in 1942 and assigned to the Motion Picture Unit of the 91st Bomber Group of the Eighth Air Force in England, with the mission of making a film about heavy bomber operations. He attended gunnery school (a

requirement to fly in combat), flew five combat missions with his film crew, and received the Air Medal. The resulting film was the documentary *Memphis Belle* (upon which the later film of the same name was based). He once asked the pilot to fly closer to the flak so that he could get a better shot. His next mission was in the Mediterranean, where he flew with the 57th Fighter Bomber Group of the 12th Air Force, where he suffered nerve damage to his ears, resulting in a partial loss of hearing for which he received the Purple Heart. He was discharged as a lieutenant colonel, with a disability pension and the Legion of Merit. There was some talk of a Distinguished Service Cross, but after he punched a doorman who made an anti-Semitic remark, he was brought up on charges, and the award recommendation was derailed.

QUOTE

Henry Wilcoxon [preaching from the pulpit at the end of the film, in the speech that FDR reprinted]: This is not only a war of soldiers in uniforms. It is a war of the people—of all the people—and it must be fought not only on the battlefield but in the cities and in the villages, in the factories and on the farms, in the home and in the heart of every man, woman, and child who loves freedom. Well, we have buried our dead, but we shall not forget them. Instead, they will inspire us with an unbreakable determination to free ourselves and those who come after us from the tyranny and terror that threaten to strike us down. This is the people's war. It is our war. We are the fighters. Fight it then. Fight it with all that is in us. And may God defend the right.

AWARDS

Academy Awards, USA, 1942

Won: *Oscar, Best Actress,* Greer Garson; *Best Cinematography, Black-and-White,* Joseph Ruttenberg; *Best Director,* William Wyler; *Best Picture,* Sidney Franklin; *Best Supporting Actress,* Teresa Wright; *Best Writing, Screenplay,* George Froeschel, James Hilton, Claudine West, Arthur Wimperis

Nominated: *Oscar, Best Actor,* Walter Pidgeon; *Best Special Effects,* A. Arnold Gillespie *(photographic),* Warren Newcombe *(photographic),* Douglas Shearer *(sound); Best Film Editing,* Harold F. Kress; *Best Sound Recording,* Douglas Shearer (MGM SSD); *Best Supporting Actor,* Henry Travers; *Best Supporting Actress,* Dame May Whitty.

MR. WINKLE GOES TO WAR

Columbia Pictures Corporation, 1944, b&w, 80 minutes.

Producer: Jack Moss; **Director:** Alfred E. Green; **Screenwriters:** George Corey, Theodore Pratt, Waldo Salt, Louis Solomon; **Music:** Carmen Dragon, Paul Sawtell; **Cast:** Robert Armstrong, Warren Ashe, Walter Baldwin, Cecil Ballerino, Hugh Beaumont, Early Cantrell, Tommy Cook, Ted Donaldson, Jeff Donnell, Nancy Evans, James Flavin, Sam Flint, William Forrest, Howard Freeman, Terry Frost, Richard Gaines, Bernadene Hayes, Bob Haymes, Herbert Heyes, Ernest Hilliard, Ted Holley, Ed Jenkins, Fred Kohler Jr., Richard Lane, Nelson Leigh, Ann Loos, Fred Lord, Robert Mitchum, Dennis Moore, Forbes Murray, Edward G. Robinson, Ann Shoemaker, Leslie Sketchley, Art Smith, Paul Stanton, Paul Stupin, Ben Taggart, Larry Thompson, George Tyne, Emmett Vogan, Ruth Warrick.

Henpecked Mr. Winkle is only too happy to go to war when he's drafted, and so escape his domestic "bliss." Later, his nagging wife and his neighbors are astonished when he returns home a decorated war hero.

The movie is based on Theodore Pratt's *Mr. Winkle Goes to War* (New York: Duell, Sloan and Pearce, 1943).

MURPHY'S WAR

Hemdale, 1971, color, 107 minutes.

Producer: Michael Deeley; **Director:** Peter Yates; **Screenwriters:** Max Catto, Stirling Silliphant; **Music:** John Barry, Ken Thorne; **Distributor:** Paramount; **Cast:** John Hallam, Horst Janson, Ingo Mogendorf, Philippe Noiret, Peter O'Toole, Siân Phillips.

Murphy (Peter O'Toole) is the sole survivor of his torpedoed ship. The crewmen who made it into the water are machine-gunned by a German U-boat in the closing days of World War II. O'Toole washes ashore on a forgotten Pacific island and begins to plot his vengeance. His first attempt is with the British patrol aircraft from his ship, which he rigs with Molotov cocktails. However, while he scores some hits, that doesn't put the U-boat out of action. He then goes after it with an old barge. The Germans have learned that the war is over and try to communicate this to O'Toole, but he doesn't care: They murdered his friends, and they're going to die. He tries to ram the submarine, and in self-defense, they fire a torpedo, which misses and runs up on the beach. They crash-dive to avoid O'Toole's barge, go down too fast, and get stuck in the mud. This gives him time to go to the beach, pick up the still-armed torpedo with the barge crane, and steam back to where the submarine is stuck on the bottom. His torpedo does its job, but in the process, the crane crashes to the deck, and his barge sinks, with him trapped on deck.

The movie is based on Max Catto's *Murphy's War* (New York: Simon and Schuster, 1969).

The Pacific was primarily a Japanese theater of operations, and although the Germans did operate submarines in the Pacific, it is nevertheless disconcerting to see a German U-boat operating among palm trees. The Pacific area was very tough on the U-boats; unlike the Atlantic, where they could return to German sub pens for refuel, resupply, and recreation, there was a real problem in supporting the subs in the Pacific.

INTERESTING FACTS

- Frank Tallman's Grumman J2F-6 Duck was used for O'Toole's aircraft.
- The movie was filmed up the Orinoco River in Venezuela, using the Venezuelan navy submarine *Carite* (ex-*Tilefish*).

MYSTERY SEA RAIDER

Paramount Pictures, 1940, b&w, 73 minutes.

Director: Edward Dmytryk; **Screenwriter:** Edward E. Paramore Jr.; **Cast:** Louis Adlon, Monte Blue, Swen Hugo Borg, Matthew Boulton, Jean Del Val, Kathleen Howard, Reed Howes, Willy Kaufman, Carole Landis, Kay Linaker, Onslow Stevens, Gohr Van Vleck, Roland Varno, Henry Victor, Henry Wilcoxon.

The Nazis hijack a freighter and then use their innocent-looking "Trojan horse" to attack Allied shipping in the Caribbean during World War II. They are even successful in sinking an unsuspecting British cruiser.

MYSTERY SUBMARINE

Universal-International Pictures, 1950, b&w, 78 minutes.

Producer: Ralph Dietrich; **Director:** Douglas Sirk; **Screenwriter:** George F. Slavin; **Music:** Daniele Amfitheatrof, David Buttolph, Joseph Gershenson, Milton Rosen, Hans J. Salter; **Distributor:** Universal Pictures; **Cast:** Orlando Beltran, Ralph Brooke, Macdonald Carey, Jacqueline Dalya, Ludwig Donath,

Robert Douglas, Carl Esmond, Jim Hayward, Thomas Browne Henry, Paul Hoffmann, Judd Holdren, Richard Mayer, Peter Michael, Bruce Morgan, Howard Negley, Fred Nurney, Damian O'Flynn, Steve Pendleton, Frank Rawls, Keith Richards, Lester Sharpe, Peter Similuk, George Spaulding, Märta Torén, Katherine Warren, Larry Winter.

After the end of World War II, Robert Douglas, the captain of a Nazi submarine, appropriates it for his own use, including kidnapping a scientist from the United States. Ultimately, the submarine is depth-charged and sunk by the U.S. Navy.

MYSTERY SUBMARINE

Bertram Ostrer, 1963, b&w, 92 minutes.

Producer: Bertram Ostrer; **Director:** C. M. Pennington-Rich; **Screenwriters:** Bertram Ostrer, Jon Manchip White, Hugh Woodhouse; **Music:** Clifton Parker; **Distributor:** Universal-International; **Cast:** Robert Brown, Richard Carpenter, John Chappell, Desmond Davis, Robert Flemyng, Joachim Fuchsberger, David Glover, Nigel Green, Jeremy Hawk, Gerard Heinz, Frederick Jaeger, Norman Johns, Edward Judd, James Robertson Justice, Sean Kelly, Albert Lieven, George Mikell, Declan Mulholland, Peter Myers, Arthur O'Sullivan, Laurence Payne, Brian Peck, Leslie Randall, Michael Rittermann, Ray Smith, Ewen Solon, Richard Thorp, Hedger Wallace, Peter Zander.

During World War II, a German U-boat is captured by the English fleet and manned by a British crew.

This movie is also known as *Decoy*.

NAKED AND THE DEAD, THE

RKO Radio Pictures Inc., 1958, color, 131 minutes.

Producer: Paul Gregory; **Director:** Raoul Walsh; **Screenwriters:** Norman Mailer, Denis Sanders, Terry Sanders; **Distributor:** Warner Bros.; **Filmed in:** Panama; **Cast:** Henry Armago, John Beradino, James Best, Joey Bishop, William Campbell, Robert Gist, Richard Jaeckel, L. Q. Jones, Raymond Massey, Edward McNally, Barbara Nichols, Jerry Paris, Aldo Ray, Cliff Robertson, Greg Roman, Max Showalter, Lili St. Cyr, Grace Lee Whitney.

In the Pacific during World War II, a general, played by Raymond Massey, sends a squad to the top of a mountain behind enemy lines to report on Japanese troop movements. The squad is commanded by a tough, cynical sergeant, Aldo Ray, who takes no prisoners, and even takes the gold from the teeth of the enemy dead. Before the mission starts, a lieutenant, Cliff Robertson, criticizes the general over his attitude toward the common soldier and as a result is reassigned to lead the squad. The veteran sergeant wants to complete this mission as ordered, and he will do everything he can to see that it is successful.

The film is based on Norman Mailer's. *The Naked and the Dead* (New York: Rinehart, 1948).

MILITARY SERVICE

- Norman Mailer was drafted into the U.S. Army when he graduated from Harvard in 1944 and was trained as an artillery surveyor. Sent to the Philippines, he was put into the intelligence section of an artillery regiment for the invasion of Luzon, where he typed combat reports and interpreted aerial photos. With the novel he would later write in mind, he transferred to a front-line unit, where he served as a rifleman with the 112th Cavalry Regiment (Special) at Luzon, attached to the First Cavalry Division. After the war, he served with the occupation forces, where he became a sergeant; also, he studied at the Sorbonne on the GI bill. His experiences helped him in writing the book on which this movie is based. He is a Pulitzer Prize winner for two of his other books.

NAKED BRIGADE, THE

Box Office Attractions Company, Alfa Studios, 1965, b&w, 101 minutes.

Producer: Albert J. Cohen; **Director:** Maury Dexter; **Screenwriters:** Albert J. Cohen, Irwin Winehouse, A. Sanford Wolfe; **Distributor:** Universal Pictures; **Filmed in:** Greece; **Cast:** Costas Balademas, Mary Chronopoulou, Shirley Eaton, John Holland, Patrick Kavanaugh, Karl Nurk, N. Papaconstantino, Clive Russell, Ken Scott, Eleni Zafiriou, Sonia Zoidou.

Ken Scott is the leader of a group of women guerrillas who resist the Nazi invasion of Crete during World War II.

NAM ANGELS

Concorde-New Horizons, New Horizon Picture Corp, 1989, color, 91 minutes.

Producers: Anna Roth, Christopher R. Santiago; **Director:** Cirio H. Santiago; **Screenwriter:** Dan Gagliasso; **Music:** Jaime Fábregas; **Cast:** Archie Adamos, Frederick Bailey, Rick Dean, Romy Diaz, Kevin Duffis, Tonichi Fructuoso, Jeff Griffith, Eric Hahn, Geronimo Holandez, Brad Johnson, Ken Metcalfe, Leah Navarro, Ruben Ramos, Mark Venturini, Vernon Wells.

A dangerous mission to rescue American POWs in the treacherous Darloc Valley in Vietnam is accomplished with the help of five young, fearless soldiers on Harleys.

NAM'S ANGELS

Fanfare Films, 1970, color, 95 minutes.

Producers: Vicente Nayve, Joe Solomon; **Director:** Jack Starrett; **Screenwriter:** Alan Caillou; **Music:** Stu Phillips; **Distributors:** Fanfare Film Productions, Fanfare Films; **Filmed in:** the Philippines; **Cast:** Alan Caillou, Eugene Cornelius, Von Deming, Vic Diaz, John Garwood, Bernie Hamilton, Fran Dinh Hy, Dan Kemp, Ann Korita, Paul Koslo, Armando Lucero, Lillian Margarejo, Paul Nuckles, Daughters of Sa Paraluman, Monica Phillips, Adam Roarke, Hernan Robles, Ronald C. Ross, Paquito Salcedo, Houston Savage, William Smith, Jack Starrett.

Bikers are hired by the CIA during the Vietnam War to rescue a captured agent from the clutches of the Chinese Red Army. After a round of drinking, fighting, and whoring, they fix up their Yamahas with machine guns, grenades, and armor plating, and storm the enemy camp.

NAVY COMES THROUGH, THE

RKO Radio Pictures Inc., 1942, b&w, 82 minutes.

Producer: Islin Auster; **Director:** A. Edward Sutherland; **Screenwriters:** Earl Baldwin, Roy Chanslor, Borden Chase, John Twist; **Distributor:** RKO Pictures; **Cast:** Stanley Andrews, Desi Arnaz, Max Baer, Lee Bonnell, Ray Collins, Jackie Cooper, Carl Esmond, Frank Fenton, Frank Jenks, Marten Lamont, John Maguire, George Murphy, Pat O'Brien, Joey Ray, Jane Wyatt.

During World War II, Pat O'Brien and George Murphy must put aside their personal differences and fight together against the Nazi menace trying to stop their supply ship from crossing the North Atlantic. During the course of their voyage, they sink a U-boat, shoot down a German bomber, and capture an enemy supply ship.

Because of constant air and submarine attacks, the U.S. Merchant Marine during World War II was not just a supply line of commercial ships delivering vital equipment to beleaguered England. Service in the Merchant Marine carried with it all the dangers of being a combat soldier.

The movie is based on Borden Chase's *The Navy Comes Through* (no publication data is available).

MILITARY SERVICE

• Desi Arnaz resigned his commission in the Cuban army and tried to enlist in the U.S. Navy after Pearl Harbor, but he couldn't because he was a foreign national. However, he could be drafted, and he was, in 1943. Assigned to the U.S. Army Air Force, he injured his knee playing ball and was put on limited duty entertaining soldiers at hospitals for the rest of the war.

NAVY WAY, THE

Paramount Pictures, 1944, b&w, 74 minutes.

Producers: William H. Pine, William C. Thomas; **Director:** William A. Berke, William H. Pine; **Screenwriter:** Maxwell Shane; **Cast:** Robert Armstrong, Joseph Crehan, Sharon Douglas, William Henry, Roscoe Karns, Tom Keene, Robert Lowery, Larry Nunn, Jean Parker, Mary Treen, Tom Tyler.

Robert Lowery plays a champion prizefighter who resents being drafted into the navy during World War II, just when he has a shot at the championship title. However, his attitude is turned around by pretty Jean Parker while he completes basic training at Great Lakes, and he is all straightened out by the time he is ready to leave for sea duty.

NEVER SO FEW

Canterbury Productions, 1959, color, 120 minutes.

Producer: Edmund Grainger; **Director:** John Sturges; **Screenwriters:** Tom T. Chamales, Millard

Kaufman; **Music:** Hugo Friedhofer; **Distributor:** Metro-Goldwyn-Mayer; **Cast:** Philip Ahn, Aki Aleong, Whit Bissell, Robert Bray, Charles Bronson, Brian Donlevy, Ross Elliott, Kipp Hamilton, Paul Henreid, James Hong, John Hoyt, Richard Johnson, Dean Jones, Peter Lawford, Gina Lollobrigida, Leon Lontoc, Richard Lupino, Steve McQueen, Frank Sinatra, William Smith, George Takei.

Frank Sinatra and his band of skilled OSS operatives are in World War II Burma to train the Kachin natives in modern warfare for their fight against the Japanese. When he hears that American soldiers have been wiped out by Chinese troops, he crosses the border against orders, massacres the offending Chinese, and unearths secret documents from the Chinese government encouraging the warlords to kill Americans and sell their equipment to the Japanese. When he returns to his base in Burma, his superiors reprimand him and try to get him to apologize to the Chinese government, but he refuses.

In a poignant scene, Frank Sinatra confronts his superiors with all of the dog tags and other personal items of the massacred American soldiers by dumping them onto a coffee table.

The movie is based on Tom T. Chamales's *Never So Few* (New York: Scribner, 1957).

NIGHT FIGHTERS, THE

Raymond Stross—DRM Cineman, 1960, b&w, 89 minutes.

Producer: Raymond Stross; **Director:** Tay Garnett; **Screenwriter:** R. Wright Campbell (as Robert Wright Campbell); **Music:** Cedric Thorpe Davie; **Distributor:** United Artists; **Cast:** Marianne Benet, Harry Brogan, Eileen Crowe, Cyril Cusack, James Devlin, Wilfred Downing, Hilton Edwards, Geoffrey Golden, Eddie Golden, Richard Harris, Anne Heywood, Marie Kenn, Joe Lynch, Niall MacGinnis, T. P. McKenna, Robert Mitchum, Jim Neylan, Dan O'Herlihy, Christopher Rhodes, Gerry Sullivan.

Robert Mitchum joins the outlawed Irish Republican Army (IRA), which is allied with Nazi Germany. He soon realizes his error and betrays the group. They capture him, but he is rescued and escapes to England.

Ireland, already independent from Great Britain by the beginning of World War II, was officially neutral. Some left Ireland to enlist in the British forces to fight Nazi Germany; others felt that they should aid Nazi Germany because it was an enemy of England and

could help them liberate the remainder of Ireland from British rule.

The movie is also known as *A Terrible Beauty*.

QUOTE

Dermot: Sometimes I think the IRA was invented by a manufacturer of trench coats to keep up sales.

NIGHT OF THE GENERALS, THE

Columbia Pictures Corporation, Filmsonor, Horizon, 1967, color, 148 minutes.

Producer: Sam Spiegel; **Director:** Anatole Litvak; **Screenwriters:** James Hadley Chase, Paul Dehn, Joseph Kessel, Hans Hellmut Kirst; **Distributor:** Columbia Pictures; **Filmed in:** Hamburg, Germany, Paris, France, and Poland; **Cast:** Patrick Allen, Harry Andrews, Yves Brainville, Coral Browne, Gérard Buhr, Nicole Courcel, Tom Courtenay, Michael Goodliffe, Charles Gray, John Gregson, Juliette Gréco, Raymond Gérome, Eléonore Hirt, Gordon Jackson, Olivier Mathot, Charles Millot, Pierre Mondy, Philippe Noiret, Jenny Orléans, Peter O'Toole, Joanna Pettet, Sascha Pitoëff, Donald Pleasence, Christopher Plummer, Omar Sharif, Nigel Stock, Véronique Vendell, Howard Vernon.

A Wehrmacht major, Omar Sharif, investigates the murder of a prostitute in 1940 in Nazi-occupied Warsaw and concludes that the murderer was one of three high-ranking German generals. Sharif's investigations take him from Warsaw to Paris and the plot to assassinate Adolf Hitler just before D day, in which two of the generals are deeply involved. The war ends with the murders unsolved, and it is not until 1965 that the guilty general, Peter O'Toole, is finally forced to atone for his sins.

The movie is based on Hans Hellmut Kirst's *The Night of the Generals* (New York: Harper & Row, 1963).

NINE MEN

Ealing Studios, 1943, b&w, 68 minutes.

Producer: Charles Crichton; **Director:** Harry Watt; **Screenwriters:** Gerald Kersh, Harry Watt; **Music:** John Greenwood; **Filmed in:** Margam and Margam Sands, Wales, both in the UK; **Cast:** Bill Blewitt, Giulio Finzi, Fred Griffiths, Jack Horsman, Gordon Jackson, Jack Lambert, Eric Micklewood, Frederick Piper, Grant Sutherland, John Varley, Richard Wilkinson.

The "nine men" are a British army patrol during World War II, stuck in a desert fort during the campaign in North Africa. They must defend the fort against Italian and German attack until they are relieved.

1941

Columbia Pictures Corporation, A-Team, 1979, color, 146 minutes.

Producers: Buzz Feitshans, Janet Healy, Michael Kahn, John Milius; **Director:** Steven Spielberg; **Screenwriters:** Bob Gale, John Milius, Robert Zemeckis; **Music:** John Williams; **Distributor:** Columbia; **Cast:** Nancy Allen, Dan Aykroyd, Susan Backlinie, E. Hampton Beagle, Ned Beatty, John Belushi, Deborah Benson, Lucille Benson, Jordan Brian, James Caan, Don Calfa, Dave Cameron, John Candy, Vito Carenzo, Mark Carlton, Gary Cervantes, Paul Cloud, Luis Contreras, Elisha Cook Jr., Carol Culver, Eddie Deezen, Bobby Di Cicco, Lucinda Dooling, Joe Flaherty, Gray Frederickson, Brian Frishman, Samuel Fuller, Marjorie Gaines, Denise Gallup, Dian Gallup, Barbara Gannen, Trish Garland, Lorraine Gary, Brad Gorman, Murray Hamilton, Jerry Hardin, Diane Hill, Robert Houston, Dianne Kay, David L. Lander, Audrey Landers, John Landis, Perry Lang, Sydney Lassick, Christopher Lee, Patti LuPone, Mark Marias, Penny Marshall, Tim Matheson, Michael McKean, John R. McKee, Ronnie McMillan, Dan McNally, J. Patrick McNamara, Frank McRae, Toshiro Mifune, Dick Miller, Akio Mitamura, Antoinette Molinari, Steven Mond, Warren Oates, Walter Olkewicz, Slim Pickens, Mickey Rourke, Whitney Rydbeck, Donovan Scott, Kerry Sherman, Hiroshi Shimizu, Geno Silva, Wendie Jo Sperber, Robert Stack, Lionel Stander, Rita Taggart, Dub Taylor, Maureen Teefy, Andy Tennant, Jack Thibeau, Galen Thompson, Frank Verroca, John Voldstad, Carol Ann Williams, Treat Williams, Jenny Williams, Iggie Wolfington, Christian Zika.

Hysteria grips California in the wake of the bombing of Pearl Harbor. An assorted group of inept defenders attempt to make the coast defensible against an imagined Japanese invasion.

In a comedic scene, John Belushi, as a crazed fighter pilot, runs out of gas and stops at a gas station in the desert to fill up, completely destroying the gas station in the process.

- Both John Wayne and Charlton Heston were offered the role of General Stilwell. Wayne phoned director Steven Spielberg, who had given him the script, and not only turned it down due to ill health but also tried to get Spielberg to drop the project. Wayne felt it was unpatriotic and a slap in the face to World War II vets. Heston is thought to have turned it down for the same reasons.
- James Caan has a cameo in the USO fight scene.
- The gas station where Capt. Wild Bill Kelso (John Belushi) lands to refuel was the same one used in Steven Spielberg's movie *Duel* (1971). Lucille Benson, who plays the gas station owner, appeared in *Duel* as the Snakerama owner at the same station.
- The scene where Wild Bill Kelso slips and tumbles off the wing of his airplane as he is about to take off was a real accident. John Belushi slipped as he was climbing into the plane. It was kept in the movie because it fit his character.

QUOTE

Japanese soldier [trying to squeeze a large radio into the sub]: We've got to figure out how to make these things smaller!

AWARDS

Academy Awards, USA, 1979
 Nominated: *Oscar, Best Cinematography*, William A. Fraker; *Best Effects, Visual Effects*, A. D. Flowers, William A. Fraker, Gregory Jein; *Best Sound*, Gene S. Cantamessa, Robert J. Glass, Robert Knudson, Don MacDougall.

1969

Atlantic Entertainment Group, Atlantic Productions, 1988, color, 95 minutes.

Producers: Bill Badalato, Ariel Bagdadi, Thomas Coleman, Daniel Grodnik, Michael Rosenblatt; **Director:** Ernest Thompson; **Screenwriter:** Ernest Thompson; **Music:** Robert Randles; **Distributor:** Atlantic Entertainment Group; **Filmed at:** Savannah and Statesboro, Georgia, Hardeeville, South Carolina; **Cast:** Joanna Cassidy, Bobby Catania, Al Cerullo, Bruce Dern, Don Devendorf, Robert Downey Jr., Carl Espy, Steve Foster, Michael Fowler, John Garber, Paul Gillon, Mariette Hartley, Mert Hatfield, Roy E. Hubbard, Howard Kingkade, Keller Kuhn, Lawrence

Lowe, Maureen Paglia, Jennifer Rothschild, Winona Ryder, James O. Stafford Jr., Scott Stevens, Jason Summers, Kiefer Sutherland, Welton Tootle, David Webster, Mical Whitaker, David Whiting, Christopher Wynne, Richard Young, Kara Zielke.

Kiefer Sutherland and Robert Downey Jr. live in a small town during the Vietnam War. When Sutherland's brothers enlist, he is outspoken in his opposition to the war. His attitude alienates him from his father, and he leaves town with Downey to explore their freedom, but they return when they learn of the death of his brother. This proves to be the catalyst needed to bridge the gap between father and son and enlightens them both to the true cost of war.

QUOTES

Scott: OK, Ralph, you know, I don't have to help you, but let me tell you something. If you flunk out and die in Vietnam, that's the end of our friendship, fuck you, you know.

Scott: If nothing happens by the time I am 20, I'm cutting it off.
Ralph: How ya going to pee there, Scott?
Scott: Sittin' down.

Scott: Hop in! We're not homosexuals or anything.
Scott: We're just gonna groove. That's what hippies do, ya know.

Scott: We had naked people giving us free food!

AWARDS

Political Film Society, USA, 1989

Nominated, PFS Award, Peace

NO MAN IS AN ISLAND

Gold Coast Productions, 1962, color, 114 minutes.

Producers: Rolf Bayer, Richard Goldstone, Albert R. Joseph, Robert E. Lewis, John Monks Jr.; **Directors:** Richard Goldstone, John Monks Jr.; **Screenwriters:** Richard Goldstone, John Monks Jr.; **Music:** Restie Umali; **Distributor:** Universal-International; **Filmed in:** Philippines; **Cast:** Mike Anzures, Lamberto. V Avellana, Mario Barri, Rolf Bayer, Amparo Chichay Custodio, Joseph De Cordova, Paul Edwards Jr., Bert La Fortesa, Jeffrey Hunter, Fred Harris II, Eddie Infante, Steve Joseph, Nena Ledesma, Vicente Liwanag, Rosa Mia, Antonio de la Mogueis, Burt Olivar, Veronica Palileo, Barbara Perez, Bruno Punzalan, Nardo Ramos, Ronald Remy, Vic Silayan, Ding Tello, Marshall Thompson, Segundo Veloria.

Jeffrey Hunter plays an American sailor who hides on a hilltop on Guam after the Japanese invade the island during World War II, eludes capture, and signals vital information to the U.S. Navy.

The movie is based on the true story of George R. Tweed (1903–1989), in his book *Robinson Crusoe, U.S.N.* He was the only serviceman on the island of Guam to avoid capture by the Japanese. A radio operator, he hid in the jungle for two years, signaling information to the U.S. Navy, until the island was liberated in 1944. For his actions, he received the Legion of Merit.

NONE BUT THE BRAVE

Sinatra Enterprises, Tokyo Eiga, Toho, 1965, color, 106 minutes.

Producers: William H. Daniels, Howard W. Koch, Kikumaru Okuda, Frank Sinatra; **Director:** Frank Sinatra; **Screenwriters:** Kikumaru Okuda, Katsuya Susaki, John Twist; **Music:** John Williams; **Distributor**: Warner Bros.; **Filmed in**: Hawaii; **Cast:** Richard Bakalyan, Tony Bill, Phillip Crosby, Christopher Dark, Hisao Dazai, Brad Dexter, Don Dorrell, Roger Ewing, Jimmy Griffin, Kenichi Hata, Toru Ibuki, Takashi Inagaki, Sammy Jackson, Rafer Johnson, Takeshi Kato, Susumu Kurobe, Tatsuya Mihashi, Kenji Sahara, Tommy Sands, Ryucho Shunputei, Frank Sinatra, Richard Sinatra, Homare Suguro, Mashahiko Tanimura, Clint Walker, John Howard Young.

During World War II, an American aircraft loaded with U.S. Marines crash-lands on a remote South Pacific island, which is already occupied by Japanese soldiers abandoned by their army's retreat. Stranded on an island where they might have to spend the rest of the war together, they enter into a truce. However, when the marines repair their radio and help arrives, they enter into a final battle, where most of the marines and all of the Japanese are killed.

NONE SHALL ESCAPE

Columbia Pictures Corporation, 1944, b&w, 85 minutes.

Producer: Samuel Bischoff; **Director:** André De Toth; **Screenwriters:** Lester Cole, Alfred Neumann, Joseph Than; **Music:** Ernst Toch; **Cast:** Trevor Bardette, Felix Basch, Richard Crane, Elvin Field, Arno Frey, Richard Hale, Marsha Hunt, Frank Jaquet, Alexander Knox, Kurt Kreuger, George Lessey, Shirley Mills, Dorothy Morris, Ruth Nelson, Erik Rolf, Art Smith, Ray Teal, Henry Travers, Hank Worden.

After the end of World War II, Nazi Alexander Knox is tried for his war crimes. He is revealed as a monster in a series of flashbacks by the people who knew him. He rapes a young girl, who commits suicide as a result, and he denounces his own brother to the Gestapo. However, his worst crime is when he shoots in cold blood his nephew, whom he has trained to be like him but who succumbs to humanity in the end when Knox's placing of the nephew's fiancée in an officer's brothel leads to her suicide.

INTERESTING FACT

- Although filmed during the war, the story is prophetically set after the war in a Nuremberg-like setting, where war criminals are being tried by an international tribunal.

AWARD

Academy Awards, USA, 1944
 Nominated: *Oscar, Best Writing, Original Story,* Alfred Neumann, Joseph Than.

NORTHERN PURSUIT

Warner Bros., 1943, b&w, 94 minutes.

Producers: Jack Chertok, Jack L. Warner (executive producer); **Director:** Raoul Walsh; **Screenwriters:** Alvah Bessie, William Faulkner, Frank Gruber, Leslie T. White (story); **Music:** Adolph Deutsch, Howard Jackson; **Cast:** Richard Alden, Richard Allord, John Alvin, Bob Ashley, Julie Bishop, Monte Blue, Glen Cavender, Ken Christy, Wallis Clark, Alec Craig, Helmut Dantine, Robert Dayne, Warren Douglas, Jim Dugan, Ben Erway, Tom Fadden, Jim Farley, Errol Flynn, John Forsythe, Arno Frey, Bob Gary, Arthur Gould-Porter, Carl Harbaugh, Joe Haworth, Joe Herrera, Herbert Heywood, Russell Hicks, Rose Higgins, Robert Hutton, Paul Irving, Charles Judels, Fred Kelsey, Bill Kennedy, Robert Kent, Milton Kibbee, Guy Kingsford, George Kirby, John Lannon Jr., Gene Lockhart, George Lynn, Charles Marsh, Clay Martin, Lester Matthews, James Millican, Pat Moriarity, Bernard Nedell, Martin Noble, Hugh Prosser, John Ridgely, John Royce, Eddie Searles, George Sherwood, Jay Silverheels, Cliff Storey, Tom Tully, George Urchell, Sam Waagenaar.

Errol Flynn, a Canadian Mountie, captures a Nazi saboteur who lands in Canada. When the saboteur escapes from a POW camp, Flynn resigns from the Mounties and lets it be known that he is a Nazi sympathizer. He falls in with the saboteurs, who are building a bomber to destroy the St. Lawrence Seaway, the vital artery for the supplies keeping England afloat during the dark days of World War II. Flynn kills the Nazi crew members and bails out; then the plane crashes without hitting its target.

NORTH STAR, THE

Goldwyn Pictures Corporation, 1943, b&w, 108 minutes.

Producer: Samuel Goldwyn, William Cameron Menzies (associate producer); **Director:** Lewis Milestone; **Screenwriters:** Lillian Hellman; **Music:** Aaron Copland, Ira Gershwin; **Distributor:** RKO Radio Pictures Inc.; **Cast:** Dana Andrews, Florence Auer, John Bagni, Art Baker, Charley Bates, Anne Baxter, Bill Borzage, Walter Brennan, Ann Carter, Edmund Cobb, Grace Cunard, Esther Dale, Emma Dunn, Martin Faust, Constant Franke, Inna Gest, Farley Granger, Paul Guilfoyle, Ann Harding, Walter Huston, Teddy Infuhr, Dean Jagger, John Judd, Ilia Khmara, Martin Kosleck, Grace Lenard, Robert Lowery, George Lynn, Jerry Mickelsen, Ruth Nelson, Gene O'Donnell, Sarah Padden, Patricia Parks, Minna Phillips, Tommy Rall, Carl Benton Reid, Eric Roberts, Ferdinand Schumann-Heink, Tonio Selwart, Clarence Straight, Harry Strang, Erich von Stroheim, Ray Teal, Joyce Tucker, Crane Whitley, Frank Wilcox, Jane Withers.

When the Nazis invade their idyllic Russian village, the townspeople are shocked into resistance by Nazi atrocities, such as using their children's blood for wounded German soldiers. With weapons smuggled through the lines by guerrillas, they rise up and annihilate the invaders occupying their town.

INTERESTING FACT

- This is a pro-Soviet film made during World War II that was fine for the time, but very un-American

during the communist era. The film was recut to make it anti-Soviet and retitled *Armored Attack*.

AWARDS

Academy Awards, USA, 1943
 Nominated: *Oscar, Best Interior Decoration, Black-and-White*, Howard Bristol, Perry Ferguson; *Best Cinematography, Black-and-White*, James Wong Howe; *Best Special Effects*, Ray Binger *(photographic)* Thomas T. Moulton *(sound)* Clarence Slifer *(photographic)*; *Best Music, Scoring of a Dramatic or Comedy Picture*, Aaron Copland' *Best Sound Recording*, Thomas T. Moulton (Samuel Goldwyn SSD); *Best Writing, Original Screenplay*, Lillian Hellman.

NOTORIOUS

RKO Radio Pictures Inc., Vanguard Films Production, 1947, b&w, 101 minutes.

Producers: Alfred Hitchcock, Barbara Keon (associate producer); **Director:** Alfred Hitchcock; **Screenwriter:** Ben Hecht; **Music:** Roy Webb; **Distributor:** RKO Radio Pictures Inc.; **Cast:** Fay Baker, Bernice Barrett, Bea Benaderet, Ingrid Bergman, Candido Bonsato, Charles D. Brown, Wally Brown, Eddie Bruce, Paul Bryan, Louis Calhern, Aileen Carlyle, Beulah Christian, Richard Clarke, Tom Coleman, Ricardo Costa, Alfredo DeSa, Lester Dorr, Ben Erway, Almeda Fowler, Gavin Gordon, William Gordon, Cary Grant, Virginia Gregg, Harry Hayden, Alfred Hitchcock, Warren Jackson, Ted Kelly, Donald Kerr, Leopoldine Konstantin, Eberhard Krumschmidt, Frederick Ledebur, James Logan, Leota Lorraine, George Lynn, Frank Marlowe, Frank McDonald, Tina Menard, Charles Mendl, Alex Minotis, Howard M. Mitchell, Antonio Moreno, Sandra Morgan, Howard Negley, Ramon Nomar, Fred Nurney, Moroni Olsen, Garry Owen, Claude Rains, Reinhold Schünzel, Luis Serrano, Patricia Smart, Ivan Triesault, Dink Trout, Emmett Vogan, John Vosper, Alan Ward, Lillian West, Frank Wilcox, Herbert Wyndham, Peter von Zerneck.

Following the conviction of her German father for treason against the United States and his suicide in prison, Ingrid Bergman takes to drink and men. She is approached by a government agent, Cary Grant, who asks her to spy on a group of her father's Nazi friends operating out of Rio de Janeiro. She accepts, hoping that this will clear her father's name. Bergman falls for Cary Grant, but then Bergman is asked by Grant to become first the lover, then the wife, of her father's friend, Claude Rains, so that she will have free access to his house. She obediently follows his instructions, feeling that he must not love her, since he asked her to marry another man. During a party, Bergman and Grant find hidden uranium dust, but Rains has already discovered she is a spy, and he is slowly poisoning her, day after day.

The original story, *The Song of the Dragon*, was first published in the *Saturday Evening Post* in November 1921. David O. Selznick sold the rights to Vanguard in order to finance part of *Duel in the Sun* (1946), which was over-budget and behind schedule.

INTERESTING FACTS

- The film has a cameo by director Alfred Hitchcock: He is seen drinking champagne at the party in Alexander Sebastian's mansion.
- Hitchcock claimed that the FBI had him under surveillance for three months because the film dealt with uranium.
- Producer David O. Selznick originally wanted Vivien Leigh to play Alicia.

MISTAKE

- In the scene in which Cary Grant and Ingrid Bergman are having a drink at an outside table in a busy café, you can see that the same portion of background film was used in two separate parts of their dialogue. Over Grant's shoulder, you see a man walking away from the camera, then a waiter approaches a distant table and starts to put down some drinks from his tray. About a minute later, this all happens again!

QUOTES

Alicia: This is a strange love affair.
Devlin: What's strange about it?
Alicia: The fact that you don't love me.

Alexander Sebastian: I'm not afraid to die.
T. R. Devlin: You've got your chance, here and now.

Madame Sebastian: You're protected by the enormity of your stupidity, for a time.

AWARDS

Academy Awards, USA, 1946
 Nominated: *Oscar, Best Supporting Actor*, Claude Rains; *Best Writing, Original Screenplay*, Ben Hecht.

NUN AND THE SERGEANT, THE

United Artists, 1962, b&w, 74 minutes.

Producer: Eugene Frenke; **Director:** Franklin Adreon; **Screenwriter:** Don Cerveris; **Music:** Jerry Fielding; **Distributor:** United Artists; **Cast:** Norman Dupont, Robert Easton, Jason Fithian, Leo Gordon, Linda Ho, Dale Ishimoto, Caroline Kido, Gregori F. Kris, Ken Miller, King Moody, Hari Rhodes, Anna Shin, Anna Sten, Roger Torrey, Valentin de Vargas, Robert Webber, Tod Windsor, Linda Wong, Yashi.

Robert Webber plays a U.S. Marine sergeant on a mission to blow up an enemy fuel dump during the Korean War, using as his squad American soldiers he recruited from the stockade. Just when these convict soldiers are ready to abandon him, this ragtag bunch is joined by a nun (Anna Shin) and her native schoolgirls, who put the men back on track.

NUN'S STORY, THE

Warner Bros. 1959, color, 149 minutes.

Producer: Henry Blanke; **Director:** Fred Zinnemann; **Screenwriters:** Robert Anderson, Kathryn Hulme (book); **Music:** Franz Waxman; **Filmed in:** Brugge, Belgium (convent exteriors, other exteriors), Democratic Republic of Congo, and Rome, Italy; **Cast:** Elsa Albani, Dorothy Alison, Peggy Ashcroft, Juan Aymerich, Ludovice Bonhomme, Patricia Bosworth, Patricia Collinge, Rosalie Crutchley, Colleen Dewhurst, Mildred Dunnock, Edith Evans, Peter Finch, Giovanna Galletti, Dara Gavin, Audrey Hepburn, Penelope Horner, Dean Jagger, Lionel Jeffries, Errol John, Eva Kotthaus, Charles Lamb, Diana Lambert, Niall MacGinnis, Orlando Martins, Stephen Murray, Ave Ninchi, Barbara O'Neil, Richard O'Sullivan, Margaret Phillips, Elfride Simbari, Frank Singuineau, Jeanette Sterke, Beatrice Straight, Molly Urquhart, Ruth White, Marina Wolkonsky.

Audrey Hepburn plays a Belgian nun who returns from missionary work in the Congo as World War II erupts in Europe. When the invaders kill her father, she decides to join the Resistance, but she must leave her religious order to fight the Nazis.

AWARDS

Academy Awards, USA, 1959
 Nominated: *Oscar, Best Actress,* Audrey Hepburn; *Best Cinematography, Color,* Franz Planer; *Best Director,* Fred Zinnemann; *Best Film Editing,* Walter Thompson; *Best Music, Scoring of a Dramatic or Comedy Picture,* Franz Waxman; *Best Picture,* Henry Blanke; *Best Sound,* George Groves (Warner Bros. SSD); *Best Writing, Screenplay Based on Material from Another Medium,* Robert Anderson

British Academy Awards, 1960
 Won: *BAFTA Film Award, Best British Actress,* Audrey Hepburn—USA
 Nominated: *BAFTA Film Award, Best British Actor,* Peter Finch—USA; *Best British Actress,* Peggy Ashcroft—USA; *Best Film from Any Source,* Fred Zinnemann—USA; *UN Award*—Fred Zinnemann—USA

Golden Globes, USA, 1960
 Won: *Outstanding Merit*

National Board of Review, USA, 1959
 Won: *NBR Award, Best Director,* Fred Zinnemann; *Best Picture; Best Supporting Actress,* Edith Evans

New York Film Critics Circle Awards, 1959
 Won: *NYFCC Award, Best Actress,* Audrey Hepburn; *Best Director,* Fred Zinnemann

San Sebastián International Film Festival, 1959
 Won: *Golden Seashell*—Fred Zinnemann; *Zulueta Prize, Best Actress,* Audrey Hepburn

Writers Guild of America, USA, 1960
 Nominated: *WGA Screen Award, Best Written American Drama,* Robert Anderson.

NURSE EDITH CAVELL

Imperadio Pictures, Ltd., Imperator, 1939, b&w, 108 minutes.

Producers: Merrill G. White (associate producer), Herbert Wilcox; **Director:** Herbert Wilcox; **Screenwriters:** Reginald Berkeley (story, *Dawn*), Michael Hogan; **Music:** Anthony Collins; **Distributor:** RKO Radio Pictures Inc.; **Cast:** Louis V. Arco, Henry Brandon, Egon Brecher, Jimmy Butler, Robert Coote, Adrienne D'Ambricourt, Richard Deane, Joe De Stefani, Ernst Deutsch, Rex Downing, Gilbert Emery, Halliwell Hobbes, Mary Howard, Gui Ignon, Will Kaufmann, Martin Kosleck, Fritz Leiber, Anna Neagle, Edna May Oliver, ZaSu Pitts, Lucien Prival, Frank Reicher, Bert Roach, May Robson, Bodil Rosing, Lionel Royce, George Sanders, Gustav von Seyffertitz, Sophie Stewart, Henry Victor, H. B. Warner.

Anna Neagle plays English nurse Edith Cavell, a matron in a private hospital in German-occupied Brussels during World War I. When the son of a patient escapes from a German prisoner-of-war camp, she helps him reach Holland and safety. This leads Cavell and others to form an organization to help other Allied soldiers escape. When the Germans uncover what she is doing, she is arrested, tried, and executed.

The movie is based on the real-life story of nurse Edith Cavell. A silent movie version of her life was made in 1918, entitled *The Woman the Germans Shot*. Director Herbert Wilcox made a silent version of her life story in 1928.

AWARD

Academy Awards, USA, 1939
 Nominated: *Oscar, Best Music, Original Score,* Anthony Collins.

OBJECTIVE, BURMA!

Warner Bros. 1945, b&w, 142 minutes.

Producers: Jerry Wald, Jack L. Warner; **Director:** Raoul Walsh; **Screenwriters:** Alvah Bessie, Lester Cole, Ranald MacDougall; **Cast:** Erville Alderson, Joel Allen, John Alvin, Warner Anderson, Hugh Beaumont, Carlyle Blackwell, James Brown, Kit Carson, Neil Carter, Anthony Caruso, Elmer Ellingwood, Richard Erdman, Errol Flynn, Shep Houghton, William Hudson, Henry Hull, Asit Koomar, Pete Kooy, Lester Matthews, Harlan Miller, William Prince, Rodd Redwing, John Sheridan, Mark Stevens, Frank Tang, George Tobias, George Tyne, John Whitney.

Errol Flynn jumps with paratroopers into Japanese-occupied Burma on a dangerous and important assignment, to locate and blow up a radar station. After successfully accomplishing their mission, the paratroopers find the Japanese waiting for them at their pickup point, and so begins a long, difficult trek through the enemy-infested jungle.

INTERESTING FACT

- Because of the predominance of American forces in this film about Burma, and the omission of the sizable British contribution, the film was banned in England after being shown for only one week. It was not re-released there until 1952.

ODD ANGRY SHOT, THE

Samson Productions, 1979, color, 92 minutes.

Producers: Tom Jeffrey, Sue Milliken; **Director:** Tom Jeffrey; **Screenwriters:** Tom Jeffrey, William Nagle; **Distributor:** Vestron Video; **Filmed in:** Canungra and Watson's Bay, Australia (final scene); **Cast:** John Allen, Brian Anderson, Tony Barry, Graeme Blundell, Bryan Brown, Brandon Burke, Max Cullen, Brian Evis, John Fitzgerald, Johnny Garfield, Ian Gilmour, John Hargreaves, Mike Harris, Sharon Higgins, Frankie J. Holden, John Jarratt, Graham Kennedy, Sarah Lee, Chuck McKinney, Ray Meagher, Richard Moir, Roger Newcombe, Tim Page, Freddie Paris, Rose Ricketts, Graham Rouse, Brian Wenzel, Joy Westmore.

Four professional Australian soldiers fighting in Vietnam become increasingly disillusioned with the war.

The movie is based on William Nagle's *The Odd Angry Shot* (Sydney: Angus & Robertson, 1975).

Although most people associate the Vietnam War with the United States, in fact, other countries fought in the conflict, under the auspices of the South East Asia Treaty Organization (SEATO), organized by Australia, France, Great Britain, New Zealand, Pakistan, the Philippines, Thailand, and the United States. Established after the French withdrawal from Indochina in 1954, SEATO was created to oppose further communist gains in Southeast Asia. With the U.S.

withdrawal from Vietnam, the future of the organization was in doubt in 1973, and SEATO was ultimately disbanded in 1977.

QUOTES

Bung: Ah, do I detect the unmistakable tang of ye olde Tiger?

Harry: Bung, you could sniff out a can of beer from half a mile away.

Bung: Just one of my many talents.

ODETTE

Wilcox-Neagle, 1951, b&w, 106 minutes.

Producer: Herbert Wilcox; **Director:** Herbert Wilcox; **Screenwriters:** Warren Chetham Strode, Jerrard Tickell; **Music:** Anthony Collins; **Distributor:** Lopert Pictures Corporation; **Cast:** Maurice Buckmaster, Marie Burke, Wolf Frees, Marius Goring, Campbell Gray, Trevor Howard, John Hunter, Bernard Lee, Anna Neagle, Catherine Paul, Derrick Penley, Gilles Quéant, Alfred Schieske, Peter Ustinov, Marianne Walla, Frederick Wendhausen.

The movie is based on a true story. Odette (Anna Neagle) volunteered to join the SOE (Special Operations Executive) during World War II. She was flown into occupied France, where she fought with the French Resistance. Captured and tortured by the Gestapo, she refused to identify her accomplices.

OFF LIMITS

20th Century Fox, 1988, color, 102 minutes.

Producers: Alan Barnette (producer), Michael S. Glick (associate producer); **Director:** Christopher Crowe; **Screenwriters:** Christopher Crowe, Jack Thibeau; **Music:** James Newton Howard; **Cast:** Richard Brooks, Woody Brown, Father Buncha, Norah Elizabeth Cazaux, Trachai Chaivan, Suksanti Cherpat, Willem Dafoe, Keith David, Greg Wayne Elam, Scott Glenn, Clive Gray, David Alan Grier, Gregory Hines, Boonchai Jakraworawut, Rungsima Kasikranund, Jim Kinnon, Gregg Knight, Piathip Kumwong, Robert Langlois, Elizabeth LeCompte, Kay Tong Lim, Nam Look, Thuy An Luu, Peter Mackenzie, Tawan Mahathavorn, Terd Porn Manophaiboon, Pipot Nalinat, Elizabeth Nguyen Thi Hoang Nga, Kim Hoa Nguyen, Raymond O'Connor, Amanda Pays, Thommas Pestonvi, Prae Petchompoo, Jean Phuturoi, Somboun Phuturoi, Pravit Piyasirikul, Arm Suvinit Pornvalai, Pradit Prasartthong, Praput Puuyatip, Richard Lee Reed, Louis Roth, Tom Schroeder, Chumpon Senetara, Ken Siu, Kamsine Spinogg, Mayura Srisittdecharak, Arun Sunantalod, Teerapat Tanapum, Tongkaow Taverprungsenukul, Wasun Uttamayodhin, Viladda Vanadurongwan, Kovit Vatan, Fred Ward, Kanya Wongsawasdi.

Willem Dafoe and Gregory Hines are plainclothes U.S. military policemen in wartime Saigon. When they are assigned to investigate the serial killings of local prostitutes, murdered witnesses and uncooperative local Vietnamese police are only some of the barriers placed in the way of bringing in their prime suspect, a high-ranking U.S. Army officer.

During their investigation, Dafoe and Hines try to question an American colonel in a helicopter. He is at the same time interrogating Vietcong prisoners, and when prisoners don't give him the answer he wants, he throws them out of the helicopter to their deaths.

QUOTE

Dix: You're floatin' in a big sea of shit and instead of just stayin' in the boat, no, you reach out and you pick up this one little turd and you say "This turd, well *this* turd pisses me off. I'm gonna do somethin' about *this* turd!"

OKINAWA

Columbia Pictures Corporation, 1952, b&w, 67 minutes.

Producer: Wallace MacDonald; **Director:** Leigh Jason; **Screenwriters:** Jameson Brewer, Arthur A. Ross, Leonard B. Stern; **Distributor:** Columbia Pictures; **Cast:** Richard Benedict, Richard Denning, James Dobson, Don Gibson, H. W. Gim, Cameron Mitchell, Alvy Moore, Pat O'Brien, Rudy Robles, Rhys Williams.

Pat O'Brien commands a destroyer in the U.S. Fifth Fleet that must survive deadly kamikaze attacks from the Japanese while it supports the Allied invasion of Okinawa in 1945.

ONE MINUTE TO ZERO

RKO Radio Pictures Inc., 1952, b&w, 105 minutes.

Producer: Edmund Grainger; **Director:** Tay Garnett; **Screenwriters:** William Wister Haines, Milton

Krims; **Music:** Victor Young; **Cast:** Ann Blyth, Wally Cassell, Richard Egan, Eddie Firestone, Eduard Franz, Robert Gist, Charles McGraw, Robert Mitchum, Robert Osterloh, Roy Roberts, Margaret Sheridan, William Talman.

An idealistic young U.N. official, Ann Blyth discovers the horrors of war when she falls in love with Robert Mitchum, the colonel in charge of evacuating Korean noncombatants as the communists drive south of the 38th parallel.

INTERESTING FACT

- The U.S. Army refused to extend its cooperation to this film because of a scene in which Robert Mitchum, when he learns that North Korean soldiers have infiltrated his lines, orders his troops to attack a column of civilians with mortars.

ONE OF OUR AIRCRAFT IS MISSING

British National Films, The Archers, 1942, b&w, 102 minutes.

Producers: John Corfield, Stanley Haynes, Michael Powell, Emeric Pressburger; **Directors:** Michael Powell, Emeric Pressburger; **Screenwriters:** Michael Powell, Emeric Pressburger; **Distributor:** United Artists; **Filmed in:** The Wash and The Fens, East Anglia, England; **Cast:** Hector Abbas, Joan Akkerman, Willem Akkerman, John Arnold, Cliff Bastin, Robert Beatty, Pamela Brown, Hugh Burden, James B. Carson, Alec Clunes, Roland Culver, William D'Arcy, James Donald, Robert Duncan, John England, David Evans, Robert Helpmann, Gordon Jackson, Emrys Jones, John Longden, Arnold Marlé, Bernard Miles, Valerie Moon, Hay Petrie, Eric Portman, Michael Powell, Joyce Redman, Stewart Rome, John Salew, Peter Schenke, Godfrey Tearle, Peter Ustinov, Selma Van Dias, David Ward, Hugh Williams, Gerry Wilmot, Googie Withers.

A bomber crew is shot down over Europe during World War II and is helped by Dutch patriots to return to England. The film is based on Michael Powell and Emeric Pressburger's *One of Our Aircraft Is Missing* (Anglo-American Film Corporation, 1942).

INTERESTING FACTS

- The title of the film derives from radio broadcasts during the Allied bombing offensive of World War II, when the public was often informed on the radio that "A raid took place last night over . . ., one of our aircraft is missing."
- John Seabourne Sr. directed the "lobster pot scenes" in the North Sea despite being seasick the whole time.
- One day Noel Coward visited the set, and after seeing how the crew staged and wrapped up an elaborate sequence in about two hours, he decided to use most of it in his film *IN WHICH WE SERVE* (1942).
- The model of Stuttgart used in the bombing raid was made by David Rawnsley at the Riverside Studio, Hammersmith, and filmed by Freddie Ford.
- Actor Emrys Jones (Bob Ashley, wireless operator and footballer) was an international soccer player before the war. The character was made to be a footballer because he could already play well.

QUOTES

Else Meertens: Do you think that we Hollanders who threw the sea out of our country will let the Germans have it? Better the sea.

Jo de Vries [as RAF bombers approach]: You see. That's what you're doing for us. Can you hear them running for shelter? Can you understand what that means to all the occupied countries? To enslave people, having it drummed into their ears that the Germans are masters of the earth. Seeing these masters running for shelter. Seeing them crouching under tables. And hearing that steady hum night after night. That noise which is oil for the burning fire in our hearts.

ONE THAT GOT AWAY, THE

British Film Productions, Julian Wintle Production, 1957, b&w, 106 minutes.

Producers: David Deutsch, Julian Wintle; **Director:** Roy Ward Baker; **Screenwriters:** Kendal Burt, Howard Clewes, James Leasor; **Distributor:** Rank Organisation; **Cast:** Terence Alexander, Robert Crewdson, Robert Dorning, Andrew Faulds, Michael Goodliffe, Colin Gordon, Jack Gwyllim, Paul Hansard, Frederick Jaeger, Hardy Krüger, Harry Lockart, Richard Marner, Alec McCowen, George Mikell, George Roubicek, Julian Somers, John Van Eyssen.

After escaping from numerous British POW camps and being recaptured, a resourceful German lieutenant finally succeeds in getting back to Germany.

- The movie is based on the true story of Oberleutnant Franz von Werra, the only German prisoner of war taken to Britain during World War II who escaped and got back to Germany.

OPERATION AMSTERDAM

Rank Organisation, 1959, b&w, 143 minutes.

Producers: Maurice Cowan, Earl St. John; **Director:** Michael McCarthy; **Screenwriters:** John Eldridge, Michael McCarthy, David E. Walker; **Music:** Philip Green; **Distributor:** Rank Organisation; **Cast:** John Bailey, Eva Bartok, Tony Britton, Alfred Burke, Max Croiset, Petra Davies, Peter Finch, Lex Goudsmit, Melvyn Hayes, John Horsley, Carl Jaffe, Malcolm Keen, Alexander Knox, John Le Mesurier, Arnold Marlé, George Pravda, Keith Pyott, Oscar Quitak, Christopher Rhodes, John Richardson, Frederick Schiller, Peter Swanwick, Tim Turner.

During World War II, British commandos enter occupied Holland to help the Dutch underground keep a fortune in diamonds out of the hands of the Gestapo. Their biggest obstacle is that one of their number is a traitor.

OPERATION BIKINI

American International Pictures, 1963, b&w, 77 minutes.

Producers: James H. Nicholson, Lou Rusoff; **Director:** Anthony Carras; **Screenwriter:** John Tomerlin; **Music:** Les Baxter; **Distributor:** American International Pictures; **Cast:** Aki Aleong, Frankie Avalon, Jim Backus, Scott Brady, Marc Cavell, Gary Crosby, Michael Dante, Tab Hunter, David Landfield, Jody McCrea, Eva Six.

Tab Hunter is a U.S. Navy underwater demolition expert who leads an operation to destroy a sunken American submarine, so that the Japanese do not salvage it and obtain top-secret radar equipment.

OPERATION BOTTLENECK

Zenith, 1961, b&w, 77 minutes.

Producer: Robert E. Kent; **Director:** Edward L. Cahn; **Screenwriter:** Orville H. Hampton; **Distributor:** United Artists; **Cast:** Norman Alden, Salvatore Baccaloni, Ben Bennett, Jane Chang, Lemoi Chu, John Clarke, Marc Eden, Ron Foster, Dale Ishimoto, Tiko Ling, Jin-Jin Mai, Miiko Taka, Ben Wright.

The movie is about soldiers fighting in Burma during World War II.

OPERATION CROSSBOW

Metro-Goldwyn-Mayer, 1965, color, 115 minutes.

Producer: Carlo Ponti; **Director:** Michael Anderson; **Screenwriters:** Duilio Coletti, Vittoriano Petrilli, Emeric Pressburger, Derry Quinn, Ray Rigby; **Music:** John Alderton, Robert Brown, Tom Courtenay, Allan Cuthbertson, Helmut Dantine, Guy Deghy, Maurice Denham, John Fraser, Wolf Frees, John G. Heller, Drewe Henley, Paul Henreid, Trevor Howard, Richard Johnson, Jeremy Kemp, Gertan Klauber, Sophia Loren, Philip Madoc, Ferdy Mayne, William Mervyn, George Mikell, John Mills, Charles Lloyd Pack, Lilli Palmer, George Peppard, Anthony Quayle, John Ronane, Barbara Rütting, Jeremy Spenser, Milo Sperber, Karel Stepanek, Sylvia Syms, Richard Todd, Moray Watson, Richard Wattis, Patrick Wymark.

George Peppard leads a special commando team assigned to find the secret launching pads for Nazi rockets. They masquerade as German agents, find and illuminate the sites to guide the Allied bombers, and are themselves obliterated in the attack.

Operation Crossbow was the name given to Allied bombing raids on V-1 and V-2 rocket sites in Holland and France at the end of World War II. These flying bombs and guided missiles, like the Scuds of the Gulf War, were not very accurate, but they could hit somewhere in London when fired from the Continent, and ultimately the death toll stood at 6000. These are another example of the superweapons that Adolf Hitler believed would turn the tide of the war. The film is based on actual incidents during the war.

- The title was (briefly) changed by MGM for the American release to *The Great Spy Mission* because MGM thought that having the word *operation* in the title might make people think it was a medical film, a genre that wasn't doing well at the box office in 1965.
- The film portrays Hannah Reitsch, who in real life was a test pilot and really did fly some of the first "flying bombs."

MISTAKE

- When the first buzz bomb falls on London the cooling towers of a nuclear power plant are visible in the top left-hand side of the screen.

OPERATION CROSS EAGLES

Triglav Films, Noble Entertainment Group, 1969, color, 90 minutes.

Producer: Ika Panajotovic; **Director:** Richard Conte; **Screenwriter:** Vincent Fotre; **Distributor:** Continental; **Filmed in:** Trieste and Yugoslavia; **Cast:** Relja Basic, Phil Brown, Rory Calhoun, Richard Conte, Rada Djuricin, Aili King, Abdul Rahman, Rick West.

Richard Conte leads a mission into Yugoslavia during World War II and rescues an American officer with the help of local partisans and three commandos who are there on a totally unrelated mission.

OPERATION DAMES

American International, 1959, b&w, 74 minutes.

Producer: Stan Kalis; **Director:** Louis Clyde Stoumen; **Screenwriter:** Edward J. Lakso; **Music:** Richard Markowitz; **Filmed in:** California; **Cast:** Alice Allyn, Ed Craig, Don Devlin, Cindy Girard, Chuck Van Haren, Chuck Henderson, Edward J. Lakso, Joe Maierhouser, Eve Meyer, Eve Miller, Byron Morrow, Barbara Skyler.

Chuck Henderson plays a sergeant in Korea, who must get members of a USO show, caught behind enemy lines, back to safety.

OPERATION DAYBREAK

American Allied Pictures, Ceskostovensky Filmexport, 1976, color, 118 minutes.

Producers: Carter DeHaven, Stanley O'Toole (associate producer); **Director:** Lewis Gilbert; **Screenwriters:** Alan Burgess (novel, *Seven Men at Daybreak*), Ronald Harwood; **Music:** David Hentschel; **Distributor:** Warner Bros.; **Filmed in:** Prague, Czechoslovakia; **Cast:** John Abineri, Josef Abrhám, Joss Ackland, Anthony Andrews, Timothy Bottoms, Diana Coupland, Cyril Cross, Anton Diffring, Vernon Dobtcheff, Jaroslav Drbohlav, Radoslav Dubansky, Carl Duering, Kim Fortune, Frank Gatliff, Keith James, Vítezslav Jandák, Gertan Klauber, Reinhard Kolldehoff, Jirí Krampol, Josef Laufer, William Lucas, Philip Madoc, Kika Markham, Pavla Matéjuvská, Neil McCarthy, Nicola Pagett, Ronald Radd, George Sewell, Cyril Shaps, Martin Shaw, Ray Smith, Nigel Stock, Aubrey Woods.

During World War II, a squad of Czech expatriates parachute into Czechoslovakia and assassinate Nazi governor Reinhard Heydrich. In retribution, the Germans destroy the town of Lidice.

Reinhard Heydrich (1904–1942), second in command to Gestapo chief Heinrich Himmler, was well known for his atrocities in Nazi-occupied Europe, especially in Czechoslovakia, for which he earned the nickname "Heydrich the Hangman." When he was assassinated by Czech patriots, the Nazis retaliated by killing large numbers of hostages and ultimately destroying the town of Lidice.

The movie is based on Alan Burgess's *Seven Men at Daybreak* (London: Evan Bros., 1960).

INTERESTING FACT

- *Hitler's Hangman*—and HITLER'S MADMAN, and HANGMEN ALSO DIE—also deal with Reinhard Heydrich. His funeral, which Hitler attended, is featured in the documentary *One Inch from Victory*.

OPERATION DIAMOND

Cine-Industrial, Renown, 1948, b&w, 53 minutes.

Producer: Patrick Matthews; **Director:** Ronnie Pilgrim; **Screenwriter:** Anthony Richardson; **Cast:** Sydney Benson, Cyril Conway, Archie Duncan, Frank Hawkins, Tonie MacMillan, Michael Medwin, Hamish Menzies, Arthur Mullard, Beth Ross, Gerik Schjelderup, Campbell Singer, Martin Wyldeck.

A Dutch soldier and an English soldier team up to prevent the Nazis from capturing a precious Dutch gem, the world's largest diamond.

INTERESTING FACT

- Included in the film is a segment detailing how the giant gem was mined and cut.

OPERATION DUMBO DROP

Interscope/Polygram/Walt Disney Pictures, 1995, color, 107 minutes.

Producers: Robert W. Cort, Ted Field, Penelope L. Foster, Edward Gold, Diane Nabatoff; **Director:**

Simon Wincer; **Screenwriters:** Jim Kouf, James Morris, Gene Quintano; **Music:** David Newman; **Distributors:** Buena Vista Pictures, Lauren Film; **Cast:** Vo Trung Anh, Marshall Bell, Mark S. Bryant, Jared Chandler, Steve Countouriotis, Doug E. Doug, Lionel Douglas, Danny Glover, James Hong, Somsak Hormsombat, Doi Chettawat Kanboon, Tchéky Karyo, Tim Kelleher, Kevin LaRosa, Dinh Thien Le, Denis Leary, Michael Lee, Ray Liotta, Hoang Ly, Robert Kevin Miller, Mac Van Nam, Corin Nemec, Long Nguyen, Thanh Nguyen, Hing Hang Quang, Nick Satriano, Scott N. Stevens, Ton Nguyen That, Wichien Nguyen Thi, Le Minh Tien, Chern Dao Van, Tien Nguyen Van, Christopher Ward.

During the Vietnam War, the Americans use a Vietnamese village as their headquarters to monitor enemy troop movements on the Ho Chi Minh Trail. When this comes to the attention of the North Vietnamese army, they kill the town's sacred elephant in retaliation. Unfortunately, the villagers need an elephant for a ceremony that will occur within the week. The U.S. Army decides to replace it. They procure another pachyderm and assemble a motley group of unlikely heroes whose mission is to transport the elephant across Vietnam and get it to the village in time.

At the end of the film, the only way to get the elephant there in time is with an air drop. As the elephant falls to earth in his parachute, the song from the Disney film *Dumbo* is played, whose refrain is "I guess I done seen everything, when I see an elephant fly."

INTERESTING FACT

• The story is based on a newspaper article by retired American general Jim Morris.

OPERATION MAD BALL

Columbia Pictures Corporation, 1957, b&w, 105 minutes.

Producer: Jed Harris; **Director:** Richard Quine; **Screenwriters:** Arthur Carter, Blake Edwards, Jed Harris; **Music:** George Duning, Fred Karger, Richard Quine; **Cast:** Bebe Allen, Sheridan Comerate, Dick Crockett, James Darren, Kathryn Grant, William Hickey, L.Q. Jones, Ernie Kovacs, Mary LaRoche, James Lanphier, Jack Lemmon, William Leslie, Jeanne Manet, David McMahon, Dale Musselman, Arthur O'Connell, Paul Picerni, Mickey Rooney, Roger Smith, Dick York.

After the end of World War II, Jack Lemmon is a U.S. Army corporal who is trying to attract a pretty nurse, while at the same time masterminding a scheme to hold an outrageous party for enlisted soldiers at a French hotel without their officers finding out.

OPERATION PACIFIC

Warner Bros., 1951, b&w, 111 minutes.

Producer: Louis F. Edelman; **Director:** George Waggner; **Screenwriter:** George Waggner; **Music:** Max Steiner; **Distributor:** Warner Bros.; **Cast:** John Baer, Ward Bond, Virginia Brissac, William Campbell, Philip Carey, Bob Carson, Cliff Clark, Gail Davis, Chris Drake, Sam Edwards, James Flavin, Scott Forbes, Vincent Forte, Kathryn Givney, Ray Hyke, Gayle Kellogg, Al Kikume, Harry Lauter, Richard Loo, Lewis Martin, Martin Milner, Louis Mosconi, Bob Nash, Patricia Neal, Jack Pennick, Paul Picerni, Carl Saxe, William Self, Harlan Warde, John Wayne, Steve Wayne, Carleton Young.

Submarine commander John Wayne feels responsible for the death of his former commanding officer, Ward Bond, and is hated by Bond's younger brother, a naval aviator who blames him for his death. These issues pull at him during a hazardous mission against the Japanese in World War II while on patrol and in command of the submarine *Thunder*.

The character of Ward Bond in this film is based on Medal of Honor recipient Cmdr. Howard Walter Gilmore, who received the medal for the acts depicted in the film.

MISTAKE

• It is impossible for a sailor to communicate with an airplane by using a sound-powered phone.

QUOTE

Martin Milner: Boy, that's the first time I ever saw a sub get knocked off! [Then he realizes that he and the crew are submariners also, and there is a silence in the conning tower.]

OPERATION PETTICOAT

Universal-International Pictures, 1959, color, 124 minutes.

Producer: Robert Arthur; **Director:** Blake Edwards; **Screenwriters:** Paul King, Maurice Richlin, Stanley

Shapiro, Joseph Stone; **Music:** Henry Mancini, David Rose; **Distributor:** Universal Pictures; **Filmed in:** Key West, Florida; **Cast:** Hal Baylor, Nicky Blair, William R. Callinan, Gordon Casell, Dick Crockett, Patrick Curtis, Tony Curtis, Frankie Darro, Alan Dexter, George Dunn, Gene Evans, Tusi Faiivae, Robert Gist, Cary Grant, Virginia Gregg, Preston Hanson, Harry Harvey Jr., Robert F. Hoy, Vi Ingraham, Glenn Jacobson, James Lanphier, Nelson Leigh, Leon Lontoc, Clarence Lung, Gavin MacLeod, Dina Merrill, John W. Morley, Joan O'Brien, Arthur O'Connell, Tony Pastor Jr., Madlyn Rhue, Marion Ross, Francis De Sales, Dick Sargent, Alan Scott, Robert F. Simon, Bob Stratton, Nino Tempo, Francis L. Ward.

Cmdr. Matt Sherman, USN (Cary Grant) is trying to fight the Japanese during World War II, but he is encumbered by both a less-than-seaworthy submarine, the *Sea Tiger*, and his first officer, Lt. Nicholas Holden (Tony Curtis), who sees ships of the U.S. Navy as a convenient way to transfer his libido and his con jobs from port to port. When the crew is forced to take on a group of stranded nurses, Sherman finds himself more worried about keeping the men and women separated than he is in fighting the Japanese.

Among the noteworthy comic scenes are these: The *Sea Tiger* is being depth-charged from an American destroyer. Cary Grant is at a loss how to tell the destroyer crew that they are an American submarine, until he finally hits upon a foolproof plan: Send up the nurses' bras through the torpedo tubes. In another scene, the men of the *Sea Tiger* try to get a primer coat of paint on the sub, and after scrounging for every gallon of paint they can find, they are forced to mix white and red in order to have enough paint—so they end up with pink. When forced to flee the repair dock during a Japanese air attack, they find themselves with the world's only pink submarine (which might have inspired the Beatles' *Yellow Submarine*).

INTERESTING FACT

- Nurse Barbara (Dina Merrill), the love interest for Tony Curtis's character, was played in the 1977 remake by Curtis's daughter, Jamie Lee Curtis.

MISTAKES

- As Commander Sherman (Cary Grant) is coming off the gangplank from the submarine, Nick Holden's kids call him Mr. Grant.

- When Holden tricks the MP outside the warehouse in the Philippines, he says that Admiral Nimitz had issued orders for everyone to "black out" their faces at night to avoid providing targets to enemy planes. At the time, December 1941, Nimitz had no jurisdiction over naval forces in the Far East, having just been relieved as chief of the Bureau of Navigation so that he could take up his duties as Commander in Chief, Pacific Fleet (not the Asiatic Fleet, which controlled all naval forces in the Philippines). He controlled all naval forces at the end of the month, after the scene in question occurred.

QUOTES

Cmdr. Matt Sherman: Lt. Holden has reached new heights in the art of scavenging. Like a spider in a web, he sits there and his victims come to him like flies bearing gifts. He's the only man I know who will probably be presented the Navy Cross at his court-martial.

Cmdr. Matt Sherman: When a girl's under 21, she's protected by law. When she's over 65, she's protected by nature. Anywhere in between, she's fair game.
Nurse [after Tony Curtis offers her his pajamas]: A girl just doesn't get into any man's pajamas.

Cmdr. Matt Sherman: Repairs progressing. Crew morale high, except for their concern that our supply officer might be caught and shot. My emotions about this are mixed. Lieutenant Holden and Sergeant Gillardo are undoubtedly the world's greatest thieves . . . ummm, um, scavengers. To paraphrase Mr. Churchill, never have so few stolen so much from so many.

Sailor [after one of the torpedoes goes up on the beach]: We just sank a truck!

AWARDS

Academy Awards, USA, 1959
 Nominated: *Oscar, Best Writing, Story and Screenplay—Written Directly for the Screen*, Paul King, Maurice Richlin, Stanley Shapiro, Joseph Stone

Writers Guild of America, USA, 1960
 Nominated: *WGA Screen Award, Best Written American Comedy*, Maurice Richlin, Stanley Shapiro.

OPERATION SECRET

Warner Bros., 1952, b&w, 108 minutes.

Producer: Henry Blanke; **Director:** Lewis Seiler; **Screenwriter:** James R. Webb; **Music:** Roy Webb; **Cast:** Harry Arnie, Baynes Barron, John Beattie, Steve Cochran, George Dee, Claude Dunkin, Anthony Eisley, Joe Espitallier, Charles Flynn, Ed Foster, Wilton Graff, Gayle Kellogg, William Leicester, Karl Malden, Lester Matthews, Jay Novello, Dan O'Herlihy, Kenneth Patterson, Paul Picerni, Montgomery Pittman, Rudy Rama, Dan Riss, Henry Rowland, Phillip Rush, Robert Shaw, Wayne Taylor, Phyllis Thaxter, Harlan Warde, Cornel Wilde.

Cornel Wilde, believed to have been shot down during World War II, is being tried in absentia for the murder of a member of the French underground while he was in France on a mission to steal film of a new Nazi jet aircraft. When he appears in court, very much alive, he is able to prove that the real murderer is a communist spy who had infiltrated the underground.

The movie is based on the true story of Lt. Col. Peter Ortiz, U.S. Marine Corps.

OPERATION SNATCH

Keep Films, Lion International, 1962, b&w, 89 minutes.

Producer: Jules Buck; **Director:** Robert Day; **Screenwriters:** Alan Hackney, Lee Heath, Paul Mills, John Warren; **Music:** Kenneth V. Jones; **Distributor:** Continental; **Cast:** Mario Fabrizi, John Gabriel, Gerard Heinz, Bernard Hunter, Lionel Jeffries, Jackie Lane, Howard H. Lang, Jeremy Lloyd, John Meillon, Warren Mitchell, Lee Montague, George Sanders, John Scott, Mark Singleton, Graham Stark, Terry Thomas, Michael Trubshawe, James Villiers, Ian Whittaker.

Terry Thomas plays a bungling British officer sent to Gibraltar during World War II to keep the Barbary apes from leaving. Legend has it that Britain will never leave this fortress that guards the Mediterranean as long as there are apes in the caves.

OPERATION WARZONE

Action International Pictures, 1991, color, 86 minutes.

Producers: Fritz Matthews, Manoj Parekh, David Winters, Marc Winters; **Director:** David A. Prior;

Screenwriters: David A. Prior, Ted Prior; **Music:** Garm Beal, Tim James, Steve McClintock; **Distributor:** Action International Pictures; **Cast:** John Cianetti, Sean Holton, Chet Hood, Sonny King, David Marriott, Fritz Matthews, Joe Spinell, William Zipp.

During the Vietnam War, a corrupt Pentagon general sells arms to the North Vietnamese for his personal profit. He seeks to prevent the United States from winning a decisive victory, because if the war comes to an end, this will put a stop to his profitable arms dealing. Meanwhile, in Vietnam, the general's weapons dealers fight those who oppose his secret arms plan.

ORDERS TO KILL

Lynx Films Ltd., 1958, b&w, 93 minutes.

Producer: Anthony Havelock-Allan; **Director:** Anthony Asquith; **Screenwriters:** Paul Dehn, George St. George; **Music:** Benjamin Frankel; **Distributor:** UMPO; **Cast:** Eddie Albert, Anne Blake, Jacques B. Brunius, John Crawford, Selma Vaz Dias, Sandra Dorne, Leslie French, Lillie Bea Gifford, Lillian Gish, William E. Greene, Robert Henderson, Miki Iveria, Lionel Jeffries, James Robertson Justice, Sam Kydd, Launce Maraschal, Paul Massie, Ralph Nossek, Nicholas Phipps, Boris Ranevsky, Ann Walford, Irene Worth.

An American intelligence officer's mission is to kill a French collaborator suspected of working with the Nazis.

O.S.S.

Paramount Pictures, 1946, b&w, 105 minutes.

Producer: Richard Maibaum; **Director:** Irving Pichel; **Screenwriter:** Richard Maibaum; **Music:** Daniele Amfitheatrof, Heinz Roemheld; **Cast:** Dorothy Adams, Philip Ahlm, Carl Andre, Albert Van Antwerp, Paul Barrett, George Barton, Don Beddoe, Holger Bendixen, Richard Benedict, Carmen Beretta, John Bogden, Egon Brecher, George Bruggeman, Bill Burt, Helen Chapman, André Charlot, Edward Clark, Louise Colombet, Catherine Craig, James Craven, Roger Creed, Joseph Crehan, Frank Dae, Julia Dean, John Dehner, Leslie Denison, Paul Diamond, Bobby Driscoll, Jimmie Dundee, Richard Elmore, Frank Ferguson, Geraldine Fitzgerald, Eugene Gericke, Jon Gilbreath, Joseph Granby, Henry Guttman, John Har-

mon, Edward Harvey, Len Hendry, John Hoyt, Jerry James, Roberta Jonay, Patric Knowles, Fred Kohler Jr., Alan Ladd, Jack Lambert, Paul Lees, Janna de Loos, John Maxwell, Tony Merlo, Peter Michael, Hans Moebus, Gavin Muir, Fred Nurney, Walter Pietila, Byron Poindexter, Renee Randall, Jean Ransome, Jean Ruth, Gloria Saunders, Tom Schamp, George Sorel, Onslow Stevens, Tom Stevenson, George Taylor, Archie Twitchell, Jean Del Val, Harold Vermilyea, Charles Victor, Henry Vroom, Richard Webb, James Westerfield, Crane Whitley, Herbert Wyndham.

OSS agent Alan Ladd is dropped into Nazi-occupied France with Geraldine Fitzgerald to blow up a railway tunnel as part of the Allied preinvasion strategy. Although they initially dislike each other, during the course of the mission they fall in love. When she is captured by the Gestapo, he is forced to reluctantly abandon her because he must get critical intelligence information back to the Allies.

Entering World War II, the United States had no effective international intelligence network. As a result, FDR created the OSS (Office of Strategic Services) on July 13, 1942, using the British Secret Service as its model, and appointed his friend and World War I Medal of Honor recipient "Wild Bill" Donovan to run it. While some generals, such as MacArthur, were openly hostile to OSS operations and refused to let OSS agents into their theater of operations, the agents were highly effective in those areas where they did operate. With the end of the war, the OSS was disbanded, but many of its operatives, such as future CIA head Allen Dulles, went on to work for the CIA when it was established.

OUR FIGHTING NAVY

Herbert Wilcox Productions Ltd., 1937, b&w, 66 minutes.

Producer: Herbert Wilcox; **Director:** Norman Walker; **Screenwriters:** H. T. Bishop, Gerald Elliott, Harrison Owen, Guy Pollock, L. DeCosta Ricci; **Music:** Noel Gay; **Distributor:** General Film Distributors; **Cast:** Richard Ainley, Noah Beery, Richard Cromwell, Frederick Culley, Robert Douglas, Esme Percy, Binkie Stuart, Julie Suedo, Hazel Terry, Henry Victor, H. B. Warner.

Noah Beery plays the president of an unnamed South American banana republic. When a group of insurgents revolt, His Majesty's Navy is dispatched to put down the rebel uprising. The film is also known as *Torpedoed*.

OUT OF THE DEPTHS

Columbia Pictures Corporation, 1946, b&w, 61 minutes.

Producer: Wallace MacDonald; **Director:** D. Ross Lederman; **Screenwriters:** Martin Berkeley, Ted Thomas; **Music:** Mischa Bakaleinikoff; **Cast:** Jim Bannon, Ken Curtis, Ross Hunter, Coulter Irwin, George Khan, Warren Mills, William Newell, George Offerman, Rodd Redwing, Robert E. Scott, Frank Sully, Loren Tindall, John Tyrrell, Robert Williams.

During World War II, when an American submarine sights a Japanese aircraft carrier loaded with kamikazes, it is determined to sink the carrier—and it finally rams it.

Viewers will benefit from background information. The *kamikaze* (Japanese for "divine wind") was named after a typhoon that sank Kublai Khan's fleet on its way to invade Japan in 1281. Officially called the Special Attack Corps, the kamikaze was initially used at the Battle of Leyte Gulf in October 1944; it was so successful in destroying American ships that the corps was enlarged. It deployed 1815 suicide planes at the battle of Okinawa, and more than 3000 pilots were sent to their deaths before the end of the war. The high command was convinced that a concentrated attack of these suicide airplanes could sink the American fleet and save Japan. However, the planes were not accurate, and although they inflicted terrible losses, it was too little and too late to affect the outcome of the war.

OUTRAGES OF THE ORIENT

Astor Pictures Corporation/Llyod Friedgen, 1948, b&w, 90 minutes.

Producer: Don Jesus Cacho; **Directors:** William H. Jansen, Carlos Vander Tolosa; **Screenwriter:** Carlos Vander Tolosa; **Music:** Julio Esteban Anguita; **Distributors:** Lloyd Friedgen, Astor Pictures Corporation; **Filmed in:** India; **Cast:** Teddy Benavides, Bimbo Danao, Linda Estrella, Conchita Montes, Fernando Royo.

The movie is a docudrama that recreates the raping and plundering during World War II of the Philippine people by Japanese troops.

OUTSIDER, THE

Universal Pictures, 1961, b&w, 105 minutes.

Producer: Sy Bartlett; **Director:** Delbert Mann; **Screenwriters:** William Bradford Huie, Stewart Stern;

Cast: Stanley Adams, James Beck, Bruce Bennett, Ted Bessell, Miriam Colon, Paul Comi, Forrest Compton, Patrick Curtis, Tony Curtis, Ray Daley, Vince Edwards, Gregory FioRito, James Franciscus, Lynda Day George, Edmund Hashim, Wayne Heffley, Riley Hill, Al Hodge, Pete Homer, Jody Johnston, Walter Woolf King, Gertrude Michael, Ralph Moody, Kathleen Mulqueen, Vivian Nathan, Mary Patton, Tom Sherlock, Jeffrey Silver, Vince St. Cyr, Charles Stevens, Ronald Trujillo, Gregory Walcott, John War Eagle.

Ira Hayes (Tony Curtis) is one of the U.S. Marines who helped raise the American flag on Iwo Jima. His life disintegrates as he uses alcohol to try to cope with his fame.

Based on William Bradford Huie's *The Hero of Iwo Jima* (New York: New American Library, 1962), this is the true story of Indian Ira Hayes, one of the marines who helped raise the American flag over Mount Suribachi after the United States took Iwo Jima from the Japanese. A photograph of this act appeared in *Life* magazine and immediately caught the imagination of the nation. It is now enshrined in stone as a monument in Washington, D.C., near Arlington Cemetery and Ft. Myer.

INTERESTING FACT

- The real-life Ira Hayes appeared in *SANDS OF IWO JIMA* as one of the marines who raise the flag at Mount Suribachi.

PACIFIC INFERNO

Nathaniel Productions, 1979, color, 90 minutes.

Producers: Jim Brown, Spencer Jourdain, Rod Perry, B. Sherry-Greenwood, Cassius Weathersby; **Director:** Rolf Bayer; **Screenwriter:** Rolf Bayer; **Filmed in:** Manila, the Philippines; **Cast:** Dick Adair, Butz Aquino, Sonny Batacan, Jim Brown, Timothy Brown, Vic Diaz, Pedro Faustino, Dindo Fernando, Tad Horino, Richard Jaeckel, Wilma Reading, Jimmy Shaw, Vic Silayan, Rik Van Nutter.

Off the Philippine coast, U.S. Navy deep-sea divers search for $16 million in silver coins hidden beneath sea.

PACK UP YOUR TROUBLES

Hal Roach Studios Inc., 1932, b&w, 68 minutes.

Producer: Hal Roach; **Directors:** George Marshall, Ray McCarey; **Screenwriter:** H. M. Walker; **Music:** William Axt, Marvin Hatley, Leroy Shield; **Distributor:** MGM; **Cast:** Robert Barrat, Frank Brownlee, Mary Carr, Nora Cecil, Richard Cramer, Donald Dilloway, Muriel Evans, James Finlayson, Billy Gilbert, Dick Gilbert, Paulette Goddard, Mary Gordon, Charlie Hall, Al Hallett, Oliver Hardy, Jack Hill, Lew Kelly, Tom Kennedy, Ham Kinsey, Stan Laurel, George Marshall, Charles Middleton, James C. Morton, Bill O'Brien, Frank Rice, Charles Rogers, C. Montague Shaw, Grady Sutton, Jacqueline Taylor, Richard Tucker, Ellinor Van der Veer, Adele Watson.

In the trenches in France during World War I, Laurel and Hardy's army buddy, Eddie Smith (Don Dillaway), is killed, leaving his new baby girl an orphan. When they return to the states after the armistice, they try to find the baby's American grandparents, but they keep coming up with the wrong Smiths as they stumble from one misadventure to the next.

INTERESTING FACTS

- Ray McCarey receives codirectorial credit, but it is widely accepted that George Marshall was the sole director.
- Marvin Hatley has a cameo role as a soldier in the battlefield scene.

PACK UP YOUR TROUBLES

20th Century-Fox, 1939, b&w, 75 minutes.

Producer: Sol M. Wurtzel; **Director:** H. Bruce Humberstone; **Screenwriters:** Lou Breslow, Owen Francis; **Music:** Sidney Clare, Samuel Kaylin, Jule Styne; **Cast:** Leon Ames, Lynn Bari, Wilhelm von Brincken, Adri-

enne D'Ambricourt, Stanley Fields, Edward Gargan, Robert Emmett Keane, Fritz Leiber, Georges Renavent, Al Ritz, Harry Ritz, Jimmy Ritz, Lionel Royce, Joseph Schildkraut, Jane Withers.

The Ritz Brothers are out-of-work vaudevillians who join the army during World War I and head for France where they encounter spies and other troubles.

PANCHO VILLA

Scotia International, Granada, Scotia, 1972, color, 92 minutes.

Producer: Bernard Gordon; **Director:** Eugenio Martín; **Screenwriters:** Eugenio Martín, Julian Zimet; **Music:** Antón García Abril; **Cast:** Antonio Casas, Chuck Connors, Alberto Dalbés, Luis Dávila, Anne Francis, Bob Hevelone, Ángel del Pozo, José María Prada, Mónica Randall, Telly Savalas, Ben Tatar, Clint Walker.

When Mexican revolutionary Pancho Villa is double-crossed in an arms deal, he plots a raid on a U.S. cavalry fort in retaliation.

PARACHUTE BATTALION

RKO Radio Pictures Inc., 1941, b&w, 75 minutes.

Producer: Howard Benedict; **Director:** Leslie Goodwins; **Screenwriters:** Hugh Fite, John Twist; **Music:** Roy Webb; **Distributor:** RKO Pictures; **Filmed at:** Fort Benning, Georgia; **Cast:** Erville Alderson, Robert Barrat, Lee Bonnell, Jack Briggs, Harry Carey, Richard Cromwell, Eddie Dunn, Buddy Ebsen, Douglas Evans, Edward Fielding, Selmer Jackson, Nancy Kelly, Paul Kelly, Edmond O'Brien, Robert Preston, Walter Sande, Kathryn Sheldon, Robert Smith, Gayne Whitman, Grant Withers.

The airborne school commander's estranged son Edmond O'Brien, football hero Robert Preston, and hillbilly Buddy Ebsen enlist in the paratroops. As O'Brien and Preston fight over a sergeant's daughter, O'Brien displays cowardice, but then redeems himself.

Made before World War II, this film is typical of the films Hollywood was asked to turn out, demonstrating that America was prepared for war—in this case, by showing the training of paratroops.

INTERESTING FACTS

- The movie was made with the cooperation of the 51st Parachute Battalion at Ft. Benning, Georgia.
- During World War II, Ft. Benning was the location of the U.S. Army jump school, which is still located there.

PARACHUTE NURSE

Columbia Pictures Corporation, 1942, b&w, 63 minutes.

Producer: Wallace MacDonald; **Director:** Charles Barton; **Screenwriters:** Rian James, Elizabeth Meehan (story); **Music:** W. Franke Harling, John Leipold, Ben Oakland, George Parrish; **Distributor:** Columbia Pictures; **Cast:** Roma Aldrich, Louise Allbritton, Audrene Brier, Barbara Brown, Sally Cairns, Alma Carroll, Marguerite Chapman, Theo Coleman, Catherine Craig, Nanette Crawford, Dona Dax, Elizabeth Dow, Helen Foster, Kit Guard, Kay Harris, Gwen Holubar, Eddie Laughton, Ann Markall, June Melville, Mary Milburn, Eileen O'Hearn, Shirley Patterson, Marjorie Riordan, Diane Royal, Lauretta M Schimmoler, Frank Sully, Dorothy Trail, Forrest Tucker, John Tyrrell, Diedra Vale, Evelyn Wahl, Jan Wiley, Mary Windsor, Douglas Wood, William Wright, Mary Zavian.

During World War II, nurses train to drop into the war zone from the air, to help the soldiers below.

PARADISE ROAD

Village Roadshow Productions, Samson Productions, 1997, color, 115 minutes.

Producers: Graham Burke, Greg Coote, David Giles, Martin Meader, Sue Milliken, Graeme Rattigan, Andrew Yap; **Director:** Bruce Beresford; **Screenwriters:** Bruce Beresford, David Giles, Martin Meader; **Music:** Ross Edwards; **Distributor:** 20th Century-Fox Film Corporation; **Filmed in:** Port Douglas, Marrickville, and Sydney, Australia, Penang, Malaysia, and Raffles Hotel, Singapore; **Cast:** Yoshi Adachi, Julie Anthony, Jason Arden, Vincent Ball, Tanya Bird, Paul Bishop, Cate Blanchett, Jemal Blattner, Pauline Chan, David Chung, Kitty Clignett, Glenn Close, Pauline Collins, Arthur Dignam, Marta Dusseldorp, Stan Egi, Jennifer Ehle, John Elcock, Noel Ferrier, Steven Grives, Robert Grubb, Penne Hackforth-Jones, Nicholas Hammond, Anita Hegh, Lisa Hensley, Wendy Hughes, Tessa Humphries, Shigenori Ito,

Clyde Kusatsu, Chi Yuen Lee, Marijke Mann, Julianna Margulies, Kristine McAlister, Frances McDormand, Taka Nagano, Geoffrey Ogden-Brown, Geoff O'Halloran, Stephen O'Rourke, Ping Pan, Susie Porter, John Proper, Pamela Rabe, Jesse Rosenfeld, Koji Sasaki, Mitsu Sato, Lia Scallon, Alwine Seinen, Sab Shimono, Elizabeth Spriggs, Johanna ter Steege, Phillip Stork, Hamish Urquhart, Shira Van Essen, Aden Young.

When the Japanese overrun Singapore during World War II, many women and children of different nationalities and backgrounds are taken prisoner and interned for the duration. A bond grows between these diverse peoples as they face the lack of food and medicine, and withstand the brutal behavior of their evil Japanese captors. To help retain their sanity, they organize a voice orchestra against the wishes of their Japanese captors.

The film is based on Betty Jeffrey's *White Coolies* (Sydney: Angus and Robertson, 1954), about Australian nurses behind enemy lines.

QUOTES

Margaret Drummond: The will to survive is strong, stronger than anything.

Margaret Drummond: I just can't bring myself to hate people. The worse they behave, the sorrier I feel for them.

PARATROOP COMMAND

Santa Rosa Productions, 1959, color/b&w, 71 minutes.

Producer: James H. Nicholson; **Director:** William Witney; **Music:** Ronald Stein; **Distributor:** American International Pictures (AIP); **Cast:** Richard Bakalyan, Jim Beck, Paul Busch, Jack Hogan, Carolyn Hughes, Patricia Huston, Sydney Lassick, Ken Lynch, Jeff Morris, Jimmy Murphy, Brad Trumbull.

In North Africa and Italy during World War II, Richard Bakalyan is shunned by the other paratroopers after he accidentally causes the death of one of their comrades, but he redeems himself when he sacrifices his life for his fellow paratroopers.

PARIS AFTER DARK

20th Century-Fox, 1943, b&w, 85 minutes.

Producer: André Daven; **Director:** Léonide Moguy; **Screenwriter:** Harold Buchman; **Music:** Hugo Friedhofer; **Cast:** Curt Bois, Ann Codee, Marcel Dalio, Jean Del Val, Philip Dorn, Gene Gary, Peter Lawford, Madeleine LeBeau, Robert Lewis, Brenda Marshall, Raymond Roe, Henry Rowland, George Sanders.

Philip Dorn returns from a concentration camp a broken man, convinced that it is impossible to fight the Nazis. Slowly he regains his confidence and ultimately joins the French Resistance.

PARIS CALLING

Charles K. Feldman Group, 1941, b&w, 108 minutes.

Producer: Benjamin Glazer; **Directors:** Edwin L. Marin, Jean Negulesco; **Screenwriters:** Benjamin Glazer, Charles Kaufman, John S. Toldy; **Music:** Richard Hageman, Charles Henderson, Werner R. Heymann, Frank Skinner; **Distributor:** Universal Pictures; **Cast:** Eric Alden, Dick Alexander, Charles Arnt, Yvette Bentley, Elisabeth Bergner, John Bleifer, Eugene Borden, Harlan Briggs, Paul Bryar, George Cathrey, Eduardo Ciannelli, Lee J. Cobb, Pedro de Cordoba, Jeff Corey, Jean Del Val, Eddie Dew, Norma Drury, William Edmunds, Ed Emerson, Martin Faust, Mary Forbes, Arno Frey, Hans Fuerberg, Eugene Gericke, Douglas Grant, Denis Green, Howard C. Hickman, Rosalind Ivan, Joe Kamaryt, Crauford Kent, Grace Lenard, Paul Leyssac, Eric Lonsdale, Alphonse Martell, John Meredith, Georges Metaxa, Adolph Milar, Hans von Morhart, Marion Murray, Ken Nolan, Gene O'Donnell, Pat O'Malley, Marcia Ralston, Basil Rathbone, Otto Reichow, Georges Renavent, Elisabeth Risdon, William Ruhl, Randolph Scott, Gale Sondergaard, Pete Sosso, Philip Van Zandt, Jacques Vanaire, Roland Varno, Frederick Vogeding, Charles Wagenheim, Ian Wolfe, William Yetter Jr.

When Elisabeth Bergner's mother is killed as she flees Paris during the Nazi invasion of France, she decides to return to the city and to fight with the French underground to disrupt the Nazi war machine.

MILITARY SERVICE

• Lee J. Cobb, already an established film actor, was 32 years old when he enlisted in the U.S. Army Air Force. He was assigned to a radio production unit for the duration of the war and was discharged as a corporal.

PARIS UNDERGROUND

Constance Bennett Productions, 1945, b&w, 97 minutes.

Producers: Constance Bennett, Harry A. Gourfair, Carley Harriman (assistant producer, executive producer); **Director:** Gregory Ratoff; **Screenwriters:** Boris Ingster, Gertrude Purcell, Etta Shiber (novel); **Music:** Alexander Tansman; **Distributor:** United Artists; **Cast:** Charles Andre, Constance Bennett, Nina Borget, Marcel de la Brosse, Maurice Cass, André Charlot, Adrienne D'Ambricourt, Ray De Ravenne, Gracie Fields, Arno Frey, Gregory Gaye, Frederick Giermann, Pete Kooy, Kurt Kreuger, Reska Law, Eily Malyon, Andrew V. McLaglen, Art Miles, Rene Mimieux, Harry Hays Morgan, Erich von Morhardt, Otto Reichow, Reni Revel, Georgette Rhodes, Georges Rigaud, Dick Ryan, Loulette Sablon, Dina Smirnova, Vladimir Sokoloff, Roland Varno, Leslie Vincent, Anthony Warde.

Constance Bennett, who plays the American wife of a Frenchman, and Gracie Fields, who owns a Paris bookshop, join forces to help downed Allied aviators escape back to their own lines. They risk detection at every turn by the Gestapo, and it is only the arrival of the Allied troops advancing on Paris that saves them from execution.

INTERESTING FACT

- The movie is based on the book *Paris Underground* (New York: Scribner's, 1943), by Etta Shiber, who helped downed Allied pilots escape from the Nazis during World War II.

AWARD

Academy Awards, USA, 1945
 Nominated: *Oscar, Best Scoring of a Dramatic or Comedy Picture*, Alexander Tansman.

PASSAGE TO MARSEILLES

Warner Bros., 1944, b&w, 110 minutes.

Producers: Hal B. Wallis, Jack L. Warner (executive producer); **Director:** Michael Curtiz; **Screenwriters:** Charles Nordhoff and James Norman Hall (novel, *Men Without Country*), Casey Robinson, Jack Moffitt; **Music:** Max Steiner; **Cast:** Carmen Beretta, Monte Blue, Humphrey Bogart, Walter Bonn, Frederic Brunn, Peter Camlin, Eduardo Ciannelli, Hans Conried, Harry Cording, Adrienne D'Ambricourt, Helmut Dantine, Jean Del Val, Philip Dorn, Diane DuBois, Fred Essler, Victor Francen, Anatol Frikin, Sydney Greenstreet, Charles La Torre, John Loder, Peter Lorre, Louis Mercier, Peter Miles, Michèle Morgan, Corinna Mura, Alex Papana, Frank Puglia, Claude Rains, Billy Roy, Raymond St. Albin, Konstantin Shayne, Vladimir Sokoloff, Mark Stevens, Donald Stuart, George Tobias.

Matrac (Humphrey Bogart) and four other convicts have escaped from Devil's Island on board a ship bound for Marseilles when France surrenders to the Nazis. Bogie was a French journalist who had opposed the Munich Pact; as a result, he was silenced by being framed for murder and sent to Devil's Island. Fascist sympathizer Sidney Greenstreet tries to seize the ship for Vichy France, but Humphrey Bogart and his fellow prisoners, still loyal to the France that has washed its hands of them, seize it for the Free French.

 The film is based on James Norman Hall's and Charles Nordhoff's *Passage to Marseille* (New York: Grosset and Dunlap, 1942) whose original title was *Men Without Country*.

MISTAKE

- Matrac's plane switches between a Fortress I (small rudder) and a Fortress II (large rudder).

PASSPORT TO DESTINY

RKO Radio Pictures Inc., 1944, b&w, 65 minutes.

Producer: Herbert Schlom; **Director:** Ray McCarey; **Screenwriters:** Muriel Roy Bolton, Val Burton; **Music:** Roy Webb; **Distributor:** RKO; **Cast:** Lénore Aubert, Lydia Bilbrook, Georgia Cooper, Lloyd Corrigan, Alec Craig, Fritz Feld, Edmund Glover, Lumsden Hare, Olaf Hytten, Charles Irwin, Guy Kingsford, Elsa Lanchester, Charles Laughton, Gavin Muir, Gordon Oliver, Betty Roadman, John Rogers, Lionel Royce, Hans Schumm, Anita Sharp-Bolster, Dorothy Vernon, Joseph Vitale.

Elsa Lanchester plays a charwoman who decides that she will journey to Germany and assassinate Adolf Hitler. Carrying her own pail and mop, she manages to stow away on a French ship and eventually gets hired as a cleaning woman in the Nazi chancellery. She pretends to be mute so that her English accent does not give her away. Nevertheless, she is detected and arrested, and must be spirited back to England by the underground. The movie is known also as *Passport to Adventure*.

- When Elsa Lanchester converses with her dead husband, the photograph depicted is that of her real-life husband, Charles Laughton.

PASSWORD IS COURAGE, THE

Metro-Goldwyn-Mayer, 1962, b&w, 116 minutes.

Producers: Andrew L. Stone, Virginia L. Stone, Sydney Streeter; **Director:** Andrew L. Stone; **Screenwriters:** John Castle, Andrew L. Stone; **Cast:** Bernard Archard, Reginald Beckwith, Colin Blakely, Dirk Bogarde, Richard Carpenter, Ed Devereaux, Mark Eden, Tommy Elliott, Lewis Fiander, John Gardiner, Philo Hauser, Douglas Livingstone, Alfred Lynch, Richard Marner, Ferdy Mayne, Michael Mellinger, George Mikell, Howard Pays, Maria Perschy, Olaf Pooley, George Pravda, Bernard Proctor, Nigel Stock, Margaret Whiting.

During World War II, a British officer, captured by the Germans, makes many daring escapes from prisoner-of-war camps. In the process, among many other adventures, he is awarded the Iron Cross.

The movie is based on the true story of British officer Charles Coward and on John Castle's book *The Password Is Courage* (London: Souvenir Press, 1954).

PATHS OF GLORY

Bryna Productions, 1957, b&w, 86 minutes.

Producer: James B. Harris; **Director:** Stanley Kubrick; **Screenwriters:** Humphrey Cobb, Stanley Kubrick, Jim Thompson, Calder Willingham; **Music:** Gerald Fried; **Distributor:** United Artists; **Filmed in:** Munich, Germany; **Cast:** Richard Anderson, Fred Bell, Harold Benedict, Paul Bös, Leon Briggs, Peter Capell, Timothy Carey, Kem Dibbs, Kirk Douglas, Bert Freed, Wally Friedrichs, Halder Hanson, James B. Harris, Jeffrey Hausner, Rolf Kralovitz, Christiane Kubrick, George Macready, Ralph Meeker, Adolphe Menjou, Emile Meyer, Ira Moore, Wayne Morris, Marshall Rainer, John Stein, Joe Turkel, Roger Vagnoid.

Colonel Dax, the commander of the 701st Regiment of the French army (Kirk Douglas), must deal with a glory-seeking general looking to pin on his next star after part of his force falls back under fire in an attack on an impossible objective called the "Ant Hill," the perfect name for almost every key position in the trench warfare of World War I. The general insists on a court-martial for three soldiers, chosen at random, for cowardice in the face of the enemy.

The film depicts both bravery and cowardice. Among the scenes showing bravery are: the way the men stand up to their execution, even though they were picked unfairly; the fact that the soldiers came out of the trenches at all in the face of impenetrable machine gun and artillery fire; Colonel Dax standing up to both of the generals, even though he knew it would mean the end of his career and his chances for promotion; and the artillery commander who refuses a direct command from General Mireau to fire on his own troops, because he knows it is the right thing to do.

Among the scenes of cowardice are: General Mireau giving in to personal ambition and pushing forward the attack, because he thought it would get him his next star; General Mireau's refusal to admit he had ordered the artillery fire in an attempt to force his men out of their trenches; General Mireau killing three men to cover up his mistake; the lieutenant who leads the scouting mission into enemy territory panics, throws a grenade toward the enemy trenches, which kills one of his own men, flees back to his own trenches, and then lies about it; the same lieutenant, when ordered to choose one man randomly from his division to face trial, chooses the only witness to his cowardice, silencing him forever.

Paths of Glory demonstrates what would become a classic Kubrick trademark, the long tracking shot of Colonel Dax (Kirk Douglas) walking through the trenches with the camera immediately in front of him as he progresses.

INTERESTING FACTS

- The film touched many raw nerves, and it was banned in several European countries, with France the last to lift the ban in the late 1970s.
- This film can be compared with BREAKER MORANT, a film that also evokes the specter of innocent soldiers being executed by their generals, not for being guilty but in furtherance of "policy" that will advance the war effort.
- Director Stanley Kubrick met his second wife, Christiane Harlan, during filming. Harlan plays the German girl who sings to the regiment at the end of the film.
- Most of the film, including the scenes of the French general headquarters, the soldiers' trial, and the site of the executions, was filmed in and around the Schleissheim Palace, near Munich, Germany. Just

beyond this location is the Dachau Concentration Camp memorial.

MISTAKE

- As Colonel Dax is running through the trenches after General Mireau gives his order, a supposedly dead soldier blinks.

QUOTES

General Broulard: Colonel Dax, you're a disappointment to me. You've spoiled the keenness of your mind by wallowing in sentimentality. You really did want to save those men, and you were not angling for Mireau's command. You are an idealist—and I pity you as I would the village idiot. We're fighting a war, Dax, a war that we've got to win. Those men didn't fight, so they were shot. You bring charges against General Mireau, so I insist that he answer them. Wherein have I done wrong?
Colonel Dax: Because you don't know the answer to that question, I pity you.

Corporal Paris [the condemned men are awaiting execution]: See that cockroach? Tomorrow morning, we'll be dead and it'll be alive. It'll have more contact with my wife and child than I will. I'll be nothing, and it'll be alive.
Private Ferol [smashing the roach]: Now you got the edge on him.

General Broulard: Colonel Dax! You will apologize at once or I shall have you placed under arrest!
Colonel Dax: I apologize . . . for not being entirely honest with you. I apologize for not revealing my true feelings. I apologize, sir, for not telling you sooner that you're a degenerate, sadistic old man. And you can go to hell before I apologize to you now or ever again!

AWARDS

British Academy Awards, 1958
 Nominated: *BAFTA Film Award, Best Film from Any Source—USA*

Italian National Syndicate of Film Journalists, 1959
 Won: *Silver Ribbon, Best Director—Foreign Film (Regista del Miglior Film, Straniero)*, Stanley Kubrick

National Film Preservation Board, USA, 1992

National Film Registry

Writers Guild of America, USA, 1958
 Nominated: *WGA Screen Award, Best Written American Drama*, Stanley Kubrick, Jim Thompson, Calder Willingham.

PATTON

20th Century-Fox, 1970, color, 172 minutes.

Producers: Frank Caffey, Frank McCarthy; **Director:** Franklin J. Schaffner; **Screenwriters:** Omar N. Bradley, Francis Ford Coppola, Ladislas Farago, Edmund H. North; **Music:** Jerry Goldsmith; **Distributor:** 20th Century-Fox Film Corporation; **Filmed in:** Almería, Spain; **Cast:** Abraxas Aaran, Peter Barkworth, John Barrie, Michael Bates, David Bauer, Ed Binns, Tim Considine, Lawrence Dobkin, John Doucette, Albert Dumortier, James Edwards, Gerald Flood, Jack Gwyllim, David Healy, Bill Hickman, Sandy Kevin, Frank Latimore, Carey Loftin, Alan MacNaughton, Karl Malden, Lionel Murton, Richard Münch, Morgan Paull, Siegfried Rauch, Bruce Rhodewalt, Clint Ritchie, George C. Scott, Paul Stevens, Michael Strong, Karl Michael Vogler, Douglas Wilmer, Stephen Young, Patrick J. Zurica.

Gen. George S. Patton Jr. (George C. Scott), a military historian and poet as well as a general, believes he was a warrior in a past life and that he is destined for something great during this life, but his stubbornness and controversial methods nearly prevent the fulfillment of his destiny.

The film is based on Ladislas Farago's *Patton, Order and Triumph* (London: Mayflower, 1979) and on Omar N. Bradley's *A Soldier's Soldier* (New York: Henry Holt & Co., 1951). Understanding of the film is enhanced with knowledge of the historical background. George S. Patton Jr. (1885–1945) was probably one of the best tank commanders of all time. However, he also had many failings. In addition to his problems described in the film are these:

Not only did Patton needlessly sacrifice the lives of his men to beat Montgomery to Messina, Patton also caused more unnecessary deaths and injuries in March 1945 when he attempted to free his son-in-law from a prisoner-of-war camp deep in enemy territory. This endeavor, motivated by personal concerns, was unsuccessful, and Patton's son-in-law was seriously wounded in the raid, but not freed.

Patton was anti-Semitic. When talking about displaced persons, he said "and this applies particularly to the Jews, who are lower than animals."

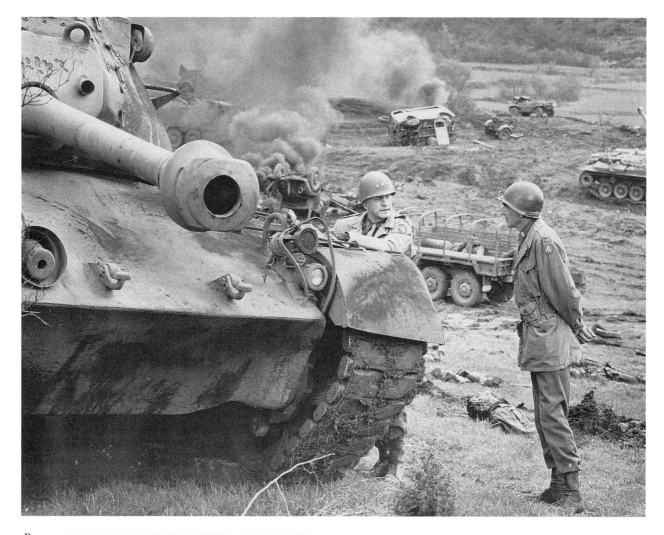

Patton (20TH CENTURY-FOX/AUTHOR'S COLLECTION)

After the war, Patton failed to implement the de-Nazification program as military governor of Bavaria. He thought that Gen. Dwight Eisenhower (who was his friend and who often intervened to protect him) was "yellow."

Patton's expressed hatred of the Russians (at that time our ally and the country that had suffered far more casualties and greater destruction from Nazi aggression than any other) caused serious diplomatic problems.

Patton would subject his troops to ranting tirades. One historian who reviewed this film had been a junior officer in Patton's command. On being subjected to a "vainglorious Patton harangue," he remembers remarking, "What an ass!"

However, Patton was still a unique asset to the war effort. Despite a few lapses, he cared for his men and was affectionate with the people on his immediate staff. He was also genuinely religious, and he was courteous to women. Many soldiers who served under him love the memory of General Patton. He inspired them and led them to victory.

The rivalry between Patton and Gen. Bernard Law Montgomery was part of the overall rivalry between the U.S. and British armies. In Patton's defense, his drive to Messina was in part to prove the superiority of his army, not only for his personal glory.

Patton received his first taste of combat in 1916 as a cavalry officer under Gen. John J. Pershing on his punitive raid into Mexico. During World War I, he was placed in command of the U.S. Tank Corps and was shot in the leg leading a tank charge on foot. When World War II neared, Patton was placed in charge of training tank commanders. At this post, he developed

tactics that he used in North Africa. He practiced the motto "When in doubt: ATTACK!" He was called "Old Blood and Guts" by his soldiers.

Eisenhower saw Patton as a volatile character with a trait of exhibitionism who was not as good as other U.S. generals at the heavy fighting necessary to break through enemy concentrations. For this reason Eisenhower did not assign Patton to the slugging match with the Germans necessary for the Allies to break out of the beachhead at Normandy. But Eisenhower properly regarded Patton as a headstrong and fearless master of the fast and overwhelming pursuit. For that reason, once the Allies had broken through in Normandy, Eisenhower put Patton's Third Army in the forefront. Eisenhower advanced General Omar Bradley over Patton because Eisenhower considered Bradley to be outstanding in every aspect of command and a master of every military maneuver.

INTERESTING FACT

- George C. Scott made an in-depth study of Patton in order to play the role. An example of his dedication to the role is in the scene in which Patton gives Gen. Lucien K. Truscott Jr. an ultimatum that if Truscott's conscience would not let him conduct a particularly risky operation,"I will relieve you and let someone else do it." Scott believed the scene was too harsh and that it suggested that Patton was indifferent to his men's welfare. He protested the scene, but the studio owners wouldn't change it. Because General Patton had never been seen lying down in a combat situation, mentally or physically, Scott purposefully played the scene with Patton reclining on a couch, hoping that people would notice its falsity.

MILITARY SERVICE

- George C. Scott enlisted in the U.S. Marines and had his nose broken in basic training in a fight with a drunken sergeant-major over the acting abilities of Ava Gardner. He was training for the invasion of Japan when the atomic bomb was dropped, and thus could be counted among the million men who owe their lives to President Truman's decision. He was then assigned to Washington, where he spent four years as part of the honor guard at Arlington National Cemetery, burying soldiers killed in the war.

MISTAKES

- A 1948 Packard car is parked in front of headquarters.
- The tanks used in the major battle scene in North

Africa are postwar tanks. On the American side, the M48 tank (1953) was used and on the German side the M47 (1952). Ironically, the latter was also called the "Patton 1."

- The opening speech was the one delivered by Patton on June 4, 1944, and hence he shouldn't have been wearing the uniform of a four-star general (he was still a lieutenant general), nor would he be festooned with orders and decorations that were awarded him by various European countries after the war.
- The prayer for good weather was actually put on the back of a small Christmas card five days before the Battle of the Bulge began. The actual prayer contained the words "these immoderate rains" while the movie version said "this immoderate weather."
- As Patton prepares to award the Purple Heart, a two-panel curtain is placed at the foot of the bed. As he moves away from the bed, the two-panel curtain becomes a single-panel curtain.

QUOTES

Patton [addressing troops in the auditorium at the beginning of the movie]: Now I want you to remember that no bastard ever won a war by dying for his country. He won it by making the other poor dumb bastard die for his country.

Patton [outmaneuvering Rommel]: Rommel, you magnificent bastard! I read your book!

Gen. George S. Patton [about his pistols]: They're ivory. Only a pimp from a cheap New Orleans whorehouse would carry a pearl-handled pistol.

Gen. George S. Patton: If we are not victorious, let no one come back alive.

Gen. George S. Patton: When you put your hand into a bunch of goo that a moment before was your best friend's face, you'll know what to do.

AWARDS

Academy Awards, USA, 1970

Won: *Oscar, Best Actor,* George C. Scott—refused to accept the nomination and the award because he did not feel himself to be in any competition with other actors; *Best Art Direction—Set Decoration,* Antonio Mateos, Urie McCleary, Gil Parrondo, Pierre-Louis Thévenet; *Best Director,* Franklin J. Schaffner; *Best Film Editing,* Hugh S.

Fowler; *Best Picture*, Frank McCarthy; *Best Sound*, Don J. Bassman, Douglas O. Williams; *Best Writing, Story and Screenplay Based on Factual Material or Material Not Previously Published or Produced*, Francis Ford Coppola, Edmund H. North

Nominated: *Oscar, Best Cinematography*, Fred J. Koenekamp; *Best Special Visual Effects*, Alex Weldon; *Best Music, Original Score*, Jerry Goldsmith

American Cinema Editors, USA, 1971

Won: *Eddie, Best Edited Feature Film*, Hugh S. Fowler

British Academy Awards, 1971

Nominated: *BAFTA Film Award, Best Actor*, George C. Scott; *Best Sound Track*, Don J. Bassman, Don Hall, Douglas O. Williams.

PEARL HARBOR

Jerry Bruckheimer Films, 2001, color, 183 minutes.

Producer: Michael Bay, Jerry Bruckheimer; **Director:** Michael Bay; **Screenwriter:** Randall Wallace; **Music:** Hans Zimmer; **Distributor:** Touchstone Pictures; **Filmed in:** Baja California, Mexico, England, San Francisco and Los Angeles, California, Pearl Harbor, Hawaii; **Cast:** Ben Affleck, Alec Baldwin, Kate Beckinsale, Ewen Bremner, Matthew Davis, Cuba Gooding Jr., Gene Hackman, Josh Hartnett, James King, William Lee Scott, Tom Sizemore.

Two best friends, U.S. Army aviators, love the same woman as they fight World War II.

INTERESTING FACTS

- The USS *Missouri* (BB63) portrays the USS *West Virginia*.
- Before shooting began in Pearl Harbor, a Hawaiian priest blessed the crew—required by law for film crews shooting in Hawaii.
- The movie was filmed in "3-strip Technicolor," the same color process used for *The Wizard of Oz* (1939) and *Gone with the Wind* (1939).
- Scenes of Tennessee farmland were shot an hour's distance outside Los Angeles, in Somas, California. For the look of Tennessee, corn was planted five months prior to shooting.
- The fictional character of Thurman (Dan Aykroyd) represents an actual team of military code breakers that deciphered Japanese transmissions days before the attack.

- Alec Baldwin spent time in flight simulators at Fort Rucker, Alabama, to prepare for his role.
- To simulate the USS *Oklahoma* capsizing, crews constructed the world's largest gimbal.
- Both of Ben Affleck's grandfathers were in WWII. Josh Hartnett's great-uncle fought on D day, and James King's cousin died at Pearl Harbor.
- Women's feet were smaller in the 1940s, so costume houses from New York City to Italy were enlisted to produce period shoes in sizes 10 and 11.
- It took eight weeks for crews to build the USS *Oklahoma*. During the capsizing sequence, there were 150 men hanging on or falling off.
- Filming was completed in 106 days, one day over schedule.
- Filming of the bombing sequence was overseen by the Environmental Protection Agency.
- The crew used 700 sticks of dynamite, 2000 feet of primer cord, and 4000 gallons of gasoline to ignite the six ships.

PHANTOM SOLDIERS

Humax, Regal Films Inc., 1987, color, 95 minutes.

Producer: Joy Tunners; **Director:** Irvin Johnson; **Cast:** Jim Gaines, Richard King, Corwin Sperry, Max Thayer, Jack Yates.

A Texas Ranger leaves for Vietnam to find his missing brother, a Green Beret who had been tracking a mysterious group of phantom soldiers. They use U.S.-made arms to massacre unarmed Vietnamese civilians. The ranger must go alone into the jungle, find his brother and stop the killers.

PIGEON THAT TOOK ROME, THE

Llenoc Productions, 1962, b&w, 103 minutes.

Producer: Melville Shavelson; **Director:** Melville Shavelson; **Screenwriter:** Melville Shavelson; **Distributor:** Paramount Pictures; **Filmed in:** Rome, Italy; **Cast:** Rudolph Anders, Salvatore Baccaloni, Gary Collins, Brian Donlevy, Bob Gandett, Harry Guardino, Charlton Heston, David Macklin, Elsa Martinelli, Gabriella Pallotta, Debbie Price, Arthur Shields, Vadim Wolkowsky, Forrest Wood.

Charlton Heston plays an American officer working undercover in Rome during World War II, collecting information for the Allied invasion and then sending it back to his own lines by carrier pigeon. When an Ital-

ian family eats his pigeons for Easter dinner, not realizing their value, they are replaced by German pigeons. Heston sends off the Nazi birds with false information, to confuse and misdirect the enemy.

PILOT #5

Metro-Goldwyn-Mayer, 1943, b&w, 70 minutes.

Producer: B. P. Fineman; **Director:** George Sidney; **Screenwriter:** David Hertz; **Music:** Lennie Hayton; **Cast:** Alan Baxter, Hobart Cavanaugh, Frank Ferguson, Howard Freeman, Ava Gardner, Steven Geray, Marsha Hunt, Van Johnson, Gene Kelly, Peter Lawford, Frank Puglia, Dick Simmons, William Tannen, Franchot Tone.

Franchot Tone plays a politician who switches sides during a governor's race, just in time to help defeat the crooked candidate for whom he is working. With the outbreak of World War II, he joins the U.S. Army Air Force, and when he reaches the Pacific he is selected from among five Allied pilots to bomb a Japanese aircraft carrier. Ultimately, he must dive his plane into the carrier, killing himself in order to destroy it.

PLATOON

Hemdale Film Corporation, 1986, color, 111 minutes.

Producers: John Daly, Derek Gibson, A. Kitman Ho, Arnold Kopelson; **Director:** Oliver Stone; **Screenwriter:** Oliver Stone; **Music:** Samuel Barber, Georges Delerue, Stephen Foster; **Filmed in:** Philippines; **Cast:** Basile Achara, Ron Barracks, Steve Barredo, Tom Berenger, Chris Castillejo, Andrew B. Clark, Willem Dafoe, Keith David, Johnny Depp, Kevin Dillon, Dale Dye, Mark Ebenhoch, Richard Edson, Kevin Eshelman, Corkey Ford, Corey Glover, J. Adam Glover, Peter Hicks, Reggie Johnson, Ivan Kane, Bernardo Manalili, John C. McGinley, James Terry McIlvain, Warren McLean, Mark Moses, David Neidorf, Nick Nickelson, Clarisa Ortacio, Bob Orwig, Chris Pedersen, Francesco Quinn, Than Rogers, Paul Sanchez, Romy Sevilla, Charlie Sheen, Oliver Stone, Li Mai Thao, Tony Todd, Li Thi Van, Mathew Westfall, Forest Whitaker.

A young recruit (Charlie Sheen) joins a platoon of American soldiers who patrol, fight, and die in the jungles of Vietnam. Two veteran sergeants clash when one of them precipitates a massacre of villagers.

INTERESTING FACTS

- The role of Chris was originally offered to Kyle MacLachlan, who turned it down.
- Oliver Stone has a cameo as an officer at the bunker that gets destroyed by a suicide runner.
- This is the first movie in Vietnam veteran Oliver Stone's Vietnam trilogy.

MILITARY SERVICE

- Oliver Stone is probably the best qualified director to have brought this script to the screen. He volunteered for Vietnam and was "gung ho" to fight communism. He was assigned to the 2nd Platoon, B Company, 3rd Battalion, 25th Infantry Division (Tropic Lightning Division), operating near the Cambodian border. On New Year's Day 1968, the first base where he was stationed was attacked by two full regiments, resulting in over 500 dead. Two weeks later, Stone was wounded in the leg while rescuing two platoons pinned down in an ambush. This put him into the hospital, where he was during the Tet Offensive. After recovery, he joined a LRRP (Long Range Reconnaissance Platoon) with the First Cavalry Division in April 1968, with the mission to operate behind enemy lines gathering intelligence. A photo of his squad appeared in *People* magazine. Stone was present at the battle of South China Beach in August 1968. Bad intelligence caused his unit to get pinned down by a vastly superior force. He was awarded the Bronze Star and two Purple Hearts.

MISTAKES

- In the upper right corner in the scene where they are emptying the shitter, the boom is in the shot.
- The boom is visible above King's head when he lights his cigarette.
- Set in 1967, the film shows Bunny listening to Merle Haggard's *Okie from Muskogee*, not released until 1969.
- The UH-1 (Huey) helicopters are seen fitted with wire cutters, which were not installed until the early 1980s.
- Near the end of the movie, Francis stabs himself in the right thigh and is seen leaving on a chopper minutes later with his left thigh bandaged.

QUOTE

Chris Taylor [last lines]: I think now, looking back, we did not fight the enemy, we fought ourselves. The enemy was in us. The war is over for me now, but it will always be there, the rest of my days. As I'm sure

Elias will be, fighting with Barnes for what Rhah called possession of my soul. There are times since, I've felt like a child, born of those two fathers. But be that as it may, those of us who did make it have an obligation to build again. To teach to others what we know, and to try with what's left of our lives to find a goodness and a meaning to this life.

AWARDS

Academy Awards, USA, 1986
Won: *Oscar, Best Director*, Oliver Stone; *Best Film Editing*, Claire Simpson; *Best Picture*, Arnold Kopelson; *Best Sound*, Charles Grenzbach, Simon Kaye, Richard D. Rogers, John Wilkinson
Nominated: *Oscar, Best Cinematography*, Robert Richardson; *Best Supporting Actor*, Tom Berenger, Willem Dafoe; *Best Writing, Screenplay Written Directly for the Screen*, Oliver Stone

American Cinema Editors, USA, 1987
Won: *Eddie, Best Edited Feature Film*, Claire Simpson

Berlin International Film Festival, 1987
Won: *Silver Berlin Bear, Best Director*, Oliver Stone
Nominated: *Golden Berlin Bear*—Oliver Stone

Boston Society of Film Critics Awards, 1987
Won: *BSFC Award, Best Director*, Oliver Stone—tied with *David Lynch* for Blue Velvet (1986)

British Academy Awards, 1988
Won: *BAFTA Film Award, Best Direction*, Oliver Stone; *Best Editing*, Claire Simpson
Nominated: *BAFTA Film Award, Best Cinematography*, Robert Richardson

Casting Society of America, USA, 1987
Won: *Artios, Best Casting for Feature Film, Drama*, Pat Golden, Bob Morones

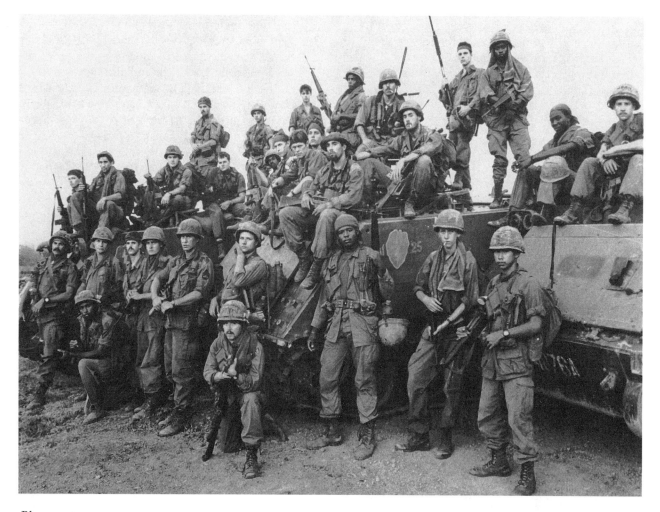

Platoon (ORION PICTURES/AUTHOR'S COLLECTION)

Directors Guild of America, USA, 1987

Won: *DGA Award, Outstanding Directorial Achievement in Motion Pictures*, H. Gordon Boos (first assistant director) (plaque), Oliver Stone

Golden Globes, USA, 1987

Won: *Golden Globe, Best Director—Motion Picture*, Oliver Stone; *Best Motion Picture—Drama; Best Performance by an Actor in a Supporting Role, in a Motion Picture*, Tom Berenger

Nominated: *Golden Globe, Best Screenplay—Motion Picture*, Oliver Stone

Independent Spirit Awards, 1987

Won: *Independent Spirit Award, Best Cinematography*, Robert Richardson; *Best Director*, Oliver Stone; *Best Feature*, Arnold Kopelson; *Best Screenplay*, Oliver Stone

Nominated: *Independent Spirit Award, Best Male Lead*, Willem Dafoe

Political Film Society, USA, 1988

Won: *PFS Award, Peace*

Writers Guild of America, USA, 1987

Nominated: *WGA Screen Award, Best Screenplay Written Directly for the Screen*, Oliver Stone.

PLATOON LEADER

Breton Film Productions, 1988, color, 97 minutes.

Producers: Avi Lerner, Harry Alan Towers; **Director:** Aaron Norris; **Screenwriters:** Andrew Deutsch, Rick Marx, James R. McDonough, Harry Alan Towers, David L. Walker; **Music:** George S. Clinton; **Cast:** Jesse Dabson, Michael DeLorenzo, Daniel Demorest, Michael Dudikoff, Dean Raphael Ferrandini, Rick Fitts, Brian Libby, Robert F. Lyons, Tony Pierce, Michael Rider, William Smith.

Michael Dudikoff is a green lieutenant, an infantry platoon leader straight out of West Point, who must learn how to become a commander of men from his two sergeants when his platoon is assigned to guard a small Vietnamese village against the Vietcong.

The film is based on *Platoon Leader* (Novato: Presidio, 1985) by James McDoughal.

INTERESTING FACT

- Director Aaron Norris is the brother of action star Chuck Norris. They lost another brother to the Vietnam War, and this presumably influenced the vision of the director.

PLAY DIRTY

Lowndes Productions Limited, 1968, color, 117 minutes.

Producer: Harry Saltzman; **Director:** André De Toth; **Screenwriters:** Melvyn Bragg, Lotte Colin, George Marton; **Music:** Michel Legrand; **Distributor:** United Artists; **Filmed in:** Spain; **Cast:** Enrique Ávila, Mohsen Ben Abdallah, Harry Andrews, Bernard Archard, Aly Ben Ayed, Dennis Brennan, Martin Burland, Michael Caine, Stanley Caine, Jeremy Child, Nigel Davenport, Takis Emmanuel, Bridget Espeet, Nigel Green, Jose Halufi, Patrick Jordan, Mohamed Kouka, George McKeenan, Denny Miller, Vivian Pickles, Daniel Pilon, Anthony Stamboulieh, Michael Stevens.

Michael Caine leads a group of misfits during World War II who are recruited and trained for the critical mission of blowing up an important fuel depot.

PORK CHOP HILL

Melville Production, 1959, b&w, 97 minutes.

Producer: Sy Bartlett; **Director:** Lewis Milestone; **Screenwriters:** James R. Webb; **Music:** Leonard Rosenman; **Distributor:** United Artists; **Cast:** Charles Aidman, John Alderman, Viraj Amonsin, Barry Atwater, Robert Blake, Paul Comi, James Edwards, Biff Elliot, Norman Fell, Abel Fernández, Lew Gallo, Michael Garth, Leonard Graves, Harry Guardino, Kevin Hagen, Chuck Hayward, Cliff Ketchum, Syl Lamont, Martin Landau, Ken Lynch, Gavin MacLeod, Buzz Martin, John McKee, Titus Moede, Gregory Peck, George Peppard, Carl Benton Reid, Bert Remsen, George Shibata, Harry Dean Stanton, Bob Steele, Woody Strode, Rip Torn, William Wellman Jr., Robert Williams.

Gregory Peck commands a company of GIs who must retake a barren and worthless hill in Korea that has been overrun by Red Chinese troops. While the battle rages, U.N. negotiators discuss an armistice, but each side wants to take Pork Chop Hill so that it will be on their side of the final boundary between North and South Korea. As the peace talks drag on, the battle becomes a meat grinder for Americans and Chinese alike. This is the story of an actual battle during the Korean War.

Korea was the first war fought by the United States after President Harry Truman integrated the armed forces. Woody Strode portrays the conflicting emotions that must have been felt by black soldiers asked to

Pork Chop Hill (UNITED ARTISTS/AUTHOR'S COLLECTION)

give their lives for an America in which they are still discriminated against.

PRIDE OF THE ARMY

Monogram Pictures Corporation, 1942, b&w, 64 minutes.

Producer: George W. Weeks; **Director:** S. Roy Luby; **Screenwriter:** John Vlahos; **Distributor:** Monogram Pictures Corporation; **Cast:** John Berkes, Steve Clark, Donald Curtis, Billy Lee, Kay Linaker, George N. Neise, Bradley Page, Lee Phelps, Hal Price, Herbert Rawlinson, Addison Richards, Bryant Washburn.

Youngster Billy Lee volunteers his pet dog for war service. The dog is trained to guard the local war plant, which he saves from destruction by saboteurs. The movie is also known as *War Dogs.*

The actual World War II program for recruiting dogs was known as Dogs for Defense. The quartermaster general of the U.S. Army eventually had more than 50,000 dogs trained for war service.

PRIDE OF THE MARINES

Warner Bros., 1945, b&w, 119 minutes.

Producer: Jerry Wald; **Director:** Delmer Daves; **Screenwriters:** Marvin Borowsky, Roger Butterfield, Delmer Daves, Albert Maltz; **Music:** Franz Waxman; **Cast:** Leonard Bremen, Michael Browne, John Campton, Anthony Caruso, Dane Clark, Tom D'Andrea, Rosemary De Camp, Ann Doran, Warren Douglas, John Garfield, Rory Mallinson, Don McGuire, John

Miles, Moroni Olsen, Eleanor Parker, John Ridgely, John Sheridan, Mark Stevens, Ann E. Todd, Dave Willock.

John Garfield plays a U.S. Marine blinded in combat who must return home and rebuild his life after World II. He comes to realize that he can have a normal life, even though he is blind.

The film is based on the true story of Al Schmid, his fellow marines and their machine gun crew's ordeal at the Battle of the Tenaru River on Guadalcanal in November 1942. The screenplay is true to Roger Butterfield's book, *Al Schmid, Marine* (New York: Farrar & Rinehart, Inc., 1944).

INTERESTING FACT

- To prepare himself for this role, John Garfield lived with Al Schmid to learn as much as he could about the man and his life.

PRISONER OF JAPAN

Producers Releasing Corporation, 1942, b&w, 64 minutes.

Producer: Edgar G. Ulmer; **Directors:** Arthur Ripley, Edgar G. Ulmer; **Screenwriters:** Robert Chapin, Arthur Ripley, Edgar G. Ulmer; **Music:** Lee Zahler; **Distributor:** Producers Releasing Corporation; **Cast:** Alan Baxter, Ray Bennett, Ernst Deutsch, Gil Frye, Gertrude Michael, Corinna Mura, Dave O'Brien, Tom Seidel, Ann Staunton, Beal Wong.

Japanese secret agents, operating from a Pacific Island, are out to destroy American warships.

PRISONER OF WAR

Metro-Goldwyn-Mayer, 1954, b&w, 80 minutes.

Producer: Henry Berman; **Director:** Andrew Marton; **Screenwriter:** Allen Rivkin; **Music:** Jeff Alexander; **Cast:** Ralph Ahn, Stephen Bekassy, Robert Ellis, Steve Forrest, Otis Greene, Peter Hansen, Darryl Hickman, Oskar Homolka, Robert Horton, Ike Jones, Weaver Levy, Clarence Lung, John Lupton, Dewey Martin, Lewis Martin, Edo Mita, Harry Morgan, Rollin Moriyama, Jerry Paris, Ronald Reagan, Lalo Rios, Paul Stewart, Leonard Strong, Leon Tyler, Stuart Whitman.

Ronald Reagan plays an a U.S. army officer troubled by reports of brutality; he volunteers to investigate conditions inside North Korean POW camps. He parachutes behind enemy lines and infiltrates a group of GIs being marched to one of these camps. There he witnesses GIs being brainwashed, beaten, subjected to mock executions, deprived of food and water, and tortured in a variety of ways by a Russian colonel.

INTERESTING FACT

- This film was based on interviews with former prisoners of war about communist atrocities.

PRISONERS OF THE SUN

Village Roadshow Productions, Blood Oath Productions, Siege, Sovereign Pictures, 1990, color, 108 minutes.

Producers: John Tarnoff, Charles Waterstreet, Denis Whitburn, Brian A. Williams; **Director:** Stephen Wallace; **Screenwriters:** Denis Whitburn, Brian A. Williams; **Music:** David McHugh; **Distributor:** Skouras Pictures; **Filmed in:** Queensland, Australia; **Cast:** David Argue, John Bach, Ray Barrett, Andrew Booth, Bryan Brown, John Clarke, Malcolm Cork, Russell Crowe, Jason Donovan, Nicholas Eadie, Sokyu Fujita, Donal Gibson, Matthew Keyes, Shane McNamara, Kazuhiro Muroyama, Terry O'Quinn, Christina Ongley, John Polson, Tim Reuther, Yuichiro Senga, Toshi Shioya, George Takei, Deborah Unger, Tetsu Watanabe, Peter Waterstreet.

During World War II, the Japanese operate a prisoner-of-war camp on the island of Ambon in Indonesia. At the close of the war, the liberated POWs tell a gruesome tale of the mass execution of over 800 soldiers, as well as the torture and killing of downed Australian airmen. No captured airmen are found alive on the island, not even the four-man crew of a reconnaissance plane shot down late in the war. To bring those responsible to justice, the Australian army establishes a war crimes tribunal to pass judgment on the brutal and sadistic Japanese who ran the camp.

PRISON SHIP

Columbia Pictures Corporation, 1945, b&w, 58 minutes.

Producer: Alexis Thurn-Taxis; **Director:** Arthur Dreifuss; **Screenwriters:** Ben Markson, Josef Mischel; **Music:** Mario Castelnuovo-Ted; **Distributor:** Colum-

bia Pictures; **Cast:** Barry Bernard, Ludwig Donath, Nina Foch, David Hughes, Coulter Irwin, Richard Loo, Robert Lowery, Louis Mercier, Moy Ming, Barbara Pepper, Erik Rolf, Robert E. Scott.

During World War II, the Japanese use a ship full of civilian POWs as a decoy. When the POWs realize that the ship is lit up at night specifically to attract Allied attack, they rise up against their captors in an unsuccessful bid to take control of their prison. The Japanese retribution is swift and cruel; they massacre women and children as an object lesson to the rest. When they are attacked by an American submarine, the POWs revolt again, take control, and run up a white flag.

The Japanese consistently refused to put special markings on POW ships, using them as decoys and thus getting double value out of the ships: American submarines wasted valuable torpedoes on targets without military value, and when the ship sank, the Japanese conveniently absolved themselves from responsibility for the care of the POWs. This outrageous violation of the laws of war and humanity has never been forgotten by the survivors. Some POWs survived the fall of Corregidor and the Bataan Death March, only to be torpedoed in the Sea of Japan. Picked up out of the shark-infested water by the Japanese, they were then transported to Japan, where they were put in slave labor camps to be held hostage and executed when the Americans invaded the home islands. The author has a personal friend, Lieutenant General Wright, who survived this ordeal as a young lieutenant and later rose to become a general during the Vietnam War.

PRIVATE JONES

Universal Pictures, 1933, b&w, 70 minutes.

Director: Russell Mack; **Screenwriters:** Prescott Chaplin, Bill Cohen, George Jessel, William N. Robson, Richard Schayer, Sam Spewack; **Distributor:** Universal Pictures; **Cast:** Richard Carle, Walter Catlett, Berton Churchill, Ethel Clayton, Donald Cook, Emma Dunn, Russell Gleason, Shirley Grey, Al Hill, Frank McHugh, Gloria Stuart, Lee Tracy, Hans Heinrich von Twardowski, Roland Varno.

Lee Tracey plays a World War I draft dodger who gets caught in the draft. His comic misadventures include run-ins with a naïve officer, do-gooder YMCA workers, and a speaker about hygiene, warning the young lads about the dangers of willing young French ladies.

PRIVATE NAVY OF SGT. O'FARRELL, THE

John Beck-Naho Productions, 1968, color, 92 minutes.

Producers: John Beck, Bill Lawrence; **Director:** Frank Tashlin; **Screenwriters:** Robert M. Fresco, John L. Greene, Frank Tashlin; **Distributor:** United Artists; **Filmed in:** Puerto Rico; **Cast:** Michael Burns, William Christopher, Christopher Dark, Mylène Demongeot, Phyllis Diller, Robert Donner, Jack Grinnage, Bob Hope, Jeffrey Hunter, Gina Lollobrigida, Mako, John Myhers, Dick Sargent, John Spina, William Wellman Jr., Henry Wilcoxon.

When a ship full of beer is torpedoed, Bob Hope leads the courageous men assigned to salvage the beer, which they plan to use to prop up the sagging morale of the troops. He also tries to add some beautiful nurses to the mix, but he gets Phyllis Diller instead.

PROFESSIONALS, THE

Pax Enterprises, 1966, color, 117 minutes.

Producer: Richard Brooks; **Director:** Richard Brooks; **Screenwriters:** Richard Brooks, Frank O'Rourke (novel, *A Mule for the Marquesa*); **Music:** Maurice Jarre; **Distributor:** Columbia Pictures; **Filmed in:** Las Vegas and Valley of Fire State Park, Nevada, Indio and Death Valley, California; **Cast:** Ralph Bellamy, Rafael Bertrand, David Cadiente, Vincente Cadiente, Elizabeth Campbell, Claudia Cardinale, Don Carlos, Leigh Chapman, José Chávez, Roberto Contreras, Dirk Evans, Marie Gomez, Foster Hood, Jorge Martínez de Hoyos, Darwin Lamb, Burt Lancaster, John Lopez, Lee Marvin, John McKee, Henry O'Brien, Jack Palance, Parslow, Carlos Romero, Robert Ryan, Joe De Santis, Eddie Little Sky, Woody Strode, Vaughn Taylor.

Wealthy Ralph Bellamy hires four hard-boiled adventurers—Burt Lancaster, Lee Marvin, Robert Ryan, and Woody Strode—each a specialist in his own field, to go into Mexico to bring back his wife, who has been kidnapped by Jack Palance, a revolutionary. They accomplish the mission, but when they learn she wasn't kidnapped but ran away because she really loved Palance, they let her go.

This film takes place in 1916, during the Mexican Revolution. In the background in some scenes, you can see "Viva Villa" painted on the walls of buildings. The movie is based on Frank O'Rourke's *A Mule for the Marquesa* (New York: Morrow, 1964).

Dolworth (Burt Lancaster): In this desert, nothing's harmless until it's dead.

Dolworth: There's only been one revolution since the beginning—the good guys versus the bad guys. The question is—who are the good guys?

J. W. Grant [last lines]: You bastard.
Rico: Yes, sir. In my case an accident of birth. But you, you're a self-made man.

AWARDS

Academy Awards, USA, 1966
 Nominated: *Oscar, Best Cinematography, Color,* Conrad L. Hall; *Best Director,* Richard Brooks; *Best Writing, Screenplay Based on Material from Another Medium,* Richard Brooks

American Cinema Editors, USA, 1967
 Nominated: *Eddie, Best Edited Feature Film,* Peter Zinner

Golden Globes, USA, 1967
 Nominated: *Golden Globe, Best Motion Picture—Drama; Most Promising Newcomer—Female,* Marie Gomez (HFPA records do not specify a film)

Golden Screen, Germany, 1967
 Won: *Golden Screen*

Writers Guild of America, USA, 1967
 Nominated: *WGA Screen Award, Best Written American Drama,* Richard Brooks.

PROUD AND PROFANE, THE

Paramount Pictures, 1956, b&w, 111 minutes.

Director: George Seaton; **Screenwriters:** Lucy Herndon Crockett, George Seaton; **Cast:** Claude Akins, Genevieve Aumont, Ross Bagdasarian, George Berlin, Loraine Bronx, Evelyn Cotton, Frank Gorshin, Geraldine Hall, Peter Hansen, William Holden, Don House, Bob Kenaston, Deborah Kerr, Dewey Martin, Taylor Mason, Joseph Moran, Ann Morris, Robert Morse, Theodore Newton, William Redfield, Jack Richardson, Thelma Ritter, Don Roberts, Marion Ross, Richard Shannon, Elizabeth Slifer, Nancy Stevens, Ray Strickland, Adam Williams, Ward Wood.

During World War II, William Holden, a tough U.S. Marine colonel, falls in love with nurse Deborah Kerr on New Caledonia, a rear-echelon base for wounded soldiers. This movie has scenes and characters comparable to those in *FROM HERE TO ETERNITY.*

PT 109

Warner Bros., 1963, color, 140 minutes.

Producer: Bryan Foy; **Director:** Leslie H. Martinson; **Screenwriters:** Richard L. Breen, Robert J. Donovan, Howard X. Flaherty, Howard Sheehan; **Music:** David Buttolph, Howard Jackson, William Lava; **Filmed in:** Little Palm Island, Florida; **Cast:** Robert Blake, Robert Culp, William Douglas, Biff Elliot, Norman Fell, Joseph Gallison, Lew Gallo, Sam Gilman, James Gregory, Ty Hardin, Clyde Howdy, Errol John, Buzz Martin, James McCallion, Michael Pate, Sammy Reese, Cliff Robertson, Glenn Sipes, John Ward, David Whorf, Grant Williams.

John F. Kennedy (Cliff Robertson) is the captain of a PT boat during World War II. When his boat is cut in two by a Japanese destroyer, the survivors swim to a neighboring island, and JFK sends a signal for help carved on a coconut.

INTERESTING FACTS

- The film is based on the true life story of President John F. Kennedy and a book by Robert J. Donovan.
- President Kennedy's personal choice of the actor to portray him was Warren Beatty.
- The coconut on which Lieutenant Kennedy carved the message for help is on display at the JFK Presidential Library in Boston, Massachusetts.
- Kennedy's father, Joseph Kennedy, exerted all the influence he could muster to get his son the Medal of Honor, but that was one thing he couldn't buy.

PURPLE HEART, THE

20th Century-Fox, 1944, b&w, 99 minutes.

Producer: Darryl F. Zanuck; **Director:** Lewis Milestone; **Screenwriters:** Jerome Cady, Darryl F. Zanuck (as Melville Crossman, story); **Music:** Alfred Newman; **Distributor:** 20th Century-Fox Film Corporation; **Cast:** Philip Ahn, Dana Andrews, Don Barry, Tala Birell, Luke Chan, Spencer Chan, Keye Chang, Peter Chong, Richard Conte, John Craven, Ángel Cruz, Igor Dolgoruki, Johnny Dong, Roque Espiritu, Benson Fong, Harold Fong, Lee Tung Foo, Wing Foo, Paul

Fung, Martin Garralaga, Gregory Gaye, Farley Granger, Allen Jung, Erwin Kalser, Kurt Katch, Pete G. Katchenaro, Joseph Kim, King Kong, Eddie Lee, James B. Leong, Sam Levene, Leon Lontoc, Richard Loo, Clarence Lung, Trudy Marshall, Torben Meyer, Kevin O'Shea, Nestor Paiva, Alex Papana, Charles Russell, Marshall Thompson, H. T. Tsiang, Beal Wong, Bruce Wong.

Dana Andrews leads the crew of a downed American bomber; they are captured after a run over Tokyo early in the war. The Japanese put them on trial as war criminals and then execute them when they refuse to reveal critical details of their mission.

The film is based on the true story of the eight men captured by the Japanese after the Doolittle Raid: Lt. Robert Hite, Lt. William G. Farrow, Lt. George Barr, Sgt. Harold A. Spatz, Cpl. Jacob De Shazer, Pvt. Dean Hallmark, Pvt. Robert Meder, and Pvt. Chase Nielsen, whose real names were not used in the film because those not executed were still prisoners of the Japanese. The trial was held at Police Headquarters in Shanghai, China, on October 14, 1942. The eight men were condemned to death. Hallmark, Farrow, and Spatz were executed by a firing squad of the Imperial Japanese Army at sunset the next day. The remainder were given an Imperial commutation to life in prison. In 1943, Meder died of mistreatment. The remaining four survived until they were freed upon Japan's surrender in August 1945.

The Purple Heart, after which the film is named, is an American military decoration awarded to soldiers who are wounded or killed in action. The airmen who died at the hands of the Japanese were awarded this decoration.

The Japanese routinely mistreated, tortured, and executed prisoners of war, repeatedly citing the fact that they had not adopted the Geneva Convention, completely ignoring the fact that such acts violated the basic tenets of humanity. While a detailed list of Japanese atrocities would take an entire book of its own, examples of their barbaric acts include the ritual decapitation of captured officers, and, during the Battle of Midway, airmen pulled from the sea were loaded down with weights and thrown back into the sea to drown.

This movie is essentially the third in a trilogy of films that deal with the actual bombing of Japan by the Doolittle Raid, very early in World War II. The first is DESTINATION TOKYO, about the submarine that went ashore to mark targets for the American raiders. The second is THIRTY SECONDS OVER TOKYO, the story of the Doolittle Raid, including the launching of the B-52s from the USS *Hornet* and the raid itself. *The Purple Heart* completes the cycle with the war trial of a captured American crew that took part in the attack.

QUOTE

Capt. Harvey Ross: It's true we Americans don't know very much about you Japanese. And we never did. And now I realize you know even less about us. You can kill us. All of us, or part of us. But if you think that's going to put the fear of God into the United States of America and stop them from sending other flyers to bomb you, you're wrong. Dead wrong. They'll come by night, they'll come by day. Thousands of them. They'll blacken your skies and burn your cities to the ground and make you get down on your knees and beg for mercy. This is your war. You wanted it. You asked for it. You started it. And now you're going to get it. And it won't be finished until your dirty little empire is wiped off the face of the earth.

PURPLE HEARTS

Warner Bros., 1984, color, 116 minutes.

Producers: Sidney J. Furie, Rick Natkin; **Director:** Sidney J. Furie; **Screenwriters:** Sidney J. Furie, Rick Natkin; **Music:** Robert Folk; **Filmed in:** Philippines; **Cast:** Paul Anderson, David Bass, Richard Bean, Rod Birch, Chuck Dougherty, Kevin Elders, R. Lee Ermey, Joel Escamilla, Hugh Gillam, Bruce Guilchard, David Harris, Cheryl Ladd, Stephen Lee, Paul McCrane, Annie McEnroe, Helen McNeely, Rudy Nash, Rick Natkin, Cyril O'Reilly, Adam Rice, Steven Rodgers, Steve Rosenbaum, Hillary Bailey Smith, John Smith, Lane Smith, Drew Snyder, Sydne Squire, Don Tamuty, Theodore Thomas, Art Thompson, Koko Trinidad, Ken Wahl, James Whitmore Jr., Paul Williams, Claude Wilson.

Ken Wahl is a U.S. Navy doctor who falls in love with Cheryl Ladd, a pretty nurse, during the Vietnam War.

PURPLE PLAIN, THE

Two Cities Films Ltd., 1954, color, 100 minutes.

Producers: John Bryan, Earl St. John; **Director:** Robert Parrish; **Screenwriters:** Eric Ambler, H. E. Bates; **Distributor:** United Artists; **Filmed in:** Openshaw, Manchester, England; **Cast:** Peter Arne, Lyndon Brook, Anthony Bushell, Brenda De Banzie, Maurice Denham, Ram Gopal, Josephine Griffin, Bernard Lee, Gregory Peck, Win Min Than.

Gregory Peck plays a neurotic, suicidal pilot serving in Burma during World War II. After his plane crashes in the jungle, he's transformed by his love for a native girl. She gives him the drive to survive the trek through the harsh jungle to freedom.

The film is based on H. E. Bates's *The Purple Plain* (Boston: Little, Brown, and Company, 1947).

PURPLE V, THE

Republic Pictures Corporation, 1943, b&w, 58 minutes.

Producer: George Sherman; **Director:** George Sherman; **Screenwriters:** Robert R. Mill, Bertram Millhauser, Curt Siodmak; **Cast:** John Archer, Eva Hyde, Kurt Katch, Fritz Kortner, Kurt Kreuger, Peter Lawford, Mary McLeod, Walter Sande, Irene Seidner, William Vaughn, Rex Williams.

John Archer plays an American pilot who is shot down behind enemy lines. He is aided in getting back to his own lines by Fritz Kortner, a German schoolteacher who does not agree with the Nazi regime.

QUICK AND THE DEAD, THE

Manson Corporation, 1963, b&w, 92 minutes.

Producer: Sam Altonian; **Director:** Robert Totten; **Screenwriters:** Sheila Lynch, Robert Totten; **Music:** Jaime Mendoza-Nava; **Cast:** James Almanzar, Majel Barrett, Jon Cedar, Frank D'Agostino, Sandy Donigan, Victor French, Ted French, William Kirschner, Joseph Locastro, Larry D. Mann, Louis Massad, Stuart Nisbet.

American GIs, their numbers thinned by combat with Germans in northern Italy during World War II, are helped by Italian partisans.

QUIET AMERICAN, THE

Figaro Films, 1958, b&w, 120 minutes.

Producers: Joseph L. Mankiewicz, Vinh Noan, Michael Waszynski; **Director:** Joseph L. Mankiewicz; **Screenwriters:** Graham Greene, Joseph L. Mankiewicz; **Distributor:** United Artists; **Filmed in:** Vietnam; **Cast:** Clinton Anderson, Georges Bréhat, Bruce Cabot, C. Long Cuoung, Claude Dauphin, Kerima, Nguyen Long, Richard Loo, Giorgia Moll, Audie Murphy, Michael Redgrave, Fred Sadoff, Yoko Tani, Peter Trent.

Audie Murphy is an American dealing in explosives during the French Indochina War. Michael Redgrave is a cynical British correspondent. They play out their widely different views in the struggle for the hearts and minds of the Vietnamese people in their competition over a young woman, Giorgia Moll. Murphy wants to reform her and make her a typical middle-class American housewife. Redgrave accepts her inability to formulate or retain a political ideal and while promising her no real future he objects to Murphy's attempts to change her. Redgrave loses his objectivity as a journalist and sides with the communists, who use him as a dupe and betray him. As a result, Murphy is killed.

The French Indochina War (1945–1954) had its roots in French colonialism. France had ruled the area that today encompasses Vietnam since the mid-1800s. When the French were defeated in 1940, they were forced to allow Germany's ally, Japan, to occupy the region. Resistance fighters, under Ho Chi Minh, fought the Japanese during World War II, and with the defeat of Japan refused to accept the return of French rule, declaring their independence on September 2, 1945. After years of guerrilla tactics, a decisive battle was fought at Dienbienphu, and with the surrender of the garrison on May 7, 1954, the French rule of Vietnam came to an end. The Geneva Accords split the country at the 17th parallel into communist North Vietnam and democratic South Vietnam, and set the stage for the later Vietnam War.

The film is based on Graham Greene's *The Quiet American* (New York: Viking Press, 1956).

RACK, THE

Metro-Goldwyn-Mayer, 1956, b&w, 100 minutes.

Producer: Arthur M. Loew Jr.; **Director:** Arnold Laven; **Screenwriters:** Rod Serling, Stewart Stern; **Distributor:** MGM; **Cast:** Barry Atwater, Trevor Bardette, James Best, David Blair, Robert Blake, Robert Burton, John Carlyle, Wendell Corey, Charles Evans, Anne Francis, Dean Jones, Byron Kane, Lois Kimbrell, Cloris Leachman, Lee Marvin, Mary McAdoo, Frank Mills, Paul Newman, Edmond O'Brien, Walter Pidgeon, Fay Roope, Willard Sage, Robert F. Simon, Ray Stricklyn, Rod Taylor, Adam Williams.

Paul Newman plays an American captain who is released after two years in a Korean POW camp. He's court-martialed for collaboration with the enemy, because he tried to convince the other prisoners they were fighting an unjust war. His defense consists of the fact that he was decorated for valor and that he was brainwashed by the communists after severe physical and mental torture. His defense is weakened because another prisoner, Lee Marvin, testifies against him, and he is convicted.

During the Korean War, the communists routinely attempted to brainwash POWs, usually in combination with intense maltreatment, physical abuse, and mental torture. Many American soldiers, untrained and unprepared for this type of warfare, were prone to manipulation by their captors.

MILITARY SERVICE

- Paul Newman enlisted in the U.S. Navy's V-5 program for training aviators but was dropped when the navy discovered he was color blind. He was trained as a radioman/gunner and served aboard Grumman TBM Avengers (naval patrol torpedo planes) in the Pacific. He flew missions over Japan near the end of the war on board the USS *Hollandia*. His crew would have been transferred to the USS *Bunker Hill*, but his pilot contracted an ear infection and they were left behind. Later, a kamikaze crashed into the briefing room of the *Bunker Hill* and killed many in the squadron.

QUOTES

Capt. Edward W. Hall Jr.: Do you know what's the matter with me?
Aggie Hall: No.
Capt. Edward W. Hall Jr.: My mother wasn't in the army, so I'm a half-breed.

RAIDERS OF LEYTE GULF, THE

Manhattan Productions, Lynro, 1963, b&w, 80 minutes.

Producer: Eddie Romero; **Director:** Eddie Romero; **Screenwriters:** Carl Kuntze, E. F. Romero; **Distributor:** Hemisphere; **Filmed in:** Leyte, the Philippines; **Cast:** Eddie Mesa, Liza Moreno, Michael Parsons, Efren Reyes, Leopoldo Salcedo, Jennings Sturgeon.

Jennings Sturgeon plays an American intelligence officer whom the Japanese hold prisoner during World War II. He is freed by Filipino guerrillas, who join with the villagers to rise up and attack their Japanese oppressors.

RAIDERS OF THE LOST ARK

Lucasfilm Ltd., 1981, color, 114 minutes.

Producers: Howard G. Kazanjian (executive producer), George Lucas (executive producer), Frank Marshall, Robert Watts (associate producer); **Director:** Steven Spielberg; **Screenwriters:** George Lucas (story), Philip Kaufman (story), Lawrence Kasdan; **Music:** John Williams; **Distributor:** Paramount Pictures; **Filmed in:** France, Kauai, Hawaii, and Tunisia; **Cast:** Karen Allen, Ishaq Bux, Sonny Caldinez, Anthony Chinn, Patrick Durkin, Denholm Elliott, Don Fellows, Harrison Ford, Christopher Frederick, Paul Freeman, Ted Grossman, Steve Hanson, George Harris, Anthony Higgins, William Hootkins, Wolf Kahler, Martin Kreidt, Ronald Lacey, Tutte Lemkow, Frank Marshall, Souad Messaoudi, Alfred Molina, Dennis Muren, John Rees, Bill Reimbold, John Rhys-Davies, Terry Richards, Pat Roach, Matthew Scurfield, Kiran Shah, Michael Sheard, Fred Sorenson, Vic Tablian, Eddie Tagoe, Tony Vogel, Malcolm Weaver.

Renowned archaeologist Indiana Jones (Harrison Ford) is out to find the Ark of the Covenant, which is believed to hold the Ten Commandments. Unfortunately, the Nazis are also after the ark, to use as a weapon to win the coming war.

INTERESTING FACTS

- Indiana Jones's name comes from the name of George Lucas's dog, and is a play on Steve McQueen's character name in *Nevada Smith*.
- The scene where Indy threatens to blow up the ark with a bazooka as it is being carried through a canyon was filmed in the same canyon in Tunisia used in *Star Wars* (1977) when R2-D2 was zapped and stolen by Jawas.
- In filming the Well of Souls sequence, the producers scoured every pet shop in London and the

south of England for every snake they could lay their hands on. Hence there are snakes that are identifiable from many different geographical areas. However, once all the snakes were on set, it became clear that there were not nearly enough of them, so Spielberg had several hoses cut into lengths, and these were used as well. Looking closely, you can tell which are the real snakes and which are not.

- An early draft of the script had Indy traveling to Shanghai to recover a piece of the staff of Ra. During his escape from the museum where it was housed, he hid from machine-gun fire behind a giant rolling gong. Also in the same script, Indy and Marion flee the chaos caused by the opening of the ark in a wild mine cart chase sequence. Both of these scenes were cut from the script, but ended up in *Indiana Jones and the Temple of Doom* (1984).
- The film begins with a shot of a peak in the jungle which is reminiscent of the Paramount Pictures logo.
- Director Steven Spielberg was quoted as saying: "I made it as a B-movie I didn't see the film as anything more than a better-made version of the Republic serials."
- Tom Selleck was originally cast as Indiana Jones, but he was committed to *Magnum P.I.* (1980), which did an episode that parodied *Raiders*, complete with hat, whip, booby traps, and so on.
- Jock's airplane at the beginning has the registration number "OB-CPO," referring to Obi-wan and C-3PO from *Star Wars* (1977).
- The script originally included a long fight between a swordsman and Indiana with his whip. Actor Harrison Ford was suffering diarrhea at the time and asked if the scene could be shortened. Spielberg said the only way he could shorten it was if Indy pulled out his gun and just shot the guy. The entire crew laughed, and that's how it was filmed.
- The truck that didn't have Marion in it was flipped over by firing a section of a telephone pole through the floorboards.
- Ford badly bruised his ribs during the scene where he is dragged behind the truck.
- The hieroglyphics in the Well of Souls include engravings of R2-D2 and C-3PO (from *Star Wars* (1977). They can be seen on a post to the right of Indy and Sallah as they remove the ark.
- Harrison Ford was actually dragged behind the truck for some of the shots. When asked if he was worried, Ford quipped: "No. If it really was dangerous, they would have filmed more of the movie first."

- Notice the cameo by special-effects whiz Dennis Muren. He appears as a Nazi spy who is tracking Indiana Jones on the airplane. Only his eyes can be seen, as most of his face is hidden behind the *Life* magazine he's reading.
- The film reused the submarine model from *Das Boot* (1981).
- During filming in Tunisia, nearly everyone in the cast and crew got sick, except director Steven Spielberg. It is thought that he avoided illness by eating only the food he'd brought with him: cans and cans of Spaghetti-O's.
- Indiana Jones's kangaroo-hide bullwhip was sold in December 1999 at Christie's auction house in London for $43,000.
- The ending of this movie has similarities to *Quatermass and the Pit* (1967): In *Quatermass*, Colonel Breen melts due to the power of an alien spaceship. In *Raiders*, Dietrich meets the same fate from the ark. In *Quatermass*, a protagonist is told "Don't look at it!" referring to the giant energy alien. In *Raiders*, Indy tells Marion the same thing in regards to the ark. News crews are filming the spaceship in *Quatermass*, and the ark in *Raiders*, when it begins destroying the area around it, including the cameras. Incidentally, Julian Glover plays the melted character in *Quatermass*, and he would go on to oppose Indiana Jones in *Indiana Jones and the Last Crusade* (1989).
- The opening scene in the lost South American temple is partly based on a classic Donald Duck adventure by the legendary artist Carl Barks, many of whose comic books have inspired George Lucas and Steven Spielberg. In exploring a lost temple, Donald Duck, his nephews, and Scrooge McDuck must evade a succession of booby traps—flying darts, a decapitating blade, a huge boulder, a tunnel flooded with a torrent of gushing water, etc.—in the story *The Prize of Pizarro* (*Uncle $crooge*, 26 June–August 1959), which hit the newsstands when Lucas and Spielberg were, respectively, 15 and 12 years old. Both men are avowed fans of the Barks comic books.
- The musical theme for scenes of the Ark of the Covenant is heard several times throughout the film. Each time, it either trails off, segues into a different theme, or modulates into a different key. Only at the climax of the film is the entire theme heard and resolved in its original key.
- The Golden Gate Bridge was not opened until 1937, but the main structure was finished in November 1936. Evidently the movie takes place later in 1936 than that. This is confirmed by the fact that in the same scene with the bridge, Toht is reading *Life* magazine, whose first issue was dated November 23, 1936. So this scene is incorrectly regarded as a goof.

MISTAKES

- The spiders on Indy's back appear and disappear.
- During the firefight in Marion's Bar, Indy's gun changes from a .38 revolver to a Colt .45, back to a .38, then back once again to a .45. This might be the reason that he is able to fire his gun seven times without reloading.
- When Indy pushes a stone block out of a wall to escape from the crypt, it bounces as it hits the ground.
- The issue of *Life* magazine that we see Toht reading has the front cover of the magazine's second issue (November 30, 1936), showing a West Point cadet, but the back cover of the following issue (December 7) advertising Stetson hats. The actual November 30 back cover advertised Lucky Strike cigarettes.
- Although the film is set in 1936, the submachine guns used are German MP-38s (a.k.a. "Schmeissers"), not adopted by the German army until 1938.
- The map showing the path of Indy's flight includes Thailand, which was called Siam at the time.
- Egypt was British-controlled in 1936. The Germans would not have been able to mount a large military operation there as shown.
- The staff is supposed to be 60 inches tall (6 kadams = 72 inches, minus 1 kadam). The pole that Indy inserts into the hole in the map room towers over his head, indicating (incorrectly) that Indy is less than 5 feet tall. The laserdisc edition disproves any claim that he's standing on a lower step.
- During the basket sequence, the sweat marks on Indy's back shrink and grow from shot to shot.
- After trapping Indy in the Well of Souls, Belloq's hat jumps from his hand to the ground.
- The driver of Belloq's car winces before Belloq hits him.
- The luggage rack detaches itself from the truck when Indy collides with the water trough, but it's fixed in subsequent shots.
- The plane that is circling on the ground is driven by a chain around its wheels.
- Note an anachronism: The Afrika Korps didn't exist until 1941.
- During the truck chase scene, after the German soldier shoots Indiana in the arm, he punches him several times. Indy's blood appears and then disappears from the German soldier's knuckles.

- When Indy threatens to blow up the ark, he is shown holding a Panzerfaust antitank weapon. The Panzerfaust was developed after World War II started.
- When Marion climbs into the basket, the lid is askew. When the shot cuts to the monkey on top, the lid is perfectly in place.
- When Indiana Jones enters the well with the mockup, he first throws his baton and then climbs down the rope. In the next scene, the baton is lying against the wall when he takes it back.
- During the truck chase, the heads of the approaching German soldiers are level with the top of the truck, yet their faces are shown reflected in the wing mirrors. This would be possible only if the mirrors were angled upward, which is an unlikely position when a truck is driven.
- When Indy is pushing the stone from the window of the Well of Souls for his escape, and when the camera shows the stone falling, you can see a man sitting on the ground below the window.
- Marion wins a drinking contest in her bar in which the Nepalese contestant passes out and falls over backward. Within minutes she is in a serious and lucid conversation with Indiana Jones, doesn't slur her words, and then takes part in a gun battle calling for a certain amount of dexterity and nimbleness.
- When Indy is climbing on the pontoon of the sea plane, his clothes appear completely dry, although he was just in the water and, in the scene before, the clothes appeared completely wet.
- In the scene where Indy shoots the person with the sword, he arrives with his right shoulder toward the swordsman, but immediately in the next shot his left side faces the swordsman.

QUOTES

Jones [needs his bullwhip to swing across a chasm]: Give me the whip!
Satipo: Throw me the idol. No time to argue. Throw me idol, I'll throw you the whip.
Jones [throws the idol]: Give me the whip!
Satipo: Adiós, señor!

Sallah [Upon opening the Well of the Souls and peering down]: Indy, why does the floor move?
Indiana Jones: Give me your torch. [Sallah does, and Indy drops it in.] Snakes. Why'd it have to be snakes?

AWARDS

Academy Awards, USA, 1981

Won: *Oscar, Best Art Direction—Set Decoration,* Leslie Dilley, Michael Ford, Norman Reynolds; *Best Effects, Visual Effects,* Richard Edlund, Joe Johnston, Bruce Nicholson, Kit West; *Best Film Editing,* Michael Kahn; *Best Sound,* Roy Charman, Gregg Landaker, Steve Maslow, Bill Varney; *Special Achievement Award,* Richard L. Anderson, Ben Burtt (For Sound Effects Editing)

Nominated: *Oscar, Best Cinematography,* Douglas Slocombe; *Best Director,* Steven Spielberg; *Best Music, Original Score,* John Williams; *Best Picture,* Frank Marshall

Academy of Science Fiction, Horror and Fantasy Films, USA, 1982

Won: *Saturn Award, Best Actor,* Harrison Ford; *Best Actress,* Karen Allen

Best Fantasy Film, American Cinema Editors, USA, 1982

Won: *Eddie, Best Edited Feature Film,* Michael Kahn

Boston Society of Film Critics Awards, 1982

Won: *BSFC Award, Best Director,* Steven Spielberg

British Academy Awards, 1982

Won: *BAFTA Film Award, Best Production Design / Art Direction,* Norman Reynolds

Nominated: *BAFTA Film Award, Best Cinematography,* Douglas Slocombe; *Best Editing,* Michael Kahn; *Best Film; Best Original Film Music,* John Williams; *Best Sound,* Ben Burtt, Roy Charman, Bill Varney; *Best Supporting Artist,* Denholm Elliott

Directors Guild of America, USA, 1982

Nominated: *DGA Award, Outstanding Directorial Achievement in Motion Pictures,* Steven Spielberg

Golden Globes, USA, 1982

Nominated: *Golden Globe, Best Director—Motion Picture,* Steven Spielberg

Grammy Awards, 1982

Won: *Grammy, Best Album of Original Score Written for a Motion Picture or Television Special,* John Williams

Hugo Awards, 1982

Won: *Hugo, Best Dramatic Presentation*

National Film Preservation Board, USA, 1999

National Film Registry

People's Choice Awards, USA, 1982

Won: *People's Choice Award, Favorite Motion Picture*

Writers Guild of America, USA, 1982

Nominated: *WGA Screen Award, Best Comedy Written Directly for the Screen,* Lawrence Kasdan, Philip Kaufman, George Lucas

Won: *Young Artist Award, Best Motion Picture—Family Enjoyment.*

RAID ON ROMMEL

Universal Pictures, 1971, color, 99 minutes.

Producer: Harry Tatelman; **Director:** Henry Hathaway; **Screenwriter:** Richard M. Bluel; **Music:** Hal Mooney; **Distributor:** Universal Pictures; **Filmed in:** Mexico; **Cast:** Karl-Otto Alberty, Chris Anders, Richard Burton, Christopher Cary, John Colicos, Clinton Greyn, Mike Kulcsar, Danielle De Metz, Greg Mullavy, John Orchard, Wolfgang Preiss, Michael Sevareid, Brook Williams, Ben Wright.

Richard Burton plans on raiding German-occupied Tobruk with a specially trained commando team, but they are captured. He allows himself to be taken prisoner to free them, but instead of being put with the crack commandos, he ends up with a medical unit led by a Quaker conscientious objector. Even though the odds are stacked against them, his replacements help him blow up the vital fuel supply of the Afrika Korps.

INTERESTING FACT

- Nearly all the action scenes were footage taken from the film *TOBRUK* (1967).

RAMBO: FIRST BLOOD PART II

TriStar Pictures, 1985, color, 96 minutes.

Producers: Mel Dellar, Buzz Feitshans, Mario Kassar, Andrew G. Vajna; **Director:** George P. Cosmatos; **Screenwriters:** James Cameron, Kevin Jarre, Sylvester Stallone; **Music:** Jerry Goldsmith; **Filmed in:** Acapulco, Mexico (waterfall scene); **Cast:** Steven Berkoff, George Cheung, Bagan Coleman, Don Collins, Richard Crenna, Tom Gehrke, William Ghent, Voyo Goric, Christopher Grant, Alain Hocquenghem, Martin Kove, Dana Lee, Tony Munafo, Charles Napier, Julia Nickson-Soul, William Rothlein, Sylvester Stallone, John Sterlini, Steven Williams, Andy Wood.

Rambo (Sylvester Stallone) is a former Green Beret serving time in a federal prison. When the U.S. military suspects that American soldiers missing in action from the Vietnam War could still be alive and held captive, Richard Crenna is authorized to send Rambo in to

get photographic evidence, but to take no military action. When Rambo shows up at the evacuation site with one of the POWs, the helicopter abandons him. Rambo is recaptured and tortured, and when he escapes the second time, he destroys the POW camp, frees all of the prisoners, and returns to the American base in a captured Soviet helicopter.

MISTAKES

- The smoke machine is visible in the passenger compartment as Rambo lands the damaged helicopter.
- The hole in the helicopter's windshield is present only when Rambo needs to fire the rocket through it.
- The weapon that Rambo holds in the helicopter is a single-shot LAW rocket, which has a trigger on the top of the tube. This is followed by a short close-up of a trigger of a rocket-propelled grenade (RPG). The LAW is back in the next shot.
- The backfire from a rocket launcher would fry the entire crew of the helicopter.

QUOTES

John Rambo: Sir, do we get to win this time?

Rambo: I want what they want: for our country to love us as much as we love it. That is what I want.

Colonel Trautman: How will you live, John?
Rambo: Day by day.

RAMBO III

Carolco Pictures, 1988, color, 101 minutes.

Producers: Buzz Feitshans, Mario Kassar, Andrew G. Vajna; **Director:** Peter MacDonald; **Screenwriters:** Sheldon Lettich, Sylvester Stallone; **Music:** Jerry Goldsmith; **Filmed in:** Israel, Yuma, Arizona, Thailand, Imperial County, California; **Cast:** Alon Abutbul, Mahmoud Assadollahi, Tikva Aziz, Shaby Ben-Aroya, Benny Bruchim, Richard Crenna, Hany Said El Deen, Harold Diamond, Spiros Focás, Sasson Gabai, Marcus Gilbert, Marc de Jonge, Tal Kastoriano, Seri Mati, Paul Dion Monte, Julian Patrice, Milo Rafi, Randy Raney, Joseph Shiloach, Marciano Shoshi, Doudi Shoua, Kurtwood Smith, Sylvester Stallone, Sadiq Tawfiq.

Rambo (Sylvester Stallone) goes to Afghanistan to rescue his old superior officer, Richard Crenna, who has been captured by the Soviets while training Afghan rebels. Bullets and bombs fly as the indestructible

Rambo destroys hordes of Soviet soldiers in the course of rescuing his friend.

The Afghanistan war is often described as the Soviet Vietnam. The Russians went into Afghanistan to prop up the weak communist government and were immediately embroiled in an internal civil war in which the rebel guerrilla forces, like the Vietcong, enjoyed extensive local support. The combat was brutal as the communist government forces wiped out whole families and villages that were suspected of supporting the rebels. However, despite the savagery aimed against them, the guerrillas continued to fight, and finally the Soviets, financially drained, with mounting casualties and with no end in sight, withdrew their support.

INTERESTING FACT

- Original director Russell Mulcahy was replaced by Peter MacDonald due to creative differences.

MISTAKE

- The three Mi-24 Hind helicopters are actually French-made Pumas with after-market bolt-ons.

QUOTES

Colonel Trautman [Rambo and Colonel Trautman stand alone facing an enemy army]: What do we do?
Rambo: Well, surrounding them's out.

Colonel Zayson: Who are you?
Rambo: Your worst nightmare.

RATS OF TOBRUK, THE

Renown Pictures Corporation Ltd., 1944, b&w, 95 minutes.

Producers: Charles Chauvel, Charles Munro; **Director:** Charles Chauvel; **Distributor:** RKO Radio Pictures Inc.; **Cast:** Peter Finch, Pauline Garrick, Mary Gay, George Gentry, Chips Rafferty, Grant Taylor, George Wallace.

Three Australian soldiers—a tough two-fisted drover, a laconic dingo trapper, and an intellectual—fight Rommel in North Africa during World War II.

RAVAGERS, THE

Hemisphere Pictures, Inc., 1965, b&w, 79 minutes.

Producers: Kane W. Lynn, Eddie Romero; **Director:** Eddie Romero; **Screenwriters:** Cesar Amigo, Eddie

Romero; **Distributor:** Hemisphere Pictures; **Cast:** Robert Arevalo, Jose Dagumboy, Vic Diaz, Bronwyn Fitzsimmons, Mike Parsons, Fernando Poe Jr., Ann Saxon, John Saxon, Kristina Scott, Vic Silayan.

During World War II, John Saxon leads Filipino guerrillas intent on keeping the Japanese from seizing gold hidden on an island.

INTERESTING FACT

- Bronwyn Fitzsimmons is Maureen O'Hara's daughter.

REACH FOR THE SKY

Rank Organisation, 1956, b&w, 123 minutes.

Producers: Daniel M. Angel, Anthony Nelson Keys; **Director:** Lewis Gilbert; **Screenwriters:** Paul Brickhill, Lewis Gilbert, Vernon Harris; **Music:** John Addison; **Distributor:** Rank Organisation; **Cast:** Ronald Adam, Dorothy Alison, Basil Appleby, Derek Blomfield, Lyndon Brook, Beverley Brooks, Eddie Byrne, Charles Carson, Ernest Clark, Michael Gough, Nigel Green, Walter Hudd, Alexander Knox, Sam Kydd, Avice Landone, Anne Leon, Harry Locke, Howard Marion-Crawford, Kenneth More, Lee Patterson, Muriel Pavlow, Eric Pohlmann, Michael Ripper, Philip Stainton, Sidney Tafler, Michael Warre, Jack Watling.

An airman overcomes the loss of both legs to become a successful fighter pilot and wing leader during World War II.

INTERESTING FACT

- The movie is based on the true story of airman Douglas Bader, who lost both of his legs in a flying accident in 1931.

REAL GLORY, THE

Samuel Goldwyn Company, 1939, b&w, 95 minutes.

Producers: Samuel Goldwyn, Robert Riskin; **Director:** Henry Hathaway; **Screenwriters:** Charles L. Clifford, Robert Presnell Sr., Jo Swerling; **Distributor:** United Artists; **Cast:** Caiyu Ambol, Luke Chan, Gary Cooper, Broderick Crawford, Roy Gordon, Russell Hicks, Benny Inocencio, Soledad Jiménez, Kay Johnson, George Kaluna, Henry Kolker, Tetsu Komai, Andrea Leeds, Elmo Lincoln, Bob Naihe, David Niven, Reginald Owen, Satini Pualoa, Rudy Robles,

Elvira Ríos, Nick Shaid, Vladimir Sokoloff, Kalu Sonkur Sr., Karen Sorrell, Charles Stevens, Kam Tong, John Villasin, Lucio Villegas, Charles Waldron, Martin Wilkins.

Gary Cooper is an army doctor, part of a handful of soldiers left behind to train the Philippine constabulary so that they can protect the local population. Moro zealots strike terror into the local militia, and then they block the village's water supply, resulting in an outbreak of cholera. Gary Cooper leads a daring raid into the jungle. He and his native troops build rafts, blow up the dam, and then surf the resulting water from the hills back to the village.

The Philippines was one of the Spanish territories inherited by the U.S. as a result of the Spanish-American War in 1898. By 1905, U.S. policy was to withdraw regular army troops and to turn administration in places like Mindanao over to the local Philippine constabulary.

The movie is based on Charles I. Clifford's *The Real Glory* (Toronto: William Heinemann, 1937).

REBELLION IN CUBA

International, 1961, b&w, 93 minutes.

Producer: Albert C. Gannaway; **Director:** Albert C. Gannaway; **Screenwriters:** Frank Graves, Mark Hanna; **Distributor:** International; **Filmed in:** Isle of Pines; **Cast:** Lon Chaney Jr., Bill Fletcher, Dan Gould, Jake LaMotta, Barbara Lea, Sonja Marrero.

Anticommunist forces attempt to depose Fidel Castro and restore democracy to Cuba.

INTERESTING FACTS

- Actor Jake LaMotta was a real-life prizefighter.
- This fictionalized story was released just a few months after the abortive Bay of Pigs invasion of Cuba.

RED BALL EXPRESS

Universal-International Pictures, 1952, b&w, 83 minutes.

Producer: Aaron Rosenberg; **Director:** Budd Boetticher; **Screenwriters:** Billy Grady Jr., John Michael Hayes, Marcel Klauber; **Cast:** Judith Braun, Jeff Chandler, Frank Chase, Robert A. Davis, Charles Drake, Jacqueline Duval, Richard Garland, Cindy Garner, Thomas Browne Henry, John Hudson, Jack Hyde, Bubber Johnson, Jack Kelly, Alex Nicol, Hugh O'Brian, Gregg Palmer, Howard Petrie, John Pickard, Sidney Poitier, Leonard Schneider, Arthur Space, Jack Warden.

In August 1944, in their rush across France, Patton's Third Army has advanced so far toward Paris that they have outrun their supply lines. To keep up the momentum, Allied HQ establishes an elite military truck route, which they call the Red Ball Express. One racially integrated platoon of the Express encounters racism, private enmities, bypassed pockets of enemy soldiers, minefields, and increasingly perilous missions as they rush to keep the advancing tanks supplied.

The Allied breakthrough in August 1944 resulted in a need for a significant tonnage of matériel, particularly food, gasoline, and ammunition, for the American troops rushing across France, especially General Patton's Third Army. Since the retreating Germans had destroyed the French railroads, the troops of these advancing armies had to be supplied by truck. In order to meet this demand, the Red Ball Plan was devised by the Transportation Corps on August 21, 1944. The Red Ball Express became operational on August 25, and its convoys operated trucks in endless numbers. The Red Ball Plan provided for two one-way reserved highway routes marked "Red Ball Trucks Only." The original route was from St.-Lô to Paris and back. On an average day, 899 vehicles on the Red Ball Express traveled 1,504,616 ton-miles on a trip that took an average time of 54 hours. Approximately 73 percent of the soldiers in the truck companies of the Motor Transport Service were black. The Red Ball Express was faded out on November 13, 1944.

MILITARY SERVICE

- Actor Hugh O'Brian was the son of a retired U.S. Marine Corps captain. He attended Roosevelt Military Academy in Illinois, and Kemper Military School in Kentucky. During World War II he entered the U.S. Marine Corps, and at 18 became one of the youngest drill sergeants in marine history. He volunteered for combat duty but was instead recommended for appointment to Annapolis and was studying to take the entrance exam when the war ended.
- Sidney Poitier enlisted during World War II and was assigned to the 1267th Medical Detachment, where he helped treat psychiatric patients suffering from shell shock.

Red Ball Express (UNIVERSAL-INTERNATIONAL PICTURES/AUTHOR'S COLLECTION)

RED DAWN

Metro-Goldwyn-Mayer, 1984, color, 114 minutes.

Producers: Sidney Beckerman, Buzz Feitshans; **Director:** John Milius; **Screenwriters:** John Milius, Kevin Reynolds; **Music:** Basil Poledouris; **Filmed in:** Las Vegas and San Miguel, New Mexico; **Cast:** Powers Boothe, Johelen Carleton, Harley Christensen, Michael D'Agosta, Darren Dalton, Sam Dodge, George Fisher, George Ganchev, Jennifer Grey, C. Thomas Howell, Tom Ireland, Christopher Janczar, Roy Jenson, Ben Johnson, Waldemar Kalinowski, Zitto Kazann, Lois Kimbrell, Frank McRae, Phil Mead, Michael Meisner, Victor Meisner, Julius L. Meyer, Tacy Norwood, Judd Omen, Ron O'Neal, Radames Pera, Raquel Provance, Fred Rexer, J. D. Ruybal, Brad Savage, Gene Scherer, Ben Schick, Pepe Serna, Charlie Sheen, Vladek Sheybal, Sam Slovick, Lane Smith, William Smith, Dan Sparks, Harry Dean Stanton, Patrick Swayze, Lea Thompson, Doug Toby, Ben Zeller.

At the outbreak of World War III, communists invade the United States from Nicaragua and Russia. Midwestern high school students, who have gone to hide in the mountains, slowly organize themselves into an effective guerrilla force based on their high school totem, the Wolverines. The pressures of their desperate existence begin to wear away at the Wolverine unity as the Soviet bloc forces hunt them down.

INTERESTING FACTS

- This is the first film to be given a PG-13 rating.
- The original trailer, which is included on the laser

disc, shows a scene with a tank rolling up to a McDonald's restaurant where enemy soldiers are eating. This scene does not appear in the final cut; it may have been removed due to a mass murder at a San Ysidro, California, McDonald's just weeks prior to the film's opening.

- The radio announces: "John has a long mustache," the same message the French resistance gets in *THE LONGEST DAY* (1962).
- The movie being shown to American prisoners at the Russian camp near Calumet is *Aleksandr Nevsky* (1938).

MISTAKES

- In the movie, not enough snow is shown in the Colorado Rockies.
- The three Mi-24 Hind helicopters are actually French-made Pumas with after-market bolt-ons.

QUOTES

Daryl Bates [Robert has just killed a Russian soldier]: How was it?
Robert: It was good.

The colonel: All that hate'll burn you up.
Boy in Classroom: Keeps me warm.

Jed Eckert: Well, who is on our side?
The colonel: 600 million screamin' Chinamen.
Matt Eckert: I thought there was a billion screamin' Chinamen.
The colonel [he throws whisky into fire, and it violently ignites for a moment]: There was.

AWARD

Young Artist Awards, 1985
 Nominated: *Young Artist Award, Best Young Supporting Actor in a Motion Picture Musical Comedy, Adventure or Drama*, Brad Savage.

REDS

Barclays Mercantile Industrial Finance, JRS, 1981, color, 194 minutes.

Producers: Dede Allen (executive producer), Warren Beatty, David Leigh MacLeod (associate producer) (as David L. MacLeod), Simon Relph (executive producer); **Director:** Warren Beatty; **Screenwriters:** Warren Beatty, Peter S. Feibleman, Trevor Griffiths, Elaine May, Jeremy Pikser; **Music:** Dave Grusin (additional music), Stephen Sondheim, Pierre Degeyter (nonoriginal music); **Distributor:** Paramount Pictures; **Filmed in:** Central Methodist Hall, Storey's Gate, London, and Frencham Ponds, England, house in Provincetown, Mass., Helsinki, Finland. Lancaster House, London (interiors of the Winter Palace, St. Petersburg) and One Great George Street, London, England, Suomenlinna, Helsinki, Finland, Zion Institute, Manchester, England (Chicago hall where Reed speaks against American involvement in World War I); **Cast:** R. G. Armstrong, Jacob Bailin, Roger Baldwin, John Ballato, Warren Beatty, Ramon Bieri, Dwayne Brenna, Joseph Buloff, Harry Carlisle, Kenneth Chamberlain, Norman Chancer, Nicolas Coster, Leigh Curran, Brenda Currin, William Daniels, Andrew Dasburg, Tess Davis, Jose De Filippo, Harry Ditson, MacIntyre Dixon, Nancy Duiguid, Will Durant, Blanche Hays Fagen, Hamilton Fish, Anthony Forrest, Dorothy Frooks, Hugo Gellert, Kathryn Grody, Stefan Gryff, Gene Hackman, Jerry Hardin, Emmanuel Herbert, Edward Herrmann, Gerald Hiken, John J. Hooker, George Jessel, Diane Keaton, Jack Kehoe, Oleg Kerensky, Dave King, Jerzy Kosinski, Andreas La Casa, Isaac Don Levine, Åke Lindman, Bessie Love, Nina Macarova, Christopher Malcolm, Galina von Meck, Arthur Meyer, Henry Miller, Adele Gutman Nathan, Scott Nearing, Jack Nicholson, Jack O'Leary, Denis Pekarev, George Plimpton, Stuart Richman, Shane Rimmer, Dora Russell, George Seldes, Nikko Seppala, Art Shields, Tony Sibbald, Roger Sloman, Jessica Smith, Josef Sommer, Paul Sorvino, Adela Rogers St. Johns, Maureen Stapleton, Pat Starr, Arne Swabeck, Dolph Sweet, Bernadine Szold-Fritz, Jan Triska, Heaton Vorse, M. Emmet Walsh, Pertti Weckström, Will Weinstone, Rebecca West, Lucita Williams, Eleanor D. Wilson, Ian Wolfe, Max Wright.

Warren Beatty is a radical American journalist who meets Diane Keaton, a respectable married woman. She becomes a feminist and radical, dumps her dentist husband, and runs away with Beatty. After involvement with labor and political disputes in the United States, they go to Russia in time for the October Revolution of 1917, when the communists seize power. Inspired, they return to the United States, hoping to lead a similar revolution, fostered out of the worker's strikes of the 1920s.

INTERESTING FACTS

- The film is based on the true story of John Reed.
- The only American to be buried in the Soviet

Union as a hero of the communist people, Reed is interred next to the Kremlin wall.
- Louise Bryant (Diane Keaton) had an affair with playwright Eugene O'Neill.
- The film includes interviews with "witnesses," real-life surviving participants of the events of the movie.

QUOTE

Louise Bryant: I'd like to see you with your pants off, Mr. Reed.

AWARDS

Academy Awards, USA, 1981
 Won: *Oscar, Best Cinematography,* Vittorio Storaro; *Best Director,* Warren Beatty; *Best Supporting Actress,* Maureen Stapleton
 Nominated: *Oscar, Best Actor,* Warren Beatty; *Best Actress,* Diane Keaton; *Best Art Direction–Set Decoration,* Michael Seirton, Richard Sylbert; *Best Costume Design,* Shirley Russell; *Best Film Editing,* Dede Allen, Craig McKay; *Best Picture,* Warren Beatty; *Best Sound,* Tom Fleischman, Simon Kaye, Dick Vorisek; *Best Supporting Actor,* Jack Nicholson; *Best Writing, Screenplay Written Directly for the Screen,* Warren Beatty, Trevor Griffiths

American Cinema Editors, USA, 1982
 Nominated: *Eddie, Best Edited Feature Film,* Dede Allen, Craig McKay

Boston Society of Film Critics Awards, 1982
 Won: *BSFC Award, Best Supporting Actor,* Jack Nicholson

British Academy Awards, 1983
 Won: *BAFTA Film Award, Best Supporting Actor,* Jack Nicholson; *Best Supporting Actress,* Maureen Stapleton
 Nominated: *BAFTA Film Award, Best Actor,* Warren Beatty; *Best Actress,* Diane Keaton; *Best Cinematography,* Vittorio Storaro; *Best Costume Design,* Shirley Russell

Directors Guild of America, USA, 1982
 Won: *DGA Award, Outstanding Directorial Achievement in Motion Pictures,* Warren Beatty, Michael Green (second assistant director, plaque), Simon Relph (first assistant director, plaque)

Golden Globes, USA, 1982
 Won: *Golden Globe, Best Director—Motion Picture,* Warren Beatty
 Nominated: *Golden Globe, Best Motion Picture—Drama; Best Motion Picture Actor—Drama,* Warren Beatty; *Best Motion Picture Actor in a Supporting Role,* Jack Nicholson; *Best Motion Picture Actress—Drama,* Diane Keaton; *Best Motion Picture Actress in a Supporting Role,* Maureen Stapleton; *Best Screenplay—Motion Picture,* Warren Beatty, Trevor Griffiths

Los Angeles Film Critics Association Awards, 1981
 Won: *LAFCA Award, Best Cinematography,* Vittorio Storaro; *Best Director,* Warren Beatty; *Best Supporting Actress,* Maureen Stapleton

National Board of Review, USA, 1981
 Won: *NBR Award, Best Director,* Warren Beatty, *Best Picture—English Language,* tied with Chariots of Fire (1981); *Best Supporting Actor,* Jack Nicholson

National Society of Film Critics Awards, USA, 1982
 Won: *NSFC Award, Best Supporting Actress,* Maureen Stapleton

New York Film Critics Circle Awards, 1981
 Won: *NYFCC Award, Best Film*

Writers Guild of America, USA, 1982
 Won: *WGA Screen Award, Best Drama Written Directly for the Screen,* Warren Beatty, Trevor Griffiths.

REGENERATION

British Broadcasting Corporation, Rafford Films, The Scottish Film Production Fund, Scottish Arts Council Lottery Fund, The Glasgow Film Fund, Norstar Entertainment Inc., 1997, color, 105 minutes.

Producers: Eric Coulter, Eddie Dick, Kathy Avrich Johnson, Allan Scott, Mark Shivas, Peter R. Simpson; **Director:** Gillies MacKinnon; **Screenwriters:** Pat Barker, Allan Scott; **Music:** Mychael Danna; **Distributors:** Alliance Communications Corporation, Imperial Entertainment, Norstar Entertainment Inc.; **Cast:** Tanya Allen, Stuart Bunce, Alastair Galbraith, David Hayman, Jonny Lee Miller, John Neville, Jonathan Pryce, Dougray Scott, James Wilby, Paul Young.

World War I soldiers are sent to an asylum to recover psychologically from their shell shock. Two of the soldiers who meet in the asylum are Wilfred Owen and Siegfried Sassoon, two of England's most important World War I poets.

The movie is based on Pat Barker's book *Regeneration* (New York: Plume, 1991).

REMEMBER PEARL HARBOR

Republic, 1942, b&w, 75 minutes.

Producer: Albert J. Cohen; **Director:** Joseph Santley; **Screenwriters:** Malcolm Stuart Boylan, Isabel Dawn; **Cast:** Don Barry, Alan Curtis, Diana Del Rio, Paul Fung, Maynard Holmes, Robert Emmett Keane, Ian Keith, James B. Leong, Fay McKenzie, Sig Ruman, Sammy Stein, Rhys Williams.

Donald Barry is a troublemaker stationed in the Philippines, who was mixed up with Japanese agents. He has a change of heart after Pearl Harbor, exposes the spy ring, and crashes a plane full of explosives into one of their invasion ships.

INTERESTING FACT

- This is one of the first films to be released about Pearl Harbor.

RENDEZVOUS 24

20th Century-Fox, 1946, b&w, 70 minutes.

Producer: Sol M. Wurtzel; **Director:** James Tinling; **Screenwriter:** Aubrey Wisberg; **Music:** Emil Newman; **Cast:** Jimmy Aubrey, John Banner, Bernard Berg, Herman Bing, John Bleifer, Frederic Brunn, George M. Carleton, Kay Connors, John Dehner, Leslie Denison, Angela DeWitt, Betty Fairfax, Douglas Fowley, Arno Frey, Gil Frye, William Gargan, Jon Gilbreath, Art Gilmore, Gary Gray, Ilka Grüning, Ann Harper, Leyland Hodgson, Boyd Irwin, Eilene Janssen, Kurt Katch, Charles Knight, Paul Kruger, David Leonard, Castle McCall, Charles F. Miller, Lorraine Miller, Clifford Moore, Jack Norton, Patrick O'Moore, Maria Palmer, Otto Reichow, Bert Roach, Henry Rowland, Marin Sais, Frieda Stoll, Hans Tanzler, Ferris Taylor, Evan Thomas, Emmett Vogan, Claude Wisberg.

After World War II, Nazi scientists secretly make atomic bombs, which they plan to drop on cities.

RETREAT, HELL!

U.S. Pictures, 1952, b&w, 95 minutes.

Producer: Milton Sperling; **Director:** Joseph H. Lewis; **Screenwriter:** Milton Sperling; **Distributor:** Warner Bros.; **Cast:** Richard Carlson, Robert Ellis, Lamont Johnson, Joseph Keane, Anita Louise, Frank Lovejoy, Peter Ortiz, Dorothy Patrick, Paul Smith, Russ Tamblyn, Morton C. Thompson, Nedrick Young.

During the Korean War, a U.S. Marine battalion must fight its way out of a frozen mountain pass despite diminishing supplies, freezing temperatures, and constant attacks by hordes of Chinese soldiers.

INTERESTING FACTS

- The movie is based on the real story of the U.S. Marines, from their successful landing at Inchon during the Korean War until their advance is stopped and reversed by overwhelming Chinese reinforcements.
- The quote below was probably inspired by a famous World War I statement by Capt. Lloyd D. Williams: "Retreat, hell! We just got here."

QUOTE

Colonel: Retreat, hell! We're just attacking in a different direction.

RETURN FROM THE RIVER KWAI

Roadshow Productions, 1988, color, 97 minutes.

Producer: Kurt Unger; **Director:** Andrew V. McLaglen; **Screenwriter:** Sargon Tamimi; **Cast:** Alexander Blaise, Timothy Bottoms, Simplicio Cahilig, Michael Dante, Patricia Edmondson, Denholm Elliott, Edward Fox, Richard Graham, Jimmy Guerrero, Paul Holm, Ryusuke Inoue, Sachiko Inoue, Koji Kato, Motoko Kobayashi, Michael Kostroff, Ronnie Lazaro, Sheila McLaglen, Lolita Mirpuri, Masato Nagamori, Tatsuya Nakadai, Chris Penn, Kashinobu Shibata, Etsushi Takahashi, George Takei, Nick Tate, Andres Tepongco, Anna Maria Tirol, Masachi Tomori, Pierre Valderon.

Australian prisoners of war from the River Kwai labor camp encounter many dangers as they are shipped by rail and sea to Japan to serve as slave laborers.

The movie is based on Joan and Clay Blair Jr.'s book, *Return from the River Kwai* (New York: Simon and Schuster, 1979), a true story.

INTERESTING FACT

- This film begins where the original Oscar-winning *BRIDGE ON THE RIVER KWAI* ended, with the blowing up of the bridge.

ROAD BACK, THE

Universal Pictures, 1937, b&w, 97 minutes.

Producers: Edmund Grainger, Charles R. Rogers (executive producer), James Whale; **Director:** James Whale; **Screenwriters:** Charles Kenyon, Erich Maria Remarque (novel), R. C. Sherriff; **Music:** Dimitri Tiomkin; **Distributor:** Universal Pictures; **Cast:** Lionel Atwill, Reginald Barlow, Noah Beery Jr., William Benedict, Larry J. Blake, Clara Blandick, Spring Byington, E. E. Clive, Laura Hope Crews, Richard Cromwell, William B. Davidson, Andy Devine, John Emery, Louise Fazenda, Bess Flowers, Francis Ford, Dwight Frye, Eugene Gericke, Etienne Girardot, Dorothy Granger, Greta Gynt, Charles Halton, Samuel S. Hinds, Arthur Hohl, Henry Hunter, John Dusty King, Edwin Maxwell, Maurice Murphy, Tempe Pigott, Barbara Read, Frank Reicher, Jean Rouverol, Tiny Sandford, Al Shean, Edward Van Sloan, Slim Summerville, Robert Warwick.

Veterans of World War I return to Germany to find revolution and hunger riots; they discover that they are ill suited for civilian life.

INTERESTING FACTS

- Fearful that this film would not do well overseas, a new regime at Universal Pictures severely edited the film before release, removing much of the strongly anti-Nazi slant that author Erich Maria Remarque included in the original novel, and which director James Whale intended to retain in the film version.
- Bowing to Nazi pressure, and "to cultivate the good will of Germany," Universal boss Charles R. Rogers took James Whale off the picture and ordered 21 cuts made to the film.
- The movie is based on Erich Maria Remarque's novel *The Road Back* (Boston: Little, Brown, and Company, 1931) which was intended as a sequel to his book *All Quiet on the Western Front.*

QUOTE

German soldier: You cannot take human beings and train them to be inhuman for four years and expect them to be a fit companion for normal men and women.

ROAD TO GLORY, THE

20th Century-Fox, 1936, b&w, 103 minutes.

Producers: Nunnally Johnson (associate producer), Darryl F. Zanuck; **Director:** Howard Hawks; **Screenwriters:** Stephen Morehouse Avery, Violet Kemble Cooper, William Faulkner, Walter Ferris, Howard Hawks, Nunnally Johnson, Joel Sayre, Darryl F. Zanuck; **Cast:** Lionel Barrymore, Warner Baxter, John Bleifer, Barlowe Borland, Theodore von Eltz, Paul Fix, Eddie Foster, Victor Kilian, Leonid Kinskey, June Lang, Jacques Lory, Fredric March, Louis Mercier, Anne O'Neal, John Qualen, Gregory Ratoff, Edythe Raynore, Hector Sarno, Paul Stanton, Julius Tannen, Jacques Vanaire, George Warrington, Pat West.

Warner Baxter is a French captain in the trenches of World War I, who tries to pull his father (Lionel Barrymore), a soldier under his command, from the front line. However, the stubborn and patriotic old man refuses to leave his position. Baxter vies with his lieutenant, Fredric March, for the love of a beautiful nurse, June Lang. As more and more of his men are killed, and new replacements arrive, Baxter becomes more and more remorseful.

In a poignant scene, mournful wails and moans echo from an injured soldier stuck on barbed wire 100 feet from the trench with dead would-be rescuers strewn about him. The enemy sniper purposely lets him live to tempt his fellow soldiers to a rescue. Finally, to stop his men from further rescue attempts, Warner Baxter shoots his own man.

In the meantime, soldiers in a bunker hear the enemy digging below them and realize they are placing explosives to blow up the trench. At the last minute, they are ordered to evacuate the trench, right before it blows up.

INTERESTING FACTS

- The incident of undermining the trenches, packing it with explosives and blowing it up, was actually based on a real event during World War I. Italian troops were ordered to remain in their trenches, even though they could hear the digging, and they were ultimately blown up.
- This is one of the last films that Lionel Barrymore made without a wheelchair.

ROAR OF THE DRAGON

RKO Radio Pictures Inc., 1932, b&w, 68 minutes.

Producer: David O. Selznick (executive producer); **Director:** Wesley Ruggles; **Screenwriters:** Howard Estabrook, George Kibbe Turner (novel, *A Passage to Hong Kong*); **Music:** Max Steiner; **Cast:** Gwili Andre,

Dudley Digges, Richard Dix, Willie Fung, C. Henry Gordon, Edward Everett Horton, Arline Judge, Michael Mark, Toshia Mori, William H. Orlamond, ZaSu Pitts, Will Stanton, Arthur Stone, James Wang.

When their Chinese riverboat is damaged on a trip through Manchuria, a boatload of Westerners take refuge in a fortified inn. With a lone machine gun, they hold off hordes of bandits until they can repair their paddle wheel and make their escape.

The movie is based on George Kibbe Turner's book *A Passage to Hong Kong* (no publication data is available).

ROGUE'S REGIMENT

Universal-International Pictures, 1948, b&w, 86 minutes.

Producer: Robert Buckner; **Director:** Robert Florey; **Screenwriters:** Robert Buckner and Robert Florey (story); **Music:** Daniele Amfitheatrof, Jack Brooks, Serge Walter; **Distributor:** Universal Pictures; **Cast:** Philip Ahn, Edgar Barrier, Eugene Borden, Paul Bryar, Kei Thin Chung, Gordon Clark, Frank Conroy, Paul Coze, Dennis Dengate, John Doucette, Charles J. Flynn, Richard Fraser, Martin Garralaga, Richard Loo, Maurice Marsac, Stephen McNally, Harro Meller, James Millican, Jerry Mills, James Nolan, Ken Nordenshield, John Peters, Albert Pollet, Dick Powell, Vincent Price, Otto Reichow, Henry Rowland, John Royce, Leo Schlesinger, Lester Sharpe, Carol Thurston, Märta Torén, Robert Verdaine, Kenny Washington, Willy Wickerhauser, Artarne Wong, Victor Sen Yung.

Dick Powell plays an American Army officer on the trail of Stephen McNally, a Nazi war criminal who escaped justice at the Nuremberg trials. He tracks the former SS officer to the French Foreign Legion, at that time fighting the Vietnamese insurrectionists in Indochina, and brings him to justice.

The background of the film THE QUIET AMERICAN is the French Indochina War.

QUOTES

Whit Corbett: Ah, you're much too smart for a beautiful girl. Don't you have any fun at all?
Lili Maubert: Perhaps. In a quiet way.
Whit Corbett: I can be very quiet.
Lili Maubert: Good [she hands him his hat]. Then you won't make any noise on the way out.

Narrator [as Martin Brunner goes to his death]: The last steps of Martin Bruner upon that scaffold are a warning to the world that such men must not march again.

ROMANCE IN FLANDERS, A

London Film Productions, 1937, b&w, 62 minutes.

Producer: Friedrich Deutschmeister; **Director:** Maurice Elvey; **Screenwriters:** Mario Fort, Harold Simpson, Ralph Vanio; **Cast:** Frank Atkinson, Paul Cavanagh, Marcelle Chantal, Bobbie Comber, Arthur Hambling, Olga Lindo, Andreas Malandrinos, Garry Marsh, Muriel Pavlow, Kynaston Reeves, Evelyn Roberts, Alastair Sim, Denise Sydney, C. Denier Warren, Kathleen Weston.

During World War I, two sergeants, Paul Cavanagh and Garry Marsh, compete for the affections of the fetching mademoiselle Marcelle Chantal. She wants Cavanagh, but when he's reported missing and presumed dead, she marries Marsh. Years later, during a British army reunion, she sees a man who is the living image of the beloved she thought was dead. Not wishing to come between her and her husband, the man feigns amnesia, but this doesn't weaken her resolve to leave her husband and run off with her lost love.

The movie is based on Mario Fort's and Ralph E. Vanloc's *The Widow's Island* (no publication date is available). The movie is also known as *Lost on the Western Front* (Great Britain).

ROOKIES IN BURMA

RKO Radio Pictures Inc., 1943, b&w, 62 minutes.

Producer: Bert Gilroy; **Director:** Leslie Goodwins; **Screenwriter:** Edward James; **Cast:** Joan Barclay, Wally Brown, Claire Carleton, Alan Carney, Erford Gage, Ted Hecht.

Wally Brown and Alan Carney play two incompetent soldiers fighting in Burma and captured by the Japanese. They escape from the prison camp, come upon two pretty USO entertainers wandering in the jungle, whom they bring along, and finally make it back to their own lines in a captured Japanese tank.

ROSIE THE RIVETER

Republic Pictures Corporation, 1944, b&w, 75 minutes.

Producer: Armand Schaefer; **Director:** Joseph Santley; **Screenwriters:** Aleen Leslie, Jack Townley; **Cast:**

Frank Albertson, Barbara Jo Allen, Roy Barcroft, Lloyd Corrigan, Maude Eburne, Louise Erickson, Frank Fenton, Jane Frazee, Frank Jenks, Tom Kennedy, Arthur Loft, Ellen Lowe, Carl Switzer.

Two men and two women, who are on different shifts at a war plant, decide to share the same room in a boarding house to save on expenses. Amid the comic misadventures that this situation produces, the two couples fall in love.

INTERESTING FACT

- During World War II, the U.S. government had a vested interest in encouraging women to leave their homes and work in the war factories, because the men were needed for service in the armed forces. The term "Rosie the Riveter" came to designate these women; in addition, the term became the title of a popular song. While women in the workplace made enormous gains during the war, with peace they were relegated back to the home for almost two decades, until the women's movement once again made the concept of women working outside the home popular.

RUN SILENT, RUN DEEP

Hecht-Hill-Lancaster, 1958, b&w, 93 minutes.

Producers: Harold Hecht, William Schorr; **Director:** Robert Wise; **Screenwriters:** Edward L. Beach, John Gay; **Music:** Franz Waxman; **Distributor:** United Artists; **Filmed in:** Imperial County, California; **Cast:** Rudy Bond, Nick Cravat, Wayne Dahmer, Brad Dexter, Clark Gable, Eddie Foy III, Mary LaRoche, Burt Lancaster, Ken Lynch, Joe Maross, Don Rickles, Skip Ward, Jack Warden, H. M. Wynant.

During World War II, Clark Gable's submarine is sunk by a Japanese kamikaze destroyer in the treacherous

Run Silent, Run Deep (UNITED ARTISTS/AUTHOR'S COLLECTION)

Bongo Straits, and he is given a new command, the USS *Nerka*. He finds the sailors of his new submarine less than welcoming; the crew expected that the popular executive officer, Burt Lancaster, would be given the command. Obsessed by vengeance on the Japanese destroyer that killed his crew, Gable relentlessly drills his men, and it pays off when they attack a convoy in the Bongo Straits. When they finally locate the enemy destroyer, Gable is injured in the first attack, and Lancaster must take command and finish the job of sinking the ship. Gable dies, knowing that he has avenged those who died serving under him.

The film is based on Edward L. Beach's book *Run Silent, Run Deep* (New York: Holt, 1955).

INTERESTING FACTS

- The underwater shots were done with miniatures in the Salton Sea, in southern California.
- The author of the novel the film was based on, Capt. Edward L. Beach, was hired as a technical adviser.
- Captain Beach was the commander of the USS *Triton* during its historic underwater circumnavigation of Earth.
- Clark Gable's obsession with the destroyer that killed his crew evokes *Moby Dick*, a book by Herman Melville.

SABOTAGE AT SEA

British National Films, Shaftesbury Films, 1942, b&w, 61 minutes.

Producer: Elizabeth Hiscott; **Director:** Leslie S. Hiscott; **Screenwriter:** Michael Barringer; **Distributor:** Anglo-American Pictures; **Cast:** Felix Aylmer, Jane Carr, Ian Fleming, William Hartnell, Martita Hunt, David Hutcheson, Arthur Maude, Wally Patch, Hay Petrie, Margaretta Scott, Ronald Shiner, Ralph Truman.

During World War II, a cargo ship captain conducts a desperate search of his vessel for a saboteur.

SABRE JET

Carl Krueger Productions, 1953, color, 90 minutes.

Producer: Carl Krueger; **Director:** Louis King; **Screenwriters:** Katherine Albert, Dale Eunson, Carl Krueger (story); **Music:** Herschel Burke Gilbert; **Distributor:** United Artists; **Cast:** Leon Ames, Richard Arlen, Julie Bishop, Amanda Blake, Kathleen Crowley, Coleen Gray, Tom Irish, Frank Kamagi, Lucy Knoch, Ray Montgomery, Michael Moore, Jerry Paris, Johnny Sands, Jan Shepard, Reed Sherman, Robert Stack.

Robert Stack is a brooding Sabre Jet pilot, flying combat missions from a base in Japan. He prefers that his wife, Coleen Gray, abandon her career as a journalist and stay at home.

The F-86 Sabre Jet was an operational jet aircraft used by the United States during the Korean War. Although the Germans had deployed operational jet aircraft during World War II, this was the first conflict in which the United States used combat jet aircraft.

INTERESTING FACTS

- This film was made years before the modern feminist movement. In the 1950s, most men and women believed that a woman's place was in the home, and "career women" were the exception, not the norm.
- American aircraft were painted to look like Russian-built MIGs.

SAFECRACKER, THE

Coronado Productions, 1958, b&w, 96 minutes.

Producer: John R. Sloan; **Director:** Ray Milland; **Screenwriters:** Rhys Davies, Paul Monash, Bruce Thomas; **Distributor:** Metro-Goldwyn-Mayer; **Cast:** Arnold Bell, Gerald Case, Ernest Clark, Jackie Collins, Carl Conway, Basil Dignam, Eddie Eddon, Barbara Everest, Hilda Fenemore, Bernard Foreman, Bernard Fox, Wolf Frees, Colin Gordon, Percy Herbert, David Horne, Barry Jones, Barry Keegan, Sam Kydd, David

Lodge, Ian MacNaughton, Victor Maddern, Richard Marner, Ferdy Mayne, Ray Milland, Clive Morton, Anthony Nicholls, Charles Lloyd Pack, Cyril Raymond, John Robinson, Richard Shaw, Jeanette Sterke, Pamela Stirling, Melissa Stribling, Colin Tapley, Henri Vidon, Ernst Walder, John Welsh.

Ray Milland plays a safecracker who is released from prison in England by British Intelligence. He is given the task of infiltrating a château in Belgium and stealing a secret list of Nazi spies.

INTERESTING FACT

• Ray Milland both directed and starred in this film.

SAHARA

Columbia Pictures Corporation, 1943, b&w, 97 minutes.

Producer: Harry Joe Brown; **Director:** Zoltan Korda; **Screenwriters:** Sidney Buchman, Zoltan Korda, John Howard Lawson, James O'Hanlon; **Music:** Miklós Rózsa; **Filmed in:** Yuma, Arizona, and southern California desert; **Cast:** Bruce Bennett, Humphrey Bogart, Lloyd Bridges, Dan Duryea, Carl Harbord, Rex Ingram, Guy Kingsford, Kurt Kreuger, Peter Lawford, Louis Mercier, J. Carrol Naish, Richard Nugent, Patrick O'Moore, Henry Rowland, Hans Schumm, John Wengraf.

Sgt. Joe Gunn (Humphrey Bogart) and his American tank crew pick up six British soldiers, a South African, a Frenchman, and a Sudanese corporal with an Italian prisoner as they cross the Libyan Desert to rejoin their command after the fall of Tobruk. Their goal is to avoid the Germans and somehow find the Allied lines. As they travel through the desert, they find an oasis with a well. When they learn that a German battalion, desperate for water, is marching toward the ruin, they decide to stand and fight, nine men against 500. They dig in and are able to stop wave after wave of attacks, but at a terrible price: By the time they are relieved, only three of the defenders are left alive. At the end of the film, Bogart learns of the victory at El Alamein and looks at the graves of the men who died fighting at the water hole, knowing that if they hadn't stopped this German battalion, it might have played a critical part in that battle.

The ad hoc tank crew, made up of American, British, Sudanese, French, and South African soldiers (even the Italian soldier changes sides and joins the tankers, presaging Italy's later switch), stand for the worldwide alliance put together to defeat the Axis powers. This alliance is eerily similar to the consortium put together to defeat Iraq in the Gulf War.

In a dramatic scene, Bogart has offered the Germans a deal: water for guns. In the climax of the movie, the German soldiers, insane with thirst, stampede forward, their guns held over their heads, yelling "*Wasser, Wasser!*" Bogart is worried, because the well is dry, and he can't pay off on the deal, but it turns out that a shell has exploded in the well, and it's flowing again. Then they're able to take the German battalion (what's left of them) prisoner.

Those interested in the background of this desert campaign should know that no American tanks fought with the British at this point in the war. This film takes place in late June 1942, after the fall of Tobruk and before the battle of El Alamein, which occurred in July. However, the Americans did not arrive in North Africa until November 1942, with Operation Torch, the armor landing in Morocco under General Patton. Early in 1941, British forces had pushed the Italians back into Libya, and in February Hitler sent Gen. Erwin Rommel with a two-division tank corps, the Afrika Korps, to help his Italian ally. Rommel launched a successful counteroffensive against the British in Libya, expelling them from the country (except for the isolated garrison at Tobruk) by April 1941, and in June 1942, Tobruk fell. The Germans drove the British right back to El Alamein, but they were defeated by Montgomery's Eighth Army.

QUOTES

Bogart [looking at the graves of his fallen comrades]: Yeah, they'd want to know . . . we stopped them at El Alamein.

Bogart: Why? Why? Why did your people go about their business while the Germans were throwing everything they had at them? Why did the Russians make a stand at Moscow? Why Bataan? Why Corregidor? Maybe they were all nuts. There's only one thing they did do. They delayed the enemy and kept delaying them until we got strong enough to hit him harder than he was hitting us.

AWARDS

Academy Awards, USA, 1943
 Nominated: *Oscar, Best Cinematography, Black-and-White;* Rudolph Maté, *Best Sound Recording,* John P. Livadary (Columbia SSD); *Best Supporting Actor,* J. Carrol Naish.

SAILORS THREE

Ealing Studios, 1940, b&w, 86 minutes.

Producers: Michael Balcon, Culley Forde; **Director:** Walter Forde; **Screenwriters:** John Dighton, Angus MacPhail, Austin Melford; **Distributor:** Associated British Film Distributors; **Cast:** Eric Clavering, Alec Clunes, Jeanne De Casalis, Derek Elphinstone, E. V. H. Emmett, Victor Fairley, Brian Fitzpatrick, John Glyn-Jones, Danny Green, James Hayter, Henry Hewitt, Claude Hulbert, Allan Jeayes, John Laurie, Carla Lehmann, Robert Rendel, Tommy Trinder, Julian Vedey, Harold Warrender, Hans Wengraf, Manning Whiley, Michael Wilding.

During World War II, when three British sailors discover they have accidentally boarded a Nazi ship, they decide to take it over and deliver it to the Royal Navy.

SALUTE JOHN CITIZEN

British National, 1942, b&w, 96 minutes.

Producer: Wallace Orton; **Director:** Maurice Elvey; **Screenwriters:** Elizabeth Baron, Clemence Dane; **Distributor:** Anglo-American; **Cast:** Mabel Constanduros, Peggy Cummins, Charles Deane, Jonathan Field, Henry Hallett, Jimmy Hanley, Stanley Holloway, David Keir, Eric Micklewood, Edward Rigby, George Robey, Stewart Rome, Dinah Sheridan, Christine Silver.

Edward Rigby is an out-of-work clerk who is rehired during the manpower shortage of World War II. His son (Jimmy Hanley) is determined to stay out of the line of fire, but his outlook changes after he witnesses the horrors of the London Blitz. This movie can be compared with MRS. MINIVER, another portrayal of proud British civilians coping with the ravages of World War II.

This movie is based on a series of novels by Robert Greenwood.

SALUTE TO THE MARINES

Metro-Goldwyn-Mayer, 1943, color, 101 minutes.

Producer: John W. Considine Jr.; **Director:** S. Sylvan Simon; **Screenwriters:** Robert Hardy Andrews, George Bruce, Wells Root; **Music:** Lennie Hayton; **Cast:** Fay Bainter, Noah Beery, Wallace Beery, Robert Blake, Ray Collins, Dick Curtis, Donald Curtis, Mark Daniels, Jim Davis, Frank Ferguson, Mary Field, Russell Gleason, Harry Hayden, Myron Healey, Rose Hobart, Fritz Leiber, Keye Luke, William Lundigan, Marilyn Maxwell, Reginald Owen, Dewey Robinson, Arthur Space, Leonard Strong, Don Taylor, Charles Trowbridge.

Wallace Beery plays a 30-year veteran of the U.S. Marine Corps whose wife has forced him to retire to the Philippines. He is totally bored by his humdrum existence, until the Japanese invade their island paradise. Using his Marine Corps skills, he successfully organizes the local resistance, and they repulse the invaders, but at the cost of his own life.

SALVADOR

Hemdale Film Corporation, 1986, color, 123 minutes.

Producers: Brad H. Aronson (associate producer), John Daly (executive producer), Derek Gibson (executive producer), Gerald Green, Bob Morones (associate producer), Oliver Stone; **Director:** Oliver Stone; **Screenwriters:** Oliver Stone, Rick Boyle (as Richard Boyle); **Music:** Georges Delerue; **Filmed in:** Alameda County and San Francisco, California, Nevada, Guerrero, Morelos, Tlayacapan, and Mexico City, Mexico. Mexico; **Cast:** María de los Ángeles Urquiza, Mário Arévalo, James Belushi, Augustin Bernal, Arturo Bonilla, Erica Carlson, Queta Carrasco, Elpidia Carrillo, Jimmy Carter, Colby Chester, José Chávez, Julie Conn, Nancy Davis, Jair De Rubin, Waldeir DeSouza, John Doe, Arturo Rodríguez Doring, Miguel Ehrenberg, Humberto Elizondo, Gary Farr, Juan Fernández, Martín Fuentes, Joshua Gallegos, Cynthia Gibb, Kara Glover, Sigridur Gudmunds, Danna Hansen, Claudia Hernández, Bill Hoag, Nicolás Jasso, Tyrone Jones, Tomás Leal, Israel León, Jorge Luke, John MacDevitt, Will MacMillan, Mauricio Martínez, Sue Ann McKean, Ramón Menéndez, Gilles Millinaire, Bob Morones, Michael Murphy, Daria Okugawa, René Pereyra, Tony Plana, Jorge Pol, Gerardo Quiroz, Ronald Reagan, Jorge Reynoso, Xochitl del Rosario, María Rubell, Bruno Rubeo, José Carlos Ruiz, John Savage, César Sobrevals, Roberto Sosa Jr., Sean Stone, María del Carmen Sánchez, Salvador Sánchez, Héctor Téllez, Juliana Urquisa, Leticia Valenzuela, Ángel Vargas, Valerie Wildman, James Woods, Gerardo Zepeda, Rosario Zúñiga.

James Woods is a down-on-his-luck journalist who has run out of friends from whom to borrow money, so he drives down to El Salvador to get a story on the civil

war raging in the country. He forms an uneasy alliance with both the guerrillas in the countryside, who want him to take his pictures of atrocities to the world press, and the right-wing military, who want him to take photographs of the rebels. After witnessing government planes bomb and strafe a village and the guerrillas execute their prisoners, he realizes that he is caught in the middle of a bloodbath in which neither side is deserving of the sympathy of the world.

QUOTE

James Woods [speaking of the El Salvador president]: You'll run with him because he's anti-Moscow. You'll let them close down the universities . . . you let them wipe out the best minds in the country . . . you let them wipe out the Catholic Church, and you let them do it all because they aren't communists.

AWARDS

Academy Awards, USA, 1986
 Nominated: *Oscar, Best Actor*, James Woods; *Best Writing, Screenplay Written Directly for the Screen*, Rick Boyle (as Richard Boyle), Oliver Stone

Independent Spirit Awards, 1987
 Won: *Independent Spirit Award, Best Male Lead*, James Woods
 Nominated: *Independent Spirit Award, Best Cinematography*, Robert Richardson; *Best Director*, Oliver Stone; *Best Feature*, Gerald Green, Oliver Stone; *Best Female Lead*, Elpidia Carrillo; *Best Screenplay*, Rick Boyle, Oliver Stone

Writers Guild of America, USA, 1987
 Nominated: *WGA Screen Award, Best Screenplay Written Directly for the Screen*, Rick Boyle, Oliver Stone.

SAND PEBBLES, THE

Solar Productions, 1966, color, 179 minutes.

Producers: Charles H. Maguire, Robert Wise; **Director:** Robert Wise; **Screenwriters:** Robert Anderson, Richard McKenna; **Distributor:** 20th Century-Fox Film Corporation; **Filmed in:** Malibu Creek State Park, California (war zone), Taiwan, Hong Kong; **Cast:** Emmanuelle Arsan, Richard Attenborough, Candice Bergen, Paul Chinpae, Richard Crenna, Joe Di Reda, Stephen Ferry, Ted Fish, Larry Gates, James Hong, Alan Hopkins, Stephen Jahn, Loren Janes, James Jeter, Tommy Lee, Richard Loo, Gavin MacLeod, Mako, Steve McQueen, Tom Middleton, Simon Oakland, Gil Perkins, Barney Phillips, Beulah Quo, Ford Rainey, Walter Reed, Charles Robinson, Shepherd Sanders, Gus Trikonis, Joe Turkel, Henry Wang, Glenn R. Wilder, Ben Wright.

Petty Officer Jake Holman (Steve McQueen) is assigned to the gunboat USS *San Pablo*, patrolling a tributary of Yangtze River in the middle of exploited and revolution-torn China in the year 1926. His iconoclasm and cynical nature soon clash with the rice bowl system that runs the ship and the uneasy symbiosis between Chinese and foreigner on the river. Hostility toward the gunboat's presence reaches a climax when the boat must crash through a river boom and rescue missionaries upriver at China Light Mission.

The film is based on *The Sand Pebbles* (New York: Harper & Row, 1962) which was based on author Richard McKenna's personal experiences while serving as a "China sailor."

Background information enhances enjoyment of the film: The Yangtze River Patrol of the U.S. Navy existed under various names between 1854 and 1941. This squadron-sized unit of the Asiatic Fleet patrolled the waters of the Yangtze River as far inland as Chungking, more than 1,300 miles from the sea. The patrol was necessary to protect U.S. citizens and their interests against pirates and warlords who attacked commercial ships on the river. In 1913 the first American gunboats were built specifically for service on the Yangtze River, the USS *Palos* and the USS *Monocacy*. Naval reaction to hostilities along the river peaked in the 1920s and 1930s. In the early 1920s the patrol found itself fighting the forces of deadly warlords and ruthless bandits; in the late 1920s, Chiang Kai-Shek and the Northern Expedition created a volatile military situation for the patrol along the Yangtze.

INTERESTING FACTS

- The movie rights to the book were originally sold for $300,000 to United Artists.
- *The Sand Pebbles* was one of 20th Century-Fox's first Panavision films. This signaled the end of an era as Fox transitioned from using its anamorphic CinemaScope lens.
- Principal filming on *The Sand Pebbles* began on November 22, 1965, and was completed in May 1966. Due to many unforeseen problems, the film took an additional three months to complete and ran $3 million over budget. In spite of this, director Robert Wise delivered the final movie on time.

The Sand Pebbles (20TH CENTURY-FOX/AUTHOR'S COLLECTION)

- The film company endured an earthquake, several storms, and a hotel fire. In addition, they were "interested and disturbed bystanders" during a three-day riot.
- Director/producer Robert Wise has been quoted as saying that *The Sand Pebbles* was the most difficult picture he ever worked on.
- Steve McQueen was paid $650,000 to star in *The Sand Pebbles*.
- The *San Pablo* was constructed for $250,000 (making it the costliest prop ever built for a motion picture at the time).
- Upon completion of *The Sand Pebbles*, the *San Pablo* was temporarily saved from the scrap heap—the fate of all gunboats—by an American construction firm that had a contract to rebuild bridges in Vietnam.
- The movie premiered on December 20, 1966, at the Rivoli in New York City.
- The original (road show) running time was approximately 196 minutes. The current running time on both videotape and laserdisc is 182 minutes; 20th Century Fox does not know the whereabouts of the missing 14 minutes of film.
- For his role in this film, Steve McQueen won his first and only Oscar nomination for best actor.
- Composer Alex North was originally slated to do the music for *The Sand Pebbles*.
- The role of Jake Holman was originally offered to Paul Newman, who declined.
- Candice Bergen was 19 years old when shooting on *The Sand Pebbles* began.

- Hong Kong action superstar Jackie Chan was trained by American stuntmen for the "Battle at the Boom" sequence.
- The theme from *The Sand Pebbles* (*And We Were Lovers*) was recorded by 22 different artists.
- Based on the real life USS *Villalobos*.

MILITARY SERVICE

- Steve McQueen enlisted in the U.S. Marine Corps on April 28, 1947, and trained as an auto mechanic and tank driver. He was repeatedly promoted and demoted due to numerous incidents of drunkenness and AWOL. He spent six weeks in the brig. He once stated that the only way he'd make corporal in the corps would be if all the Pfcs. died at the same time. However, when in Labrador, he rescued five marines when their Amtrac (amphibious tracked vehicle) overturned in freezing water.

QUOTES

Jake Holman [as he dies]: What happened? I was home. What the hell happened?

Richard Crenna: The *San Pablo* will die clean.

AWARDS

Academy Awards, USA, 1966
Nominated: *Oscar, Best Actor,* Steve McQueen; *Best Art Direction–Set Decoration, Color,* William Kiernan, Boris Leven, Walter M. Scott, John Sturtevant; *Best Cinematography, Color,* Joseph MacDonald; *Best Film Editing,* William Reynolds; *Best Music, Original Score,* Jerry Goldsmith; *Best Picture,* Robert Wise; *Best Sound,* James Corcoran (20th Century-Fox SSD); *Best Supporting Actor,* Mako

American Cinema Editors, USA, 1967
Nominated: *Eddie, Best Edited Feature Film,* William Reynolds

Golden Globes, USA, 1967
Won: *Golden Globe, Best Supporting Actor,* Richard Attenborough
Nominated: *Golden Globe, Best Motion Picture—Drama; Best Motion Picture Actor—Drama,* Steve McQueen; *Best Motion Picture Director,* Robert Wise; *Best Original Score,* Jerry Goldsmith; *Best Screenplay,* Robert Anderson; *Best Supporting Actor,* Mako; *Most Promising Newcomer—Female,* Candice Bergen (HFPA records do not specify a film)

Writers Guild of America, USA, 1967
Nominated: *WGA Screen Award, Best Written American Drama,* Robert Anderson.

SANDS OF IWO JIMA

Republic Pictures Corporation, 1949, b&w, 100 minutes.

Producers: Edmund Grainger, Herbert J. Yates; **Director:** Allan Dwan; **Screenwriters:** Harry Brown, James Edward Grant; **Music:** Victor Young; **Distributor:** Republic Pictures; **Filmed at:** U.S. Marine Corps Base, Camp Pendleton, California; **Cast:** John Agar, Hal Baylor, Julie Bishop, John H. Bradley, James Brown, Wally Cassell, David Clarke, Peter Coe, Lt. Col H. P. Crowe, Bruce Edwards, Dorothy Ford, Arthur Franz, Rene A. Gagnon, Leonard Gumley, Don Haggerty, Ira H. Hayes, Gil Herman, James Holden, Richard Jaeckel, I. Stanford Jolley, Dickie Jones, Adele Mara, John McGuire, Martin Milner, William Murphy, William Self, David M. Shoup, Captain Harold Shrier, Forrest Tucker, George Tyne, John Wayne, Richard Webb, Dick Wessel, John Whitney.

Marine sergeant John Stryker (John Wayne) trains young marines for combat in the Pacific during World War II. After his wife takes their son and leaves him, Stryker becomes embittered and takes out his misery on the men under his command. Even his old friends start to wonder if he's gone from being the epitome of the tough marine drill instructor to a man over the edge. The green recruits have a hard time dealing with Stryker's tough drills and thicker skin. However, in the end, as survival in the bloody battle of Iwo Jima depends on the lessons Stryker has drilled into them, his troops discover why he was so hard on them.

General Kuribayashi, the Japanese commander of Iwo Jima, had his men cut 1500 bunkers into the rock, connected with 16 miles of tunnels. His orders were to have "no Japanese survivors"; each soldier was to kill 10 Americans before they themselves were killed. General Kuribayashi had been told "if America's casualties are high enough, Washington will think twice before launching an invasion against Japanese territory." Iwo Jima was Japanese home soil, only 650 miles from Tokyo, administered by the Tokyo metropolitan government. To the United States, Iwo Jima's importance lay in its three airfields, ideally located as a fighter escort station for the B-29s that were now bombing Japan, and also as a sanctuary for crippled bombers returning from Japan. The United States sent more marines to Iwo Jima than to any other battle: 110,000 marines in 880 ships. It was the largest armada invasion up to that time in the

Pacific war. Once ashore, the marines were bedeviled by the loose volcanic ash. Unable to dig foxholes, they were sitting ducks for the hidden Japanese gunners. Mt. Suribachi, the 550-foot volcanic cone at the island's southern tip, dominated both possible landing beaches. From here, Japanese gunners zeroed in on every inch of the beaches with machine guns. Rockets, antiboat, and antitank guns also rained down on the beaches. The marines on Iwo Jima rarely saw a Japanese soldier. Historians described the attack by U.S. forces against the Japanese defense as "throwing human flesh against reinforced concrete." The battle was won by the inch-by-inch tenacity of the foot soldier. Liquid gas, napalm, and hand grenades were more useful against the underground Japanese than rifles. More marines earned the Medal of Honor on Iwo Jima than in any other battle in U.S. history. There were 25,851 U.S. casualties (one in three were killed or wounded). Virtually all 22,000 Japanese died. The marines' effort provided a vital link in the U.S. chain of bomber bases. By war's end, 2,400 B-29 bombers carrying 27,000 crewmen had made emergency landings on Iwo Jima.

INTERESTING FACT

- The three survivors of the famous flag raising on Mt. Suribachi appear as themselves in the film, but they were conned into doing it. Republic Pictures approached the U.S. Marine Corps asking it to get the participation of the three vets. The marines knew that Ira Hayes was suffering from post-traumatic stress and alcoholism, and seemed to alternate between relishing his war experience and despising it. John H. Bradley tried his best to forget everything about his experience on Iwo Jima, where his best buddy was captured and tortured to death by the Japanese. The marines went to each man and said that the other two had agreed to do it. Marine camaraderie won out, because none of the men wanted to let the others down. The three reunited and put in their few days on the set.

MILITARY SERVICE

- John Wayne, the actor probably most identified with the history of the American military, with films that range from the Civil War to Vietnam, never served in the armed forces.

QUOTES

John Wayne [just before he is killed by a sniper]: I feel a lot better, too. Matter of fact, I never felt so good in my life. How about a cigarette?

John Wayne [after Forrest Tucker has let his two friends get killed while he went for coffee]: A lot of guys makes mistakes, I guess, but every one we make, a whole stack of chips goes with it. We make a mistake, and some guy don't walk away—forevermore, he don't walk away.

AWARDS

Academy Awards, USA, 1949
 Nominated: *Oscar, Best Actor,* John Wayne; *Best Film Editing,* Richard L. Van Enger; *Best Sound, Recording; Best Writing, Motion Picture Story,* Harry Brown

Photoplay Awards, 1949
 Won: *Most Popular Male Star*—John Wayne.

SAVING PRIVATE RYAN

Mutual Film Company, Mark Gordon Productions, DreamWorks SKG, Amblin Entertainment, Paramount Pictures, 1998, color, 170 minutes.

Producers: Ian Bryce, Bonnie Curtis, Kevin De La Noy, Mark Gordon, Mark Huffam, Gary Levinsohn, Allison Lyon Segan, Steven Spielberg; **Director:** Steven Spielberg; **Screenwriters:** Frank Darabont, Robert Rodat; **Music:** John Williams; **Distributor:** Paramount Pictures; **Filmed in:** Thames Park (storming the machine-gun nest, all the shots of large fields, and the half-track ambush), London, Hatfield (British former aerospace factory), England, Normandy, France, County Wexford, (Omaha Beach), Curracloe Beach (Omaha Beach), Ballinesker, County Wexford, Ireland; **Cast:** Loclann Aiken, John Barnett, Martin Beaton, Amanda Boxer, Nick Brooks, Dylan Bruno, Maclean Burke, Victor Burke, Edward Burns, Kathleen Byron, Linda Carol, Marc Cass, Daniel Cerqueira, Valerie Colgan, Aiden Condron, Stephane Cornicard, Bryan Cranston, Matt Damon, Ted Danson, Jeremy Davies, Vin Diesel, Dale Dye, Sam Ellis, Michelle Evans, Dennis Farina, Nathan Fillion, Neil Finnighan, Rob Freeman, Paschal Friel, Paul Garcia, Paul Giamatti, Thomas Gizbert, Adam Goldberg, Demetri Goritsas, Steve Griffin, Stephen Grothgar, Dorothy Grumbar, Shane Hagan, Tom Hanks, Crofton Hardester, Paul Hickey, Martin Hub, Ryan Hurst, James Innes-Smith, Corey Johnson, Shane Johnson, Tilo Keiner, Ronald Longridge, Eric Loren, Laird Mackintosh, Anna Maguire, Michael Mantas, William Marsh, Max Martini, Brian Maynard, Martin McDougall, Seamus McQuade, Peter Miles, Markus Napier, Leland Orser, Barry Pepper,

Mark Phillips, Ian Porter, Harve Presnell, Erich Redman, Giovanni Ribisi, Lee Rosen, Rolf Saxon, Andrew Scott, Sam Scudder, Gary Sefton, John Sharian, Matthew Sharp, Adam Shaw, Tom Sizemore, James Smith-Innes, Julian Spencer, Joerg Stadler, Raph Taylor, David Vegh, Vincent Walsh, John Walters, Nigel Whitmey, David Wohl, Grahame Wood, Glenn Wrage, Harrison Young.

On D day, Private James Ryan's (Matt Damon) three brothers are killed. The army doesn't want the publicity of the fourth and last brother dying in action, so a mission, commanded by Tom Hanks, is sent to find Private Ryan and get him out of harm's way. The problem is, they don't know where he is, and once they do find him, he doesn't want to leave his comrades. Hanks and his patrol must help Private Ryan and his unit defend a critical bridge in their sector from an expected German advance before he will agree to return with them to the safety of the rear area.

The film is based on the true story of the Niland brothers. One was killed on D day while in the 82nd Airborne, one was killed on Utah Beach with the Fourth Infantry Division, and a third was reported killed that same week in Burma (but later turned up alive). Mrs. Niland received all three death notification telegrams on the same day. The fourth son was serving with the 101st Airborne and was ordered pulled out of the front lines, but he couldn't be found. He survived anyway.

The basic premise of this film, that a sole surviving son will be removed from combat, is still the law. It is based on the disaster that befell the Sullivan family, who lost all five of their sons who were in the navy and whose ship went down during World War II. The resulting national backlash sent Congress scrambling, and it immediately instituted this new policy. The story of the Sullivan family is portrayed in the film *THE SULLIVANS*. The Sullivans were killed on Friday the 13th (in November 1942).

INTERESTING FACTS

- Director Steven Spielberg considered casting Matt Damon after viewing his performance in *COURAGE UNDER FIRE* (1996) but thought he was too skinny. Robin Williams introduced Damon to Spielberg on the set of *Good Will Hunting* (1997), and Spielberg changed his mind.
- Filming switched from the UK to Ireland after the British Ministry of Defence declined to provide the huge number of soldiers needed to act as extras in the film.

- In the scene in which Tom Hanks's character tells the rest of the unit what he does for a living back at home, Hanks's speech was much longer in the original script. But Hanks felt that his character wouldn't have said so much about himself, and he told director Steven Spielberg, who agreed, and the speech was shortened.
- Many veterans of D day have praised director Steven Spielberg for the film's authenticity, including actor James Doohan, best known as Scotty from *Star Trek*. Doohan lost the middle finger of his right hand and was wounded in the leg during the war. He commended Spielberg for not leaving out any gory details.
- All the principal actors underwent several days of grueling army training—except for Matt Damon, who was spared so that the other actors would resent him and would convey that resentment in their performances.
- Steven Spielberg took 60 percent of the color out of the movie in postproduction.
- The Edith Piaf song that the soldiers question the meaning of before the final battle is the same song that the commandos of *THE DIRTY DOZEN* (1967) question in their tents.
- The letter General Marshall quotes is in fact wrong. Of Mrs. Bixby's five sons, only two were dead. One was captured at Gettysburg, one deserted to join the Confederates, and one deserted to Cuba. On top of all this, Mrs. Bixby was in fact an ardent pacifist: She tried to prevent all her sons from enlisting.
- Real amputees were used for the shots of people with limbs missing.
- The German Tiger tank in the movie is in fact a Russian T-34 tank modified to appear as a convincing Tiger tank.

MISTAKES

- Several times when Corporal Upham is seen carrying .30 caliber ammunition belts, you can see that more than half the rounds have the primers missing, thus making them useless.
- In the scene with the mother finding out about her three sons, we see a picture of all four boys in uniform. Later, Ryan says that the last time the four of them were together was when his oldest brother went off to basic training.
- Miller states that the air force will provide air support, however, there was no U.S. Air Force in 1944; there was the U.S. Army Air Force. The U.S. Air Force was not established until 1947.

- The phone cord in the Ryan farmhouse is coiled. Phone cords in 1944 were straight.
- When the army car drives toward the Ryan farmhouse, the fields are brown; Iowa farm fields are green in June.
- At the beginning of the film, an aged Ryan flashes back to the beach landing at Normandy. But Ryan wasn't at Normandy; he was a paratrooper with the 101st, dropped behind enemy lines.
- As the squad travels at night, the flashes and sounds of distant explosions are seen and heard simultaneously. The sound of an explosion a mile away should be heard about five seconds after the flash is seen.
- Continuity error: Upham nervously knocks over a shelf full of items, including two helmets (his own and a German souvenir). A moment later, he reaches back to take a helmet, which has magically replaced itself on the shelf.
- The blood coming from Wade's mouth appears and disappears.
- Miller refers to the two types of German tanks as Tigers and Panzers. The word *Panzer* is simply the German term for tank or armor. The German army had begun naming their tank models after wildcats. What Miller and the other Rangers refer to as a Panzer tank should have been referred to as a Panther tank. A Ranger company commander like Miller would have been aware of the proper terminology.
- Ryan should, but does not, have a rural-Iowa accent.
- In the scene with Gen. George C. Marshall the general is wearing general staff lapel insignia. Generals wear no branch lapel insignia at all. Their staff officers wear general staff insignia.
- In the field scene (before they meet the German APC), we can see the camera's square shadow on Corporal Upham's shoulder.
- After the team goes out in search of Private Ryan, they are seen crossing fields. Then a couple of them are killed, but in another scene, the whole team is seen crossing a field.
- The "person" on top of the tank that gets his head blown off during the final bridge scene is obviously a dummy.
- The background on the Ryan brothers states that they all were members of the 29th Infantry Division before the Sullivan brothers were killed. After that they were split up. It's doubtful that all four would have been assigned to the 29th in the first place, as the 29th was mostly comprised of Virginia National Guard troops.
- When the soldiers arrive at the 101st rally point, the same extra walks by several times.

- The middle-aged Ryan, whom we see at the beginning and end of the movie, is wearing a Purple Heart lapel pin. This seems to mean that the mission to save him was a failure and that Ryan was ultimately assigned to combat duty and wounded (barring, of course, the possibility that he earned it before the events in the movie).
- As Upham and Mellish are loading ammo in preparation for the final battle, Upham (who is smoking) is telling Mellish how he didn't take any cigarettes from the supply officer before leaving England. However, in the earlier scene in which Upham is talking with the German soldier, he shares a cigarette with him.
- During the scene at the 101st rally point, where a long line of troops is walking past, at one point you can clearly see in the background the extras lined up waiting for their cue to start walking.
- The soldier with a drooping mouth in the back of Miller's transport is seen later at the 101st Airborne rally point as the paratrooper with Ryan's deaf friend.
- Upham is chastised for saluting Captain Miller because it makes Miller a sniper target, yet Miller is wearing bright silver captain bars on his helmet, which would be recognized by any good sniper anyway.
- The first time a soldier attempts to put a "sticky bomb" on the German tank, he is blown to bits. The soldier that attempts this is wearing a tan uniform. However, the dummy that gets blown up a second later is wearing a green uniform.
- On the beach near the seawall when the man next to Captain Miller gets shot in the face, his head appears as an empty ball. The remaining structures of the head, brain tissue, bone, and blood, not a black abyss, would have been visible through the wound.
- When the troops are storming the beach at the beginning of the movie, their M1 rifles are shown in waterproof clear plastic bags. In reality these bags would have been an opaque olive drab.
- When the soldiers are about to search through the airborne's dog tags, they head toward a single crate, meaning to use it as a table. When they reach the crate, an ammo box has appeared, stacked on top. Jackson knocks the top box off.

QUOTES

Private Reiben: You want to explain the math of this to me? I mean where's the sense in risking the lives of the eight of us to save one guy?

Capt. John Miller: Anyone wanna answer that?

Medic Wade: Hey, think about the poor bastard's mother.

Private Reiben: Hey, Wade, I got a mother, you got a mother, the sarge has got a mother. I'm willing to bet that even the captain's got a mother. Well, maybe not the captain, but the rest of us have got mothers.

Private Jackson: Seems to me, Cap'n, this mission is a serious misallocation of valuable military resources.

Capt. John Miller: He better be worth it. He better go home and cure a disease, or invent a longer-lasting light bulb.

AWARDS

Academy Awards, USA, 1998

Won: *Oscar, Best Cinematography,* Janusz Kaminski; *Best Director,* Steven Spielberg; *Best Effects, Sound Effects Editing,* Richard Hymns, Gary Rydstrom; *Best Film Editing,* Michael Kahn; *Best Sound,* Ron Judkins, Andy Nelson, Gary Rydstrom, Gary Summers

Nominated: *Oscar, Best Actor,* Tom Hanks; *Best Art Direction–Set Decoration,* Lisa Dean, Thomas E. Sanders; *Best Makeup,* Lois Burwell, Conor O'Sullivan, Daniel C. Striepeke; *Best Music, Original Dramatic Score,* John Williams; *Best Picture,* Ian Bryce, Mark Gordon, Gary Levinsohn, Steven Spielberg; *Best Writing, Screenplay Written Directly for the Screen,* Robert Rodat

Academy of Science Fiction, Horror and Fantasy, Films, USA, 1999

Won: *Saturn Award, Best Action/Adventure/Thriller*

Nominated: *Saturn Award, Best Special Effects,* Neil Corbould, Stefen Fangmeier, Roger Guyett

American Cinema Editors, USA, 1999

Won: *Eddie, Best Edited Feature Film,* Michael Kahn

American Society of Cinematographers, USA, 1999

Nominated: *ASC Award, Outstanding Achievement in Cinematography in Theatrical Releases,* Janusz Kaminski

Blockbuster Entertainment Awards, 1999

Won: *Blockbuster Entertainment Award, Favorite Actor —Drama,* Tom Hanks

Nominated: *Blockbuster Entertainment Award, Favorite Supporting Actor—Drama,* Jeremy Davies

Boston Society of Film Critics Awards, 1998

Won: *BSFC Award, Best Cinematography,* Janusz Kaminski

British Academy Awards, 1999

Won: *BAFTA Film Award, Best Sound,* Richard Hymns, Ron Judkins, Andy Nelson, Gary Rydstrom, Gary Summers; *Best Special Effects,* Neil Corbould, Stefen Fangmeier, Roger Guyett

Nominated: *BAFTA Film Award, Anthony Asquith Award for Film Music,* John Williams; *Best Cinematography,* Janusz Kaminski, *Best Editing,* Michael Kahn; *Best Film,* Ian Bruce, Mark Gordon, Gary Levinsohn, Steven Spielberg; *Best Make-Up/Hair,* Lois Burwell, Jeanette Freeman; *Best Performance by an Actor in a Leading Role,* Tom Hanks; *Best Production Design,* Thomas E. Sanders, David Lean; *Award for Direction—* Steven Spielberg

Broadcast Film Critics Association Awards, 1999

Won: *BFCA Award, Best Director,* Steven Spielberg; *Best Picture; Best Score,* John Williams

Camerimage, 1998

Nominated: *Golden Frog—*Janusz Kaminski,

Casting Society of America, USA, 1999

Won: *Artios, Best Casting for Feature Film Drama,* Denise Chamian

Chicago Film Critics Association Awards, 1999

Won: *CFCA Award, Best Picture*

Nominated: *CFCA Award, Best Actor,* Tom Hanks; *Best Cinematography,* Janusz Kaminski; *Best Director,* Steven Spielberg

Cinema Audio Society, USA, 1999

Won: *CAS Award, Outstanding Achievement in Sound Mixing for a Feature Film,* Ron Judkins (production mixer), Andy Nelson (re-recording mixer), Gary Rydstrom (re-recording mixer), Gary Summers (re-recording mixer)

Czech Film and Television Academy Awards, 1999

Won: *Czech Lion, Best Foreign Language Film (Nejlepsí zahranicní film),* Steven Spielberg

César Awards, 1999

Nominated: *César, Best Foreign Film* (Meilleur film étranger), Steven Spielberg (director)—USA,

Dallas–Fort Worth Film Critics Association Awards, 1999

Won: *DFWFCA Award, Best Picture*

Directors Guild of America, USA, 1999

Won: *DGA Award, Outstanding Directorial Achievement in Motion Pictures,* Adam Goodman (second

assistant director, plaque), Mark Huffam (production manager, plaque), Sergio Mimica-Gezzan (first assistant director, plaque), Karen Richards (second assistant director, plaque), Steven Spielberg

European Film Awards, 1998
Nominated: *Five Continents Award*—Steven Spielberg —USA

Florida Film Critics Circle Awards, 1999
Won: *FFCC Award, Best Cinematography*, Janusz Kaminski

Golden Globes, USA, 1999
Won: *Golden Globe, Best Director–Motion Picture*, Steven Spielberg; *Best Motion Picture—Drama*
Nominated: *Golden Globe, Best Original Score— Motion Picture*, John Williams; *Best Performance by an Actor in a Motion Picture—Drama*, Tom Hanks; *Best Screenplay—Motion Picture*, Robert Rodat

Golden Satellite Awards, 1999
Won: *Golden Satellite Award, Best Motion Picture Film Editing*, Michael Kahn
Nominated: *Golden Satellite Award, Best Director of a Motion Picture*, Steven Spielberg; *Best Motion Picture—Drama*, Ian Bryce, Mark Gordon, Gary Levinsohn, Steven Spielberg; *Best Motion Picture Cinematography*, Janusz Kaminski; *Best Motion Picture Score*, John Williams; *Best Motion Picture Screenplay—Original*, Robert Rodat; *Best Performance by an Actor in a Supporting Role in a Motion Picture—Drama*, Tom Sizemore; *Best Visual Effects in a Motion Picture*, Neil Corbould, Stefen Fangmeier

Roger Guyett, Grammy Awards, 1999
Won: *Grammy, Best Instrumental Composition Written for a Motion Picture or for Television*, John Williams

Italian National Syndicate of Film Journalists, 1999
Won: *Silver Ribbon, Best Director—Foreign Film (Regista del Miglior, Film Straniero)*, Steven Spielberg

London Critics Circle Awards, 1999
Won: *ALFS Award, Film of the Year*
Nominated: *ALFS Award, Actor of the Year*, Matt Damon—also for his performances in *The Rainmaker* (1997) and *Good Will Hunting* (1997); *Director of the Year*, Steven Spielberg

Los Angeles Film Critics Association Awards, 1998
Won: *LAFCA Award, Best Cinematography*, Janusz Kaminski; *Best Director*, Steven Spielberg, *Best Picture*

MTV Movie Awards, 1999
Nominated: *MTV Movie Award, Best Action Sequence*, Tom Hanks—for Tom Hanks and company landing on Normandy beach; *Best Male Performance*, Tom Hanks

Best Movie, Motion Picture Sound Editors, USA, 1999
Won: *Golden Reel Award, Best Sound Editing— Dialogue and ADR*, Sara Bolder (dialogue editor), Richard Hymns (supervising sound editor), Gary Rydstrom (supervising sound editor), Larry Singer (supervising ADR editor), Ewa Sztompke (dialogue editor), Denise Whiting (ADR editor), Thomas Whiting (ADR editor), Gwendolyn Yates Whittle (supervising dialogue editor); *Best Sound Editing— Sound Effects & Foley*, Sandina Bailo-Lape (supervising foley editor), Teresa Eckton (sound effects editor), Frank E. Eulner (sound effects editor), Richard Hymns (supervising sound editor), Bruce Lacey (foley editor), Larry Oatfield (sound effects editor), Gary Rydstrom (supervising sound editor/sound designer), Ethan Van der Ryn (sound effects editor), Karen G. Wilson (sound effects editor)
Nominated: *Golden Reel Award, Best Sound Editing—Music (Foreign & Domestic)*, unknown

New York Film Critics Circle Awards, 1998
Won: *NYFCC Award, Best Film*

Online Film Critics Society Awards, 1998
Won: *OFCS Award, Best Cinematography*, Janusz Kaminski; *Best Director*, Steven Spielberg; *Best Ensemble Cast Performance*; *Best Film Editing*, Michael Kahn
Nominated: *OFCS Award, Best Actor*, Tom Hanks; *Best Original Score*, John Williams

PGA Golden Laurel Awards, 1999
Won: *Motion Picture Producer of the Year Award*— Ian Bryce, Bonnie Curtis, Mark Gordon, Gary Levinsohn, Allison Lyon Segan, Steven Spielberg

People's Choice Awards, USA, 1999
Nominated: *People's Choice Award, Favorite Dramatic Motion Picture*

Political Film Society, USA, 1999
Nominated: *PFS Award*

Screen Actors Guild Awards, 1999

 Nominated: *SAG Award, Outstanding Performance by a Cast,* Edward Burns, Matt Damon, Jeremy Davies, Vin Diesel, Adam Goldberg, Tom Hanks, Barry Pepper, Giovanni Ribisi, Tom Sizemore; *Outstanding Performance by a Male Actor in a Leading Role,* Tom Hanks

Society of Motion Picture and Television Art Directors, USA, 1999

 Nominated: *Award for Excellence in Production Design, Feature Film,* Thomas E. Sanders

Southeastern Film Critics Association Awards, 1999

 Won: *SFCA Award, Best Director,* Steven Spielberg; *Best Picture*

Toronto Film Critics Association Awards, 1998

 3rd place, TFCA Award, Best Male Performance, Tom Hanks

 Won: *TFCA Award, Best Direction,* Steven Spielberg; *Best Film*

Writers Guild of America, USA, 1999

 Nominated: *WGA Screen Award, Best Screenplay Written Directly for the Screen,* Robert Rodat.

SAVIOR

Initial Entertainment 1998, color, 103 minutes.

Producers: Joseph Bruggeman (coproducer), Cindy Cowan (executive producer), Naomi Despres (coproducer), Molly M. Mayeux (associate producer), Mirjana Mijojlic (line producer, as Miryana Mijojlic), Scott Moore (associate producer), Oliver Stone, Janet Yang; **Director:** Predrag Antonijevic (as Peter Antonijevic); **Screenwriter:** Robert Orr; **Music:** David Robbins; **Distributor:** Lions Gate Films Inc. (formerly Cinepix Film Properties); **Filmed in:** Budva and Kotor, Crna Gora, mountains nr. Kotor and Skadar Lake, Montenegro, Rijeka Crnojevica, Skadarsko jezero, Crna Gora—all in Yugoslavia; **Cast:** Kosta Andrejevic, Ljiljana Blagojevic, Aleksandra Borodenko, Sanja Borodenko, Marina Bukvicki, Svetozar Cvetkovic, Cedo Dragovic, Catlin Foster, Nebojsa Glogovac, Beau Holden, Dusan Janicijevic, Nastassja Kinski, Ljiljana Krstic, Miodrag Krstovic, John MacLaren, Irfan Mensur, Natasa Ninkovic, Veljko Otasevic, Dusan Perkovic, Dennis Quaid, Dajana Radevic, Pascal Rollin, Stellan Skarsgård, Josif Tatic, Darka Toskovic, Sergej Trifunovic, Vesna Trivalic, Renata Ulmanski, Sanja Zogovic.

Dennis Quaid is a former U.S. military official whose wife is killed by a bomb set by Muslim fundamentalists in Paris. He finds a new home in the French Foreign Legion, fighting in the Yugoslav civil war on the Serbian side against the Muslims. After delivering the baby (which is half-Muslim) of a recently exchanged prisoner, he becomes the reluctant guardian of her and the baby.

QUOTES

Guy: Sorry about your family.
Vera: It's war.
Guy: Don't any of the tits in this country work?

AWARD

Political Film Society, USA, 1999
 Won: *PFS Award, Peace.*

SAYONARA

Pennebaker Productions, William Goetz Productions, 1957, color, 147 minutes.

Producer: William Goetz; **Director:** Joshua Logan; **Screenwriters:** James Michener (novel), Paul Osborn; **Music:** Irving Berlin (theme song), Franz Waxman; **Distributor:** Warner Bros.; **Filmed in:** Japan; **Cast:** Marlon Brando, Red Buttons, James Garner, Reiko Kuba, Ricardo Montalban, Patricia Owens, Martha Scott, Kent Smith, James Stacy, Miiko Taka, Miyoshi Umeki, Harlan Warde, Douglass Watson, Soo Yong.

Marlon Brando is a U.S. Air Force fighter pilot during the Korean War who is pulled out of action and sent to Kobe, Japan, ostensibly for rest and recreation. But the trip is actually arranged by the father of his fiancée, an influential air force general. However, once he is in Japan, Brando meets a traditional Japanese performer and they fall in love. In a parallel story, airman Red Buttons has also fallen in love with a Japanese national and wants to take her back to the United States, in spite of harsh paperwork impediments and orders to the contrary. When Buttons realizes that the military is going to separate him from his bride, they both commit suicide. This ultimate act of love gives Brando the courage to leave his Caucasian fiancée, who could have been very helpful to his military career, and to openly embrace his new Japanese love, despite the fact that it could ruin his chances of advancement.

 The film is based on James Michener's *Sayonara* (New York: Random House, 1954).

INTERESTING FACT

- This was the film debut for Miyoshi Umeki, who won the best supporting actress Academy Award.

QUOTE

Hana-ogi: The pleasure does not lie in the end itself. It's in the pleasurable steps to that end.

AWARDS

Academy Awards, USA, 1957
 Won: *Oscar, Best Art Direction–Set Decoration,* Ted Haworth, Robert Priestley; *Best Sound,* George Groves (Warner Bros. SSD); *Best Supporting Actor,* Red Buttons; *Best Supporting Actress,* Miyoshi Umeki
 Nominated: *Oscar, Best Actor,* Marlon Brando; *Best Cinematography,* Ellsworth Fredericks; *Best Director,* Joshua Logan; *Best Film Editing,* Philip W. Anderson, Arthur P. Schmidt; *Best Picture,* William Goetz; *Best Writing, Screenplay Based on Material from Another Medium,* Paul Osborn

British Academy Awards, 1959
 Nominated: *BAFTA Film Award, Most Promising Newcomer,* Red Buttons

Golden Globes, USA, 1958
 Won: *Golden Globe, Best Supporting Actor,* Red Buttons

Writers Guild of America, USA, 1958
 Nominated: *WGA Screen Award, Best Written American Drama,* Paul Osborn.

SCARLET DAWN

Vitaphone Corporation, 1932, b&w, 60 minutes.

Director: William Dieterle; **Screenwriters:** Mary C. McCall Jr. (novel, *Revolt*), Niven Busch, Erwin S. Gelsey (as Erwin Gelsey), Douglas Fairbanks Jr.; **Music:** Milan Roder; **Distributor:** Warner Bros.; **Cast:** Richard Alexander, Hadji Ali, Mischa Auer, Yola d'Avril Maurice Black, Mae Busch, Nancy Carroll, Harry Cording, Douglas Fairbanks Jr., Earle Foxe, Betty Gillette, C. Henry Gordon, Guy Kibbee, Alphonse Kohlmar, Lee Kohlmar, Arnold Korff, William Le Maire, Ivan Linow, John Marston, Eric Mayne, Frank Reicher, William Ricciardi, Dewey Robinson, Lilyan Tashman, Sheila Terry, Ellinor Vanderveer.

Douglas Fairbanks Jr. is an aristocratic Russian officer who returns to his brigade on the German front in February 1917, only to be met by the first troop revolts against the czar. The soldiers kill their officers and go home. In the growing anarchy of the revolution, it is too dangerous for him to remain in Russia, so he makes his way to Constantinople, in the unexpected company of his adoring and virtuous former servant, Nancy Carroll, whom he marries. There he finds a life of decadence with his fellow expatriates and renews his relationship with his former mistress, Lilyan Tashman. Dissatisfied with what he has become, and realizing that he loves his wife, he returns to Russia.

The movie is based on Mary McCall's book *Revolt* (no publication data is available).

SCHINDLER'S LIST

Amblin Entertainment, 1993, b&w, 197 minutes.

Producers: Irving Glovin, Kathleen Kennedy, Branko Lustig, Gerald R. Molen, Robert Raymond, Lew Rywin, Steven Spielberg; **Director:** Steven Spielberg; **Screenwriters:** Thomas Keneally, Steven Zaillian; **Music:** Johann Sebastian Bach, John Williams; **Distributor:** Universal Pictures; **Filmed in:** Jerusalem, Israel, Auschwitz, and Krakow, Poland; **Cast:** Peter Appiano, Joachim Paul Assböck, Hans-Jörg Assmann, Uri Avrahami, Dominika Bednarczyk, Sigurd Bemme, Dirk Bender, Martin Bergmann, Henryk Bista, Tadeusz Bradecki, Stanislaw Brejdygant, Alexander Buczolich, Haymon Maria Buttinger, Piotr Cyrwus, Oliwia Dabrowska, Ezra Dagan, Grzegorz Damiecki, Magdalena Dandourian, Embeth Davidtz, Tomasz Dedek, Pawel Delag, Miri Fabian, Ruth Farhi, Ravit Ferera, Ralph Fiennes, Peter Flechtner, Jeremy Flynn, Malgoscha Gebel, Marian Glinka, Caroline Goodall, Michael Gordon, Aldona Grochal, Marcin Grzymowicz, Gerald Alexande Held, Rami Heuberger, Michael Z. Hoffmann, Slawomir Holland, Tadeusz Huk, Razia Israeli, Mark Ivanir, Jan Jurewicz, Piotr Kadlcik, Georges Kern, Ben Kingsley, Wojciech Klata, Anemona Knut, Stanislaw Koczanowicz, Ewa Kolasinska, Wieslaw Komasa, Magdalena Komornicka, Shabtai Konorti, Sebastian Konrad, Agnieszka Korzeniowska, Hanna Kossowska, Leopold Kozlowski, Maciej Kozlowski, Zbigniew Kozlowski, Hubert Kramer, Agnieszka Kruk, Agnieszka Krukówna, Radoslaw Krzyzowski, Alicja Kubaszewska, Bettina Kupfer, Grzegorz Kwas, Geno Lechner, Erwin Leder, Jacek Lenczowski, Shmulik Levy, Edward Linde Lubaszenko, Olaf Linde Lubaszenko, Krzysztof Luft, Branko Lustig, Elina Löwensohn, Béatrice Macola, Wilhelm Manske, Danny Marcu, Artus Maria Matthiessen, Vili Matula,

Albert Misak, Thomas Morris, Anna Mucha, Liam Neeson, Harry Nehring, Jochen Nickel, Bartek Niebielski, Adi Nitzan, Jerzy Nowak, Beata Nowak, Maciej Orlós, Maja Ostaszewska, Götz Otto, Beata Paluch, Ludger Pistor, Piotr Polk, Daniel Del Ponte, Eugeniusz Priwieziencew, Jacek Pulanecki, Ryszard Radwanski, Osman Ragheb, Hans-Michael Rehberg, Hans Rosner, Beata Rybotycka, Jonathan Sagall, Jerzy Sagan, Michael Schiller, August Schmölzer, Michael Schneider, Dorit Seadia, Wolfgang Seidenberg, Martin Semmelrogge, Andrzej Seweryn, Adam Siemion, Sebastian Skalski, Alexander Strobele, Ethel Szyc, Dariusz Szymaniak, Friedrich von Thun, Agnieszka Wagner, Norbert Weisser, Andrzej Welminski, Maciej Winkler, Dieter Witting, Marek Wrona, Lidia Wyrobiec-Bank, Jacek Wójcicki, Esti Yerushalmi, Lucyna Zabawa.

Oskar Schindler (Liam Neeson) is a businessman who tries to make his fortune during World War II by exploiting cheap Jewish labor. He witnesses the Holocaust and the toll it takes on the Jewish people. As World War II progresses, and the fate of the Jews becomes more and more clear, Schindler's motivations switch from profit to human sympathy, and he is able to save more than 1100 Jews from death in the gas chambers.

The film is based on Thomas Keneally's novel *Schindler's List* (Hingham: Wheeler Pub., 1994) itself based on a true story.

INTERESTING FACTS

- Martin Scorsese turned down the chance to direct this film in the 1980s; he felt he couldn't do as good a job as a Jewish director.
- Coproducer Branko Lustig plays the nightclub maître d' in Schindler's first scene. Lustig is an Auschwitz survivor and has produced other movies about the Holocaust, including *Sophie's Choice* (1982) and *Shoah* (1985).
- Director Steven Spielberg was unable to get permission to film inside Auschwitz, so the scenes of the death camp were actually filmed outside the gates on a set constructed in a mirror image of the real location.
- Claire Danes was originally considered by Spielberg for a role, but she turned it down because he could not provide her with tutoring on the set. The part she was considered for is unknown.
- Ralph Fiennes put on 13 kilograms by drinking Guinness for his role. Spielberg cast him because of his evil-looking sexuality.

- The person who places the flower on top of the stones in the closing credits is Liam Neeson, not Spielberg, as some people think.

MISTAKE

- Schindler was never awarded the Golden Nazi Party Badge and thus couldn't have sold it to save more Jews. In any event, all but a few of the badges were made of gold-plated brass.

QUOTES

Amon Goeth: They cast a spell on you, you know, the Jews. When you work closely with them, like I do, you see this. They have this power. It's like a virus. Some of my men are infected with this virus. They should be pitied, not punished. They should receive treatment because this is as real as typhus. I see it all the time. It's a matter of money? Hmm?

Amon Goethe: The truth is always the right answer.

Amon Goethe: You're cruel, Oskar. You're giving them hope. Now *that's* cruel!

Itzhak Stern: This list . . . is an absolute good.

AWARDS

Academy Awards, USA, 1993
 Won: *Oscar, Best Art Direction—Set Decoration,* Ewa Braun, Allan Starski; *Best Cinematography,* Janusz Kaminski; *Best Director,* Steven Spielberg; *Best Film Editing,* Michael Kahn; *Best Music, Original Score,* John Williams; *Best Picture,* Branko Lustig, Gerald R. Molen, Steven Spielberg; *Best Writing, Screenplay Based on Material from Another Medium,* Steven Zaillian
 Nominated: *Oscar, Best Actor,* Liam Neeson; *Best Costume Design,* Anna B. Sheppard; *Best Makeup,* Judith A. Cory, Matthew W. Mungle, Christina Smith; *Best Sound,* Ron Judkins, Scott Millan, Andy Nelson, Steve Pederson; *Best Supporting Actor,* Ralph Fiennes

American Cinema Editors, USA, 1994
 Nominated: *Eddie, Best Edited Feature Film,* Michael Kahn

American Society of Cinematographers, USA, 1994
 Nominated: *ASC Award, Outstanding Achievement in Cinematography in Theatrical Releases,* Janusz Kaminski

Boston Society of Film Critics Awards, 1993
Won: *BSFC Award, Best Cinematography*, Janusz Kaminski; *Best Director*, Steven Spielberg; *Best Film*; *Best Supporting Actor*, Ralph Fiennes

British Academy Awards, 1994
Won: *BAFTA Film Award, Best Supporting Actor*, Ralph Fiennes; *Best Adapted Screenplay*, Steven Zaillian; *Best Cinematography*, Janusz Kaminski; *Best Editing*, Michael Kahn; *Best Film*, Branko Lustig, Gerald R. Molen, Steven Spielberg; *Best Score*, John Williams, David Lean; *Award for Direction*—Steven Spielberg
Nominated: *BAFTA Film Award, Best Leading Actor*, Liam Neeson; *Best Supporting Actor*, Ben Kingsley; *Best Costume Design*, Anna B. Sheppard; *Best Make-Up Artist*, Pauline Heys, Matthew W. Mungle, Waldemar Pokromski, Christina Smith; *Best Production Design*, Allan Starski; *Best Sound*, Charles L. Campbell, Louis L. Edemann, Robert Jackson, Ron Judkins, Scott Millan, Andy Nelson, Steve Pederson

British Society of Cinematographers, 1993
Won: *Best Cinematography Award*—Janusz Kaminski

Chicago Film Critics Association Awards, 1994
Won: *CFCA Award, Best Cinematography*, Janusz Kaminski; *Best Director*, Steven Spielberg; *Best Picture*; *Best Screenplay*, Steven Zaillian; *Best Supporting Actor*, Ralph Fiennes

Directors Guild of America, USA, 1994
Won: *DGA Award, Outstanding Directorial Achievement in Motion Pictures*, Michael Helfand (second assistant director, plaque), Branko Lustig (unit production manager, plaque), Sergio Mimica-Gezzan (first assistant director, plaque), Steven Spielberg

Golden Globes, USA, 1994
Won: *Golden Globe, Best Director—Motion Picture*, Steven Spielberg; *Best Motion Picture—Drama*; *Best Screenplay—Motion Picture*, Steven Zaillian
Nominated: *Golden Globe, Best Original Score—Motion Picture*, John Williams; *Best Performance by an Actor in a Motion Picture—Drama*, Liam Neeson; *Best Performance by an Actor in a Supporting Role in a Motion Picture*, Ralph Fiennes

Grammy Awards, 1995
Won: *Grammy, Best Instrumental Composition Written for a Motion Picture or for Television*, John Williams

Humanitas Prize, 1994
Won: *Humanitas Prize, Feature Film Category*, Steven Zaillian

London Critics Circle Awards, 1995
Won: *ALFS Award, British Actor of the Year*, Ralph Fiennes; *Director of the Year*, Steven Spielberg; *Film of the Year*
Nominated: *ALFS Award, Actor of the Year*, Liam Neeson

Los Angeles Film Critics Association Awards, 1993
Won: *LAFCA Award, Best Cinematography*, Janusz Kaminski—tied with Stuart Dryburgh, for *The Piano, Best Picture*; *Best Production Design*, Allan Starski

MTV Movie Awards, 1994
Nominated: *MTV Movie Award, Best Breakthrough Performance*, Ralph Fiennes

Best Movie, National Board of Review, USA, 1993
Won: *NBR Award, Best Picture—English Language*

National Society of Film Critics Awards, USA, 1994
Won: *NSFC Award, Best Cinematography*, Janusz Kaminski; *Best Director*, Steven Spielberg; *Best Film*; *Best Supporting Actor*, Ralph Fiennes

New York Film Critics Circle Awards, 1993
Won: *NYFCC Award, Best Cinematography*, Janusz Kaminski; *Best Film*; *Best Supporting Actor*, Ralph Fiennes

Norwegian International Film Festival, 1994
Won: *Amanda, Best Foreign Language Feature Film*, Steven Spielberg

PGA Golden Laurel Awards, 1994
Won: *Motion Picture Producer of the Year Award*—Branko Lustig, Gerald R. Molen, Steven Spielberg

Political Film Society, USA, 1994
Won: *PFS Award, Human Rights*
Nominated: *PFS Award, Exposé*

USC Scripter Award, 1994
Won: *USC Scripter Award*—Thomas Keneally (author), Steven Zaillian (screenwriter)

Writers Guild of America, USA, 1994
Won: *WGA Screen Award, Best Screenplay Based on Material Previously Produced or Published*, Steven Zaillian.

SCHOOL FOR DANGER

RAF Film Unit, 1947, b&w, 68 minutes.

Director: Edward Baird; **Screenwriters:** Edward Baird, J. Woolaston; **Music:** John Greenwood; **Distributor:** English Films; **Cast:** Edward Baird, Jacqueline Nearne, Captain Harry Ree.

During World War II, Capt. Harry Ree and Jacqueline Nearne become saboteurs with the French Resistance.

INTERESTING FACTS

- The film was directed by Wing Cmdr. Edward Baird, who, though undeniably a heroic aviator, was no David Lean.
- Real-life wartime secret agents Capt. Harry Ree and Jacqueline Nearne are the two stars; they play themselves, recreating their wartime experiences.

SCHOOL FOR SECRETS

Two Cities, 1946, b&w, 108 minutes.

Producers: George H. Brown, Peter Ustinov; **Director:** Peter Ustinov; **Screenwriter:** Peter Ustinov; **Music:** Alan Rawsthorne; **Distributor:** General Film Distributors; **Cast:** Joseph Almas, Tony Arpino, Richard Attenborough, Robin Bailey, Guy Belmore, Andrew Blackett, Kenneth Buckley, Paul Carpenter, O. B. Clarence, Finlay Currie, Anthony Dawson, Hugh Dempster, Bob Elson, Peggy Evans, Ingrid Forrest, Joan Haythorne, Trevening Hill, Edward Hodge, Sonia Holm, Vida Hope, Michael Hordern, Raymond Huntley, David Hutcheson, Ernest Jay, Roger Keyes, Geraldine Keyes, Robert Lang, John Laurie, Edward Lexy, Alvar Liddell, Aubrey Mallalieu, Richard Mantell, Peter March, Murray Matheson, Pamela Matthews, Kenneth More, Karl Morel, Bill Owen, Hugh Pryse, Marjorie Rhodes, Ralph Richardson, Arthur Rieck, Desmond Roberts, Cyril Smith, D. Bradley Smith, David Tomlinson, Ernest Urbank, Patrick Waddington, Norman Webb, Ann Wilton, Anthony Wyckham, Robert Wyndham, Joan Young.

At the beginning of World War II, a group of British scientists develop the first radar system. Background information will help the viewer appreciate the significance of radar during the Battle of Britain.

After the fall of Dunkirk (see *DUNKIRK*), Hitler intended to invade England. Before he could launch a successful invasion across the channel, it was imperative that he gain air supremacy, because England had naval supremacy and would undoubtedly sacrifice every ship in the British fleet to protect the homeland. Thus began the Battle of Britain (see *BATTLE OF BRITAIN*), a furious air war over the skies of England in which the Luftwaffe sought to crush the RAF. The critical factor in this conflict was radar, which could detect German aircraft while they were still over the English Channel and track their movements. The RAF high command could then determine which RAF squadrons would be the most effective and delay their takeoff until the last possible moment. The RAF pilots, fresh from crew rest, and with full tanks of gas, had a decided edge over the Luftwaffe pilots, who were flying longer missions, had already used a large amount of their fuel, and who needed to save fuel for the flight home. Without radar, the RAF would have had to rely on coast watchers, who were not effective at night or when planes had cloud cover. In addition, the RAF would have had to keep a constant umbrella of aircraft airborne, in much the same manner as a modern aircraft carrier in combat. Because the RAF was outnumbered and outmanned, lack of radar would have severely degraded the ability of the RAF to win the Battle of Britain.

SCREAMING EAGLES

Bischoff-Diamond, Allied Artists Pictures Corporation, 1956, b&w, 79 minutes.

Producers: Samuel Bischoff, David Diamond; **Director:** Charles F. Haas; **Screenwriters:** Virginia Kellogg, David Lang, Robert Presnell Jr.; **Music:** Harry Sukman; **Distributor:** Columbia Pictures; **Cast:** Jacqueline Beer, Robert Blake, Robert Boon, Paul Burke, Pat Conway, Mark Damon, Joe Di Reda, Bob Dix, Werner Klingler, Keith Larsen, Jan Merlin, Peter Michaels, Martin Milner, Alvy Moore, Robert Roark, Edward G. Robinson Jr., Paul Smith, Wayne Taylor, Tom Tryon, Ralph Votrian.

During the D day invasion in Normandy during World War II, the 101st Airborne Division airdrops behind enemy lines. Their mission: Take and hold a bridge vitally needed for the Allied push inland.

INTERESTING FACTS

- "Screaming Eagles" is the nickname for the 101st Airborne Division. During World War II, the division gained fame with the D day jumps depicted in this film, and also with the division's determined defense of Bastogne during the Battle of the Bulge.

Today, the 101st is an air assault unit, using helicopters instead of parachutes.

- The author served with the 101st from 1991 to 1996, stationed at Ft. Campbell, Kentucky.
- The 101st Airborne Division is depicted by Red Buttons and John Wayne in THE LONGEST DAY, and also depicted in THE BATTLE OF THE BULGE. The command to the rescue of which George C. Scott is racing across France in PATTON is the 101st.

SEA CHASE

Warner Bros., 1955, color, 117 minutes.

Producer: John Farrow; **Director:** John Farrow; **Screenwriters:** James Warner Bellah, Andrew Geer (novel), John Twist; **Music:** Roy Webb; **Distributor:** Warner Bros.; **Filmed in:** Hawaii; **Cast:** Claude Akins, James Arness, Lyle Bettger, Richard Davalos, Gloria Dea, Jean De Briac, John Doucette, Anthony Eustrel, David Farrar, Paul Fix, Lowell Gilmore, Wilton Graff, Alan Hale Jr., Tab Hunter, Alan Lee, James Lilburn, Gavin Muir, Patrick O'Moore, Tudor Owen, Gil Perkins, John Qualen, Gail Robinson, Luis Van Rooten, John Sheffield, Lana Turner, John Wayne, Peter Whitney, Adam Williams.

At the beginning of World War II, anti-Nazi German freighter captain John Wayne tries to get his ship from Australia back to the fatherland through a gauntlet of Allied warships.

This film would have worked better with another actor, since John Wayne is such an American icon that he cannot be believed as a Nazi commander, albeit a sympathetic one.

INTERESTING FACT

- The movie is based on the true story of Capt. Karl Ehrlich and Andrew Geer's *The Sea Chase* (New York: Harper, 1948).

SEALED CARGO

RKO Radio Pictures Inc., 1951, b&w, 90 minutes.

Producers: Samuel Bischoff, Warren Duff; **Director:** Alfred L. Werker; **Screenwriters:** Oliver H. P. Garrett, Edmund Gilligan, Roy Huggins, Dale Van Every; **Music:** Roy Webb; **Distributor:** RKO; **Cast:** Dana Andrews, Carla Balenda, Whit Bissell, Philip Dorn, Morgan Farley, Eric Feldary, Steve Forrest, Skip Homeier, J. M. Kerrigan, Claude Rains, Henry Rowland, Arthur Shields, Onslow Stevens, David Thursby.

Dana Andrews plays a fisherman off the coast of Nova Scotia who comes across a badly damaged Danish schooner, with only the captain, Claude Rains, left alive on board. It apparently has been shelled by a German U-boat. Andrews tows the derelict to port. When he discovers that the ship contains a secret compartment filled with torpedoes, he must fight Claude Rains and his secret Nazi crew to blow up the ship.

The movie is based on Endmund Gilligan's *The Gaunt Woman* (New York: Scribner's, 1943).

SEA OF SAND

Tempean Films Ltd., 1958, b&w, 97 minutes.

Producers: Robert S. Baker, Monty Berman; **Director:** Guy Green; **Screenwriter:** Robert Westerby; **Music:** Clifton Parker; **Distributor:** Rank Organisation; **Cast:** Richard Attenborough, Vincent Ball, Michael Craig, Barry Foster, Andrew Foulds, Wolf Frees, Harold Goodwin, John Gregson, Percy Herbert, Ray McAnally, George Mikell, George Murcell, Tony Thawnton.

A British army patrol, while on a mission to destroy a German petrol dump in North Africa, spots a movement of tanks and realizes that the high command must be informed or the Tommies are going to be hit hard. They are spotted by the Germans, and a deadly chase across the desert begins.

SEARCH, THE

Metro-Goldwyn-Mayer, 1948, b&w, 105 minutes.

Producer: Lazar Wechsler; **Director:** Fred Zinnemann; **Screenwriters:** Montgomery Clift, Paul Jarrico, Richard Schweizer, David Wechsler; **Filmed in:** Ingolstadt, Bavaria, Germany; **Cast:** Leopold Borkowski, Montgomery Clift, Wendell Corey, Claude Gambier, Ivan Jandl, Aline MacMahon, Ewart G. Morrison, Jarmila Novotna, Mary Patton, William Rogers.

A silent, nine-year-old Czech boy, a survivor of Auschwitz, is befriended by American GI Montgomery Clift, who plans to adopt him and take him back to the United States. When he takes the boy to a U.N. relief agency to register him, he is recognized by the boy's mother, the sole surviving member of his family, who has been searching refugee centers for her son.

AWARDS

Academy Awards, USA, 1949
 Won: *Juvenile Award*, Ivan Janl; *Oscar, Best Writing, Motion Picture Story*, Richard Schweizer, David Wechsler
 Nominated: *Oscar, Best Actor in a Leading Role*, Montgomery Clift; *Best Director*, Fred Zinnemann; *Best Writing, Screenplay*, Richard Schweizer, David Wechsler

BAFTA Awards, 1950
 Won: *UN Award, USA*

Golden Globes, USA, 1949
 Won: *Golden Globe, Best Film Promoting International Understanding; Best Screenplay*, Richard Schweizer; *Special Award For Best Juvenile Actor*, Ivan Jandl

New York Film Critics, 1948

Venice Film Festival, 1948
 Nominated: *Golden Lion*, Fredd Zinnemann.

SEARCHING WIND, THE

Paramount Pictures, 1946, b&w, 108 minutes.

Producer: Hal B. Wallis; **Director:** William Dieterle; **Screenwriter:** Lillian Hellman; **Cast:** Frank Arnold, Albert Bassermann, Eugene Borden, Sam D. Brown, Marietta Canty, Ann Carter, Don Castle, Daniel De Jonghe, Douglas Dick, Dudley Digges, Frank Ferguson, Albert Ferris, Adolph Freeman, Frederick Giermann, Eva Heyde, Hans Hoebus, Mickey Kuhn, Arthur Loft, Louis Lowy, Maurice Marsac, Jack Mulhall, John Mylong, Ann Richards, Henry Rowland, Harry Semels, Elmer Serrano, Dan Seymour, Reginald Sheffield, Sylvia Sidney, William Trenk, Norma Varden, Dave Willock, Al Winters, Robert Young.

Robert Young is an indecisive American diplomat in Europe between the two world wars. Sylvia Sidney, his true love, a journalist, wants him to be more decisive and leaves him in Rome just as Mussolini is coming to power. He then marries the wrong woman, Ann Richards, the daughter of a newspaper publisher who hires Sylvia Sidney for his Paris bureau. Robert Young fails to understand the evils of fascism in Italy or the significance of the rise of the Nazis in Germany.

The film is based on Lillian Hellman's stage play *The Searching Wind* (New York: The Viking Press, 1944). She also wrote the script.

INTERESTING FACTS

- The story is told in flashback, from the perspective of Robert Young's son, who has just returned from active duty in World War II.
- The film failed to find an audience in its theatrical release.

SEAS BENEATH, THE

Fox Film Corporation, 1931, b&w, 90 minutes.

Producer: John Ford; **Director:** John Ford; **Screenwriters:** William Collier Sr. (dialogue), Dudley Nichols, James Parker Jr. (story, as Cmdr. James Parker U.S.N. retired), Kurt von Fuerberg (dialogue); **Music:** María Grever, Troy Sanders; **Distributor:** Fox Film Corporation; **Filmed in:** Isthmus of Santa Catalina Island, California; **Cast:** Philip Ahlm, Al Bennett, Earl Wayland Bowman, Bill Brande, William Collier Sr., Leonard Davison, Joseph Depew, Francis Ford, Robert Ford, Hans Fuerberg, Kurt von Fuerberg, Al Generaux, Bob Gillette, George Golden, Ben Hall, George Harris, Warren Hymer, Walter C. Kelly, Larry Kent, Bob Kyle, Marion Lessing, John Loder, Mona Maris, Jack Martin, Walter McGrail, Harry Mount, Jack Murphy, Maurice Murphy, Bob Nelson, George O'Brien, Edward Peil Jr., Nat Pendleton, Steve Pendleton, Terrance Ray, Harry Schultz, Ferdinand Schumann-Heink, Marvin Shechter, Robert Shepherd, Harry Strang, Anton Tell, George Templeton, Harry Tenbrook, Henry Victor, T.J.F. Von Blankerburg, Frank Walton, Harry Weil, Hans Winterhalder.

During World War I, a harmless-looking U.S. schooner sets sail for the coast of Spain. The crew's mission is to find U-172, a German submarine that has been especially effective in attacking Allied shipping. This schooner is in fact fitted with a formidable hidden deck gun, which eventually sinks the U-boat.

INTERESTING FACTS

- John Loder was paid an extra $1000 because he had to get a close haircut for his role.
- The U.S. Navy placed at Ford's disposal a flotilla of destroyers, cruisers, and submarines, as well as the services of naval personnel.
- The three-masted schooner used as the decoy mystery ship was the same one used in the movies *The Sea Wolf* (1930) and *The Painted Woman* (1932).
- What's most striking about this early Ford talkie is the location (shipboard) filming: Few films from the studio era make such a point of actually filming

at sea instead of on a set in front of a sky backdrop. The vivid realism of these scenes is remarkable today.

SEA SHALL NOT HAVE THEM, THE

Alliance Film Studio, 1954, b&w, 91 minutes.

Producers: Daniel M. Angel, Anthony Nelson Keys; **Director:** Lewis Gilbert; **Screenwriters:** Lewis Gilbert, John Harris, Vernon Harris; **Distributor:** United Artists; **Cast:** Michael Balfour, Dirk Bogarde, Eddie Byrne, Paul Carpenter, Bonar Colleano, Anton Diffring, Nigel Green, Ann Gudrun, Glyn Houston, Griffith Jones, Moultrie Kelsall, Rachel Kempson, James Kenney, Jack Lambert, Victor Maddern, Guy Middleton, Nigel Patrick, Michael Redgrave, Michael Ripper, George Rose, Joan Sims, Anthony Steele, Sidney Tafler, Jack Taylor, Jack Watling, Ian Whittaker.

During World War II, a British bomber is forced down in the English Channel. While the bomber crew waits to be rescued, to keep up their morale they talk about their lives.

The movie is based on John Harris's *The Sea Shall Not Have Them* (London: Hurst & Blackett, 1953).

SEA WOLVES: THE LAST CHARGE OF THE CALCUTTA LIGHT HORSE, THE

Lorimar Productions, Richmond Light Horse Productions, Varius AG, 1980, color, 121 minutes.

Producers: Jorge L. Araneta, Harold Buck, Chris Chrisafis, Euan Lloyd; **Director:** Andrew V. McLaglen; **Screenwriters:** James Leasor, Reginald Rose; **Filmed in:** Goa, India; **Cast:** Mohan Agashe, Patrick Allen, Jürgen Andersen, Bernard Archard, Martin Benson, Faith Brook, Farid Currim, Allan Cuthbertson, Edward Dentith, Clifford Earl, Scott Finch, Rusi Gandhi, Martin Grace, Kenneth Griffith, Percy Herbert, Robert Hoffmann, Patrick Holt, Donald Houston, Glyn Houston, Trevor Howard, Dan van Husen, Wolf Kahler, Barbara Kellerman, Victor Langley, Terence Longdon, Patrick Macnee, Michael Medwin, George Mikell, Roger Moore, David Niven, Gregory Peck, William Morgan Sheppard, John Standing, Graham Stark, Keith Stevenson, Jack Watson, Moray Watson, Brook Williams, Marc Zuber.

Three retired British officers—Gregory Peck, Roger Moore, and David Niven—lead a daring mission into a neutral harbor during World War II to destroy secret Nazi radio ships, whose transmissions are helping Nazi submarines locate and sink Allied ships. Since the ships are in neutral territory, the British high command will deny any knowledge of the mission if it fails. Masquerading as drunken elderly fishermen, the soldiers board and destroy the three Nazi ships.

The movie is based on a true story and on the book by James Leasor called *The Sea Wolves* (London: Corgi, 1980).

QUOTES

Jack Cartwright [complaining about Grice's driving]: Gentlemen, I want you to know that our commanding officer has just tried to kill me.

W. H. Grice: Have you taken a look at the engine in this thing?
Col. Lewis Pugh: No, but I have a general idea.
W. H. Grice: It belongs in a museum!
Col. Lewis Pugh: So do some of us.

Col. Lewis Pugh: Of course, authentic drunken businessmen seldom run about with machine guns.

SECRET INVASION, THE

American International Pictures, 1964, color, 95 minutes.

Producer: Gene Corman; **Director:** Roger Corman; **Screenwriter:** R. Wright Campbell; **Distributor:** American International Pictures; **Filmed in:** Dubrovnik, Yugoslavia; **Cast:** Charles Brent, Kurt Bricker, Edd Byrnes, William Campbell, Peter Coe, Enzo Fiermonte, Stewart Granger, Richard Johns, Helmo Kindermann, Craig March, Giulio Marchetti, Mia Massin, Nan Morris, Nicholas Rend, Mickey Rooney, Katrina Rozan, Helmut Schneider, Henry Silva, Raf Vallone, Todd Williams.

Stewart Granger is a British officer put in charge of a raid to rescue an Italian general in Nazi-controlled Yugoslavia. His commando squad is made up of military convicts who will have their sentences commuted if the mission is a success. All but one member of the team is killed, but they get the general, only to learn they have rescued an impersonator, a double created to fool the enemy.

INTERESTING FACT

• A related film is *THE DIRTY DOZEN*, which also uses military prisoners as commandos.

SECRET OF SANTA VITTORIA, THE

Stanley Kramer Productions, 1969, color, 136 minutes.

Producers: George Glass, Stanley Kramer; **Director:** Stanley Kramer; **Screenwriters:** Ben Maddow, William Rose; **Music:** Ernest Gold; **Distributor:** United Artists; **Filmed in:** Anticoli Corrado, Italy; **Cast:** Karl-Otto Alberty, Chris Anders, Gigi Ballista, Gigi Bonos, Carlo Capannelle, Carlo Caprioli, Renato Chiantoni, Eduardo Ciannelli, Valentina Cortese, Aldo De Carellis, Tim Donnelly, Pino Ferrara, Sergio Franchi, Giancarlo Giannini, Wolfgang Jansen, Hardy Krüger, Peter Kuiper, Pippo Lauricella, Virna Lisi, Curt Lowens, Anna Magnani, Francesco Mulé, Quinto Parmeggiani, Anthony Quinn, Renato Rascel, Leopoldo Trieste, Marco Tulli, Patrizia Valturri, Dieter Wilken.

In World War II Italy, Bombolini (Anthony Quinn) is Santa Vittoria's town drunk. When he learns that the fascist government has surrendered, he climbs a water tower to pull down a pro-Mussolini sign. He gets stuck up there; he can't get down, and the crowd chants his name to give him confidence. The fascist town council hears the chanting, believes he is the town's new leader, and appoints him the new mayor. His appointment brings about a new respectability. When he learns that the Germans plan to occupy the town and take their principle asset, a million bottles of wine, he creates a plan to hide it.

The film is based on Robert Crichton's novel.

QUOTES

Bombolini [as the captain leaves, Bambolini offers the Nazi captain a bottle of wine]: To the captain, from the people of Santa Vittoria. It's not a great wine, but it's not bad!

Captain: You're sure you can spare it?

Bombolini: There's one million more where this came from.

AWARDS

Academy Awards, USA, 1969
> **Nominated:** *Oscar*, *Best Film Editing*, Earle Herdan, William A. Lyon; *Best Music, Original Score for a Motion Picture (not a Musical)*, Ernest Gold

American Cinema Editors, USA, 1970
> **Nominated:** *Eddie, Best Edited Feature Film*, Earle Herdan, William A. Lyon

Golden Globes, USA, 1970
> **Won:** *Golden Globe, Best Motion Picture—Musical/Comedy*

> **Nominated:** *Golden Globe, Best Director—Motion Picture*, Stanley Kramer; *Best Motion Picture Actor—Musical/Comedy*, Anthony Quinn; *Best Motion Picture Actress—Musical/Comedy*, Anna Magnani; *Best Original Score*, Ernest Gold; *Best Original Song*, Norman Gimbel (lyrics), Ernest Gold (music), for the song *Stay*.

SECRET WAR OF HARRY FRIGG, THE

Albion Film Corp., 1968, color, 110 minutes.

Producer: Hal E. Chester; **Director:** Jack Smight; **Screenwriters:** Peter Stone, Frank Tarloff; **Distributor:** Universal Pictures; **Filmed in:** Sierra Madre, California (villa); **Cast:** Tom Bosley, Andrew Duggan, Horst Ebersberg, Norman Fell, Charles Gray, James Gregory, Johnny Haymer, Buck Henry, George Ives, Sylva Koscina, Fabrizio Mioni, Paul Newman, Werner Peters, Jacques Roux, Vito Scotti, Richard X. Slattery, John Williams.

Paul Newman is Pvt. Harry Frigg, a soldier with a knack for escaping from the guardhouse, at which he is a frequent "guest." When four Allied generals are captured in Italy during World War II, the major stumbling block to their escape is the fact that they are all one-star generals and that they refuse to take orders from each other. To spring the generals, the Allies promote Newman from private to major general (two stars), and then get him captured so that he is thrown in with the other generals. However, his motivation to escape disappears when he meets the beautiful countess who owns the castle where they are imprisoned.

SERGEANT MIKE

Columbia Pictures Corporation, 1945, b&w, 60 minutes.

Producer: Jack Fier; **Director:** Henry Levin; **Screenwriter:** Robert Lee Johnson; **Music:** Mischa Bakaleinikoff; **Cast:** Eddie Acuff, Jim Bannon, Jeanne Bates, Tom Keene, Larry Olsen, Larry Parks, Loren Tindall, John Tyrrell, Charles Wagenheim, Robert Williams.

Larry Parks is transferred to the K-9 Corps and assigned Sergeant Mike, a dog donated to the army by a young boy whose father was killed in action. Sergeant Mike sniffs out Japanese machine-gun nests and carries vital messages in combat.

A related film is *WAR DOG* (a.k.a. *Pride of the Army*).

SERGEANT YORK

Warner Bros., 1941, b&w, 134 minutes.

Producers: Howard Hawks, Jesse L. Lasky, Hal B. Wallis; **Director:** Howard Hawks; **Screenwriters:** Harry Chandlee, Sam Cowan, Abem Finkel, John Huston, Howard Koch, Tom Skeyhill, Alvin C. York; **Music:** Max Steiner; **Distributor:** Warner Bros.; **Cast:** Erville Alderson, Murray Alper, James Anderson, Arthur Aylesworth, Noah Beery Jr., Clem Bevans, Ward Bond, Walter Brennan, David Bruce, Sonny Bupp, Lucia Carroll, Lane Chandler, Elisha Cook Jr., Gary Cooper, Howard Da Silva, Jean Del Val, Donald Douglas, Charles Drake, Roland Drew, Theodore von Eltz, Carl Esmond, Frank Faylen, Pat Flaherty, Jody Gilbert, Joseph W. Girard, Kit Guard, William Haade, Creighton Hale, Herbert Heywood, Russell Hicks, George Irving, Jane Isbell, Selmer Jackson, Si Jenks, Edward Keane, Victor Kilian, Rita La Roy, Joan Leslie, June Lockhart, Frank Marlowe, Tully Marshall, Charles Middleton, Dickie Moore, Frank Orth, Steve Pendleton, Jack Pennick, Robert Porterfield, Stanley Ridges, Walter Sande, Joe Sawyer, Dick Simmons, Harvey Stephens, Kay Sutton, Ray Teal, George Tobias, Charles Trowbridge, Eddy Waller, Lee Lasses White, Frank Wilcox, Guy Wilkerson, Tom Wilson, Douglas Wood, Margaret Wycherly, Gig Young.

Alvin York (Gary Cooper), the town's biggest hooligan, gets religion and becomes a man of the Bible. When he is drafted into the U.S. Army at the beginning of World War I, he tries to resist induction as a pacifist, but he is drafted anyway. Target practice reveals him to be a dead shot, yet he doesn't want to shoot anyone: According to York's creed, killing is

Sergeant York (WARNER BROS./AUTHOR'S COLLECTION)

against the Good Book. His commanding officer uses his limited knowledge of the Bible to persuade York that, in some circumstances, fighting can be the right thing. He then gives York a book about the history of the United States, which includes the story of Daniel Boone (from his home state of Tennessee). York is sent home, leaving it to him to decide whether he will fight or not. He comes to the realization that sometimes people have to fight for freedom. At the front in France, Alvin and his unit are pinned down by machine-gun fire. York single-handedly knocks out all of the enemy machine guns with nothing but his dead aim. York knows how to hunt turkeys: You shoot the last one in line, and then you shoot each one in succession, so that the others don't see. When he's in the trenches fighting Germans, he uses the same technique. He shoots the last German in the trench and works his way down the line. He has them out-flanked, and finally he gets the whole German unit to surrender.

Afterward, in perhaps the most amazing part of his story, he claims that he killed only to save lives. York leaves the war as a hero, but he's ashamed of the act of courage that made him famous. He turns down big money endorsements, because in his mind, it wouldn't be right to make money out of killing.

The film is based on three books, two by Sam K. Cowman, *War Diary of Sgt. York* and *Sgt. York and his People* (no publication dates are available), and one by Tom Skeyhill, *Sgt. York—Last of the Long Hunters* (Philadelphia: The John C. Winston Company, 1930).

INTERESTING FACTS

- Cooper was 41 when he made this film, and Leslie only 16, but this is consistent with the true ages of York and Gracie when they were beginning their relationship.
- At the beginning of World War II, York tried to serve in the army again, but the army, fearing that the country was going to lose a war hero, wouldn't let him serve.
- The real Alvin York refused permission to film his life for over 20 years. When Warner Bros. agreed to donate money to his educational charity, he finally relented.

MILITARY SERVICE

- Here is the citation with Sergeant York's Medal of Honor: After his platoon had suffered heavy casualties, and three other noncommissioned officers had become casualties, Corporal York assumed command. Fearlessly leading seven men, he

charged with great daring a machine-gun nest that was pouring deadly and incessant fire upon his platoon. In this heroic feat the machine-gun nest was taken, together with four officers, 128 men, and several guns.

Walter Brennan spent 19 months on the Western Front in France during World War I, from 1917 to 1919, assigned to the 101st Field Artillery.

MISTAKE

- The rifle used in the movie was a 1903 Springfield; in reality York was issued a P-17 Enfield.

QUOTES

Sergeant: Where did ya learn to shoot, York?

Alvin: Well, I ain't never learned, sergeant; folks back home used to say I could shoot a rifle before I was weaned. But they was exaggeratin' some.

George Tobias [last words after being shot; he's a subway guard from New York]: This is where we change cars, Alvin. The end of the line.

Alvin York [after turning down numerous commercial endorsements]: I ain't proud of what I done over there. What we done in France is something we had to do. Some fellers done it ain't a-comin' back. So, the way I figure, things like that ain't for buyin' and sellin'.

Alvin York [after his heroic act and after killing enemy soldiers]: I'm as much agin killin' as ever. But when I heard those machine guns . . . well, them guns was killin' hundreds, maybe thousands, and there weren't nothin' anybody could do but to stop them guns.

AWARDS

Academy Awards, USA, 1941
Won: *Oscar, Best Actor,* Gary Cooper; *Best Film Editing,* William Holmes
Nominated: *Oscar, Best Interior Decoration, Black-and-White,* John Hughes, Fred M. MacLean; *Best Cinematography, Black-and-White,* Sol Polito; *Best Director,* Howard Hawks; *Best Music Scoring of a Dramatic Picture,* Max Steiner; *Best Picture,* Jesse L. Lasky, Hal B. Wallis; *Best Sound Recording,* Nathan Levinson (Warner Bros. SSD); *Best Supporting Actor,* Walter Brennan; *Best Supporting Actress,* Margaret Wycherly; *Best Writing, Original Screenplay,* Harry Chandlee, Abem Finkel, John Huston, Howard Koch

New York Film Critics Circle Awards, 1941
Won: *NYFCC Award, Best Actor,* Gary Cooper.

SEVENTH CROSS, THE

Metro-Goldwyn-Mayer, 1944, b&w, 110 minutes.

Producer: Pandro S. Berman; **Director:** Fred Zinnemann; **Screenwriters:** Helen Deutsch, Anna Seghers (novel, *Das siebte Kreuz*); **Music:** Roy Webb; **Cast:** Felix Bressart, Paul E. Burns, William Challee, Ray Collins, Hume Cronyn, Steven Geray, Connie Gilchrist, Alexander Granach, Paul Guilfoyle, Signe Hasso, Jimmy Hawkins, Hans Herbert, Kurt Katch, Mitchell Lewis, Adolf E. Licho, Katherine Locke, George Macready, Eily Malyon, Agnes Moorehead, Steven Muller, Herbert Rudley, Konstantin Shayne, George Suzanne, Jessica Tandy, Spencer Tracy, Kaaren Verne, Faye Wall, Helene Weigel, John Wengraf, George Zucco.

In 1936, seven prisoners escape from a Nazi concentration camp, and the Nazi commander vows to capture and crucify all of them. One by one they are captured and nailed to crosses outside the camp. The seventh cross, already in place, awaits the final escapee, the desperate fugitive played by Spencer Tracy. He is finally given asylum by a German couple, Hume Cronyn and Jessica Tandy, who hide him at the risk of their own lives. The seventh cross remains empty and becomes a symbol of the Resistance.

The film is based on Anna Seghers's *Das siebte Kreuz* (New York: Monthly Review Press, 1987).

INTERESTING FACT

- The German couple who hide Spencer Tracy, Hume Cronyn and Jessica Tandy, are married in real life.

AWARD

Academy Awards, USA, 1944
 Nominated: *Oscar, Best Supporting Actor,* Hume Cronyn.

7TH DAWN, THE

Holdeana, 1964, color, 123 minutes.

Producer: Charles K. Feldman; **Director:** Lewis Gilbert; **Screenwriter:** Karl Tunberg; **Distributor:** United Artists; **Cast:** Allan Cuthbertson, Maurice Denham, Michael Goodliffe, William Holden, David Keith, Beulah Quo, Sidney Tafler, Tetsuro Tamba, Susannah York.

William Holden fights the Chinese communists in Malaya, only to discover that his best friend is a terrorist.

After the close of the World War II, there was a 12-year emergency situation, starting in the early 1950s, between British soldiers and Chinese communist guerrillas in Malaya.

SEVENTH SURVIVOR, THE

British National, 1941, b&w, 75 minutes.

Producer: Elizabeth Hiscott; **Director:** Leslie S. Hiscott; **Screenwriter:** Michael Barringer; **Distributor:** Anglo-American; **Cast:** Felix Aylmer, Jane Carr, Martita Hunt, Wally Patch, Frank Pettingell, Ronald Shiner, John Stuart, Linden Travers, Austin Trevor, Ralph Truman.

During World War II, six survivors of a U-boat attack are adrift in a lifeboat. One of them (they don't know which one) is a German spy carrying classified information stolen from the Allies. The survivors are then joined by a British counter-spy, who uncovers which of the six is the Nazi.

SEVEN THUNDERS

Dial, 1957, b&w, 100 minutes.

Producer: Daniel M. Angel; **Director:** Hugo Fregonese; **Screenwriter:** Rupert Croft-Cooke; **Music:** Antony Hopkins; **Distributor:** Lopert; **Cast:** Stephen Boyd, Edric Connor, George Coulouris, Rosalie Crutchley, Eugene Deckers, Anton Diffring, Carl Duering, Anna Gaylor, Kathleen Harrison, James Robertson Justice, Katherine Kath, James Kenney, Martin Miller, Yvonne Romain, John Schlesinger, Tony Wright.

Stephen Boyd and Tony Wright are two escaped POWs hiding out in Marseilles during World War II. When they are not battling over the affections of a local gamine, they spend their time planning an elaborate breakout for the other POWs sequestered in the French port city.

Also known as *The Beasts of Marseilles* in the United States.

SEVEN WOMEN

Metro-Goldwyn-Mayer, 1965, color, 87 minutes.

Producers: John Ford, Bernard Smith; **Director:** John Ford; **Screenwriters:** Janet Green, Norah Lofts (novel),

John McCormick; **Music:** Elmer Bernstein; **Cast:** Eddie Albert, Anne Bancroft, Jane Chang, Mildred Dunnock, Betty Field, H. W. Gim, Anna Lee, Hans William Lee, Margaret Leighton, Sue Lyon, Mike Mazurki, Flora Robson, Woody Strode, Irene Tsu.

Anne Bancroft plays a modern-thinking doctor who arrives at an American mission in northern China in 1935. The mission is attacked by Mongolian bandits, who rob, murder, and rape the local Chinese inhabitants. Bancroft submits to their chief, in return for his allowing her seven female compatriots from the mission to leave unharmed. After their departure, she poisons herself and the leader.

INTERESTING FACT

- Anne Bancroft replaced Patricia Neal when Neal suffered a stroke during filming.

QUOTE

Anne Bancroft: I spent years in slum hospitals. I never saw God come down and take care of anyone.

SEVEN WOMEN FROM HELL

20th Century-Fox, 1961, b&w, 88 minutes.

Producer: Harry Spalding; **Director:** Robert D. Webb; **Screenwriters:** Jesse Lasky Jr., Pat Silver; **Music:** Paul Dunlap; **Cast:** Evadne Baker, Yankee Chang, Yvonne Craig, Sylvia Daneel, Denise Darcel, Margia Dean, Kam Fong, John Kerr, Lloyd Kino, Richard Loo, Bob Okazaki, Patricia Owens, Cesar Romero, Pilar Seurat, Yuki Shimoda.

Women break out of a Japanese prison camp in New Guinea and try to reach the safety of the American lines, all the while pursued by enemy soldiers.

QUOTES

Women [as they find American troops]: Yanks!
Soldiers [reacting]: Broads!

SHAKE HANDS WITH THE DEVIL

Pennebaker Productions, Troy Films, 1959, b&w, 111 minutes.

Producers: Michael Anderson, George Glass (executive producer), Walter Seltzer (executive producer); **Director:** Michael Anderson; **Screenwriters:** Rearden Conner (novel), Marian Spitzer (adaptation, as Marian Thompson), Ivan Goff, Ben Roberts; **Music:** Original music by William Alwyn; **Distributor:** United Artists; **Filmed in:** Bray and Dublin, Ireland; **Cast:** Marianne Benet, John Breslin, Harry Brogan, Robert Brown, James Cagney, John Cairney, Lewis Casson, Christopher Casson, Harry H. Corbett, Eileen Crowe, Cyril Cusack, Allan Cuthbertson, Donal Donnelly, Wilfred Downing, Eithne Dunne, Paul Farrell, Richard Harris, William Hartnell, Glynis Johns, Niall MacGinnis, Patrick McAlinney, Ray McAnally, John Le Mesurier, Clive Morton, Don Murray, Noel Purcell, Michael Redgrave, Peter Reynolds, Christopher Rhodes, Sybil Thorndike, Ronald Walsh, Alan White, Dana Wynter.

In 1921 Dublin, the British employ the "Black & Tans," special forces designed to turn the IRA's own harsh tactics against them. Irish-American medical student Don Murray hopes to stay aloof from the fight, but saving a wounded friend brands him an outlaw and inexorably draws him into the rebel organization under his former professor, James Cagney. When the British try to make peace, Cagney doesn't want to stop the war; he has "shaken hands with the devil," he has reached the point where fighting is an end in itself.

The movie is based on Rearden Conner's novel, *Shake Hands with the Devil* (London: Dent, 1933).

SHIPS WITH WINGS

Ealing Studios, 1941, b&w, 103 minutes.

Producer: Michael Balcon, S. C. Balcon; **Director:** Sergei Nolbandov; **Screenwriters:** Patrick Kirwan, Austin Melford, Diana Morgan, Sergei Nolbandov; **Music:** Geoffrey Wright; **Distributor:** United Artists; **Cast:** Leslie Banks, Jane Baxter, Hugh Burden, Frank Cellier, Edward Chapman, John Clements, Ian Fleming, Morland Graham, John Laurie, Betty Marsden, George Merritt, Cecil Parker, Frank Pettingell, Michael Rennie, Charles Russell, John Stuart, Basil Sydney, Ann Todd, Charles Victor, Michael Wilding, Hugh Williams.

John Clements is dismissed from the Fleet Air Arm for misconduct and promptly joins the aircraft carrier HMS *Ark Royal*. When it goes into battle in the Mediterranean, he volunteers for a dangerous mission and dies a hero, crashing his aircraft into a dam that must be destroyed.

INTERESTING FACTS

- The aircraft depicted in the film include Swordfish, Fairy Fulmars (the Royal Navy's first eight-gun fighter), and Skuas.

- The title, *Ships with Wings*, refers to the aircraft carrier *Ark Royal*.
- One of the cameramen, Roy Kellino, actually sailed on the British aircraft carrier HMS *Ark Royal* to obtain the excellent footage of the ship. Deck scenes from the *Ark Royal* give an insight into British carrier operations.
- During shooting, stage 2 at Ealing Studios was hit and badly damaged by German bombs.
- A real-life carrier-based action against the Italian naval base at Taranto occurred between the completion of the film and its release, which offered an opportunity for the publicists to hype the movie.
- Winston Churchill was worried that the suicidal heroics and the loss of an entire squadron in the film would depress the English public, and he tried to get the film shelved.

SHOCK

Monogram Pictures Corporation, 1934, b&w, 70 minutes.

Director: Roy Pomeroy; **Screenwriter:** Madeleine Ruthven; **Cast:** Billy Bevan, Charles Coleman, Clyde Cook, Ralph Forbes, Gwenllian Gill, David Holt, Monroe Owsley, Reginald Sharland, C. Montague Shaw, Douglas Walton.

Ralph Forbes plays a British officer who suffers shell shock in the trenches of World War I and is nursed back to health by his wife.

Called shell shock in World War I, battle fatigue in World War II, and post-traumatic battle syndrome in Vietnam, the condition results from prolonged exposure to combat. Some soldiers are so numbed by combat that they are physically incapacitated, and the condition, even if it is presumed cured, can later reoccur.

SHOPWORN ANGEL, THE

Metro-Goldwyn-Mayer, 1938, b&w, 85 minutes.

Producer: Joseph L. Mankiewicz; **Director:** H. C. Potter; **Screenwriters:** Dana Burnet, Waldo Salt; **Cast:** Charles D. Brown, George Chandler, Alan Curtis, Virginia Grey, Sam Levene, Eleanor Lynn, Hattie McDaniel, Nat Pendleton, Walter Pidgeon, James Stewart, Margaret Sullavan.

During World War I, Gary Cooper, a naive young Texan, is sent to New York for basic training. He meets worldly wise Broadway actress Nancy Carroll when she nearly runs him over with her car. She agrees to be his girl to impress his military buddies before they ship out for France, but this blossoms into a real romance.

INTERESTING FACTS

- Margaret Sullavan's singing was dubbed by Mary Martin.
- The costumes worn by the chorus girls in the final song were used in the final number of *Born to Dance* (1936), *Swinging the Jinx Away*.

QUOTE

Showgirl [showing off her diamonds]: That's what good little girls get for doing what their mommas told them not to do.

SIEGE OF FIREBASE GLORIA, THE

Eastern Film Management, 1989, color, 97 minutes.

Producer: Antony I. Ginnane; **Director:** Brian Trenchard-Smith; **Screenwriters:** Tony Johnston, William Nagle; **Distributor:** Fries Entertainment; **Filmed in:** Philippines; **Cast:** Cris Albert, David Anderson, Robert Arevalo, Dan Austin, Sonny Bee, Thomas Brazzo, Albert Bronski, John Calvin, Mark Calvo, Chris Castillejo, Ray Cerdena, Chika Chikason, Dennis Chuks, Benny Collins, Michael Cruz, Gerard Danlon, Warren Dickson, Christine Erlandson, R. Lee Ermey, Simon Finch, Margi Gerard, Philip Gordon, Eric Hauser, Wings Hauser, Gary Hershberger, Don Holtz, Leila Johnson, Clyde R. Jones, Randy Knudson, Richard Kuhlman, Mark Neely, Nick Nicholson, Banjay Oges, Femi Oladipupo, Albert Popwell, Guel Romero, Mike Silva, Raffy Soques, Mike Soquez, Wendy Stone, Warren Tiller, Ben Uri, Val Victa, Donald Wilson, Mike Wonders.

In the 1968 Tet Offensive during the Vietnam War, a demoralized military base has to be whipped into shape before the Vietcong attack.

SILENT CRIES

Yorkshire Television, 1993, color, 120 minutes.

Producers: Walter Halsey Davis, Paul Pompian, Carol Williams; **Director:** Anthony Page; **Screenwriters:** Janice Young Brooks, Walter Halsey Davis, Vickie Patik; **Music:** Billy Goldenberg; **Cast:** Kim Braden, Pamela Brull, Ginger Darnell, Stan Egi,

Annabeth Gish, Clyde Kusatsu, Lauren Levy, Phyllis Logan, Cherie Lunghi, Lorna Newberry, Natsuko Ohama, Judy Parfitt, Gena Rowlands, James Saito, Mary Nell Santacroce, Sab Shimono, Sylvia Short, Taylor Simpson, Gail Strickland, Nick Tate, Simon Templeton, Chloe Webb.

Gena Rowlands and Annabeth Gish are among the large group of civilians taken prisoner by the Japanese after the fall of Singapore. The women must band together to survive the harsh life of imprisonment, made all the more miserable by the evil camp commandant.

In 1942, during World War II, the Japanese captured the British island fortress of Singapore. During the occupation, not only soldiers were taken prisoner but also innocent civilians, particularly women and children. The Japanese were forced to intern this large number of civilians for the duration of the war, during which time the Japanese showed no regard for the rules of civilized warfare. The women and children had to survive brutal treatment, harsh conditions, and ruthless captors in order to live through their internment.

SILENT ENEMY, THE

Romulus, 1958, b&w, 112 minutes.

Producers: Bertram Ostrer, James Woolf, John Woolf; **Director:** William Fairchild; **Screenwriters:** William Fairchild, Marshall Pugh; **Distributor:** Universal; **Cast:** Dawn Addams, Gianna Maria Canale, John Clements, Michael Craig, Arnoldo Foà, Carlo Giustini, Laurence Harvey, Sid James, Terence Longdon, Howard Marion-Crawford, Alec McCowen, John Moffatt, Lee Montague, Yvonne Romain, Giacomo Rossi-Stuart, Massimo Serato, Cyril Shaps, Nigel Stock, Alan Webb, Ian Whittaker, Raymond Young.

In the Mediterranean during World War II, the Italians start using underwater demolition experts to mine the undersides of Allied ships. British explosives expert Lionel Crabb is sent to Gibraltar to stop the attacks. His mission is complicated by the fact that he only has two other divers to help him, and the Italians are secretly using nearby neutral Spain as their base.

INTERESTING FACT

• This is based on Marshall Pugh's *Commander Crabb*, the true story of Lionel Crabb, a frogman who became famous during World War II for his underwater attacks on Italian ships.

SILENT RAIDERS

L&B Productions, 1954, b&w, 68 minutes.

Producers: Richard Bartlett, Earle Lyon; **Director:** Richard Bartlett; **Screenwriter:** Richard Bartlett; **Music:** Elmer Bernstein; **Distributor:** Lippert Pictures Inc.; **Cast:** Richard Bartlett, Nanette Bordeaux, Huntz Hall, Earl Hansen, Robert Knapp, Earle Lyon, Frank Stanlow, Carl Swanstrom.

Just prior to D day, a commando team lands on the beach to knock out a Nazi communications center.

INTERESTING FACTS

• Star Earle Lyon wrote and performed the haunting title song.
• Look for Bowery Boys star Huntz Hall in the cast.

SILVER FLEET, THE

The Archers, 1943, b&w, 88 minutes.

Producers: Michael Powell, Emeric Pressburger, Ralph Richardson; **Director:** Vernon Sewell, Gordon Wellesley; **Screenwriters:** Emeric Pressburger, Vernon Sewell, Gordon Wellesley; **Distributor:** Rank Organisation; **Cast:** Willem Akkerman, Joss Ambler, John Arnold, Ivor Barnard, Frederick Burtwell, Kathleen Byron, John Carol, Valentine Dyall, Beresford Egan, Margaret Emden, Anthony Eustrel, Dorothy Gordon, Esmond Knight, Philip Leaver, John Longden, Neville Mapp, Charles Minor, Lawrence O'Madden, Ralph Richardson, George Schelderup, Lieutenant Schouwenaar, Lieutenant Van Dapperen, Charles Victor, Googie Withers.

The officer in charge of a shipyard in Nazi-occupied Holland collaborates with the Germans as the easiest course of action. However, when a child's rhyme stirs him to do his patriotic duty, he must discover a way to resist the Nazis without endangering the lives of his wife and workers.

SINCE YOU WENT AWAY

Selznick International Pictures, 1944, b&w, 172 minutes.

Producer: David O. Selznick; **Director:** John Cromwell; **Screenwriters:** David O. Selznick, Margaret Buell Wilder; **Music:** Louis Forbes, Max Steiner; **Distributor:** United Artists; **Cast:** Irving Bacon, Cecil Ballerino, Dick Baron, Lionel Barrymore, Albert Bassermann, Florence Bates, Lela Bliss, Johnny Bond,

George Chandler, Jimmy Clemons Jr., Claudette Colbert, Lloyd Corrigan, Joseph Cotten, Dorothy Dandridge, William B. Davidson, John Derek, Jane Devlin, Janelle Johnson Dolenz, Theodore von Eltz, Rhonda Fleming, Byron Foulger, Dorothy Garner, Ann Gillis, Jonathan Hale, Neil Hamilton, Marilyn Hare, Harry Hayden, Warren Hymer, Eilene Janssen, Robert Johnson, Jennifer Jones, Guy Madison, Edwin Maxwell, Hattie McDaniel, Andrew V. McLaglen, Butterfly McQueen, Terry Moore, Agnes Moorehead, Jackie Moran, Alla Nazimova, Gordon Oliver, Barbara Pepper, Adeline De Walt Reynold, Addison Richards, Ruth Roman, Craig Stevens, Grady Sutton, Shirley Temple, Robert Walker, Jill Warren, Doodles Weaver, Monty Woolley, Keenan Wynn.

When her husband is declared missing in action during World War II, Claudette Colbert must cope with problems on the home front, including raising two daughters, played by Shirley Temple and Jennifer Jones, who are infatuated with soldiers Guy Madison and Robert Walker.

The movie is based on Margaret Buell Wilder's book *Together* (London: McGraw-Hill Book Co., 1943). Coping on the home front during World War II was portrayed effectively in *MRS. MINIVER*.

QUOTES

Claudette Colbert [talking to a stranger on a train, discovering their daughters are the same age]: Where is your daughter now?
Stranger: I don't know. You see, she was at Corregidor.

AWARDS

Academy Awards, USA, 1944
 Won: *Oscar, Best Music, Scoring of a Dramatic or Comedy Picture*, Max Steiner
 Nominated: *Oscar; Best Supporting Actor,* Monty Woolley; *Best Actress,* Claudette Colbert; *Best Supporting Actress,* Jennifer Jones; *Best Interior Decoration, Black-and-White,* Victor A. Gangelin, Mark-Lee Kirk; *Best Cinematography, Black-and-White,* Stanley Cortez, Lee Garmes; *Best Special Effects,* John R. Cosgrove *(photographic)*, Arthur Johns *(sound); Best Film Editing,* Hal C. Kern, James E. Newcom; *Best Picture,* David O. Selznick.

SINGLE-HANDED

20th Century-Fox, 1953, b&w, 100 minutes.

Producer: Frank McCarthy; **Director:** Roy Boulting; **Screenwriters:** Valentine Davies, Hornblower and Hornblower; **Music:** Clifton Parker; **Filmed in:** Gozo Island, Malta; **Cast:** Robin Bailey, Patrick Barr, Martin Boddey, Nicholas Bruce, James Copeland, Robert Dean, James Drake, Peter van Eyck, Wendy Hiller, John Horsley, Jeffrey Hunter, Sam Kydd, Bernard Lee, Guido Lorraine, Victor Maddern, Derek Prentice, Michael Rennie, John Schlesinger, Lockwood West.

A British naval officer has a brief affair with a woman, who bears him a son. Twenty years later, his son is assigned to a ship in his command. They track a German raider, which sinks his son's ship. He must find a way to slow the German's progress and rescue his son.

The movie is based on C. S. Forester's *Brown on Resolution;* U.S. title, *Sailor of the King* (London: John Lane, 1929).

SINK THE BISMARCK!

20th Century-Fox, 1960, b&w, 97 minutes.

Producer: John Brabourne; **Director:** Lewis Gilbert; **Screenwriter:** Edmund H. North; **Music:** Clifton Parker; **Cast:** Sean Barrett, Johnny Briggs, Peter Burton, Ernest Clark, Maurice Denham, Mark Dignam, Michael Goodliffe, Walter Gotell, Jack Gwyllim, Ian Hendry, Michael Hordern, John Horsley, Glyn Houston, Walter Hudd, Geoffrey Keen, Esmond Knight, Kenneth More, Edward R. Murrow, Carl Möhner, Laurence Naismith, Karel Stepanek, John Stuart, Sidney Tafler, Jack Watling, Dana Wynter.

During World War II, the British fleet tracks down and destroys the ~~pocket~~ battleship *Bismarck*, sent into the North Atlantic by Nazi Germany to wreak havoc on England's maritime lifeline to the United States.

This film is based on a true story. The *Bismarck* was Hitler's pride and joy. Tracking down and sinking this warship during the dark early days of World War II gave Britain a well-needed morale boost.

QUOTE

Captain Jonathan Shepard [to his assistant Anne Davis, after the battle]: Take a message: Request pleasure of the company of Second Officer Anne Davis at dinner.

SIROCCO

Santana, 1951, b&w, 98 minutes.

Producers: Henry S. Kesler (associate producer), Robert Lord (producer); **Director:** Curtis Bernhardt;

Screenwriters: A. I. Bezzerides, Hans Jacoby, Joseph Kessel (novel, *Coup de Grace*); **Music:** George Antheil; **Distributor:** Columbia Pictures; **Cast:** Humphrey Bogart, David Bond, Peter Brocco, Lee J. Cobb, Edward Colmans, Nick Dennis, Ludwig Donath, Al Eben, Harry Guardino, Gerald Mohr, Zero Mostel, Jay Novello, Peter Ortiz, Leonard Penn, Vincent Renno, Everett Sloane, Onslow Stevens, Märta Torén, Martin Wilkins.

Humphrey Bogart runs guns to the Druse, who are in revolt against French rule in Syria. When he's arrested by the French, they offer him a deal: They will release him if he will act as an intermediary with the rebels.

The Druse are a Muslim sect that revolted against French misrule in Syria, which had been given to the French as a mandate by the Treaty of Versailles after World War I. For two years the Druse, joined by other disaffected Syrian minorities, fought bravely, made cavalry charges against tanks, and at one point even took Damascus. However, it was an uneven struggle. In June 1927 the revolt collapsed, and the rebel leaders fled to the British mandate in Palestine.

The movie is based on Joseph Kessel's book *Coup de Grace* (Paris: Les Editions de France, 1931).

SITUATION HOPELESS, BUT NOT SERIOUS

Castle, 1965, b&w, 97 minutes.

Producers: Jose De Villaverde (assistant producer), Gottfried Reinhardt; **Director:** Gottfried Reinhardt; **Screenwriters:** Jan Lustig, Silvia Reinhardt, Robert Shaw (novel); **Music:** Harold Byrne; **Distributor:** Paramount; **Cast:** John Briley, Mike Connors, Paul Dahlke, Alec Guinness, Anita Höfer, Elisabeth von Molo, Mady Rahl, Robert Redford, Carola Regnier, Frank Wolff.

During World War II, two American fliers, Mike Connors and Robert Redford, bail out and parachute into a small German town. Mild-mannered clerk Alec Guinness captures them and, being lonely, decides to hold them prisoner in his basement. Unwilling to lose his reluctant guests, he doesn't tell them when the war is over. When they escape six years later, they think they are in a world dominated by the Nazis.

As the two captives flee across Germany, they stumble onto the set of a war film. Thinking that the extras, dressed as German soldiers, are going to recapture them, they are forced to escape and evade.

INTERESTING FACT

- This was Robert Redford's big-screen debut.

633 SQUADRON

Mirisch Company, 1964, color, 101 minutes.

Producers: Cecil F. Ford, Lewis J. Rachmil; **Director:** Walter Grauman; **Screenwriters:** James Clavell, Howard Koch, Frederick E. Smith; **Music:** Ron Goodwin; **Distributor:** United Artists; **Filmed in:** RAF Bovingdon Air Base, England; **Cast:** Harry Andrews, Barbara Archer, John Bonney, Edward Brayshaw, Johnny Briggs, George Chakiris, John Church, Suzan Farmer, Scott Finch, Geoffrey Frederick, Michael Goodliffe, Drewe Henley, Donald Houston, Sean Kelly, Peter Kriss, Angus Lennie, Arnold Locke, Cavan Malone, John Meillon, Maria Perschy, Cliff Robertson, Richard Shaw, Julian Sherrier, Chris Williams.

The 633 Squadron has enjoyed an unqualified string of successes, until it is assigned to bomb a German heavy-water plant in Norway, which is shielded by a mountain and guarded by heavy anti-aircraft defenses. The nearly impossible mission, with its difficult target approach, is further complicated by the capture and torture of the underground leader who is assisting the squadron.

This film is similar to *THE DAM BUSTERS* in that a British squadron is training for a very specific mission against a unique target. In this film, the huge rock ledge hanging over the factory presents a unique obstacle for the planes to overcome, and, as expected, some planes cannot make the turn, crashing into the rock.

The film is based on Frederick E. Smith's book *633 Squadron* (London: Cassell, 1975).

INTERESTING FACTS

- Only three of the De Havilland Mosquitoes seen in this film were airworthy and another two could only taxi on the ground. The latter two were deliberately destroyed in crash scenes. One of the crashes was filmed from two angles and used for separate scenes.
- The German fighters were actually four-seat Messerschmitt 108 "Taifuns," painted to look like Me-109 fighters.

MISTAKE

- During the practice bombing scene in Scotland, one of the planes crashes into a hillside. The next shot shows a number of officers standing next to a Land Rover. This film takes place during World War II, and the Land Rover did not begin production until 1948.

QUOTES

Squadron Leader Adams: Then what's it all add up to? All their sacrifice?
Air Vice Marshal Davis: A successful operation.
Squadron Leader Adams: But they're probably all dead. All 633 Squadron!
Air Vice Marshal Davis: You can't kill a squadron.

SKI PATROL

Universal Pictures, 1940, b&w, 64 minutes.

Director: Lew Landers; **Screenwriter:** Paul Huston; **Music:** Ralph Freed, Charles Henderson, Charles Previn, Heinz Roemheld, Hans J. Salter, Frank Skinner, Franz Waxman; **Cast:** Kathryn Adams, Hardie Albright, John Arledge, Henry Brandon, Luli Deste, Philip Dorn, Ivan Dubroski, John Ellis, Stanley Fields, Reed Hadley, Samuel S. Hinds, Edward Norris, John Qualen.

Philip Dorn leads his brave ski troops against the invading Russian hordes in the mountains of his native Finland.

Near the beginning of World War II, the Russians invaded Finland (the Russo-Finnish War). The Finns fought bravely, but the struggle was grossly unequal, and the Russian victory was inevitable.

SKI TROOP ATTACK

New World Pictures, 1960, b&w, 63 minutes.

Producer: Roger Corman; **Directors:** Roger Corman, Monte Hellman; **Screenwriter:** Charles B. Griffith; **Music:** Fred Katz; **Distributor:** Filmgroup **Filmed in:** Deadwood, South Dakota; **Cast:** Skeeter Bayer, Chan Biggs, Wally Campo, Sheila Carol, Roger Corman, Michael Forest, James Hoffman, Wayne Lasher, David Mackie, Richard Sinatra, Tom Staley, Frank Wolff.

American ski troops journey behind enemy lines to blow up a Nazi-held bridge.

INTERESTING FACT

- Roger Corman had his actors positioned for a ski run down a mountain of virgin snow. When he called for action on his bullhorn, however, the sound waves started an avalanche. No one was hurt, but Corman was frustrated by this unplanned event. There was only one thing he could do. Corman raised the bullhorn to his mouth and ordered his crew to "stop that snow!"

SKY COMMANDO

Columbia Pictures Corporation, 1953, b&w, 69 minutes

Producer: Sam Katzman; **Director:** Fred F. Sears; **Screenwriters:** Samuel Newman, Arthur E. Orloff, William Sackheim; **Music:** Ross DiMaggio; **Cast:** Morris Ankrum, Mike Connors, Dan Duryea, Michael Fox, Frances Gifford, Selmer Jackson, William Klein, Dick Lerner, Paul McGuire, Freeman Morse, Dick Paxton.

Dan Duryea plays a jet fighter pilot during the Korean War held responsible by an officer in his command for his brother's death. All of the men in his squadron believe he is an inflexible martinet whose orders will get them killed. However, when they hear about his exploits during World War II, in which he was the unpopular commander of a photo reconnaissance squadron that conducted a successful mission over the oil fields of Rumania, when other squadrons were sustaining heavy casualties, they gain a new respect for the abilities of their commander.

SKY HAWK

Fox Film Corporation, 1930, b&w, 67 minutes.

Director: John G. Blystone; **Screenwriters:** Campbell Gullan, Llewellyn Hughes (also article, "Chap Called Bardell"); **Music:** Charles Wakefield Cadman, Edward Lynn; **Distributor:** Fox Film Corporation; **Cast:** Billy Bevan, Percy Challenger, Helen Chandler, Joyce Compton, Gilbert Emery, John Garrick, Lumsden Hare, David Manners, Lennox Pawle, Daphne Pollard.

During World War I, an RAF flier misappropriates an airplane to see his lady love and crashes it; his legs are paralyzed. Rejected by his comrades, he finds a badly damaged plane, has it rebuilt, and uses it to shoot down a zeppelin, thereby redeeming himself.

INTERESTING FACT

- The battle sequences use miniatures on a set that cost a quarter of a million dollars, a fantastic amount for special effects at that time.

SLAUGHTERHOUSE FIVE

Vanadas Productions, 1972, color, 104 minutes.

Producers: Jennings Lang (executive producer), Paul Monash; **Director:** George Roy Hill; **Screen-

writers: Kurt Vonnegut Jr. (novel, *Slaughterhouse-Five Or the Children's Crusade*), Stephen Geller; **Music:** Glenn Gould, Johann Sebastian Bach; **Distributor:** Universal Pictures; **Filmed in:** Minnesota, USA and Prague, Czechoslovakia; **Cast:** Karl-Otto Alberty, Nick Belle, Lucille Benson, Roberts Blossom, Sorrell Booke, Henry Bumstead, Kevin Conway, John Dehner, Sharon Gans, Stan Gottlieb, Perry King, Frederick Ledebur, Ron Leibman, Gilmer McCormick, Holly Near, Valerie Perrine, Eugene Roche, Michael Sacks, Richard Schaal, Gary Waynesmith, John Wood.

Pilgrim (Michael Sacks) is an average guy who, like Walter Mitty, escapes his bland and humdrum existence by "time-tripping" to the planet Tralfamadore, where his escapades including being seduced by the sexy Montana Wildhack (Valerie Perrine). His earthbound adventures include internment as a POW during World War II, surviving the 1945 firebombing of Dresden, and living in suburbia as a middle-aged optometrist in Ilium, New York, with an overweight wife and two annoying children.

The film is based on Kurt Vonnegut's book *Slaughterhouse Five* (New York: Dell, 1969).

SMALL BACK ROOM, THE

British Lion Film Corporation, London Film Productions, The Archers, 1949, b&w, 106 minutes.

Producers: George R. Busby, Anthony Bushell, Michael Powell, Emeric Pressburger; **Directors:** Michael Powell, Emeric Pressburger; **Screenwriters:** Nigel Balchin, Michael Powell, Emeric Pressburger; **Filmed in:** Chesil Bank, Dorset, England; **Cast:** Renée Asherson, Leslie Banks, Elwyn Brook-Jones, Anthony Bushell, Kathleen Byron, Henry Caine, James Carney, Cyril Cusack, James Dale, June Elvin, David Farrar, Walter Fitzgerald, Brian Forbes, Michael Goodliffe, Michael Gough, Jack Hawkins, Ted Heath, Roddy Hughes, David Hutcheson, Sid James, Emrys Jones, Geoffrey Keen, Sam Kydd, Roderick Lovell, Robert Morley, Michael Powell, Milton Rosmer.

A bomb disposal officer is badly injured and in frequent pain. He finds solace and relief from his pain in the whisky and pills that are never far away. A new type of booby-trapped bomb pushes his nerves and resolution to the limit.

The movie is based on Nigel Balchin's book *The Small Back Room* (London: Collins, 1943).

QUOTES

Sammy Rice: I must have a drink. Ask me to have a drink, woman.
Susan: Have a drink, Sammy.
Sammy Rice: Whisky?
[Susan nods.]
Sammy Rice: No thanks, Susan.

Susan: Where were you going, Sammy?
Sammy Rice: I don't know.
Susan: A woman?
Sammy Rice: Maybe.
Susan: How about me?

SNIPER'S RIDGE

Associated Producers, Inc., 1961, b&w, 61 minutes.

Producer: John A. Bushelman; **Director:** John A. Bushelman; **Screenwriter:** Tom Maruzzi; **Music:** Richard LaSalle; **Distributor:** 20th Century-Fox Film Corporation; **Cast:** Gabe Castle, Joe Cawthon, Stanley Clements, Mason Curry, Henry Darrow, Mark Douglas, Al Freeman Jr., Jack Ging, John Goddard, Douglas Henderson, Richard Jeffries, Allan Marvin, Scott Randall, Thomas A. Sweet, Anton Van Stralen, George Yoshinaga.

John Goddard is a mentally unstable, gung-ho officer during the Korean War. His men know that an armistice is imminent, but instead of trying to keep them out of harm's way so that they can survive the war, he decides to take them on a dangerous mission.

SNOW TREASURE

Sagittarius Productions, 1967, color, 95 minutes.

Producer: Irving Jacoby; **Director:** Irving Jacoby; **Screenwriters:** Irving Jacoby, Marie McSwigan; **Music:** Egil Monn-Iversen; **Distributor:** Allied Artists; **Filmed in:** Norway; **Cast:** Paul Austad, Randi Borch, Wilfred Breistrand, James Franciscus, Bente Nielsen, Raoul Oyen, Ilona Rodgers, Tor Stokke.

Norway is occupied by Nazi Germany during World War II. The Norwegians must save their gold from the Nazis, but all of the adults are continually searched by the invaders. Therefore the children, who are avid skiers, carry the gold bars, one at a time, in their backpacks across the mountains by ski, to a waiting fishing boat. It is a race against time, because it is spring and the snow is melting.

The movie is based on Marie McSwigan's book *Snow Treasure* (New York: E. P. Dutton and Company, Inc., 1942).

SO ENDS OUR NIGHT

David L. Loew-Albert Lewin, 1941, b&w, 117 minutes.

Producers: Albert Lewin, David L. Loew; **Director:** John Cromwell; **Screenwriters:** Talbot Jennings, Erich Maria Remarque; **Music:** Louis Gruenberg; **Distributor:** United Artists; **Cast:** Edit Angold, Roman Bohnen, Allan Brett, Wilhelm von Brincken, James Bush, Joseph Cawthorn, Spencer Charters, Frances Dee, Ernst Deutsch, Edward Fielding, Glenn Ford, Lisa Golm, Alexander Granach, Leonid Kinskey, Kate MacKenna, Fredric March, Joe E. Marks, Adolph Milar, Emory Parnell, Marjorie Rambeau, Lionel Royce, Greta Rozan, Sig Ruman, Hans Schumm, William Stack, Walter O Stahl, Anna Sten, Erich von Stroheim, Margaret Sullavan, Philip Van Zandt, Frederick Vogeding, Gisela Werbisek.

Refugees from the Nazis travel across Europe, avoiding the police and the Gestapo, using counterfeit passports to travel from country to country. Fredric March is a political refugee whose politics do not agree with the Nazis.

The film is based on Erich Maria Remarque's book *Flotsam* (Boston: Little, Brown and Company, 1941).

SOLDIER'S STORY, A

Caldix, Columbia Pictures Corporation, Delphi, 1984, color, 96 minutes.

Producers: Norman Jewison, Charles Milhaupt (associate producer), Patrick J. Palmer (as Patrick Palmer), Charles Schultz (executive producer), Ronald L. Schwary; **Director:** Norman Jewison; **Screenwriter:** Charles Fuller (also stageplay, *A Soldier's Play*); **Music:** Herbie Hancock; **Distributor:** Columbia Pictures; **Filmed at:** Fort Chaffee, Arkansas; **Cast:** David Ashley, Patricia Brandkamp, James W. Bryant, Adolph Caesar, Warren Clements, Terry Dodd, Carl Dreher, Art Evans, Calvin Franklin, Pat Grabe, Ronald E. Greenfield, David Alan Grier, John Hancock, David Harris, Wings Hauser, Lacarnist Hiriams, Thomas Howard, Patti LaBelle, Tommy G. Liggins, Dennis Lipscomb, Bobby McGee, Kevin T. Mosley, Scott Paulin, Rick Ramey, Vaughn Reeves, Larry Riley, Howard E. Rollins Jr., Anthony C. Sanders, Traftin E. Thompson, Robert Townsend, Robert Tyler, John Valentine, Denzel Washington, Roy Wells, Michael Williams, Trey Wilson, William Allen Young.

In World War II–era Tynen, Louisiana, a black master sergeant is found shot to death just outside the local army base for black soldiers. A military lawyer, also a black man, is sent from Washington to conduct an investigation. Facing an uncooperative chain of command and fearful black troops, the investigator must battle deceit and prejudice to find out who really killed the sergeant. At first he suspects the white townspeople, but as he digs deeper, he discovers that the sergeant was unpopular with his own black troops.

MISTAKE

- The film image is reversed during a baseball play at second base, evidenced by the mirror-image numbers on the uniforms of the players.

QUOTES

Private Wilkie: Is it true, sir, that when they found him, his stripes and insignia were still on the uniform?
Captain Davenport: Yes.
Private Wilkie: Something's wrong, ain't it, sir? I mean, those Klan boys, they can't stand to see us in these uniforms. They usually take the stripes and stuff off before they lynch us.

Master Sgt. Vernon Waters: You know the damage one ignorant Negro can do? We were in France in the first war; we'd won decorations. But the white boys had told all them French gals that we had tails. Then they found this ignorant colored soldier, paid him to tie a tail to his ass and run around half-naked, making monkey sounds. Put him on the big round table in the Café Napoleon, put a reed in his hand, crown on his head, blanket on his shoulders, and made him eat bananas in front of all them Frenchies. Oh, how the white boys danced that night . . . passed out leaflets with that boy's picture on it. Called him Moonshine, King of the Monkeys. And when we slit his throat, you know that fool asked us what he had done wrong?

AWARDS

Academy Awards, USA, 1984
 Nominated: *Oscar*, *Best Picture*, Norman Jewison, Patrick J. Palmer, Ronald L. Schwary; *Best Supporting Actor*, Adolph Caesar; *Best Writing, Screenplay Based on Material from Another Medium*, Charles Fuller

Casting Society of America, USA, 1985
 Nominated: *Artios, Best Casting for Feature Film,* Reuben Cannon

Edgar Allan Poe Awards, 1985
 Won: *Edgar, Best Motion Picture,* Charles Fuller

Golden Globes, USA, 1985
 Nominated: *Golden Globe, Best Motion Picture—Drama; Best Performance by an Actor in a Supporting Role in a Motion Picture,* Adolph Caesar; *Best Screenplay—Motion Picture,* Charles Fuller

Los Angeles Film Critics Association Awards, 1984
 Won: *LAFCA Award, Best Supporting Actor,* Adolph Caesar

Writers Guild of America, USA, 1985
 Nominated: *WGA Screen Award, Best Screenplay Based on Material from Another Medium,* Charles Fuller.

SOLDIER'S SWEETHEART, A

Moloney/Donnelly Productions, Showtime Networks Inc., 1998, color, 112 minutes.

Producers: William S. Gilmore, Marianne Moloney; **Director:** Thomas Michael Donnelly; **Screenwriters:** Thomas Michael Donnelly, Tim O'Brien; **Distributor:** Paramount Pictures; **Filmed in:** Auckland, New Zealand; **Cast:** Christopher Birt, Georgina Cates, Larry Gilliard Jr., Daniel London, Kiefer Sutherland, Skeet Ulrich, Louis Vanaria.

During the Vietnam War, an army medic brings his girlfriend to stay with him at a remote outpost. When she disappears, he sets out to find her.

SOMETHING OF VALUE

Metro-Goldwyn-Mayer, 1957, b&w, 113 minutes.

Producer: Pandro S. Berman; **Director:** Richard Brooks; **Screenwriters:** Richard Brooks, Robert C. Ruark (novel); **Music:** Miklos Rozsa; **Filmed in:** Africa; **Cast:** Bob Anderson, Robert Beatty, Barry Bernard, Wesley Bly, Naaman Brown, Carl Christian, Leslie Denison, Ivan Dixon, Walter Fitzgerald, Barbara Foley, Kim Hamilton, Juano Hernandez, Wendy Hiller, Rock Hudson, Samandu Jackson, Ike Jones, Bruce Lester, William Marshall, Lester Matthews, Paulene Myers, Ottola Nesmith, Frederick O'Neal, Michael Pate, Sidney Poitier, Ken Renard, Duncan Richardson, Morgan Roberts, Garry Stafford, Madame Sul-Te-Wan, Paul Thompson, Dana Wynter.

Sidney Poitier grows up in Kenya, subjected to the tyranny of white rule, and joins the Mau Mau rebellion. Rock Hudson, his friend since they were boys, wants the violence to stop and wants equality for the black tribesmen.

The Mau Mau rose up in a bloody revolt in the 1950s in Kenya, East Africa, against British rule. Mainly Kikuyu tribesmen, the Mau Mau killed many white settlers on isolated farms before the uprising was finally crushed in 1956.

The film is based on Robert C. Ruark's book *Something of Value* (Garden City: Doubleday, 1955).

AWARD

Venice Film Festival, 1957
 Nominated: *Golden Lion,* Richard Brooks.

SOMEWHERE ON LEAVE

Butchers, Mancunian Film Corp., 1942, b&w, 96 minutes.

Producer: John E. Blakeley; **Director:** John E. Blakeley; **Screenwriters:** Roney Parsons, Frank Randle, Anthony Toner; **Cast:** Tonie Bruce, Noel Dainton, Harry Korris, Antoinette Lupino, Pat McGrath, Frank Randle, Robbie Vincent, Dan Young.

Four crazy soldiers get a much-needed furlough, which they decide to spend in the posh home of their rich and wealthy buddy. As the guys enjoy themselves, their host gets to fall in love with the girl of his dreams.

INTERESTING FACT

• This film is part of the British "Somewhere . . ." series.

SONG OF RUSSIA

Metro-Goldwyn-Mayer, 1943, b&w, 107 minutes.

Producers: Pandro S. Berman, Joe Pasternak; **Director:** Gregory Ratoff; **Screenwriters:** Richard Collins, Guy Endore (story), Paul Jarrico, Leo Mittler (story), Victor Trivas (story), Edgar G. Ulmer; **Music:** Jerome Kern (song, *And Russia Is Her Name*), Herbert Stothart, Eric Zeisl, Pyotr Ilyich Tchaikovsky; **Distributor:** MGM; **Cast:** Robert Benchley, Felix Bressart, Barbara Bulgakov, Leo Bulgakov, Michael Chekhov, Darryl

Hickman, John Hodiak, Zoia Karabanova, Joan Lorring, Leo Mostovoy, John Nesbitt, Moyshe Oysher, Susan Peters, Patricia Prest, Tommy Rall, Konstantin Shayne, Tamara Shayne, Vladimir Sokoloff, Robert Taylor, John Wengraf, Jacqueline White.

Robert Taylor plays an American bandleader who falls in love with a Russian pianist. Then the Nazis invade Russia.

INTERESTING FACT

- This was one of the films, showing Russia as a brave ally and made with the full endorsement of the U.S. government during World War II, that subjected its creators to later investigation by the House Un-American Activities Committee.

MILITARY SERVICE

- Immediately after completing this film, Robert Taylor enlisted in the U.S. Navy.

SO PROUDLY WE HAIL!

Paramount Pictures, 1943, b&w, 126 minutes.

Producer: Mark Sandrich; **Director:** Mark Sandrich; **Screenwriter:** Allan Scott; **Music:** Edward Heyman, Miklós Rózsa; **Cast:** Walter Abel, Dorothy Adams, Amparo Antenercruz, James Bell, Linda Brent, Barbara Britton, Dr. Hugh Ho Chang, Claudette Colbert, Isabel Cooper, Richard Crane, Boyd Davis, Yvonne De Carlo, Eddie Dew, Ann Doran, Mimi Doyle, Edward Earle, Julia Faye, James Flavin, William Forrest, Byron Foulger, Paulette Goddard, Bill Goodwin, Roy Gordon, Lorna Gray, Ted Hecht, Dick Hogan, Elsa Janssen, Hazel Keener, Kitty Kelly, Victor Kilian, Veronica Lake, Charles Lester, John Litel, Jack Luden, Helen Lynd, James Millican, Frances Morris, Damian O'Flynn, Hugh Prosser, George Reeves, Mary Servoss, Byron Shores, Harry Strang, Joan Tours, Mary Treen, Sonny Tufts, Lynn Walker, Jan Wiley, Jean Willes, Hank Worden, Will Wright.

A group of freshly minted U.S. Army nurses leave for what they expect will be an easy tour of duty in Hawaii, but the attack on Pearl Harbor changes their destination to beleaguered Bataan in the Philippines. They quickly become battle-weary veterans who, amid daily bombardments by the Japanese and dwindling medical supplies, are overwhelmed by the number of casualties. After the fall of Bataan, they flee with the American forces to the offshore island of Corregidor, where they continue to help the wounded under the continual Japanese assault.

This is based on the true story of the suffering of the military nurses who fought alongside the soldiers defending Bataan and Corregidor against the brutal assault of the Japanese on the Philippines during World War II.

INTERESTING FACTS

- Paulette Goddard won an Oscar nomination for best supporting actress, even though she was billed as a star.
- The Oscar-nominated script was based on firsthand accounts of what the nurses actually went through.
- The ordeal of the nurses was well known to the public at the time, because of a pictorial series in *Life* magazine.

MILITARY SERVICE

- George Reeves would later become TV's Superman. Paramount was grooming him to be a major star, but his career was derailed by his draft notice. After Reeves spent the war in the U.S. Army Air Force making training films, his film career would never regain the same level.

AWARDS

Academy Awards, USA, 1943
 Nominated: *Oscar, Best Cinematography, Black-and-White,* Charles Lang; *Best Special Effects,* George Dutton *(sound),* Farciot Edouart *(photographic),* Gordon Jennings *(photographic); Best Supporting Actress,* Paulette Goddard; *Best Writing, Original Screenplay,* Allan Scott.

SOUTHERN COMFORT

EMI Films Ltd., 1981, color, 99 minutes.

Producers: David Giler, William J. Immerman; **Director:** Walter Hill; **Screenwriters:** David Giler, Walter Hill, Michael Kane; **Music:** Ry Cooder; **Filmed in:** Louisiana, and Caddo Lake, Texas; **Cast:** Alan Autry, Dewey Balfa, Powers Boothe, June Borel, Orel Borel, Jeanne-Louise Bulliard, Keith Carradine, T. K. Carter, Peter Coyote, Ned Dowd, Allan Graf, Greg Guirard, Brion James, Sonny Landham, Les Lannom, Rob Ryder, Frank Savoy, Marc Savoy, Franklyn Seales, Lewis Smith, Jeannie Spector, John Stelly, Fred Ward.

A squad of National Guardsmen on an weekend training exercise in a Louisiana swamp must fight for their lives when they anger local Cajuns by stealing their canoes. Without live ammunition, and with no experience in the swamp, their trek to safety, as they lose one man after another, becomes a nightmare.

This film was made in 1981, while the Vietnam War experience was still fresh in the minds of the audience. The struggles of the soldiers in a countryside with which they are unfamiliar, fighting against an often unseen enemy who speaks a different language, fighting for reasons they do not believe are important, takes on an eerie Vietnam feel.

QUOTES

Hardin: Four of them with automatic weapons against some swamp rat. I make it even money.

Simms: Why are we following this dumb bastard?
Stuckey: Because he's got stripes.

SOUTH PACIFIC

South Pacific Enterprises, Magna Corporation, 1958, color, 151 minutes.

Producer: Buddy Adler; **Director:** Joshua Logan; **Screenwriters:** Oscar Hammerstein II, Joshua Logan, James Michener, Paul Osborn; **Music:** Richard Rodgers; **Distributor:** 20th Century-Fox Film Corporation; **Filmed in:** Ibiza, Balearic Islands, and Kauai, Hawaii; **Cast:** Beverly Aadland, Joe Bailey, Rossano Brazzi, Russ Brown, Ken Clark, Buck Class, Richard H. Cutting, Ron Ely, Darleen Engle, Stephen Ferry, Joan Fontaine, Linc Foster, Ed Fury, John Gabriel, Mitzi Gaynor, Juanita Hall, Richard Harrison, Warren Hsieh, Robert Jacobs, Francis Kahele, John Kerr, Richard Kiser, Tom Laughlin, Bill Lee, Candace Lee, Doug McClure, Jack Mullaney, France Nuyen, Archie Savage, Floyd Simmons, Muriel Smith, James Stacy, Giorgio Tozzi, Ray Walston, Steve Wiland.

It is 1943 and the U.S. Navy has secured several bases in the Solomon Islands in preparation for an invasion of New Guinea. On one such island lives a French planter named Emile de Becque, whom the navy wishes to employ as a scout of nearby Japanese-held islands. Against this backdrop of the Solomons campaign unfolds the story of two romances, both of which explore racial miscegenation. One is the story of a young naval lieutenant's passion for a young native girl; the other explores the love of a young navy nurse for the French planter de Becque.

A historical background is helpful for maximum enjoyment of this film. On August 7, 1942, as part of their march across the Pacific to Japan, the First Marine Division landed on Guadalcanal and seized Henderson Field. Later they were reinforced by the Second Marine and the 25th and Americal Infantry divisions. After six months of bloody jungle warfare, the Americans wiped out the last enemy units on February 8, 1943. New Georgia was taken on August 6, 1943, by the 37th, 43rd, and 25th Infantry divisions. Bougainville was invaded on November 1, 1943, by the Third Marines, later reinforced by the 37th, 93rd, and Americal Infantry divisions. In a series of five naval engagements from August 9 to November 15, 1942, the U.S. Navy protected the invasion of the Solomon Islands. A large portion of the Japanese fleet was destroyed, but at a heavy cost in American ships. During the Battle of Savo Island (August 9), a Japanese night attack was repulsed, but the United States lost the cruisers *Quincy*, *Vincennes*, and *Astoria*. During the Battle of Eastern Solomons (August 23–25), American carrier planes forced the enemy fleet to withdraw; later actions sunk the carrier *Wasp* and five destroyers. During the Battle of Cape Esperance (October 11–12), an American night attack again drove off the Japanese. At the Battle of Santa Cruz Island (October 26), American and Japanese carriers exchanged blows; two enemy carriers were sunk and about 100 planes shot down at a cost of the carrier *Hornet* and 74 planes. (The Japanese had made a special target of the *Hornet*, ever since it had carried the Doolittle Raid to attack Japan, so it was only a matter of time until it was sunk.) At the Battle of Guadalcanal (November 13–15), Japanese attacks were repulsed with heavy losses on both sides, including the American cruisers *Atlanta* and *Juneau*; the cruiser *Northampton* was sunk two weeks later off Lunga Point.

The film is based on James Michener's *Tales of the South Pacific* (New York: The Macmillan Company, 1947).

INTERESTING FACTS

- Early casting considerations for the role of Nellie Forbush included Doris Day, Audrey Hepburn, and Elizabeth Taylor.
- Concerned that the film's lush tropical settings would appear unnatural in Technicolor, director Joshua Logan hoped to soften the effect by filming several scenes through colored filters.
- Juanita Hall, who played Bloody Mary in the original Broadway production, sang her own songs onstage but was dubbed in the film version at the request of composer Richard Rodgers.

- Director Joshua Logan began his military career at Culver Military Academy, where his stepfather, Colonel Noble, was on the faculty. In the U.S. Army in World War II, his first assignment was working with Irving Berlin on the song *This Is the Army*. He then entered OCS, graduated first in a class of 3000, and served with the Ninth Air Force, as an intelligence officer with the 405th Fighter Group.
- James Michener based this film on his experiences during World War II. Commissioned a lieutenant, he was made the publications editor for the Bureau of Aeronautics, which he hated, and finally was able to sail for the South Pacific in 1944, where he was assigned as the liaison officer to the native populations of 49 different islands. He was discharged as a lieutenant commander.

MISTAKES

- In the first scene between Nellie and Luther Billis (during the song *There Is Nothing Like a Dame*), Luther's shirt unbuttons and rebuttons itself several times.
- The tattoo on the stomach of Luther Billis disappears and reappears when he is stranded in the lifeboat.

AWARDS

Academy Awards, USA, 1958
 Won: *Oscar, Best Sound*, Fred Hynes (Todd-AO SSD)
 Nominated: *Oscar, Best Cinematography, Color*, Leon Shamroy; *Best Music, Scoring of a Musical Picture*, Ken Darby, Alfred Newman

Writers Guild of America, USA, 1959
 Nominated: *WGA Screen Award, Best Written American Musical*, Paul Osborn.

SOUTH SEA WOMAN

Warner Bros. Pictures Inc., 1953, b&w, 99 minutes.

Producer: Samuel Bischoff; **Director:** Arthur Lubin; **Screenwriters:** Earl Baldwin, Edwin Blum, William Rankin (play), Stanley Shapiro; **Music:** David Buttolph; **Distributor:** Warner Bros.; **Cast:** John Alderson, Richard Alexander, Rudolph Anders, Leon Askin, Alena Awes, Paul Bryar, Paul Burke, Cliff Clark, Chuck Connors, Noel Cravat, Viola Daniels, Violetta Daniels, Raymond Greenleaf, Jim Hayward, Barry Kelley, Burt Lancaster, Henri Letondal, Keye Luke, Strother Martin, Virginia Mayo, William O'Leary, Hayden Rorke, Georges Savrel, Arthur Shields, Bob Sweeney, Veola Vonn.

U.S. Marine Burt Lancaster tries to stop his buddy, Chuck Connors, from marrying pretty blonde Virginia Mayo in Shanghai. As a result, they miss their troop ship and decide to hire a Chinese junk to catch up. Ending up stranded on an island controlled by Vichy France, they pretend to be deserters from the Marine Corps and start fighting their own war, freeing prisoners, blowing up a Japanese destroyer, and interfering with a Japanese invasion.

 Under the Uniform Code of Military Justice, "missing movement" (missing the ship) is a very serious offense. Trying to catch up with your unit is a good way to mitigate your punishment. Such travel is at the personal expense of the soldier.

SPY IN BLACK, THE

Harefield, 1939, b&w, 82 minutes.

Producer: Irving Asher; **Director:** Michael Powell; **Screenwriters:** J. Storer Clouston, Roland Pertwee, Emeric Pressburger; **Distributor:** Columbia Pictures; **Filmed in:** Orkney Islands, Scotland; **Cast:** Esma Cannon, June Duprez, Marius Goring, Helen Haye, Valerie Hobson, Skelton Knaggs, Agnes Laughlin, Bernard Miles, Margaret Moffatt, Mary Morris, Hay Petrie, Cyril Raymond, Robert Rendel, Sebastian Shaw, Diana Sinclair-Hall, Athole Stewart, George Summers, Grant Sutherland, Torin Thatcher, Conrad Veidt, Kenneth Warrington.

During World War I, when a German U-boat captain is sent as a spy to the north of Scotland, he finds more than he bargained for in the mission when he meets his contact, the local schoolmistress.

 The movie is based on Storer J. Clouston's book *The Spy in Black* (New York: Doran, 1918); retitled in the United States as *U-Boat 29*.

QUOTES

The Rev. John Harris: That medal ribbon. I don't seem to recognize it. What is it?
Captain Hardt: The Iron Cross . . . Second Class.
The Rev. John Harris: Second Class . . . then you must be a prisoner of war?
Captain Hardt [draws Luger]: No. You are.
The Rev. John Harris: Oh dear.

SPY TRAIN

Monogram Pictures Corporation, 1943, b&w, 61 minutes.

Producer: Max King; **Director:** Harold Young; **Screenwriters:** Bart Lytton, Wallace Sullivan; **Cast:** Evelyn Brent, Chick Chandler, Catherine Craig, John Hamilton, Bill Hunter, Warren Hymer, Stephen Roberts, Fred Toones, Richard Travis, Thelma White.

Richard Travis barrels through the countryside on a train with Nazi secret agents.

SQUADRON LEADER X

RKO Radio British Productions, 1942, b&w, 90 minutes.

Producer: Victor Hanbury; **Director:** Lance Comfort; **Screenwriters:** Miles Malleson, Emeric Pressburger, Wolfgang Wilhelm; **Music:** William Alwyn; **Cast:** Ann Dvorak, Walter Fitzgerald, Carl Jaffe, Barry Jones, Mary Merrall, Martin Miller, Henry Oscar, David Peel, Eric Portman, Marjorie Rhodes, Friedrich Richter, Beatrice Varley, Charles Victor.

Wearing an RAF uniform, speaking with an English accent, possessing a photograph of his wife and a packet of Players cigarettes (an English brand), a German agent is parachuted into occupied Belgium to create anti-British propaganda. Unfortunately for his plan, the Belgian Resistance is very efficient, and, before he knows it, he has been smuggled across the Channel to England. He can't protest because he is supposed to be a downed British aviator. Stuck in England, he must find a way back to Germany.

SQUARE OF VIOLENCE

Lovcen Film, Crna Gora, Metro-Goldwyn-Mayer, 1961, b&w, 98 minutes.

Producer: Leonardo Bercovici; **Director:** Leonardo Bercovici; **Screenwriters:** Eric Bercovici, Leonardo Bercovici; **Distributor:** MGM; **Music:** Dusan Radic; **Cast:** Bibi Andersson, Anita Björk, Valentina Cortese, Broderick Crawford, Dragomir Felba, Hermina Pipinic, Branko Plesa, Bert Sotlar, Viktor Starcic.

Broderick Crawford plays a partisan who kills 30 German soldiers. In retaliation, the Nazis round up 300 local citizens and threaten to kill them unless the partisan surrenders. Crawford is in the process of turning himself in when he is killed by his fellow partisans, who believe he will be tortured until he betrays his comrades. Enraged, the Germans kill the hostages.

INTERESTING FACTS

- This was a joint production between the United States and Yugoslavia.
- This film is based on a true story, the only major difference being that the incident occurred in Rome, not Yugoslavia.

STALAG 17

Paramount Pictures, 1953, b&w, 120 minutes.

Producers: William Schorr, Billy Wilder; **Director:** Billy Wilder; **Screenwriters:** Donald Bevan, Edwin Blum, Edmund Trzcinski; **Music:** Franz Waxman; **Cast:** Ross Bagdasarian, Peter Baldwin, Neville Brand, Mike Bush, Tommy Cook, Richard Erdman, Peter Graves, William Holden, Erwin Kalser, Jay Lawrence, Peter Leeds, Harvey Lembeck, Michael Moore, William Pearson, Joe Ploski, Otto Preminger, Sig Ruman, Paul Salata, Robert Shawley, Robinson Stone, Gil Stratton, Robert Strauss, Anthony M. Taylor, Don Taylor, Edmund Trzcinski, Max Willenz.

Airmen shot down during the Allied bombing campaign over Germany are held in a prisoner-of-war camp. Each escape attempt has resulted in failure, and the prisoners are convinced that there is a spy in the barracks. Suspicion falls on the barracks entrepreneur (William Holden), whose trading with the camp guards makes him a natural suspect. It doesn't help that he bets against those who are escaping, and they are always killed. In self-defense, it falls on William Holden to ferret out the real spy, before his fellow prisoners kill him.

The film was adapted from the successful stage play. Stalag 17 was situated six miles northwest of the village of Gniexendorf, Austria. The camp was used as a concentration camp from 1938 until 1940, when it began receiving French and Poles as the first POWs. On October 13, 1943, 1350 noncommissioned officers of the U.S. Army Air Force were transferred from Stalag 7 to Stalag 17, which already contained POWs from France, Italy, Russia, Yugoslavia, and various smaller nations. From then until the last days of the war, a constant stream of NCOs arrived; their strength reached 4237 in spite of protests to the detaining power about the overcrowded conditions. The entire camp contained 29,794 prisoners of war of various nations. The blame for the bad conditions that existed

at this camp has been placed on Kommandant Oberst Kuhn, who was both unreasonable and uncooperative. Repeated protests were lodged about the entry of Gestapo agents (Gheime Staatspolizei) into the American compound.

INTERESTING FACTS

- The movie was shot in sequence (i.e., the scenes were filmed in the same order they're shown). Many of the actors were surprised by the final plot twist.
- The uncredited soldier singing at the Christmas party is Ross Bagdasarian, also known as Dave Seville, the leader/creator/voice of Alvin and the Chipmunks.
- Otto Preminger, better known as a director, plays the camp commandant.

MILITARY SERVICE

- Six-time Oscar-winning director and producer Billy Wilder joined the U.S. Army Psychological Warfare Section late in World War II and was commissioned a colonel. He was sent overseas and spent six months working with the denazification program charged with restructuring German radio.

QUOTES

Duke [after hearing gunshots, Sefton, who bet against the escapees, is collecting]: Hold it, Sefton. I said hold it! So we heard some shots. So who says they didn't get away?
Sefton: Anybody here want to double their bet?

Sefton: What is this anyway, a kangaroo court? Why don't you get a rope and do it right?

Duke: You make my mouth water.

Sefton: You're all wire-happy, boys. You've been in this camp too long. You put two and two together and it comes out four—only it ain't four.
Hoffy: What's it add up to you, Sefton?
Sefton: It adds up that you got yourselves the wrong guy. Because I'm telling you, the krauts wouldn't plant two stoolies in one barracks. And whatever you do to me, you're gonna have to do all over again when you find the right guy.

AWARDS

Academy Awards, USA, 1953
Won: *Oscar, Best Actor,* William Holden

Nominated: *Oscar, Best Director,* Billy Wilder; *Best Supporting Actor,* Robert Strauss
Writers Guild of America, USA, 1954
Nominated: *WGA Screen Award, Best Written American Comedy,* Edwin Blum, Billy Wilder.

STALINGRAD

Perathon Film und Fernsehproduktions GmbH, Royal Film, B.A. Productions, Bavaria Film, 1993, color, 132 minutes.

Producers: Mark Damon, Hanno Huth, Michael Kroline, Günter Rohrbach, Joseph Vilsmaier; **Director:** Joseph Vilsmaier; **Screenwriters:** Jürgen Büscher, Johannes M. M. Heide, Joseph Vilsmaier; **Music:** Norbert Jürgen Schneider; **Distributor:** Strand Releasing; **Cast:** Ulrike Arnold, Martin Benrath, Thorsten Bolloff, Oliver Broumis, Flip Cap, Hynek Cermak, Otmar Dvorak, Heinz Emigholz, Sylvester Groth, Kaja Hermanek, Karel Hermánek, Karel Hlusicka, Dominique Horwitz, Karel Hábl, Christian Knoepfle, Alexander Koller, Thomas Kretschmann, Mark Kuhn, Thomas Lange, Pirjo Leppänen, Pavel Mang, Aale Mantila, J. Alfred Mehnert, Jochen Nickel, Dieter Okras, Jan Preucil, Cestmír Randa, Svatopiunk Ricanek, Jophi Ries, Sebastian Rudolph, Ferdinand Schuster, Oto Sevdk, Petr Skarke, Oliver Steindler, Jana Steindlerova, Bohumil Svarc, Jaroslav Tomsa, Zdenek Vend, Janina Vilsmaier, Theresa Vilsmaier, Dana Vávrová, Alexander Wachholz.

A German platoon is almost wiped out in the brutal fighting at the battle of Stalingrad during World War II. When they are placed under the command of a sadistic captain, the lieutenant has had enough and decides to lead the remnants of his men to desert and escape from the city which is now surrounded by the Soviet Army.

QUOTES

One German foot soldier: Where is our artillery?
Another German foot soldier: You're the artillery!

STAMBOUL QUEST

Metro-Goldwyn-Mayer, 1934, b&w, 90 minutes.

Producers: Bernard H. Hyman, Sam Wood; **Director:** Sam Wood; **Screenwriters:** Leo Birinsky (story, as Leo Birinski), Herman J. Mankiewicz; **Cast:**

Rudolph Anders, Hooper Atchley, Lionel Atwill, Mischa Auer, Walter Brennan, George Brent, Leo G. Carroll, Tito Davison, Douglass Dumbrille, Helen Freeman, Robert Gleckler, C. Henry Gordon, Jamiel Hasson, Perry Ivins, Edward Keane, Henry Kolker, Theodore Lodi, Myrna Loy, Michael Mark, Belle Mitchell, Russ Powell, Frank Puglia, Georges Renavent, Adrian Rosley, Christian Rub, Joe Sawyer, Harry Schultz, Judith Vosselli.

During World War I, German counterintelligence learns that someone is providing the British with critical strategic planning for the Turkish theater. They suspect the Turkish commander for the Dardanelles and dispatch spy Myrna Loy to Constantinople to secure proof.

The movie is based on the true story of Maria Lesser, known as "Fraulein Doktor," Germany's top female spy during World War I.

INTERESTING FACT

- The movie was made during the rise of the Nazis. It was unusual during this time for Hollywood to make a film with a German spy as the hero.

QUOTE

Turkish officer: I know what war is. You go out and fight. You shoot and get shot. That's what war is. You don't use women as weapons.

STAND BY FOR ACTION

Metro-Goldwyn-Mayer, 1943, b&w, 109 minutes.

Producers: Orville O. Dull, Robert Z. Leonard; **Director:** Robert Z. Leonard; **Screenwriters:** Laurence Kirk (story, *A Cargo of Innocence*), Harvey S. Haislip (story, as Capt. Harvey Haislip), R. C. Sherriff (story), George Bruce, John L. Balderston, Herman J. Mankiewicz; **Music:** Lennie Hayton; **Cast:** Walter Brennan, Hobart Cavanaugh, Inez Cooper, Brian Donlevy, Douglass Dumbrille, Harry Fleischmann, Byron Foulger, Douglas Fowley, Charles Laughton, Marta Linden, Marilyn Maxwell, Henry O'Neill, Richard Quine, Tim Ryan, Dick Simmons, William Tannen, Robert Taylor, Ben Welden, Frank Whitbeck, Chill Wills.

Robert Taylor plays a brand new lieutenant fresh out of school who is second in command to a gruff old veteran of the last war, Brian Donlevy, who commands a recommissioned World War I vessel. They are

assigned to guard a convoy against the Japanese following the attack on Pearl Harbor. After rescuing a lifeboat full of babies, Donlevy is knocked out of action, and it is up to cocky Robert Taylor to prove himself and sink an enemy battleship.

AWARDS

Academy Awards, USA, 1943
> Nominated: *Oscar, Best Special Effects,* A. Arnold Gillespie *(photographic),* Donald Jahraus *(photographic),* Michael Steinore *(sound).*

STEEL CLAW, THE

Ponderey, 1961, color, 96 minutes.

Producers: Ferde Grofé Jr., George Montgomery; **Director:** George Montgomery; **Screenwriters:** Ferde Grofé Jr., George Montgomery; **Distributor:** Warner Bros.; **Filmed in:** Philippines; **Cast:** Carmen Austin, Mario Barri, Amelia De La Rama, Pedro Faustino, Oscar Keesee Jr., Charito Luna, John MacGloan, George Montgomery, Ben Perez, Joe Sison, Paul Sorenson, Al Wyatt Sr.

A U.S. Marine who is about to be discharged because he lost his hand is suddenly drawn into organizing guerrillas to fight the Japanese invaders of the Philippines in World War II.

STEEL HELMET, THE

Lippert Pictures Inc., 1951, b&w, 85 minutes.

Producers: William A. Berke, Samuel Fuller; **Director:** Samuel Fuller; **Screenwriter:** Samuel Fuller; **Distributor:** Lippert Pictures Inc.; **Cast:** Steve Brodie, William Chun, James Edwards, Gene Evans, Harold Fong, Robert Hutton, Richard Loo, Sid Melton, Richard Monahan, Neyle Morrow, Lynn Stalmaster.

During the Korean War, a patrol is sent out to set up an observation post in a Buddhist temple. They are joined by Sergeant Zack, whose own unit has been wiped out, a black medic who is lost, and a young, orphaned Korean boy. In the temple, they find an English-speaking North Korean major, who tries to split them apart. He works on the African American, questioning why he would fight for a country that discriminates against him, and then he works on a Japanese-American member of the squad. Finally, the

sergeant, distraught over the death of the Korean boy, and sick of the major's attempts to create discord, shoots the unarmed major.

The hard and callous Sergeant Zack, an expert at staying alive, warns them not to take the dog tags off a dead GI. They disregard his advice, the body is booby trapped, and another soldier is killed.

INTERESTING FACTS

- This is one Sam Fuller movie that doesn't have a character named "Griff."
- The title of the film comes from a steel helmet with a bullet hole in it. The members of the squad think it's lucky, because they don't think it will be hit again by a bullet.

MILITARY SERVICE

- Immediately after the Japanese attack on Pearl Harbor, director Sam Fuller enlisted in the U.S. Army and was assigned to the 16th Infantry of the First Division, the famous "Big Red One." By the fall of 1942, he was on his way to Europe, destined to be part of the bloody campaigns in North Africa and Italy, finally landing on the beaches of Normandy in the D day invasion. Marching into Germany after the liberation of Paris, Fuller's war-weary division bore first witness to the horrors of the death camps. He was awarded the Silver Star, Bronze Star, and the Purple Heart.

QUOTE

Sergeant Zack: Dead man's nothin' but a corpse. No one cares what he is now.

AWARD

Writers Guild of America, USA, 1952
 Won: *WGA Screen Award, Best Written American Low-Budget*, Samuel Fuller.

STORM AT DAYBREAK

Metro-Goldwyn-Mayer, 1933, b&w, 80 minutes.

Director: Richard Boleslawski; **Screenwriters:** Sándor Hunyady (novel), Bertram Millhauser; **Music:** William Axt; **Cast:** Nils Asther, James Bell, Kay Francis, C. Henry Gordon, Louise Closser Hale, Phillips Holmes, Walter Huston, Eugene Pallette, Jean Parker.

During World War I, the mayor of a Serbian village, played by Walter Huston, must deal with the fact that

The Steel Helmet (LIPPERT PICTURES/AUTHOR'S COLLECTION)

his wife is in love with his best friend, a Hungarian officer. When she is suspected of helping Serbian deserters from the Hungarian army, her husband sacrifices his life to save her.

The movie is based on Sándor Hunyady's play, *Storm at Daybreak* (no publication date is available).

STORY OF A FLEMISH FARM, THE

Two Cities Films Ltd., 1943, b&w, 82 minutes.

Producer: Sydney Box; **Director:** Jeffrey Dell; **Screenwriters:** Jeffrey Dell, Jill Dell; **Music:** Ralph Vaughan Williams; **Cast:** Jane Baxter, Clive Brook, Charles Compton, Clifford Evans, Philip Friend, Richard George, Irene Handl, Mary Jerrold, Brefni O'Rorke, Ronald Squire, Wylie Watson.

An Allied airman goes into occupied France in a risky commando operation for the honor of his regiment. The movie is based on a true story.

STORY OF DR. WASSELL, THE

Paramount Pictures, 1944, color, 140 minutes.

Producers: Sidney Biddell (associate producer), Cecil B. DeMille, Buddy G. DeSylva (executive producer); **Director:** Cecil B. DeMille; **Screenwriters:** Charles Bennett, James Hilton (story), Alan Le May, Cmdr. Corydon M. Wassell (story); **Music:** Victor Young; **Distributor:** Paramount Pictures; **Cast:** Philip Ahn, Eric Alden, Joel Allen, Irving Bacon, Griff Barnett, Edith Barrett, Richard Barrett, Joe Bautista, Hugh Beaumont, John Benson, Carlyle Blackwell, Carla Boehm, John Bogden, Louis Borel, Swen Hugo Borg, Victor Borge, Linda Brent, Barbara Britton, George Bronson, Edgar Caldwell, Anthony Caruso, Luke Chan, Oie Chan, Lane Chandler, Tony Cirillo, Davison Clark, Russ Clark, Gary Cooper, Isabel Cooper, James Cornell, James Courtney, Catherine Craig, Mary Currier, Laraine Day, Gloria Dea, Yvonne De Carlo, Forrest Dickson, Joe Dominguez, Ludwig Donath, Ann Doran, Clint Dorrington, Reynold DuPont, Gretl Dupont, Edward Earle, Sarah Edwards, George Eldredge, Frank Elliott, Carl Esmond, Roque Espiritu, Julia Faye, Edward Fielding, Maxine Fife, Geraldine Fissette, Sam Flint, William Forrest, Douglas Fowley, Melvin Francis, Jody Gilbert, Gus Glassmire, Roy Gordon, Greta Granstedt, William Hall, Chuck Hamilton, Mildred Harris, Beth Hartman, Signe Hasso, Louis Jean Heydt, Edward Howard, Boyd Irwin, Si Jenks, Hazel Keener, Paul Kelly, Milton Kibbee, June Kilgour, Mike Killian, Fred Kohler Jr., Henry Kraft, Frank Lackteen, Mike Lally, Isabel La Mal, Ameda Lambert, Doris Lilly, Elmo Lincoln, Richard Loo, Morton Lowry, Jack Luden, Loretta Luiz, George Lynn, Edmund MacDonald, George Macready, Miles Mander, Lester Matthews, Frank Mayo, Renny McEvoy, John Meredith, Sybil Merritt, Buddy Messinger, James Millican, Moy Ming, Frances Morris, Gavin Muir, Forbes Murray, John Mylong, Ottola Nesmith, Jack Norton, Richard Nugent, Dennis O'Keefe, Phyllis Perry, Stanley Price, Frank Puglia, Allan Ray, Rodd Redwing, Elliott Reid, Gordon Richards, Stanley Ridges, Ronald R. Rondell, Ferdinand Schumann-Heink, William Severn, Harvey Stephens, Yu Feng Sung, Marion de Sydow, Oliver Thorndike, Olga Marie Thunis, Carol Thurston, Ivan Triesault, Charles Trowbridge, Philip Van Zandt, Victor Varconi, Bruce Warren, Minor Watson, Doodles Weaver, Cecil Weston, Bob Wilbur, Frank Wilcox.

Dr. Wassell (Gary Cooper) is a U.S. Navy doctor ordered not to evacuate severely wounded seamen and to abandon Java during World War II. He disobeys this order, refusing to leave behind 12 of the sailors, but gets them safely to Australia.

Cmdr. Wassell was awarded the Navy Cross for his heroism in saving the lives of the seamen. The movie is based on a true story and on James Hilton's *The Story of Dr. Wassell* (Boston: Little, Brown and Company, 1943).

INTERESTING FACT

- Cecil B. DeMille became interested in doing this film after hearing President Roosevelt talk about the heroism of Dr. Wassell in one of his radio speeches.

AWARDS

Academy Awards, USA, 1944
 Nominated: *Oscar, Best Special Effects*, George Dutton *(sound)*, Farciot Edouart *(photographic)*, Gordon Jennings *(photographic)*.

STORY OF G.I. JOE, THE

United Artists, 1945, b&w, 109 minutes.

Producers: Lester Cowan, David Hall; **Director:** William A. Wellman; **Screenwriters:** Leopold Atlas, Guy Endore, Ernie Pyle, Philip Stevenson; **Distributor:** United Artists; **Cast:** William "Billy" Benedict, Hal Boyle, Wally Cassell, Chris Cunningham, Jack Foisie, George Lah, Bob Landry, Jimmy Lloyd, Burgess Meredith, Robert Mitchum, William Murphy, Jack Reilly, Clete Roberts, Robert Rueben, William Self, Freddie Steele, Don Whitehead.

Reporter Ernie Pyle (Burgess Meredith) joins an infantry squad, and he becomes a backdrop against which is portrayed the life of the average foot soldier from North Africa to Italy.

Ernie Pyle (1900–45) was a Pulitzer Prize–winning war correspondent who was killed in action at Iwo Jima in the South Pacific by a sniper near the end of the war. His trademark was his portrayal of the life and tribulations of the average GI as he slogged through the mud, death, and misery of World War II.

INTERESTING FACTS

- Ernie Pyle personally requested that Burgess Meredith play him in the film.

- The film was criticized in England for leaving out any reference to British forces in North Africa or Italy during World War II.

MILITARY SERVICE

- Burgess Meredith enlisted in the U.S. Army during World War II and was sent to Air Corps intelligence school, commissioned a lieutenant, and sent to London to make films promoting Anglo-American and Franco-American relations. An aide for President Roosevelt arranged for Meredith to be discharged in 1944 so that he could play the lead in this film. He was later nominated for an Oscar for *Rocky* and won an Emmy for his part in *Tail Gunner Joe*.
- This film is based on a book by Ernie Pyle, *Here Is Your War* (New York: H. Holt and Company, 1943).

QUOTE

Tired soldier: It sounds kind of silly, but when I'm resting like this I get a kick out of just being alive.

STRANGE DEATH OF ADOLF HITLER, THE

Universal Pictures, 1943, b&w, 74 minutes.

Producer: Ben Pivar; **Director:** James P. Hogan; **Screenwriter:** Fritz Kortner; **Cast:** Charles Bates, Joan Blair, George Dolenz, Ludwig Donath, Frederick Giermann, Fritz Kortner, Kurt Kreuger, John Mylong, Merrill Rodin, Gale Sondergaard, Ludwig Stössel, William Trenk.

A double is forced to impersonate Adolf Hitler. The double's wife, unaware of the substitution, decides to assassinate the führer and mistakenly kills her own husband. This film is totally fictional.

STRANGER, THE

International Pictures Inc., 1946, b&w, 95 minutes.

Producer: Sam Spiegel (as S. P. Eagle); **Director:** Orson Welles; **Screenwriters:** Victor Trivas (story), Victor Trivas (adaptation), Decla Dunning (adaptation), Anthony Veiller (screenplay), John Huston, Orson Welles; **Music:** Bronislau Kaper (as Bronislaw Kaper); **Distributor:** RKO Radio Pictures; **Cast:** David Bond, Billy House, Byron Keith, Richard Long, Philip Merivale, Isabel O'Madigan, Edward G. Robin-

son, Johnny Sands, Konstantin Shayne, Pietro Sosso, Brother Theodore, Orson Welles, Martha Wentworth, Loretta Young.

Edward G. Robinson plays a member of the War Crimes Commission who searches for Orson Welles, mastermind of World War II's Holocaust. Welles has effectively erased his identity and disappeared. In order to flush him out, Robinson lets one of Welles's former Nazi comrades loose, and he leads him right to Harper, Connecticut. However, when Welles sees his old friend he realizes that the man can blow his cover, and he kills him to protect his new identity. Robinson now has only one lead, Welles's fascination with antique clocks. Ironically, when Welles attempts to evade his pursuer, he is impaled by a statue in the clock tower where he is hiding.

QUOTES

Wilson: Well, who but a Nazi would deny that Karl Marx was a German . . . because he was a Jew?
Mr. Potter [after Meineke's body is dug up]: 'Course, he's changed some. Being buried in the earth does that.

AWARDS

Academy Awards, USA, 1946
 Nominated: *Oscar, Best Writing, Original Story,* Victor Trivas

Venice Film Festival, 1947
 Nominated: *Golden Lion,* Orson Welles.

STRATEGIC AIR COMMAND

Paramount Pictures, 1955, color, 112 minutes.

Producer: Samuel J. Briskin; **Director:** Anthony Mann; **Screenwriters:** Valentine Davies, Beirne Lay Jr. (story); **Music:** Victor Young; **Filmed at:** Carswell Air Force Base, Fort Worth, Texas, MacDill Air Force Base, Tampa, Florida, and Plant City, Florida; **Cast:** June Allyson, James Bell, Bruce Bennett, Helen Brown, Rosemary DeCamp, Glenn Denning, Jay C. Flippen, Don Haggerty, Don C. Harvey, Len Hendry, William Hudson, Frank Lovejoy, Richard Lupino, Strother Martin, John R. McKee, James Millican, Harry Morgan, Alex Nicol, House Peters Jr., Max Power, William Pullen, Vernon Rich, Richard Shannon, James Stewart, Barry Sullivan, David Vaile, Anthony Warde, Harlan Warde, Stephen Wyman.

Jimmy Stewart is a baseball star who was an ace bomber pilot during World War II. The new Strategic

Air Command is America's main nuclear strike force, but finds itself short-staffed and recalls the aging Stewart to active duty. Since war may come at any moment, Stewart and his crew must constantly train so that they are prepared to fly their nuclear-armed bomber to Moscow.

MILITARY SERVICE

- After accepting his Oscar in 1941 for *The Philadelphia Story*, Jimmy Stewart enlisted as a private in the U.S. Army Air Force. He was already a civilian pilot with a number of flight hours, and he was put through flight training and commissioned. After a tour as an instructor in B-17s he went overseas and flew over 20 missions in the B-24 Liberator. Promoted to major, he was operations officer for the 453rd Bombardment Group. By 1945 he was a colonel and chief of staff of the 2nd Combat Wing, Eighth Air Force. He was awarded the Distinguished Flying Cross for his leadership of the 703rd Squadron on a raid over Brunswick, Germany, on February 20, 1944. He was also awarded the Croix de Guerre and the Air Medal with Oak Leaf Cluster. Staying in the reserves after the war, he made brigadier general before his retirement in 1968.

AWARD

Academy Awards, USA, 1955
 Nominated: *Oscar, Best Writing, Motion Picture Story*, Beirne Lay Jr.

STREAMERS

Streamers International, 1983, color, 118 minutes.

Producers: Robert Altman, Scott Bushnell, Robert Michael Geisler, Nick J. Mileti, John Roberdeau; **Director:** Robert Altman; **Screenwriter:** David Rabe; **Distributor:** United Artists Classics; **Filmed in:** Irving, Texas; **Cast:** Bill Allen, Guy Boyd, BJ Cleveland, George Dzundza, Mark Fickert, David Alan Grier, Paul Lazar, Mitchell Lichtenstein, Albert Macklin, Terry McIlvain, Matthew Modine, Robert S. Reed, Todd Savell, Phil Ward, Dustye Winniford, Michael Wright.

Four young recruits about to be sent to Vietnam confront their prejudicial feelings toward one another in their barracks when it's learned that one of them is homosexual.

AWARD

Cast ensemble acting award, Venice Film Festival.

STRIKE COMMANDO

Flora Film, 1987, color, 88 minutes.

Director: Bruno Mattei (a.k.a. Vincent Dawn); **Screenwriters:** Claudio Fragasso, Bruno Mattei; **Music:** Luigi Ceccarelli; **Filmed in:** Philippines; **Cast:** Rene Abadeza, Reb Brown, Christopher Connelly, Fred Gahudo, Jim Gaines, Philip Gordon, Loes Kamma, Juliet D. Lei, Karen Lopez, Edison Navarro, Charlie Patiro, Luciano Pigozzi, Ricardo Santos, Alex Vitale.

Reb Brown seeks revenge on the colonel who deserted him and his buddies in Vietnam. This plot is very similar to *RAMBO: FIRST BLOOD PART II*.

STRIKE COMMANDO 2

Florafilm, 1989, color, 102 minutes.

Producer: Franco Gaudenzi; **Director:** Bruno Mattei; **Music:** Stefano Mainetti; **Filmed in:** Philippines; **Cast:** Richard Harris, Brent Huff, Mary Stavin.

Brent Huff is a commando in search of his old Vietnam buddy Richard Harris.

STRIPES

Columbia Pictures Corporation, 1981, color, 101 minutes.

Producers: Daniel Goldberg, Joe Medjuck (associate producer), Ivan Reitman; **Director:** Ivan Reitman; **Screenwriters:** Len Blum, Daniel Goldberg (as Dan Goldberg), Harold Ramis; **Music:** Elmer Bernstein; **Distributor:** Columbia Pictures; **Filmed in:** Fort Knox and Louisville Kentucky, Graystone Mansion, Beverly Hills, California; **Cast:** Lois Areno, Pamela Bowman, Sue Bowser, Samuel Briggs, Yefim Buntsis, Timothy Busfield, John Candy, Dawn Clark, Gerard J. Counts, J. A. Crawford, John Diehl, Robert Dulaine, Linda Dupree, Bruce E. Ellis, Joe Flaherty, Michael Flynn, Donald Gibb, Larry R. Gillette, Gino Gottarelli, Hershel B. Harlson, Joyce D. Helmus, Leslie Henderson, George Jenesky, Glenn-Michael Jones, Robin Klein, Larry Odell Lane, John Larroquette, Lance LeGault, Roberta Leighton, William

Lucking, Mark S. Markowicz, Glenn Leigh Marshall, Susan Mechsner, Juanita Merritt, Norman Mont-Eton, David A. Mullins, Bill Murray, Warren Oates, Antone Pagan, Bill Paxton, David D. Platko, Dale Prince, Arkady Rakhman, Harold Ramis, Judge Reinhold, Fran Ryan, Craig Schaefer, Gene Scherer, Solomon Schmidt, P. J. Soles, William R. Sykes, Dave Thomas, Nick Toth, Phillip A. Urbansky, Semyon Veyts, Jeff Viola, John Voldstad, Robert J. Wilke, Sean Young.

Bill Murray, who realizes that his life is going nowhere, convinces his friend Harold Ramis that they should join the army and change their lives. In basic training, Murray finds that his platoon is made up of other misfits and assorted losers. Constantly at odds with their drill instructor, they are really left

without direction when he is accidentally injured by a mortar during training. Forced to finish basic training on their own, they oversleep and almost miss graduation. Sent to Europe to test a new "urban assault vehicle," they end up taking it for a joyride into communist-controlled Czechoslovakia to rescue their friends.

Although designed to lampoon the army, the movie was done in such an even-handed and equitable style by director Ivan Reitman that it has actually become a favorite film of U.S. soldiers.

INTERESTING FACT

- The character nicknamed "Psycho" is actually named Francis. Francis is Norman Bates's middle name in *Psycho* (1960).

MISTAKES

- The white van behind John's taxi disappears when an aerial view of the taxi is shown.
- John's taxi suddenly gains and loses a dent.
- John's girlfriend puts her boots on twice.
- In the barracks, the first time Sergeant Hulka meets with his troops, the boom mike is visible.
- Soviet soldiers didn't carry Israeli Uzis.
- At graduation, when the band stops playing and Bill Murray et al. come running in, the band leader is still conducting, yet the band has stopped playing.
- John drives in the wrong direction in the opening cab scene. He is going north on the Second Street Bridge (to Indiana) when he should be going south to the airport (located south of downtown Louisville).
- In the strip club, one of the female mud wrestlers that Ox is fighting has her hair down; in the next scene her hair is up.
- The sergeant tells the men that the next morning there will be a locker box inspection, then a 10-mile run. The next morning he tells the men there will be a 5-mile run, which is upped to 10 only after Winger mouths off.

Stripes (COLUMBIA PICTURES/AUTHOR'S COLLECTION)

QUOTES

Recruiting Sergeant: Are you men homosexuals?
John Winger: No. But we're willing to learn!

John Winger: We're all very different people. We're not Watusi, we're not Spartans, we're Americans! With a capital "A," huh? And you know what that means? Do you? That means that our forefa-

thers were kicked out of every decent country in the world!

John Winger: Lee Harvey! You are a madman! When you stole that cow? And your friend tried to make it with the cow? I wanna party with you.

General Barnicke: Where is your drill sergeant, men?
John Winger: Blown up, sir!

John Winger: Chicks dig me because I rarely wear underwear, and when I do it's usually something unusual.

General Barnicke: Where have you been, soldier?
John Winger: Training, sir!
Soldiers: Training, sir!
General Barnicke: What kind of training?
John Winger: Army training, sir.
Soldiers: Army training, sir!
General Barnicke: Are you telling me that you men finished your training on your own?
John Winger: That's a fact, Jack!
Soldiers: That's a fact, Jack!

John Winger: I've had an interesting morning. In the last two hours I've lost my job, my apartment, my car, and my girlfriend.
Russell Ziskey: You still have your health.

Psycho: The name's Francis Sawyer, but everybody calls me Psycho. Any of you guys call me Francis, and I'll kill you.
Leon: Ooooooh.
Psycho: You just made the list, buddy. Also, I don't like no one touching my stuff. So just keep your meat hooks off. If I catch any of you guys in my stuff, I'll kill you. And I don't like nobody touching me. Any of you homos touch me, and I'll kill you.
Sergeant Hulka: Lighten up, Francis.

STRYKER'S WAR

Action Pictures, Renaissance Pictures, 1985, color, 84 minutes.

Producers: Arnold Becker, Pam Becker, Shirley Becker, Scott Spiegel; **Director:** Josh Becker; **Screenwriters:** Josh Becker, Bruce Campbell, Sheldon Lettich, Scott Spiegel; **Music:** Joseph LoDuca; **Distributor:** Film World Distributors Inc., Prism Pictures; **Filmed in:** Detroit, Michigan; **Cast:** Glenn Barr, Pam Becker, Steve Benson, Terry-Lynn Brum-

field, Tom Bruny, Bruce Campbell, Paul Christy, Connie Craig, Matt DeWan, Ivitch Fraser, Dave Gibson, David H. Goodman, Paul Grabke, Dave Grenaey, Jim Griffen, Kirk Haas, Dwayne Hall, Cheryl Hausen, Rick Hudson, Dave Hutzley, Chunli In, Dave Ivey, Kevin Jackunas, Saule Jackunas, Jim Johnson, Al Johnston, Gary Jones, Barry Kahn, Bradley Kahn, David Kelly, Sopha Ket, Ray Ketchledge, Theo Kruszewski, Ray Lacelle, Pam Lewis, Hton Lorn, Alex Macalinden, Aimee Majdi, Perry Mallette, John Manfredi, Krista Manfredi, Randy Mann, Danny Merritt, Scott Mitchell, Chuck Morris, Debbie Napoleon, Stanley Need, Dan Nelson, Lam Ngoyen, Eve Nixon, Kirk Nolan, Gary O'Conner, Marek Pacholec, Michele Poulik, Danny Quill, Timothy Patrick Quill, Linda Quiroz, Sam Raimi, Ted Raimi, Allison Reed, Robert Rickman, Fran Robbins, Robert Rook, Brian Schulz, Bill Siegrest, Nick Snover, Scott Spiegel, Barbara Spiegel, Hironao Sugiura, Matthew Taylor, Jenny Thompson, Joe Toupin, Kathryn Turnbull, Anna C. Webb, Sam Yee.

An army unit on patrol in Vietnam is ambushed and almost wiped out. Those who survive are given leave; they return stateside to see their families. When they visit one of their buddies who was wounded in the ambush, they run into a killer cult led by a murderous psychopath.

INTERESTING FACT

- The movie was mostly shot in the garage and on the lawn of the house where director Josh Becker's longtime friend Bruce Campbell grew up.

QUOTE

Cult Leader: You dirty little son of a bitch! I'm gonna do some nasty things to you.

SUBMARINE BASE

Producers Releasing Corporation, 1943, b&w, 65 minutes.

Producers: Harry D. Edwards, Leon Fromkess, Jack Schwarz; **Director:** Albert H. Kelley; **Screenwriters:** George M. Merrick, Arthur St. Claire; **Music:** Charles Dant; **Distributor:** Producers Releasing Corporation; **Cast:** Iris Adrian, Luis Alberni, Alan Baxter, Eric Blore, Maurice Cass, Jacqueline Dalya, Anna Demetrio, Fifi D'Orsay, George Flaherty, John Litel, Georges Metaxa, Lucien Prival, Rafael Storm.

Spies are involved in the destruction of a secret enemy submarine base.

SUBMARINE COMMAND

Paramount Pictures, 1952, b&w, 87 minutes.

Producer: Joseph Sistrom; **Director:** John Farrow; **Screenwriter:** Jonathan Latimer; **Music:** David Buttolph; **Cast:** Leslie Banning, William Bendix, Richard Bergren, John Close, James Cornell, Don Dunning, Thomas M. Dykers, Benson Fong, Harold Fong, Arthur Franz, Jack Gregson, Darryl Hickman, William Holden, Don House, Frank Iwanaga, Jerry James, Jack Kelly, Paul Lees, Nelson Leigh, Mark Lowell, Freeman Lusk, John Mallory, William McLean, Charles Meredith, Rollin Moriyama, Noel Neill, Moroni Olsen, Nancy Olson, Jerry Paris, Steve Pendleton, Gordon Polk, Joey Ray, Walter Reed, Don Shelton, Don Taylor, George Wallace, Peggy Webber, Philip Van Zandt, Fred Zendar.

William Holden is forced to take his submarine down, leaving his wounded captain on deck to drown. Wracked with guilt, although it was the right thing to do to save the rest of the crew, he finally comes to grips with his actions with the help of his girlfriend.

INTERESTING FACT

* In *OPERATION PACIFIC*, the hero is also forced to take the submarine down with his wounded commander still on deck.

SUBMARINE PATROL

20th Century-Fox, 1938, color/b&w, 95 minutes.

Producers: Gene Markey (associate producer), Darryl F. Zanuck; **Director:** John Ford; **Screenwriters:** Rian James, Ray Milholland (novel, *Splinter Fleet*), Darrell Ware, Jack Yellen; **Music:** Arthur Lange; **Distributor:** 20th Century-Fox Film Corporation; **Cast:** Murray Alper, Henry Armetta, George Bancroft, Ward Bond, John Carradine, Lon Chaney Jr., E. E. Clive, Elisha Cook Jr., Preston Foster, Douglas Fowley, Richard Greene, Dick Hogan, Warren Hymer, Nancy Kelly, Robert Lowery, J. Farrell MacDonald, Moroni Olsen, Jack Pennick, Max Rosenbloom, George E. Stone, Harry Strang, Slim Summerville, Charles Tannen, Charles Trowbridge, Joan Valerie, Victor Varconi.

Richard Greene plays a chief petty officer who commands a subchaser in pursuit of German U-boats during World War I.

Subchasers were small wooden craft built in 1917 to take out U-boats, a cheap substitute for the destroyers that were in short supply.

INTERESTING FACTS

* The four subchasers that were used in this film were all that were left of the fleet produced during World War I. They were docked at Annapolis, and director John Ford received special permission to use them in making this film.
* The film is based on Ray Milholland's *Splinter Fleet* (Indianapolis: Bobbs Merrill, 1936).

SUBMARINE RAIDER

Columbia Pictures Corporation, 1942, b&w, 65 minutes.

Producer: Wallace MacDonald; **Directors:** Budd Boetticher, Lew Landers; **Screenwriter:** Aubrey Wisberg; **Distributor:** Columbia Pictures; **Cast:** Philip Ahn, Warren Ashe, Bruce Bennett, Gary Breckner, Stanley Brown, Marguerite Chapman, Roger Clark, John Howard, Eddie Laughton, Eileen O'Hearn, Larry Parks, Nino Pipitone, Rudy Robles, John Shay, Forrest Tucker.

A submarine sights the attack fleet headed for Pearl Harbor but is not able to warn the U.S. Navy. After the attack, the captain of the submarine is able to sink a Japanese aircraft carrier, but at the price of killing his girlfriend, who is being held captive on board the ship.

SUBMARINE SEAHAWK

Golden State Productions, 1958, b&w, 83 minutes.

Producers: Samuel Z. Arkoff (executive producer), Alex Gordon, James H. Nicholson (executive producer), Lou Rusoff (executive producer); **Director:** Spencer Gordon Bennet; **Screenwriters:** Orville H. Hampton (as Owen Harris), Lou Rusoff; **Music:** Alexander Laszlo; **Distributor:** American International Pictures; **Cast:** Alan Aric, John Bentley, Nicky Blair, Hal Bogart, Jan Brooks, Edmund Cobb, Dolores Domasin, Don Fenwick, Ted Fish, Frank Gerstle, Brett Halsey, Howard Hampton, Marilyn Hanold, Wayne Heffley, Paul Maxwell, Henry

McCann, Steve Mitchell, Scott Peters, Robin Priest, Frankie Ray, Mabel Rea, Leon Tyler, Frank Watkins, Vince Williams, Brian Wood.

On his first command in the Pacific theater, a by-the-book officer is ordered to take his submarine on a reconnaissance mission to locate a fleet of Japanese fighting ships. The crew resents his distant manner and the way he avoids attacking the Japanese ships they sight. However, they finally realize that he is avoiding a battle because these ships will lead him to the main Imperial battle fleet.

SUBMARINE X-1

Mirisch Films, 1968, color, 89 minutes.

Producers: John G. Champion, Ted Lloyd, Irving Temaner; **Director:** William A. Graham; **Screenwriters:** John C. Champion, Guy Elmes, Edmund H. North, Donald S. Sanford; **Music:** Ron Goodwin; **Distributor:** United Artists; **Filmed in:** UK; **Cast:** Diana Beevers, Norman Bowler, James Caan, Rupert Davies, William Dysart, Kenneth Farrington, Brian Grellis, Paul Hansard, John Kelland, George Pravda, Carl Rigg, George Roubicek, David Sumner, Hans De Vries, Paul Young.

After losing his submarine command and its 50-man crew in a battle with a German ship during World War II, a Royal Navy officer gets a second chance when he is given command of a daring raid with midget subs.

SUICIDE BATTALION

Zuma Productions, 1958, b&w, 79 minutes.

Producers: Samuel Z. Arkoff, Lou Rusoff; **Director:** Edward L. Cahn; **Screenwriter:** Lou Rusoff; **Music:** Ronald Stein; **Distributor:** American International Pictures; **Cast:** John Ashley, Gordon Barnes, Russ Bender, Mike Connors, Isabel Cooley, Jan Englund, Art Gilmore, Hilo Hattie, Jackie Joseph, Clifford Kawada, Jewell Lain, Walter Maslow, John McNamara, Scott Peters, Bing Russell, Marjorie Stapp, Bob Tetrick, Sammee Tong.

During World War II, soldiers are recruited for the dangerous mission of destroying an American base in the Philippines to keep strategic papers out of the hands of the invading Japanese.

SUICIDE FLEET

RKO–Pathe, 1931, b&w, 86 minutes.

Producers: Harry Joe Brown (associate producer), Charles R. Rogers; **Director:** Albert S. Rogell; **Screenwriters:** Lew Lipton (story), F. McGrew Willis (dialogue); **Distributor:** RKO; **Cast:** Ben Alexander, Robert Armstrong, Yola d'Avril, Harry Bannister, William Boyd, James P. Burtis, Charles Delaney, Joe Dominguez, Nanette Faro, James Gleason, Hans Joby, Tom Keene, John Kelly, James Pierce, Frank Reicher, Ginger Rogers, Harry Semels, Harry Strang, Charles Sullivan, Harry Tenbrook, Henry Victor.

William Boyd, Robert Armstrong, and James Gleason are buddies who run booths in an amusement park before joining the U.S. Navy during World War I. The U.S. Navy discovers that a schooner is being used as a contact ship by German U-boats, so they send out a similar schooner, manned by Boyd, Armstrong, and Gleason, as a decoy for the U-boats. The plan lures the subs into the trap, but the Germans manage to sink the schooner as the U.S. warships close in and sink the three U-boats.

INTERESTING FACTS

- The film contains real-life aerial footage of DD-345, the USS *Preble* (commissioned March 19, 1920), while running at flank speed.
- Although this story on which the film is based was written by H. A. Jones, a commander in the U.S. Navy, the film is totally fictional.

SULLIVANS, THE

20th Century-Fox, 1944, b&w, 112 minutes.

Producers: Sam Jaffe, Robert Kane (associate producer); **Director:** Lloyd Bacon; **Screenwriters:** Edward Doherty (story), Mary C. McCall Jr., Jules Schermer (story); **Music:** Cyril J. Mockridge, Alfred Newman; **Distributor:** 20th Century-Fox; **Cast:** John Alvin, Anne Baxter, Ward Bond, Barbara Brown, Johnny Calkins, John Campbell, James Cardwell, Michael Chapin, Billy Cummings, Marvin Davis, Bobby Driscoll, Selmer Jackson, Bobby Larson, Trudy Marshall, Mary McCarty, Thomas Mitchell, George Offerman, Addison Richards, Roy Roberts, Nancy June Robinson, Merrill Rodin, Selena Royle, Edward Ryan, Harry Shannon, Buddy Swan.

The Sullivans are a working-class Irish-American family from Waterloo, Iowa, with five sons and a daughter, who get through tough times by sticking together. The Sullivan boys march down to the recruiting office to join up right after Pearl Harbor, and the navy recruiting officer promises that they can serve together on the same ship. They are assigned to the USS *Juneau*, and when it is sunk in a sea battle in the Solomons, they all go down together. That same recruiting officer has to deliver the Navy Department telegram to the Sullivan household. Their parents and their surviving elder sister take the blow with stoicism, and the sister immediately goes out and joins the navy.

Thomas Mitchell, who played Scarlett O'Hara's father in *Gone with the Wind*, plays the father of the Sullivan family as the same kind of tough, cocky little Irishman. Early in the movie, there is the family ritual of his going to work on the railroad, where he is a conductor. As he swings up onto the caboose of the freight train, an honest working man proud to provide for his family, his five boys rush pell-mell up the ladder of the water tower to the encircling balcony. They wave goodbye to him, and he waves back. At the end of the picture, after the death of his sons, Mr. Sullivan goes back to work. As he boards the caboose, he looks up and sees the water tower balcony. It's empty. His knees bend, his shoulders slump, and you can see all the hope and pride drain out of him as the blow finally hits home.

The film, better known today as *The Fighting Sullivans*, is based on the true story of the Sullivan brothers. The five brothers joined the navy after Pearl Harbor on the condition that they be allowed to serve on the same ship, a recruiting gimmick used by the pre-World War II navy that was still in force. All five were killed when the USS *Juneau* was sunk by a Japanese submarine off Guadalcanal in November 1942. The Office of War Information allowed their loss to be reported (an exception to policy), presumably because the family's fortitude in the face of this catastrophe was thought inspirational. No mention was made of the fact that the rest of the *Juneau*'s task force sailed away without trying to rescue survivors and that fewer than 10 of the crew were ultimately saved.

The *Juneau* was hit in a powder magazine, and the explosion killed a large number of the crew. One of the brothers survived the explosion and the sinking but died in the water waiting to be rescued.

Because the Sullivans' story was so well known at the time, the audience would have gone into the picture knowing how it must end. A destroyer, the USS *The Sullivans*, was named in honor of the brothers; it was launched during World War II. The so-called Sullivan

Law, which was adopted after this tragedy, prohibits brothers from serving in the same combat unit. This policy was expanded during Vietnam to prohibit all sons from being "in country" at the same time. An adjunct to this policy was the "sole surviving son," which granted a voluntary draft deferment to any person who had lost all of his brothers in combat.

The Sullivan sister, who joined the navy in the film, actually joined the WAVES, since no women actually joined the navy at that time. The WAVES were later integrated into the U.S. Navy.

INTERESTING FACT

- Spielberg's *SAVING PRIVATE RYAN* was inspired by the story of the Sullivans.

QUOTE

Mrs. Sullivan [as the USS *The Sullivans* is launched]: Our boys are afloat again.

AWARD

Academy Awards, USA, 1944
 Nominated: *Oscar, Best Writing, Original Story,* Edward Doherty, Jules Schermer.

SUNDAY DINNER FOR A SOLDIER

20th Century-Fox, 1944, b&w, 85 minutes.

Producer: Walter Morosco; **Director:** Lloyd Bacon; **Screenwriters:** Martha Cheavens, Melvin Levy, Wanda Tuchock; **Music:** Alfred Newman; **Cast:** Robert Bailey, Anne Baxter, Rory Calhoun, Marietta Canty, Chester Conklin, Billy Cummings, Jane Darwell, Bobby Driscoll, John Hodiak, Connie Marshall, Anne Revere, Barbara Sears, Bernard Sell, Larry Thompson, Chill Wills, Charles Winninger.

A poor family living on a barge in Florida save their money so that they can invite a soldier to dinner from the local base, just as everyone else in the town does. Even buying a chicken is a financial challenge for them. On the scheduled day, love blossoms between the soldier and the oldest daughter.

SUNDOWN

Walter Wanger Productions, 1941, b&w, 90 minutes.

Producer: Walter Wanger; **Director:** Henry Hathaway; **Screenwriters:** Charles G. Booth, Barré Lyn-

don; **Music:** Miklós Rózsa; **Distributor:** United Artists; **Filmed in:** Acomoa Pueblo and Gallup, New Mexico; **Cast:** William Broodes, Ivan Browning, Bruce Cabot, Rory Calhoun, Joseph Calleia, Harry Carey, Frank Clark, Frederick Clark, Dorothy Dandridge, Eddie Das, William H. Dunn, Al Duvall, Gilbert Emery, Carl Esmond, Riccardo Freda, Wesley Gale, Reginald Gardiner, Jester Hairston, Cedric Hardwicke, Darby Jones, Walter Knox, Tetsu Komai, Lawrence LaMarr, Marc Lawrence, Jeni Le Gon, Prince Maelupe, Gustas Nero, Hassan Said, George Sanders, Emmett Smith, Woody Strode, Gene Tierney, Horace Walker, Blue Washington, Kenny Washington.

George Sanders is sent to East Africa during World War II to help the local British administrator, Bruce Cabot, discover who is supplying the natives with arms and inciting them to rebellion against the British. He is aided by Gene Tierney, a British agent, and together they uncover and attack the secret Nazi supply depot responsible for supplying the weapons.

SURFACE TO AIR

Cabin Fever Entertainment, 1997, color, 93 minutes.

Director: Rodney McDonald; **Music:** David Wurst, Eric Wurst; **Distributors:** Artisan Entertainment; **Cast:** Matthew R. Anderson, Michael Madsen, Chad McQueen, John Robert, Melanie Shatner, Larry Thomas, Miranda Wolfe.

Two brothers, estranged for years, find themselves fighting the same war. When one brother (Chad McQueen), gets shot down, the other (Michael Madsen) has to save him.

SURRENDER

Fox Film Corporation, 1931, b&w, 69 minutes.

Director: William K. Howard; **Screenwriters:** S. N. Behrman, Pierre Benoît (novel, *Axelle*), Sonya Levien; **Cast:** Warner Baxter, Ralph Bellamy, George Beranger, Al Burke, Jack Conrad, Bert Hanlon, Leila Hyams, Alexander Kirkland, J. Carrol Naish, William Pawley, Howard Phillips, Tom Ricketts, Bodil Rosing, Joe Sawyer, C. Aubrey Smith, Frank Arthur Swales.

Warner Baxter is a French POW during World War I, whose prison camp is located near a Prussian castle ruled over by a proud father who waits for the day when his four sons will march into Paris. One of the sons' fiancées lives at the castle, and she falls in love with the POW. When the son returns home, crippled, the father realizes the truth about the war.

QUOTE

Soldier [to his father]: Everything was different in your days. You fought with music playing and flags flying, gloriously, magnificently. The war we're fighting is different, entirely different. A war impossible to describe to you.

SURRENDER—HELL!

Allied Artists Pictures Corporation, 1959, b&w, 85 minutes.

Producer: Edmund Goldman; **Director:** John Barnwell; **Screenwriter:** John Barnwell; **Music:** Francisco Buencamino, **Filmed in:** Philippines; **Cast:** Keith Andes, Susan Cabot, Nestor De Villa, Paraluman.

Keith Andes leads Filipino guerrillas against the invading Japanese. They force the enemy to abandon several provinces and, with the arrival of MacArthur, help in the liberation of the Philippines.

The movie is based on the true story of Lt. Donald D. Blackburn, who, during World War II, evaded capture by the Japanese and became a leader of a tribe of headhunters who fought the Japanese.

INTERESTING FACT

- Filipino actress Paraluman was hired to provide local color and the sexy scenes.

SWORD IN THE DESERT

Universal Pictures, 1949, b&w, 101 minutes.

Producer: Frank Buckner; **Director:** George Sherman; **Screenwriter:** Frank Buckner; **Music:** Frank Skinner; **Cast:** Dana Andrews, Jeff Chandler, Peter Coe, Campbell Copelin, George Dockstader, Art Foster, Hugh French, Philip Friend, Martin Garralaga, Lowell Gilmore, Marten Lamont, Stanley Logan, Paul Marion, Stephen McNally, Emil Rameau, Liam Redmond, Hayden Rorke, Gilchrist Stuart, Märta Torén, Joe Turkel, George Tyne, Jack Webb, David Wolfe.

Cynical freighter captain Dana Andrews hopes to take the money and run after landing Jewish refugees in Palestine. Reluctantly, he's drawn into the escalating fight between British occupation forces and the founders of Israel. A related film, *EXODUS*, also concerns the landing of Jewish refugees in Palestine after World War II.

MILITARY SERVICE

- Jack Webb, best known as Sgt. Joe Friday on TV's *Dragnet*, joined the U.S. Army Air Force as an aviation cadet in 1943. After preflight training at Camp St. Cloud in Minnesota, he served as a pilot of B-26s before receiving a dependency discharge in 1945. While in the service, he served on two occasions as the master of ceremonies for USO shows.

QUOTES

David Vogel: You haven't much faith in mankind, have you?

Mike Dillon: Why should I have? What's it ever done for me?

British Commander: This isn't a Jewish, British, or Arab problem. It's a problem for all mankind.

TAKE THE HIGH GROUND!

Metro-Goldwyn-Mayer, 1953, color, 101 minutes.

Producers: Herman Hoffman, Dore Schary; **Director:** Richard Brooks; **Screenwriter:** Millard Kaufman; **Music:** Dimitri Tiomkin; **Filmed in:** El Paso and Fort Bliss, Texas; **Cast:** Iris Adrian, Robert Arthur, Carleton Carpenter, Jerome Courtland, Steve Forrest, Bert Freed, William Hairston, Maurice Jara, Karl Malden, Elaine Stewart, Russ Tamblyn, Regis Toomey, Chris Warfield, Richard Widmark.

Richard Widmark, a cynical and hard-nosed drill instructor, and Karl Malden, both of whom fought with distinction in Korea, take a group of raw recruits and turn them into infantry soldiers.

INTERESTING FACTS

- This movie was filmed at Fort Bliss, Texas, on an active-duty military base, and the soldiers who appear in the background were actually going through infantry training with the very real possibility of going into combat in Korea.
- The opening scene of the newly arrived trainees getting off the train and the scene three months later of the disciplined troops getting onto the train for their new assignments were filmed on the same day with the same Southern Pacific locomotive and equipment.

AWARD

Academy Awards, USA, 1954
 Nominated: *Oscar, Best Writing, Story and Screenplay*, Millard Kaufman.

TANK BATTALION

Viscount Films, 1957, b&w, 80 minutes.

Producers: Richard Bernstein, Richard B. Duckett, George Waters; **Director:** Sherman A. Rose; **Screenwriters:** Richard Bernstein, George Waters; **Music:** Richard LaSalle; **Distributor:** American International Pictures; **Cast:** Baynes Barron, Warren Crosby, Don Devlin, Regina Gleason, Frank Gorshin, Don Kelly, Tetsu Komai, Barbara Luna, Robert Paget, Leslie Parrish, Troy Patterson, Edward G. Robinson Jr., Mark Sheeler, John Trigonis.

Tank commander Don Kelly and his crew must keep the North Koreans at bay while they wait for parts to repair their tank.

TANK COMMANDOS

El Monte Productions, 1959, b&w, 79 minutes.

Producer: Burt Topper; **Director:** Burt Topper; **Screenwriter:** Burt Topper; **Music:** Ronald Stein;

Distributor: American International Pictures; **Cast:** David Addis, Robert Barron, Wally Campo, Joan Connors, Carmen D'Antonio, Donato Farretta, Fred Gavlin, Larry Hudson, Noberto Kerner, Maggie Lawrence, Jerry Lear, Leo V. Matranga, Maria Monay, Russ Prescott, Lee Redman, Anthony Rich, Federico Roberto, Larry Shuttleworth, Jack B. Sowards.

Robert Barron leads a demolition unit that must find a secret underwater bridge being used by German tanks in Italy and blow it up.

TANK FORCE

Warwick Films, 1958, color, 103 minutes.

Producers: Irwin Allen, Albert R. Broccoli, Phil C. Samuel; **Director:** Terence Young; **Screenwriters:** Richard Maibaum, Merle Miller, Terence Young; **Music:** Kenneth V. Jones; **Distributor:** Columbia; **Cast:** Anne Aubrey, Martin Boddey, Robert Bruce, Alfred Burke, Bonar Colleano, Kenneth Cope, George Coulouris, Peter Elliott, Kenneth Fortescue, Leo Genn, Percy Herbert, Sean Kelly, David Lodge, Andreas Malandrinos, Richard Marner, Victor Mature, Anthony Newley, Luciana Paluzzi, George Pravda, Robert Rietty, Maxwell Shaw, Julian Sherrier, Bob Simmons, Alan Tilvern, Ernst Walder.

Thatcher (Victor Mature) is an American sergeant serving with a British tank corps in North Africa whose unit is captured by the Germans. The Nazis discover they have captured the soldier who once tried to assassinate Josef Goebbels (Hitler's right-hand man). Thatcher prefers not to go back to Germany as a prize, so he leads his fellow tankers in an escape. Retitled *Tank Force* for U.S. release; U.K. title is *No Time to Die*.

TANKS ARE COMING, THE

Warner Bros., 1951, b&w, 90 minutes.

Producer: Bryan Foy; **Directors:** D. Ross Lederman, Lewis Seiler; **Screenwriters:** Robert Hardy Andrews, Samuel Fuller; **Cast:** Mari Aldon, Harry Bellaver, Robert Boon, Philip Carey, Steve Cochran, James Dobson, Robert Horton, D. Ross Lederman, John McGuire, George O'Hanlon, Paul Picerni, Michael Steele.

Steve Cochran is a tough sergeant who has his own innovative way of doing things in his tank platoon.

This brings him into conflict with his lieutenant, until his ideas prove effective against the superior Nazi Tiger tanks.

The tank crew in the movie is part of the U.S. Third Armored Division during its advance from St.-Lô to Germany. The American tanks took heavy losses because they were inferior to Germany's Tiger tank.

INTERESTING FACT

- Actual combat camera footage is integrated into the film.

TARAWA BEACHHEAD

Columbia Pictures Corporation, 1958, b&w, 77 minutes.

Producer: Charles H. Schneer; **Director:** Paul Wendkos; **Screenwriter:** Richard Alan Simmons; **Cast:** Julie Adams, Morris Ankrum, John Baer, William Boyett, Ray Danton, Lee Farr, Michael Garth, Buddy Lewis, Kerwin Mathews, Don Reardon, Dan Riss, Eddie Ryder, Karen Sharpe, Onslow Stevens, Larry Thor, Russell Thorson, John Zaremba.

During the Battle of Guadalcanal, a marine sergeant witnesses his platoon commander murder one of his men to cover his own incompetence. Later in the war, at Tarawa, the guilty officer is killed in action. The authorities want to recommend him for the Medal of Honor, but the sergeant stops the recommendation.

TARGET UNKNOWN

Universal-International Pictures, 1951, b&w, 90 minutes.

Producer: Aubrey Schenck; **Director:** George Sherman; **Screenwriter:** Harold Medford; **Cast:** Hugh Beaumont, James Best, Richard Carlyle, Tony Christian, Suzanne Dalbert, Robert Douglas, Malú Gatica, Steven Geray, Joyce Holden, Alex Nicol, Johnny Sands, Mark Stevens, Don Taylor, Gig Young, James R. Young.

When luck runs out for a bomber, the crew is forced to bail out. They are captured by the Germans and brought to a pleasant interrogation center, where the highly trained staff of German officers, through conversations with the prisoners in innocuous settings such as at meals, begins to collect small bits and pieces of information from which the officers are able to deduce the details of a large upcoming Allied raid.

This film would have made a valuable training film during World War II, along the theme of "Loose Lips Sink Ships." Soldiers should give only their name, rank, and serial number. As the crew gives away small pieces of information, all of them seemingly innocent, they create a mosaic that the Nazi commander is able to piece together.

QUOTE

German officer: You're the traitor. You and that stupid crew of yours. You know what you have done? You've given us a first-rate briefing on your Cambrais raid.

TARGET ZERO

Warner Bros., 1955, b&w, 92 minutes.

Producer: David Weisbart; **Director:** Harmon Jones; **Screenwriters:** James Warner Bellah, Sam Rolfe; **Music:** David Buttolph; **Distributor:** Warner Bros.; **Cast:** John Anderson, Joby Baker, Charles Bronson, Peggie Castle, George Chan, Chuck Connors, Richard Conte, Terrence De Marney, John Dennis, Abel Fernández, L. Q. Jones, Angela Loo, Ralph Lorraine, Strother Martin, Don Oreck, Hal Sheiner, Aaron Spelling, Richard Wyler.

A ragtag force consisting of the remnants of a British tank crew, a patrol of American GIs, and a female UN employee is faced with holding a critical ridge during the Korean War.

TASK FORCE

Warner Bros., 1949, b&w, 116 minutes.

Producer: Jerry Wald; **Director:** Delmer Daves; **Screenwriter:** Delmer Daves; **Music:** Franz Waxman; **Cast:** Art Baker, Roscoe J. Behan, Bruce Bennett, Walter Brennan, Fred Clark, Gary Cooper, Sally Corner, Warren Douglas, Joe Forte, Edwin Fowler, John Gallaudet, Alex Gerry, William Gould, James Holden, Jack Holt, Reed Howes, William Hudson, Tetsu Komai, Mary Lawrence, Julie London, Rory Mallinson, Mickey McCardle, John McGuire, Paul McWilliams, Mal Merrihugh, Ray Montgomery, Wayne Morris, Moroni Olsen, John Ridgely, Stanley Ridges, Richard Rober, Robert Rockwell, Basil Ruysdael, Charles Sherlock, Kenneth Tobey, Laura Treadwell, Charles Waldron Jr., Tommy Walker, Harlan Warde, Charles Williams, Beal Wong, Jane Wyatt.

Gary Cooper plays a World War I naval aviator who spends the two decades after the war promoting the superiority of naval air power, at the risk of his own military career. Military and political red tape continually frustrate his efforts, prompting him to consider leaving the navy for a more lucrative civilian job. However, World War II finally gives him the opportunity to prove to Washington the valuable role aircraft carriers can play in winning the war.

This movie is a navy version of THE COURT-MARTIAL OF BILLY MITCHELL. Billy Mitchell sacrifices his career for army air power, while this fictional officer does the same thing for navy air power. Coincidentally, Gary Cooper stars in both films.

TASTE OF HELL, A

Boxoffice International Pictures, 1973, color, 90 minutes.

Producers: Ben Balatrat, John Garwood, Harry H. Novak; **Directors:** Basil Bradbury, Neil Yarema; **Screenwriter:** Neil Yarema; **Distributors:** Boxoffice International Pictures; **Filmed in:** Philippines; **Cast:** Angel Buenaventura, Vic Diaz, John Garwood, Lloyd Kino, Liza Lorena, Ruben Rustia, William Smith.

An American officer, fighting with the Filipinos against the Japanese, is captured with his men. The sadistic Japanese officer in command orders machine guns turned on the soldiers after they have surrendered. Even though he is seriously wounded, he escapes the massacre, and ultimately he cuts off the head of the Japanese officer in revenge.

TELL ENGLAND

British Instructional Films, 1931, b&w, 80 minutes.

Producer: H. Bruce Woolfe; **Director:** Anthony Asquith; **Screenwriters:** Anthony Asquith, A. P. Herbert, Ernest Raymond; **Distributor:** Capitol; **Filmed in:** Malta; **Cast:** Tony Bruce, Fay Compton, Toni Edgar-Bruce, C. M. Hallard, Hubert Harben, Carl Harbord, Dennis Hoey, Frederick Lloyd, Wally Patch, Gerald Rawlinson.

Two boyhood friends enlist in the British army at the outbreak of World War I and become part of the British expedition to Gallipoli. The horrors of war slowly begin to dampen their romantic enthusiasm. Then one of them is completely devastated mentally

by the cruel slaughter of his men by a Turkish trench mortar. To redeem himself, he leads a raid on the Turkish trenches, and, although mortally wounded, he manages to single-handedly put the trench mortar post out of action. Shortly after his death, the British withdraw from Gallipoli.

The battle to take Gallipoli was a great and tragic failure. The concept of the Allied plan was to open the straits at Gallipoli, split Turkey, and open an all-weather line of communication to Russia. However, miscalculations and military blunders turned what should have been a quick and decisive campaign by the Mediterranean Expeditionary Force into another campaign of attrition, just like the western front. After massive losses, the British withdraw, leaving only their graves behind them.

The film is known as *The Battle of Gallipoli* (1931) in the United States.

TEN SECONDS TO HELL

Hammer Film Productions–Seven Arts, 1959, b&w, 93 minutes.

Producer: Michael Carreras; **Director:** Robert Aldrich; **Screenwriters:** Robert Aldrich, Lawrence P. Bachmann, Teddi Sherman; **Music:** Kenneth V. Lones; **Distributor:** United Artists; **Filmed in:** Berlin, Germany; **Cast:** Wesley Addy, Virginia Baker, Martine Carol, Jeff Chandler, Robert Cornthwaite, Jimmy Goodwin, Nancy Lee, Charles Nolte, Jack Palance, Richard Wattis, Dave Willock.

At the end of World War II, six German former soldiers return to Berlin to work in bomb disposal. The city is full of dangerous, unexploded 1000-pound bombs dropped by the Allies. As they become increasingly aware of the fact that they could all be killed, the six men agree to a tontine: They will pool half their pay and the survivor will take it all.

The movie is based on Lawrence P. Bachmann's book *The Phoenix* (London: Collins, 1955).

MILITARY SERVICE

- Robert Cornthwaite spent four years in the U.S. Army Air Force during World War II.

TERRIBLE BEAUTY, A

Stross, D.R.M. Productions, 1960, b&w, 89 minutes.

Producer: Raymond Stross; **Director:** Tay Garnett; **Screenwriter:** R. Wright Campbell; **Distributor:**

United Artists; **Cast:** Marianne Benet, Harry Brogan, Eileen Crowe, Cyril Cusack, James Devlin, Wilfred Downing, Hilton Edwards, Eddie Golden, Geoffrey Golden, Richard Harris, Anne Heywood, Marie Kenn, Joe Lynch, Niall MacGinnis, Robert Mitchum, Dan O'Herlihy, Christopher Rhodes.

Robert Mitchum becomes increasingly ensnared in the Irish Rebellion.

The movie is known as *Night Fighters* in the United States.

QUOTES

Dermot: Have I the look of an idiot?
Sean: For the sake of our friendship, I'd better not answer.

Dermot: Sometimes I think the IRA was invented by a manufacturer of trench coats to keep up sales.

THAT NAZTY NUISANCE

United Artists, 1943, b&w, 43 minutes.

Producer: Glenn Tryon; **Director:** Glenn Tryon; **Screenwriters:** Clarence Marks, Earle Snell; **Music:** Edward Ward; **Cast:** Johnny Arthur, Joe Devlin, Rex Evans, Frank Faylen, Abe Kashey, Ian Keith, Ed Lewis, Wedgwood Nowell, Emory Parnell, Jean Porter, Charles Rogers, Henry Victor, Bobby Watson.

Three Axis dictators—Hitler, Mussolini, and a Japanese ruler named Suki Yaki—are transported to a fantasy world where they are confronted by the victims of a torpedoed merchant ship.

THEN THERE WERE THREE

Parade, 1961, b&w, 82 minutes.

Director: Alex Nicol; **Screenwriter:** Frank Gregory; **Music:** Tarcisio Fusco; **Cast:** Michael Billingsley, Richard Bull, Barry Cahill, Fredrick R. Clark, Sidney Clute, Brendan Fitzgerald, Frank Gregory, Gerald Herter, Frank Latimore, Alex Nicol, Kurt Polter.

American soldiers struggle to get back to their own lines in Italy during World War II. They know that one of them is an undercover Nazi soldier who is going to kill an Italian guerrilla leader, and they have to discover which one of them is the assassin.

THERE'S SOMETHING ABOUT A SOLDIER

Columbia Pictures Corporation, 1944, b&w, 81 minutes.

Producer: Samuel Bischoff; **Director:** Alfred E. Green; **Screenwriters:** Horace McCoy, Barry Trivers; **Filmed in:** Camp Davis, North Carolina; **Cast:** Hugh Beaumont, Louise Beavers, Bruce Bennett, Jeff Donnell, Jonathan Hale, John Hubbard, Evelyn Keyes, Johnny Mitchell, Tom Neal, Kane Richmond, Robert Stanford, Frank Sully, Lewis Wilson, Craig Woods.

Tom Neal plays a headstrong officer going through training at an anti-aircraft artillery school during World War II. He goes through an attitude adjustment and takes his training a lot more seriously after he comes into contact with Bruce Bennett, who fought Rommel's Afrika Corps in North Africa.

THEY CAME TO CORDURA

Columbia Pictures Corporation, 1959, color, 123 minutes.

Producer: William Goetz; **Director:** Robert Rossen; **Screenwriters:** Ivan Moffat, Robert Rossen, Glendon Swarthout; **Music:** Elie Siegmeister; **Distributor:** Columbia Pictures; **Filmed in:** Utah; **Cast:** Jim Bannon, Sam Buffington, Michael Callan, Richard Conte, Gary Cooper, Clem Fuller, Arthur Hanson, Rita Hayworth, Van Heflin, Tab Hunter, Maurice Jara, Robert Keith, Edward Platt, Carlos Romero, Dick York.

After a desperate cavalry charge during the 1916 U.S. punitive expedition against Pancho Villa, awards officer Gary Cooper recommends five men for the Medal of Honor. Cooper is given this job because he has shown himself to be a coward, disgraced in battle. He is ordered to take these new heroes to Cordura, along with prisoner Adelaide Geary, a gringo friendly to the enemy. On the arduous journey to Cordura, his heroes show a different face, and he ultimately turns out to be the most courageous.

This film, based on Glendon Swarthout's book *They Came to Cordura* (New York: Random House, 1958), centers on five army soldiers recommended for the Medal of Honor during the punitive expedition against Pancho Villa in Mexico in 1916. However, there were only eight Medals of Honor awarded during 1915–1916, and all of them went to the navy; none of them went to the army.

INTERESTING FACTS

- Actor Dick York is the soldier who captures the gate and is one of those recommended for the Medal of Honor. At the end of the scene, he makes an incredible jump from the top of the gate. He sustained a critical back injury from this jump, from which he never recovered. Despite painkillers, the injury ultimately ended his acting career; he was forced to leave the television show *Bewitched* and was replaced by another actor as the husband of good witch Elizabeth Montgomery.

QUOTES

Maj. Thomas Thorn: I became two men. One can't stand living in the same skin with the other.

Maj. Thomas Thorn: Did you ever see the Medal of Honor?
Private Renziehausen: No, sir.
Maj. Thomas Thorn: It's the most beautiful decoration of all, as it should be. I'd trade an ear for one any time, two in fact.
Private Renziehausen: Excuse me, sir, but I'd rather have the ear.

THEY DARE NOT LOVE

Columbia Pictures Corporation, 1941, b&w, 76 minutes.

Producer: Samuel Bischoff; **Directors:** Charles Vidor, James Whale; **Screenwriters:** Charles Bennett, James Edward Grant, Ernest Vajda; **Cast:** Edgar Barrier, Roman Bohnen, Egon Brecher, George Brent, Lloyd Bridges, Peter Cushing, Kay Linaker, Paul Lukas, Frank Reicher, Martha Scott.

George Brent, an anti-Nazi leader, volunteers to give himself up in exchange for prisoners held in Germany.

THEY RAID BY NIGHT

Producers Releasing Corporation, 1942, b&w, 73 minutes.

Producer: Dixon R. Harwin; **Director:** Spencer Gordon Bennet; **Screenwriter:** Jack Natteford; **Music:** David Chudnow; **Distributor:** Producers Releasing Corporation; **Cast:** Paul Baratoff, John Beck, Swen Hugo Borg, Leslie Denison, June Duprez, Robert Fischer, Bruce Kellogg, Pierce Lyden, George N. Neise, Brian O'Hara, Snub Pol-

lard, Charles Rogers, Lyle Talbot, Sigfrid Tor, Victor Varconi, Crane Whitley, Eric Wilton.

During World War II, three British commandos raid a Nazi concentration camp to rescue a Norwegian chief of staff.

THEY WERE EXPENDABLE

Metro-Goldwyn-Mayer, 1945, b&w, 135 minutes.

Producers: John Ford, Cliff Reid; **Director:** John Ford; **Screenwriters:** Frank Wead, William L. White; **Music:** Herbert Stothart, Eric Zeisl; **Distributor:** MGM; **Filmed in:** Florida Keys and Key Biscayne, Florida, and Melville, Rhode Island; **Cast:** Philip Ahn, Murray Alper, Leon Ames, Robert Barrat, Betty Blythe, Ward Bond, John Carlyle, Pedro de Cordoba, Donald Curtis, William B. Davidson, Blake Edwards, Jim Farley, Lee Tung Foo, Wallace Ford, Alex Havier, Louis Jean Heydt, Jack Holt, Bruce Kellogg, Michael Kirby, Stubby Kruger, Paul Langton, Trina Lowe, Eve March, Kermit Maynard, Cameron Mitchell, Robert Montgomery, Tim Murdock, Robert Emmett O'Connor, Max Ong, Jack Pennick, Donna Reed, Russell Simpson, Vernon Steele, Sammy Stein, Harry Tenbrook, Marshall Thompson, Pacita Tod-Tod, Charles Trowbridge, Tom Tyler, Arthur Walsh, John Wayne, Billy Wilkerson, Jeff York.

The fall of the Philippines to the Japanese in World War II and the heroism of the defenders is exemplified by the story of one American PT boat squadron. Unappreciated by the navy brass, these plywood boats carry out a number of important missions, including the evacuation of General MacArthur from Corregidor and suicidal forays against Japanese ships that delay their advance while the American troops fall back and reorganize. John Wayne plays the executive officer who doesn't believe in the boats and has to be convinced. The movie ends with some of the squadron going back to the United States to train more PT boat crews for the war in the Pacific; the rest are headed for certain captivity and death as Japanese prisoners of war.

The title *They Were Expendable* says it all about the navy's attitude towards the PT boats and their crews. *IN HARM'S WAY* is another movie in which the PT boat crews were slaughtered.

INTERESTING FACTS

- The real-life nurse Beulah Greenwalt thought that Donna Reed's portrayal "cheapened her character," sued, and won a judgment for $290,000.

- The real-life Kelley (played by John Wayne) claimed that Wayne's depiction hurt his reputation, but he won only $3000 in damages.
- John Ford was a good friend of John Bulkeley, whom he served with in World War II. During the Normandy landings, he spent five days with Bulkeley, by that time a lieutenant commander in charge of a squadron of PT boats involved in the Normandy invasion.

MILITARY SERVICE

- Based on the real-life heroics of Lt. John Bulkeley (Brickley, played by Robert Montgomery) as transcribed by William S. White in his wartime bestseller, the movie accurately depicts the defense of the Philippines by American PT boats from December 1941 through April 1942, for which Lieutenant (later vice admiral) Bulkeley was awarded the Medal of Honor for conspicuous gallantry and skillfully executed attacks against the enemy.
- Six-time Academy Award–winning director John Ford was a navy commander when this was shot; ultimately he became an admiral. He applied to Annapolis, but didn't get in. He then followed his brother to Hollywood and was an assistant director when World War I broke out, but he was exempt because filmmaking was considered an essential industry. In 1934 he finally obtained a commission in the Naval Reserves as a lieutenant commander, and he went to Mexico in his yacht, where he gathered information on Japanese ships for naval intelligence. In April 1940, Ford formed a naval reserve unit of filmmakers, the Naval Field Photographic Unit. As a commander, he was present at the Battle of Midway, and after seeing the film that Ford shot of the battle, President Roosevelt said, "I want every mother in America to see this picture." Ford then attended commando school in Scotland to prepare himself to film the American landings in North Africa. Attaching himself to Company D, 13th Armored Regiment, he landed at Tunisia with his film crew; on one occasion, he and his crew captured a German aviator who was shot down. He was promoted to captain, and his next assignment was to photograph the landings at Normandy. He supervised all of the camera crews and was present at Omaha Beach. He received the Legion of Merit from William Donovan, head of the OSS, and retired from the Navy Reserve as an admiral. John Ford's six Oscars include four for best director: *The Informer, The Grapes of Wrath, How Green Was My Valley,* and *The Quiet Man;* one for best documentary: *The Battle of Midway;* and one for best picture: *The Quiet Man.*

- The screenwriter was World War I naval aviator Frank "Spig" Wead, scribe of 32 films, whom John Wayne portrayed in the biopic *Wings of Eagles*.
- Robert Montgomery (father of *Bewitched* actress Elizabeth Montgomery) was himself a PT boat skipper in World War II. Commissioned on April 28, 1941, he was a naval attaché at the American Embassy in London when the Japanese bombed Pearl Harbor. He applied for sea duty, was trained in PT boats, and saw action at Guadalcanal and the Marshall Islands. He then was trained as a deck officer, assigned to the destroyer USS *Barton* (DD-722) and took part in the D day invasion at Normandy, providing naval gunfire support to the invasion. He was promoted to lieutenant commander and awarded the Bronze Star.

AWARDS

Academy Awards, USA, 1945
 Nominated: *Oscar*, *Best Special Effects*, A. Arnold Gillespie (*photographic*), Donald Jahraus (*photographic*), R. A. MacDonald (*photographic*), Michael Steinore (*sound*); *Best Sound Recording*, Douglas Shearer (MGM SSD).

THEY WHO DARE

Mayflower Film Corporation, 1953, color, 107 minutes.

Producers: Aubrey Baring, Maxwell Setton; **Director:** Lewis Milestone; **Screenwriter:** Robert Westerby; **Music:** Robert Gill; **Distributor:** British Lion; **Cast:** Dirk Bogarde, Peter Burton, Kay Callard, Denholm Elliott, Lisa Gastoni, Sam Kydd, Anthea Leigh, Alec Mango, Michael Mellinger, Gérard Oury, David Peel, Eric Pohlmann, William Russell, Harold Siddons, Akim Tamiroff, Eileen Way.

In Greece during World War II, a small group of British commandos land on an island crawling with enemy troops. Their mission is to attack two airfields from which the Luftwaffe is attacking Allied forces in Egypt.

THIN RED LINE, THE

Allied Artists, 1964, b&w, 99 minutes.

Producers: Bernard Glasser, Sidney Harmon, Lester A. Sansom, Philip Yordan; **Director:** Andrew Marton; **Screenwriters:** Bernard Gordon, James Jones; **Filmed in:** Madrid, Spain; **Cast:** Ray Daley, Keir Dullea, Jason Fithian, Jim Gillen, Bob Kanter, Kieron Moore, James Philbrook, Steve Rowland, Charles Stalmaker, Ben Tatar, Jack Warden, Merlyn Yordan.

Separated from his new wife after only eight days of marriage, Private Doll (Keir Dullea) is determined to survive the war. He decides he will not blindly follow the orders of his superiors; he will follow his own mind. During a series of poorly planned attacks, Doll saves the day time after time, eventually leading to the taking of critical terrain in the battle of Guadalcanal.

The film is based on James Jones's book *The Thin Red Line* (New York: Scribner, 1962).

THIN RED LINE, THE

Geisler-Roberdeau, Fox 2000 Pictures, Phoenix Pictures, 1998, color, 170 minutes.

Producers: Robert Michael Geisler, Grant Hill, Sheila Davis Lawrence, John Roberdeau, George Stevens Jr., Michael Stevens; **Director:** Terrence Malick; **Screenwriters:** James Jones, Terrence Malick; **Distributor:** 20th Century Fox Film Corporation; **Filmed in:** New South Wales and in Port Douglas, Cairns, Daintree, Mossman, and Bramston Beach, Queensland—all in Australia—and Honiara, Solomon Islands; **Cast:** Kirk Acevedo, Penelope Allen, John Augwata, Joshua Augwata, John Bakotee, Charlie Beattie, Simon Billig, Mark Boone Jr., Adrien Brody, Norman Patrick Brown, James Caviezel, Ben Chaplin, George Clooney, John Cusack, Immanuel Dato, Jarrod Dean, Matt Doran, Travis Fine, Paul Gleeson, Benjamin Green, Kick Gurry, Lukas Haas, Woody Harrelson, David Harrod, Don Harvey, Kengo Hasuo, Shawn Hatosy, Ben Hines, Danny Hoch, Robert Roy Hofmo, Michael Iha, Thomas Jane, Randall Duk Kim, Darrin Klimek, Emmunual Konai, Stephen Konai, Elias Koteas, Polyn Leona, Jared Leto, Donal Logue, Simon Lyndon, Gordon MacDonald, Kazuki Maehara, Marina Malota, Michael McGrady, Dash Mihok, Ken Mitsuishi, Ryûji Mizukami, Peter Morosiro, Tim Blake Nelson, Larry Neuhaus, Amos Niuga, Nick Nolte, Taiju Okayasu, Takamitsu Okubo, Miranda Otto, David Paschall, Sean Penn, Jace Phillips, Bill Pullman, John C. Reilly, Larry Romano, Kazuyoshi Sakai, John Savage, Masayuki Shida, Jennifer Siugali, John Dee Smith, Stephan Spacek, Nick Stahl, Hiroya Sugisaki, Kouji Suzuki, Tomohiro Tanji, Carlos Tome, Selina Tome, Minoru Toyoshima, John Travolta, Terutake Tsuji, Arie Verveen, Steven Vidler, Todd Wallace, Will Wal-

lace, Joe Watanabe, Simon Westaway, Vincent Wild, Felix Williamson, Daniel Wyllie, Jimmy Xihite, Yasoumi Yoshino.

During World War II, at the Battle of Guadalcanal, young soldiers are brought in to relieve a battle-weary marine unit. The exhausting fight for a critical strategic airfield puts the men of Charlie Company through a living hell.

The film GUADALCANAL DIARY also portrays the Battle of Guadalcanal.

The film is based on James Jones's *The Thin Red Line* (New York: Scribner, 1962).

INTERESTING FACTS

- Billy Bob Thornton recorded a narration for the three-hour epic under the supervision of director Terence Malick. But the final print of the film has voice-overs by eight of the main characters in the film; none of the narration from Thornton is in the final print.
- Malick shot for 100 days in Australia, 24 in the Solomon Islands, and three in the United States.
- The original cut of the film was just under six hours long. More than 1 million feet of film was shot.
- The captured Japanese soldier in the middle of the movie is saying, "You will die too."
- The Japanese soldier who shoots Witt at the end of the movie is saying, "I don't want to kill you. Don't move."

QUOTES

Lt. Col. Gordon Tall: It's never necessary to tell me that you think I'm right. We'll just . . . assume it.

Capt. James "Bugger" Staros: I've lived with these men, sir, for two and a half years, and I will not order them all to their deaths.

First Sgt. Edward Welsh: What difference do you think you can make, one man in all this madness?

Lt. Col. Gordon Tall: The only time you should start worrying about a soldier is when they stop bitchin'.

13 MEN AND A GUN

Two Cities–Pisorno, 1938, b&w, 64 minutes.

Producer: Mario Zampi; **Director:** Mario Zampi; **Screenwriter:** Basil Dillon; **Cast:** Clifford Evans, Donald Gray, Allan Jeayes, Howard Marion-Crawford,

Gibb McLaughlin, Bernard Miles, Wally Patch, Arthur Wontner.

During World War I, a traitor in a 13-man gun crew betrays the location of their artillery battery to the Russians. However, nobody knows which soldier informed. The tension mounts as the Austrian high command orders all 13 soldiers executed. The soldiers must figure out the identity of the traitor to save their own lives.

13 RUE MADELEINE

20th Century-Fox, 1946, b&w, 95 minutes.

Producer: Louis De Rochemont; **Director:** Henry Hathaway; **Screenwriters:** Sy Bartlett, John Monks Jr.; **Music:** David Buttolph; **Filmed at:** Boston, Massachusetts, Québec, Canada; **Cast:** Walter Abel, Leslie Barrie, Roland Belanger, Martin Brandt, Frederic Brunn, Red Buttons, James Cagney, Charles D. Campbell, Richard Conte, Edward Cooper, Melville Cooper, Julius Cramer, James Craven, Albert D'Arno, Frank DeLangton, Jean Del Val, Frank Ferreira, Arno Frey, Dick Gordon, Walter Greaza, Reed Hadley, Sam Jaffe, Alexander Kirkland, Frank Latimore, Alfred Linder, Ben Low, Judith Lowry, Karl Malden, E. G. Marshall, Reginald Mason, Horace McMahon, Sally McMarrow, William Mendrek, John Moore, Robert Morgan, Coby Neal, Fred Nurney, Don Randolph, Otto Reichow, Durant Rice, Marcel Rousseau, Otto Simánek, William Syran, Dick Wessel, Roland Winters, Harold Young, Blanche Yurka, Peter von Zerneck.

OSS agents are trained for World War II espionage work behind enemy lines. One of the agent trainees is a German mole. James Cagney is aware of this and schemes to feed him false information about the invasion of Europe. However, the German spy outsmarts the agents and rejoins his people, now knowing too much. Cagney must take the risk of going in after him. Cagney is captured, and because he knows about the invasion, the Allies must bomb Gestapo headquarters, where he is being held, and kill him to ensure that he reveal nothing under torture.

In a poignant scene, during the graduation training exercise for OSS agents, Cagney is still trying to determine which one of the students is a German spy (double agent). During the exercise, the German spy produces fake credentials to save him and his partner from being caught. Cagney then realizes he is the spy, because the fake credentials are too clever for a beginning student, and two regular American kids would have just slugged their way out of the jam.

The Gestapo was the official state secret police, the name an acronym for *Geheime Staatzpolizei*. It was founded in 1933 in Prussia under Hermann Göring, then Prussian state minister of the interior. It later was made a national organization under Heinrich Himmler, and then its control was extended into the occupied countries. It functioned with unlimited arrest powers, brutal torture, authority to execute its prisoners without trial—then removing all official records of its acts so that the victims disappeared without a trace. Operating with the SS, who ran the concentration camps, they were feared by both the Allies and the German people themselves.

THIRTY SECONDS OVER TOKYO

Metro-Goldwyn-Mayer, 1944, b&w, 138 minutes.

Producer: Sam Zimbalist; **Director:** Mervyn LeRoy; **Screenwriters:** Robert Considine, Ted W. Lawson, Dalton Trumbo; **Music:** Herbert Stothart; **Distributor:** MGM; **Filmed in:** Fort Walton Beach, Florida; **Cast:** Leon Ames, Morris Ankrum, Robert Bice, Douglas Cowan, Donald Curtis, Don DeFore, Benson Fong, Herbert Gunn, Louis Jean Heydt, Van Johnson, Dr. Hsin Kung, Paul Langton, Ching Wah Lee, Scott McKay, Stephen McNally, Robert Mitchum, Dorothy Morris, Tim Murdock, Alan Napier, William Phillips, John R. Reilly, Selena Royle, Ann Shoemaker, Phyllis Thaxter, Spencer Tracy, Gordon Trigg, Robert Walker, Jacqueline White, Bill Williams, Guinn Williams.

Stunned by Pearl Harbor and a string of defeats, America needs a victory badly. Lt. Col. Jimmy Doolittle, a former air racer and stunt pilot, devises a plan for a daring raid into the heart of Japan. To do this, he must train army bomber pilots to do something no one ever dreamed possible: Launch 16 fully loaded

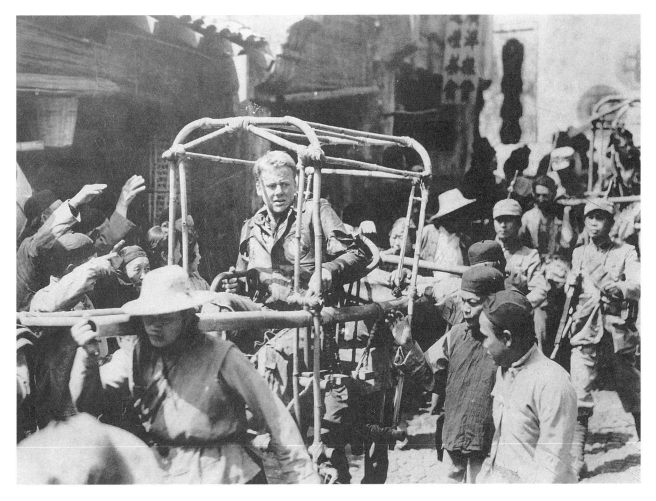

Thirty Seconds Over Tokyo (MGM/AUTHOR'S COLLECTION)

bombers from an aircraft carrier. They successfully bomb Tokyo, crash-land in China, and are guided to safety by Chinese villagers.

The film is based on Lt. Ted Lawson's *Thirty Seconds over Tokyo* (New York: Random House, 1943).

INTERESTING FACTS

- Screenwriter Dalton Trumbo was very concerned about the dramatic structure of the film. The natural climax of the film (and hence its ending) should have been the raid. As he notes, he "had to go through so many tricks to cover it up," to make the story work for an hour after the film should have ended.
- The film *PEARL HARBOR* (2001) ends with the heroes on the Doolittle Raid.
- When Lawson's book came out, it concealed the name of the aircraft carrier from the Japanese by calling it the "Shangri La." This didn't fool the Japanese, and the sinking of the *Hornet* became the number-one priority of the Imperial Japanese Fleet. They finally got it on October 26, 1942, defending Guadalcanal in the Battle of Santa Cruz.
- The Japanese captured the crews of three of the 16 planes, and then, in violation of all rules of civilized warfare, brutally beheaded three of the officers with samurai swords.
- The friendly Chinese troops that rescued the American crews were communist, not soldiers serving under Chiang Kai-Shek.
- Screenwriter Trumbo interviewed men from the raid and took a number of rides on B-25s, until he knew every position on the aircraft (it has a crew of five).
- Six of the raiders were technical advisers on the film.
- The names of missing raiders were disguised in the film for fear the raiders might fall into the hands of the Japanese and be executed.
- The Japanese put a bounty of $5000 on the head of each of the 80 men who flew the mission.
- The film uses actual combat camera footage from the raid.

MILITARY SERVICE

- Spencer Tracy, who played Jimmy Doolittle, tried to join the U.S. Marine Corps in World War I, but he was too young. He and his boyhood friend Pat O'Brien, who also became an actor, got their parents' permission and joined the U.S. Navy. But Tracy never got overseas; he spent the entire war at Great Lakes Naval Station, near Chicago.

- The author of the book, Lieutenant Lawson (played in the film by Van Johnson), was one of the pilots in the Doolittle Raid and really lost his leg.
- One of the pilots on the actual raid was named Davenport (played in the film by Tim Murdock).
- Robert Mitchum served as an army drill instructor during World War II.
- Lt. Col. Jimmy Doolittle received a direct promotion to brigadier general and the Medal of Honor from President Roosevelt for his part in conceiving, organizing, and heroically leading the raid.

MISTAKE

- Ted Lawson's amputated left leg is briefly visible when he puts the sandal on his right foot.

AWARDS

Academy Awards, USA, 1944
 Won: *Oscar, Best Special Effects*, A. Arnold Gillespie (photographic), Donald Jahraus (photographic), Warren Newcombe (photographic), Douglas Shearer (sound)
 Nominated: *Oscar, Best Cinematography, Black-and-White*, Harold Rosson, Robert Surtees.

36 HOURS

Metro-Goldwyn-Mayer, 1964, b&w, 115 minutes.

Producer: William Perlberg; **Director:** George Seaton; **Screenwriters:** Roald Dahl, Carl K. Hittleman, George Seaton, Luis H. Vance; **Music:** Dimitri Tiomkin; **Distributor:** MGM; **Cast:** Chris Anders, Rudolph Anders, John Banner, Marjorie Bennett, Oscar Beregi Jr., Leslie Bradley, Paul Busch, Howard Curtis, George Dee, John Dennis, James Doohan, Harold Dyrenforth, Horst Ebersberg, Kort Falkenberg, Walter Friedel, James Garner, Ed Gilbert, John Gilgreen, John Hart, Karl Held, Walter Janovitz, Roy Jenson, Martin Kosleck, Celia Lovsky, Barry Macollum, Owen McGiveney, Joseph Mell, Eric Micklewood, Jeff Morris, Alan Napier, Richard Peel, Werner Peters, Hilda Plowright, Joe Di Reda, Otto Reichow, Henry Rowland, Sig Ruman, Eva Marie Saint, Norbert Schiller, Rolfe Sedan, William Smith, Michael Stroka, Rod Taylor, Russell Thorson.

James Garner, a U.S. Army major, is captured by the Germans during World War II. They attempt to make him believe that he has been unconscious for six years, recovering in the hospital, and that the war is long over.

By making him believe that the war is over and that he is safe in an Allied hospital, they hope that he will talk about the upcoming Allied invasion of Normandy, since he will believe that it is now ancient history.

MILITARY SERVICE

- Screenwriter Roald Dahl was a fighter pilot in the Royal Air Force during World War II. He was shot down over the Libyan Desert and as a result spent 16 weeks in a German hospital.

 Actor James Doohan (Scotty on *Star Trek*) was a Royal Canadian Air Force fighter pilot during World War II. He was cited for performing daredevil aerobatics over aerodromes where he was stationed, but cited also for performance above and beyond the call of duty on fighter sweeps (destroying enemy targets on the ground) deep into enemy-held territory. It was during one of these fighter sweeps that he lost the middle finger on his right hand from enemy fire.

 The film is based on the book *Beware of the Dog*, by Roald Dahl.

THIS ABOVE ALL

20th Century-Fox, 1942, b&w, 110 minutes.

Producer: Darryl F. Zanuck; **Director:** Anatole Litvak; **Screenwriters:** Eric Knight, R. C. Sherriff; **Music:** Alfred Newman; **Cast:** John Abbott, Sara Allgood, May Beatty, Harold De Becker, Dorothy Daniels de Becker, Billy Bevan, Nigel Bruce, Colin Campbell, Leonard Carey, Andy Clyde, Valerie Cole, Melville Cooper, Gladys Cooper, Alec Craig, Carol Curtis-Brown, Alan Edmiston, Jill Esmond, Mary Field, Joan Fontaine, Brenda Forbes, Mary Forbes, Denis Green, Lumsden Hare, Forrester Harvey, Holmes Herbert, Dennis Hoey, Olaf Hytten, Stephanie Insall, Lilyan Irene, Alexander Knox, Queenie Leonard, Doris Lloyd, Thomas Louden, Morton Lowry, Miles Mander, Aubrey Mather, Virginia McDowall, Philip Merivale, Thomas Mitchell, Jessica Newcombe, Rita Page, Tyrone Power, Jean Prescott, Stuart Robertson, Anita Sharp-Bolster, Arthur Shields, Wyndham Standing, Val Stanton, Henry Stephenson, Heather Thatcher, Cyril Thornton, Clare Verdera, Rhys Williams, Joyce Wynn.

Aristocratic Prudence Cathaway (Joan Fontaine) shocks her family by enlisting in the WAFs. A fellow WAF sets her up on a blind date with handsome but moody Clive Briggs (Tyrone Power). Prudence learns that Clive, disillusioned with the war after the evacuation at Dunkirk, is a deserter. However, she still loves him and believes he will prove himself a patriot.

The movie is based on Eric Knight's book *This Above All* (New York and London: Harper & Brothers, 1941).

THIS LAND IS MINE

RKO Radio Pictures Inc., 1943, b&w, 103 minutes.

Producers: Eugène Lourié, Dudley Nichols, Jean Renoir; **Director:** Jean Renoir; **Screenwriter:** Dudley Nichols; **Music:** Lothar Perl; **Distributor:** RKO Radio Pictures; **Cast:** Philip Ahlm, Frank Alten, John Banner, Joan Barclay, Linda Ann Bieber, Tommy Bond, Swen Hugo Borg, Leo Bulgakov, George M. Carleton, Wheaton Chambers, Gordon Clark, George Coulouris, Albert D'Arno, John Dilson, John Donat, Ludwig Donath, Margaret Fealy, Nancy Gates, Thurston Hall, Otto Hoffman, Russell Hoyt, Lloyd Ingraham, Casey Johnson, Charles Laughton, Oscar Loraine, George MacQuarrie, Hal Malone, Jack Martin, Ed McNamara, Philip Merivale, Hans Moebus, Hans von Morhart, Rudolph Myzet, Una O'Connor, Maureen O'Hara, Emory Parnell, John Rice, Henry Roquemore, George Sanders, Ferdinand Schumann-Heink, Hans Schumm, Lester Sharpe, Jack Shea, Ida Shoemaker, Ivan F. Simpson, Walter Slezak, Kent Smith, George Sorel, Bob Stevenson, Mary Stuart, Gus Taillon, Walter Thiele, Nicholas Vehr, Cecil Weston, William Yetter Jr.

Charles Laughton plays a timid teacher in France. He is revealed as a coward during an air raid, but the excesses of the Nazi occupation of his peaceful town slowly turn him into a determined Resistance fighter. When he is arrested by the Germans for a murder he did not commit, the previously mild-mannered teacher uses his show trial as an opportunity to speak out on liberty and civil disobedience.

THIS MAD WORLD

Metro-Goldwyn-Mayer, 1930, b&w, 70 minutes.

Director: William C. de Mille; **Screenwriters:** Clara Beranger, Arthur Caesar, Madeleine Ruthven; **Distributor:** MGM; **Cast:** Veda Buckland, Louise Dresser, Kay Johnson, Louis Natheaux, Basil Rathbone.

Basil Rathbone plays a French spy who visits his mother behind German lines during World War I. He falls in love with a German officer's wife, and she betrays him.

THIS MAN'S NAVY

Metro-Goldwyn-Mayer, 1945, b&w, 100 minutes.

Producer: Samuel Marx; **Director:** William A. Wellman; **Screenwriters:** Borden Chase, Allen Rivkin; **Music:** Nathaniel Shilkret; **Cast:** Noah Beery, Wallace Beery, Steve Brodie, Paul Cavanagh, George Chandler, Jan Clayton, Dick Crockett, Donald Curtis, Tom Drake, Will Fowler, James Gleason, Henry O'Neill, Selena Royle, Arthur Walsh.

Wallace Beery plays a chief petty officer serving in the U.S. Navy Blimp Corps. He battles Nazi submarines during World War II.

INTERESTING FACTS

- This movie shows a lot of real-life footage of naval airships.
- The navy continued to use airships through the 1950s.
- The veterans of this branch of the navy can join the Naval Airship Association.

THIS WAS PARIS

Warner Bros., 1942, b&w, 77 minutes.

Producer: Max Milder; **Director:** John Harlow; **Screenwriters:** Edward Dryhurst, Gordon Wellesley, Brock Williams, Basil Woon; **Distributor:** Warner Bros.; **Cast:** Vera Bogetti, Frederick Burtwell, Ann Dvorak, Billy Holland, Harold Huth, Griffith Jones, Ben Lyon, Mary Maguire, Miles Malleson, Harry McElhone, Bernard Miles, Robert Morley, Hay Petrie, Marian Spencer, Harry Welchman.

Ann Dvorak is an ambulance driver in the early days of World War II. Ben Lyon is a bibulous American newspaperman called Butch, who likes to throw his weight around Paris because he knows he can get away with it. As the clouds of war gather all over Europe, Ann finds romance with a British intelligence agent, while Butch sobers up and begins taking his responsibilities seriously.

INTERESTING FACTS

- The movie was filmed in England at Warner Bros.'s Teddington Studios.
- American actors Ann Dvorak and Ben Lyon were British residents at the time.
- This film didn't receive an American release until several years after its production.

THOUSAND PLANE RAID, THE

Oakmont Productions, 1969, color, 93 minutes.

Producer: Lewis J. Rachmil; **Directors:** Boris Sagal, Erich von Stroheim Jr.; **Screenwriter:** Robert Vincent Wright; **Distributor:** United Artists; **Cast:** Barry Atwater, J. D. Cannon, John Carter, Charles Dierkop, Michael Evans, James Gammon, Christopher George, Bo Hopkins, Henry Jaglom, Gavin MacLeod, Gary Marshal, Tim McIntire, Ben Murphy, Noam Pitlik, Philip Proctor, Laraine Stephens, Scott Thomas.

A U.S. Army Air Force colonel convinces his superiors to launch a massive raid to prove his theory of daylight precision bombing. His commanders select the toughest target, a city deep in German territory that is well defended by both fighters and anti-aircraft batteries.

The actual thousand-plane raid was against the city of Cologne on May 30, 1942. The goal of the new U.S. Army Air Force, whose officers had been advocating strategic bombing for 20 years, was to show off this new type of warfare. The B-17 raid did inflict heavy damage on the war industries in the city. It was designed to hit the city in three waves. A nighttime raid, the first of three, carried incendiaries and lit up the city, followed by two waves that rained destruction on those below.

INTERESTING FACT

- The film acknowledges that this was the first bombing raid of its size during World War II, confirming that the raid depicted is the Cologne raid.

THREE CAME HOME

20th Century-Fox, 1950, b&w, 106 minutes.

Producer: Nunnally Johnson; **Director:** Jean Negulesco; **Screenwriters:** Nunnally Johnson, Agnes Newton Keith; **Music:** Hugo Friedhofer; **Distributor:** 20th Century-Fox Film Corporation; **Cast:** Sylvia Andrew, John Burton, Howard Chuman, Claudette Colbert, Campbell Copelin, Leslie Denison, Florence Desmond, Alex Frazer, Clarke Gordon, Jim Hagimori, Sessue Hayakawa, Mimi Heyworth, Robin Hughes, Virginia Keiley, Mark Keuning, Patric Knowles, Frank Kobata, Ken Kurosa, George Leigh, Sung Li, James Logan, Lee MacGregor, Drue Mallory, John Mantley, Harry Martin, David Matshushama, Phyllis Morris,

Giro Murashami, Patricia O'Callaghan, Patrick O'Moore, Melinda Plowman, Duncan Richardson, Al Saijo, Leslie Thomas, Douglas Walton, Helen West-cott, Kermit Whitfield, Pat Whyte, Leonard Willey, Mazaji Yamamoto, James Yanari.

Claudette Colbert is captured with her young son during the Japanese wave of conquest through the South Pacific. Put into an internment camp for civilians, she endures hardship at the hands of her cruel and brutal Japanese captors as she struggles to keep her young son alive.

This is the true story of Agnes Newton Keith's imprisonment in Japanese prisoner-of-war camps from 1941 to the end of World War II.

THREE COMRADES

Metro-Goldwyn-Mayer, 1938, b&w, 100 minutes.

Producer: Joseph L. Mankiewicz; **Director:** Frank Borzage; **Screenwriters:** F. Scott Fitzgerald, Edward E. Paramore Jr., Erich Maria Remarque (novel); **Music:** Franz Waxman; **Cast:** Ricca Allen, Stanley Andrews, Jessie Arnold, Lionel Atwill, Barbara Bedford, Walter Bonn, Henry Brandon, Ralph Bushman, George Chandler, Spencer Charters, Roger Converse, Charley Grapewin, William Haade, Donald Haines, Henry Hull, Alva Kellogg, Guy Kibbee, Priscilla Lawson, Mitchell Lewis, Marjorie Main, Claire McDowell, Edward McWade, Esther Muir, Ferdinand Munier, George Offerman, Sarah Padden, Leonard Penn, Frank Reicher, Margaret Sullavan, Robert Taylor, Phillip Terry, Franchot Tone, Morgan Wallace, E. Allyn Warren, Josephine Whittell, Norman Willis, Monty Woolley, Robert Young, George Zucco.

Three young soldiers (Robert Taylor, Franchot Tone, and Robert Young) return from World War I to face a bleak life in postwar Germany.

The film is based on Erich Maria Remarque's book *Three Comrades* (Boston: Little, Brown and Company, 1937). This is the third film in Remarque's war trilogy, the first two being ALL QUIET ON THE WESTERN FRONT (1930) and THE ROAD BACK (1937).

AWARDS

Academy Awards, USA, 1938
 Nominated: *Oscar, Best Actress,* Margaret Sullavan

New York Film Critics Circle Awards, 1938
 Won: *NYFCC Award, Best Actress,* Margaret Sullavan.

THREE KINGS

Village Roadshow Productions, Coast Ridge, Atlas Entertainment, Warner Bros., 1999, color, 114 minutes.

Producers: Bruce Berman, Alan Glazer, Gregory Goodman, Paul Junger Witt, Edward McDonnell, John Ridley, Kim Roth, Charles Roven, Douglas Segal; **Director:** David O. Russell; **Screenwriters:** John Ridley, David O. Russell; **Music:** Carter Burwell; **Distributor:** Warner Bros.; **Filmed in:** Niland, Los Angeles, and Calexico, California, Casa Grande, Arizona, and Mexico; **Cast:** Joseph Abi-Ad, Jacqueline Abi-Ad, Bonnie Afsary, Fadil Al-Badri, Abdullah Al-Dawalem, Mohamad Al-Jalahma, Jassim Al-Khazraji, Fahd Al-Ujaimy, Haidar Alatowa, Ghanem Algarawi, Jabir Algarawi, Omar Alhegelan, Ali Alkind, Haider Alkindi, Hassan Allawati, Sara Aziz, Sayed Badreya, Bret Bassett, Anthony Batarse, Brian Bosworth, Dylan Brown, George Clooney, Ice Cube, Cliff Curtis, Donte Delila, Scott Dillon, Alex Dodd, Christopher B. Duncan, Nora Dunn, Farinaz Farrokh, Jim Gaffigan, Jay Giannone, Judy Greer, Troy Hartman, Sam Hassan, Kwesi Okai Hazel, Marsha Horan, Doug Jones, Larry Jones, Partrick O'Neal Jones, Spike Jonze, Jamie Kennedy, Christopher Lohr, Peter Macdissi, Brad Martin, Holt McCallany, Randy W. McCoy, Rick Mendoza, Halim Mostafa, Al Mustafa, Kalid Mustrafa, Joey Naber, Al No-Omani, Gary Parker, Brian Patterson, Scott Pearce, Shawn Pilot, Derick Qaqish, Ghazwyn Ramiawi, Magdi Rashwan, Mark Rhodes, Basim Ridha, Joseph Richard Romanov, Salah Salea, Wessam Saleh, Hillel Michael Shamam, Mohammed Sharafi, Alia Shawkat, Tony Shawkat, Hassan Bach-Agh Sitto, Jon Sklaroff, Liz Stauber, Saïd Taghmaoui, Raad Thomasian, Mark Wahlberg, Al Whiting, Mykelti Williamson.

George Clooney, Mark Wahlberg, and Ice Cube lead a small group of adventurous American soldiers who set out at the end of the Gulf War to find and steal a cache of gold hidden somewhere near their desert base in Iraq. They not only find the gold but also innocent villagers who need their protection. In the end, they give up the gold to save their new friends.

This film should be compared with KELLY'S HEROES, in which the lead characters are never out for anything but their own greedy interests, and in the end they keep the gold. What makes the characters in *Kelly's Heroes* sympathetic is that it is established early in the film that they have been in the front line continually and that their platoon has virtually been wiped out by

the combat. Those left in Kelly's unit have "earned" the gold, even before they steal it.

INTERESTING FACT

- In the ending sequence, Mark Wahlberg's character is said to move to Torrance, California. In the movie *Boogie Nights*, Wahlberg's character is from Torrance, Calif.

QUOTES

Troy Barlow [Walter is wearing night-vision goggles in broad daylight]: Take those off!
Walter: I didn't get to use night vision.
Troy Barlow: They don't work during the day!
Walter: They do, kinda.

Archie Gates: Bush told the people to rise up against Saddam. They thought they'd have our support. They didn't. Now they're being slaughtered.

THREE RUSSIAN GIRLS

Gregor Rabinovitch, 1944, b&w, 80 minutes.

Producer: Gregor Rabinovitch; **Directors:** Henry S. Kesler, Fyodor Otsep; **Screenwriter:** Aben Kandel; **Music:** W. Franke Harling; **Distributor:** United Artists; **Cast:** Feodor Chaliapin Jr., Mimi Forsythe, Kathy Frye, Jack Gardner, Alexander Granach, Dorothy Gray, Paul Guilfoyle, Mary Herriot, Manart Kippen, Kane Richmond, Kent Smith, Anna Sten, Anna Marie Stewart.

Anna Sten is a Red Cross volunteer in a field hospital located in an old prerevolution mansion in Russia during World War II. American test pilot Kent Smith is wounded and brought to the hospital. As he slowly recovers from his wounds, they fall in love. The hospital personnel are forced to move to Leningrad as the Nazis advance in their 1941 invasion of the Soviet Union.

This movie is another in a wartime cycle of Hollywood films lauding America's Soviet allies. Ironically, less than a decade later, the same filmmakers who made these pro-Russian films in support of the war effort would be hauled before congressional investigators, accused of being communists.

INTERESTING FACTS

- At the time this film was made, star Anna Sten was the wife of codirector Fyodor Otsep.

- Most of the "counterattack" scenes were lifted from the original *GIRL FROM STALINGRAD*, a movie made in Russia.

AWARD

Academy Awards, USA, 1944
Nominated: *Oscar, Best Music, Scoring of a Dramatic or Comedy Picture*, W. Franke Harling.

THUNDER AFLOAT

Metro-Goldwyn-Mayer, 1939, b&w, 94 minutes.

Producer: J. Walter Ruben; **Director:** George B. Seitz; **Screenwriter:** Wells Root; **Music:** David Snell, Edward Ward; **Cast:** Leon Ames, Wallace Beery, Clem Bevans, Wade Boteler, Douglass Dumbrille, Carl Esmond, Virginia Grey, Jonathan Hale, Henry Hunter, Hans Joby, Charles Lane, Chester Morris, John Qualen, Addison Richards, Phillip Terry, Franchot Tone, Regis Toomey, Henry Victor.

Wallace Beery is a captain whose tugboat is sunk by a German submarine during World War I. He joins the navy to sink submarines and is given command of a subchaser, but his inability to follow orders results in his being busted to seaman. Captured by a submarine after his ship is sunk, he taps out its location using Morse code.

Although this is a fictional movie, it is based on the actual German submarine raids on the U.S. coast during World War I, which ultimately resulted in the loss of 80 Allied ships.

INTERESTING FACT

- This was a topical film, since in 1939 people in the United States were looking with concern at the war in Europe, and losses to German submarines were once again in the headlines.

THUNDERBIRDS

Republic Pictures Corporation, 1952, b&w, 98 minutes.

Producer: John H. Auer; **Director:** John H. Auer; **Screenwriter:** Mary C. McCall Jr.; **Music:** Victor Young; **Distributor:** Republic Pictures; **Cast:** Benny Baker, John Drew Barrymore, Ward Bond, Norman Budd, Wally Cassell, Eileen Christy, Mae Clarke, Ben Cooper, Suzanne Dalbert, John Derek, Gene Evans, Mona Freeman, Pepe Hern, Barton MacLane, Sammy McKim, Victor Millan, Robert Neil, Barbara Pepper,

Slim Pickens, Walter Reed, Allene Roberts, Armando Silvestre, Dick Simmons.

The Thunderbird Division is mobilized, goes through basic training, and fights its way through World War II.

The Thunderbird Division, from which this film takes its name, is part of the Oklahoma National Guard. Following the mobilization of this division during World War II, it fought in Italy at Salerno, Anzio, and Sicily, and also in France and Germany.

TIGER FANGS

Producers Releasing Corporation, 1943, b&w, 59 minutes.

Producers: Fred McConnell, Arthur Schwartz; **Director:** Sam Newfield; **Screenwriter:** Arthur St. Claire; **Music:** Lee Zahler; **Distributors:** Producers Releasing Corporation; **Cast:** Howard Banks, Frank Buck, June Duprez, Arno Frey, Alex Havier, J. Farrell MacDonald, Pedro Regas, Duncan Renaldo, Dan Seymour.

A special squad goes into Malaya to stop drugged man-eating tigers, put into the jungle by Nazis determined to destroy Allied rubber production.

The premise of this film is not historically accurate. All of the rubber-producing areas in Malaya had fallen into Japanese hands at the beginning of the war, while the United States, especially, had converted to the production of synthetic rubber.

TILL THE END OF TIME

RKO Radio Pictures Inc., 1946, b&w, 105 minutes.

Producer: Dore Schary; **Director:** Edward Dmytryk; **Screenwriters:** Niven Busch (novel, *They Dream of Home*), Allen Rivkin; **Music:** Leigh Harline, Buddy Kaye (songs), Ted Mossman (songs); **Cast:** John Bailey, Bill Bauman, Richard Benedict, Paul Birch, George Burnett, Ellen Corby, Eddie Craven, Blake Edwards, William Forrest, Gil Frye, William Gargan, Harry Hayden, Fred Howard, Teddy Infuhr, Stan Johnson, Michael Kostrick, Stubby Kruger, Robert Lowell, Guy Madison, Anthony Marsh, Dorothy McGuire, Robert Mitchum, Ruth Nelson, William Newell, Jack Parker, Jean Porter, John S. Roberts, Selena Royle, Tim Ryan, Johnny Sands, Lee Slater, Richard X. Slattery, Loren Tindall, Tom Tully, Richard Tyler, Peter Varney, Margaret Wells, Bill Williams, Mary Worth, Harry von Zell.

Three U.S. Marines return from World War II and must adjust to becoming civilians again. Robert Mitchum suffers from a head injury, and his plans of owning a ranch are dashed after a run of bad luck in Las Vegas. Guy Madison drifts aimlessly, despite his parents' attempts to marry him off or to enroll him in college under the GI bill. Bill Williams was a boxer before the war, but he has lost both his legs and doesn't know in what direction to take his life.

In the movie, Robert Mitchum and Bill Williams tangle with a group in a bar who, even though they call themselves the "American War Patriots," are really just racists who hate just about every ethnic group that fought in the war. Mitchum and Williams take them and the bar apart and leave the fight feeling better about themselves.

The movie is based on Niven Busch's *They Dream of Home* (New York: D. Appleton-Century Company, Inc., 1944). THE BEST YEARS OF OUR LIVES is very similar in plot and character to this movie and was released the same year.

TILL WE MEET AGAIN

Paramount Pictures, 1944, b&w, 88 minutes.

Producer: David Lewis; **Director:** Frank Borzage; **Screenwriter:** Lenore J. Coffee; **Music:** David Buttolph; **Cast:** Barbara Britton, George Davis, William Edmunds, Mona Freeman, Peter Helmers, Ray Milland, Konstantin Shayne, Walter Slezak, Vladimir Sokoloff, Lucile Watson.

Allied pilot Ray Milland is shot down, then rescued by the French Resistance. He is given important documents to take back to England and a fake wife to make it easier for him to travel. The person impersonating his wife is actually a very innocent girl from a convent. When she is caught by the Nazis and they decide to put her into a brothel as punishment, a French mayor kills her to save her from a fate worse than death.

TIME LIMIT

Heath Productions, 1957, b&w, 96 minutes.

Producers: William Reynolds, Richard Widmark; **Director:** Karl Malden; **Screenwriters:** Ralph Berkey and Henry Denker (play); **Music:** Fred Steiner; **Distributor:** United Artists; **Cast:** Kenneth Alton, Martin Balsam, Richard Basehart, Alan Dexter, Khigh Dhiegh, Joe Di Reda, James Douglas, June Lockhart, Skip McNally, Dolores Michaels, Carl Benton Reid, Man-

ning Ross, Rip Torn, Jack Webster, Yale Wexler, Richard Widmark.

Richard Basehart plays a major accused of collaborating with the North Korean enemy while a prisoner of war. As the court-martial unfolds, the sympathetic investigator, Richard Widmark, learns that there had been an informer in the camp, the son of a general, whom the other prisoners had murdered. It is only when the commandant decided to execute 16 men in retribution for the death of the informer that Basehart collaborates, to save the lives of the innocent POWs.

INTERESTING FACT

- This is the only feature film directed by actor Karl Malden.

QUOTE

General [father of the informer]: The choice you had to make in that prison camp is no different than the choice that confronts every military leader, the decision involving the life and death of his men. You are a sensitive man, a humane man. I sympathize with that man. But you are also a soldier. And as a soldier you have failed, just as my son failed.

AWARD

British Academy Awards, 1958
 Nominated: *BAFTA Film Award, Best Foreign Actor*, Richard Basehart.

TIME OF DESTINY, A

Columbia Pictures Corporation, Alive Films, Nelson Entertainment, 1988, color, 118 minutes.

Producers: Shep Gordon, Carolyn Pfeiffer, Anna Thomas; **Director:** Gregory Nava; **Screenwriters:** Gregory Nava, Anna Thomas; **Distributor:** Columbia Pictures; **Filmed in:** Basque country of Spain, San Diego, California, and Istria Peninsula of Yugoslavia; **Cast:** Félix Arcarazo, Robin Bennett, Henry Bumstead, Mark Burton, Nicolasa Calvo, Allan Chambers, Stockard Channing, Frederick Coffin, Ron Davis, Joe Faust, Megan Follows, Nancy Gair, Ralph Gallucci, David Gillum, Charmaine Glennon, Justin Gocke, Jeff Harding, John Hawker, Concha Hidalgo, Erik Holland, William Hurt, Timothy Hutton, Vjenceslav Kapural, Art K. Koustik, Melissa Leo, Bill Luckey, Michael Miller, Elizabeth Nava, John O'Leary, Kelly Pacheco, Peter Palmér, Jasmina Pasalic, Predrag

Petrovic, Julie Philips, Francisco Rabal, George Reel, Mike Robelo, Harriet Robinson, Rolf Saxon, Francisco Senosiain, John Thatcher, Alan Tilvern, Sam Vlahos, Darin Willis.

During World War II, Timothy Hutton falls in love with a beautiful Italian girl whose family opposes their relationship. When their elopement results in the accidental death of her father, her brother, William Hurt, vows revenge. He follows Timothy Hutton into the army, becomes his best friend, and plots his death.

TIME TO LOVE AND A TIME TO DIE, A

Universal-International Pictures, 1958, color, 132 minutes.

Producer: Robert Arthur; **Director:** Douglas Sirk; **Screenwriters:** Orin Jannings, Erich Maria Remarque; **Filmed in:** Berlin, Germany; **Cast:** Dieter Borsche, Clancy Cooper, Thayer David, Don DeFore, John Van Dreelen, Alexander Engel, Paul Frees, John Gavin, Wolf Harnisch, Lisa Helwig, Jim Hutton, Klaus Kinski, Bengt Lindström, Karl Ludwig Lindt, Jock Mahoney, Kurt Meisel, Liselotte Pulver, Erich Maria Remarque, Charles Régnier, Barbara Rütting, Alice Treff, Dorothea Wieck, Agnes Windeck, Keenan Wynn.

John Gavin plays a young German soldier on the Russian front who finally gets his long-awaited furlough. He is shocked to discover when he returns to Germany that the same devastation he has seen in Russia has now befallen his own country. Meeting a young girl, he quickly falls in love and they are married. Returning to the front, he executes a fellow soldier who is about to kill three prisoners; then, ironically, one of the prisoners he has just saved kills him.

The movie is based on Erich Maria Remarque's book *A Time to Love and a Time to Die* (New York: Harcourt, Brace, 1954).

INTERESTING FACT

- Erich Maria Remarque, author of the novel on which this film is based, has a cameo as a high school teacher. He also wrote *ALL QUIET ON THE WESTERN FRONT*.

MILITARY SERVICE

- John Gavin attended St. John's Military Academy and Beverly Hills High School, then enrolled in U.S. Navy ROTC at Stanford. After graduation, he

served for four years as a naval officer. He saw combat during the Korean War aboard the USS *Princeton* (CV-37) as an intelligence officer. Because of his knowledge of Spanish (his mother was Mexican), he was then assigned as a civil affairs aide to Admiral Miles, commandant of the 15th Naval District, and served until 1955. After the navy, he applied for a job as a technical adviser on a navy film, but instead was given a screen test.

QUOTE

Professor Pohlmann: Without doubt, there would be no need for faith.

TO BE OR NOT TO BE

Romaine Film Productions, 1942, b&w, 99 minutes.

Producers: Alexander Korda, Ernst Lubitsch; **Director:** Ernst Lubitsch; **Screenwriters:** Melchior Lengyel, Ernst Lubitsch, Edwin Justus Mayer; **Music:** Werner R. Heymann, Miklós Rózsa; **Distributor:** United Artists; **Cast:** Rudolph Anders, Lionel Atwill, Paul Barrett, Jack Benny, Swen Hugo Borg, Felix Bressart, Peter Caldwell, Alec Craig, Helmut Dantine, Leslie Denison, Tom Dugan, Maude Eburne, James Finlayson, James Gillette, Charles Halton, Halliwell Hobbes, Leyland Hodgson, Olaf Hytten, Charles Irwin, John Kellogg, Adolf E. Licho, Carole Lombard, George Lynn, Miles Mander, John Meredith, Maurice Murphy, Frank Reicher, Otto Reichow, Stanley Ridges, Gene Rizzi, Sig Ruman, Robert Stack, Roland Varno, Ernö Verebes, Henry Victor, Armand Wright, Wolfgang Zilzer.

In World War II, after the fall of Poland, a troupe of stage actors (led by vain Jack Benny) match wits with the Nazis. A spy has information that would damage the Polish Resistance, and they must prevent it from being delivered to the Germans.

INTERESTING FACTS

- This film was released after the death of star Carole Lombard, killed in an airplane crash while returning from a tour selling war bonds. Her distraught husband, Clark Gable, immediately enlisted.
- This farce about occupied Poland was made at the beginning of the war, for America, and many people thought the timing was bad; people were quite depressed about the war.
- Director Ernst Lubitsch was criticized at the time for making this black comedy.

MILITARY SERVICE

- Jack Benny enlisted in the U.S. Navy in 1918, during World War I. After basic training at Great Lakes Naval Training Center, he performed in shows for the other sailors. It was in one of these shows that Benny first did comedy. The wife of his base commander (Capt. William Moffett) convinced him to tour the country and do shows for Naval Relief. After his discharge in 1921, he went into show business.
- This film was remade with writer/producer/director Mel Brooks in the title role. Mel Brooks enlisted in the U.S. Army and was sent to VMI (Virginia Military Institute), where he learned mounted cavalry drills before being sent to school to learn how to deactivate mines. He first saw combat during the Battle of the Bulge in Belgium in December 1944. On one occasion during the battle at Bastogne, Brooks responded to German loudspeakers asking them to surrender by setting up his own loudspeaker and belting out an Al Jolson imitation of the song "Toot, Toot, Tootsie." His talent recognized, he was transferred to special services, where he entertained troops in occupied Germany.

QUOTES

Colonel Ehrhardt: Oh, yes, I saw him in *Hamlet* in London. What he did to Shakespeare we are doing to Poland.

Josef Tura [disguised as Colonel Ehrhardt]: I can't tell you how delighted we are to have you here.
Professor Alexander Siletsky: May I say, dear colonel, that it's good to breathe the air of the Gestapo again. . . . You know, you're quite famous in London, colonel. They call you Concentration Camp Ehrhardt.
Josef Tura: Ha ha. Yes, yes . . . we do the concentrating and the Poles do the camping.

Adolf Hitler: Heil myself!

TO BE OR NOT TO BE

20th Century-Fox, Brooksfilms, 1983, color, 107 minutes.

Producers: Mel Brooks, Howard Jeffrey (executive producer); **Director:** Alan Johnson; **Screenwriters:** Ronny Graham, Ernst Lubitsch (story), Thomas Meehan; **Music:** Mel Brooks (songs), Ronny Graham (songs), John Morris; **Distributor:** 20th Century-Fox; **Cast:** Phil Adams, Anne Bancroft, Ivor

Barry, Scott Beach, Earl Boen, Henry Brandon, Mel Brooks, Max Brooks, Ian Bruce, George Caldwell, Clare Culhane, Ron Diamond, Charles Durning, Gillian Eaton, Paddi Edwards, José Ferrer, John Francis, John Frayer, George Gaynes, William Glover, Robert Goldberg, Roy Goldman, Ronny Graham, Leeyan Granger, Sandra Gray, James Haake, Robin Haynes, Edward J. Heim, Spencer Henderson, Milt Jamin, George Jayne, Henry Kaiser, Zale Kessler, Manny Kleinmuntz, Ron Kuhlman, Frank Lester, Christopher Lloyd, Curt Lowens, Laurie Manning, Terence Marsh, Tim Matheson, Winnie McCarthy, John McKinney, Eda Reiss Merin, Wolf Muser, John Otrin, Paul Ratliff, Estelle Reiner, Bill K. Richards, Jack Riley, Larry Rosenberg, Blane Savage, Neil J. Schwartz, Joey Sheck, Marley Sims, Raymond Skipp, Tucker Smith, Ted Sprague, Lewis J. Stadlen, Lee E. Stevens, Stephanie Wingate, George Wyner.

Mel Brooks is a very, very bad Polish actor, trying to scrape out a living, when what should intrude, but World War II! The Nazi invasion of Poland greatly reduces the demand for Jewish theater. When his wife, Anne Bancroft, who has a habit of entertaining young Polish officers when he is on stage, discovers that her latest conquest, Tim Matheson, is on a secret mission, Brooks masterminds a plan to get them all out of Poland.

The film features the song *Sweet Georgia Brown* (sung in Polish), which did not appear in the original.

INTERESTING FACTS

- A street sign reads "Kubelski Avenue." *TO BE OR NOT TO BE* (1942) starred Jack Benny, whose real name is Benny Kubelski.
- In the credits at the end, Anne Bancroft's name first appears in parentheses, until Mel Brooks "waves" them off. This is a reference to a poster in the movie that has Anna Bronski's name in parentheses.
- At the end of the movie, each cast member comes and takes a bow, as they would for a stage play, while their names are on the screen.
- Mel Brooks and Anne Bancroft, who play husband and wife, are married in real life as well.
- The subplot of the Nazi persecution of a backstage dresser was not in the original version of the film.

QUOTES

Announcer: For the sake of clarity and sanity, the rest of this movie will *not* be in Polish.

Frederick Bronski (Mel Brooks): If it wasn't for Jews, fags, and gypsies, there would be no theater!

Anna Bronski: All these flowers on a lieutenant's pay, you shouldn't have.
Lt. Sabenski: That's OK! My father is a florist.

Frederick Bronski [Mel Brooks disguised as Hitler]: Heil myself!

Colonel Ehrhardt [of Bronski's performance.]: What he did to *Hamlet*, we are now doing to Poland.

AWARDS

Academy Awards, USA, 1983
 Nominated: *Oscar, Best Actor in a Supporting Role,* Charles Durning

Golden Globes, USA, 1984
 Nominated: *Golden Globe, Best Performance by an Actor in a Supporting Role in a Motion Picture,* Charles Durning; *Best Performance by an Actress in a Motion Picture—Comedy/Musical,* Anne Bancroft

Writers Guild of America, USA, 1984
 Nominated: *WGA Screen Award, Best Comedy Adapted from Another Medium,* Ronny Graham, Thomas Meehan.

TOBRUK

Universal Pictures, The Corman Company, Gibraltar Productions, 1967, color, 107 minutes.

Producer: Gene Corman; **Director:** Arthur Hiller; **Screenwriter:** Leo Gordon; **Music:** Bronislau Kaper; **Distributor:** Universal Pictures; **Filmed in:** Almería, Spain, Tucson, Arizona, Imperial County, California; **Cast:** Phil Adams, Anthony Ashdown, Rico Cattani, Peter Coe, Leo Gordon, Nigel Green, Percy Herbert, Robert F. Hoy, Rock Hudson, Heidy Hunt, Curt Lowens, Lawrence Montaigne, George Peppard, Liam Redmond, Ronnie Rondell Jr., Norman Rossington, Joseph Sargent, Guy Stockwell, Jack Watson, Robert Wolders.

George Peppard commands a group of German Jews who impersonate Nazis. With British commandos and an American demolitions expert as their fake "prisoners," they penetrate German lines to blow up one of Rommel's major fuel depots. The expedition must contend with the desert, German patrols, and a traitor in their midst.

Mussolini occupied Tobruk as part of his campaign to invade the Suez Canal, but the British easily took it from him on January 21, 1941. Hitler sent Rommel and the Afrika Korps to retake the city, and after a siege of 242 days, they entered the city in December 1941. In 1942, the British surrendered the city because they needed troops to fight the Japanese, and Rommel retook Tobruk on June 21, 1942. It was not until November 13, 1942, that Montgomery and his Eighth Army were able to secure it once and for all for the Allies.

Other films about Tobruk include *THE DESERT RATS*, *RAID ON ROMMEL*, and *THE RATS OF TOBRUK*.

MILITARY SERVICE

- George Peppard entered the U.S. Marine Corps in 1951 and served in the artillery, on 105mm and 155mm cannon. He was discharged as a corporal.
- Rock Hudson enlisted in the U.S. Navy and shipped out on the USS *Lew Wallace* for the Philippines during World War II. There, he was assigned to AROU-2 (Aviation Repair Overhaul Unit 2) on Samar Island, where he was responsible for unloading naval aircraft from carriers. In August 1945, he was considered responsible for a serious accident, and he was transferred to laundry duties for the rest of the war.

TODAY WE LIVE

Metro-Goldwyn-Mayer, 1933, b&w, 113 minutes.

Producer: Howard Hawks; **Directors:** Howard Hawks, Richard Rosson; **Screenwriters:** William Faulkner, Edith Fitzgerald, Dwight Taylor; **Music:** William Axt, David Snell, Herbert Stothart; **Distributor:** Metro-Goldwyn-Mayer; **Filmed at:** March Field, California (aerial sequences); **Cast:** Ernie Alexander, Edward Cooper, Gary Cooper, Joan Crawford, Louise Closser Hale, Roscoe Karns, Murray Kinnell, Rollo Lloyd, Eily Malyon, Carlyle Moore Jr., Bert Moorhouse, David Newell, Ronald R. Rondell, C. Montague Shaw, Franchot Tone, Hilda Vaughn, Robert Young.

During World War I, American pilot Gary Cooper falls in love with Joan Crawford, who had always assumed she would marry Robert Young. After she erroneously learns that Young was killed in flight training, she falls in love with Cooper. When Robert Young returns alive, and then is accidentally blinded, Gary Cooper does the honorable thing and bows out

of the picture. In an act of self-sacrifice, after Robert Young learns that Gary Cooper is going on a dangerous mission to bomb a German ship, he and Joan Crawford's brother, Franchot Tone, go out in a torpedo boat and sacrifice their lives in sinking the German warship.

INTERESTING FACTS

- *Variety* reported in its review that Hawks used footage from the movie *HELL'S ANGELS* (1930) for the big bomber expedition sequence, the main dogfight, and the head-on collision of two airplanes.
- The preview running time was 135 minutes, indicating that a lot of footage was cut before its final release.

TO HAVE AND HAVE NOT

Warner Bros., 1944, b&w, 100 minutes.

Producers: Howard Hawks, Jack L. Warner; **Director:** Howard Hawks; **Screenwriters:** William Faulkner, Jules Furthman, Ernest Hemingway; **Music:** Hoagy Carmichael, Franz Waxman; **Distributor:** Warner Bros.; **Cast:** Lauren Bacall, Humphrey Bogart, Eugene Borden, Walter Brennan, Hoagy Carmichael, Marcel Dalio, Adrienne D'Ambricourt, Fred Dosch, Elzie Emanuel, Fred Farrell, Lance Fuller, Harold Garrison, Janette Grae, Sir Lancelot, Sheldon Leonard, Paul Marion, Maurice Marsac, Louis Mercier, Dolores Moran, Aldo Nadi, Pedro Regas, Walter Sande, Dan Seymour, Patricia Shay, Emmett Smith, George Suzanne, Walter Szurovy, Pat West, Crane Whitley, Andy Williams.

Humphrey Bogart captains a boat for hire on the island of Martinique. World War II is bad for business, so he and his crew are forced by financial necessity and against their better judgment, to violate their preferred neutrality. They take a job for the Resistance, transporting a fugitive on the run from the Nazis.

The film is based on Ernest Hemingway's novel *To Have and Have Not* (New York: Collier, 1937).

INTERESTING FACTS

- Humphrey Bogart and Lauren Bacall fell in love during the production of this film. Director Howard Hawks afterward said that it was actually Bacall's character Marie that Bogart had fallen for, so she had to keep playing it the rest of her life.
- Ernest Hemingway had bet Hawks that Hawks couldn't film this novel. Hawks did it by deleting most of the story, including the class references that

justified the title, and shifting to an earlier point in the lives of the lead characters.

- The setting was shifted to Martinique because the Office of Inter-American Affairs would not have allowed export of a film showing smuggling and insurrection in Cuba.
- Andy Williams was hired to dub Bacall singing *How Little We Know*, but Hawks decided to go with Bacall.

MILITARY SERVICE

- Screenwriter William Faulkner, an American, enlisted in the Royal Air Force in Canada in June 1918, hoping to go to Europe to participate in the "Great War," but he was disappointed because the war ended before he finished training. For a time after the war, he dressed in an English officer's uniform, pretending to be a wounded British aviator. He is a winner of both the Nobel Prize for literature and the Pulitzer Prize.

QUOTES

Slim: Who was the girl?
Harry: What girl?
Slim: The one who gave you such a high opinion of women.

Slim: You know, Steve, you're not so hard to figure. I know what you're going to say some of the time. Most of the time. The rest of the time . . . the rest of the time you're just a stinker.
Slim [after kissing Steve]: It's even better when you help.

Slim: I'm hard to get, Steve. All you have to do is ask me.

Slim: You don't have to act with me, Steve. You don't have to say anything and you don't have to do anything. Oh, maybe just whistle. You know how to whistle, don't you, Steve? You just put your lips together and . . . blow.

TO HELL AND BACK

Universal-International Pictures, 1955, color, 106 minutes.

Producer: Aaron Rosenberg; **Director:** Jesse Hibbs; **Screenwriters:** Gil Doud, Audie Murphy; **Music:** Ken Hart, Henry Mancini; **Distributor:** Universal; **Filmed in:** Fort Lewis, Oak Creek Game Reserva-

tion, and on Yakima River, all in Washington; **Cast:** Art Aragon, Nan Boardman, Rand Brooks, John Bryant, Alexander Campbell, Richard Castle, Joey Costaretta, Maria Costi, Ashley Cowan, Bruce Cowling, Charles Drake, Mary Field, Anthony Garcen, Gordon Gebert, Ralph Sanford Gen, Brett Halsey, Tommy Hart, Edna Holland, Barbara James, David Janssen, Jack Kelly, Don Kennedy, Susan Kohner, Henry Kulky, Paul Langton, Rankin Mansfield, John McIntire, Madge Meredith, Mort Mills, Audie Murphy, Felix Noriego, Gregg Palmer, Paul Picerni, John Pickard, Howard Price, Denver Pyle, Didi Ramati, Anabel Shaw, Walter Bed Smith, Marshall Thompson, Julian Upton, Howard Wright.

Audie Murphy (playing himself), a native of Texas, was placed in charge of his many younger siblings on the death of his mother and decided to join the military to provide for them. Enlisting as a private in the U.S. Army, he achieved many acts of bravery and heroism during the army's advance through Italy, France, and into Germany, which earn him increasing rank and responsibility, as well as the respect of his comrades in arms.

INTERESTING FACTS

- Based on the true life story of Audie Murphy, the most decorated soldier in World War II.
- Audie Murphy, who played himself in the movie, originally declined the role, not wanting people to think that he was attempting to cash in on his role as a war hero.
- After the war, he signed an agreement with James Cagney to begin acting lessons and, ultimately, appeared in 40 movies.
- Audie Murphy suffered from post-traumatic stress syndrome. He drank heavily, gambled, had nightmares, and slept with a loaded gun.
- Audie Murphy is buried at Arlington National Cemetery.

MILITARY SERVICE

- Fighting across Europe with the Third Infantry Division, Audie Murphy became the most highly decorated soldier of World War II. His 28 decorations include the Medal of Honor, the Distinguished Service Cross, three Silver Stars, the Legion of Merit, the Bronze Star, three Purple Hearts, the French Legion of Honor, and the Croix de Guerre. The citation for Audie Murphy's Medal of Honor cited his "indomitable courage" under fire in many combat engagements.

TOKYO ROSE

Pine-Thomas Productions, 1946, b&w, 69 minutes.

Producers: William H. Pine, Maxwell Shane, William C. Thomas; **Director:** Lew Landers; **Screenwriter:** Daniel Mainwaring; **Music:** Rudy Schrager; **Distributor:** Paramount Pictures; **Cast:** Byron Barr, William Challee, Donald Douglas, Chris Drake, Blake Edwards, Leslie Fong, Grace Lem, H. T. Liang, Lotus Long, Richard Loo, Keye Luke, Osa Massen, James Millican, Al Ruiz, Larry Young.

An Allied airman shot down over Japan is selected for a radio interview with Tokyo Rose. While he is at the radio station, an air raid sets him free, and he manages to contact the Japanese underground. With its help, he kidnaps her, and smuggles Tokyo Rose to an American submarine.

Tokyo Rose was born Ikuko Toguri in Los Angeles on July 4, 1916, and graduated from UCLA. On July 5, 1941, she sailed for Japan without a U.S. passport, giving two reasons for her trip: to visit a sick aunt and to study medicine. In November 1943, she began her career as a broadcaster for Tokyo Radio and continued as a broadcaster to the end of the war. Her program, *The Zero Hour*, became part of Japanese psychological warfare, designed to lower the morale of the U.S. armed forces. She did not use the nickname Tokyo Rose on her show; the name was applied by U.S. armed forces personnel in the South Pacific area to any English-speaking Japanese announcer. However, she was the only American-born broadcaster. While she was in prison, she signed autographs as Tokyo Rose. On September 29, 1949, she was convicted in a jury trial, becoming only the seventh person in the history of the United States to be convicted of treason, and was sentenced to 10 years imprisonment and fined $100,000. She successfully fought government efforts to deport her and applied for pardons in 1954 and 1968, finally getting one in 1977. She was last known to be living in Chicago.

INTERESTING FACTS

- While there really was a historical Tokyo Rose, this film is pure fiction.
- If there was a real Japanese underground, it was kept incredibly well hidden.

QUOTE

Tokyo Rose [from an actual broadcast]: Hello, boneheads. This is your favorite enemy. How are all you orphans of the Pacific? Are you enjoying yourselves while your wives and sweethearts are running around with the 4Fs in the States? How do you feel now when all your ships have been sunk by the Japanese Navy? How will you get home? Here's another record to remind you of home.

TONIGHT WE RAID CALAIS

20th Century-Fox, 1943, b&w, 70 minutes.

Producer: André Daven; **Director:** John Brahm; **Screenwriter:** Waldo Salt; **Music:** Emil Newman; **Cast:** John Banner, Beulah Bondi, Lee J. Cobb, Ann Codee, Marcel Dalio, Howard Da Silva, Nigel De Brulier, Leslie Denison, Richard Derr, William Edmunds, Robert Lewis, Lester Matthews, Reginald Sheffield, John Sutton, Leslie Vincent, Blanche Yurka.

John Sutton is an English agent who parachutes into France and persuades French farmers to set their fields on fire to guide RAF bombers in their attack on a German munitions plant.

TOO LATE THE HERO

Cinerama Productions Corp., ABC Pictures Corporation, Palomar Pictures, 1970, color, 144 minutes.

Producers: Robert Aldrich, Walter Blake; **Director:** Robert Aldrich; **Screenwriters:** Robert Aldrich, Lukas Heller, Robert Sherman; **Music:** Gerald Fried; **Filmed in:** Philippines, Klosterneuburg, Austria; **Cast:** Harry Andrews, Ian Bannen, William Beckley, Michael Caine, Martin Dorsey, Denholm Elliott, Henry Fonda, Ronald Fraser, Percy Herbert, Martin Horsey, Harvey Jason, Patrick Jordan, Don Knight, Sam Kydd, Sean MacDuff, Roger Newman, Michael J. Parsons, Lance Percival, Cliff Robertson, Ken Takakura, Frank Webb.

Cliff Robertson (USN) and Michael Caine (British army) are two members of a team who blow up a Japanese radio transmitter in the South Pacific. As they work their way to safety, the enemy kills the men of the team, one by one. Finally, Robertson and Caine are the only ones left, with only a large open clearing between them and the safety of a British base. As they sprint for safety, a machine gun kills Robertson, leaving Caine as the sole survivor of the mission.

MILITARY SERVICE

- Henry Fonda, like his character in *MR. ROBERTS*, wanted to be in the real war and thus enlisted in the

U.S. Navy, despite the fact that he was already a film star and exempt from the draft because he was 37 years old and married with three children. He turned down a direct commission and was trained as a quartermaster and signalman. He served on the destroyer USS *Saterlee* (DD-626) in the Pacific. He was then commissioned a lieutenant (j.g.) assigned to making training films, but he got out of that and convinced the navy to send him to air combat intelligence training, where he graduated near the top of his class. In 1944 he was assigned to the carrier USS *Essex* (CV-9), Admiral Nimitz's flagship. Transferred to the USS *Curtis* (AV-4), a seaplane tender, Fonda survived submarines, air attacks, and kamikazes at Guam, Iwo Jima, and Saipan. At Saipan, for his actions in tracking and trapping a submarine, he earned a Bronze Star. He was fortunate that he was not on board the *Curtis* when a kamikaze struck the side of the ship, destroying the cabin where he slept (Mr. Roberts would die in a similar manner). He ended the war as a full lieutenant.

MISTAKE

- When Lieutenant Lawson confers with Colonel Thompson in the headquarters, the British flag on the wall behind Thompson is upside down. In another scene it is magically righted.

QUOTES

Captain Hornsby: What an extraordinary fellow!
Colonel Thompson: Well, he is an American.

TORA! TORA! TORA!

20th Century-Fox, Toei, 1970, color, 144 minutes.

Producers: Otto Lang, Elmo Williams; **Directors:** Richard Fleischer, Kinji Fukasaku, Toshio Masuda; **Screenwriters:** Larry Forrester, Ryuzo Kikushima, Hideo Oguni; **Music:** Jerry Goldsmith; **Cast:** Wesley Addy, Norman Alden, Frank Aletter, Leon Ames, Richard Anderson, Keith Andes, Edward Andrews, Martin Balsam, Neville Brand, Walter Brooke, Harold Conway, Rick Cooper, Joseph Cotten, Leora Dana, June Dayton, Jeff Donnell, Bill Edwards, Richard Erdman, Jerry Fogel, Susumu Fujita, Elven Havard, Tosio Hosokawa, Kazuko Ichikawa, Hank Jones, Kazuo Kitamura, Karl Lukas, Ken Lynch, George Macready, E. G. Marshall, Ron Masak, Tatsuya Mihashi, Bontaro Miyake, Shunichi Nakamura, Kan Nihonyanagi, Carl Reindel, Ichiro Reuzaki, Jason Robards, Edmon Ryan, Koreya Senda, Robert Shayne, Shogo Shimada, G. D.

Spradlin, Takahiro Tamura, Hisao Toake, Eijiro Tono, Asao Uchida, Junya Usami, James Whitmore, So Yamamura.

This film is a historically accurate recreation of the Japanese sneak attack on Pearl Harbor, told from both sides, the American and the Japanese.

By December 1941, American public opinion had turned against Japan because of its alliance with Germany, the atrocities committed by Japanese troops against civilians, and the threat to American interests posed by Japanese expansionism. There was, however, no overwhelming desire to go to war against Japan. By December 1941, the only important step taken against Japan was the denial of oil export licenses. However, Japan saw the United States as the only obstacle to its plan to dominate Asia. The December 7, 1941, surprise attack on Pearl Harbor was a major victory for the Japanese navy. In less than two hours it destroyed 188 planes, damaged 159 planes, and sunk or seriously damaged 18 warships. The battleships *Arizona* and *Oklahoma* were sunk. The *California*, the *West Virginia*, and the *Tennessee* (also battleships) were badly damaged and would not rejoin the U.S. fleet for months. A total of 2,403 American military personnel were killed and 1,178 wounded. The Japanese losses were minimal: 29 planes and pilots, five midget submarines, and one large submarine.

INTERESTING FACTS

- The Japanese section of the film was originally to be directed by Akira Kurosawa.
- Actor Jason Robards Jr. was actually present at the bombing of Pearl Harbor on December, 7, 1941.
- When Japanese characters in the film refer to the date of the attack, they are actually saying December 8, which is technically correct, as Japan is a day ahead of the United States. However, the date is translated as December 7 in the subtitles to avoid confusing American audiences.
- The U.S. Navy's Office of Information was inundated with complaints from U.S. citizens when the military agreed to allow active-duty U.S. service personnel to participate in the recreation of the attack on Pearl Harbor, which some viewed as glorifying Japanese aggression and showing Americans as unprepared.
- Admiral Yamamoto was killed in April 1943, when the United States, using decoded Japanese messages, ambushed his plane over the Solomon Islands.
- This movie was a joint U.S./Japanese production released in 1970, made in the context of the cold

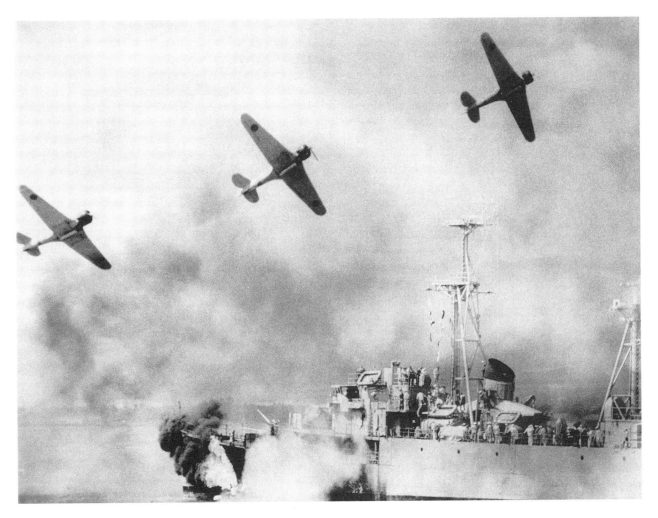

Tora! Tora! Tora! (20TH CENTURY-FOX/AUTHOR'S COLLECTION)

war when Japan was one of our primary allies in the Pacific. The movie ignores the brutality of the Japanese aggression against Manchuria, China, and Indochina.

- The movie was made as two separate films. The studio was concerned that the footage would not cut together. However, this discontinuity actually heightens the realism of the film.

MISTAKES

- As the bombers fly toward Pearl Harbor they pass over the white cross at Schofield Barracks, which was erected in memory of the people that are about to be killed in the raid.
- Many of the U.S. Navy ships visible during the attack on Pearl Harbor were not commissioned until the 1960s and 1970s.

QUOTE

Admiral Kimmel [Martin Balsam, as a spent bullet hits the window in front of him]: It would have been kinder if it had killed me.

TORPEDO ALLEY

Allied Artists Pictures Corporation, 1953, b&w, 84 minutes.

Producer: Lindsley Parsons; **Director:** Lew Landers; **Screenwriters:** Warren Douglas, Samuel Roeca; **Cast:** John Alvin, Raymond Bovee, Charles Bronson, Carl Christian, John Close, Warren Douglas, Richard Garland, William Henry, Douglas Kennedy, Keith Larsen, Dorothy Malone, James Millican, Martin Milner, Ralph Reed, Robert Rose, Ralph Sanford, William

Schallert, James Seay, Mark Stevens, Ross Thompson, Bill Williams, Charles Winninger, Carleton Young.

Mark Stevens is a World War II U.S. Navy pilot who is shot down and rescued by a submarine. He blames himself for the death of his two crewmen, and during the Korean War he seeks redemption through a transfer to the silent service (submarines).

TORPEDO BOAT

Paramount, 1942, b&w, 69 minutes.

Producers: William H. Pine, William C. Thomas; **Director:** John Rawlins; **Screenwriters:** Paul Franklin (story), Aaron Gottlieb (story), Maxwell Shane; **Cast:** Richard Arlen, Mary Carlisle, William Haade, Robert Middlemass, Oscar O'Shea, Jean Parker, Dick Purcell, Virginia Sale, Ralph Sanford, Phillip Terry.

Richard Arlen and Phil Terry design and test a new high- speed torpedo boat (PT boat).

TORPEDO RUN

Metro-Goldwyn-Mayer, 1958, color, 98 minutes.

Producer: Edmund Grainger; **Director:** Joseph Pevney; **Screenwriters:** William Wister Haines, Richard Sale; **Distributor:** MGM; **Cast:** Ernest Borgnine, Diane Brewster, Richard Carlyle, Glenn Ford, Robert Hardy, Hobart Haroy, Dean Jones, L.Q. Jones, Don Keefer, Philip Ober, Paul Picerni, William Schallert, Fredd Wayne.

Glenn Ford, the commander of an American submarine during World War II, sets out to destroy the Japanese aircraft carrier that launched the attack on Pearl Harbor. His wife and child have been captured by the Japanese, and they are using them and other prisoners of war in a prison ship as human shields for the carrier. When his family is killed by one of his own torpedoes, he avenges them by sending the carrier to the bottom.

Related films are *PRISON SHIP* (1945) and *SUBMARINE RAIDER* (1942).

TO THE SHORES OF HELL

Robert Patrick Productions, 1966, color, 82 minutes.

Producers: Robert Patrick, Will Zens, **Director:** Will Zens; **Screenwriters:** Robert McFadden, Will Zens; **Distributor:** Crown International Pictures; **Filmed in:** Vietnam; **Cast:** Richard Arlen, Bill Bierd, Robert Dornan, Richard Jordahl, Kiva Lawrence, Freeman Lusk, Dick O'Neill, Jeff Pearl, Marshall Thompson, Marvin Yim.

Marshall Thompson, a U.S. Marine, goes into enemy territory to rescue his brother, a doctor being captive by the Vietcong and being forced to minister to their wounded soldiers.

TO THE SHORES OF TRIPOLI

20th Century-Fox, 1942, color, 86 minutes.

Producers: Milton Sperling (associate producer), Darryl F. Zanuck; **Director:** H. Bruce Humberstone; **Screenwriters:** Steve Fisher (story), Lamar Trotti; **Music:** Alfred Newman; **Distributor:** 20th Century-Fox Film Corporation; **Filmed at:** Marine Base, San Diego, California; **Cast:** Iris Adrian, Stanley Andrews, Hillary Brooke, Joseph Crehan, Margaret Early, Alan Hale Jr., John Hamilton, Russell Hicks, Gordon Jones, Nancy Kelly, Richard Lane, Edmund MacDonald, Harry Morgan, James C. Morton, Ted North, Maureen O'Hara, Frank Orth, John Payne, Max Rosenbloom, Randolph Scott, Charles Tannen, William Tracy, Elena Verdugo, Basil Walker, Minor Watson, Harold Yager.

Spoiled rich kid John Payne competes against Randolph Scott for the affections of beautiful Maureen O'Hara as they go through U.S. Marine Corps basic training. However, after Pearl Harbor, they're off to kill the Japanese.

AWARD

Academy Awards, USA, 1943
 Nominated: *Oscar, Best Cinematography, Color,* Edward Cronjager, William V. Skall.

TOWN LIKE ALICE, A

Vic Films, 1956, b&w, 117 minutes.

Producer: Joseph Janni; **Director:** Jack Lee; **Screenwriters:** W. P. Lipscomb, Richard Mason, Nevil Shute; **Distributor:** Rank Organisation; **Filmed in:** Burnham Beeches, Buckinghamshire, England; **Cast:** Mary Allen, Jean Anderson, Vincent Ball, Meg Buckenham, Edwina Carroll, Virginia Clay, Margaret Eaden, Gwenda Ewen, John Fabian, Peter Finch, Geoffrey Hawkins, Renee Houston, Sanny Bin Hussan, Peter John, Geoffrey Keen, Tran Van Khe, Domenic Lieven,

Marie Lohr, Charles Marshall, Virginia McKenna, Josephine Miller, Cameron Moore, Eileen Moore, Philippa Morgan, Dorothy Moss, Nora Nicholson, Armine Sandford, June Shaw, Maureen Swanson, Kenji Takagi, Vu Ngoc Tuan, Tim Turner, Bay White, Jane White, Munesato Yamada, Yukio Yamada.

During World War II, the advancing Japanese army is so successful that it overruns British colonies and is faced with interning the thousands of captured British civil servants and their families. The men are sent off to labor camps, and the women and children are placed in large concentration camps. One of the women meets an Australian soldier who sneaks food to them from his labor camp. After the war, she goes to Australia to visit the town he was from and decides to settle there.

The film is based on Nevil Shute's *A Town Like Alice* (New York: Morrow, 1950).

TRAIN, THE

Dear Film Produzione, Les Productions Artistes Associés, Les Films Ariane, 1964, b&w, 133 minutes.

Producers: Jules Bricken, Bernard Farrel; **Directors:** John Frankenheimer, Arthur Penn; **Screenwriters:** Walter Bernstein, Franklin Coen, Frank Davis, Rose Valland; **Distributor:** United Artists; **Filmed in:** Acquigny, St-Ouen, and Vaires, France; **Cast:** Richard Bailey, Jean-Claude Bercq, Paul Bonifas, Jean Bouchaud, Arthur Brauss, Gérard Buhr, Louis Falavigna, Suzanne Flon, Max From, Christian Fuin, Bernard La Jarrige, Helmo Kindermann, Burt Lancaster, Daniel Lecourtois, Roger Lumont, Jacques Marin, Charles Millot, Jeanne Moreau, Richard Münch, Donald O'Brien, Wolfgang Preiss, Albert Rémy, Christian Rémy, Paul Scofield, Michel Simon, Howard Vernon, Jean-Pierre Zola.

An art connoisseur and Nazi, Oberst von Waldheim (Paul Scofield), wants to take Old Masters out of Paris before the Allies liberate Paris; he is able to persuade his superiors to give him a train. Labiche (Burt Lancaster), the superintendent of the railway yard, is asked by the management of the museum from which the Nazis have stolen the paintings to stop the train, but he does not understand that the art has great value and is the heritage of France; he is not willing to risk the life of his people for art. But when his old friend is shot by the Germans for sabotaging the engine, he begins to understand the cause for which they are fighting and starts to work against the Germans to delay the train until the Allies arrive.

In real life the museum's paintings were indeed loaded into a train for shipment to Germany. The train was routed onto a ring railway and circled around and around Paris until the Allies arrived. The wartime curator of the Musée du Jeu de Paume, represented in the movie by Mlle. Villard, was in real life Rose Valland. The movie was inspired by her 1961 nonfiction book *Le front de l'art: défense des collections françaises, 1939–1945* (*The Art Front: Defense of the French Collections, 1939–1945*).

INTERESTING FACTS

- In the opening sequence, many names of major artists are stenciled on packing crates—Gauguin, Renoir, Van Gogh, Manet, Picasso, Degas, Miro, Cezanne, Matisse, Braque, Seurat, Utrillo. They are immediately followed by the director's credit for John Frankenheimer.
- An out-of-service railway station was blown up for this film.
- Burt Lancaster badly injured his leg during shooting. Instead of delaying filming, a scene was added where he is running from the Nazis and is shot in the leg. The end of the movie, which shows him limping, was filmed next, giving his leg time to heal for the earlier scenes.
- As the art train is coming to its final stop where von Waldheim will be killed, we see a close-up of his face. Prominently placed in the background is a sign on the train, never shown earlier in the movie, that warns of *"danger de mort"*—lethal danger. (It actually refers to the live wires that run above some tracks.)

MISTAKES

- The cab of a moving steam locomotive is noisy, even when air raid sirens aren't sounding. Papa Boule should never have been able to hear Labiche shouting at him from 50 feet away.
- Labiche shouts, "You can't get through because the switch is set wrong," but it is a trailing switch (convergence) and hence would move under the weight of the train to the right position.
- During the shunting of the armored engine, Labiche waits until just before the engine reaches each facing switch (divergence) before ordering it thrown. An experienced railway worker would never do that, due to the risk of derailment if his assistant is too slow with the lever.
- Waldheim originally orders the train to depart on the morning of August 3, but in all later scenes everyone knows that daylight runs are much too

The Train (UNITED ARTISTS/AUTHOR'S COLLECTION)

dangerous (danger did not suddenly increase on that date).

• When the train is to resume its journey from Rive-Reine after the engine failure, Waldheim knows he must wait for nightfall before it can safely leave. Sunset on August 5, 1944, would be at 9:20 P.M. but he sets the departure time at 7 P.M. When the train leaves, it is dark.

QUOTES

Colonel von Waldheim: Labiche! Here's your prize, Labiche. Some of the greatest paintings in the world. Does it please you, Labiche? Give you a sense of excitement in just being near them? A painting means as much to you as a string of pearls to an ape. You won by sheer luck. You stopped me without knowing what you were doing, or why. You are nothing, Labiche—a lump of flesh. The paintings are mine; they always will be; beauty belongs to the man who can appreciate it! They will always

belong to me or to a man like me. Now, this minute, you couldn't tell me why you did what you did.

Labiche: Where are the Allies?
Resistance leader: It has been arranged for a French division to reach Paris first. A gesture.
Labiche: Gesture! They can make gestures! Let them make one for Pesquet, or Jacques! That kid of Lefèvre's . . . he'd appreciate a gesture.

Didont: With luck, no one will be hurt.
Labiche: No one's ever hurt. Just dead.

Didont: Paul, uh, have you ever seen any of those paintings on that train? I haven't. You know, when it's over, I think maybe we should take a look, hmm?

AWARDS

Academy Awards, USA, 1965
 Nominated: *Oscar, Best Writing, Story and*

Screenplay—Written Directly for the Screen, Franklin Coen, Frank Davis

British Academy Awards, 1965
 Nominated: *BAFTA Film Award, Best Film from any Source.*

TRENCH, THE

Le Studio Canal Plus, 1999, color, 98 minutes.

Producer: Steve Clark-Hall; **Director:** William Boyd; **Screenwriter:** William Boyd; **Distributor:** Entertainment Film Distributors; **Cast:** Daniel Craig, James D'Arcy, Danny Dyer, Ciarán McMenamin, Paul Nicholls, Julian Rhind-Tutt, Anthony Strachan, Tam Williams.

This movie is a somber account of young British soldiers fighting the Battle of the Somme during World War I.

The Battle of the Somme, like most battles in World War I, was total carnage. In a single day, 60,000 British troops were killed, more than the total number of men killed in Vietnam over the course of 10,000 days.

AWARD

British Independent Film Awards, 1999
 Nominated: *British Independent Film Award, Best Achievement in Production; Best Actor,* Daniel Craig.

TROUBLE IN MOROCCO

Columbia Pictures Corporation, 1937, b&w, 62 minutes.

Producer: Larry Darmour; **Director:** Ernest B. Schoedsack; **Screenwriters:** Paul Franklin, J. D. Newsom (story); **Cast:** Oscar Apfel, Mae Clarke, C. Henry Gordon, Jack Holt, Harold Huber, Paul Hurst, Bradley Page, Victor Varconi.

Jack Holt is a foreign correspondent who joins the French Foreign Legion to get a story on a mobster who is hiding out in the military.

TWELVE O'CLOCK HIGH

20th Century-Fox, 1949, b&w, 132 minutes.

Producer: Darryl F. Zanuck; **Director:** Henry King; **Screenwriters:** Sy Bartlett, Henry King, Beirne Lay Jr.; **Music:** Alfred Newman; **Distributor:** 20th Century-Fox Film Corporation; **Filmed in:** RAF Barford St. John Air Base, England, Fort Walton Beach and Eglin AFB, Florida, Ozark Air Field, Alabama; **Cast:** Richard Anderson, Roger Anderson, Robert Arthur, Steve Clark, Russ Conway, Campbell Copelin, Leslie Denison, Lawrence Dobkin, Sam Edwards, Don Gaudagno, Don Hicks, Ray Hyke, Dean Jagger, Barry Jones, John Kellogg, Harry Lauter, Lee MacGregor, Joyce Mackenzie, Hugh Marlowe, John R. McKee, Gary Merrill, Millard Mitchell, Peter Ortiz, Robert Patten, Gregory Peck, William Short, Paul Stewart, Kenneth Tobey, Patrick Whyte, John Zilly.

In the early days of daylight bombing raids over Germany, General Frank Savage (Gregory Peck) must take command of a "hard luck" bomber group, relieving the previous commanding officer, who has cracked under the strain of command. As he struggles to whip his group into a disciplined fighting unit in spite of heavy losses over their targets from flak and German fighters, he gradually succumbs to the same problem as his predecessor, which is identifying with, and worrying about, his officers and men, and eventually he too cracks under the strain.

The film is based on Sy Bartlett's and Beirne Lay Jr.'s *Twelve O'Clock High* (New York: Harper, 1948).

In 1943 the English and the Americans disagreed about tactics for the air war against Germany. The English had suffered unacceptably high losses during daylight bombing. In response, they equipped their heavy bombers, the Lancasters and the Halifaxes, for night bombing, which was not precise and could target only general areas. The American B-17 Flying Fortresses and B-24 Liberators were more heavily armored than the English planes and had bombsights that allowed them to strike specific targets during the day. The differences in tactical views were accommodated by permitting the English to bomb at night while the Americans tried to prove that daylight raids would not result in unacceptable losses.

The average survival rate of a B-17 crew was 15 missions. After October 1943, when one in four American bombers did not return from the raid against the ball-bearing plants in Schweinfurt, daylight bombing was curtailed until 1944 when long-range fighter escorts, most often P-51 Mustangs, became available. The film depicts an American bomber group during 1943, before the curtailment of daylight precision bombing.

The B-17 Flying Fortress was a high-speed offensive bomber developed by Boeing in the late 1930s. It had heavy armor and 13 machine guns, which were

effective against enemy fighters. The air war against Germany had mixed results. It did not destroy civilian morale. It did reduce steel and synthetic oil production dramatically, but German production of fighter planes and armored vehicles reached its peak in the second half of 1944, in spite of Allied daylight bombing. It was discovered that German war production was on a 9 to 5 schedule before the bombing campaign, and the Germans were forced to transition to a more serious wartime production schedule by the raids.

INTERESTING FACTS

- John Wayne turned down the leading role, which was later played by Gregory Peck.
- The B-17 bomber crash-landing at the airstrip near the beginning of the movie was no special effect or combat camera footage. Stunt pilot Paul Mantz was paid $4500 to crash-land the bomber. Mantz walked away from the wreck. Until the 1970s, that was the largest amount ever paid to a stuntman for a single stunt.
- The movie contains lots of actual B-17 combat footage.
- Ozark Air Field was selected because it still had black runways, just like the airfields in World War II, which made them less vulnerable to being spotted from the air by German bombers.
- The U.S. Air Force collected 12 B-17s from the Air-Sea Rescue Service and refitted them to wartime configuration for the film.
- This film was made with U.S. Air Force support, despite the negative depiction of combat leaders during the war.

Twelve O'Clock High (20TH CENTURY-FOX/AUTHOR'S COLLECTION)

MILITARY SERVICE

- Darryl Zanuck lied about his age and enlisted in the U.S. Army at the age of 14 in 1916. With the outbreak of World War I, he went to France with the 37th Division, where he was a messenger and a runner, and represented the U.S. Army as a flyweight boxer at the Allied Forces championships. In 1942, he was commissioned a lieutenant colonel in the U.S. Army Signal Corps and went to London as chief liaison officer to the British army film units. There he became famous for his "blitz parties," with plenty of food, booze, and women, entertaining Eisenhower and Laurence Olivier with equal aplomb. One of his guests, Lord Mountbatten, was persuaded to take Zanuck along on a Royal Marine commando raid into France, where they came under heavy fire while destroying a German radar station. Zanuck then went to North Africa to film the invasion and produced *At the Front*. He subsequently was recalled to active duty during the Korean War, and retired as a colonel.

MISTAKE

- Filter cigarettes, shown in the film, weren't invented until after World War II.

AWARDS

Academy Awards, USA, 1949
 Won: *Oscar, Best Sound Recording; Best Supporting Actor,* Dean Jagger
 Nominated: *Oscar, Best Actor,* Gregory Peck; *Best Picture,* Darryl F. Zanuck

National Film Preservation Board, USA, 1998

National Film Registry

New York Film Critics Circle Awards, 1950
 Won: *NYFCC Award, Best Actor,* Gregory Peck.

TWO MAN SUBMARINE

Columbia Pictures Corporation, 1944, b&w, 62 minutes.

Producer: Jack Fier; **Director:** Lew Landers; **Screenwriters:** Griffin Jay, Leslie T. White; **Music:** Mario Castelnuovo-Tedesco; **Distributor:** Columbia Pictures; **Cast:** Abner Biberman, Alex Havier, George Lynn, J. Carrol Naish, Tom Neal, Ann Savage, Robert Williams, Shelley Winters.

Japanese and Nazi agents combine to steal the secret of penicillin from American researchers. Instead of stealing the information, they go to their deaths in a submarine.

2,000 WOMEN

Gainsborough Pictures, 1944, b&w, 97 minutes.

Producers: Edward Black, Maurice Ostrer; **Director:** Frank Launder; **Screenwriters:** Sidney Gilliat, Frank Launder, Michael Pertwee; **Music:** Hans May; **Distributor:** General Film Distributors; **Cast:** Muriel Aked, Robert Arden, Kathleen Boutall, Phyllis Calvert, Anne Crawford, Christiane De Maurin, Christiana Forbes, Dulcie Gray, Thora Hird, Renee Houston, Joan Ingram, Carl Jaffe, Betty Jardine, Jean Kent, Guy Le Feuvre, Christiane De Maurin, James McKechnie, Reginald Purdell, Flora Robson, Patricia Roc, Hilda Campbell Russell, Paul Sheridan.

During World War II, a group of English women are caught behind enemy lines after the fall of France and are interned by the Germans in a posh hotel. With a typical British attitude of "There'll always be an England" and stiff upper lip, the women settle in for the duration, until their camp routine is disrupted by the arrival of Royal Air Force fliers who have bailed out of their stricken plane and landed in the camp. The woman have to hide them from their German captors and then smuggle the soldiers out of the camp.

U

U-BOAT PRISONER

Columbia Pictures Corporation, 1944, b&w, 66 minutes.

Producer: Wallace MacDonald; **Directors:** Budd Boetticher, Lew Landers; **Screenwriters:** Malcolm Stuart Boylan, Aubrey Wisberg; **Distributor:** Columbia Pictures; **Cast:** John Abbott, Trevor Bardette, Bruce Bennett, Swen Hugo Borg, Egon Brecher, Paul Conrad, Ralph Dunn, Eric Feldary, Arno Frey, Frederick Giermann, Fred Graham, Erwin Kalser, Nelson Leigh, Kenneth MacDonald, Erik Rolf, John Wengraf, Robert Williams.

Bruce Bennett's ship is sunk, and when he is picked up by a Nazi submarine, he convinces the Nazis that he is a German sailor. He reveals his true identity to the POWs on board, and together they take over the U-boat.

The movie is based on the true story of Archie Gibbs, a seaman who was held onboard a German submarine.

U-571

Universal Pictures, Canal Plus Image International, 2000, color, 116 minutes.

Producers: Dino De Laurentiis, Hal Lieberman, Martha Schumacher, Lucio Trentini; **Director:** Jonathan Mostow; **Screenwriters:** David Ayer, Sam Montgomery, Jonathan Mostow; **Music:** Richard Marvin; **Distributor:** Universal Pictures; **Filmed at:** St. Paul's Bay, Malta, Rome, Italy (interiors), San Pedro, California, and Russia; **Cast:** Robin Askwith, Jon Bon Jovi, Terrence "T.C." Carson, Derk Cheetwood, Will Estes, Tom Guiry, Harvey Keitel, David Keith, Thomas Kretschmann, Matthew McConaughey, Jack Noseworthy, Erik Palladino, Bill Paxton, Dave Power, Matthew Settle, Jake Weber.

When a U-boat is damaged in battle and sends out an SOS during World War II, the Allies realize this is their chance to seize the critical Enigma code machine. The Allied sailors get on board by masquerading as Germans and quickly gain control of the stricken U-boat. However, the tables turn as the American ship is destroyed by the arrival of Nazi ships that were also dispatched in response to the SOS. Stranded on their captured U-boat, the Americans must use their own submarine training, complicated by the fact that all of the controls in this submarine are labeled in German, to pilot U-571 and get home alive.

The movie is loosely based on the true story of the capture of the Enigma machine. During World War II, a top priority for the Allies was cracking the encoded German military message traffic. The key to breaking the code was capturing one of Germany's Enigma code machines, an intricate clockwork mechanism that could turn scrambled letters into clear statements, and a clear message into scrambled letters.

The captured machine is now in a military museum at Fort Mead, Maryland.

Modern encryption is not dependent on a classified machine for security. While flying atomic weapons early in his military career, the author used an encryption system in which the machine was unclassified; however, it was totally useless without the settings, which were changed on a regular basis.

UNCENSORED

Gainsborough, 1942, b&w, 108 minutes.

Producer: Edward Black; **Director:** Anthony Asquith; **Screenwriters:** Rodney Ackland, Terence Rattigan, Wolfgang Wilhelm; **Distributor:** 20th Century-Fox Film Corporation; **Cast:** Felix Aylmer, Phyllis Calvert, Frederick Culley, Peter Glenville, Irene Handl, Walter Hudd, Carl Jaffe, Griffith Jones, Raymond Lovell, Eliot Makeham, Phyllis Monkman, Lloyd Pearson, Eric Portman.

Eric Portman runs a nightclub in Nazi-occupied Belgium during World War II. He is persuaded by the underground to secretly publish an anti-Nazi newspaper. His assistant publisher is the alluring Phyllis Calvert. But the co-owner of the cabaret, Peter Glenville, jealous of her relationship with Portman, betrays them to the Nazis. The staff is arrested, although Portman and Calvert are able to elude the Gestapo. When the two of them manage to put out another issue of the paper, the Nazis believe that they have arrested the wrong people, and they release the staff.

The movie is based on Oscar E. Millard's *Uncensored: The True Story of the Clandestine Newspaper "La Libre Belgique"* (London: R. Hale, 1937).

UNCERTAIN GLORY

Warner Bros. 1944, b&w, 102 minutes.

Producer: Robert Buckner; **Director:** Raoul Walsh; **Screenwriters:** Max Brand, Joe May (story), László Vadnay (story); **Music:** Adolph Deutsch; **Cast:** Per Aabel, Albert Van Antwerp, Trevor Bardette, Felix Basch, Wallis Clark, Pedro de Cordoba, Jean Del Val, Douglass Dumbrille, Faye Emerson, James Flavin, Errol Flynn, Joel Friedkin, Creighton Hale, Carl Harbaugh, Dennis Hoey, Victor Kilian, Charles La Torre, Sheldon Leonard, Paul Lukas, Michael Mark, Odette Myrtil, Sarah Padden, Paul Panzer, Francis Pierlot, Erskine Sanford, Hans Schumm,

Mary Servoss, Art Smith, Jean Sullivan, Zina Torchina, Ivan Triesault, Joyce Tucker, Bobby Walberg, Lucile Watson.

Errol Flynn, about to be guillotined for his crimes, escapes his fate as the result of an Allied air raid. He is persuaded to turn himself in and impersonate a saboteur wanted by the Nazis, in order to save the lives of 100 hostages.

UNCOMMON VALOR

Milius-Feitshans, Paramount Pictures, 1983, color, 105 minutes.

Producers: Burton Elias, Buzz Feitshans, Wings Hauser, Ted Kotcheff, John Milius; **Director:** Ted Kotcheff; **Screenwriter:** Joe Gayton; **Music:** James Horner; **Distributor:** Paramount Pictures; **Cast:** Charles Aidman, Todd Allen, David Austin, Bruce Paul Barbour, Justin Bayly, Kevin Brando, Reb Brown, Darwyn Carson, Randall Tex Cobb, David Dangler, Michael Dudikoff, Joseph Dypwick, James Edgcomb, Ken Farmer, Charles Faust, Juan Fernández, Constance Forslund, Gene Hackman, William S. Hamilton, Napoleon Hendrix, Tad Horino, Emmett Dennis III, Brett Johnson, Jane Kaczmarek, Jeremy Kemp, Marcello Krakoff, Lau Nga Lai, Chip Lally, Angela Lee, Kwan Hi Lim, Nancy Linari, Don Mantooth, Michael P. May, Laurence Neber, Barret Oliver, Debi Parker, Tom Randa, John Reilly, Steve Solberg, Robert Stack, Gail Strickland, Gloria Stroock, Jerry Supiran, Patrick Swayze, Harold Sylvester, Tim Thomerson, Jan Tríska, Le Tuan, Fred Ward, Larry Charles White, Kelly Yunkermann.

Millionaire Robert Stack and retired military officer Gene Hackman, both of whom have sons who were declared missing in action in Vietnam, are convinced they are still being held as prisoners of war. They join forces to recruit a team of Vietnam veterans to pull them out. Standing in their way are the U.S. government, which believes that the rescue mission will upset delicate negotiations with the Vietnamese, and the CIA, which convinces the Bangkok police to confiscate all of their weapons. Despite the obstacles, the rescue mission reaches the POW camp and slaughters the guards. Although Hackman learns that his son died in the prison years earlier, they are successful in rescuing the other prisoners.

RAMBO: FIRST BLOOD PART II and *MISSING IN ACTION* both deal with the theme of rescuing POWs left behind in Vietnam.

QUOTES

Sailor: You don't quit, boy. Not when it's for real!

Mrs. Wilkes: It's taken me 10 years to get that damn war out of his head!
Rhodes: Oh yeah? Well it looks like it's still in there to me.

Sailor: Boy, you just bought the whole can of whup-ass!

UNDER FIRE

Regal Films Inc., 1957, b&w, 76 minutes.

Producer: Plato A. Skouras; **Director:** James B. Clark; **Screenwriters:** James Landis; **Music:** Paul Dunlap; **Distributor:** 20th Century Fox; **Cast:** William Allyn, Steve Brodie, David Carlisle, George Chakiris, Frank Gerstle, Seymour Green, Ed Hinton, Gregory LaFayette, Robert Levin, Jon Locke, Karl Lukas, Walter Maslow, Tom McKee, Harry Morgan, Edmund Penney, Rex Reason, David Tomack, Peter Walker.

Four American soldiers are court-martialed for desertion. Their defense, which is ultimately successful, is that they got lost and were separated from their command.

UNDERGROUND

Brighton Pictures, 1970, color, 96 minutes.

Producers: Arthur Gardner, Jules Levy; **Director:** Arthur N. Nadel; **Screenwriters:** Ron Bishop, Andy Lewis, Marc L. Roberts; **Music:** Stanley Myers; **Distributor:** United Artists; **Cast:** Gerry Alexander, Jim Bartley, Sebastian Breaks, Harry Brooks Jr., Bob Carlile, Andre Charisse, Barry Cowan, Nicole Croisille, Martin Crosbie, Roger Delgado, Lawrence Dobkin, Carl Duering, Conor Evans, Stephen Follett, Danièle Gaubert, Bill Golding, Robert Goulet, Joachim Hansen, Frank Hayden, Jeremy Jones, Eamon Keane, Maura Keeley, David Leland, Leon Lissek, Andreas Malandrinos, Brendan Matthews, Fred Meany, Paul Murphy, Liam O'Callaghan, Chris O'Neill, Alexander Peleg, Joe Pilkington, Derry Power, George Pravda, Vincent Smith, Gerry Sullivan.

An American agent parachutes into occupied France during World War II. His mission is to link up with the French Resistance and to kidnap a German general.

UNDERWATER WARRIOR

Hunterhaven, Metro-Goldwyn-Mayer, 1958, b&w, 91 minutes.

Producers: John Florea (associate producer), Ivan Tors; **Director:** Andrew Marton; **Screenwriters:** Gene Levitt; **Music:** Harry Sukman; **Filmed in:** Hawaii, Marshall Islands, North Pacific, San Clemente Island, Coronado, and California; **Cast:** Raymond Bailey, Genie Coree, Dan Dailey, Alex Fane, Alex Gerry, James Gregory, Charles Keane, Claire Kelly, Jon Lindbergh, Ross Martin, Zale Parry.

Commander Francis D. Fane (Dan Dailey) must convince his skeptical superiors during World War II, and then later in Korea, that frogmen can successfully perform their undersea mission.

The movie is based on the true story of Cmdr. Francis D. Fane (USNR), the father of the U.S. Navy's underwater demolition frogmen.

UP FROM THE BEACH

20th Century-Fox, Panoramic Productions, 1965, b&w, 99 minutes.

Producer: Christian Ferry; **Director:** Robert Parrish; **Screenwriters:** George Barr, Claude Brulé, Howard Clewes, Stanley Mann; **Music:** Edgar Cosma; **Distributor:** 20th Century-Fox Film Corporation; **Cast:** Georges Adet, Charles Bouillaud, Raymond Bussières, Red Buttons, Georges Chamarat, Louise Chevalier, Nicole Chollet, Broderick Crawford, Brian Davies, Paula Dehelly, Germaine Delbat, Irina Demick, Gabriel Gobin, Marius Goring, Robert Hoffmann, James Robertson Justice, Billy Kearns, Fernand Ledoux, Raoul Marco, Paul Maxwell, Pierre Moncorbier, Bibi Morat, Slim Pickens, Cliff Robertson, Françoise Rosay, Roy Stephens, Joe Warfield, Ken Wayne, Tracy Keenan Wynn.

Cliff Robertson plays a sergeant who leads his squad up from the Normandy beach as part of the American thrust inland after the D day invasion. After liberating a farmhouse where a large group of French civilians are being held hostage by German soldiers, he takes the hostages back to the beach, but the beach master does not want any part of the refugees.

The movie is based on George Barr's *Epitaph for an Enemy* (New York: Harper, 1959).

UP FRONT

Universal-International Pictures, 1951, b&w, 92 minutes.

Producer: Leonard Goldstein; **Director:** Alexander Hall; **Screenwriters:** Bill Mauldin (book), Stanley Roberts; **Cast:** Marina Berti, Maurice Cavell, Harry Cording, Roger De Koven, Richard Egan, Tom Ewell, James Flavin, Peter Graves, Paul Harvey, Jack Hyde, Mickey Knox, Jeffrey Lynn, Silvio Minciotti, Grazia Narciso, Gregg Palmer, James Seay, Arthur Space, Vaughn Taylor, Kenneth Tobey, Tito Vuolo, David Wayne.

Willie (Tom Ewell) and Joe (David Wayne) are two lowbrow GIs on the Italian front, who counter the actions of their gung-ho captain and other military snafus with a barrage of wry comments. As they take a break from the war in Naples, Joe's penchant for wine, women, and song gets them into all sorts of trouble.

The film is based on Bill Mauldin's cartoon collection *Up Front* (New York: Holt, 1944).

INTERESTING FACT

- This film is based on the famous World War II cartoon characters Willie and Joe. Although the humorous cartoons in the military newspaper *Stars and Stripes* were often irreverent jibes at the U.S. Army, the popularity of the paper kept the brass from shutting it down.

MILITARY SERVICE

- Cartoonist William Henry Mauldin, the creator of Willie and Joe, enlisted in the U.S. Army and served with the 45th Infantry Division (Thunderbird Division of the National Guard). He served in Italy and Germany, saw action at Cassino and Anzio, received a Purple Heart for wounds received at Salerno in 1943, and became one of the popular cartoonists of the war. Willie and Joe regularly appeared in *Stars and Stripes*, the official newspaper of the armed forces.

QUOTES

Captain Johnson: Is there no discipline up here?
Corporal Miller: Yes, sir!

Willie [Willie and Joe hit the dirt under unfriendly fire]: Get down lower!
Joe: I can't get no lower, Willie, my buttons is in the way.

UP IN ARMS

Avalon Productions Inc., Samuel Goldwyn Company, 1944, color, 106 minutes.

Producers: Samuel Goldwyn, Don Hartman (associate producer); **Director:** Elliott Nugent; **Screenwriters:** Owen Davis (play, *The Nervous Wreck*), Don Hartman, Allen Boretz, Robert Pirosh; **Music:** Harold Arlen, Sylvia Fine, Louis Forbes, Ray Heindorf, Howard Jackson (incidental music), Ted Koehler, Max Liebman, Max Steiner (incidental music); **Distributor:** RKO Radio Pictures; **Cast:** Betty Alexander, Gale Amber, Gloria Anderson, Dana Andrews, Sig Arno, Charles Arnt, Benny Baker, Al Benault, Oliver Blake, Charles D. Brown, Jan Bryant, Louis Calhern, Alma Carroll, Maurice Cass, Walter Catlett, Joan Chaffee, Linda Christian, Elisha Cook Jr., Virginia Cruzon, Helen Darling, William B. Davidson, Myrna Dell, Donald Dickson, Constance Dowling, Tom Dugan, Margaret Dumont, Maude Eburne, Fred Essler, Rudolf Friml, Dorothy Gardner, Inna Gest, Stanley Gilbert, Renee Godfrey, Ellen Hall, Charles Halton, John Hamilton, June Harris, Eloise Hart, Harry Hayden, Mary Ann Hyde, Eddie Kane, Danny Kaye, Tom Keene, June Lang, Rosalyn Lee, Florence Lundeen, Mickey Malloy, Knox Manning, George Mathews, Virginia Mayo, George Meeker, Dorothy Merritt, Lorraine Miller, Mary Moore, Kay Morley, Diana Mumby, Lee Nugent, Dorothy Patrick, Shelby Payne, Terrance Ray, Frosty Royce, Dinah Shore, Larry Steers, Leonard Strong, Lyle Talbot, Helen Talbot, Ruth Valmy, Ricki Van Dusen, Alice Wallace, Virginia Wicks, Audrey Wilder, Matt Willis, Isabel Withers.

Hypochondriac Danny Kaye gets drafted into the army and makes life miserable for his fellow GIs. Sent to the Pacific, he is captured by the Japanese, and before you know it, he has captured them all and taken them back to his own lines.

The film is based on a stage play by Owen Davis, *The Nervous Wreck* (New York: S. French, 1926), which was adapted into a musical, *Whoopee* (1930), starring Eddie Cantor.

INTERESTING FACT

- The large musical production number, "All Out for Freedom," is performed by the Goldwyn Girls.

AWARDS

Academy Awards, USA, 1944
Nominated: *Oscar, Best Music, Scoring of a Musical*

Picture, Louis Forbes, Ray Heindorf; *Best Music, Song*, Harold Arlen (music), Ted Koehler (lyrics), for the song *Now I Know*.

UP PERISCOPE

Lakeside Productions, Warner Bros., 1959, color, 112 minutes.

Producer: Aubrey Schenck; **Director:** Gordon Douglas; **Screenwriters:** Richard H. Landau, Robb White (novel); **Music:** Adolph Deutsch, Ray Heindorf, Max Steiner, Franz Waxman, nonoriginal music by Daniele Amfitheatrof, Erich Wolfgang Korngold, Roy Webb;

Distributor: Warner Bros.; **Cast:** Robert Aiken, Richard Bakalyan, Edd Byrnes, Carleton Carpenter, George Crise, James Garner, Sean Garrison, Frank Gifford, Alan Hale Jr., Henry Kulky, William Leslie, Andra Martin, Warren Oates, Edmond O'Brien.

Navy frogman James Garner, who takes a casual attitude about the war, is sent on a dangerous mission to steal vital encryption information from the Japanese. When he is captured, it falls to a by-the-book submarine captain, who dislikes Garner, to come to his rescue.

The movie is based on Robb White's *Up Periscope* (Garden City: Doubleday, 1956).

VALIANT, THE

BHP-Euro International, 1962, b&w, 90 minutes.

Producer: Jon Penington; **Directors:** Roy Ward Baker, Giorgio Capitani; **Screenwriters:** Willis Hall, Robert Mallet, Keith Waterhouse; **Distributor:** United Artists; **Cast:** Patrick Barr, Leonardo Cortese, Colin Douglas, Charles Houston, Dinsdale Landen, Ettore Manni, John Meillon, Ralph Michael, John Mills, Laurence Naismith, Gordon Rawlings, Liam Redmond, Roberto Rissi, Robert Shaw, Moray Watson.

During World War II, the hard-bitten commander of a British battleship stationed in Alexandria Harbor tries to force two captured Italian frogmen to divulge the location of the underwater charges they planted on the ship's hull. The captives refuse to cooperate, and as the minutes tick by and the increasingly nervous British sailors wait for the bomb to explode, they begin to question their leader's judgment. Finally, the captain decides to evacuate the ship, leaving the prisoners onboard. He surreptitiously remains behind, eavesdrops on the POWs, and learns the mines' locations, but not in time to stop them from exploding and badly damaging the ship. Hoping to mislead Italian reconnaissance planes, the captain puts most of his crew on deck to make the Italian fliers think their mission failed, as the rest of the crew frantically try to repair the damage to the hull.

VICTORS, THE

Open Road-High Road, 1963, b&w, 175 minutes.

Producers: Harold Buck, Carl Foreman; **Director:** Carl Foreman; **Screenwriters:** Alexander Baron, Carl Foreman; **Distributor:** Columbia Pictures Corporation; **Filmed in:** Tilbury, England; **Cast:** Peter Arne, Alan Barnes, Senta Berger, Veite Bethke, Tom Busby, Michael Callan, Larry Caringhi, James Chase, John Crawford, Marianne Deming, Bee Duffell, Vince Edwards, Elizabeth Ercy, Albert Finney, Joël Flateau, Peter Fonda, Vanda Godsell, Graydon Gould, George Hamilton, Ian Hughes, Mervyn Johns, Patrick Jordan, Sean Kelly, Alf Kjellin, Mickey Knox, Tutte Lemkow, Albert Lieven, Colin Maitland, Anthony McBride, Melina Mercouri, George Mikell, James Mitchum, Jeanne Moreau, Malya Nappi, Robert Nichols, Riggs O'Hara, George Peppard, John Rogers, Maurice Ronet, George Roubicek, Rosanna Schiaffino, Romy Schneider, Elke Sommer, Milo Sperber, Marianne Stone, Charles De Temple, Russ Titus, Peter Vaughan, Tony Wallace, Eli Wallach, Al Waxman.

The movie depicts individual experiences of soldiers in an American infantry company as they fight from the time of the Italian campaign to the final victory over Nazi Germany. The movie is based on Alexander Baron's *The Human Kind* (New York: Washburn, 1953).

MILITARY SERVICE

- Eli Wallach served in the U.S. Army Medical Corps during World War II and was discharged as a captain.

VICTORY

Lorimar Film Entertainment, Victory Company, 1981, color, 110 minutes.

Producer: Freddie Fields; **Director:** John Huston; **Screenwriters:** Evan Jones, Yabo Yablonsky; **Music:** Bill Conti; **Distributor:** Paramount Pictures; **Cast:** Amidou, Osvaldo Ardiles, Arthur Brauss, Michael Caine, Julian Curry, Kazimierz Deyna, Anton Diffring, Benoît Ferreux, Carole Laure, Soren Lindsted, Daniel Massey, Clive Merrison, George Mikell, Bobby Moore, Kevin O'Callaghan, Russell Osman, Pelé, Tim Pigott-Smith, Werner Roth, Maurice Roëves, David Shawyer, Laurie Sivell, Sylvester Stallone, Jean-François Stévenin, Mike Summerbee, Max von Sydow, Hallvar Thoresen, Robin Turner, Paul Van Himst, Gary Waldhorn, John Wark, Michael Wolf.

In World War II, the Nazis come up with a propaganda stunt in which an all-star Nazi team will play the best soccer players culled from Allied POWs. The POWs realize they can use the game, which is being held in France, to stage an escape. However, when they reach the time in the game scheduled for the breakout, they are losing, so they decide to give up their chance to escape, finish the game, and win. They manage to tie the score. In a surprise ending, the massive crowd of Frenchmen surge onto the field, surround the players, exchange clothes with them, and then help them escape in the mass of humanity, while the German guards look on powerlessly.

MISTAKE

- The vast majority of the extras in the soccer stadium have hairstyles and wear clothes associated with the time period in which the film was made, the late 1970s and early 1980s (long hair, flares, and wide-collared shirts).

QUOTES

Max von Sydow [referring to soccer]: In all these years we have never beaten England.

Officer [deciding which dressing rooms at the French stadium the Germans should get]: Germany is the home team, wouldn't you agree?

Max von Sydow: Politically? Historically? I'd rather not make that decision.

VILLA RIDES

Paramount Pictures, 1968, color, 125 minutes.

Producer: Ted Richmond; **Director:** Buzz Kulik; **Screenwriters:** William Douglas Lansford, Sam Peckinpah, Robert Towne; **Music:** Maurice Jarre; **Distributor:** Paramount Pictures; **Filmed in:** Spain; **Cast:** Charles Bronson, Yul Brynner, Maria Grazia Buccella, Bob Carricart, Regina De Julyan, Jill Ireland, John Ireland, Alexander Knox, Herbert Lom, Diana Lorys, Robert Mitchum, Andrés Monreal, Julio Peña, José María Prada, Fernando Rey, Antonio Ruiz, Robert Viharo, Frank Wolff.

Pancho Villa (Yul Brynner) fights to put the humane Madero into power in Mexico. As does the former peasant Villa, Madero favors agrarian reform by breaking up the great estates and distributing the land to the peasants. Robert Mitchum is an American pilot and mercenary who joins Villa.

The Mexican revolution was particularly bloodthirsty, both sides regularly engaged in the practice of shooting prisoners. This is exemplified in a scene with Charles Bronson, a vicious Villa lieutenant. He releases different numbers of prisoners, and they are given a chance to "run for their life" to a nearby wall. However, Bronson is a crack shot, and even when a large number are released from the holding pen, he always gets them all.

INTERESTING FACT

- The leading film on Pancho Villa, although no more historically accurate than this one, is *VIVA VILLA!*, with Wallace Beery.

VIRGIN SOLDIERS, THE

Columbia Pictures Corporation, 1969, color, 96 minutes.

Producers: Carl Foreman, Lester Gilliat, Ned Sherrin; **Director:** John Dexter; **Screenwriters:** John Hopkins, John McGrath, Leslie Thomas; **Cast:** Hywel Bennett, Tsai Chin, James Cosmo, Graham Crowden, Nigel Davenport, Michael Gwynn, Don Hawkins, Roy Holder, Geoffrey Hughes, Rachel Kempson, Riggs O'Hara, Nigel Patrick, Gregory Phillips, Lynn Redgrave, Jack Shepherd, Wayne Sleep, Christopher Timothy.

In 1950 Singapore, a group of young British soldiers dream about winning the love of the daughter of the sergeant of the regiment.

The movie is based on Leslie Thomas's *The Virgin Soldiers* (London: Constable, 1966).

VIVA VILLA!

Metro-Goldwyn-Mayer, 1934, b&w, 115 minutes.

Producer: David O. Selznick; **Directors:** Jack Conway, Howard Hawks; **Screenwriters:** Edgecumb Pinchon (book), O. B. Stade (book), Ben Hecht, Howard Hawks; **Music:** Herbert Stothart; **Filmed in:** Mexico; **Cast:** Henry Armetta, Mischa Auer, Wallace Beery, Noah Beery Jr., Nigel De Brulier, Ralph Bushman, Leo Carrillo, Shirley Chambers, Emile Chautard, Steve Clemente, Donald Cook, Phillip Cooper, Harry Cording, John Davidson, Katherine DeMille, Nick De Ruiz, Dan Dix, David Durand, Stuart Erwin, Sam Godfrey, Anita Gordiano, Brandon Hurst, Chris-Pin Martin, James Martin, Francis McDonald, Robert McKenzie, John Merkel, Belle Mitchell, Leonard Mudie, Herbert Prior, Frank Puglia, Pedro Regas, George Regas, Charles Requa, Tom Ricketts, Julian Rivero, Adrian Rosley, Hector Sarno, Joseph Schildkraut, Harry Semels, Paul Stanton, Charles Stevens, George E. Stone, Arthur Thalasso, Carlos De Valdez, Henry B. Walthall, H.B. Warner, Clarence Wilson, Fay Wray.

Pancho Villa (Wallace Beery) as a young boy takes to the hills after killing an overseer in revenge for his father's death. In 1910, a meeting with visionary Francisco Madero transforms Villa from an avenging bandit into a revolutionary general. To the tune of the song *La Cucaracha*, his armies sweep Mexico and put Madero into power. After Madero's fall, Villa must raise his peoples' army once again and return to save Mexico from yet another tyrant.

The film is based on Edgcumb Pinchon and Odo B. Stade's *Viva Villa! A Recovery of the Real Pancho Villa, Peon, Bandit, Soldier, Patriot* (New York: Harcourt, 1933).

Pancho Villa (1877–1923), bandit turned revolutionary leader, originally helped put Madero into power in 1911. When Madero was ousted, Villa helped put Carranza into power. When Carranza didn't implement land reform and other programs as fully and as quickly as promised, Villa allied with Zapata against him. After the United States sided with Carranza in 1914, Villa raided Columbus, New Mexico, in 1916, giving the United States an excuse to mobilize the National Guard, something it had wanted to do in preparation for entering World War I. They never caught Villa; it was not until 1923 that he was assassinated, thus permanently taken out of Mexican politics.

INTERESTING FACTS

- On November 19, 1933, during location filming in Mexico, Lee Tracy, originally cast as Johnny Sykes, urinated from his hotel balcony onto a military parade. He was arrested, fired from the film, and replaced by Stuart Erwin. Original director Howard Hawks was also fired for refusing to testify against Tracy; Hawks was replaced by Jack Conway.
- Much of the footage originally shot by Howard Hawks is said to have been lost in a plane crash. However, Hawks claimed that most of the location footage (except battle scenes) was his.
- The role of the reporter was based on real-life Hearst correspondent John W. Roberts.
- Screenwriter Ben Hecht took many liberties with history in his script. The real Pancho Villa was more ruthless bandit than revolutionary.

QUOTES

Wallace Beery [after Villa is assassinated, speaking to his best friend, the reporter]: Johnny, what were my last words?
Wallace Beery [right before Villa dies]: What did I do wrong?

AWARDS

Academy Awards, USA, 1934
 Won: *Oscar, Best Assistant Director,* John Waters
 Nominated: *Oscar, Best Picture; Best Sound Recording,* Douglas Shearer; *Best Writing, Adaptation,* Ben Hecht

Venice Film Festival, 1934
 Won: *Golden Medal, Best Actor,* Wallace Beery; *Special Recommendation,* Jack Conway
 Nominated: Mussolini Cup, Jack Conway.

VIVA ZAPATA!

20th Century-Fox, 1952, b&w, 113 minutes.

Producer: Darryl F. Zanuck; **Director:** Elia Kazan; **Screenwriters:** John Steinbeck, Edgecumb Pinchon; **Music:** Alex North; **Distributor:** 20th Century-Fox; **Filmed in:** Rio Grande City, Texas; **Cast:** Florenz Ames, Ross Bagdasarian, Salvador Baguez, Abner Biberman, Marlon Brando, John F. Bray, Henry Corden, Frank DeKova, Mildred Dunnock, Robert

Filmer, Richard Garrick, Leonard George, Lou Gilbert, Harold Gordon, Bernie Gozier, Joseph Granby, Harry Kingston, Will Kuluva, George J. Lewis, Peter Mamakos, Margo, Tiger Joe Marsh, Julia Montoya, Arnold Moss, Nestor Paiva, Jean Peters, Anthony Quinn, Alan Reed, Pedro Regas, Ric Roman, Fay Roope, Henry Silva, Frank Silvera, Guy Thomajan, Philip Van Zandt, Nina Varela, Joseph Wiseman.

Zapata (Marlon Brando) fights for the rights of the peasants. After winning two revolutions, he is ambushed by his enemies and dies in a hail of bullets.

Emiliano Zapata fought in the Mexican Revolution of 1910–1921, and was primarily interested in land reform for the peasants. He was instrumental in putting Madero into power, and after that leader's assassination, he joined with Pancho Villa in another revolution. After their victory, he took control of the government. When he discovered that it is much harder to be in charge than to fight for control, he resigned. Military officers assassinated him, fearful that he would return to power.

QUOTES

Madero [pointing to a map]: You know what this is, General? This is your ranch.
Zapata: I did not fight for a ranch.

Madero: You must surrender your weapons.
Zapata: And who will enforce the laws?
Madero: The regular army, the police.
Zapata: They're the ones we just fought!

Zapata: You always look for leaders. Strong men without faults. There aren't any. There are only men like ourselves. There are no leaders but yourselves. A strong people is the only lasting strength.

AWARDS

Academy Awards, USA, 1952
Won: *Oscar, Best Supporting Actor,* Anthony Quinn
Nominated: *Oscar, Best Actor,* Marlon Brando; *Best Art Direction–Set Decoration, Black-and-White,* Claude E. Carpenter, Leland Fuller, Thomas Little, Lyle R. Wheeler; *Best Music, Scoring of a Dramatic or Comedy Picture,* Alex North; *Best Writing, Story and Screenplay,* John Steinbeck

British Academy Awards, 1953
Won: *BAFTA Film Award, Best Foreign Actor,* Marlon Brando, USA
Nominated: *BAFTA Film Award, Best Film from Any Source,* USA

Cannes Film Festival, 1952
Won: *Best Actor,* Marlon Brando.

VON RICHTHOFEN AND BROWN

The Corman Company, 1971, color, 97 minutes.

Producers: Gene Corman, Jimmy T. Murakami (associate producer); **Director:** Roger Corman; **Screenwriters:** John William Corrington, Joyce Hooper Corrington; **Music:** Hugo Friedhofer; **Distributors:** MGM, United Artists; **Filmed in:** Weston Aerodrome, Leixlip, County Kildare, Ireland; **Cast:** Tom Adams, George Armitage, Emmet Bergin, Maureen Cusack, Brian Foley, Seamus Forde, Hurd Hatfield, Karen Huston, Fred Johnson, Clint Kimbrough, Robert LaTourneaux, John Phillip Law, Peter Masterson, Ferdy Mayne, Stephen McHattie, Des Nealon, David Osterhout, Gordon Phillips, Barry Primus, Lorraine Rainer, Corin Redgrave, Don Stroud, Brian Sturdivant, David Weston.

During World War I, the aristocratic Red Baron (John Phillip Law), the deadliest air ace in the war, leads his German squadron with a code of honor and chivalry. He faces cynical and ruthless Capt. Roy Brown, a former Canadian wheat farmer who describes himself as a "technician" whose job is to turn aviators into corpses. When they finally meet, chivalry dies, and the modern era of mechanized killing is ushered in.

INTERESTING FACTS

- One of the stunt flyers was Richard D. Bach, the pilot and author of *Jonathan Livingston Seagull* (1973).
- The movie reused the vintage airplanes from THE BLUE MAX (1966).
- Director Roger Corman's soon-to-be wife, Julie Halloran, filled in as a gunner in one of the planes during the raid sequence when the production came up one actor short.
- Production was shut down briefly due to a disaster on another semirelated film in the area. Birch Williams, an American expatriate living in Ireland, was the owner of the period planes Corman leased for the production. He was so interested in and excited by what Corman was doing that he decided to make a similar film himself, using his own planes. Unfortunately, there was a midair mishap, and Williams and two pilots were killed. In response, the Irish government shut down all films about flying, and the insurance company canceled Corman's

policy. It took several days of negotiation to get its status restored and to resume production.

- Although the dogfights were shot in Ireland over a two-week period using actual vintage planes, the crash sequences were filmed at Andrews Air Force base, near Los Angeles, in a single day, using models assembled by a group of teenaged hobbyists Corman happened across while scouting locations.
- One of the characters in the film, Hermann Göring, would later become one of Hitler's inner circle. Although Göring did indeed fly with the Flying Circus during World War I, he did not join the squadron until after the Red Baron was killed.
- The film is also known as *The Red Baron.*

MILITARY SERVICE

- Baron Manfred von Richthofen (1892–1918), the famous Red Baron, was so named because of the scarlet Fokkers flown by his squadron, the "Flying Circus." He was credited with 80 kills, making him the leading air ace of World War I. Although Capt. A. Roy Brown, a Canadian in the RAF, is credited with shooting him down during an aerial dogfight that involved some 50 aircraft, there is also evidence that he was downed by ground fire. He was buried with full military honors by Allied soldiers, such was the sense of chivalry that still surrounded aviation during World War I.

QUOTE

Von Richthofen: It's the hunt I find most satisfying.

VON RYAN'S EXPRESS

P-R Productions Picture, 20th Century-Fox, 1965, color, 112 minutes.

Producers: Saul David, Mark Robson; **Director:** Mark Robson; **Screenwriters:** Joseph Landon, Wendell Mayes, David Westheimer; **Music:** Jerry Goldsmith; **Distributor:** 20th Century-Fox Film Corporation; **Cast:** Richard Bakalyan, James Brolin, Raffaella Carrà, Adolfo Celi, John Daheim, Domenick Delgarde, Brad Dexter, Sergio Fantoni, Barry Ford, Brian Gaffikin, Donald F. Glut, Michael Goodliffe, Gino Gottarelli, Joe Gray, Peter Hellman, Robert Buzz Henry, Trevor Howard, John Leyton, Walter Linden, Eric Micklewood, John Mitory, Ernesto Moli-nari, Edward Mulhare, Wolfgang Preiss, Benito Prezia, Mike Romanoff, Bob Rosen, Vito Scotti, James Sikking, Frank Sinatra, Michael St. Clair, Jacques Stanislawski, Brad Stevens, Ivan Triesault, John Van Dreelen, Al Wyatt Jr.

American POW Ryan (Frank Sinatra) leads his fellow prisoners on a dangerous escape from the Germans in Italy. They take control of their POW train, impersonate their German guards, and take their train on a mad dash for Switzerland.

The movie is based on David Westheimer's *Von Ryan's Express* (Garden City: Doubleday, 1964).

INTERESTING FACTS

- As the quote below demonstrates, the central theme of most POW escape movies (see also THE GREAT ESCAPE) is that POWs accomplish much more than gaining their freedom when they escape. They also divert vital German war resources by requiring more men as guards, and more men to chase those who have escaped.
- This film can be compared with THE TRAIN, starring Burt Lancaster. Both use the same device of moving a train by outsmarting the Germans.

MISTAKES

- Sunbeams cannot shine simultaneously into the boxcar from opposite sides.
- The planes used to attack the train near the Swiss border are P-51 Mustangs, which the Germans never flew, and they fire rockets, which the Germans never used for air-to-ground attacks.
- As the Padre begins to type the change orders for the train to be rerouted, he says (in German) the date of September 11, 1941. The United States was not involved in the war until December 1941. The year stated should have been 1943.

QUOTE

Trevor Howard [voice-over of Ryan dead on the railroad tracks]: Remember, Ryan, if only one man escapes, it's a victory.

AWARD

Academy Awards, USA, 1965
 Nominated: *Oscar, Best Sound Effects,* Walter Rossi.

WACKIEST SHIP IN THE ARMY, THE

Columbia Pictures Corporation, 1960, color, 99 minutes.

Director: Richard Murphy; **Screenwriters:** Herbert Carlson, Herbert H. Margolis, Richard Murphy, William Raynor; **Cast:** Richard Anderson, Joby Baker, Warren Berlinger, Nesdon Booth, Patricia Driscoll, Mike Kellin, Jack Lemmon, John Lund, Alvy Moore, Ricky Nelson, Chips Rafferty, George Shibata, Teru Shimada, Tom Tully.

During World War II, Jack Lemmon is given command of a broken-down sailing ship, a garbage scow with a crew of misfits who don't know a jib from a jigger. Their mission is to deliver an Australian coast watcher to an island where he can monitor Japanese ship movements. The movie is based on a true story.

WAKE ISLAND

Paramount Pictures, 1942, b&w, 87 minutes.

Producer: Joseph Sistrom; **Director:** John Farrow; **Screenwriters:** W. R. Burnett, Frank Butler; **Music:** David Buttolph; **Filmed in:** Salton Sea, California; **Cast:** Walter Abel, Frank Albertson, Holly Bane, Hugh Beaumont, William Bendix, Barbara Britton, Hillary Brooke, James Brown, Rod Cameron, Macdonald Carey, Robert Carson, Don Castle, Jack Chapin, Dane Clark, Angelo Cruz, Albert Dekker, Brian Donlevy, Edward Earle, Frank Faylen, Mary Field, William Forrest, Bill Goodwin, Alan Hale Jr., Earle Harris, Marvin Jones, Richard Loo, Patti McCarty, Ivan Miller, Jack Mulhall, Anthony Nace, Damian O'Flynn, Robert Preston, Mikhail Rasumny, Keith Richards, Willard Robertson, Rudy Robles, John Sheehan, Phillip Terry, Mary Thomas, Charles Trowbridge, Philip Van Zandt.

In December 1941, after the sneak attack on Pearl Harbor, the next target in the Japanese plan for domination of the Pacific is Wake Island, which is defended by a small band of determined U.S. Marines. After naval bombardment, aerial attack, and banzai charges, the resolute leathernecks are finally overrun by the sheer numbers of the attacking Japanese.

Of the 449 U.S. Marines (1st Defense Battalion and VMF-211 detachments) who manned Wake's defenses, 49 were killed, 32 were wounded, and the remainder became prisoners of war. Of the 68 navy officers and men, three were killed, five wounded, and the rest taken prisoner. The five-man army communications detachment suffered no fatalities; all five were taken prisoner. Of the 1,146 civilians involved in construction programs on Wake Island, 70 were killed and 12 were wounded. Five of Wake's defenders were executed by the Japanese on board the *Nitta Maru*. With the exception of 98 contractors who remained on

Wake Island, all the rest of the civilians joined Wake's marines, sailors, and soldiers in prisoner-of-war camps, which had about a 30 percent survival rate. The Japanese executed the 98 contractors in October 1943, an atrocity for which Rear Adm. Shigematsu Sakaibara was hanged after the war.

The Japanese paid dearly for Wake Island. They lost four warships and hundreds of soldiers.

INTERESTING FACT

- The studio kept delaying release of the film, waiting for an American victory, especially in light of the defeat at the end of the movie. When no victory materialized, they were forced to release the film anyway. Surprisingly, the film's release created a surge in U.S. Marine Corps enlistment.

MILITARY SERVICE

- Director John Farrow (father of actress Mia Farrow) was a graduate of the Royal Naval Academy. He served four years in the Royal Navy after graduation before going to Hollywood. In World War II, he went back into the Royal Navy, rose to the rank of lieutenant commander, and was injured in the line of duty.
- Robert Preston enlisted in the U.S. Army Air Force and served as a captain in military intelligence in Europe, setting routes and briefing aircrews.
- Capt. Henry T. Elrod, USMC, received the Medal of Honor for the defense of Wake Island. The Medal cited Elrod for conspicuous gallantry and intrepidity at the risk of his life above and beyond the call of duty.

AWARDS

Academy Awards, USA, 1942
 Nominated: *Oscar, Best Director*, John Farrow; *Best Picture*, Joseph Sistrom; *Best Supporting Actor*, William Bendix; *Best Writing, Original, Screenplay*, W. R. Burnett, Frank Butler

New York Film Critics Circle Awards, 1942
 Won: *NYFCC Award, Best Director*, John Farrow.

WALKING DEAD, THE

Savoy Pictures, 1995, color, 88 minutes.

Producers: Bill Carraro, George Jackson, Doug McHenry, Frank Price, Lee Rafner; **Director:** Preston A. Whitmore II; **Screenwriter:** Preston A. Whitmore

II; **Filmed in:** Chuluota and Orlando, Florida; **Cast:** Carlos Joshua Agrait, Joshua Armstrong, Nicole Avant, Wilmer Calderon, Roger Floyd, Eddie Griffin, Kyley Jackman, Kevin Jackson, Damon Jones, Terry King, Jean LaMarre, Bernie Mac, Frank Eugene Matthews Jr., Joe Morton, Ion Overman, Sharon Parra, Allen Payne, Dana Point, Frank Price, Wendy Raquel Robinson, Lena Sang, Vivienne Sendaydiego, Hank Stone, Vonte Sweet, Velma Thompson, Susan Ursitti, Lisa Walker, Doil Williams.

During the Vietnam War, U.S. Marines are sent on a mission to rescue POWs. The guaranteed cold landing zone is hot, and only four of the rescuers survive. As they trudge toward their destination, they link up with the other platoon assigned to the mission, only to discover that it has just one survivor, who is now a total nut case.

WALK IN THE SUN, A

20th Century-Fox, 1945, b&w, 117 minutes.

Producer: Lewis Milestone; **Director:** Lewis Milestone; **Screenwriters:** Harry Brown, Robert Rossen; **Distributor:** 20th Century-Fox Film Corporation; **Cast:** Dana Andrews, Richard Benedict, Lloyd Bridges, Steve Brodie, James Cardwell, Harry Cline, Richard Conte, Victor Cutler, Dick Daniels, Anthony Dante, Danny Desmond, Chris Drake, Huntz Hall, Alvin Hammer, Sterling Holloway, John Ireland, John Kellogg, Norman Lloyd, Robert Lowell, Grant Maiben, Jay Norris, Malcolm O'Guinn, George Offerman, Herbert Rudley, Don Summers, George Turner, George Tyne, Matt Willis.

Dana Andrews leads a platoon assigned to take a German-held farmhouse in the advance on Salerno. The title of the film is ironic: The action is not just a "little walk in the sun." As they advance, the men reflect on their lives. They know that by the end of the day, some of them will reach the farmhouse alive; others will die in the attack.

The film is based on Harry Brown's *A Walk in the Sun* (New York: Knopf, 1944). The theme song, was It *Was Just a Little Walk in the Sun*, written by Earl Robinson, lyrics by Millard Lampell. It goes like this:

> It was just a little walk
> In the warm Italian sun
> But it was not an easy thing.
> And poets are writing

The tale of that fight
And songs for the children to sing. . . .

QUOTES

Friedman: You ever think you'll live to make corporal?
Rivera: Baby, I just want to live long enough to make civilian.

Sergeant Tyne: It's a funny thing, how many people you meet in an army that cross your path for a few seconds and you never see 'em again.
Rivera: Nobody dies.

WAR, THE

Island World, 1994, color, 127 minutes.

Producers: Jon Avnet, Todd R. Baker, Eric Eisner, Martin Huberty, Jordan Kerner, Lisa Lindstrom, Deborah Love, Kathy McWorter; **Director:** Jon Avnet; **Screenwriter:** Kathy McWorter; **Distributors:** Universal Pictures Corporation, United International Pictures; **Filmed in:** Coweta County and Tate, Georgia, Beaufort, South Carolina; **Cast:** Christine Baranski, Gary Basaraba, Lucas Black, Jay Brooks, LaToya Chisholm, Bill Coates, Kevin Costner, Dorothy Davis, Tom Even, Christopher Fennell, J. Don Ferguson, Brennan Gallagher, Adam Henderson, Charlotte Lewis, Justin Lucas, Wilson L. Middlebrooks, Afemo Omilami, Lexi Randall, Mary Nell Santacroce, Raynor Scheine, Nick Searcy, Donald Sellers, Leon Sills, Ron Clinton Smith, Jennifer Tyler, Judson Vaughn, Tim Ware, Will West, Mare Winningham, Elijah Wood, Bruce A. Young.

Kevin Costner is a Vietnam veteran who must deal with a war of a different sort between his son and a rival group of children. At the same time, he must try to come to terms with his own personal problems, which have resulted from his Vietnam experiences.

MISTAKE

- The Lipnicki gang dries off too quickly after exiting the lake at the quarry.

QUOTE

Lydia: War is like a big machine that no one really knows how to run, and when it gets out of control it ends up destroying the things you thought you were fighting for, and a lot of other things you kinda forgot you had.

WAR CORRESPONDENT

Columbia, 1932, b&w, 76 minutes.

Director: Paul Sloane; **Screenwriter:** Jo Swerling; **Cast:** Ralph Graves, Jack Holt, Tetsu Komai, Lila Lee, Richard Loo, Victor Wong.

Jack Holt, a mercenary pilot, goes to the rescue of Lila Lee, a prostitute who is being held by a Chinese warlord. He is aided by Ralph Graves, a war correspondent, who gets the girl after Holt is killed in the rescue.

This film focuses on one period of the Chinese civil wars (1911–1937, 1945–1949) in the late 1920s, when the democratic forces of Chang Kai-Shek's nationalists were subduing the local bandits and warlords.

WAR DOG

Feature Films, 1986, color, 95 minutes.

Producers: Björn Carlström, Daniel Hübenbecher, Anders Nilsson, Thomas Wredler; **Directors:** Björn Carlström, Daniel Hübenbecher; **Screenwriters:** Björn Carlström, Daniel Hübenbecher; **Music:** Dag Unenge; **Cast:** Timothy Earle, Gunnar Ernblad, Bengt Fridh, David Gillies, Iréne Grönwall, Catherine Jeppsson, Wolf Linder, Sydney Livingstone, David Lundberg, Jan Lundberg, Chris Masters, Bill Redvers.

While investigating his brother's death in Vietnam, the hero uncovers a secret government project to turn soldiers into drug-controlled killing machines.

WARHEAD

Worldvision Enterprises, 1974, color, 90 minutes.

Producers: Guy Della-Cioppa, Buddy Ruskin; **Director:** John O'Connor; **Screenwriters:** Patrick Foulk, Donovan Karnes, Buddy Ruskin; **Distributor:** Worldvision Enterprises Inc.; **Cast:** Pupik Arnon, Karin Dor, Joan Freeman, Arie Hamburger, David Janssen, Art Metrano, D. R. Morris, Eddy Muktar, Poly Reshef, Jacob Roda, David Semadar, Ellen Stern, Christopher Stone, Tuvia Tavi, Rachel Terry, Nicholas Torzeski, Itzik Weiss.

A weapons expert is reluctantly sent on a mission to the Middle East to locate a lost nuclear warhead and dismantle it before it falls into the wrong hands. However, the plan goes bad, and he is taken prisoner.

WAR HUNT

United Artists, 1962, b&w, 81 minutes.

Producers: Noel Black, Denis Sanders, Terry Sanders; **Director:** Denis Sanders; **Screenwriter:** Stanford Whitmore; **Music:** Bud Shank; **Distributor:** United Artists; **Cast:** Charles Aidman, William Challee, Nancy Hsueh, Gavin MacLeod, Tommy Matsuda, Sydney Pollack, Anthony Ray, Robert Redford, John Saxon, Tom Skerritt.

John Saxon plays a young soldier fighting in Korea, who finds he loves the killing more and more.

WAR IS HELL

Allied Artists, 1963, b&w, 81 minutes.

Producer: Burt Topper; **Director:** Burt Topper; **Screenwriter:** Burt Topper; **Music:** Ronald Stein; **Cast:** Baynes Barron, Michael Bell, Bobby Byles, Wally Campo, Kei Chung, J. J. Dahner, Judy Dan, Robert Howard, Audie Murphy, Russ Prescott, Tony Rich, Tony Russel, Paul Sheriff, Burt Topper.

Tony Russel plays a soldier obsessed with personal glory. When his comrades are killed knocking out a North Korean pillbox, he takes sole credit. When his lieutenant questions his story, he shoots him, takes command, and leads the men in further assaults, even after the cease-fire is declared.

INTERESTING FACTS

- This movie was double-billed with *CRY OF BATTLE* (1963) at the Texas Theater in Dallas where Lee Harvey Oswald was apprehended after assassinating president John F. Kennedy.
- War hero and actor Audie Murphy introduces the film.

WARKILL

Balut Productions, Centaur Film Company, 1967, color, 99 minutes.

Producer: Ferde Grofé Jr.; **Director:** Ferde Grofé Jr.; **Screenwriter:** Ferde Grofé Jr.; **Distributor:** Universal Pictures; **Cast:** Henry Duval, Eddie Infante, George Montgomery, Conrad Parham.

George Montgomery plays a brutal American colonel leading Filipino troops in mopping up isolated pockets of Japanese soldiers. A war correspondent, who once idolized the colonel, is shocked by his cruel tactics, which include forcing hungry rats down into the caves where the soldiers are hiding. However, he comes to finally realize that the colonel's tactics pale beside the atrocities committed by the Japanese.

QUOTE

Colonel: In every man there is a beast, and it's only this war that makes us animals.

WAR LOVER, THE

British Lion Film Corporation, Columbia Pictures Corporation, 1962, b&w, 105 minutes.

Producer: Arthur Hornblow Jr.; **Director:** Philip Leacock; **Screenwriters:** John Hersey, Howard Koch; **Distributor:** Columbia; **Cast:** Ed Bishop, Bernard Braden, Tom Busby, Gary Cockrell, Michael Crawford, Charles De Temple, Louise Dunn, Robert Easton, Bill Edwards, Shirley Ann Field, Arthur Hewlett, Chuck Julian, Bob Kanter, Sean Kelly, Richard Leech, Justine Lord, Neil McCallum, Steve McQueen, George Sperdakos, Jerry Stovin, Robert Wagner, Al Waxman.

Steve McQueen plays a daredevil World War II B-17 bomber pilot who lives for the most dangerous assignments. Between missions, he competes with Robert Wagner for the same girl.

In a dramatic scene, McQueen, returning from a mission, has his crew bail out as his crippled bomber heads for the white cliffs of Dover. Convinced he can make it, he sticks with the aircraft, but this time his luck, or his skill, runs out, and he crashes into the cliff.

The movie is based on John Hersey's novel *The War Lover* (New York: Knopf, 1959).

WARN THAT MAN

Associated British Pictures Corporation, 1944, b&w, 82 minutes.

Producer: Warwick Ward; **Director:** Lawrence Huntington; **Screenwriters:** Lawrence Huntington, Vernon Sylvaine; **Cast:** Patrick Aherne, Frederick Cooper, Finlay Currie, Philip Friend, Gordon Harker, Anthony Hawtrey, Anthony Holles, Carl Jaffe, Jean Kent, Raymond Lovell, Veronica Rose, John Salew.

During World War II, German paratroopers drop into England, take over Buckley Hall, replace the lord and

his staff with German operatives, and wait for the expected guest, Winston Churchill, to arrive. Fortunately, the lord's niece has evaded capture. She is able to sneak out of the house and return with British soldiers to retake the castle.

WATERFRONT

Producers Releasing Corporation, 1944, b&w, 68 minutes.

Producer: Arthur Alexander; **Director:** Steve Sekely; **Screenwriters:** Irwin Franklyn, Martin Mooney; **Distributor:** Producers Releasing Corporation; **Cast:** John Bleifer, John Carradine, Olga Fabian, Terry Frost, Marten Lamont, Edwin Maxwell, J. Carrol Naish, Billy Nelson, Claire Rochelle, Gene Roth, Maris Wrixon.

J. Carrol Naish and John Carradine play evil enemy agents working for the Nazis during World War II.

WATERLOO BRIDGE

Universal Pictures, 1931, b&w, 81 minutes.

Producer: Carl Laemmle Jr.; **Director:** James Whale; **Screenwriters:** Benn W. Levy, Tom Reed, Robert E. Sherwood; **Music:** Val Burton; **Distributor:** Universal Pictures; **Filmed in:** Pasadena, California (Wetherby House, exteriors); **Cast:** Enid Bennett, Billy Bevan, Rita Carlyle, Mae Clarke, Bette Davis, Ethel Griffies, Ruth Handforth, Frederick Kerr, Doris Lloyd, Douglass Montgomery.

Roy (Kent Douglass) plays a Canadian soldier in London on furlough who falls in love with Myra (Mae Clarke), unaware that she is a prostitute. She accepts his proposal of marriage. Before he leaves for the front, they visit his family in the country. Myra realizes she cannot escape her past and, after Roy leaves for France, tells his aristocratic mother about her sordid life. The mother encourages her to break off the relationship for the sake of her son. When Myra returns to London, she is killed in an air raid.

The film is based on Robert E. Sherwood's play *Waterloo Bridge* (New York: London: Scribner's, 1930).

WATERLOO BRIDGE

Metro-Goldwyn-Mayer, 1940, b&w, 108 minutes.

Producers: Sidney Franklin, Mervyn LeRoy; **Director:** Mervyn LeRoy; **Screenwriters:** Robert E. Sherwood (play), S. N. Behrman, Hans Rameau, George Froeschel; **Music:** Herbert Stothart; **Distributor:** MGM; **Cast:** Harry Allen, Jimmy Aubrey, Florence Baker, Phyllis Barry, Colin Campbell, Rita Carlyle, Virginia Carroll, Leo G. Carroll, David Clyde, Kathryn Collier, Tom Conway, Dennis D'Auburn, Frank Dawson, Steffi Duna, Connie Emerald, Gilbert Emery, Herbert Evans, Virginia Field, Maria Genardi, Douglas Gordon, Denis Green, Ethel Griffies, Bobby Hale, Winifred Harris, Halliwell Hobbes, Harold Howard, Charles Irwin, Bill James, George Kirby, Vivien Leigh, Eric Lonsdale, Wilfred Lucas, Frances MacInerney, Margery Manning, Dan Maxwell, James May, Florine McKinney, Charles McNaughton, Frank Mitchell, Leonard Mudie, Judith Nelles, Leda Nicova, Gordon Orbell, Maria Ouspenskaya, Tempe Pigott, John Power, Elsie Prescott, Jean Prescott, Clara Reid, Fred Sassoni, Paul Scardon, Janet Shaw, C. Aubrey Smith, Wyndham Standing, Eleanor Stewart, Harry Stubbs, Robert Taylor, William Tetley, Cyril Thornton, David Thursby, Norma Varden, Janet Waldo, Lucile Watson, Martha Wentworth, Eric Wilton, Robert Winkler, Douglas Wood.

Robert Taylor plays a British officer who meets Vivien Leigh, a young ballerina. When she stays out late with him, she is dismissed from the corps de ballet for violating curfew. He is ordered to the front and the trenches of World War I. Without the ballet, she is forced to survive on the streets of London, and when she hears that he has been killed in action, she turns to prostitution. Going to the train station to meet potential customers, she is unexpectedly faced with her true love, returning from France, wounded but very much alive. When he takes her to his family estate to meet his family, she confesses everything to his mother. Realizing that her dream can never come true, she leaves him and commits suicide by throwing herself in front of a troop transport on Waterloo Bridge.

The film is based on Robert E. Sherwood's play *Waterloo Bridge* (New York: London: C. Scribner's Sons, 1930).

INTERESTING FACT

- Of all her films, this was Vivien Leigh's personal favorite.

AWARDS

Academy Awards, USA, 1941
 Nominated: *Oscar, Best Cinematography, Black-and-White,* Joseph Ruttenberg; *Best Music, Original Score,* Herbert Stothart.

WAY AHEAD, THE

Two Cities Films Ltd., 1944, b&w, 115 minutes.

Producers: Stanley Haynes, John Sutro, Norman Walker; **Director:** Carol Reed; **Screenwriters:** Eric Ambler, Peter Ustinov; **Distributor:** 20th Century-Fox; **Cast:** Grace Arnold, Renée Asherson, Hugh Burden, Esma Cannon, A. Bromley Davenport, James Donald, Penelope Dudley-Ward, Leslie Dwyer, Eileen Erskine, Leo Genn, Alfred Goddard, Jimmy Hanley, William Hartnell, Stanley Holloway, Trevor Howard, Raymond Huntley, Mary Jerrold, John Laurie, Raymond Lovell, A. E. Matthews, George Merritt, David Niven, Tessie O'Shea, Lloyd Pearson, Quentin Reynolds, John Ruddock, John Salew, Johnnie Schofield, Reginald Tate, Peter Ustinov, Jack Watling.

Young British men are drafted into the infantry during World War II. At first, the conscripts appear hopeless as soldiers, but their sergeant and lieutenant mold them into a team, in time for them to go into action in North Africa.

INTERESTING FACT

- David Niven stated in his autobiography that the film was shown for many years as a training film at Sandhurst (the British army's officer training school).

WELCOME, MR. WASHINGTON

British National-Shafesbury, 1944, b&w, 90 minutes.

Producer: Elizabeth Hiscott; **Director:** Leslie S. Hiscott; **Screenwriter:** Jack Whittingham; **Cast:** Paul Blake, Leslie Bradley, George Carney, Peggy Cummins, Roy Emerton, Shelagh Fraser, Martita Hunt, Louise Lord, Graham Moffatt, Barbara Mullen, Arthur Sinclair, Donald Stewart, Beatrice Varley, Drusilla Wills.

When a farming community finds itself dangerously short-handed at harvest time, American GIs pitch in and help their British brethren in true "hands across the sea" fashion.

American troops "invaded" England during World War II, turning it into an island fortress overflowing with "Yanks." There was a clash of cultures, which resulted in friction and resentment between the soldiers and the people they were there to save. The popular saying at the time was that they were "overpaid, oversexed, and over here." This issue was dealt with not only in this film but also in *A CANTERBURY TALE*.

INTERESTING FACT

- Real-life American army lieutenant Donald Stewart is cast as the nominal romantic lead. His lack of professional polish is obvious in his scenes with the talented Barbara Mullen.

WELCOME TO SARAJEVO

Dragon Pictures, Channel Four Films, Miramax Films, 1997, color, 102 minutes.

Producers: Graham Broadbent, Damian Jones, Paul Sarony; **Director:** Michael Winterbottom; **Screenwriters:** Frank Cottrell Boyce, Michael Nicholson; **Music:** Adrian Johnston; **Distributor:** Miramax Films; **Filmed in:** Skopje, Macedonia, Sarajevo, Bosnia-Herzegovina, and Trogir, Croatia; **Cast:** Cesar Adi, Petre Arsovski, Juliet Aubrey, Senad Basic, Dijana Bolanca, Paige Brogan-Smith, Izudina Brutus, Sanja Buric, Frank Dillane, Stephen Dillane, Igor Dzambazov, Pejdah Dzevad, Ines Fancovic, Kerry Fox, Gordana Gadzic, Ines Hadzovic, Woody Harrelson, Davor Janjic, Brankica Jankoska, Vladimir Jokanovic, Peter Kelly, Nikolina Kujaca, Nino Levi, Emily Lloyd, Dragan Marinkovic, Labina Mitevska, Goran Momiroski, James Nesbitt, Emira Nusevic, Vesna Orel, Viktorija Peceva, Milan Plestina, Joana Popovska, Natali Rajcinovska, Berina Salijevic, Haris Sarvan, Haris Secic, Kerry Shale, Drazen Sivak, Marisa Tomei, Majda Tusar, Goran Visnjic, Miralem Zubcevic.

Two journalists meet in Sarajevo at the beginning of the war in Bosnia. They become involved with an orphanage and decide to smuggle the orphans illegally back to England.

QUOTE

Michael Henderson: The Beatles aren't English. They're from Liverpool.

WESTFRONT 1918

Nero Film AG, 1930, b&w, 90 minutes.

Director: Georg Wilhelm Pabst; **Screenwriters:** Ernst Johannsen, Peter Martin Lampel, Ladislaus Vajda; **Distributor:** Lupe; **Cast:** Carl Ballhaus, Claus Clausen, Gustav Diessl, Else Heller, Hanna Hoessrich, Fritz Kampers, Hans-Joachim Moebis, Jackie Monnier, Gustav Püttjer, Vladimir Sokoloff.

A group of German infantrymen live in terror in the trenches of the western front during World War I. One of the men goes home on leave only to discover that wartime poverty has made life miserable for his family. He returns to the front line in time to face a massive attack by French tanks.

The movie is based on Ernst Johannsen's *Vier von der Infanterie.*

WEST OF SHANGHAI

Warner Bros., 1937, b&w, 65 minutes.

Producer: Bryan Foy; **Director:** John Farrow; **Screenwriters:** Porter Emerson Browne, Crane Wilbur; **Music:** Heinz Roemheld; **Distributor:** Warner Bros.; **Cast:** Sheila Bromley, Luke Chan, Ricardo Cortez, Paul Fung, Chester Gan, Gordon Hart, Mia Ichioka, Selmer Jackson, Boris Karloff, Tetsu Komai, Eddie Lee, James B. Leong, Maurice Liu, Richard Loo, Maurice Lui, Daro Meya, Gordon Oliver, Beverly Roberts, Vladimir Sokoloff, Frank Tang, Sammee Tong, Tom Ung, Bruce Wong, Douglas Wood.

Chinese warlord General Wu Yen Fang (Boris Karloff), captures a group of Americans. He is just as likely to engage them in spirited conversation as to kill them. As they await his pleasure, a similar fate is catching up with Karloff. After battling government troops, he is captured and meets his end in front of a firing squad.

This film takes place during the earlier period of the Chinese Civil Wars (1911–1937, 1945–1949), when the government is engaged in breaking the power of the warlords. It is also known as *The War Lord.* The movie is based on Porter Emerson Browne's play *The Bad Man* (London, New York: French's Standard Library Edition, 1926).

INTERESTING FACT

- Boris Karloff once more played an Oriental in the Mr. Wong detective series the following year for Monogram.

WE'VE NEVER BEEN LICKED

Universal Pictures, 1943, b&w, 103 minutes.

Producer: Walter Wanger; **Director:** John Rawlins; **Screenwriters:** Nick Grinde, Norman Reilly Raine; **Music:** Frank Skinner; **Distributor:** Universal Pictures; **Filmed at:** Texas A&M University, College Station, Texas, Calabasas, California; **Cast:** Edgar Barrier,

Noah Beery Jr., William Blees, Worth Crouch, Harry Davenport, Alfredo DeSa, William Frawley, Roland Got, Anne Gwynne, Samuel S. Hinds, Allen Jung, Malcolm McTaggart, Robert Mitchum, Mantan Moreland, Martha O'Driscoll, Moroni Olsen, George Putnam, Richard Quine, Bill Stern.

Richard Quine enters military school at Texas A&M with a chip on his shoulder, which Robert Mitchum and other upperclassmen quickly knock off. He associates with Japanese spies bent on stealing a secret chemical compound being developed at the university, and he is expelled when school officials learn that he turned the formula over to the enemy. He goes to Japan, where he starts making propaganda broadcasts for the Japanese directed at Allied soldiers serving in the Pacific. However, in actuality, he is a double agent, and these broadcasts include secret messages for American intelligence. When he gets an opportunity to fly on a Japanese bombing mission, he overpowers the pilot and crashes the plane into a Japanese aircraft carrier.

A related film, APPOINTMENT IN BERLIN, has a similar plot, with George Sanders gaining the trust of the Nazis, secretly broadcasting vital military information to the Allies, and being killed at the end.

INTERESTING FACTS

- A stunt player was killed when the caisson he was riding flipped over.
- William Frawley, who plays the Japanese spy at Texas A&M, later played Fred Mertz on *I Love Lucy.*

WHAT DID YOU DO IN THE WAR, DADDY?

Mirisch Company, 1966, color, 119 minutes.

Producers: Dick Crockett, Owen Crump, Blake Edwards; **Director:** Blake Edwards; **Screenwriters:** William Peter Blatty, Blake Edwards, Maurice Richlin; **Distributor:** United Artists; **Cast:** Eric Anderson, Leon Askin, William Bryant, Robert Carricart, Rico Cattani, James Coburn, Ken Del Conte, Herbert Ellis, Sergio Fantoni, Danny Francis, Tom Hunter, Kelly Johnson, Kurt Kreuger, James Lanphier, Art Lewis, Ralph Manza, Jerry Martin, Harry Morgan, Jay Novello, Carroll O'Connor, Giovanna Ralli, Aldo Ray, Vito Scotti, Johnny Seven, Dick Shawn, Ken Wales.

An Italian army unit offers to surrender, but only on one condition: They must have a wine festival and soccer game first. The American GIs decide that this is an

excellent idea. They send messages back to HQ reporting heavy resistance, as they party with their new Italian friends.

MILITARY SERVICE

- Carroll O'Connor spent three years as a seaman in the U.S. Merchant Marine during World War II, serving aboard tankers delivering fuel supplies across the sub-infested waters of the North Atlantic. If they had been hit by a torpedo, they wouldn't have had a chance; the fuel would have gone up in a tremendous explosion.

QUOTES

Italian commander: Are you ready to surrender?
American captain: Hell, no! Do you surrender?
Italian commander: Of course.

WHAT PRICE GLORY?

20th Century-Fox, 1952, color, 111 minutes.

Producer: Sol C. Siegel; **Director:** John Ford; **Screenwriters:** Maxwell Anderson, Henry Ephron, Phoebe Ephron, Laurence Stallings; **Music:** Alfred Newman; **Cast:** Luis Alberni, Olga Andre, Ed Begley, Danny Borzage, George Bruggeman, James Cagney, Corinne Calvet, Ann Codee, Dan Dailey, William Demarest, Charles B. Fitzsimons, Paul Fix, Scott Forbes, James Gleason, Paul Guilfoyle, William Henry, Craig Hill, Ray Hyke, Stanley Johnson, Henry Kulky, Henri Letondal, Fred Libby, James Lilburn, Sean McClory, Louis Mercier, Torben Meyer, Harry Morgan, Barry Norton, Peter Ortiz, Marisa Pavan, Jack Pennick, Max Showalter, Mickey Simpson, Tom Tyler, Wally Vernon, Robert Wagner, Alfred Zeisler.

In 1918 France, James Cagney commands a company of U.S. Marines. His new top sergeant is his friendly rival, Dan Dailey. The two men are rivals for the favors of the fair innkeeper's daughter, but the rivalry goes into reverse when she proves to be angling for a husband. When the company is ordered to the front, this romantic comedy interlude gives way to the grim realities of war.

The movie is based on the stage play by Maxwell Anderson and Laurence Stallings, *What Price Glory* (New York: Harcourt, Brace and Company, 1926).

MILITARY SERVICE

- Six-time Academy Award winner John Ford directed this film at the end of World War II, after his own service in the U.S. Navy.

QUOTES

Lieutenant Moore: What about those three men who were supposed to go up to Le Mans to get the Croix de Guerre?
Captain Flagg: Oh, yeah. Yes, yes. All right, get 'em out of the guardhouse and have 'em take a bath and send 'em over with an MP escort.

Captain Flagg: Quirt loves the bottle, and when he's drunk he is the lousiest, filthiest tramp that ever wore a uniform. He's even worse than I am, and you know I don't allow anybody to get as bad as that.

Captain Flagg: It's a lousy war, kid . . . but it's the only one we've got.

WHEN HELL BROKE LOOSE

Paramount Pictures, 1958, b&w, 78 minutes.

Producers: Edward B. Barison, Harry Rybnick; **Director:** Kenneth G. Crane; **Screenwriters:** Oscar Brodney, Ib Melchior; **Music:** Albert Glasser; **Distributor:** Paramount Pictures; **Cast:** Charles Bronson, Kathy Carlyle, Robert Easton, Eddie Foy III, Richard Jaeckel, Dennis McCarthy, John Morley, Arvid Nelson, Ed Penny, Violet Rensing, Bob Stevenson.

Charles Bronson, a reluctant GI who enlisted in the army only to beat a prison sentence, learns from his new German girlfriend that her brother is going to assassinate General Eisenhower, and he foils the plot.

The film uses a plot device of infiltration by English-speaking Nazis wearing American uniforms. This did not occur as depicted in this film, but it did happen at the Battle of the Bulge. The enemy soldiers, dressed as military police, effectively misdirected troops moving up to the line and caused endless confusion and disorganization at the front. Once the Americans wised up, they started using those old standby challenges like "Who won the 1939 World Series?" They ferreted out the spies and summarily executed them.

WHEN WILLIE COMES MARCHING HOME

20th Century-Fox, 1950, b&w, 82 minutes.

Producer: Fred Kohlmar; **Director:** John Ford; **Screenwriters:** Sy Gomberg (story), Mary Loos, Richard Sale; **Music:** Alfred Newman; **Distributor:** 20th Century-Fox Film Corporation; **Filmed in:**

Conejo Valley in Thousand Oaks, and Santa Catalina Island, California; **Cast:** Luis Alberni, Michael Alvarez, Beau Anderson, Frank Baker, Jackie Barnett, Gregg Barton, Norman Bergman, Whit Bissell, George Blagoi, Jack Boyle, Frederick Brunn, Paul Bryar, Corinne Calvet, Peter Camlin, Allen Church, Lee Clark, Les Clark, Russ Clark, Ann Codee, Gene Collins, Russ Conway, Clyde Cook, Lloyd Corrigan, Dan Dailey, Lloyd Dawson, William Demarest, Mimi Doyle, Michael Dugan, Johnny Duncan, James Eagles, George Edwards, Robert Einer, Barney Elmore, James Flavin, Everett Glass, Clarke Gordon, Wilton Graff, Fred Graham, Alan Hale Jr., Charles Halton, Sam Harris, Joe Hartman, Paul Harvey, William Hawes, Don Hayden, Gil Herman, Don Hicks, Robin Hughes, Tim Huntley, Ray Hyke, Ken Lynch, Frank Johnson, Ted Jordan, Larry Keating, William Klein, Don Kohler, Harry Lauter, Fred Libby, Jimmy Lydon, Farrell Mac-Donald, Lee MacGregor, Harry Mack, George Magrill, Mike Mahoney, Hank Mann, Mae Marsh, Mickey McCardle, Keith McConnell, John McGuire, John McKee, David McMahon, Louis Mercier, Vera Miles, Edwin Mills, John Mitchum, Alberto Morin, Peter Ortiz, Robert Patten, Jack Pennick, Frank Pershing, Paul Picerni, Otto Reichow, Dan Riss, Felippa Rock, Carol Savage, John Shulick, Mickey Simpson, George Spaulding, Harry Strang, Gilchrist Stuart, Don Summers, Harry Tenbrook, Tiny Timbrell, Kenneth Tobey, Colleen Townsend, Charles Trowbridge, Evelyn Varden, Arthur Walsh, Harlan Warde, James Waters, Cecil Weston, Kenny Williams, Hank Worden, Sally Yarnell, William Yetter Sr.

When Willie (Dan Dailey) enlists in World War II, he wants to be a hero. He is humiliated when he is posted to a base right next to his hometown. Finally getting an assignment as a gunner on a B-17, he is asleep on a mission when the rest of the crew bails out, and he manages to escape only at the last minute. Picked up by the French underground, he is given a top-secret microfilm to take back to England, and when he arrives there the top brass labels him a hero. However, when he returns to his hometown, they refuse to believe his story.

The movie is based on Sy Gomberg's short story, "When Leo Came Marching Home" (*Collier's*, May 12, 1945).

AWARD

Academy Awards, USA, 1950
Nominated: *Oscar, Best Writing, Motion Picture Story*, Sy Gomberg.

WHERE EAGLES DARE

Winkast, Metro-Goldwyn-Mayer, 1969, color, 148 minutes.

Producers: Denis Holt, Elliott Kastner; **Director:** Brian G. Hutton; **Screenwriter:** Alistair MacLean; **Music:** Ron Goodwin; **Distributor:** MGM; **Filmed in:** Ebensee, Austria, Bavaria, Germany; **Cast:** Vincent Ball, Peter Barkworth, Richard Beale, Robert Beatty, Victor Beaumont, Richard Burton, Ivor Dean, Guy Deghy, Anton Diffring, Clint Eastwood, Max Faulkner, John G. Heller, Michael Hordern, Donald Houston, Nigel Lambert, Olga Lowe, Ferdy Mayne, Neil McCarthy, Derren Nesbitt, Ingrid Pitt, William Squire, Philip Stone, Mary Ure, Ernst Walder, Brook Williams, Patrick Wymark.

During World War II, the Germans shoot down an American general who has full knowledge of the D-day operation, and imprison him in a mountain-top *schloss* (castle). The British decide that the general must not be allowed to divulge any details of the Normandy landing and order a crack commando team led by Richard Burton to rescue him. Among the team is American ranger Lt. Schaffer (Clint Eastwood), who is puzzled by his inclusion in an all-British operation, until double and triple agents start showing up in the team. As an outsider, and an American, he's the only one who can be trusted. The team infiltrates the *schloss*, rescues the general, fights its way to the airfield, steals a German transport, and flies to safety.

The movie is based on Alistair MacLean's *Where Eagles Dare* (Garden City: Doubleday, 1967).

INTERESTING FACTS

- The driving force behind the film was Richard Burton's son, who wanted to see his father in a good old-fashioned adventure movie. Burton approached producer Elliott Kastner for ideas; he asked Alistair MacLean. At that time, most of MacLean's novels had either been made into films or were in the process of being filmed. Kastner persuaded MacLean to write a new story. Six weeks later, MacLean delivered the script.
- Clint Eastwood was reluctant to receive second billing to Burton but agreed after being paid $800,000.
- The Schloss Adler is actually the Schloss Hohenwerfen in Austria. At the time of filming, the castle was being used as a police training camp.

- An accident during one of the action scenes left Kastner and director Brian G. Hutton badly burnt.
- Schaffer greets each of his intended victims with a "hello" before he kills them.
- Despite Eastwood's reputation for violence in other films, his character kills more people in this film than in any other.

MISTAKES

- Helicopters weren't used in military operations until well after World War II, and especially not in the Third Reich. The helicopter shown is a U.S. model that wasn't built before the 1950s.
- When Schaffer starts the cable car and runs to it to jump on, it doesn't actually start moving until he is nearly aboard.
- In Germany, Major Smith impersonates a German army major. On the gray braided shoulder strap, the number of studs is wrong. In reality, one stud would indicate a major, two a lieutenant colonel, and three a colonel. Smith wears four. This is not a legitimate insignia of rank; all ranks above colonel wore gold-braided shoulder boards.
- During the classic corridor shootout between Schaffer and the Nazis, the soldier who gets hit lying at the other end flies backward before the ricochet charges in front of him go off.
- When Christiansen (Donald Houston) fires at Smith through the roof of the cable car, he fires five shots, yet the pistol can be heard to click empty on the fifth.
- When Smith shoots the radio operator twice in the back, the second blood bag fails to go off in sync with the gunshot.

QUOTES

Maj. John Smith: Lieutenant, in the next 15 minutes we have to create enough confusion to get out of here alive.
Lt. Morris Pimpennel Schaffer: Major, right now you got me about as confused as I ever hope to be.

Lt. Morris Pimpennel Schaffer: You seem to have a lot of women stashed around this country, Major.
Col. Wyatt Turner: Some people have a sixth sense. He has a sixth, a seventh, and an eighth.

WHICH WAY TO THE FRONT?

Jerry Lewis Films, Warner Bros., 1970, color, 96 minutes.

Producers: Jerry Lewis, Joe E. Stabile; **Director:** Jerry Lewis; **Screenwriters:** Dee Caruso, Gerald Gardner, Richard Miller; **Music:** Louis Y. Brown; **Distributor:** Warner Bros.; **Cast:** Kaye Ballard, Joe Besser, Gary Crosby, Willie Davis, Danny Dayton, Steve Franken, Kathleen Freeman, Neil Hamilton, Myron Healey, Martin Kosleck, Bob Layker, Artie Lewis, Bobo Lewis, Jerry Lewis, Ron Lewis, Kenneth MacDonald, Mickey Manners, Mike Mazurki, Robert Middleton, Sidney Miller, Jan Murray, Dack Rambo, Harold Stone, George Takei, Paul Winchell, John Wood.

Brendan Byers III (Jerry Lewis), the richest man in America, is pronounced 4-F by his draft board. However, he is not the kind of man to take "no" for an answer, and soon a new player enters World War II. Assembling a ragtag unit, consisting of other 4-Fs and his personal servants, he sails his yacht to Italy, where he manages to capture a Nazi general.

WHITE CLIFFS OF DOVER, THE

Metro-Goldwyn-Mayer, 1944, b&w, 126 minutes.

Producer: Sidney Franklin; **Director:** Clarence Brown; **Screenwriters:** George Froeschel, Jan Lustig, Alice Duer Miller, Robert Nathan, Claudine West; **Cast:** Harry Allen, Wilson Benge, Matthew Boulton, Edmund Breon, Charles Coleman, Clyde Cook, Gladys Cooper, Alec Craig, Ann Curzon, George Davis, Kay Deslys, Tom Drake, Irene Dunne, Isobel Elsom, Jill Esmond, Herbert Evans, Brenda Forbes, Bunny Gordon, Vera Graaff, Gary Gray, Ethel Griffies, Lumsden Hare, Keith Hitchcock, Charles Irwin, Van Johnson, George Kirby, Molly Lamont, Peter Lawford, Nelson Leigh, Adolf E. Licho, Doris Lloyd, June Lockhart, Miles Mander, Alan Marshal, Roddy McDowall, Jimmie Menzies, Frank Morgan, Leo Mostovoy, Norbert Muller, Steven Muller, Jean Prescott, Mabel Row, Anita Sharp-Bolster, Arthur Shields, C. Aubrey Smith, Elizabeth Taylor, Norma Varden, John Warburton, Dame May Whitty, Ian Wolfe.

Irene Dunne marries an English aristocrat; he is killed in World War I. She takes her young son to America, only to see him enlist in World War II. Volunteering as a Red Cross nurse, she finds him mortally wounded in an army hospital. As he dies, she reflects on the life that has brought her to this moment.

The film is based on the poem *The White Cliffs*, by Alice Duer Miller. Related films are MRS. MINIVER (1942), THIS ABOVE ALL (1942), and *Forever and a Day* (1943).

Susan Dunn's landlady [about Susan]: Such a nice young thing. Not a bit like an American.

WHO GOES NEXT?

Fox British, 1938, b&w, 85 minutes.

Producer: Ivor McLaren; **Director:** Maurice Elvey; **Screenwriter:** David Evans; **Cast:** Barry K. Barnes, Frank Birch, Charles Eaton, Jack Hawkins, Meinhart Maur, Andrew Osborn, Sophie Stewart.

During World War I, a group of British soldiers imprisoned in a German POW camp build an escape tunnel. When one of the prisoners breaks under the strain and betrays them, they are forced to immediately begin their escape. When the prisoner who betrayed them discovers that the group leader is the husband of his lover, he sacrifices his life for the leader.

WIFE TAKES A FLYER, THE

Columbia Pictures Corporation, 1942, b&w, 86 minutes.

Producer: B. P. Schulberg; **Director:** Richard Wallace; **Screenwriters:** Jay Dratler, Gina Kaus; **Cast:** Joan Bennett, Barbara Brown, Georgia Caine, Romaine Callender, Nora Cecil, Wheaton Chambers, Roger Clark, Chester Clute, Hans Conried, Lloyd Corrigan, Cecil Cunningham, Arno Frey, Allyn Joslyn, Manart Kipper, Lyle Latell, Kate MacKenna, Aubrey Mather, Erskine Sanford, Margaret Seddon, Franchot Tone.

Joan Bennett, a Dutch woman seeking a divorce, hides Franchot Tone, a downed British pilot who pretends to be her husband. He steals a plane, and they escape together to England.

WILD BLUE YONDER, THE

Republic Pictures Corporation, 1951, b&w, 98 minutes.

Producer: Herbert J. Yates; **Director:** Allan Dwan; **Screenwriters:** Andrew Geer, Charles Grayson, Richard Tregaskis; **Cast:** Joel Allen, Richard Avonde, Hall Bartlett, Hal Baylor, Andy Brennan, Walter Brennan, James Brown, Joe Brown Jr., Harry Carey Jr., Wally Cassell, William Ching, Peter Coe, Wendell Corey, Ruth Donnelly, Penny Edwards, Richard Erdman, Kathleen Freeman, Don Garner, Reed Hadley, Phil Harris, Myron Healey, Stan Holbrook, Ray Hyke, Robert Karnes, Gayle Kellogg, Jack Kelly, Robert Kent, Paul Livermore, Bob Morgan, Phillip Pine, Vera Ralston, David Sharpe, Jay Silverheels, Forrest Tucker, Glen Vernon, Steve Wayne, William Witney.

Wendell Corey and Forrest Tucker disagree over the capabilities of the B-29 Super Fortress during World War II. The reckless Corey believes that it can withstand a lot more punishment than thought by the deskbound bureaucrat Tucker. On the same bomber during a mission over Japan, Corey is wounded, and it's up to Tucker to bring the badly damaged plane home; he thus learns its amazing capabilities.

WILD GEESE, THE

Richmond, 1978, color, 134 minutes.

Producers: Chris Chrisafis, Euan Lloyd, Douglas Netter; **Director:** Andrew V. McLaglen; **Screenwriters:** Daniel Carney, Reginald Rose; **Distributor:** Allied Artists; **Cast:** John Alderson, Patrick Allen, Glyn Baker, Thomas Baptiste, Anna Bergman, Fats Bookholane, Fred Bryant, Richard Burton, Sydney Chama, Joe Cole, Joanna Collings, Jeff Corey, Robert Cunningham, Suzanne Danielle, John Dennison, Frank Finlay, Barry Foster, Ronald Fraser, Ken Gampu, Martin Grace, Stewart Granger, Kenneth Griffith, Richard Harris, Percy Herbert, Patrick Holt, Jane Hylton, John Kani, Hardy Krüger, David Ladd, Valerie Leon, Rosalind Lloyd, Terence Longdon, Roger Moore, Winston Ntshona, Taks Senekal, Paul Spurrier, Jules Walters, Jack Watson, Terry Wells, Brook Williams, Ian Yule.

A British multinational company seeks to overthrow a vicious dictator in central Africa. It hires a band of mercenaries in London and sends them to save the imprisoned opposition leader before he can be executed. The team completes the perfect rescue, but then the multinational company makes a deal with the dictator: The team's evacuation flight aborts before landing, and the mercenary band is forced to fight its way out of Africa on foot.

"Wild Geese" are Irish mercenaries who have fought for hire in wars since the 1700s.

The movie is based on Daniel Carney's book *The Wild Geese* (London: Heinemann, 1977).

Faulkner: There is a clause in all of my contracts, that my liver is to be buried separately, and with honors.

Esposito [as the enemy attacks]: We're dead!
Sandy Young: Esposito, you're not dead until I *tell* you you're dead.

WIND AND THE LION, THE

Metro-Goldwyn-Mayer, 1975, color, 119 minutes.

Producers: Herb Jaffe, Phil Rawlins; **Director:** John Milius; **Screenwriter:** John Milius; **Music:** Jerry Goldsmith; **Distributor:** MGM; **Cast:** Chris Aller, Luis Barboo, Deborah Baxter, Candice Bergen, Charly Bravo, Deborah Burnett, Anita Colby, Sean Connery, Jack Cooley, Rusty Cox, Larry Cross, Michel Damian, Audrey San Felix, Darrell Fetty, Polly Gottesmann, Frank Gussman, Simon Harrison, John Huston, Roy Jenson, Steve Kanaly, Brian Keith, Geoffrey Lewis, Dr. Akio Mitamura, Shirley Rothman, Aldo Sambrell, Nadim Sawalha, Vladek Sheybal, Antoine St. John, Ben Tatar, Alexander Weldon, Billy Williams, Marc Zuber.

Raisuli, Lord of the Rif, a Berber bandit (Sean Connery), kidnaps an American widow (Candice Bergen) in Morocco. Teddy Roosevelt (Brian Keith) exploits the situation for his own political advantage. This incident is supposedly based on a real historical event.

In a dramatic scene, American officers sent to rescue Candice Bergen debate what action to take. They decide to capture the local Berber leader. One officer

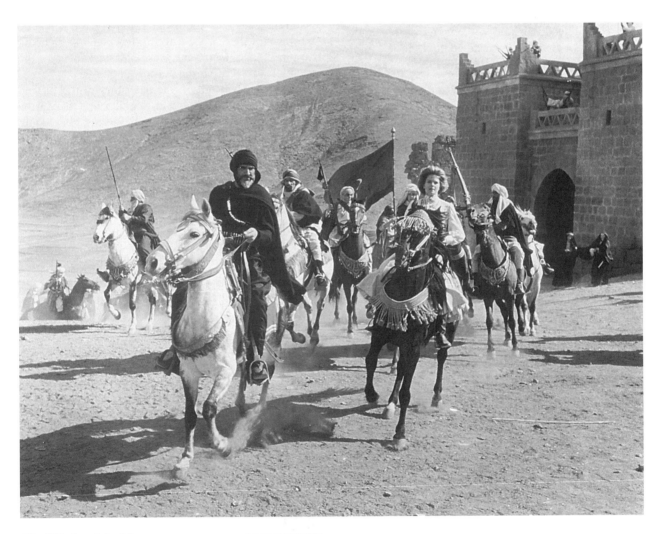

The Wind and the Lion (MGM/AUTHOR'S COLLECTION)

wonders what the U.S. president would think, and another confirms that is exactly what Teddy would do. Then the opinion is advanced that if they are killed, the nations of the world might go to war. At that point, one officer exclaims, "If we're killed, I hope the world does go to war."

QUOTES

Eden: Why would anyone want to cut out a man's tongue?

Raisuli: Perhaps the previous owner had nothing pleasant to say.

Raisuli: I am Raisuli. Do not laugh at me again.

Sherif of Wazan: Great Raisuli, we have lost everything. All is drifting on the wind as you said. We have lost everything.

Raisuli: Sherif, is there not one thing in your life that is worth losing everything for?

John Hay: Theodore! You are dangerous. You might even shoot somebody—accidentally I mean.

Theodore Roosevelt: John, I'd never shoot anyone accidentally. I need their votes.

AWARDS

Academy Awards, USA, 1975
 Nominated: *Oscar, Best Music, Original Score,* Jerry Goldsmith, *Best Sound,* Roy Charman, William L. McCaughey, Aaron Rochin, Harry W. Tetrick

British Academy Awards, 1976
 Nominated: *Anthony Asquith Award for Film Music,* Jerry Goldsmith

Writers Guild of America, USA, 1976
 Nominated: *WGA Screen Award, Best Drama Written Directly for the Screen,* John Milius.

WINDMILL, THE

Warner Bros.-First National Teddington Studios, 1937, b&w, 62 minutes.

Producer: Irving Asher; **Director:** Arthur B. Woods; **Screenwriters:** John Drabble, Tom Phipps, Brock Williams; **Cast:** Glen Alyn, John Carol, William Dewhurst, George Galleon, John Laurie, Bruce Lister, Henry Mollison, Winifred Oughton, Anthony Shaw, Hugh Williams.

During World War I, an English soldier falls in love with an innkeeper's daughter. She is already engaged to a German, who turns out to be a spy.

WINDTALKERS

Metro-Goldwyn-Mayer, 2001, color/b&w, 134 minutes.

Producers: Arthur Anderson (associate producer), Terence Chang, C. O. Erickson (executive producer), Tracie Graham, Caroline Macaulay (coproducer), Alison R. Rosenzweig, John J. Smith (line producer), Richard Stenta (line producer), John Woo; **Director:** John Woo; **Screenwriters:** Joe Batteer (written by), John Rice (written by); **Distributor:** MGM; **Filmed in:** Hawaii and Los Angeles, California; **Cast:** Adam Beach, Nicolas Cage, Kevin Cooney, Jeremy Davidson, James D. Dever, Noah Emmerich, David L. Hall, Martin Henderson, Brian Van Holt, Josh Hopkins, Emily Mortimer, Frances O'Connor, Simon Rhee, Mark Ruffalo, Christian Slater, Peter Stormare, Roger Willie.

A young Navajo code talker during World War II is put under the protection of a U.S. Marine bodyguard, who must safeguard him from capture by the Japanese. However, if there is a chance of the code talker's being captured, then the marine must kill him to prevent the enemy from learning the Navajo language.

This film is based on the true story of the Navajo Code Talkers. During World War II, the U.S. Marine Corps realized that if it enlisted Navajos, they could speak in their native language over the radio, in the clear, and the Japanese would not be able to understand what they were saying. However, this code-talking would be secure only as long as no Navajo marines fell into the hands of the enemy.

WING AND A PRAYER

20th Century-Fox, 1944, b&w, 97 minutes.

Producers: William A. Bacher, Walter Morosco; **Director:** Henry Hathaway; **Screenwriters:** Jerome Cady (screenplay and story); **Music:** Hugo Friedhofer; **Distributor:** 20th-Century Fox Film Corporation; **Cast:** Murray Alper, Don Ameche, Dana Andrews, Stanley Andrews, Irving Bacon, Robert Bailey, Charles Bickford, George Chandler, Richard Crane, Blake Edwards, William Eythe, Reed Hadley, Cedric Hardwicke, Joe Haworth, Richard Jaeckel, John Kellogg, John Kelly, Carl Knowles, Charles Lang, Glenn Langan, Billy Lechner, William Manning, George Mathews, Renny McEvoy, Matt McHugh, John Miles, Harry Morgan, Kevin O'Shea, B. S. Pulley, Raymond Roe, Jerry Shane, Mel Shubert, Charles B. Smith, Ray Teal, Larry Thompson, Charles Trowbridge, Edward Van Sloan, Dave Willock.

An aircraft carrier is sent into the Pacific to trick the Japanese into believing that the Americans have no stomach for a fight. Every time the Americans encounter a Japanese carrier, the American pilots are ordered to turn and run. The men become more and more frustrated as their losses mount and they are not allowed to engage the enemy. Ultimately, the Japanese fleet is decoyed deep into the Pacific, near the island of Midway. The American carriers are ready for them; this time, they don't have to turn tail.

The Battle of Midway is described in the film *MIDWAY*.

AWARD

Academy Awards, USA, 1944
 Nominated: *Oscar, Best Writing, Original Screenplay*, Jerome Cady.

WINGED VICTORY

20th Century-Fox, 1944, b&w, 130 minutes.

Producer: Darryl F. Zanuck; **Director:** George Cukor; **Screenwriter:** Moss Hart; **Music:** Tod B. Galloway, Meade Minnigerode, George S. Pomeroy, David Rose; **Filmed in:** Taft, California; **Cast:** Keith Andes, Jane Ball, Alan Baxter, Don Beddoe, Richard Benedict, Ray Bidwell, Philip Bourneuf, Sascha Brastoff, Red Buttons, Lee J. Cobb, Fred Ayres Cotton, Jeanne Crain, Mark Daniels, Jo-Carroll Dennison, Brad Dexter, Frances Gladwin, Timmy Hawkins, Peter Lind Hayes, Gil Herman, Richard Hogan, Judy Holliday, Rune Hultman, George Humbert, Mario Lanza, Harry Lewis, Moyna MacGill, Karl Malden, Lon McCallister, Kevin McCarthy, Gary Merrill, Leonard Mudie, Ellanora Needles, Barry Nelson, Jim Nolan, Edmond O'Brien, Damian O'Flynn, Margaret Parmentier, George Petrie, George Reeves, Carroll Riddle, Martin Ritt, Archie Robbins, Anthony Ross, Henry Rowland, Alfred Ryder, Henry Slate, Jack Slate, Don Taylor, Ken Terrell, Geraldine Wall, Sally Yarnell.

During World War II, six young men from different backgrounds enlist in the U.S. Army Air Force and train for their silver wings.

The movie is based on Moss Hart's Broadway play *Winged Victory* (New York: Random House, 1943).

WINGS

Paramount, 1927, b&w, 139 minutes.

Producers: Lucien Hubbard, B. P. Schulberg; **Director:** William A. Wellman; **Screenwriters:** Julian Johnson, Louis D. Lighton, Hope Loring, John Monk Saunders; **Music:** J. S. Zamecnik; **Distributor:** Paramount Pictures; **Filmed in:** Bexar County, Camp Bullis, Fort Sam Houston, and San Antonio, all in Texas; **Cast:** Richard Arlen, Clara Bow, El Brendel, Thomas Carr, Thomas Carrigan, Margery Chapin, Andy Clark, Gary Cooper, Nigel De Brulier, Julia Swayne Gordon, Dick Grace, Carl von Haartman, William Hickey, Hedda Hopper, George Irving, Roscoe Karns, Arlette Marchal, James Pierce, Jobyna Ralston, Buddy Rogers, Rod Rogers, Gunboat Smith, Frank Tomick, Richard Tucker, Henry B. Walthall, Gloria Wellman, William A. Wellman.

Charles "Buddy" Rogers and Richard Arlen both desire Jobyna Ralston. To make the love triangle a quadrangle, the "It" girl, Clara Bow, is after Rogers, but he does not reciprocate her love. Arlen and Rogers go through flight training, Clara Bow trains as a nurse, and they all go to fight in France during World War I. In a massive dogfight involving hundreds of planes, Arlen is shot down. He manages to escape in a German plane and almost makes it back to his own lines, when he is ironically shot down by his best friend, Rogers, but has time to forgive him before he dies.

INTERESTING FACTS

- The shooting-star design that Buddy Rogers paints on his car, and later on his fighter plane, was actually the insignia of the 22nd Aero Pursuit Squadron during the war.
- A scene of an aerial raid on a German troop train was filmed but not used. It later turned up as part of *The Legion of the Condemned* (1928).
- The two leads did their own flying.
- There is a scene in which Clara Bow is innocently changing her clothes behind one of those folding screens while her boyfriend is sleeping it off. If you run the film frame-by-frame, you can see her naked breasts.
- Gary Cooper has a small part as a cadet flyer killed in fight training.
- Jobyna Ralston was actually Richard Arlen's wife at the time of making the film.
- Hollywood columnist Hedda Hopper has a cameo role playing herself.

MILITARY SERVICE

- Screenwriter John Monk Saunders was a pursuit pilot during World War I.
- Director William Wellman flew with the Lafayette Flying Corps and the U.S. Army Air Service.

Academy Awards, USA, 1927–28
Won: *Oscar, Best Engineering Effects*, Roy Pomeroy; *Best Picture*, Lucien Hubbard

National Film Preservation Board, USA, 1997

National Film Registry

Newport Beach International Film Festival, 1998
Won: *Special Recognition Award*—A. C. Lyles (Paramount Studios), William Wellman Jr. (on behalf of director William Wellman)—for the first Academy Award–winning film.

WINGS OF EAGLES, THE

Metro-Goldwyn-Mayer, 1957, color, 110 minutes.

Producers: James E. Newcom (associate producer), Charles Schnee; **Director:** John Ford; **Screenwriters:** Frank Fenton, William Wister Haines, Frank Wead; **Music:** Jeff Alexander; **Distributor:** MGM; **Cast:** Tige Andrews, Ward Bond, Veda Ann Borg, Danny Borzage, Willis Bouchey, Olive Carey, Ken Curtis, Dan Dailey, James Flavin, Mimi Gibson, Fred Graham, Sam Harris, William Henry, Louis Jean Heydt, Stuart Holmes, Christopher James, Dorothy Jordan, Barry Kelley, Janet Lake, Edmund Lowe, William Paul Lowery, Cliff Lyons, Mae Marsh, May McAvoy, Alberto Morin, Maureen O'Hara, Henry O'Neill, Peter Ortiz, Jack Pennick, Chuck Roberson, Evelyn Rudie, Sig Ruman, Arthur Salzfass, Kenneth Tobey, James Todd, William Tracy, Charles Trowbridge, Harlan Warde, John Wayne.

Spig Wead (John Wayne) is a World War I naval aviator who tries to get the U.S. Navy brass to see the value of air power. When he is hit with an incapacitating illness, he must fight to get back on active duty. During World War II, he develops the concept of "jeep" carriers, small aircraft carriers capable of supplying the main battle carriers with replacement fighter planes.

The movie is based on the true story of Cmdr. Frank W. Wead, a naval aviator who became a writer after his medical discharge from the military.

INTERESTING FACTS

- Most of the extras in the Pensacola, Florida, scenes were actual U.S. Navy flight students and flight instructors. Although the navy objected, director John Ford made certain that the military men were paid "extra" wages.

- Ward Bond, who plays a film director, modeled his character on his lifelong friend, director John Ford, who directed this feature.
- Aviator Frank "Spig" Wead wrote the following war films: *DESTROYER, THEY WERE EXPENDABLE, DIVE BOMBER*, and *INTERNATIONAL SQUADRON*.

WINGS OF THE HAWK

Universal-International Pictures, 1953, color, 81 minutes.

Producers: David Johnston (associate producer), Aaron Rosenberg; **Director:** Budd Boetticher; **Screenwriters:** Gerald Drayson Adams (novel), Kay Lenard, James E. Moser; **Music:** Frank Skinner; **Distributor:** Universal-International; **Cast:** Rodolfo Acosta, Julie Adams, Rico Alaniz, Ricardo Alba, Noah Beery Jr., John Daheim, George Dolenz, Paul Fierro, Pedro Gonzales-Gonzales, Van Heflin, Abbe Lane, Antonio Moreno, Mario Siletti, Nancy Westbrook.

Van Heflin is a gringo engineer who has his gold mine taken from him by the Federales. As a result, he decides to join Pancho Villa and the Mexican Revolution.

The movie is based on Gerald Drayson Adams's book *Wings of the Hawk* (no publication data is available).

WINGS OVER THE PACIFIC

Monogram Pictures Corporation, 1943, b&w, 60 minutes.

Producer: Lindsley Parsons; **Director:** Phil Rosen; **Screenwriter:** George Wallace Sayre; **Music:** Eddie Cherkose, Edward J. Kay; **Distributor:** Monogram Pictures Corporation; **Cast:** Ernie Adams, Robert Armstrong, Inez Cooper, Jody Gilbert, Henry Guttman, Alex Havier, George Kamel, Jimmy Lono, Montagu Love, Edward Norris, Hawksha Paia, Satini Pualoa, John Roth.

Montagu Love plays a veteran of World War I who thought he had escaped from the insanity of war on his idyllic Pacific island, where he is raising his beautiful daughter. World War II intrudes on his peaceful existence when a German pilot and an American naval aviator both parachute onto his island. The American falls in love with the daughter. The German finds oil and radios the information to the Japanese. When a Nazi agent shows up, it falls to the American flier to save the day and defeat the Axis invaders.

WITHOUT RESERVATIONS

RKO Radio Pictures Inc., 1946, b&w, 107 minutes.

Producers: Jesse L. Lasky, Walter MacEwen; **Director:** Mervyn LeRoy; **Screenwriters:** Jane Allen, Mae Livingston, Andrew Solt; **Music:** Roy Webb; **Distributor:** RKO; **Cast:** Eric Alden, Fernando Alvarado, Jose Alvarado, Ernest Anderson, Robert Anderson, Charles Arnt, Lois Austin, Griff Barnett, William Benedict, Lee Bennett, Jack Benny, John Bleifer, Lela Bliss, Phil Brown, Marilyn Buferd, Raymond Burr, William Challee, Tom Chatterton, Fred Coby, Claudette Colbert, John Crawford, Roger Creed, Frank Dae, Sid Davies, Harold Davis, Don DeFore, Dick Dickerson, Dudley Dickerson, Dona Drake, Tay Dunn, Michael Economides, Charles Elmergreen, Herbert Espinosa, Charles Evans, Harry Evans, Joel Fluellen, Jon Gilbreath, June Glory, Lisa Golm, Cary Grant, Jesse Graves, Paul Gustine, Thelma Gyrath, Charlie Hall, Thurston Hall, Grayce Hampton, Henry Hastings, Joe Haworth, Harry Hayden, Harry Holman, Esther Howard, Ralph Hubbard, Tom Hubbard, Brock Hunt, J. Louis Johnson, John Kellogg, Cy Kendall, Jean Koehler, Mervyn LeRoy, Bruce Lester, Rose Mary Lopez, Leona Maricle, Junius Matthews, Sam McDaniel, Peter Michael, Chef Milani, Art Miles, Marvin Miller, Henry Mirelez, Charles R. Moore, Dolores Moran, Bill O'Leary, Oscar O'Shea, Jack Parker, Louella Parsons, Bob Pepper, Frank Puglia, Lorin Raker, Verne Richards, Ruth Roman, Al Rosen, Erskine Sanford, Wallace Scott, Bill Shannon, Robin Short, Warren Smith, Houseley Stevenson, Harry Strang, Miguel Tapia, Anne Triola, Bill Udell, Minerva Urecal, Nanette Vallon, Blanca Vischer, Henry Vroom, Bob Wallace, John Wayne, Lee Lasses White, Russ Whiteman, Frank Wilcox, Jane Wiley, Charles Williams, Ian Wolfe, Jean Wong, Will Wright.

An author travels by train to Hollywood, where her best-selling novel is to be made into a movie. Onboard, she encounters a U.S. Marine who doesn't think much of her book. As she falls in love with him, she must decide how to tell him that he is falling in love with the author he hates.

The movie is based on Jane Allen's and Mae Livingston's *Thanks, God! I'll Take It From Here* (London: Faber & Faber, 1946).

WOMAN I LOVE, THE

RKO Radio Pictures Inc., 1937, b&w, 85 minutes.

Producer: Albert Lewis; **Director:** Anatole Litvak; **Screenwriters:** Mary Borden, Joseph Kessel (novel, *L'Equipage*); **Music:** Arthur Honegger, Maurice Thiriet; **Cast:** Wally Albright, Vince Barnett, Don Red Barry, Mady Christians, Dudley Clements, Colin Clive, William Corson, Alec Craig, Alan Curtis, Owen Davis Jr., Paul Guilfoyle, Louis Hayward, Otto Hoffman, Sterling Holloway, Miriam Hopkins, Maxine Jennings, Leonid Kinskey, Richard Lane, Art Lewis, Mary MacLaren, Adrian Morris, Paul Muni, Elisabeth Risdon, William Stelling, Richard Tucker, Joe Twerp, Roland Varno, Minor Watson, Doodles Weaver.

Paul Muni plays a pilot in the French Flying Corps during World War I whose fellow squadron members believe he is a jinx. When Louis Hayward joins the squadron, he is the only one willing to become Muni's friend. Life gets complicated when Hayward falls in love with Miriam Hopkins, who is married to Muni. In a dogfight with the enemy, Hayward is killed and Muni is seriously wounded. He is nursed back to health by his wife, and they fall in love again.

The movie is based on Joseph Kessel's book *L'Equipage* (London: Victor Gollancz, 1928).

WOMEN AREN'T ANGELS

Associated British Pictures Corporation, 1942, b&w, 85 minutes.

Producer: Warwick Ward; **Director:** Lawrence Huntington; **Screenwriters:** Bernard Mainwaring, Vernon Sylvaine; **Cast:** Ethel Coleridge, Alfred Drayton, Robertson Hare, Joyce Heron, Mary Hinton, Ralph Michael, Charles Murray Jr., Peggy Novak, Leslie Perrins, John Stuart, Polly Ward.

During World War II, two music publishers are left on their own when their wives sign up for the Auxiliary Territorial Service (ATS). To be near them, the bored fellows dress up in women's uniforms, infiltrate the ATS, and end up capturing a band of fifth columnists.

WOMEN IN BONDAGE

Monogram Pictures Corporation, 1943, b&w, 72 minutes.

Producer: Herman Millakowsky; **Director:** Steve Sekely; **Screenwriters:** Houston Branch, Frank Wisbar; **Distributor:** Monogram Pictures Corporation; **Cast:** Felix Basch, Alan Baxter, Tala Birell, Francine Bordeaux, Frederic Brunn, Mary Forbes, Una Franks, William Henry, Nancy Kelly, Ralph Linn, Gertrude Michael, Anne Nagel, Wally Patch, Gail Patrick, Rita

Quigley, Hermine Sterler, Roland Varno, H. B. Warner, Gisela Werbisek, Maris Wrixon.

Gail Patrick plays the wife of a paralyzed German soldier. The Nazis pressure her to have a child, even though she would have to conceive it with someone other than her husband. Disgusted with her country, she decides to help Allied bombers find their targets.

Nazi Germany was determined that the women of Germany produce as many soldiers as possible. As a result, they encouraged illegitimate births and any other type of conception.

WOMEN IN THE NIGHT

Film Classics, 1947, b&w, 90 minutes.

Producer: Louis K. Ansell; **Director:** William Rowland; **Screenwriters:** William Rowland, Robert St. Claire; **Music:** Raúl Lavista; **Cast:** Philip Ahn, Tala Birell, Virginia Christine, Frances Chung, Iris Flores, Benson Fong, Kathy Frye, Bernadene Hayes, William Henry, Richard Loo, Helen Mowery, Gordon Richards.

Nazi and Japanese officers degrade and rape women who fall into their power.

The film is based on true case histories found in the files of the United Nations Information Office. More and more "comfort women," Chinese and Korean women forced into prostitution by the Japanese army during World War II, are coming forward and telling their stories of humiliation and degradation at the hands of the invader.

WOODEN HORSE, THE

British Lion, Wessex Productions, 1950, b&w, 101 minutes.

Producer: Ian Dalrymple; **Director:** Jack Lee; **Screenwriter:** Eric Williams; **Distributor:** British Lion; **Filmed in:** Germany and Denmark; **Cast:** Jacques B. Brunius, Peter Burton, Dan Cunningham, Philip Dale, Anthony Dawson, Herbert Eilitz, Helge Erickssen, Peter Finch, Bryan Forbes, Leo Genn, Michael Goodliffe, Walter Gotell, David Greene, Walter Hertner, Lis Løwert, Meinhart Maur, Hans Meyer, Franz Schafheitlin, Anthony Steel, David Tomlinson, Patrick Waddington, Ralph Ward, Russell Waters.

In a POW camp, the Nazis place the prisoners' huts far from the wire, which makes it extremely difficult to dig an escape tunnel. One British officer has the idea of starting a daily gymnastics routine using a vaulting horse: they place it near the wire, then start the tunnel right under it. Three escape using this plan and make their way to neutral Sweden.

YANKEE DOODLE DANDY

Warner Bros., 1942, b&w, 126 minutes.

Producers: William Cagney (associate producer), Hal B. Wallis, Jack L. Warner; **Director:** Michael Curtiz; **Screenwriters:** Robert Buckner (also story), Edmund Joseph; **Music:** George M. Cohan, Ray Heindorf, Heinz Roemheld; **Distributor:** Warner Bros.; **Cast:** Eddie Acuff, Murray Alper, George Barbier, Leon Belasco, Henry Blair, Walter Brooke, Leslie Brooks, James Cagney, Jeanne Cagney, Georgia Carroll, Walter Catlett, Dick Chandlee, Spencer Charters, Wallis Clark, Chester Clute, Douglas Croft, William B. Davidson, Rosemary DeCamp, Ann Doran, Tom Dugan, Bill Edwards, Frank Faylen, Pat Flaherty, Robert Flatley, James Flavin, William Forrest, Eddie Foy Jr., Joe Gray, Creighton Hale, John Hamilton, Harry Hayden, William Hopper, Joyce Horne, Walter Huston, Charles Irwin, Thomas E Jackson, Marijo James, Edward Keane, Dorothy Kelly, Fred Kelsey, Phyllis Kennedy, Frances Langford, Joan Leslie, Vera Lewis, Audrey Long, Irene Manning, Jo Ann Marlowe, Frank Mayo, Lon McCallister, George Meeker, Dolores Moran, Jack Mower, Lee Murray, Odette Myrtil, Garry Owen, Patsy Lee Parsons, Francis Pierlot, Joyce Reynolds, Ruth Robinson, Clinton Rosemond, Thomas W. Ross, S. Z. Sakall, Syd Saylor, Harry Seymour, John Sheehan, Charles Smith, George Tobias, Sailor Vincent, Minor Watson, Dick Wessel, Richard Whorf, Poppy Wilde, Dave Willock, Joan Winfield, Jack Young.

Composer/singer/dancer George M. Cohan (James Cagney) creates patriotic songs and musical shows that are an inspiration to Americans during World War I.

The film is based on the life of entertainer George M. Cohan (1878–1942). This great American song and dance man spent 56 of his 64 years on the stage. During his lifetime, he wrote 40 plays, collaborated with others on another 40 plays, and shared production of still another 150 plays. He made over 1000 appearances as an actor. Some of the more than 500 songs that he wrote were major national hits.

INTERESTING FACTS

- Fred Astaire was first offered the leading role but turned it down.
- James Cagney reprised his role as George M. Cohan in *The Seven Little Foys* (1955).
- James Cagney's real-life sister Jeanne Cagney was cast as George M. Cohan's sister, Josie.
- George M. Cohan really was born on the fourth of July. Other famous people born on that date include Tokyo Rose and Ron Kovic.
- Franklin Delano Roosevelt gave permission to have himself impersonated in the film.

- George M. Cohan never received the Congressional Medal of Honor, as depicted in the film. He received a different medal.
- James Cagney gave one of the most memorable performances of his career.
- The songs in the film were all written by George M. Cohan, including *Over There.*

MISTAKES

- There are no mountains visible from Providence, Rhode Island, despite what is shown in the opening scene.
- A shadow of a boom mike sweeps across the set during the singing of *Yankee Doodle Dandy.*
- The American flag shown in the film should have had fewer than 48 stars.
- In the dressing room scene, just before Albee's visit, Jerry Cohan wraps a scarf around his neck while he's talking to George and leaves one end outside of his dressing gown. In the next shot, the scarf is tucked in.

QUOTES

George M. Cohan: My mother thanks you, my father thanks you, my sister thanks you, and I thank you.

George M. Cohan [coming into the apartment and smelling something cooking]: Mmmmm . . . ham or bacon?
Mary: Bacon.
George M. Cohan: Good. Ham makes me self-conscious.

AWARDS

Academy Awards, USA, 1942
 Won: *Oscar, Best Actor,* James Cagney; *Best Music, Scoring of a Musical Picture,* Ray Heindorf, Heinz Roemheld; *Best Sound Recording,* Nathan Levinson (Warner Bros. SSD)
 Nominated: *Oscar, Best Director,* Michael Curtiz; *Best Film Editing,* George Amy; *Best Picture,* William Cagney, Hal B. Wallis, Jack L. Warner; *Best Supporting Actor,* Walter Huston; *Best Writing, Original Story,* Robert Buckner

National Film Preservation Board, USA, 1993

National Film Registry

New York Film Critics Circle Awards, 1942
 Won: *NYFCC Award, Best Actor,* James Cagney.

YANK IN INDO-CHINA

Columbia Pictures Corporation, 1952, b&w, 67 minutes.

Producer: Sam Katzman; **Director:** Wallace Grissell; **Screenwriter:** Samuel Newman; **Cast:** John Archer, Douglas Dick, Harold Fong, Don C. Harvey, Hayward Soo Hoo, Rory Mallinson, Maura Murphy, Leonard Penn, Kam Tong, Pierre Watkin, Jean Willes.

John Archer and Douglas Dick run their own airfreight service in Indochina. When Red Chinese guerrillas come after them, they blow up the communist supplies and escape through the jungle with two women.

The French Indochina War (1945–1954) is described under the film *THE QUIET AMERICAN.*

YANK IN KOREA, A

Columbia Pictures Corporation, 1951, b&w, 73 minutes.

Producer: Sam Katzman; **Director:** Lew Landers; **Screenwriters:** Leo Lieberman, William Sackheim; **Cast:** Lonnie Burr, Tommy Farrell, Richard Gould, William Haade, Ralph Hodges, Brett King, Lon McCallister, Richard Paxton, William Phillips, Larry Stewart, William Tannen, Sunny Vickers, Norman Wayne, Rusty Wescoatt.

Lon McCallister's reckless acts in Korea turn the rest of his unit against him when they realize that he could get them all killed. However, he redeems himself with his heroic acts, which include the destruction of an ammo dump.

YANK IN LIBYA, A

Producers Releasing Corporation, 1942, b&w, 65 minutes.

Producer: George M. Merrick; **Director:** Albert Herman; **Screenwriters:** Sherman L. Lowe, Arthur St. Claire; **Distributor:** Producers Releasing Corporation; **Cast:** Howard Banks, Walter Woolf King, George J. Lewis, Amarilla Morris, Harry Parke, Duncan Renaldo, William Vaughn, H. B. Warner, Joan Woodbury.

Walter Woolf King plays an investigative reporter and war correspondent who uncovers a Nazi ring of gun smugglers in Libya during World War II.

YANK IN THE R.A.F., A

20th Century-Fox, 1941, b&w, 98 minutes.

Producer: Darryl F. Zanuck; **Director:** Henry King; **Screenwriters:** Karl Tunberg, Darrell Ware, Darryl F. Zanuck; **Cast:** Claud Allister, Fortunio Bonanova, Ralph Byrd, James Craven, Richard Fraser, Reginald Gardiner, Stuart Gilchrest, Betty Grable, Denis Green, Ethel Griffies, John Hartley, Dennis Hoey, G. P. Huntley, Charles Irwin, Guy Kingsford, Bruce Lester, Irene Lilyan, Eric Lonsdale, Morton Lowry, Alphonse Martell, Lester Matthews, Hans von Morhart, Reginald Owen, Tyrone Power, Lynne Roberts, Stuart Robertson, John Rogers, Hans Schumm, Donald Stuart, John Sutton, John Wilde, Frederick Worlock.

Tyrone Power, a wild civilian pilot ferrying bombers to beleaguered England, meets pretty Betty Grable and joins the RAF to impress her. The highlight of the film is the miracle at Dunkirk, during which Allied fighters provide air cover for the massive evacuation (see *DUNKIRK*).

YANK IN VIET-NAM, A

Kingman Productions, 1964, b&w, 80 minutes.

Producer: Wray Davis; **Director:** Marshall Thompson; **Screenwriters:** Jack Lewis, Jane Wardell; **Distributor:** Allied Artists; **Cast:** Mario Barri, René Laporte, Enrique Magalona, Donald Seely, Marshall Thompson, Kieu Chinh, Kieu Nanh.

Marshall Thompson, a U.S. Marine whose helicopter was shot down, joins with guerrillas who help him rescue a Vietnamese doctor from the Vietcong.

INTERESTING FACT

- This film was made during America's early involvement in Vietnam, and is interesting as a historical document revealing America's attitudes about Vietnam before the rise of the antiwar movement.

YANK ON THE BURMA ROAD

Metro-Goldwyn-Mayer, 1942, b&w, 66 minutes.

Producer: Samuel Marx; **Director:** George B. Seitz; **Screenwriters:** Hugo Butler, Gordon Kahn, David Lang; **Cast:** Philip Ahn, Turhan Bey, Matthew Boulton, Stuart Crawford, Laraine Day, James B. Leong, Keye Luke, Knox Manning, Barry Nelson, Mrs. Poo Sai, Victor Sen Yung.

Barry Nelson plays a truck driver hired by the Chinese to get vital medical supplies to Chungking during the Sino-Japanese War.

YANKS

United Artists, 1979, color, 139 minutes.

Producers: Joseph Janni, Edward Joseph, Lester Persky; **Director:** John Schlesinger; **Screenwriters:** Walter Bernstein, Colin Welland; **Music:** Richard Rodney Bennett; **Filmed in:** Keithley (railway station) and Stockport, England; **Cast:** Gertie Almond, David Bart, Caroline Blakiston, Nick Brimble, Lynne Carol, John Cassidy, Angela Curran, Janet Dale, Rachel Davies, William Devane, Harry Ditson, Kenneth Drury, Patrick Durkin, Ann Dyson, Lisa Eichhorn, June Ellis, Weston Gavin, Richard Gere, Joe Gladwin, Pearl Hackney, Barry Halliday, George Harris, Simon Harrison, Harriet Harrison, Ray Hassett, Joan Hickson, Nat Jackley, Gerald Jones, Margaret Lacey, Eugene Lipinski, Paul Luty, Al Matthews, Everett McGill, Tony Melody, David Miller, Wendy Morgan, Francis Napier, Jeremy Newson, Tom Nolan, Helen Palmer, Andy Pantelidou, Donald Pickering, John Ratzenberger, Vanessa Redgrave, Rachel Roberts, Sue Robinson, Annie Ross, Antony Sher, Martin Smith, Jackie Smith, Arlen Dean Snyder, Derek Thompson, Paula Tilbrook, Chick Vennera, Philip Whileman, Stephen Whittaker, Marty Wray.

Richard Gere, Chick Vennera, and William Devane portray American GIs who have liaisons with English girls as they train for the invasion of Europe.

The race riot that erupts after a black soldier dances with a white woman is based on historical fact. Although segregation was ended in the U.S. military by President Truman's executive order in 1948, it was still official policy in the U.S. military during World War II. The English people, who did not have the same racial attitudes prevalent in the United States at that time, treated all GIs the same. The U.S. government, afraid that such acceptance, especially of white women by black soldiers, would increase racial problems in the United States after the war, coerced England into officially recognizing American racial policies. The black Yanks also knew the rules, and tried to follow them, although the English people themselves largely ignored these policies.

INTERESTING FACTS

- Over 1 million American soldiers were stationed in England as part of the Allied buildup for D day. With most of the English young men in the army, stationed in places like North Africa, romantic liaisons were bound to arise between American soldiers and young English women.
- A popular phrase of the day was that Americans were "overpaid, oversexed, and over here."

YESTERDAY'S ENEMY

Hammer Film Productions Limited, 1959, b&w, 95 minutes.

Producer: Michael Carreras; **Director:** Val Guest; **Screenwriter:** Peter R. Newman; **Distributor:** Columbia; **Cast:** Philip Ahn, Stanley Baker, Timothy Bateson, Nicholas Brady, Edwina Carroll, Donald Churchill, Bryan Forbes, Barry Foster, Percy Herbert, Gordon Jackson, Alan Keith, David Lodge, Arthur Lovegrove, Barry Lowe, Leo McKern, Wolfe Morris, David Oxley, Richard Pasco, Guy Rolfe, Barry Steele, Russell Waters, Howard Williams.

A small group of British soldiers take over a Burmese jungle village.

YOU CAME ALONG

Paramount Pictures, 1945, b&w, 103 minutes.

Producer: Hal B. Wallis; **Director:** John Farrow; **Screenwriters:** Ayn Rand, Robert Smith (also story); **Music:** Victor Young; **Cast:** Hugh Beaumont, Julie Bishop, Robert Cummings, William B. Davidson, Hal K. Dawson, Don DeFore, Charles Drake, Frank Faylen, Helen Forrest, Howard Freeman, Cindy Garner, Louis Jean Heydt, Kim Hunter, Robert Emmett Keane, Franklin Pangborn, Ruth Roman, Lewis L. Russell, Lizabeth Scott, Robert Sully, Andrew Tombes, Charles La Torre, Minor Watson, Crane Whitley, Rhys Williams, Marjorie Woodworth, Will Wright.

War hero Robert "Bob" Cummings, with two other pilots, is sent on a war bond tour run by Treasury Department worker Lizabeth Scott. Everyone loves Bob; he is a cheerful Lothario with a girl in every town on the tour. After some amusing escapades, Bob and Lizabeth become romantically involved, although they agree that it is "just fun, up in the air." There is a secret reason he doesn't tell her: He doesn't have long to live.

World War II was very expensive, and the U.S. government had to pay for it. The solution, at a time when the personal income tax was just evolving, was to get each American to buy war bonds. You weren't considered a loyal and patriotic citizen unless you bought them. However, people needed to be encouraged to part with their money, so Hollywood personalities and war heroes would be sent on war bond drives, at which crowds would be assembled using the personalities as attractions, and then everyone would be asked to buy a war bond.

YOUNG AND THE BRAVE

Metro-Goldwyn-Mayer, 1963, b&w, 84 minutes.

Producer: A.C. Lyles; **Director:** Francis D. Lyon; **Screenwriters:** Ronald Davidson (story), Beirne Lay Jr., Harry M. Slott (story); **Music:** Ronald Stein; **Distributor:** MGM; **Cast:** John Agar, Richard Arlen, William Bendix, Rory Calhoun, Robert Ivers, Richard Jaeckel, Beirne Lay Jr., Willard Lee, Weaver Levy, Manuel Padilla Jr., Dennis Richards.

Rory Calhoun and William Bendix play sergeants trying to get their unit back to their own lines, with the help of a young Korean orphan and his dog.

YOUNG LIONS, THE

20th Century-Fox, 1958, b&w, 167 minutes.

Producer: Al Lichtman; **Director:** Edward Dmytryk; **Screenwriter:** Edward Anhalt; **Distributors:** 20th Century-Fox; **Cast:** John Alderson, Parley Baer, John Banner, Hal Baylor, Stephen Bekassy, Marlon Brando, May Britt, Julian Burton, Robert Burton, Montgomery Clift, Paul Comi, Ashley Cowan, Dora Doll, Robert Ellenstein, Arthur Franz, Milton Frome, John Gabriel, Richard Gardner, Sam Gilman, L.Q. Jones, Stan Kamber, Kurt Katch, Hope Lange, Dean Martin, Liliane Montevecchi, Clive Morgan, Michael Pataki, Otto Reichow, Gene Roth, Herbert Rudley, Barbara Rush, Jeffrey Sayre, Maximilian Schell, Kendall Scott, Harvey Stephens, Vaughn Taylor, Ivan Triesault, Lee Van Cleef.

Marlon Brando plays a young German officer who sincerely believes that Hitler and the Nazi Party will be good for Germany. As the war progresses, and he witnesses the death and destruction brought on by the war, and the mounting atrocities committed by the Gestapo and other Nazi troops, he becomes increasingly disillusioned. When he arrives at a concentration camp and finds a Nazi officer complaining that he does not have

The Young Lions (20TH CENTURY-FOX/AUTHOR'S COLLECTION)

enough staff to kill all of the prisoners, he smashes his gun and stumbles off into the forest. Montgomery Clift is a Jewish-American soldier determined to withstand the anti-Semitism directed at him. He fist-fights four other soldiers, one at a time. The first three give him terrible beatings, but he wins the fourth fight. Dean Martin is a Broadway singer who tries to dodge the draft. When that doesn't keep him out of the war, he gets himself transferred out of his combat unit and into a safe and cushy rear-echelon job. He feels guilty about what he has done and transfers back to his combat unit and his friend Montgomery Clift. Martin and Clift see Marlon Brando stumbling through the woods and kill him.

The film is based on Irwin Shaw's book *The Young Lions* (New York: Modern Library, 1958).

INTERESTING FACTS

• It was critical to the story that the German officer be an appealing and sympathetic character. There-fore, Marlon Brando, then at the height of his pop-ularity, was cast.

• The novel has a different ending. In the novel, Marlon Brando's character shoots Montgomery Clift, and Brando is then killed by Dean Martin.

QUOTE

Marlon Brando [on hearing the cries of a prisoner being tortured by the Gestapo]: I do not think it's possi-ble to remake the world from the basement of this dirty little police station.

AWARDS

Academy Awards, USA, 1958
Nominated: *Oscar, Best Cinematography, Black-and-White,* Joseph MacDonald; *Best Music, Scoring of a Dramatic or Comedy Picture,* Hugo Friedhofer; *Best Sound,* Carl Faulkner (20th Century-Fox SSD)

British Academy Awards, 1959

 Nominated: *BAFTA Film Award, Best Film from any Source*—USA, *Best Foreign Actor,* Marlon Brando—USA.

YOUNG WARRIORS, THE

Universal Pictures, 1967, color, 93 minutes.

Producer: Gordon Kay; **Director:** John Peyser; **Distributor:** Universal Pictures; **Cast:** Steve Carlson, Jonathon Daly, James Drury, Norman Fell, Hank Jones, Tom Nolan, Robert Pine, Michael Stanwood, Buck Young.

James Drury plays a sergeant leading inexperienced young soldiers, including Steve Carlson, who mature under combat conditions.

The movie is based on Richard Matheson's book *The Beardless Warriors* (Boston: Little, Brown, 1960).

MILITARY SERVICE

- Norman Fell (later Mr. Roper on TV's *Three's Company*) was a U.S. Army Air Force tail gunner in the Pacific during World War II.

Bibliography

Adair, Gilbert. *Hollywood's Vietnam: From The Green Berets to Full Metal Jacket.* London: Heinemann, 1989.

Adair, Gilbert. *Vietnam on Film: From The Green Berets to Apocalypse Now.* New York: Proteus, 1981.

Aldgate, Anthony. *Cinema and History: British Newsreels and the Spanish Civil War.* London: Scolar Press, 1979.

Aldgate, Anthony, and Jeffrey Richards. *Britain Can Take It: The British Cinema in the Second World War.* 2nd ed. Edinburgh: Edinburgh University Press, 1994.

Anderegg, Michael, ed. *Inventing Vietnam: The War in Film and Television, Culture and the Moving Image.* Philadelphia: Temple University Press, 1991.

Auster, Albert, and Leonard Quart. *How the War Was Remembered: Hollywood & Vietnam.* New York: Praeger, 1988.

Baker, Melva Joyce. *Images of Women in Film: The War Years, 1941–1945.* Ann Arbor, Mich.: UMI Research Press, 1980.

Basinger, Jeanine. *The World War II Combat Film: Anatomy of a Genre.* New York: Columbia University Press, 1986.

Bates, Milton J. *The Wars We Took to Vietnam: Cultural Conflict and Storytelling* Berkeley: University of California Press, 1996.

Beidler, Philip D. *The Good War's Greatest Hits: World War II and American Remembering.* Athens: University of Georgia Press, 1998.

Bohn, Thomas W. *An Historical and Descriptive Analysis of the "Why We Fight" Series.* New York: Arno Press, 1977.

Broderick, Mick. *Hibakusha Cinema: Hiroshima, Nagasaki, and the Nuclear Image in Japanese Film.* London: Kegan Paul International; New York: Columbia University Press, 1996.

Broderick, Mick. *Nuclear Movies: A Filmography.* Northcote, Australia: Post-Modern Publishing, 1988.

Brownlow, Kevin. *The War, the West, and the Wilderness.* New York: Knopf, 1978.

Butler, Ivan. *The War Film.* New York: A.S. Barnes, 1974.

Calloway, Catherine. "American Literature and Film of the Vietnam War: Classroom Strategies and Critical Sources," in *The Vietnam War: Teaching Approaches and Resources,* Marc Jason Gilbert. New York: Greenwood Press, 1991.

Campbell, Craig W. *Reel America and World War I: A Comprehensive Filmography and History of Motion Pictures in the United States, 1914–1920.* Jefferson, N.C.: McFarland, 1985.

Chambers, John Whiteclay, and David Culbert, eds. *World War II, Film, and History.* New York: Oxford U. Press, 1996.

Chapman, James. *The British at War: Cinema, State, and Propaganda, 1939–1945.* London, I. B. Tauris, 1998.

Christopher, Renny. *The Viet Nam War/The American War: Images and Representations in Euro-American and Vietnamese Exile Narratives.* Amherst: University of Massachusetts Press, 1995.

Coultass, Clive. *Images for Battle: British Film and the Second World War, 1939–1945.* Newark: University of Delaware Press, 1989.

Cullen, Jim. *The Civil War in Popular Culture: A Reusable Past.* Washington: Smithsonian Institution Press, 1995.

DeBauche, Leslie Midkiff. *Reel Patriotism: The Movies and World War I.* Madison, Wis. : U. of Wisconsin Press, 1997

Devine, Jeremy M. *Vietnam at 24 Frames a Second: A Critical and Thematic Analysis of Over 400 Films About the Vietnam War.* Jefferson, N.C.: McFarland, 1995.

Dibbets, Karel, and Bert Hogenkamp, eds. *Film and the First World War.* Amsterdam: Amsterdam Univers. Press, 1995.

Dick, Bernard F. *The Star-Spangled Screen: The American World War II Film.* Lexington: University Press of Kentucky, 1985.

Ditmar, Linda, and Gene Michaud, eds. *From Hanoi to Hollywood: The Vietnam War in American Film.* New Brunswick, N.J.: Rutgers University Press, 1990.

Doherty, Thomas Patrick. *Projections of War: Hollywood, American Culture, and World War II.* New York: Columbia University Press, 1993.

Dolan, Edward F. *Hollywood Goes to War.* Twickenham, U.K.: Hamlyn, 1985.

Dowling, John. *War/Peace Film Guide. Rev. Ed.* Chicago: World Without War Publications, 1980.

Elley, Derek. *The Epic Film: Myth and History.* Boston: Routledge and Kegan Paul, 1984.

Evans, Gary, John Grierson, and the National Film Board. *The Politics of Wartime Propaganda.* Toronto: University of Toronto Press, 1984.

Evans, Joyce A. *Celluloid Mushroom Clouds: Hollywood and the Atomic Bomb.* Boulder, Colo.: Westview Press, 1998.

Foertsch, Jacqueline. *Enemies Within: the Cold War and the AIDS Crisis in Literature, Film, and Culture.* Urbana: University of Illinois Press, 2001.

Fyne, Robert. *The Hollywood Propaganda of World War II.* Metuchen, N.J.: Scarecrow Press, 1994.

Gheorghiu-Cernat, Manuela. *Arms and the Film: War and Peace in European Films.* Bucharest: Meridiane Publishing House, 1983.

Gilman, Owen Jr. and Lorrie Smith, Eds. *America Rediscovered: Critical Essays on Literature and Film of the Vietnam War.* New York: Garland, 1990.Gifford, Denis. *The British Film Catalogue, 1895-1985: a Reference Guide.* New York: Facts on File, Inc.,1987.

Gledhill, Christine, and Gillian Swanson, eds. *Nationalising Femininity: Culture, Sexuality, and British Cinema in the Second World War.* New York: Facts On File, 1986.

Hellmann, John. *American Myth and the Legacy of Vietnam.* New York: Columbia University Press, 1986.

Hillstrom, Kevin. *The Vietnam Experience: A Concise Encyclopedia of American Literature, Songs, and Films.* Westport, Conn.: Greenwood Press, 1998.

Holsinger, M. Paul, ed. *War and American Popular Culture: a Historical Encyclopedia.* Westport, Conn.: Greenwood Press, 1999.

Hoopes, Roy. *When the Stars Went to War: Hollywood and World War II.* New York: Random House, 1994.

Hyams, Jay. *War Movies.* New York: W.H. Smith, 1984.

Isenberg, Michael T. *War on Film: The American Cinema and World War I, 1914–1941.* London and Toronto: Associated University Presses, 1981.

Jeffords, Susan. *The Remasculinization of America: Gender and the Vietnam War.* Bloomington: Indiana University Press, 1989.

Kane, Kathryn. *Visions of War: Hollywood Combat Films of World War II.* Ann Arbor, Mich.: UMI Research Press, 1982.

Kedward, H.R., and Nancy Wood. *The Liberation of France: Image and Event.* Washington, D.C.: Berg, 1995.

Kelly, Andrew. *Cinema and the Great War.* London; New York: Routledge, 1997.

Kinney, Katherine. *Friendly Fire: American Images of the Vietnam War.* Oxford and New York: Oxford University Press, 2000.

Klein, Michael, ed. *Vietnam Era: Media and the Pop Culture in the US and Vietnam.* London: Pluto Press, 1989.

Koppes, Clayton R., and Gregory D. Black. *Hollywood Goes to War: How Politics, Profits, and Propaganda Shaped World War II Movies.* New York: Free Press, 1987.

Korte, Barbara. "The Grandfathers' War: Re-Imagining World War I in British Novels and Films of the 1990s," in *Retrovisions: Reinventing the Past in Film and Fiction,* edited by Deborah Cartmell, I.Q. Hunter, and Imelda Whelehan. Sterling, Va.: Pluto Press, 2001.

Langman, Larry and Ed Borg, Eds. *Encyclopedia of American War Films.* New York: Garland, 1989.

Lant, Antonia. *Blackout: Reinventing Women for Wartime British Cinema.* Princeton, N.J.: Princeton University Press, 1991.

Lipschutz, Ronnie D. *Cold War Fantasies: Film, Fiction, and Foreign Policy.* Lanham, Md.: Rowman & Littlefield, 2001.

Look, *Editors of Movie Lot to Beachhead, The Motion Picture Goes to War and Prepares for the Future.* Garden City, N.Y.: Doubleday, Doran, 1945.

Mannix, Patrick. *The Rhetoric of Antinuclear Fiction: Persuasive Strategies in Novels and Films.* Lewisburg, Pa.: Bucknell University Press, 1992.

Malo, Jean-Jacques, and Tony Williams, eds. *Vietnam War Films: Over 600 Feature, Made-for-TV, Pilot, and Short Movies,1939–1992, From the United States, Vietnam, France, Belgium, Australia, Hong Kong, South Africa, Great Britain, and Other Countries.* Jefferson, N.C.: McFarland, 1994.

Manvell, Roger. *Films and the Second World War.* South Brunswick, N.J.: A. S. Barnes, 1974.

Martin, Andrew. *Receptions of War: Vietnam in American Culture.* Norman: University of Oklahoma Press, 1993.

Marx, Samuel. "The Bomb Movie," in *The Movies: Texts, Receptions, Exposures,* Laurence Goldstein and Ira Konigsberg. Ann Arbor: University of Michigan Press, 1996.

Michalczyk, John J. *Andre Malraux's Espoir: The Propaganda/Art Film and the Spanish Civil War.* University, Mich.: Romance Monographs, 1977.

Monteath, Peter. *The Spanish Civil War in Literature, Film, and Art: An International Bibliography of Secondary Literature.* Westport, Conn.: Greenwood Press, 1994.

Mould, David Harley. *American Newsfilm, 1914–1919: The Underexposed War.* New York: Garland, 1983.

Muse, Eben J. *The Land of Nam: The Vietnam War in American Film.* Lanham, Md.: Scarecrow Press, 1995.

Newman, Kim. *Apocalypse Movies: End of the World Cinema.* New York: St. Martin's Griffin, 2000.

O'Nan, Stewart, ed. *The Vietnam Reader: the Definitive Collection of American Fiction and Nonfiction on the War.* New York : Anchor Books, c1998.

Paris, Michael. *The First World War and Popular Cinema: 1914 to the Present.* Brunswick, N.J. : Rutgers University Press, 2000.

Pendergast, Tom and Sara Pendergast, eds. *St. James Encyclopedia of Popular Culture.* 5 vols. Detroit : St. James Press, 2000.

Pendo, Stephen. *Aviation in the Cinema.* Metuchen, N.J.: Scarecrow Press, 1985.

Pronay, Nicholas D., and D. W. Spring, eds. *Propaganda, Politics, and Film, 1918–45.* London: Macmillan Press, 1982.

Reeves, Nicholas. *Official British Film Propaganda During the First World War.* London and Wolfeboro, N.H.: C. Helm, 1986.

Reimer, Robert, and Carol J. Reimer. *Nazi-retro Film: How German Narrative Cinema Remembers the Past.* New York: Twayne, 1992.

Renov, Michael. "*Hollywood's Wartime Woman: Representation and Ideology.*" Studies in cinema, no. 42. Ann Arbor, Mich.: UMI Research Press, c1988.

Santner, Eric L. *Stranded Objects: Mourning, Memory, and Film in Postwar Germany*. Ithaca, N.Y.: Cornell University Press, 1990.

Sayre, Nora. *Running Time: Films of the Cold War*. New York: Dial Press, 1982.

Searle, William J., ed. *Search and Clear: Critical Responses to Selected Literature and Films of the Vietnam War*. Bowling Green, Ohio: Bowling Green State University Popular Press, 1988.

Shaheen, Jack G., ed. *Nuclear War Films*. Carbondale: Southern Illinois University Press, 1978

Shapiro, Jerome F. *Atomic Bomb Cinema: the Apocalyptic Imagination on Film*. New York: Routledge, 2002.

Shaw, Tony. *British Cinema and the Cold War: the State, Propaganda and Consensus*. London: I. B. Tauris; New York: St. Martin's Press, 2001.

Shindler, Colin. *Hollywood Goes to War: Films and American Society, 1939–1952*. Boston : Routledge & K. Paul, 1979.

Shull, Michael S., and David Edward Wilt. *Hollywood War Films, 1937–1945: an Exhaustive Filmography of American Feature-length Motion pictures Relating to World War II*. Jefferson, N.C.: McFarland, 1996.

Shull, Michael S., and David E. Wilt. *Doing Their Bit: Wartime American Animated Short Films, 1939–1945*. Jefferson, N.C.: McFarland, 1987.

Simone, Sam. *Hitchcock as Activist: Politics and the War Films*. Ann Arbor, Mich.: UMI Research Press, 1985.

Slotkin, Richard. *Gunfighter Nation: The Myth of the Frontier in Twentieth-Century America*. New York: Harper, 1993.

Stewart, Ian, and Susan L. Carruthers, eds. *War, Culture, and the Media: Representations of the Military in 20th Century Britain*. Trowbridge, Wiltshire : Flicks Books ; Madison, N.J. : Fairleigh Dickinson University Press, 1996.

Studlar, Gaylyn. "Never Having to Say You're Sorry: Rambo's Rewriting of the Vietnam War." In *From Hanoi to Hollywood: The Vietnam War in American Film*, ed. Linda Dittmar and Gene Michaud. New Brunswick: Rutgers University Press, 1990. pp 101–112.

Sturken, Marita. *Tangled Memories: the Vietnam War, the AIDS Epidemic, and the Politics of Remembering*. Berkeley : University of California Press, 1997.

Taylor, Philip M., ed. *Britain and the Cinema in the Second World War*. New York: St. Martin's Press, 1988.

Tucker, Spencer C., ed. *Encyclopedia of the Vietnam War: a Political, Social, and Military History*. Santa Barbara, Calif.: ABC-CLIO, 1998.

Valleau, Marjorie A. *The Spanish Civil War in American and European Films*. Ann Arbor, Mich.: UMI Research Press, 1982.

Virilio, Paul. *War and Cinema: the Logistics of Perception*. Translated by Patrick Camiller. London and New York: Verso, 1989.

Walker, Mark. *Vietnam Veteran Films*. Metuchen, N.J.: Scarecrow Press, 1991.

War Movies: *A Guide to More than 500 Films on Videocassette*. Evanston, Ill.: CineBooks, 1989.

Wetta, Frank J. and Stephen J. Curley, Eds. *Celluloid Wars: A Guide to Film and the American Experience of War*. New York: Greenwood, 1992.

West, Philip, Steven I. Levine, and Jackie Hiltz, eds. *America's Wars in Asia: a Cultural Approach to History and Memory*. Armonk, N.Y. : M.E. Sharpe, 1997.

Wilson, James. *Vietnam in Prose and Film*. Jefferson, N.C.: McFarland, 1982.

Wood, Robin. *Hollywood from Vietnam to Reagan*. New York: Columbia University Press. 2003.

Wright, Basil. "Land Without Bread and Spanish Earth." In *The Documentary Tradition*, ed. Lewis Jacobs. 2nd ed. New York: Norton, 1979. pp 146–148.

Zabecki, David T., ed. *World War II in Europe: an Encyclopedia*. New York : Garland Pub., 1999.

Index

Page numbers in **bold** indicate main headings. Page numbers followed by the letter *f* indicate illustrations.